Portable Edition | Book 6

Fifth Edition

ART HISTORY

Eighteenth to Twenty-First Century Art

MARILYN STOKSTAD

Judith Harris Murphy Distinguished Professor of Art History Emerita The University of Kansas

MICHAEL W. COTHREN

Scheuer Family Professor of Humanities Department of Art, Swarthmore College

PEARSON

Boston Columbus Indianapolis New York San Francisco Upper Saddle River

Amsterdam Cape Town Dubai London Madrid Milan Munich Paris Montréal Toronto

Delhi Mexico City São Paulo Sydney Hong Kong Seoul Singapore Taipei Tokyo

¿ditorial Director: Craig Campanella Editor in Chief: Sarah Touborg

Senior Sponsoring Editor: Helen Ronan Editorial Assistant: Victoria Engros

Vice-President, Director of Marketing: Brandy Dawson

Executive Marketing Manager: Kate Mitchell

Marketing Assistant: Paige Patunas Managing Editor: Melissa Feimer

Project Managers: Barbara Cappuccio and Marlene Gassler

Senior Operations Supervisor: Mary Fischer

Operations Specialist: Diane Peirano Media Director: Brian Hyland Senior Media Editor: David Alick Media Project Manager: Rich Barnes Pearson Imaging Center: Corin Skidds Printer/Binder: Courier / Kendallville

Cover Printer: Lehigh-Phoenix Color / Hagerstown

This book was designed by Laurence King Publishing Ltd, London www.laurenceking.com

Editorial Manager: Kara Hattersley-Smith

Senior Editor: Clare Double

Production Manager: Simon Walsh

Page Design: Nick Newton Cover Design: Jo Fernandes Picture Researcher: Evi Peroulaki Copy Editor: Jennifer Speake Indexer: Vicki Robinson

Cover image: Judy Chicago, *The Dinner Party*, 1974–1979. White tile floor inscribed in gold with 999 women's names; triangular table with painted porcelain, sculpted porcelain plates, and needlework, each side 48′ × 42′ × 3′ (14.6 × 12.8 × 1 m). Collection of The Brooklyn Museum of Art, Gift of the Elizabeth A. Sackler Foundation. Photograph © Donald Woodman/Through the Flower. © 2012 Judy Chicago/Artists Rights Society (ARS), New York.

Credits and acknowledgments borrowed from other sources and reproduced, with permission, in this textbook appear on the appropriate page within text or on the credit pages in the back of this book.

Copyright © 2014, 2011, 2008 by Pearson Education, Inc.

All rights reserved. Printed in the United States of America. This publication is protected by Copyright and permission should be obtained from the publisher prior to any prohibited reproduction, storage in a retrieval system, or transmission in any form or by any means, electronic, mechanical, photocopying, recording, or likewise. To obtain permission(s) to use material from this work, please submit a written request to Pearson Education, Inc., Permissions Department, One Lake Street, Upper Saddle River, New Jersey 07458 or you may fax your request to 201-236-3290.

Library of Congress Cataloging-in-Publication Data

Stokstad, Marilyn

Art history / Marilyn Stokstad, Judith Harris Murphy Distinguished Professor of Art History Emerita, The University of Kansas, Michael W. Cothren, Scheuer Family Professor of Humanities, Department of Art, Swarthmore College. — Fifth edition.

pages cm Includes bibliographical references and index. ISBN-13: 978-0-205-87347-0 (hardcover) ISBN-10: 0-205-87347-2 (hardcover)

1. Art--History--Textbooks. I. Cothren, Michael Watt. II. Title.

N5300.S923 2013 709--dc23

2012027450

10 9 8 7 6 5 4 3 2 1

Prentice Hall is an imprint of

ISBN 10: 0-205-87756-7 ISBN 13: 978-0-205-87756-0

Contents

Pearson Choices v . Starter Kit vi

Eighteenth- and Early Nineteenth-Century Art in Europe and North America 904

INDUSTRIAL, INTELLECTUAL, AND POLITICAL **REVOLUTIONS 906**

ROCOCO 907

Rococo Salons 907 Rococo Painting and Sculpture 908 Rococo Church Decoration 912

ITALY: THE GRAND TOUR AND **NEOCLASSICISM 913**

Grand Tour Portraits and Views 913 Neoclassicism in Rome 915

NEOCLASSICISM AND EARLY ROMANTICISM IN BRITAIN 917

The Classical Revival in Architecture and Design 918 The Gothic Revival in Architecture and Design 921 Trends in British Painting 922

LATER EIGHTEENTH-CENTURY ART IN FRANCE 932

Architecture 932 Painting and Sculpture 934

ART IN SPAIN AND SPANISH AMERICA 940

Portraiture and Protest in Spain: Goya 940 The Art of the Americas under Spain 943

EARLY NINETEENTH-CENTURY ART: NEOCLASSICISM AND ROMANTICISM 945

Developments in France 946

Romantic Landscape Painting 954

GOTHIC AND NEOCLASSICAL STYLES IN EARLY NINETEENTH-CENTURY ARCHITECTURE 958

BOXES

ART AND ITS CONTEXTS

Academies and Academy Exhibitions 926

A BROADER LOOK

The Raft of the "Medusa" 948

A CLOSER LOOK

Georgian Silver 921

ELEMENTS OF ARCHITECTURE

Iron as a Building Material 928

TECHNIQUE

Lithography 954

Mid- to Late Nineteenth-Century Art in Europe and the United States 962

EUROPE AND THE UNITED STATES IN THE MID TO LATE NINETEENTH CENTURY 964

FRENCH ACADEMIC ARCHITECTURE AND ART 964

Academic Architecture 965 Academic Painting and Sculpture 966

EARLY PHOTOGRAPHY IN EUROPE AND THE UNITED STATES 968

REALISM AND THE AVANT-GARDE 972

Realism and Revolution 972 Manet: "The Painter of Modern Life" 976 Responses to Realism beyond France 980

IMPRESSIONISM 987

Landscape and Leisure 987 Modern Life 991

THE LATE NINETEENTH CENTURY 994

Post-Impressionism 994 Symbolism 999 French Sculpture 1003 Art Nouveau 1004

THE BEGINNINGS OF MODERNISM 1007

European Architecture: Technology and Structure 1007 The Chicago School 1009 Cézanne 1012

BOXES

ART AND ITS CONTEXTS

Orientalism 968 The Mass Dissemination of Art 978 Art on Trial in 1877 985

■ A BROADER LOOK

Modern Artists and World Cultures: Japonisme 996

A CLOSER LOOK

Mahana no atua (Day of the God) 1000

ELEMENTS OF ARCHITECTURE

The City Park 1010

■ TECHNIQUE

The Photographic Process 971

EUROPE AND AMERICA IN THE EARLY TWENTIETH CENTURY 1018

EARLY MODERN ART IN EUROPE 1019

The Fauves: Wild Beasts of Color 1019
Picasso, "Primitivism," and the Coming of Cubism 1021
The Bridge and Primitivism 1026
Independent Expressionists 1028
Spiritualism of the Blue Rider 1029
Extensions of Cubism 1031
Toward Abstraction in Traditional Sculpture 1036
Dada: Questioning Art Itself 1037

MODERNIST TENDENCIES IN AMERICA 1040

Stieglitz and the "291" Gallery 1040 The Armory Show and Home-Grown Modernism 1041

EARLY MODERN ARCHITECTURE 1044

European Modernism 1044 American Modernism 1046

ART BETWEEN THE WARS IN EUROPE 1050

Utilitarian Art Forms in Russia 1050 De Stijl in the Netherlands 1052 The Bauhaus in Germany 1054 Surrealism and the Mind 1057 Unit One in England 1060

MODERN ART IN THE AMERICAS BETWEEN THE WARS 1060

The Harlem Renaissance 1060 Rural America 1065 Canada 1067 Mexico 1068 Brazil 1070 Cuba 1071

POSTWAR ART IN EUROPE AND THE AMERICAS 1071

Figural Responses and Art Informel in Europe 1071 Experiments in Latin America 1072 Abstract Expressionism in New York 1073

BOXES

ART AND ITS CONTEXTS

Suppression of the Avant-Garde in Nazi Germany 1056 Federal Patronage for American Art During the Depression 1066

A BROADER LOOK

Guernica 1062

A CLOSER LOOK

Portrait of a German Officer 1042

■ ELEMENTS OF ARCHITECTURE

The Skyscraper 1049
The International Style 1057

THE WORLD SINCE THE 1950s 1084

The Art World since the 1950s 1084

THE EXPANDING ART WORLD 1084

Assemblage 1084 Happenings and Performance Art 1087 Photography 1089 Pop Art 1091

THE DEMATERIALIZATION OF THE ART OBJECT 1095

Minimalism 1095
Conceptual and Performance Art 1096
Process Art 1099
Feminism and Art 1101
Earthworks and Site-Specific Sculpture 1102

ARCHITECTURE: MID-CENTURY MODERNISM TO POSTMODERNISM 1104

Mid-century Modernist Architecture 1104 Postmodern Architecture 1106

POSTMODERNISM 1107

Painting 1107
Postmodernism and Gender 1109
Postmodernism and Race or Ethnicity 1111
Sculpture 1114

ART, ACTIVISM, AND CONTROVERSY: THE NINETIES 1116 The Culture Wars 1116

The Culture Wars 1116
Activist Art 1120
Postcolonial Discourse 1124
High Tech and Deconstructivist Architecture 1125
Video and Film 1128

GLOBALISM: INTO THE NEW MILLENNIUM 1129

Art and Technology 1130 Art and Identities 1132

BOXES

ART AND ITS CONTEXTS

The Guerrilla Girls 1110 Controversies over Public Funding for the Arts 1118

A BROADER LOOK

The Dinner Party 1100

A CLOSER LOOK

Plenty's Boast 1117

Map 1138 • Glossary 1139 • Bibliography 1148 Credits 1151 • Index 1153

Give Your Students Choices

ORDERING OPTIONS

Pearson arts titles are available in the following formats to give you and your students more choices—and more ways to save.

MyArtsLab with eText: the Pearson eText lets students access their textbook anytime, anywhere, and any way they want, including listening online or downloading to an iPad.

MyArtsLab with eText Combined: 0-205-88736-8 MyArtsLab with eText Volume I: 0-205-94839-1 MyArtsLab with eText Volume II: 0-205-94846-4

Build your own Pearson Custom e-course material. Pearson offers the first eBook-building platform that empowers educators with the freedom to search, choose, and seamlessly integrate multimedia. *Contact your Pearson representative to get started.*

The **Books à la Carte edition** offers a convenient, three-hole-punched, loose-leaf version of the traditional text at a discounted price—allowing students to take only what they need to class. Books à la Carte editions are available both with and without access to MyArtsLab.

Books à la Carte edition Volume I: 0-205-93840-X Books à la Carte edition Volume I plus MyArtsLab: 0-205-93847-7 Books à la Carte edition Volume II: 0-205-93844-2 Books à la Carte edition Volume II plus MyArtsLab: 0-205-93846-9

The CourseSmart eTextbook offers the same content as the printed text in a convenient online format—with highlighting, online search, and printing capabilities. www.coursesmart.com

Art History **Portable edition** has all of the same content as the comprehensive text in six slim volumes. If your survey course is Western, the Portable Edition is available in value-package combinations to suit Western-focused courses (Books 1, 2, 4, and 6). Portable Edition volumes are also available individually for period or region specific courses.

Book 1 - Ancient Art (Chapters 1-6): 978-0-205-87376-0

Book 2 – Medieval Art (Chapters 7–9, 15–18):

978-0-205-87377-7

Book 3 – A View of the World, Part One (Chapters 9–14): 978-0-205-87378-4

Book 4 – Fourteenth to Seventeenth Century Art (Chapters 18–23): 978-0-205-87379-1

Book 5 – A View of the World, Part Two (Chapters 24–29): 978-0-205-87380-7

Book 6 – Eighteenth to Twenty-first Century Art (Chapters 30–33): 978-0-205-87756-0

INSTRUCTOR RESOURCES

All of our instructor resources are found on MyArtsLab and are available to faculty who adopt *Art History*. These resources include:

PowerPoints featuring nearly every image in the book, with captions and without captions.

Teaching with MyArtsLab PowerPoints help instructors make their lectures come alive. These slides allow instructors to display the very best rich media from MyArtsLab in the class-room—quickly and easily.

Instructor's Manual and Test Item File

This is an invaluable professional resource and reference for new and experienced faculty.

The Class Preparation Tool collects these and other presentation resources in one convenient online destination.

Starter Kit

Art history focuses on the visual arts—painting, drawing, sculpture, prints, photography, ceramics, metalwork, architecture, and more. This Starter Kit contains basic information and addresses concepts that underlie and support the study of art history. It provides a quick reference guide to the vocabulary used to classify and describe art objects. Understanding these terms is indispensable because you will encounter them again and again in reading, talking, and writing about art.

Let us begin with the basic properties of art. A work of art is a material object having both form and content. It is often described and categorized according to its *style* and *medium*.

FORM

Referring to purely visual aspects of art and architecture, the term form encompasses qualities of line, shape, color, light, texture, space, mass, volume, and composition. These qualities are known as formal elements. When art historians use the term formal, they mean "relating to form."

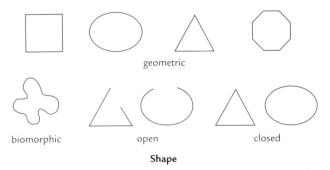

Line and shape are attributes of form. Line is an element—usually drawn or painted—the length of which is so much greater than the width that we perceive it as having only length. Line can be actual, as when the line is visible, or it can be implied, as when the movement of the viewer's eyes over the surface of a work follows a path determined by the artist. Shape, on the other hand, is the two-dimensional, or flat, area defined by the borders of an enclosing *outline* or *contour*. Shape can be *geometric*, *biomorphic* (suggesting living things; sometimes called *organic*), *closed*, or *open*. The *outline* or *contour* of a three-dimensional object can also be perceived as line.

Color has several attributes. These include hue, value, and saturation.

Hue is what we think of when we hear the word *color*, and the terms are interchangeable. We perceive hues as the result of differing wavelengths of electromagnetic energy. The visible spectrum, which can be seen in a rainbow, runs from red through violet. When the ends of the spectrum are connected through the hue red-violet, the result may be diagrammed as a color wheel. The primary hues (numbered 1) are red, yellow, and blue. They are known as primaries because all other colors are made by combining these hues. Orange, green, and violet result from the mixture of two primaries and are known as secondary hues (numbered 2). Intermediate hues, or tertiaries (numbered 3), result from the mixture of a primary and a secondary. Complementary colors are the two colors directly opposite one

another on the color wheel, such as red and green. Red, orange, and yellow are regarded as warm colors and appear to advance toward us. Blue, green, and violet, which seem to recede, are called cool colors. Black and white are not considered colors but neutrals; in terms of light, black is understood as the absence of color and white as the mixture of all colors.

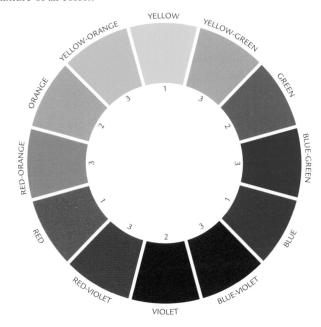

Value is the relative degree of lightness or darkness of a given color and is created by the amount of light reflected from an object's surface. A dark green has a deeper value than a light green, for example. In black-and-white reproductions of colored objects, you see only value, and some artworks—for example, a drawing made with black ink—possess only value, not hue or saturation.

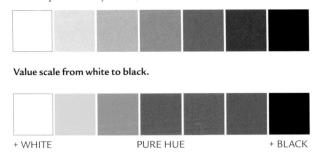

Value variation in red.

Saturation, also sometimes referred to as *intensity*, is a color's quality of brightness or dullness. A color described as highly saturated looks vivid and pure; a hue of low saturation may look a little muddy or grayed.

Intensity scale from bright to dull.

Texture, another attribute of form, is the tactile (or touch-perceived) quality of a surface. It is described by words such as *smooth*, *polished*, *rough*, *prickly*, *grainy*, or *oily*. Texture takes two forms: the texture of the actual surface of the work of art and the implied (illusionistically described) surface of objects represented in the work of art.

Space is what contains forms. It may be actual and three-dimensional, as it is with sculpture and architecture, or it may be fictional, represented illusionistically in two dimensions, as when artists represent recession into the distance on a flat surface—such as a wall or a canvas—by using various systems of perspective.

Mass and volume are properties of three-dimensional things. Mass is solid matter—whether sculpture or architecture—that takes up space. Volume is enclosed or defined space, and may be either solid or hollow. Like space, mass and volume may be illusionistically represented on a two-dimensional surface, such as in a painting or a photograph.

Composition is the organization, or arrangement, of forms in a work of art. Shapes and colors may be repeated or varied, balanced symmetrically or asymmetrically; they may be stable or dynamic. The possibilities are nearly endless and artistic choice depends both on the

time and place where the work was created as well as the object of individual artists. Pictorial depth (spatial recession) is a special ized aspect of composition in which the three-dimensional world is represented on a flat surface, or *picture plane*. The area "behind" the picture plane is called the *picture space* and conventionally contains three "zones": *foreground*, *middle ground*, and *background*.

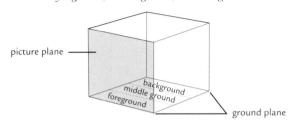

Various techniques for conveying a sense of pictorial depth have been devised by artists in different cultures and at different times. A number of them are diagrammed here. In some European art, the use of various systems of *perspective* has sought to create highly convincing illusions of recession into space. At other times and in other cultures, indications of recession are actually suppressed or avoided to emphasize surface rather than space.

TECHNIQUE | Pictorial Devices for Depicting Recession in Space

overlapping

In overlapping, partially covered elements are meant to be seen as located behind those covering them.

diminution

In diminution of scale, successively smaller elements are perceived as being progressively farther away than the largest ones.

vertical perspective

Vertical perspective stacks elements, with the higher ones intended to be perceived as deeper in space.

atmospheric perspective

Through atmospheric perspective, objects in the far distance (often in bluish-gray hues) have less clarity than nearer objects. The sky becomes paler as it approaches the horizon.

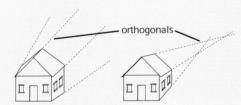

divergent perspective

In divergent or reverse perspective, forms widen slightly and imaginary lines called orthogonals diverge as they recede in space.

intuitive perspective

Intuitive perspective takes the opposite approach from divergent perspective. Forms become narrower and orthogonals converge the farther they are from the viewer, approximating the optical experience of spatial recession.

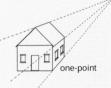

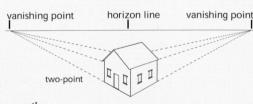

linear perspective

Linear perspective (also called scientific, mathematical, one-point and Renaissance perspective) is a rationalization or standardization of intuitive perspective that was developed in fifteenth-century Italy. It uses mathematical formulas to construct images in which all elements are shaped by, or arranged along, orthogonals that converge in one or more vanishing points on a horizon line.

CONTENT

Content includes subject matter, but not all works of art have subject matter. Many buildings, paintings, sculptures, and other art objects include no recognizable references to things in nature nor to any story or historical situation, focusing instead on lines, colors, masses, volumes, and other formal elements. However, all works of art—even those without recognizable subject matter—have content, or meaning, insofar as they seek to communicate ideas, convey feelings, or affirm the beliefs and values of their makers, their patrons, and usually the people who originally viewed or used them.

Content may derive from the social, political, religious, and economic *contexts* in which a work was created, the *intention* of the artist, and the *reception* of the work by beholders (the audience). Art historians, applying different methods of *interpretation*, often arrive at different conclusions regarding the content of a work of art, and single works of art can contain more than one meaning because they are occasionally directed at more than one audience.

The study of subject matter is called *iconography* (literally, "the writing of images") and includes the identification of *symbols*—images that take on meaning through association, resemblance, or convention.

STYLE

Expressed very broadly, *style* is the combination of form and composition that makes a work distinctive. *Stylistic analysis* is one of art history's most developed practices, because it is how art historians recognize the work of an individual artist or the characteristic manner of groups of artists working in a particular time or place. Some of the most commonly used terms to discuss *artistic styles* include *period style*, *regional style*, *representational style*, *abstract style*, *linear style*, and *painterly style*.

Period style refers to the common traits detectable in works of art and architecture from a particular historical era. It is good practice not to use the words "style" and "period" interchangeably. Style is the sum of many influences and characteristics, including the period of its creation. An example of proper usage is "an American house from the Colonial period built in the Georgian style."

Regional style refers to stylistic traits that persist in a geographic region. An art historian whose specialty is medieval art can recognize Spanish style through many successive medieval periods and can distinguish individual objects created in medieval Spain from other medieval objects that were created in, for example, Italy.

Representational styles are those that describe the appearance of recognizable subject matter in ways that make it seem lifelike.

Realism and Naturalism are terms that some people used interchangeably to characterize artists' attempts to represent the observable world in a manner that appears to describe its visual appearance accurately. When capitalized, Realism refers to a specific period style discussed in Chapter 31.

Idealization strives to create images of physical perfection according to the prevailing values or tastes of a culture. The artist may work in a representational style and idealize it to capture an underlying value or expressive effect.

Illusionism refers to a highly detailed style that seeks to create a convincing illusion of physical reality by describing its visual appearance meticulously.

Abstract styles depart from mimicking lifelike appearance to capture the essence of a form. An abstract artist may work from nature or from a memory image of nature's forms and colors, which are simplified, stylized, perfected, distorted, elaborated, or otherwise transformed to achieve a desired expressive effect.

Nonrepresentational (or Nonobjective) Art is a term often used for works of art that do not aim to produce recognizable natural imagery.

Expressionism refers to styles in which the artist exaggerates aspects of form to draw out the beholder's subjective response or to project the artist's own subjective feelings.

Linear describes both styles and techniques. In linear styles artists use line as the primary means of definition. But linear paintings can also incorporate *modeling*—creating an illusion of three-dimensional substance through shading, usually executed so that brush-strokes nearly disappear.

Painterly describes a style of representation in which vigorous, evident brushstrokes dominate, and outlines, shadows, and highlights are brushed in freely.

MEDIUM AND TECHNIQUE

Medium (plural, media) refers to the material or materials from which a work of art is made. Today, literally anything can be used to make a work of art, including not only traditional materials like paint, ink, and stone, but also rubbish, food, and the earth itself.

Technique is the process that transforms media into a work of art. Various techniques are explained throughout this book in Technique boxes. Two-dimensional media and techniques include painting, drawing, prints, and photography. Three-dimensional media and techniques are sculpture (for example, using stone, wood, clay or cast metal), architecture, and many small-scale arts (such as jewelry, containers, or vessels) in media such as ceramics, metal, or wood.

Painting includes wall painting and fresco, illumination (the decoration of books with paintings), panel painting (painting on wood panels), painting on canvas, and handscroll and hanging scroll painting. The paint in these examples is pigment mixed with a liquid vehicle, or binder. Some art historians also consider pictorial media such as mosaic and stained glass—where the pigment is arranged in solid form—as a type of painting.

Graphic arts are those that involve the application of lines and strokes to a two-dimensional surface or support, most often paper. Drawing is a graphic art, as are the various forms of printmaking. Drawings may be sketches (quick visual notes, often made in preparation for larger drawings or paintings); studies (more carefully drawn analyses of details or entire compositions); cartoons (full-scale drawings made in preparation for work in another medium, such as fresco, stained glass, or tapestry); or complete artworks in themselves. Drawings can be made with ink, charcoal, crayon, or pencil. Prints, unlike drawings,

are made in multiple copies. The various forms of printmaking include woodcut, the intaglio processes (engraving, etching, drypoint), and lithography.

Photography (literally, "light writing") is a medium that involves the rendering of optical images on light-sensitive surfaces. Photographic images are typically recorded by a camera.

Sculpture is three-dimensional art that is *carved*, *modeled*, *cast*, or *assembled*. Carved sculpture is subtractive in the sense that the image is created by taking away material. Wood, stone, and ivory are common materials used to create carved sculptures. Modeled sculpture is considered additive, meaning that the object is built up from a material, such as clay, that is soft enough to be molded and shaped. Metal sculpture is usually cast or is assembled by welding or a similar means of permanent joining.

Sculpture is either free-standing (that is, surrounded by space) or in pictorial relief. Relief sculpture projects from the background surface of the same piece of material. High-relief sculpture projects far from its background; low-relief sculpture is only slightly raised; and sunken relief, found mainly in ancient Egyptian art, is carved into the surface, with the highest part of the relief being the flat surface.

Ephemeral arts include processions, ceremonies, or ritual dances (often with décor, costumes, or masks); performance art; earthworks; cinema and video art; and some forms of digital or computer art. All impose a temporal limitation—the artwork is viewable for a finite period of time and then disappears forever, is in a constant state of change, or must be replayed to be experienced again.

Architecture creates enclosures for human activity or habitation. It is three-dimensional, highly spatial, functional, and closely bound with developments in technology and materials. Since it is difficult to capture in a photograph, several types of schematic drawings are commonly used to enable the visualization of a building:

Plans depict a structure's masses and voids, presenting a view from above of the building's footprint or as if it had been sliced horizontally at about waist height.

Plan: Philadelphia, Vanna Venturi House

Sections reveal the interior of a building as if it had becvertically from top to bottom.

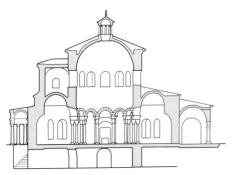

Section: Rome, Sta. Costanza

Isometric drawings show buildings from oblique angles either seen from above ("bird's-eye view") to reveal their basic three-dimensional forms (often cut away so we can peek inside) or from below ("worm's-eye view") to represent the arrangement of interior spaces and the upward projection of structural elements.

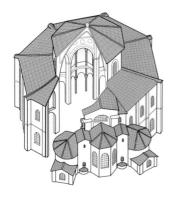

Isometric cutaway from above: Ravenna, San Vitale

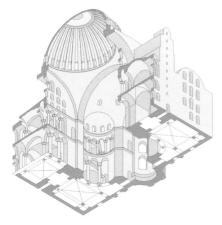

Isometric projection from below: Istanbul, Hagia Sophia

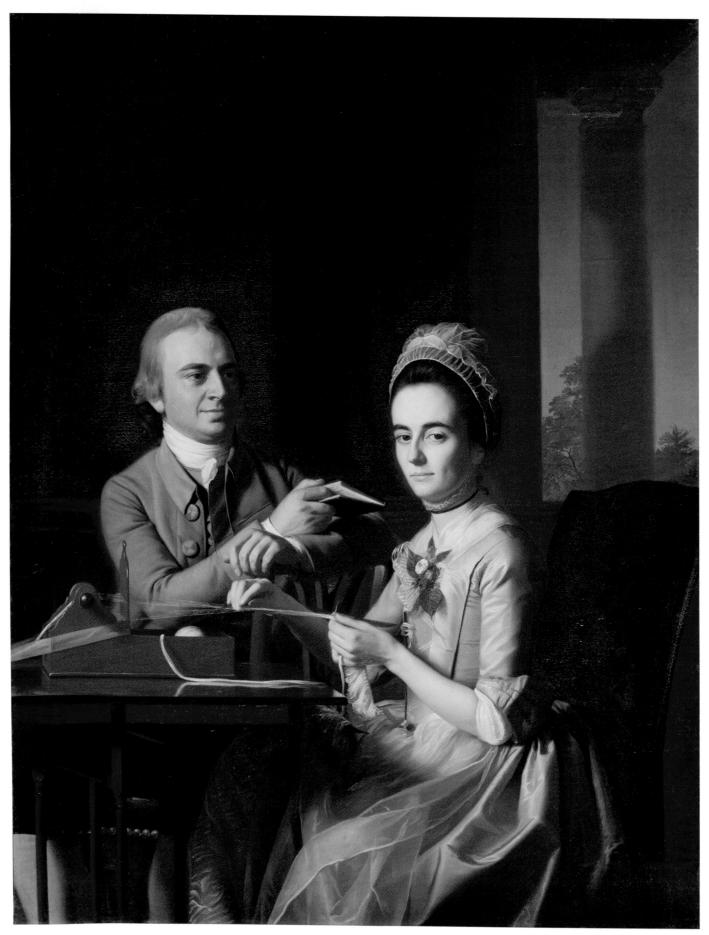

30–1 • John Singleton Copley **THOMAS MIFFLIN AND SARAH MORRIS (MR. AND MRS. MIFFLIN)** 1773. Oil on canvas, 61%" \times 48" (156.5 \times 121.9 cm). Philadelphia Museum of Art.

Eighteenth- and Early Nineteenth-Century Art in Europe and North America

John Singleton Copley (1738–1815) painted this double portrait of Thomas Mifflin and his wife, Sarah Morris (FIG. 30-1), in 1773, when the Philadelphia couple was visiting Boston for a family funeral. This was the same year when American colonists protested against the British tax on tea by staging the Boston Tea Party—seizing British tea and tossing it into Boston harbor. The painting must have hung in the couple's Philadelphia home when Thomas Mifflin, a prominent merchant and politician, and other leading representatives of the colonies negotiated a strategy for the impending break with Britain at the First Continental Congress. Indeed, the painting proclaims the couple's identity as American patriots, committed to the cause of independence.

Sarah—not her famous husband—is the center of attention. She sits in the foreground, wearing a stylish silk dress decorated with expensive laces, a finely wrought lace cap atop her smoothly coiffed head. She is certainly rich and elegant, but she wears no jewelry except for a modest choker. In fact, rather uncharacteristically for a woman of her social status, she is shown with her sleeves rolled up, working silk threads on the large wooden frame that sits on her polished table. Her work is domestic and pragmatic, not the kind of activity we expect to see highlighted in a large and expensive formal portrait, but it was included here for important political reasons. Sarah is weaving a type of decorative silk fringe that would have been imported from England in the past. By

portraying her involved in this work, Copley demonstrates her commitment both to her home as a good and industrious wife, and also to the revolutionary cause as a woman without pretension who can manage well without British imported goods. Meeting the viewer's gaze with confidence and intelligence, she is clearly a full partner with her patriot husband in the important work of resisting British colonial power. He is content to sit in the background of this picture, interrupting his reading to look admiringly at his beloved Sarah.

John Singleton Copley was, by 1773, Boston's preeminent portrait painter and a wealthy man. His reputation stood on his remarkable ability to represent the upper strata of society in a clear, sharp, precise painting style that seemed to reveal not only every detail of his sitter's physical appearance and personality, but also the gorgeous satins, silks and laces of the women's dresses and the expensive polished furniture that were the signs of his patrons' wealth and status. Although his father-in-law was the Boston representative of the East India Company (whose tea was dumped into the harbor), Copley was sympathetic to the revolutionary cause and, in fact, tried unsuccessfully to mediate the crisis in Boston. This portrait of Sarah Morris and Thomas Mifflin was painted when Copley himself was ambivalent about the political future of the colonies—he would flee the unsettled climate of the colonies the following year to begin a second career in London-but his sitters reveal only their own sober commitment to the cause.

LEARN ABOUT IT

- 30.1 Investigate the origins and understand the characteristics of the stylistic movements art historians label Rococo, Neoclassicism, and Romanticism.
- 30.2 Explore the many subjects of Romanticism, from the sublime in nature to the cruelty of the slave trade, with a common interest in emotion and feeling.
- **30.3** Trace the relationships between the complex mix of artistic styles in this period and the complex political climate of Europe and America.
- **30.4** Discover Neoclassicism's relationship with Enlightenment values and its roots in the study of Classical antiquity in Rome.

INDUSTRIAL, INTELLECTUAL, AND POLITICAL REVOLUTIONS

The American War of Independence was just one of many revolutions to shake the established order during the eighteenth and early nineteenth centuries. This was an age of radical change in society, thought, and politics, and while these transformations were felt especially in England, France, and the United States, they had consequences throughout the West and, eventually, the world.

The transformations of this period were informed by a new way of thinking that had its roots in the scientific revolution of the previous century (see "Science and the Changing Worldview," page 756). In England, John Locke (1632–1704) argued that reasonable and rational thought should supplant superstition, and Isaac Newton (1643–1727) insisted upon empirical observation, rational evaluation, and logical consideration in mathematics and science. In 1702, Bernard de Fontenelle (1657–1757), a French popularizer of scientific innovation, wrote that he anticipated "a century which will become more enlightened day by day, so that all previous centuries will be lost in darkness by comparison." Over the course of the eighteenth century, this emphasis

on thought "enlightened" by reason was applied to political and moral philosophy as well as science. Enlightenment thinking is marked by a conviction that humans are not superstitious beings ruled by God or the aristocracy, and that all men (some thinkers also included women) should have equal rights and opportunities for "life, liberty, and the pursuit of happiness." Most Enlightenment philosophers believed that, when freed of past religious and political shackles, men and women could and would act rationally and morally. The role of the state was to protect and facilitate these rights, and when the state failed, the moral solution was to change it. Both the American Revolution of 1776 and the French Revolution of 1789 were justified on this basis.

The eighteenth century was also a period of economic and social transformation, set in motion by the Industrial Revolution. In the Europe of 1700, wealth and power belonged to the aristocracy, who owned the land and controlled the lives of poor tenant farmers. The Industrial Revolution eventually replaced the landbased power of the aristocracy with the financial power of capitalists, who were able to use new sources of energy to mechanize manufacturing and greatly increase the quantity and profitability of saleable goods. Factory work lured the poor away from the

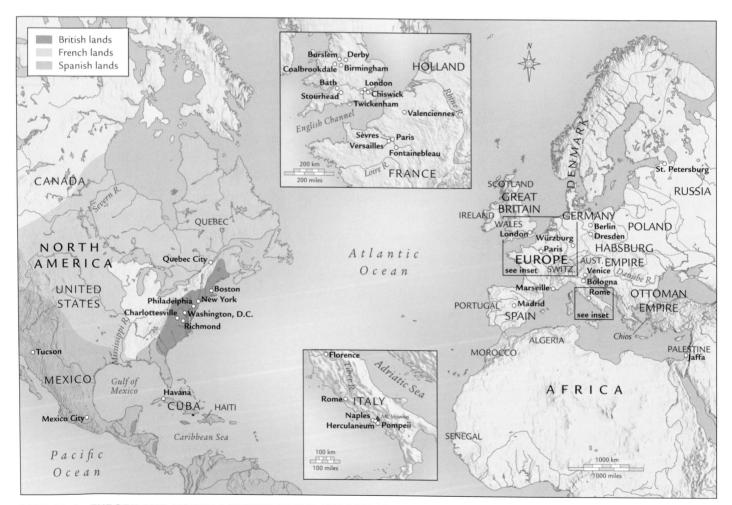

MAP 30-1 • EUROPE AND NORTH AMERICA IN THE EIGHTEENTH CENTURY

906

During the 18th century, three major artistic styles—Rococo, Neoclassicism, and Romanticism—flourished in Europe and North America.

countryside to the cities with the promise of wages and greater independence. The conditions that urban workers endured, however, were dreadful, both at their grueling factory jobs and in their overcrowded and unsanitary neighborhoods. These conditions would sow the seeds of dissent and revolution in several European countries in the mid nineteenth century. Industrialization also produced a large middle class that both bought and sold the new goods made in factories.

By the early nineteenth century, the aristocracy was weak and ineffectual in many nations, and virtually eliminated in France. Upper-middle-class industrialists and merchants dominated European commerce, industry, and politics, and their beliefs and customs defined social norms. At the same time, the idealism of the Enlightenment had eroded, particularly in France in the wake of the Revolution, when the new republican form of government "by the people" brought chaos and bloodshed rather than order and stability. A new intellectual trend, known as Romanticism, started as a literary movement in the 1790s and served as a counterpoint to Enlightenment rationalism. It critiqued the idea that the world was knowable and ruled by reason alone. The central premise of Romanticism was that an exploration of emotions, the imagination, and intuition—areas of the mind not addressed by Enlightenment philosophy—could lead to a more nuanced understanding of the world. Rather than one supplanting the other, Romanticism and Enlightenment thought coexisted as different parts of a complex cultural whole.

ROCOCO

In the modern age, the shift from art produced at the behest of individual or institutional patrons—the monarchy, aristocracy, Church, as well as wealthy merchants—to art produced as a commodity on sale to the industrial rich and even the emerging middle classes had its roots in the Rococo when the court culture of Versailles was replaced by the salon culture of Paris. The term Rococo combines the Italian word *barocco* (an irregularly shaped pearl, possibly the source of the word "baroque") and the French *rocaille* (a popular form of garden or interior ornamentation using shells and pebbles) to describe the refined and fanciful style that became fashionable in parts of Europe during the eighteenth century. The Rococo developed in France around 1715, when the duc d'Orléans, regent for the boy-king Louis XV (r. 1715–1774), moved his home and the French court from Versailles to Paris. The movement spread quickly across Europe (MAP 30-1).

ROCOCO SALONS

The French court was happy to escape its confinement in the rural palace of Versailles and relocate to Paris. There courtiers built elegant town houses (in French, $h\delta tels$), whose social rooms may have been smaller than at Versailles, but were no less lavishly decorated. These became the center of social life for aristocrats who cultivated witty exchanges, elegant manners, and a playfully luxurious life

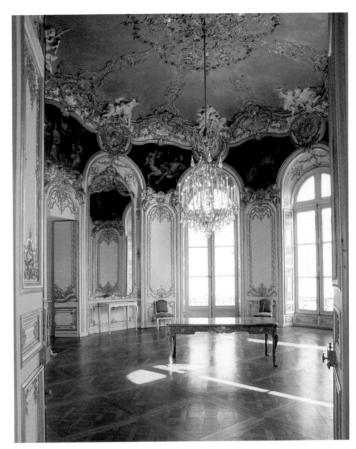

30-2 • Germain Boffrand SALON DE LA PRINCESSE, HÔTEL DE SOUBISE

Paris. Begun 1732.

specifically dedicated to pleasure, leisure, and sensuality that frequently masked social insecurity and ambivalence. **Salons**, as the rooms and the events held in them were known, were intimate, fashionable, and intellectual gatherings, often including splendid entertainments that mimicked in miniature the rituals of the Versailles court. The salons were hosted on a weekly basis by accomplished, educated women of the upper class including Mesdames de Staël, de La Fayette, de Sévigné, and du Châtelet.

The Rococo style cannot be fully appreciated through single objects, but is evident everywhere in the salons, with their profusely decorated walls and ceilings bursting with exquisite three-dimensional embellishments in gold, silver, and brilliant white paint; their intimate, sensual paintings hung among the rich ornament; and their elaborate crystal chandeliers, mirrored walls, and delicate decorated furniture and tabletop sculptures. When these Parisian salons were lit by candles, they must have glittered with light reflected and refracted by the gorgeous surfaces. The rooms were no doubt also enlivened by the energy of aristocrats, fancifully dressed in a profusion of pastel blues, yellows, greens, and pinks to complement the light, bright details of the Rococo architecture, paintings, and sculptures around them.

The **SALON DE LA PRINCESSE** in the Hôtel de Soubise (**FIG. 30-2**), designed by Germain Boffrand (1667–1754), was the

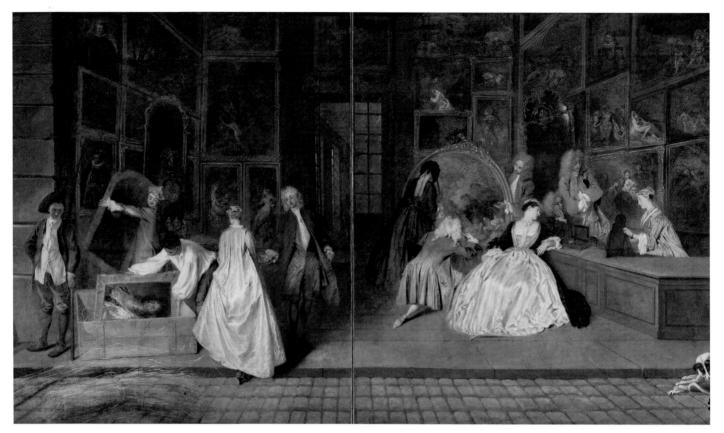

30-3 • Jean-Antoine Watteau THE SIGNBOARD OF GERSAINT

c. 1721. Oil on canvas, $5'4'' \times 10'1''$ (1.62 \times 3.06 m). Stiftung Preussische Schlössen und Gärten Berlin-Brandenburg, Schloss Charlottenburg.

Watteau painted this signboard for the Paris art gallery of Edmé-François Gersaint, a dealer who introduced to France the English idea of selling paintings by catalog. The systematic listing of works for sale gave the name of the artist and the title, the medium, and the dimensions of each work of art. The shop depicted on the signboard, however, is not Gersaint's but a gallery created from Watteau's imagination and visited by typically elegant and cultivated patrons. The sign was so admired that Gersaint sold it only 15 days after it was installed. Later it was cut down the middle, and each half was framed separately, which resulted in the loss of some canvas along the sides of each section. The painting was restored and its two halves reunited only in the twentieth century.

Read the document related to Jean-Antoine Watteau on myartslab.com

setting for such intimate gatherings of the Parisian aristocracy in the years prior to the French Revolution. Its delicacy and lightness are typical of French Rococo salon design of the 1730s, with architectural elements rendered in sculpted stucco, including arabesques (characterized by flowing lines and swirling shapes), S-shapes, C-shapes, reverse C-shapes, volutes, and naturalistic plant forms. Intricate polished surfaces included carved wood panels called *boiseries* and inlaid wood designs on furniture and floors. The glitter of silver and gold against white and pastel shades and the visual confusion of mirror reflections all enhanced this Rococo interior.

ROCOCO PAINTING AND SCULPTURE

The paintings and sculpture that decorated Rococo salons and other elegant spaces were instrumental in creating their atmosphere of sensuality and luxury. Pictorial themes were often taken from Classical love stories, and both pictures and sculpted ornament were typically filled with playful *putti*, lush foliage, and fluffy

clouds. The paintings of Jean-Antoine Watteau, François Boucher, and Jean-Honoré Fragonard and the tabletop sculpture of Claude Michel, known as Clodion, were highly coveted in salon culture.

WATTEAU Jean-Antoine Watteau (1684–1721) has been seen as the originator, and for some the greatest practitioner, of the French Rococo style in painting. Born in the provincial town of Valenciennes, Watteau came to Paris around 1702, where he studied Rubens's paintings for Marie de' Medici (see FIG. 23–27), then displayed in the Luxembourg Palace, and the paintings and drawings of sixteenth-century Venetians such as Giorgione and Titian (see FIGS. 21–24, 21–25), which he saw in a Parisian private collection. Incorporating the fluent brushwork and rich colors of such works from the past, Watteau perfected a graceful personal style that embodied the spirit of his own time.

Watteau painted for the new urban aristocrats who frequently purchased paintings for their homes through art dealers in the city. The signboard he painted for the art dealer Edmé-François Gersaint (FIG. 30-3) shows the interior of one of these shops—an art gallery filled with paintings from the Venetian and Netherlandish schools that Watteau admired. Indeed, the glowing satins and silks of the women's gowns pay homage to artists such as Gerard ter Borch (see FIG. 23-41). The visitors to the gallery are elegant ladies and gentlemen, at ease in these surroundings and apparently knowledgeable about painting; they create an atmosphere of aristocratic sophistication. At the left, a woman in shimmering pink satin steps across the threshold, ignoring her companion's outstretched hand, to watch the two porters packing. While one porter holds a mirror, the other carefully lowers into the wooden case a portrait of Louis XIV, which may be a reference to the name of Gersaint's shop, Au Grand Monarque ("At the Sign of the Great King"). It also suggests the passage of time, for Louis had died six vears earlier.

Other elements in the work also suggest transience. On the left, the clock directly above the king's portrait, surmounted by an allegorical figure of Fame and sheltering a pair of lovers, is a **memento mori**, a reminder of mortality, suggesting that both love and fame are subject to the ravages of time. Well-established *vanitas* emblems are the easily destroyed straw (in the foreground)

and the young woman gazing into the mirror (set next to a vanity case on the counter)—mirrors and images of young women looking at their reflections had been familiar symbols of the fragility of human life since the Baroque period. Notably, the two gentlemen at the end of the counter also appear to gaze at the mirror, and are thus also implicated in the *vanitas* theme. Watteau, who died from tuberculosis before he was 40, produced this painting during his last illness. Gersaint later wrote that Watteau had completed the painting in eight days, working only in the mornings because of his failing health. When the *Signboard* was installed, it was greeted with almost universal admiration; Gersaint sold it within a month.

In **PILGRIMAGE TO THE ISLAND OF CYTHERA** (**FIG. 30–4**), painted four years earlier, Watteau portrayed an imagined vision of the idyllic and sensual life of Rococo aristocrats, but with the same undertone of melancholy that hints at the fleeting quality of human happiness. This is a dream world in which beautifully dressed and elegantly posed couples, accompanied by *putti*, conclude the romantic trysts of their day on Cythera, the island sacred to Venus, the goddess of love, whose garlanded statue appears at the extreme right. The lovers, dressed in exquisite satins, silks, and velvets, gather in the verdant landscape. Such idyllic and wistfully melancholic visions of aristocratic leisure charmed

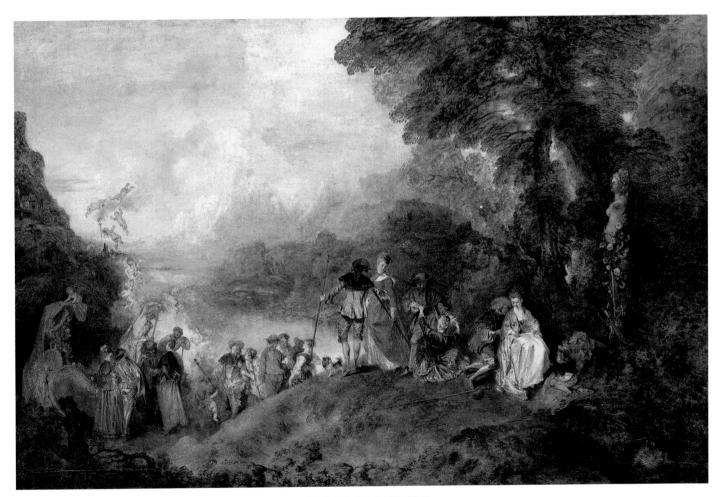

30-4 • Jean-Antoine Watteau PILGRIMAGE TO THE ISLAND OF CYTHERA 1717. Oil on canvas, 4'3" × 6'4½" (1.3 × 1.9 m). Musée du Louvre, Paris.

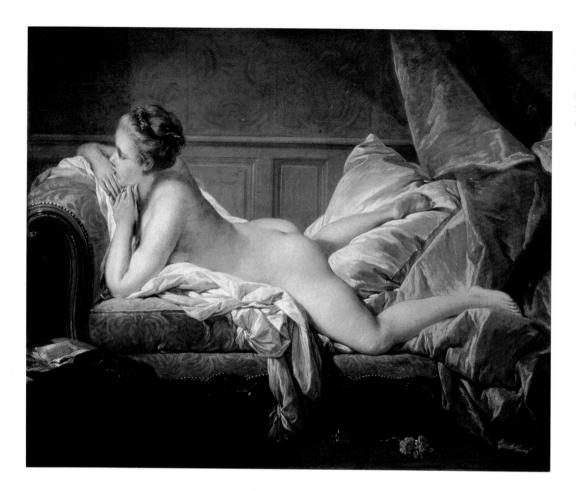

30-5 • François Boucher **GIRL RECLINING: LOUISE O'MURPHY**1751. Oil on canvas, 28¾" × 23¼" (73 × 59 cm).
Wallraf-Richartz Museum, Cologne.

both early eighteenth-century Paris and most of Europe. Watteau painted *Pilgrimage to the Island of Cythera* in 1717 as his official examination canvas for admission to membership of the French Royal Academy of Painting and Sculpture (see "Academies and Academy Exhibitions," page 926). Although there was no academic category to cover the painting, the academicians were so impressed by the canvas that they created a new category, the **fête galante**, or elegant outdoor entertainment, to describe this genre.

BOUCHER The artist most closely associated with Parisian Rococo painting after Watteau's death is François Boucher (1703–1770). The son of a minor painter, Boucher in 1723 entered the workshop of an engraver where he was hired to reproduce Watteau's paintings for a collector, laying the groundwork for the future direction of his career.

After studying in Rome from 1727 to 1731 at the academy founded there by the French Royal Academy of Painting and Sculpture, Boucher settled in Paris and became an academician. Soon his life and career were intimately bound up with two women. The first was his artistically talented wife, Marie-Jeanne Buseau, who was her husband's frequent model as well as his studio assistant. The other was Louis XV's mistress, Madame de Pompadour, who became his major patron and supporter. Pompadour was an amateur artist herself and took lessons in printmaking from Boucher. After he received his first royal commission in 1735, Boucher worked almost continuously on the decorations for the

royal residences at Versailles and Fontainebleau. In 1755, he was made chief inspector at the Gobelins tapestry manufactory, and provided designs for it as well as for the Sèvres porcelain and Beauvais tapestry manufactories. All these workshops produced both furnishings for the king and wares for sale on the open market by merchants such as Gersaint. Indeed, Boucher operated in a much more commercial market than artists in the previous century.

In 1765, Boucher became First Painter to the King. In this role he painted several portraits of Louis XV, scenes of daily life and mythological pictures, and a series of erotic works for private enjoyment, often depicting the adventures of Venus. The subject of one such painting—GIRL RECLINING: LOUISE O'MURPHY (FIG. 30-5)—however, is hardly mythological. The teenage Louise O'Murphy, who would soon be one of the mistresses of Louis XV, appears provocatively pink and completely naked, sprawled across a day bed on her stomach, looking out of the painting and completely unaware of our presence. Her satiny clothing is crushed beneath her, and her spread legs sink into a pillow; braids and a blue ribbon decorate her hair, while a fallen pink rose is highlighted on the floor. Louise's plump buttocks are displayed enticingly at the very center of the painting, leaving little doubt about the painting's subject. In contrast to Watteau's fête galante, in which imaginary aristocrats and putti frolic decorously in idyllic settings, the overtly sensual woman shown here is clearly human, a known contemporary personality, and presented to us a very real Rococo room.

FRAGONARD Another noteworthy master of French Rococo painting, Jean-Honoré Fragonard (1732–1806), studied with Boucher, who encouraged him to enter the competition for the Prix de Rome, the three- to five-year scholarship awarded to the top students graduating from the art school of the French Royal Academy of Painting and Sculpture. Fragonard won the prize in 1752 and spent the years 1756 to 1761 in Italy; however, it was

not until 1765 that he was finally accepted as a member of L. Academy. He catered to the tastes of an aristocratic clientele, and, as a decorator of interiors, began to fill the vacuum left by Boucher's death in 1770.

Fragonard's **THE SWING** (**FIG. 30-6**) of 1767 was originally commissioned from painter Gabriel-François Doyen, although the identity of the patron is unknown. Doyen described the subject he

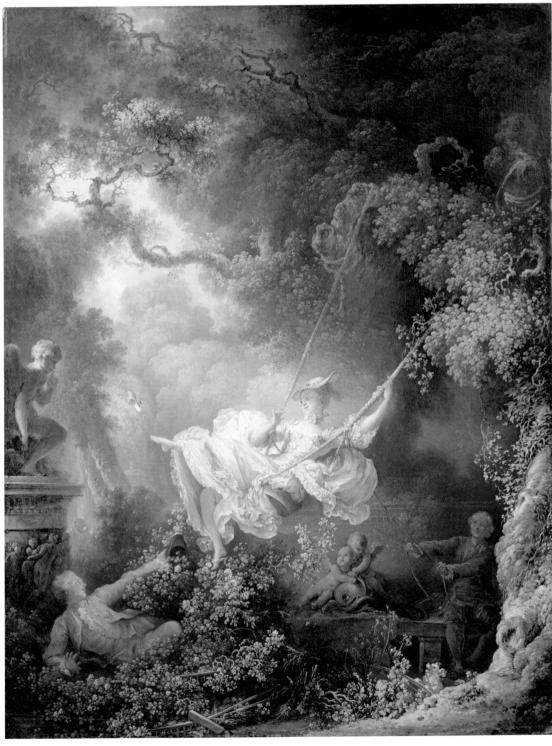

30-6 • Jean-Honoré Fragonard THE SWING 1767. Oil on canvas, 2'85%" × 2'2" (82.9 × 66 cm). The Wallace Collection, London.

was asked to paint as sensually explicit, and he refused the commission, giving it to Fragonard, who created a small jewel of a painting. A pretty young woman is suspended on a swing, her movement created by an elderly bishop obscured by the shadow of the bushes on the right, who pulls her with a rope. On the left, the girl's blushing lover hides in the bushes, swooning with

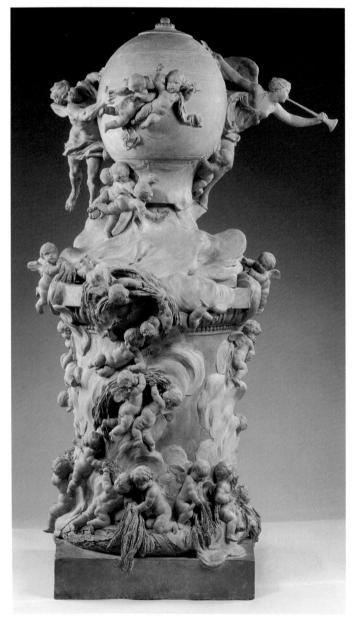

30–7 • Clodion THE INVENTION OF THE BALLOON 1784. Terra-cotta model for a monument, height $43\frac{1}{2}$ " (110.5 cm). Metropolitan Museum of Art, New York. Rogers Fund and Frederick R. Harris Gift, 1944 (44.21a b)

Clodion had a long career as a sculptor in the exuberant Rococo manner seen in this work commemorating the 1783 invention of the hot-air balloon. During the austere revolutionary period of the First Republic (1792–1795), he became one of the few Rococo artists to adopt successfully the more acceptable Neoclassical manner. In 1806, he was commissioned by Napoleon to provide the relief sculpture for two Paris monuments, the Vendôme Column and the Carrousel Arch near the Louvre.

anticipation. As the swing approaches, he is rewarded with an unobstructed view up her skirt, lifted on his behalf by an extended leg. The young man reaches out toward her with his hat as if to make a mockingly useless attempt to conceal the view, while she glances down, seductively tossing one of her shoes toward him. The playful abandon of the lovers, the complicity of the sculpture of Cupid on the left, his shushing gesture assuring that he will not tell, the *putti* with a dolphin beneath the swing who seem to urge the young woman on, and the poor duped bishop to the right, all work together to create an image that bursts with anticipation and desire, but also maintains a robust sense of humor.

CLODION In the last quarter of the eighteenth century, Rococo largely fell out of favor in France, its style and subject matter attacked for being frivolous at best and immoral at worst. One sculptor who clung onto the style almost until the French Revolution, however, was Claude Michel, known as Clodion (1738-1814). Most of his work consisted of playful, erotic tabletop sculpture, mainly in unpainted terra cotta. Typical of his Rococo designs is the terra-cotta model he submitted to win a 1784 royal commission for a large monument to THE INVENTION OF THE BALLOON (FIG. 30-7). In the eighteenth-century, hot-air balloons were elaborately decorated with painted Rococo scenes, gold braid, and tassels. Clodion's balloon, circled with bands of ornament, rises from a columnar launching pad belching billowing clouds of smoke, assisted at the left by a puffing wind god with butterfly wings and heralded at the right by a trumpeting Victory. Some putti stoke the fire basket, providing the hot air that allows the balloon to ascend, while others gather reeds for fuel and carry them up to feed the fire.

ROCOCO CHURCH DECORATION

The beginning of the Rococo coincided with the waning importance of the Church as a major patron of art in northern Europe. Although churches continued to be built and decorated, the dominance of both the Church and the hereditary aristocracy as patrons diminished significantly. The Rococo proved, however, to be a powerful vehicle for spiritual experience. Several important churches were built in the style, showing how visual appearance can be tailored to a variety of social meanings. One of the most opulent Rococo churches is dedicated to the Vierzehnheiligen (the "Fourteen Auxiliary Saints" or "Holy Helpers") and designed by Johann Balthasar Neumann (1687-1753). Constructed in Bavaria between 1743 and 1772, the plan (FIG. 30-8), based on six interpenetrating oval spaces of varying sizes around a vaulted ovoid center, recalls that of Borromini's Baroque church of San Carlo alle Quattro Fontane in Rome (see FIG. 23-6B). But the effect here is airy lightness. In the nave (FIG. 30-9), the Rococo love of undulating surfaces with overlays of decoration creates a visionary world where surfaces scarcely exist. Instead, the viewer is surrounded by clusters of pilasters and engaged columns interspersed with two levels of arched openings to the side aisles, and large clerestory

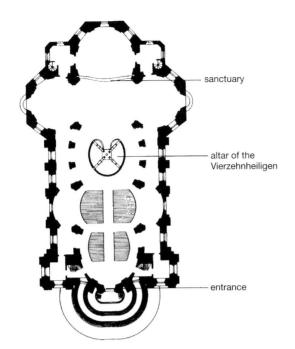

30-8 • PLAN OF THE CHURCH OF THE VIERZEHNHEILIGEN

Near Bamberg, Bavaria, Germany. c. 1743.

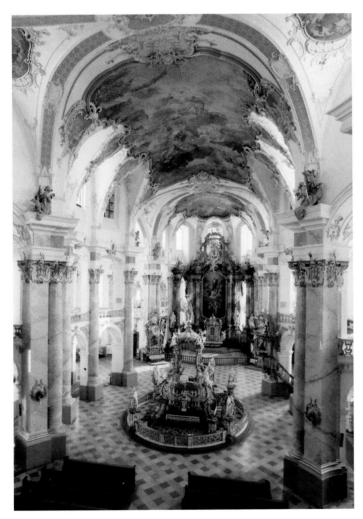

30-9 • Johann Balthasar Neumann INTERIOR, CHURCH OF THE VIERZEHNHEILIGEN

Near Bamberg, Bavaria, Germany. 1743-1772.

windows illuminating the gold and white of the interior. The foliage of the fanciful capitals is repeated in arabesques, wreaths, and the ornamented frames of irregular panels lining the vault. An ebullient sense of spiritual uplift is achieved by the complete integration of architecture and decoration.

ITALY: THE GRAND TOUR AND NEOCLASSICISM

From the late 1600s until well into the nineteenth century, the education of a wealthy young northern European or American gentleman—few women were considered worthy of such education—was completed on the **Grand Tour**, an extended visit to the major cultural sites of southern Europe. Accompanied by a tutor and an entourage of servants, the Grand Tourist began in Paris, moved on to southern France to visit a number of well-preserved Roman buildings and monuments there, then headed to Venice, Florence, Naples, and Rome. As the repository of the Classical and Renaissance pasts, Italy was the focus of the Grand Tour.

Italy, and Rome in particular, was also the primary destination for artists and scholars interested in the Classical past. In addition to the ancient architecture and sculpture throughout Rome, the nearby sites of Pompeii and Herculaneum offered sensational new material for study and speculation (see Chapter 6). In the mid eighteenth century, archaeologists began the systematic excavation of these two prosperous Roman towns, buried by a sudden volcanic eruption in 79 ce.

The artists and intellectuals who found inspiration in the Classical past were instrumental in the development of Neoclassicism, which was both a way of viewing the world and an influential movement in the visual arts. Neoclassicism (neo means "new") sought to present Classical ideals and subject matter in a style derived from Classical Greek and Roman sources. Neoclassical paintings reflect the crystalline forms, tight compositions, and shallow space of ancient relief sculpture. Because the ancient world was considered the font from which British and European democracy, secular government, and civilized thought and action flowed, its art was viewed as the embodiment of timeless civic and moral lessons. Neoclassical paintings and sculptures were frequently painted for and displayed in public places in order to inspire patriotism, nationalism, and courage. Neoclassicism was especially popular in Britain, America, and France as a visual expression of the state and political stability.

GRAND TOUR PORTRAITS AND VIEWS

Artists in Italy benefited not only from their access to authentic works of antiquity, but also from the steady stream of wealthy art collectors on the Grand-Tour. Tourists visited the studios of important Italian artists in order to view and purchase works that could be brought home and displayed as evidence of their cultural travels.

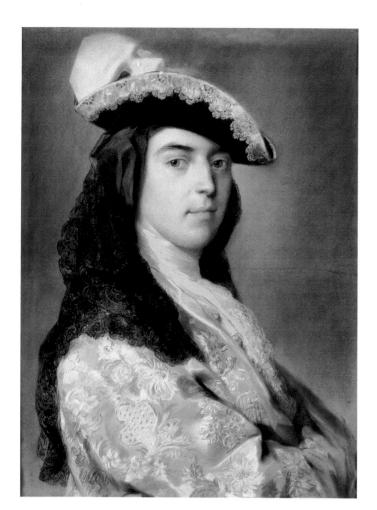

30-10 • Rosalba Carriera CHARLES SACKVILLE, 2ND DUKE OF DORSET

c. 1730. Pastel on paper, $25'' \times 19''$ (63.5 \times 48.3 cm). Private collection.

CARRIERA Wealthy European visitors to Italy frequently sat for portraits by Italian artists. Rosalba Carriera (1675–1757), the leading portraitist in Venice in the first half of the eighteenth century, worked mainly in pastel, a medium better suited than slow-drying oil to accommodate sitters whose time in the city was limited. **Pastel** is a fast and versatile medium: Pastel crayons, made of pulverized pigment bound to a chalk base by weak gum water, can be used to sketch quickly and spontaneously, or they can be rubbed and blended on the surface of paper to produce a shiny and highly finished surface.

Carriera began her career designing lace patterns and painting miniature portraits on the ivory lids of snuffboxes before she graduated to pastel portraits. Her portraits were so widely admired that she was awarded honorary membership of Rome's Academy of St. Luke in 1705, and was later admitted to the academies in Bologna and Florence. In 1720, she traveled to Paris, where she made a pastel portrait of the young Louis XV and was elected to the French Royal Academy of Painting and Sculpture, despite the 1706 rule forbidding the further admission of women. Returning to Italy in 1721, she established herself in Venice as a portraitist

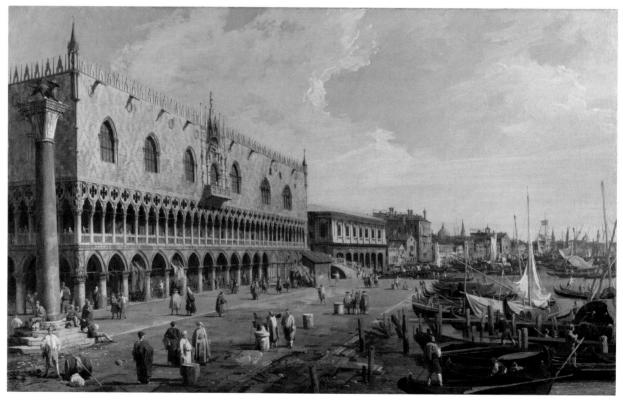

30–11 • Canaletto THE DOGE'S PALACE AND THE RIVA DEGLI SCHIAVONI Late 1730s. Oil on canvas, 24%" \times 39½" (61.3 \times 99.8 cm). National Gallery, London. Wynn Ellis Bequest 1876 (NG 940)

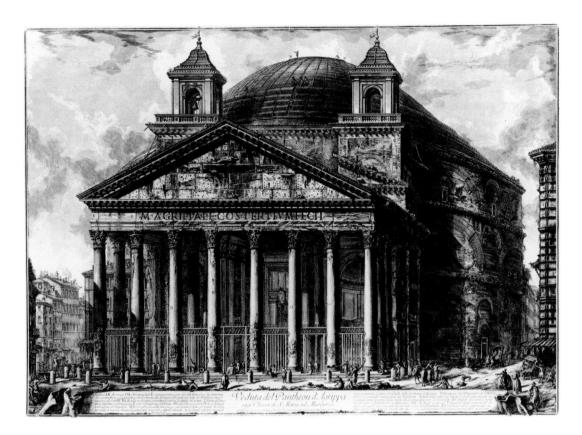

30-12 • Giovanni Battista Piranesi VIEW OF THE PANTHEON, ROME

From the *Views of Rome* series, first printed in 1756. Etching, $18\%6'' \times 27\%''$ (47.2 \times 69.7 cm). Kupferstich-Kabinett, Staatliche Museen, Berlin.

of handsome young men such as the British aristocrat **CHARLES SACKVILLE, 2ND DUKE OF DORSET** (FIG. **30-10**).

CANALETTO A painted city view was by far the most prized souvenir of a stay in Venice. Two kinds of views were produced in Venice: the capriccio ("caprice," plural capricci), an imaginary landscape or cityscape in which the artist mixed actual structures, such as famous ruins, with imaginary ones to create attractive compositions; and the veduta ("view," plural vedute), a more naturalistic rendering of famous views and buildings, well-known tourist attractions, and local color in the form of tiny figures of the Venetian people and visiting tourists. Vedute often encompassed panoramic views of famous landmarks, as in THE DOGE'S PAL-ACE AND THE RIVA DEGLI SCHIAVONI (FIG. 30-11) by the Venetian artist Giovanni Antonio Canal, called Canaletto (1697-1768). It was thought that Canaletto used the camera obscura (see page 968) to render his vedute with exact topographical accuracy, but his drawings show that he seems to have worked freehand. In fact, his views are rarely topographically accurate; more often than not, they are composite images, so skillfully composed that we want to believe that Canaletto's vedute are "real." He painted and sold so many to British visitors that his dealer sent him to London from 1746 to 1755 to paint views of the English capital city for his British clients, who included several important aristocrats as well as King George III.

PIRANESI The city of Rome was also captured in *vedute* for the pleasure of tourists and armchair travelers, notably by Giovanni

Battista Piranesi (1720–1778). Trained in Venice as an architect, he moved to Rome in 1740 and studied etching, eventually establishing a publishing house and becoming one of the century's most successful printmakers. Piranesi produced a large series of *vedute* of ancient Roman monuments, whose ruined, deteriorating condition made them even more interesting for his customers. His **VIEW OF THE PANTHEON** (**FIG. 30-12**) is informed by a careful study of this great work of ancient Roman architecture, which seems even more monumental in relation to the dramatic clouds that frame it and the lively, small figures who surround it on the ground, admiring its grandeur from all directions.

NEOCLASSICISM IN ROME

The intellectuals and artists who came to study and work in Rome often formed communities with a shared interest in Neoclassical ideals. A British coterie, for example, included Angelica Kauffmann (see Fig. 30-26), Benjamin West (see Fig. 30-28), and Gavin Hamilton (1723–1798), all of whom contributed to early Neoclassicism, and there were similar gatherings of artists from France and Germany. One of the most influential communities formed at the Villa Albani on the outskirts of Rome, under the sponsorship of Cardinal Alessandro Albani (1692–1779).

Cardinal Albani built his villa in 1760–1761 specifically to house and display his vast collection of antique sculpture, sarcophagi, intaglios (objects in which the designs are carved into the surface), cameos, and ceramics, and it became one of the most important stops on the Grand Tour. The villa was more than a museum: It was also a place to buy art and artifacts. Albani sold

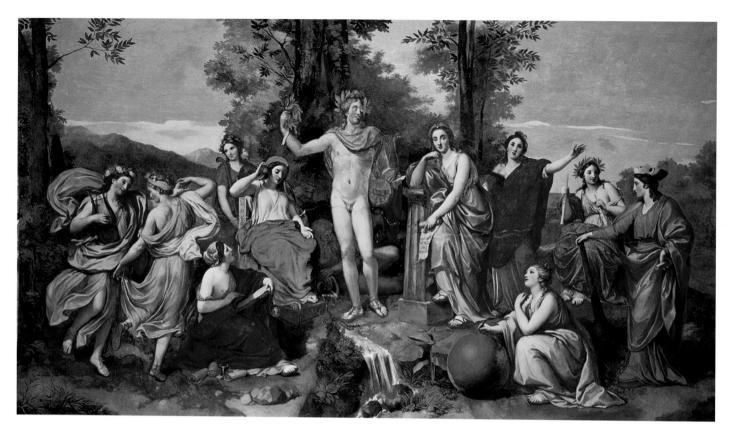

30-13 • Anton Raphael Mengs **PARNASSUS** Ceiling fresco in the Villa Albani, Rome. 1761.

items to artists and tourists alike, to help satisfy the growing craze for antiquities; unfortunately, many were faked or heavily restored by artisans in the cardinal's employ.

In 1758, Albani hired Johann Joachim Winckelmann (1717–1768), the leading theoretician of Neoclassicism, as his secretary and librarian. The Prussian-born Winckelmann had become an expert on Classical art while working in Dresden, where the French Rococo style that he deplored was still fashionable. In 1755, he published a pamphlet, *Thoughts on the Imitation of Greek Works in Painting and Sculpture*, in which he attacked the Rococo as decadent, arguing that modern artists could only claim their status as legitimate artists by imitating Greek art. Shortly after relocating to Rome to work for Albani, Winckelmann published a second influential treatise, *The History of Ancient Art (1764)*, often considered the beginning of modern art-historical study. Here Winckelmann analyzed the history of art for the first time as a succession of period styles, an approach which later became the norm for art history books (including this one).

MENGS Winckelmann's closest friend and colleague in Rome was a fellow German, the painter Anton Raphael Mengs (1728–1779). In 1761, Cardinal Albani commissioned Mengs to paint the ceiling of the great gallery in his new villa. To our eyes Mengs's **PARNASSUS** ceiling (**FIG. 30–13**) may seem stilted, but it is nevertheless significant as the first full expression of Neoclassicism in painting. The scene is taken from Classical mythology. Mount Parnassus in cen-

tral Greece was where the ancients believed Apollo (god of poetry, music, and the arts) and the nine Muses (female personifications of artistic inspiration) resided. Mengs depicted Apollo-practically nude and holding a lyre and olive branch to represent artistic accomplishment—standing at the compositional center, his pose copied from the famous Apollo Belvedere in the Vatican collection, one of Winckelmann's favorite Greek statues. Around Apollo are the Muses and their mother, Mnemosyne (Memory, leaning on a Doric column). Mengs arranged his figures in a roughly symmetrical, pyramidal composition parallel to the picture plane, like the relief sculpture he had studied at Herculaneum. Winckelmann praised this work, claiming that it captured the "noble simplicity and calm grandeur" of ancient Greek sculpture. Shortly after its completion, Mengs left for Spain, where he served as court painter until 1777, bringing Neoclassical ideas with him. Other artists from Rome carried the style elsewhere in Europe.

CANOVA The theories of the Albani–Winckelmann circle were applied most vigorously by sculptors in Rome, who remained committed to Neoclassicism for almost 100 years. The leading Neoclassical sculptor of the late eighteenth and early nineteenth centuries was Antonio Canova (1757–1822). Born near Venice into a family of stonemasons, he settled in Rome in 1781, where he adopted the Neoclassical style under the guidance of the Scottish painter Gavin Hamilton and quickly became the most soughtafter European sculptor of the period.

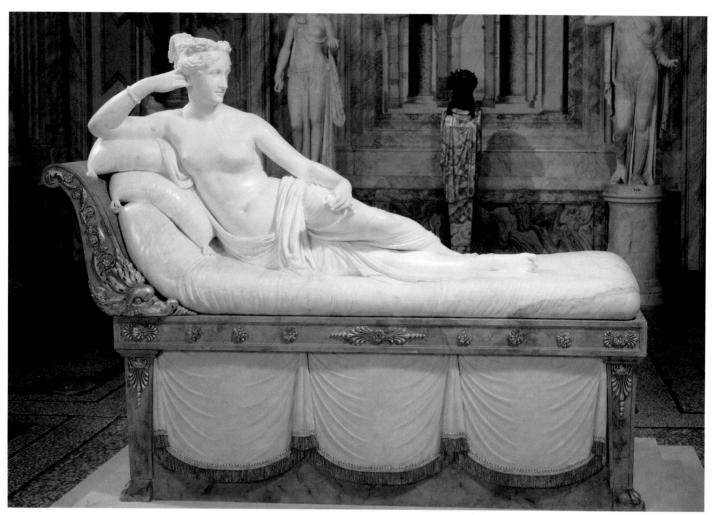

30–14 • Antonio Canova **PAULINE BORGHESE AS VENUS** 1808. Marble, length 6'7" (2.18 m). Galleria Borghese, Rome.

Canova specialized in two types of sculpture: grand public monuments for Europe's leaders, and eroticized mythological subjects for the pleasure of private collectors. His PAULINE BORGHESE AS VENUS (FIG. 30-14) falls into the latter category, although it was commissioned by one of the most powerful rulers of Europe in the later eighteenth century, Emperor Napoleon of France (1769–1821). This is actually a portrait of Napoleon's sister, Pauline, whom the emperor had arranged to marry Prince Camillo Borghese, a member of the famous Roman Borghese family. But Pauline wished to be portrayed as Venus. She is shown seminude, reclining on a divan, holding the golden apple given to Venus by Paris, prince of Troy, as a sign that she was the fairest of the three major goddesses. The marble renderings of cushions and drapery seem almost real, while the glistening white marble flesh evokes the sensuality seen in Hellenistic sculpture, especially in contrast to the precise linearity of the gray, white, and gold piece of furniture that serves as a base. Pauline's husband was displeased with the sculpture, which seemed to confirm rumors about his wife's questionable behavior, and installed Canova's work in a private room in the Villa Borghese, where it remains today.

NEOCLASSICISM AND EARLY ROMANTICISM IN BRITAIN

British tourists and artists in Italy became leading supporters of early Neoclassicism, partly because of the early burgeoning taste for revival styles at home, but the Classical revival in Britain had a slightly different focus from what we saw in Rome. While Roman Neoclassicism looked to the past in order to revive a sense of moral and civic virtue, many later eighteenth-century British artists harnessed the concept of civic virtue to patriotism to create more Romantic works of art dedicated specifically to the British nation. It is in British art and literature that we find the beginnings of Romanticism.

Like Neoclassicism, Romanticism describes not only a style but also an attitude: It celebrates the individual and the subjective, while Neoclassicism celebrates the universal and the rational. Romanticism takes its name and many of its themes from the "romances"—novellas, stories, and poems written in Romance (Latin-derived) languages. The term "Romantic" suggests something fantastic or novelistic, perhaps set in a remote time or place, infused

by a poetic melancholy, occasionally inciting terror or horror. One of the best examples of early Romanticism in literature is *The Sorrows of Young Werther* (1774) by Johann Wolfgang von Goethe (1749–1832), in which a sensitive, outcast young man fails at love and kills himself. This is a story about a troubled individual who loses his way; it does not recall ancient virtues or civic responsibility.

Neoclassicism and Romanticism existed side by side in the later eighteenth and early nineteenth centuries—two ways of looking at the world, serving distinct purposes in society. Neoclassicism tended to be a more public art form, and Romanticism more individual and private. Sometimes Neoclassicism even functioned within Romanticism. Distinctions were not always clear.

THE CLASSICAL REVIVAL IN ARCHITECTURE AND DESIGN

Ancient Greece and Rome provided impeccable pedigrees for eighteenth-century British buildings, utensils, poetry, and even clothing fashions. Women donned white muslin gowns and men curled their hair forward in imitation of Classical statues. In the 1720s, a group of professional architects and wealthy amateurs in Britain, led by a Scot, Colen Campbell (1676–1729), stood against what they viewed as the immoral extravagance of the Italian Baroque. They advocated a return to the austerity and simplicity of the Classically inspired architecture of Andrea Palladio, and his country houses in particular.

CHISWICK HOUSE Designed in 1724 by its owner, Richard Boyle, the third Earl of Burlington (1695–1753), **CHISWICK HOUSE** (**FIG. 30–15**) is a fine example of British Neo-Palladianism. In visiting Palladio's country houses in Italy, Burlington was particularly struck by the Villa Rotonda (see **FIGS. 21–45**, 21–46), which inspired his design for Chiswick House. The plan shares the bilateral symmetry of Palladio's villa, although its central core is octagonal rather than round and there are only two entrances. The

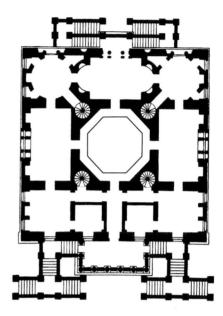

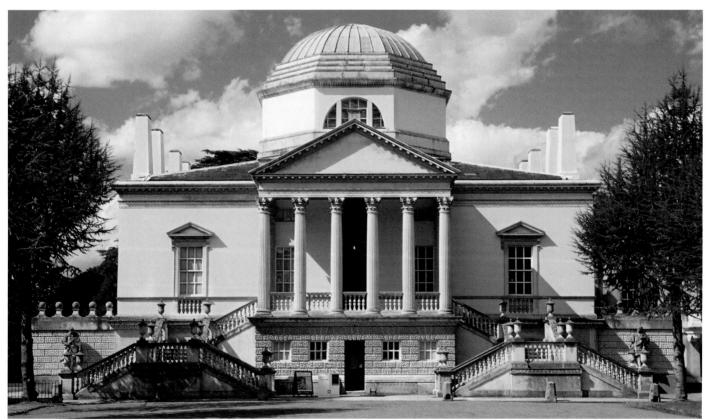

30–15 • Richard Boyle (Lord Burlington) PLAN (A) AND EXTERIOR VIEW (B) OF CHISWICK HOUSE West London, England. 1724–1729. Interior decoration (1726–1729) and new gardens (1730–1740) by William Kent.

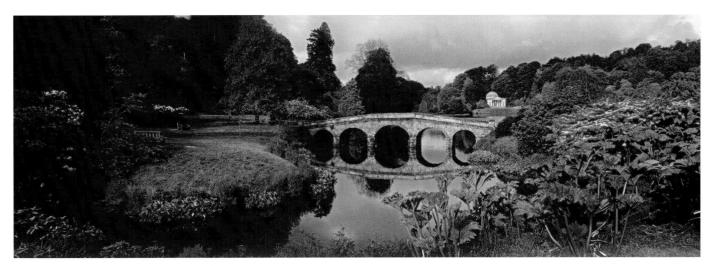

30–16 • Henry Flitcroft and Henry Hoare **THE PARK AT STOURHEAD** Wiltshire, England. Laid out 1743, executed 1744–1765, with continuing additions.

main entrance, flanked here by matching staircases, is a Roman temple front, an imposing entrance for the earl. Chiswick's elevation is characteristically Palladian, with a main floor resting on a basement, and tall, rectangular windows with triangular pediments. The few, crisp details seem perfectly suited to the refined proportions of the whole. The result is a lucid evocation of Palladio's design.

When in Rome, Burlington persuaded the English expatriate William Kent (1685–1748) to return to London as his collaborator. Kent designed Chiswick's surprisingly ornate interior as well as its grounds, the latter in a style that became known throughout Europe as the English landscape garden. Kent's garden abandoned the regularity and rigid formality of Baroque gardens (see "Garden Design," page 761). It featured winding paths, a lake with a cascade, irregular plantings of shrubs, and other effects that imitated the appearance of a natural rural landscape. In fact, it was carefully designed and manicured.

STOURHEAD Following Kent's lead at Chiswick, landscape architecture flourished in England in the hands of such designers as Lancelot ("Capability") Brown (1716-1783) and Henry Flitcroft (1697-1769). In the 1740s, the banker Henry Hoare began redesigning the grounds of his estate at Stourhead in Wiltshire (FIG. **30-16**) with the assistance of Flitcroft, a protégé of Burlington. The resulting gardens at Stourhead carried Kent's ideas for the English garden much further. Stourhead is a perfect example of the English picturesque garden. Its conception and views intentionally mimic the compositional devices of "pictures" by French landscape painter Claude Lorrain (see FIG. 23-56), whose paintings were popular in England. The picturesque view illustrated here shows a garden designed with "counterfeit neglect," intentionally contrived to look natural and unkempt. The small lake is crossed by a rustic bridge, while in the background we see a "folly," a miniature version of the Pantheon in Rome. The park is punctuated by other Classically inspired temples, copies of antique statues, artificial grottoes, a rural cottage, a Chinese bridge, a Gothic spire, and even a Turkish tent. The result is a delightful mixture of styles and cultures that combines aspects of both the Neoclassical and the Romantic. Inside the house, Hoare commissioned Mengs to paint *The Meeting of Antony and Cleopatra*, a blended work that chooses from Classical history a Romanticized subject.

WEDGWOOD The interiors of country houses like Chiswick and Stourhead were designed partly as settings for the art collections of British aristocrats, which included antiquities as well as a range of Neoclassical paintings, sculpture, and decorative wares (see "A Closer Look," page 921). The most successful producer of Neoclassical decorative art was Josiah Wedgwood (1730-1795). In 1769, near his native village of Burslem, he opened a pottery factory called Etruria after the ancient Etruscan civilization in central Italy known for its pottery. His production-line shop had several divisions, each with its own kilns and employing workers trained in diverse specialties. A talented chemist, in the mid 1770s Wedgwood perfected a fine-grained, unglazed, colored pottery which he called jasperware. His most popular jasperware featured white figures against a blue ground, as in THE APO-**THEOSIS OF HOMER** jar (**FIG. 30-17**). The low-relief decoration was designed by the sculptor John Flaxman, Jr. (1755–1826), who worked for Wedgwood from 1775 to 1787. Flaxman based this scene on a book illustration portraying a particular Greek vessel in the collection of William Hamilton (1730–1803), a leading collector of antiquities and one of Wedgwood's major patrons. Flaxman simplified the original design to accommodate both the popular and idealized notion of ancient Greek art and the demands of mass production.

The socially conscious Wedgwood, informed by Enlightenment thinking, established a village for his employees and showed concern for their well-being. He was also active in the international

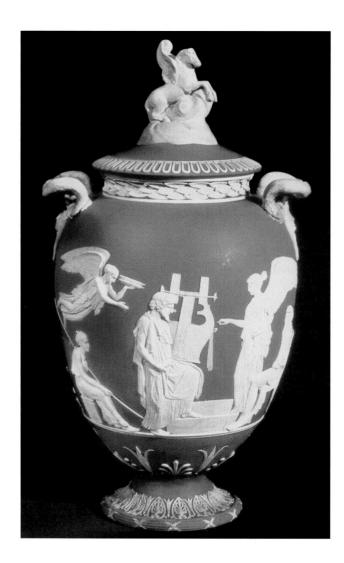

30-17 • (left) Josiah Wedgwood **THE APOTHEOSIS OF HOMER**

Made at the Wedgwood Etruria factory, Staffordshire, England. 1790–1795. White jasperware body with a mid-blue dip and white relief, height 18" (45.7 cm). Relief of The Apotheosis of Homer adapted from a plaque by John Flaxman, Jr., 1778. Trustees of the Wedgwood Museum, Barlaston, Staffordshire, England.

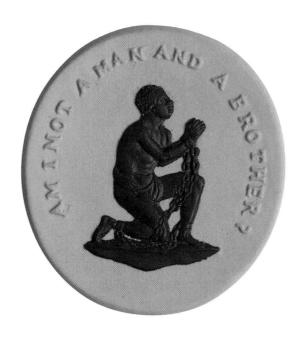

30-18 • (above) William Hackwood for Josiah Wedgwood "AM I NOT A MAN AND A BROTHER?"

1787. Black-and-white jasperware, 1%" \times 1%" \times 1%" (3.5 \times 3.5 cm). Trustees of the Wedgwood Museum, Barlaston, Staffordshire, England.

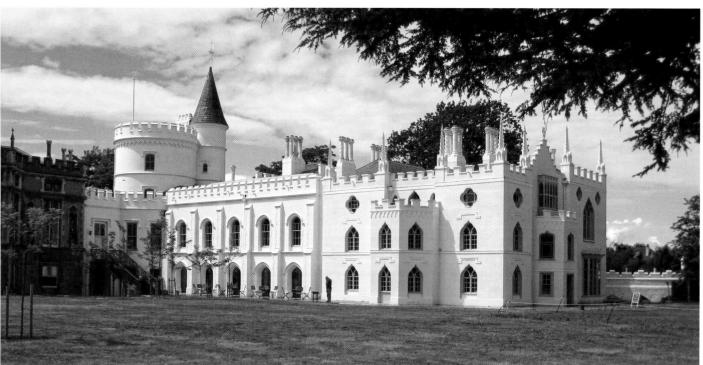

30–19 • Horace Walpole and others STRAWBERRY HILL Twickenham, England. 1749–1776.

A CLOSER LOOK | Georgian Silver

Elizabeth Morley: George III toddy ladle, 1802; Alice and George Burrows: George III snuffbox, 1802; Elizabeth Cooke: George III salver, 1767; Ann and Peter Bateman: George III goblet, 1797; Hester Bateman: George III double beaker, 1790

National Museum of Women in the Arts, Washington, DC. Silver collection assembled by Nancy Valentine. Purchased with funds donated by Mr. and Mrs. Oliver Grace and family

All of the objects shown here bear the marks of silver shops run either wholly or partly by women, who played a significant role in the production of silver during the Georgian period—the years from 1714 to 1830, when Great Britain was ruled by four successive kings named George.

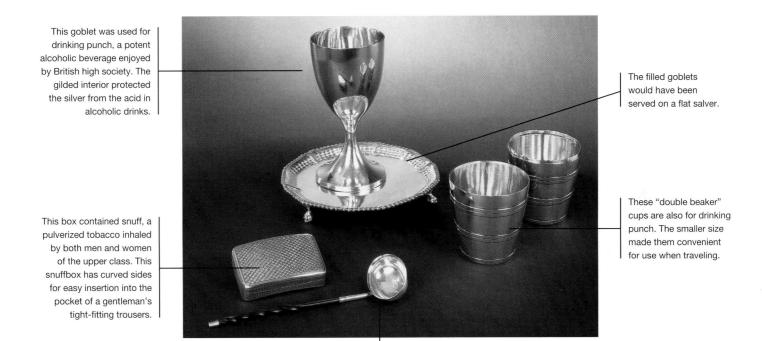

This ladle was used to pour punch from a bowl into a goblet. Its twisted whalebone handle floats, making it easy to retrieve from the bowl.

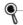

View the Closer Look for Georgian silver on myartslab.com

effort to halt the African slave trade and abolish slavery. In an attempt to publicize the abolitionist cause, he commissioned the sculptor William Hackwood (c. 1757-1839) to design an emblem for the British Committee to Abolish the Slave Trade, formed in 1787. Hackwood created a small medallion of black-and-white jasperware, with a cameo likeness of an African man kneeling in chains, and the legend "AM I NOT A MAN AND A BROTHER?" (FIG. 30-18). Wedgwood sent copies of the medallion to Benjamin Franklin, the president of the Philadelphia Abolition Society, and to others in the abolitionist movement. The image was so compelling that the women's suffrage movement in the United States later used it to represent a woman in chains with the motto "Am I Not a Woman and a Sister?"

THE GOTHIC REVIVAL IN ARCHITECTURE AND DESIGN

The Gothic Revival emerged alongside Neoclassicism in Britain in the mid eighteenth century and spread to several other nations after 1800. An early advocate of the Gothic Revival was the conservative politician and author Horace Walpole (1717–1797), who in 1764 published The Castle of Otranto, widely regarded as the first Gothic novel. This tale of mysterious and supernatural happenings, set in the Middle Ages, almost single-handedly launched a fashion for the Gothic. In 1749, Walpole began to remodel his country house, STRAWBERRY HILL, transforming it into the kind of Gothic castle that he described in his fiction (FIG. 30-19). Working with several friends and architects, over the next 30 years

30-20 • Horace Walpole, John Chute, and Richard Bentley PICTURE GALLERY SHOWING FAN-VAULTED CEILING, STRAWBERRY HILL After 1754.

he added decorative crenellations (alternating higher and lower sections along the top of a wall), tracery windows, and turrets, to create a fanciful Gothic castle. The interior, too, was redesigned according to Walpole's interpretation of the British historical past. In the **PICTURE GALLERY** (**FIG. 30–20**), he drew on engravings of medieval architecture from antiquarian books in his library. The gallery ceiling is modeled on that of the Chapel of Henry VII at Westminster, but transformed to suit Walpole's taste. For example, the strawberry design on the fan vaults would not have appeared in medieval architecture.

TRENDS IN BRITISH PAINTING

In the mid eighteenth century, portraits remained popular in British painting among those with the means to commission them. But a taste was also developing for other subjects, such as moralizing satire and caricature, ancient and modern history, scenes from British literature, and the actual British landscape and its people. Whatever their subject matter, many of the paintings and prints created in Britain reflected Romantic sensibilities and Enlightenment values, including an interest in social change, an embrace of natural beauty, and an enthusiasm for science and technology.

THE SATIRIC SPIRIT The industrialization of Britain created a large and affluent middle class with the disposable income to purchase smaller and less formal paintings such as landscapes and genre scenes, as well as prints. Relatively inexpensive printed versions of paintings could also be sold to large numbers of people. William Hogarth (1697–1764) capitalized on this new market for

art and was largely responsible for reviving the British print industry in the eighteenth century.

Trained as a portrait painter, Hogarth believed art should contribute to the improvement of society. He worked within the flourishing culture of satire in Britain directed at a variety of political and social targets, illustrating works by John Gay, a writer whose 1728 play *The Beggar's Opera* portrayed all classes as corrupt, but caricatured aristocrats in particular as feckless. In about 1730, Hogarth began illustrating moralizing tales of his own invention in sequences of four to six paintings, which he then produced in sets of mass-produced prints, enabling him to both maximize his profits and reach as many people as possible.

Between 1743 and 1745, Hogarth produced his Marriage à la Mode suite, inspired by Joseph Addison's 1712 essay in the Spectator promoting the concept of marriage based on love rather than on aristocratic machinations. In his series of paintings and later prints, Hogarth portrays the sordid story and sad end of an arranged marriage between the children of an impoverished aristocrat and a social-climbing member of the newly wealthy merchant class. In the opening scene of the series, THE MARRIAGE CONTRACT (FIG. 30-21), the cast of characters is assembled to legalize the union. At the right of the painting sits Lord Squanderfield, raising his gout-ridden right foot on a footstool as he points to his lengthy family tree (with a few wilted branches), which goes all the way back to medieval knights, as if to say that the pile of money in front of him on the table is not payment enough for the marriage contract he is being asked to sign. Young Squanderfield, a fop and a simpleton, sits on the far left, admiring himself in the

922

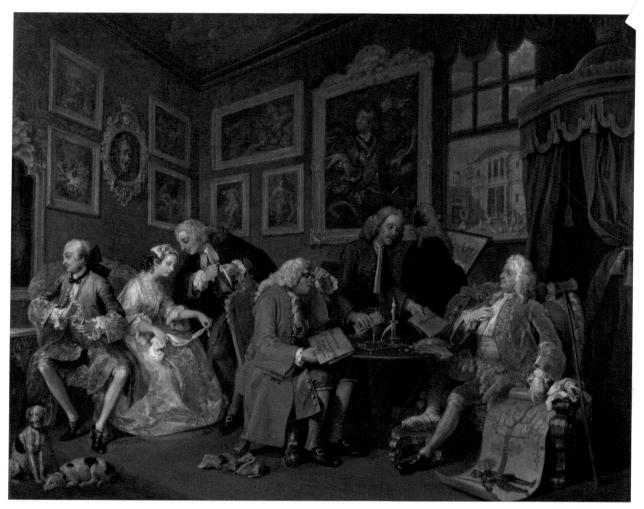

30–21 • William Hogarth THE MARRIAGE CONTRACT From *Marriage à la Mode*, 1743–1745. Oil on canvas, $27\frac{1}{2}$ × $35\frac{3}{4}$ " (69.9 × 90.8 cm). National Gallery, London.

mirror and ignoring his future wife as he takes a pinch of snuff. His neck is already showing signs of syphilis. The unhappy bride-to-be is extravagantly dressed but rather plain, and her wedding ring is threaded through a handkerchief to wipe away her tears. In the center, her father, the uncultured but wealthy merchant in the brash red coat, leans forward to study Lord Squanderfield's pedigree, an empty sack of money at his feet. The other men are lawyers, including the slippery Silvertongue, who is sharpening the quill that will seal the young couple's fate. The next five scenes of this sad tale describe the progressively disastrous results of such a union, culminating in murder and suicide.

Hogarth hoped to create a distinctively British style of art, free of obscure mythological references and encouraging the self-improvement in viewers that would lead to social progress. His contempt for the decadent tastes of the aristocracy can be seen in the comic detail of the paintings hanging on Lord Squanderfield's walls. Hogarth wanted to entertain and amuse his audiences, but at the same time his acerbic wit lays open the tensions of class and wealth so prevalent in the Britain of his day. Hogarth's work became so popular that in 1745 he was able to give up portraiture, which he considered a deplorable form of vanity.

PORTRAITURE Sir Joshua Reynolds (1723–1792) was a generation younger than Hogarth, and represented the mainstream of British art at the end of the century. After studying Renaissance art in Italy, Reynolds settled in London in 1753, where he worked vigorously to educate artists and patrons to appreciate Classically inspired history painting. In 1768, he was appointed the first president of the Royal Academy (see "Academies and Academy Exhibitions," page 926). His *Fifteen Discourses to the Royal Academy* (1769–1790) set out his theories on art in great detail. He argued that artists should follow rules derived from studying the great masters of the past, especially those who worked in the Classical tradition; he claimed that the ideal image communicated universal truths, and that artists should avoid representations based solely on observation, as these paintings merely communicated base reality.

Reynolds was able to combine his own taste for history painting with his patrons' desire for images of themselves by developing a type of historical or mythological portraiture that he called the **Grand Manner. LADY SARAH BUNBURY SACRIFICING TO THE GRACES** (FIG. 30-22) is a good example. The large scale of the canvas suggests that it is a history painting, and its details evoke a Classical setting. Framed by a monumental Classical pier and

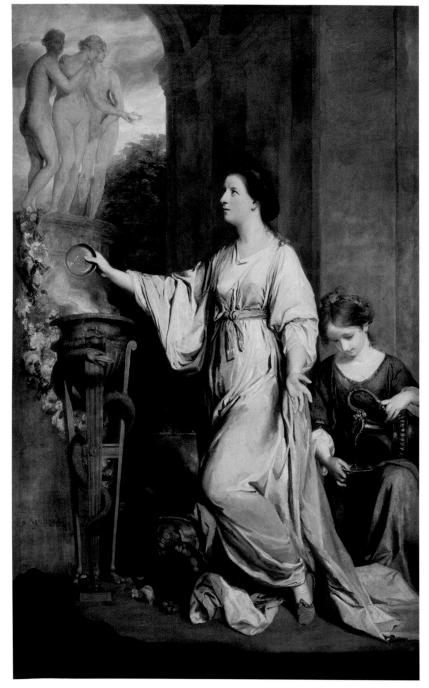

30-22 • Joshua Reynolds LADY SARAH BUNBURY SACRIFICING TO THE GRACES

1765. Oil on canvas, 7'10" \times 5' (2.42 \times 1.53 m). The Art Institute of Chicago. Mr. and Mrs. W. W. Kimball Collection, 1922.4468

Lady Sarah Bunbury was one of the great beauties of her era. A few years before this portrait was painted, she turned down a proposal of marriage from George III.

Read the document related to Joshua Reynolds on myartslab.com

arch, and dressed in a classicizing costume, Lady Sarah plays the part of a Roman priestess making a sacrifice to the Three Graces, personifications of female beauty. Portraits such as this were intended for the public rooms, halls, and stairways of aristocratic

residences. Reynolds's Grand Manner portraits were widely celebrated, and his London studio was abuzz with sitters, patrons, and assistants. But Reynolds experimented with his paints, so many of his canvases have faded badly.

A counterpoint to Reynolds's style of portraiture is found in the art of Thomas Gainsborough (1727-1788). Gainsborough later set up a studio in Bath, a resort frequented by the rich and fashionable, and catered to his clients' tastes for the informal poses and natural landscapes introduced to England by Van Dyck in the 1620s (see Fig. 23-28). Gainsborough's early, unfinished ROBERT ANDREWS AND FRANCES CARTER (FIG. 30-23), painted soon after their wedding in 1748, shows the wealthy young rural landowner and his wife posed on the grounds of their estate, with the Sudbury River and the hills of Suffolk in the background. The youthful Frances Carter sits stiffly on a decorative seat, the shimmering satin of her fine dress arranged around her, while her husband appears more relaxed, his hunting rifle tucked casually under his arm and his favorite dog at his side. The couple's good care of the land is revealed as well: The neat rows of grain stocks and stubble in the foreground show Robert Andrews's use of the seed drill and plant husbandry. Sheep and horses graze in separate fields. The significance of this painting lies in the natural pose of the couple, the depictions of their land and the pride they take in it and the wealth and power it provides, and the artist's emphasis on nature as the source of bounty and beauty.

THE ROMANCE OF SCIENCE In the English Midlands, artist Joseph Wright of Derby (1734–1797) shows an Enlightenment fascination with the drama and romance of science in his depiction of AN EXPERIMENT ON A BIRD IN THE AIR-PUMP (FIG. 30-24). Wright set up his studio during the first wave of the Industrial Revolution, and many of his patrons were self-made wealthy industrial entrepreneurs. He belonged to the Lunar Society, a group of industrialists (including Wedgwood), merchants, traders, and progressive aristocrats who met monthly in or near Birmingham to exchange ideas about science and technology. As part of the society's attempts to popularize science, Wright painted a series of "entertaining"

scenes of scientific experiments.

The second half of the eighteenth century was an age of rapid technological change (see "Iron as a Building Material," page 928), and the development of the air-pump was among the

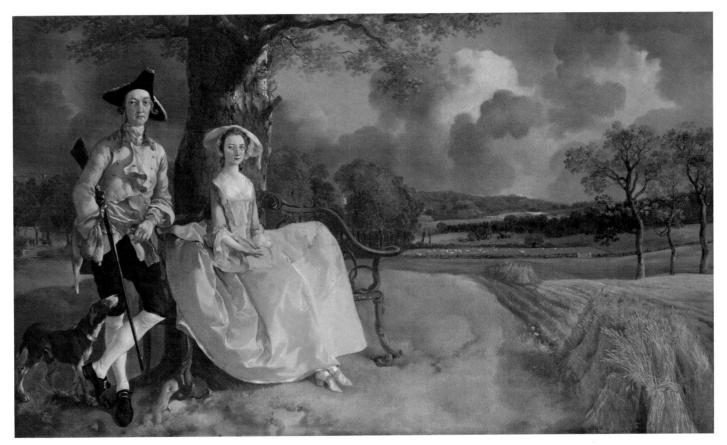

30–23 • Thomas Gainsborough **ROBERT ANDREWS AND FRANCES CARTER (MR. AND MRS. ANDREWS)** c. 1748–1750. Oil on canvas, $27\frac{1}{2}$ " \times 47" (69.7 \times 119.3 cm). National Gallery, London.

Gainsborough was engaged to paint this couple's portrait shortly after the 20-year-old Robert Andrews married 16-year-old Frances Carter in November 1748. An area of painting in Frances's lap has been left unfinished, perhaps anticipating the later addition of a child for her to hold.

30-24 • Joseph Wright of Derby AN EXPERIMENT ON A BIRD IN THE AIR-PUMP 1768. Oil on canvas, $6' \times 8'$ (1.82 \times 2.43 m). National Gallery, London.

ART AND ITS CONTEXTS | Academies and Academy Exhibitions

During the seventeenth century, the French government founded a number of **academies** for the support and instruction of students in literature, painting and sculpture, music and dance, and architecture. In 1664, the French Royal Academy of Painting and Sculpture in Paris began to mount occasional exhibitions of members' recent work. This exhibition came to be known as the Salon because it was held in the Salon Carré in the Palace of the Louvre. As of 1737, the Salon was held every other year, with a jury of members selecting the works to be shown.

History paintings (based on historical, mythological, or biblical narratives and generally conveying a high moral or intellectual idea) were accorded highest place in the Academy's hierarchy of genres, followed by historical portraiture, landscape painting, various other forms of portraiture, genre painting, and still life. The Salon shows were the only public art exhibitions of importance in Paris, so they were highly influential in establishing officially approved styles and in molding public taste; they also consolidated the Academy's control over the production of art.

In recognition of Rome's importance as a training ground for aspiring history painters, the French Royal Academy of Painting and Sculpture opened a French Academy in Rome in 1666. A competitive "Prix de Rome," or Rome Prize, enabled the winners to study in Rome for three to five years. A similar prize was established by the French Royal Academy of Architecture in 1720. Many Western cultural capitals emulated the French academic model: Academies were established in Berlin in 1696, Dresden in 1705, London in 1768 (Fig. 30–25), Boston in 1780, Mexico City in 1785, and New York in 1802.

Although there were several women members of the European academies of art before the eighteenth century, their inclusion amounted to little more than an honorary recognition of their achievements. In France, Louis XIV proclaimed in his founding address to the French Royal Academy that its purpose was to reward all worthy artists "without regard to the difference of sex," but this resolve was not put into practice. Only seven women gained the title of "Academician" between 1648 and 1706, after which the Academy was closed to women. Nevertheless, four more women were admitted by 1770; however, the

men, worried that women would become "too numerous," limited the total number of female members to four. Young women were neither admitted to the French Academy School nor allowed to compete for Academy prizes, both of which were required for professional success. They fared even worse at London's Royal Academy. The Swiss painters Mary Moser and Angelica Kauffmann were both founding members in 1768, but no other women were elected until 1922, and then only as associates.

30-25 • Johann Zoffany ACADEMICIANS OF THE ROYAL ACADEMY

1771–1772. Oil on canvas, $47\frac{1}{2}$ " \times 59 $\frac{1}{2}$ " (120.6 \times 151.2 cm). The Royal Collection, Windsor Castle, England.

Zoffany's group portrait of members of the London Royal Academy reveals how mainstream artists were taught in the 1770s. The painting shows artists, all men, setting up a life-drawing class and engaging in lively conversation. The studio is decorated with the academy's study collection of Classical statues and plaster copies. Propriety prohibited the presence of women in life-drawing studios, so Zoffany includes Royal Academicians Mary Moser and Angelica Kauffmann in portraits on the wall on the right.

many scientific innovations of the time. Although primarily used to study the properties of gas, it was also widely used in dramatic public demonstrations of scientific principles. In the experiment shown here, air was pumped out of the large glass vessel above the scientist's head until the bird inside collapsed from lack of oxygen. Before the animal died, air was reintroduced by a simple mechanism at the top. Wright depicts the exciting moment before air is reintroduced. Dramatically lit from below by a single light source on the table, the scientist peers out of the picture and gestures like a magician about to perform a trick. By delaying the reintroduction of air, the scientist has created considerable suspense. The three men on the left watch the experiment with great interest, while the young girls on the right have a more emotional response

to the proceedings. Near the window at upper right—through which a full moon shines (an allusion to the "Lunar" Society)—a boy stands ready to lower a cage when the bird revives. Science, the painting suggests, holds the potential for wonder, excitement, and discovery about matters of life and death.

HISTORY PAINTING By the time it was adapted to Neoclassicism, history painting had long been considered the highest form of art. The Swiss history painter Angelica Kauffmann (1741–1807), trained in Italy and one of the greatest exponents of early Neoclassicism, arrived in London in 1766 to great acclaim, inspiring British artists to paint Classical history paintings and British patrons to buy them. She was welcomed immediately

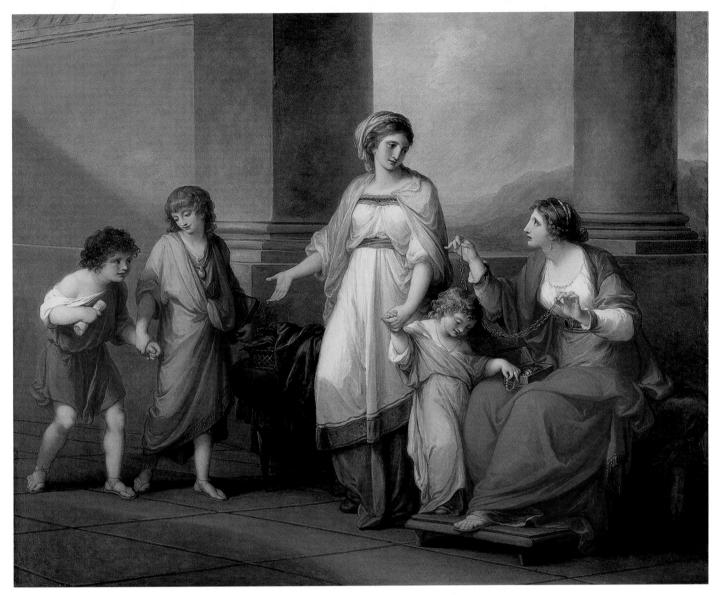

30–26 • Angelica Kauffmann CORNELIA POINTING TO HER CHILDREN AS HER TREASURES c. 1785. Oil on canvas, $40'' \times 50''$ (101.6×127 cm). Virginia Museum of Fine Arts, Richmond, Virginia. The Adolph D. and Wilkins C. Williams Fund

into Joshua Reynolds's inner circle; in 1768 she was one of only two women artists named among the founding members of the Royal Academy (see "Academies and Academy Exhibitions," opposite).

Already accepting portrait commissions at age 15, Kauffmann painted Winckelmann's portrait in Rome, became an ardent practitioner of Neoclassicism, and was elected to the Roman Academy of St. Luke. Most eighteenth-century women artists specialized in the "lower" painting genres of portraiture or still life, but Kauffmann boldly embarked on an independent career as a history painter. In London, where she lived from 1766 to 1781, she produced numerous history paintings, many of them with subjects drawn from Classical antiquity. After her return to Italy, Kauffmann painted **CORNELIA POINTING TO HER CHILDREN AS HER TREASURES** (FIG. 30-26) for an English patron. The scene

in the painting took place in the second century BCE, during the republican era of Rome. A woman visitor shows Cornelia her jewels and then asks to see those of her hostess. In response, Cornelia shows off her daughter and two sons, saying: "These are my most precious jewels." Cornelia exemplifies the "good mother," a popular theme among some later eighteenth-century patrons who preferred Classical subjects that taught metaphorical lessons of civic and moral virtue. The value of her maternal dedication is emphasized by the fact that her sons, Tiberius and Gaius Gracchus, grew up to be political reformers. Kauffmann's composition is severe and Classical, but she softens the image with warm, subdued lighting and with the tranquil grace of her figures.

Kauffmann's devotion to Neoclassical history painting emerged during her friendship with American-born Benjamin West (1738– 1820) in Rome. West studied in Philadelphia before he left for

ELEMENTS OF ARCHITECTURE | Iron as a Building Material

In 1779, Abraham Darby III built a bridge over the Severn River (**Fig. 30–27**) at Coalbrookdale in Shropshire, England, a town typical of industrial England, with factories and workers' housing filling the valley. Built primarily for function, the bridge demonstrated a need for newer, better transportation routes for moving industrial goods. Its importance lies in the fact that it is probably the first large-scale example of the use of structural metal in bridge building, in which iron struts replace the heavy, hand-cut stone voussoirs of earlier bridges. Five pairs of cast-iron, semicircular arches form a strong, economical 100-foot span.

In functional architecture such as this, the available technology, the properties of the material, and the requirements of engineering in large part determine form, often producing an unintended new aesthetic. Here, the use of metal made possible the light, open, skeletal structure sought by builders since the twelfth century. Cast iron was quickly adopted for the construction of such engineering wonders as the soaring train stations of the nineteenth century, leading ultimately to such marvels as the Eiffel Tower (see Fig. 31–1).

30-27 • Abraham Darby III **SEVERN RIVER BRIDGE** Coalbrookdale, England. 1779.

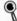

View a simulation about cast-iron structures on myartslab.com

Rome in 1759, where he met Winckelmann and became a student of Mengs. In 1763, he moved permanently to London, where he specialized in Neoclassical history painting. In 1768, along with Kauffmann and Reynolds, he became a founding member of the Royal Academy.

Two years later, West shocked Reynolds and his other academic friends with his painting **THE DEATH OF GENERAL WOLFE** (FIG. 30-28), which seemed to break completely with Neoclassicism and academic history painting. West argued that history painting was not dependent on dressing figures in Classical costume; in fact, it could represent a contemporary subject as long as the grand themes and elevated message remained intact. Thus, West's painting, and the genre it spawned, came to be known as "modern history" painting. At first, George III and Joshua Reynolds were appalled, but modern history pieces had too strong an attraction for both British collectors and the British public. The king eventually commissioned one of the four replicas of the painting.

West's painting glorifies the British general James Wolfe, who died in 1759 in a British victory over the French for the control of Quebec during the Seven Years War (1756-1763). West depicted Wolfe in his red uniform expiring in the arms of his comrades under a cloud-swept sky. In fact, Wolfe actually died at the base of a tree, surrounded by two or three attendants, but the laws of artistic decorum demanded a much nobler scene. Thus, though West's painting seems naturalistic, it is not an objective document, nor was it intended to be. West employs the Grand Manner that Reynolds proposed in his Discourses, celebrating the valor of the fallen hero, the loyalty of the British soldiers, and the justice of their cause. To indicate the North American setting, West also included at the left a Native American warrior who contemplates the fallen Wolfe. This was another fiction, since the Native Americans in this battle fought on the side of the French, but his presence here establishes the North American site of the event. The dramatic illumination increases the emotional intensity of the scene, as do the poses of Wolfe's attendants, arranged to suggest a Lamentation

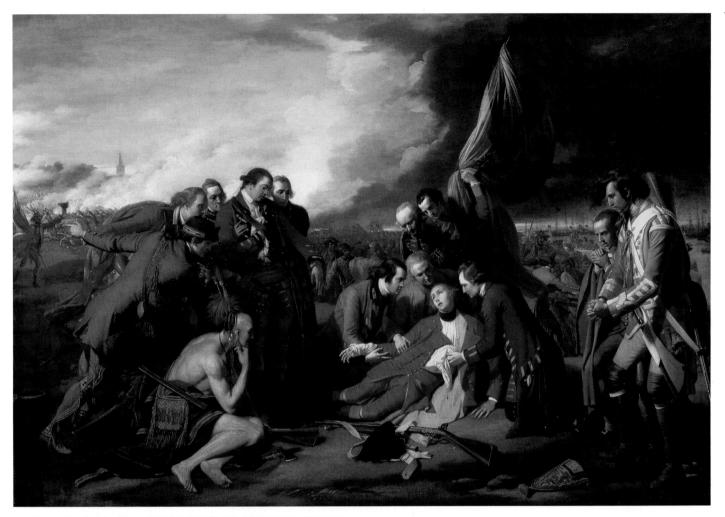

30–28 • Benjamin West **THE DEATH OF GENERAL WOLFE** 1770. Oil on canvas, $4'11\frac{1}{2}'' \times 7'$ (1.51 \times 2.14 m). National Gallery of Canada, Ottawa. Transfer from the Canadian War Memorials, 1921. Gift of the 2nd Duke of Westminster, Eaton Hall, Cheshire, 1918

The famous actor David Garrick was so moved by this painting that he enacted an impromptu interpretation of the dying Wolfe in front of the work when it was exhibited at the Royal Academy.

over the dead Christ. Extending the analogy, the British flag above Wolfe replaces the Christian cross. Just as Christ died for humanity, Wolfe sacrificed himself for the good of the nation. The brilliant color, emotional intensity, and moralizing message made this image extremely popular with the British public. It was translated into a print and received the widest circulation of any image in Britain up to that time.

ROMANTIC PAINTING The emotional drama of West's painting helped launch Romanticism in Britain. Among its early practitioners was John Henry Fuseli (1741–1825), who arrived in London from his native Switzerland in 1764. Trained in theology, philosophy, and the Neoclassical aesthetics of Winckelmann (whose writings he translated into English), Fuseli quickly became a member of London's intellectual elite. Joshua Reynolds encouraged Fuseli to become an artist, and in 1770 he left England to study in Rome, where he spent most of the next eight years.

His encounter with the sometimes tortured and expressive aspects of both Roman sculpture and Michelangelo's painting led him not to Neoclassicism but to develop his own powerfully expressive style. In his work, Fuseli drew more heavily on the passion of some Roman art, and later that of Michelangelo, than on the ancient Greek art admired by Winckelmann.

Back in London, Fuseli established himself as a history painter, but he specialized in dramatic subjects drawn from Homer, Dante, Shakespeare, and Milton. His interest in the dark recesses of the human mind led him to paint supernatural and irrational subjects. In **THE NIGHTMARE** (FIG. 30-29), he depicts a sleeping woman sprawled across a divan with her head thrown back, oppressed by a gruesome incubus (or *mara*, an evil spirit) crouching on her pelvis in an erotic dream. According to legend, the incubus was believed to feed by stealing women and having sex with them. In the background a horse with wild, phosphorescent eyes thrusts its head into the room through a curtain. The image communicates fear

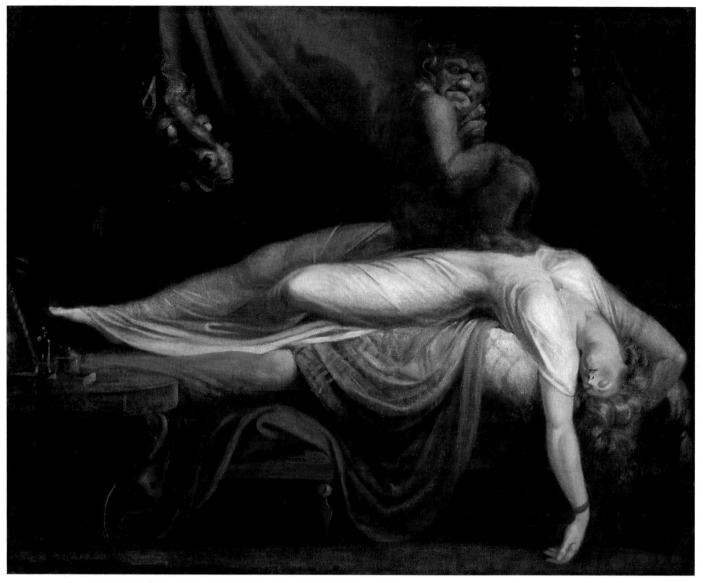

30–29 • John Henry Fuseli THE NIGHTMARE

1781. Oil on canvas, 39¾" × 49½" (101 × 127 cm). The Detroit Institute of Arts.

Founders Society purchase with Mr. and Mrs. Bert L. Smokler and Mrs. Lawrence A. Fleischmann funds

Fuseli was not popular with the English critics. One writer said that his 1780 entry in the London Royal Academy exhibition "ought to be destroyed," and Horace Walpole called another painting in 1785 "shockingly mad, mad, mad, madder than ever." Even after achieving the highest official acknowledgment of his talents, Fuseli was called "the Wild Swiss" and "Painter to the Devil." But the public appreciated his work, and *The Nightmare*, exhibited at the Royal Academy in 1782, was repeated in at least three more versions and its imagery was disseminated through prints published by commercial engravers. One of these prints would later hang in the office of the Austrian psychoanalyst Sigmund Freud, who believed that dreams were manifestations of the dreamer's repressed desires.

of the unknown and unknowable, and sexuality without restraint. The painting was exhibited at the Royal Academy in 1782, and although not well received by Fuseli's peers, it clearly struck a chord with the public. He painted at least four versions of this subject and prints of it had a wide circulation.

Fuseli's friend William Blake (1757–1827), a highly original poet, painter, and printmaker, was also inspired by the dramatic aspect of Michelangelo's art. Trained as an engraver, he enrolled briefly at the Royal Academy, where he quickly rejected the teachings of Reynolds, believing that rules hinder rather than aid

creativity. He became a lifelong advocate of probing the unfettered imagination. For Blake, the imagination provided access to the higher realm of the spirit while reason was confined to the lower world of matter.

Blake was interested in probing the nature of good and evil, developing an idiosyncratic form of Christian belief that drew on elements from the Bible, Greek mythology, and British legend. His "prophetic books," designed and printed in the mid 1790s, brought together painting and poetry to explore themes of spiritual crisis and redemption. Thematically related to the prophetic

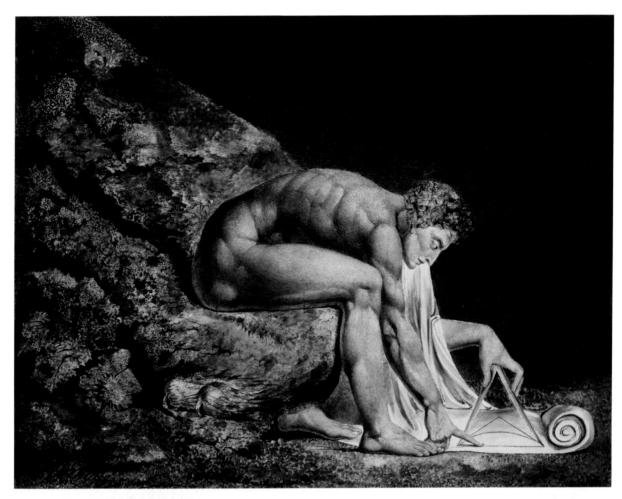

30–30 • William Blake NEWTON 1795–c. 1805. Color print finished in ink and watercolor, $18\frac{1}{6}$ " \times 23 $\frac{5}{6}$ " (46 \times 60 cm). Tate, London.

books are an independent series of 12 large color prints that he executed mostly in 1795. These include the large print of **NEW-TON** (**FIG. 30-30**), the epitome of eighteenth-century rationalism, heroically naked in a cave, obsessed with reducing the universe to a mathematical drawing with his compasses in an image that recalls medieval representations of God the Creator, designing the world.

John Singleton Copley, whose portrait of Sarah Morris and Thomas Mifflin opened this chapter (see Fig. 30-1), moved from Boston to London after the Revolutionary War, never to return to his native land. In London, he established himself as a portraitist and painter of modern history in the vein of fellow American expatriate Benjamin West. Copley's most distinctive modern history painting was WATSON AND THE SHARK (FIG. 30-31), commissioned by Brook Watson, a wealthy London merchant and Tory politician, in 1778. Copley's painting dramatizes an episode of 1749, in which the 14-year-old Watson was attacked by a shark while swimming in Havana Harbor, and lost part of his right leg before being rescued by his comrades. Copley's pyramidal composition is made up of figures in a boat and the hapless Watson in the water with a highly imaginary shark set against the backdrop of the harbor. Several of the figures were inspired by Classical sources, but the scene portrayed is anything but Classical. In the

foreground, the ferocious shark lunges toward the helpless, naked Watson, while at the prow of the rescue boat a man raises his harpoon to attack the predator. At the left, two of Watson's shipmates strain to reach him while others in the boat look on in alarm. An African man, standing at the apex of the painting, holds a rope that curls over Watson's extended right arm, connecting him to the boat.

Some scholars have read the African figure as a servant waiting to hand the rope to his white master, but his inclusion has also been interpreted in more overtly political terms. The shark attack on Watson in Havana Harbor occurred while he was working in the transatlantic shipping trade, one aspect of which involved the shipment of slaves from Africa to the West Indies. At the time when Watson commissioned this painting, debate was raging in the British Parliament over the interconnected issues of the Americans' recent Declaration of Independence and the slave trade. Several Tories, including Watson, opposed American independence, highlighting the hypocrisy of American calls for freedom from the British crown while the colonists continued to deny freedom to African slaves. Indeed, during the Revolutionary War the British offered freedom to every runaway American slave who joined the British army or navy.

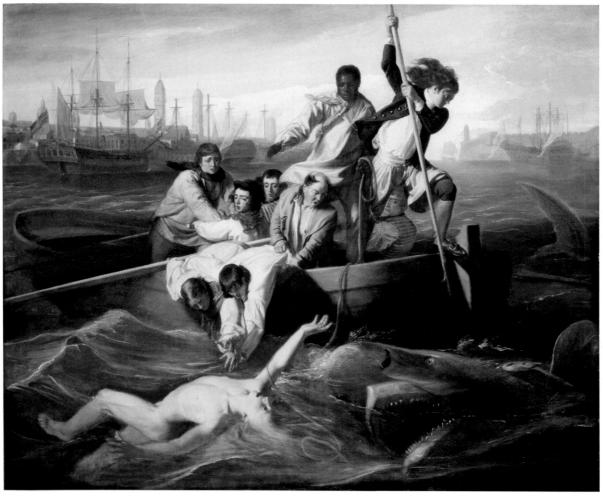

30–31 • John Singleton Copley WATSON AND THE SHARK 1778. Oil on canvas, $5'10^3$ /4" \times $7'6^1$ /2" (1.82 \times 2.29 m). National Gallery of Art, Washington, DC. Ferdinand Lammot Belin Fund

Copley's painting, its subject doubtless dictated by Watson, may therefore indicate Watson's sympathy for American slaves; or the figure may be included simply to indicate that the event took place in Havana, much as the inclusion of a Native American in West's painting of the death of Wolfe (see FIG. 30–28) sites that picture. Copley was one of the first artists in the capital to exhibit his modern history paintings in public places around London, making money by charging admission fees and advertising his large paintings for sale. His extraordinary images and exhibitions took advantage of the spectacular displays of early nineteenth-century London's Phantasmagoria (a sensational magic lantern display with smoke, mirrors, lights, and gauze "ghosts"), panoramas, dioramas, and the Eidophusikon (a miniature theater with special effects).

LATER EIGHTEENTH-CENTURY ART IN FRANCE

In late eighteenth-century France, the Rococo was replaced by Enlightenment ideas and by the gathering storm clouds of revolution. French art moved increasingly toward Neoclassicism as French architects held closer to Roman proportions and sensibility, while painters and sculptors increasingly embraced didactic presentations in sober, Classical style.

ARCHITECTURE

French architects of the late eighteenth century generally considered Classicism not one of many alternative artistic styles but as the single, true style. Winckelmann's argument that "imitation of the ancients" was the key to good taste was taken to heart in France. The leading French Neoclassical architect was Jacques-Germain Soufflot (1713-1780), whose church of Sainte-Geneviève, known today as the PANTHÉON (FIG. 30-32), is the most typical Neoclassical building in Paris. In it, Soufflot attempted to integrate three traditions: the Roman architecture he had seen on two trips to Italy; French and English Baroque Classicism; and the Palladian style being revived at the time in England. The façade of the Panthéon, with its huge portico, is modeled on the proportions of ancient Roman temples. The dome, on the other hand, was inspired by seventeenth-century architecture, including Sir Christopher Wren's St. Paul's Cathedral in London (see FIG. 23-60), while the radical geometry of its central-plan layout (FIG. 30-33) owes as much to Burlington's Neo-Palladian Chiswick House (see FIG.

30-32 • Jacques-Germain Soufflot PANTHÉON (CHURCH OF SAINTE-GENEVIÈVE), PARIS

1755-1792.

This building has an interesting history. Before it was completed, the revolutionary government in control of Paris confiscated all religious properties to raise desperately needed public funds. Instead of selling Sainte-Geneviève, however, they voted in 1791 to make it the Temple of Fame for the burial of Heroes of Liberty. Under Napoleon I (r. 1799-1814), the building was resanctified as a Catholic church and was again used as such under King Louis-Philippe (r. 1830-1848) and Napoleon III (r. 1852-1870). Then it was permanently designated a nondenominational lay temple. In 1851, the building was used as a physics laboratory. Here the French physicist Jean-Bernard Foucault suspended his now-famous pendulum in the interior of the high crossing dome, and by measuring the path of the pendulum's swing proved his theory that the Earth rotated on its axis in a counterclockwise motion. In 1995, the ashes of Marie Curie, who had won the Nobel Prize for Chemistry in 1911, were moved into this "memorial to the great men of France," making her the first woman to be enshrined there.

30-33 • CUTAWAY ILLUSTRATION OF THE PANTHÉON

Explore the architectural panoramas of the Panthéon on myartslab.com

30–15) as it does to Christian tradition. The Panthéon, however, is not simply the sum of its parts. Its rational, ordered plan is constructed with rectangles, squares, and circles, while its relatively plain surfaces communicate severity and powerful simplicity.

PAINTING AND SCULPTURE

While French painters such as Boucher, Fragonard, and their followers continued to work in the Rococo style in the later decades of the eighteenth century, a strong reaction against the Rococo had set in by the 1760s. A leading detractor of the Rococo was Denis Diderot (1713–1784), whose 32-volume compendium of knowledge and skill, the *Encyclopédie* (produced in collaboration with Jean le Rond d'Alembert, 1717–1783) served as an archive of Enlightenment thought in France. In 1759, Diderot began to write reviews of the official Salon for a periodic newsletter for wealthy subscribers, and he is generally considered to be the founder of modern art criticism. Diderot believed that it was art's proper function to "inspire virtue and purify manners," a function that the Rococo was not designed to fulfill.

CHARDIN Diderot greatly admired Jean-Siméon Chardin (1699–1779), an artist who as early as the 1730s began to create moralizing pictures in the tradition of seventeenth-century Dutch genre painting by focusing on carefully structured but touching

scenes of everyday middle-class life. **THE GOVERNESS** (**FIG. 30-34**), for instance, shows a finely dressed boy with books under his arm, addressed by his governess as she prepares to brush his tricorne (three-cornered hat). Scattered on the floor are a racquet, a shuttlecock, and playing cards, the childish pleasures that the boy leaves behind as he prepares to go to his studies and, ultimately, to a life of responsible adulthood. The work suggests the benevolent exercise of authority and willing submission to it, both seen as critical to proper political as well as familial life.

GREUZE Diderot reserved his highest praise for Jean-Baptiste Greuze (1725–1805), and his own plays of the late 1750s served as a source of inspiration for Greuze's painting. Diderot expanded the traditional range of theatrical works in Paris from mostly tragedy and comedy to include the *drame bourgeois* (middle-class drama) and "middle tragedy" (later called the "melodrama"), both of which communicated moral and civic lessons through simple, clear stories of ordinary life. Greuze's domestic genre paintings, such as **THE VILLAGE BRIDE** (FIG. 30-35), were visual counterparts to Diderot's *drame bourgeois* and "middle tragedy." In this painting, Greuze presents the action on a shallow, stagelike space under a dramatic spotlight. An elderly father reaches out to his affectionate family as he hands the dowry for his daughter to his new son-in-law; a notary records the event. The young couple

tentatively link their arms, while the bride is embraced within her family by her mother and sister. What a contrast to the simmering deception and self-serving objectives highlighted in Hogarth's marriage contract (see FIG. 30–21). Greuze's painting seeks to demonstrate that virtue and poverty can coexist. This kind of highly emotional, theatrical, and moralizing genre scene was widely praised in Greuze's time, offering a counterpoint to early Neoclassical history painting in France.

VIGÉE-LEBRUN While Greuze painted scenes of the poor and middle class, Marie-Louise-Élisabeth Vigée-Lebrun (1755–1842) became famous as Queen Marie Antoinette's

30–34 • Jean-Siméon Chardin THE GOVERNESS 1739. Oil on canvas, $18\frac{1}{8}$ " \times $14\frac{3}{4}$ " (46 \times 37.5 cm). National Gallery of Canada, Ottawa. Purchase, 1956

Chardin was one of the first French artists to treat the lives of women and children with sympathy and to portray the dignity of women's work in his images of young mothers, governesses, and kitchen maids. Shown at the Salon of 1739, *The Governess* was praised by contemporary critics, one of whom noted "the graciousness, sweetness, and restraint that the governess maintains in her discipline of the young man about his dirtiness, disorder, and neglect; his attention, shame, and remorse; all are expressed with great simplicity."

30-35 • Jean-Baptiste Greuze THE VILLAGE BRIDE, OR THE MARRIAGE, THE MOMENT WHEN A FATHER GIVES HIS SON-IN-LAW A DOWRY

1761. Oil on canvas, 36" × 461/2" (91.4 × 118.1 cm). Musée du Louvre, Paris.

favorite portrait painter. Vigée-Lebrun was also notable for her election into the French Royal Academy of Painting and Sculpture, which then made only four places available to women. In 1787, she painted **MARIE ANTOINETTE WITH HER CHILDREN** (FIG. 30-36). Drawing on the theme of the "good mother" seen earlier in Angelica Kauffmann's Neoclassical painting of Cornelia (see FIG. 30-26), Vigée-Lebrun portrays the queen as a kindly, stabilizing mother, a flagrant work of royal propaganda aimed at counteracting public perceptions of her as selfish, extravagant, and immoral. The queen maintains her appropriately regal pose, but her children are depicted more sympathetically. The princess leans affectionately against her mother's arm and the little dauphin—heir to a throne he

30–36 • Marie-Louise-Élisabeth Vigée-Lebrun **PORTRAIT OF MARIE ANTOINETTE WITH HER CHILDREN** 1787. Oil on canvas, $9'\sqrt[3]{2}'' \times 7'\sqrt[5]{8}''$ (2.75 × 2.15 m). Musée National du Château de Versailles.

As the favorite painter to the queen, Vigée-Lebrun escaped from Paris with her daughter on the eve of the Revolution of 1789 and fled to Rome. After a very successful self-exile working in Italy, Austria, Russia, and England, the artist finally resettled in Paris in 1805 and again became popular with Parisian art patrons. Over her long career, she painted about 800 portraits in a vibrant style that changed very little over the decades.

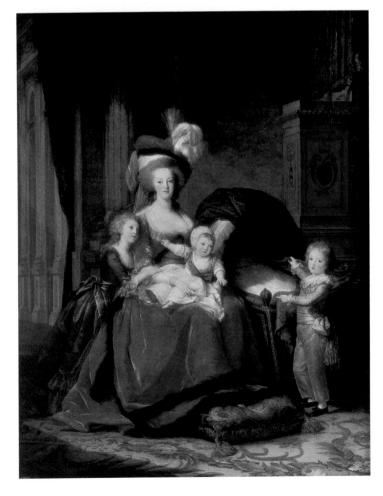

would never inherit—poignantly points to the empty cradle of a recently deceased sibling. The image alludes to the allegory of Abundance and is intended to signify peace and prosperity for France under the reign of Marie Antoinette's husband, Louis XVI, who came to the throne in 1774 but would be executed, along with the queen, in 1793.

DAVID The most important French Neoclassical painter of the era was Jacques-Louis David (1748–1825), who dominated French art for over 20 years during the French Revolution and the subsequent reign of Napoleon. In 1774, he won the Prix de Rome and spent six years in that city, studying antique sculpture and learning the principles of Neoclassicism. After his return to Paris, he produced a series of severely plain Neoclassical paintings extolling the antique virtues of stoicism, masculinity, and patriotism.

Perhaps the most significant of these works was the **OATH OF THE HORATII** (**FIG. 30-37**) of 1784–1785. A royal commission that David returned to Rome to paint, the work reflects the taste and values of Louis XVI, who, along with his minister of the arts, Count d'Angiviller, was sympathetic to the Enlightenment. Like Diderot, d'Angiviller and the king believed that art should improve public morals. One of d'Angiviller's first official acts was to ban indecent nudity from the Salon of 1775 and commission a series of didactic history paintings. The commission for David's *Oath of the Horatii* in 1784 was part of that general program.

The subject of the painting was inspired by the drama *Horace*, written by the great French playwright Pierre Corneille (1606–1684), which was in turn based on ancient Roman historical texts. The patriotic oath-taking incident David depicted, however, is not taken directly from these sources and was apparently the artist's

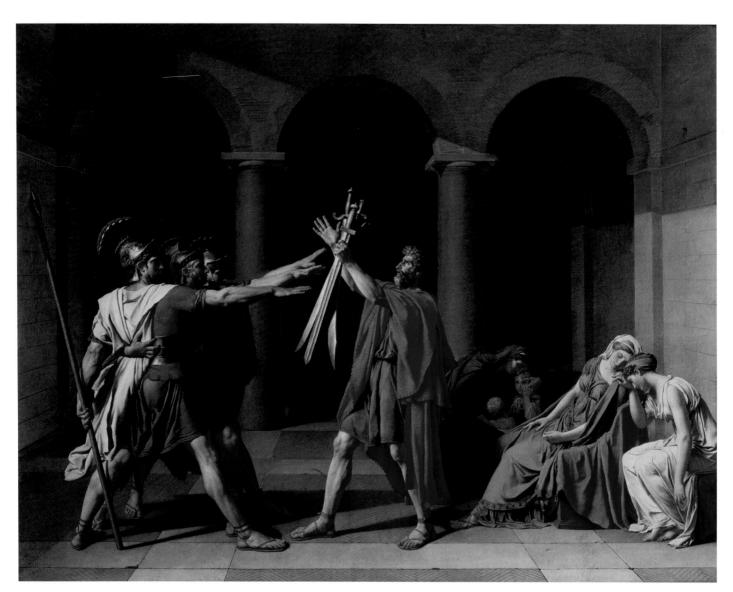

30-37 • Jacques-Louis David OATH OF THE HORATII 1784–1785. Oil on canvas, 10'81⁄4" \times 14' (3.26 \times 4.27 m). Musée du Louvre, Paris.

Read the document related to Jacques-Louis David on myartslab.com

own invention. The story is set in the seventh century BCE, at a time when Rome and its rival, Alba, a neighboring city-state, agreed to settle a border dispute and avert a war by holding a battle to the death between the three sons of Horace (the Horatii), representing Rome, and the three Curatii, representing Alba. In David's painting, the Horatii stand with arms outstretched toward their father, who reaches toward them with the swords on which they pledge to fight and die for Rome. The power gestures of the young men's outstretched hands almost pushes their father back. In contrast to the upright, tensed, muscular angularity of the men, the group of swooning women and frightened children are limp. They weep for the lives of both the Horatii and the Curatii. Sabina (in the center) is a sister of the Curatii, and also married to one of the Horatii; Camilla (at the far right) is sister to the Horatii and engaged to one of the Curatii. David's composition, which separates the men from the women and children spatially by the use of framing

background arches, dramatically contrasts the young men's stoic and willing self-sacrifice with the women's emotional collapse.

The moving intensity of this history painting pushed French academic rules on decorum to their limit. Originally a royal commission, it quickly and ironically became an emblem of the 1789 French Revolution since its message of patriotism and sacrifice for the greater good effectively captured the mood of the leaders of the new French Republic established in 1792. As the revolutionaries abolished the monarchy and titles of nobility, took education out of the hands of the Church, and wrote a declaration of human rights, David joined the leftist Jacobin party.

In 1793, David painted the death of the Jacobin supporter, Jean-Paul Marat (**FIG. 30-38**). A radical journalist, Marat lived simply among the packing cases that he used as furniture, writing pamphlets urging the abolition of aristocratic privilege. Because he

suffered from a painful skin ailment, he would often write while sitting in a medicinal bath. Charlotte Corday, a supporter of an opposition party, held Marat partly responsible for the 1792 riots in which hundreds of political prisoners judged sympathetic to the king were killed, and in retribution she stabbed Marat as he sat in his bath. David avoids the potential for sensationalism in the subject by portraying not the violent event but its tragic aftermath—the dead Marat slumped in his bathtub, his right hand still holding a quill pen, while his left hand grasps the letter that Corday used to gain access to his home. The simple wooden block beside the bath, which Marat used as a desk, is inscribed with the names of both Marat and the painter's in a dedicatory inscription—"to Marat, David." It almost serves as the martyr's tombstone.

David's painting is a tightly composed, powerfully stark image. The background is blank, adding to the quiet mood and timeless feeling of the picture, just as the very different background of the

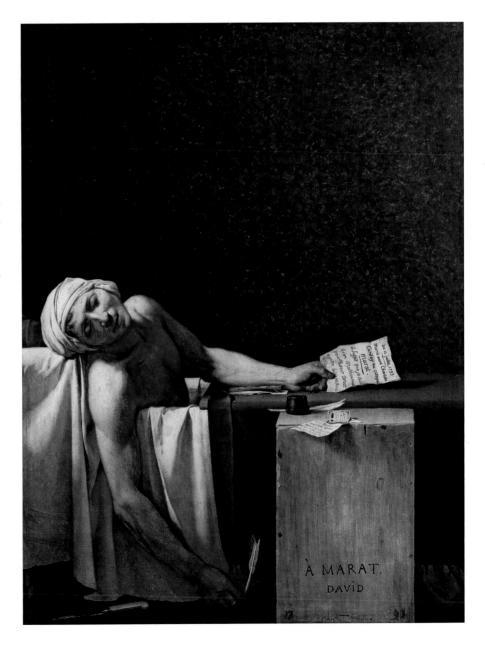

30-38 • Jacques-Louis David
DEATH OF MARAT

1793. Oil on canvas, 5′5″ \times 4′2½″ (1.65 \times 1.28 m). © Royal Museums of Fine Arts of Belgium, Brussels.

Oath of the Horatii also added to its drama. The color of Marat's pale body coordinates with the bloodstained sheets on which he lies, creating compact shape that is framed by the dark background and green blanket draped over the bathtub. David manages to transform an ugly, brutal event into an elegiac statement of somber eloquence. Marat's pose, which echoes Michelangelo's Vatican *Pietà* (see FIG. 21–9), implies that, like Christ, Marat was a martyr for the people.

The French Revolution eventually degenerated into mob rule in 1793–1794 as Jacobin leaders orchestrated the ruthless execution of thousands of their opponents in what became known as the Reign of Terror. David, as a Jacobin, was elected a deputy to the National Convention and served a two-week term as president, during which time he signed several arrest warrants. When the Jacobins lost power in 1794, he was twice imprisoned, albeit under lenient conditions that allowed him to continue to paint. He later emerged as a supporter of Napoleon and re-established his career at the height of Napoleon's ascendancy.

GIRODET-TRIOSON David was a charismatic and influential teacher who trained most of the major French painters of the 1790s and early 1800s, including Anne-Louis Girodet-Trioson (1767-1824). His POR-TRAIT OF JEAN-BAPTISTE BELLEY (FIG. 30-39) combines the restrained color and tight composition of David with a relaxed elegance that makes the subject more accessible to the viewer. And like many of David's works, this portrait was political. The Senegal-born Belley (1747?-1805) was a former slave who was sent to Paris as a representative to the French Convention by the colony of Saint-Domingue (now Haiti). The Haitian Revolution of 1791, in which African slaves overturned the French colonial power, resulted in the first republic to be ruled by freed African slaves. In 1794, Belley led the successful legislative campaign to abolish slavery in the colonies and to grant full citizenship to people of African descent. In the portrait, Belley leans casually on the pedestal of a bust of the abbot Guillaume Raynal (1711–1796), the French philosopher whose 1770 book condemned slavery and paved the way for such legislation, making the portrait a tribute to both Belley and Raynal. Napoleon re-established slavery in the Caribbean islands in 1801, but the revolt continued until 1804, when Haiti finally achieved full independence.

30-39 • Anne-Louis Girodet-Trioson **PORTRAIT OF JEAN-BAPTISTE BELLEY**

1797. Oil on canvas, $5'21\!/\!_{2}''\times3'81\!/\!_{2}''$ (1.59 \times 1.13 m). Musée National du Château de Versailles.

LABILLE-GUIARD Also reflecting the revolutionary spirit of the age, the painter Adélaïde Labille-Guiard (1749-1803) championed the rights of women artists. Elected to the French Royal Academy of Painting and Sculpture in the same year as Vigée-Lebrun, Labille-Guiard asserted her worthiness for this honor in a SELF-PORTRAIT WITH TWO PUPILS that she submitted to the Salon of 1785 (FIG. 30-40). The painting was a response to sexist rumors that her work, and that of Vigée-Lebrun, had actually been painted by men. In a witty role reversal, the only male in this monumental painting of the artist at her easel is her father, shown in a bust behind her canvas, as her muse, a role usually played by women. While the self-portrait flatters the painter, it also portrays Labille-Guiard as a force to be reckoned with, a woman who engages our gaze uncompromisingly, and whose students are serious and intent on their study. In the year following the French Revolution, Labille-Guiard successfully petitioned the French Academy of Painting and Sculpture to end the restriction that lim-

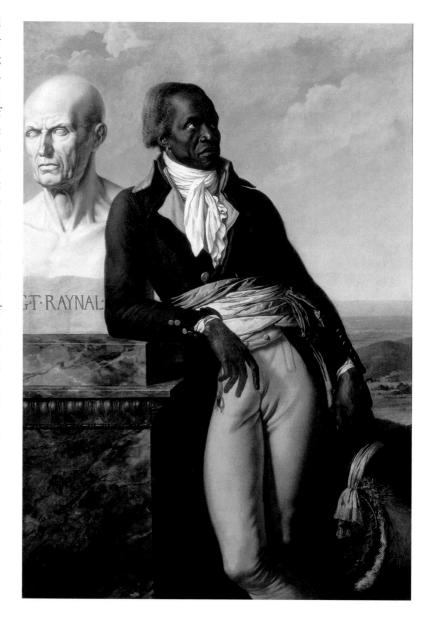

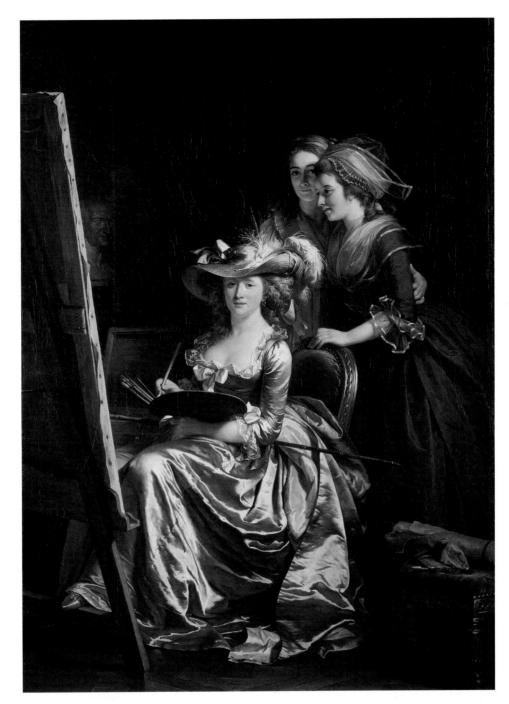

30–40 • Adélaïde Labille-Guiard **SELF-PORTRAIT WITH TWO PUPILS** 1785. Oil on canvas, 6'11" × 4'11½" (2.11 × 1.51 m). Metropolitan Museum of Art, New York. Gift of Julia A. Berwind, 1953 (53.225.5)

ited its membership to four women. The reform was later reversed by the revolutionary government as it became more authoritarian.

HOUDON The French Neoclassical sculptor Jean-Antoine Houdon (1741–1828), who studied in Italy between 1764 and 1768 after winning the Prix de Rome, imbued the Classical style with a new sense of realism. He carved busts and full-length statues of a number of the important figures of his time, including Diderot, Voltaire, Jean-Jacques Rousseau, Catherine the Great, Thomas

Jefferson, Benjamin Franklin, Lafayette (a Revolutionary hero), and Napoleon, and his studio produced a steady supply of replicas, much in demand because of the cult of great men promoted by Enlightenment thinkers to provide models of virtue and patriotism. On the basis of his bust of Benjamin Franklin, Houdon was commissioned by the Virginia State Legislature to make a portrait of its native son **GEORGE WASHINGTON** to be installed in the Neoclassical Virginia state capitol building designed by Jefferson. In 1785, Houdon traveled to the United States to make

a cast of Washington's features and create a bust in plaster, returning to Paris to execute the life-size marble figure (**FIG. 30-41**). The sculpture represents Washington in the Classical manner but dressed in contemporary clothes, much as Benjamin West had

GEORGE WASHINGTO

30-41 • Jean-Antoine Houdon GEORGE WASHINGTON 1788–1792. Marble, height 6'2" (1.9 m). State Capitol, Richmond, Virginia.

The plow share behind Washington alludes to Cincinnatus, a Roman soldier of the fifth century BCE who was appointed dictator and dispatched to defeat the Aequi, who had besieged a Roman army. After the victory, Cincinnatus resigned the dictatorship and returned to his farm. Washington's contemporaries compared him with Cincinnatus because, after leading the Americans to victory over the British, he resigned his commission and went back to farming rather than seeking political power. Just below Washington's waistcoat hangs the badge of the Society of the Cincinnati, founded in 1783 by the officers of the disbanding Continental Army who were returning to their peacetime occupations. Washington lived in retirement at his Mount Vernon, Virginia, plantation for five years before his 1789 election as the first president of the United States.

represented General Wolfe (see FIG. 30–28). Houdon imbues the portrait with Classical ideals of dignity, honor, and civic responsibility. Washington wears the uniform of a general, the rank he held in the Revolutionary War, but he also rests his left hand on a Roman *fasces*, a bundle of 13 rods (representing the 13 colonies) tied together with an axe face, that served as a Roman symbol of authority. Attached to the *fasces* are both a sword of war and a plowshare of peace. Significantly, Houdon's Washington does not touch the sword.

ART IN SPAIN AND SPANISH AMERICA

In the first half of the eighteenth century, Philip V (r. 1700–1746) marginalized the Spanish art world by awarding most royal commissions to foreign artists. German painter Mengs introduced Neoclassicism into Spain with his work for Charles III (r. 1759–1788), but Spanish artists did not embrace Neoclassicism the way they had Baroque during the previous century. At the end of the eighteenth century, however, the Spanish court appointed one of the greatest Spanish artists of the period as court painter: Francisco Goya y Lucientes (1746–1828).

Since the sixteenth century, the Spanish had commissioned art in the distant lands of their American colonies. During the eighteenth century this colonial art and architecture remained rooted in the enduring traditions of the Spanish Baroque intermingled with the artistic traditions of native peoples, joining the symbolism and the artistic vocabulary of two distinct cultures into a new art in Mexico and the American Southwest.

PORTRAITURE AND PROTEST IN SPAIN: GOYA

Goya was introduced to the Spanish royal workshop in 1774, when he produced tapestry cartoons under the direction of Mengs. He painted for Charles III and served as court painter to Charles IV (r. 1788–1808), but he also belonged to an intellectual circle that embraced the ideals of the French Revolution, and his work began subtly to criticize the court in which he served.

Charles IV, threatened by the possibility of similar social upheaval in Spain, reinstituted the Inquisition soon after the French Revolution, halted reform, and even prohibited the entry of French books into Spain. Goya responded to this new situation by creating a series of prints aimed at the ordinary people, with whom he identified. The theme of *Los Caprichos (The Caprices*, a folio of 80 etchings produced between 1796 and 1798) is that reason ignored is a sleeping monster. In the print entitled **THE SLEEP OF REASON PRODUCES MONSTERS (FIG. 30-42**), the slumbering personification of Reason is haunted by a menagerie of demonic-looking owls, bats, and a cat that are let loose when Reason sleeps. Other *Caprichos* enumerate the follies of Spanish society that Goya and his circle considered equally monstrous. His implicit goal with this series was to incite action, to alert the Spanish people

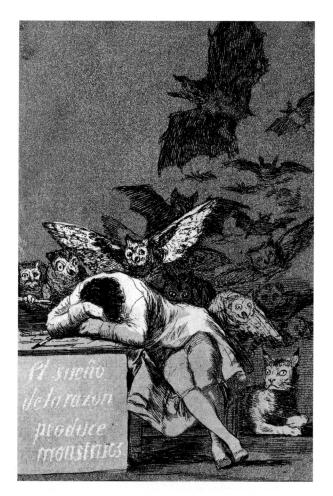

30-42 • Francisco Goya THE SLEEP OF REASON PRODUCES MONSTERS

No. 43 from Los Caprichos (The Caprices). 1796–1798; published 1799. Etching and aquatint, $8\frac{1}{2}$ " \times 6" (21.6 \times 15.2 cm). Courtesy of the Hispanic Society of America, New York.

After printing about 300 sets of this series, Goya offered them for sale in 1799. He withdrew them two days later without explanation. Historians believe that he was probably warned by the Church that if he did not do so he might have to appear before the Inquisition because of the unflattering portrayal of the Church in some of the etchings. In 1803, Goya donated the plates to the Royal Printing Office.

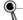

View the Closer Look for *The Sleep of Reason Produces Monsters* on myartslab.com

to the errors of their foolish ways, and to reawaken them to reason. He tried to market his etchings as Hogarth had done in England, but his work aroused controversy and was brought to the attention of his royal patrons. To deflect additional trouble, Goya presented the metal plates of the series to the king, suggesting that the images were not intentionally critical of the monarchy. He was torn between his position as a court painter who owed allegiance to the king and his passionate desire for a more open Spain.

His large portrait of the **FAMILY OF CHARLES IV** (**FIG. 30–43**) reveals some of Goya's ambivalence. He clearly wanted his patron to connect this portrait to an earlier Spanish royal portrait,

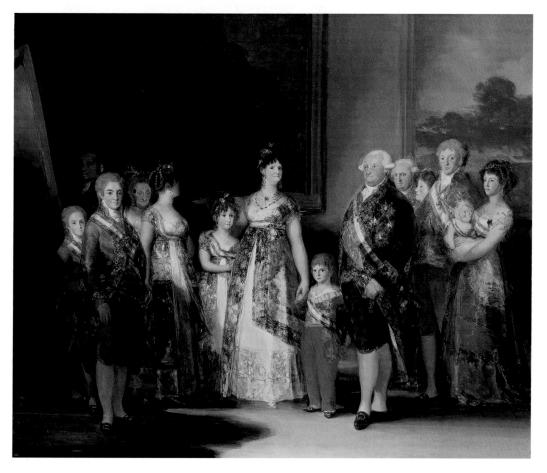

30–43 • Francisco Goya **FAMILY OF CHARLES IV** 1800. Oil on canvas, $9'2'' \times 11' (2.79 \times 3.36 \text{ m})$. Museo del Prado, Madrid.

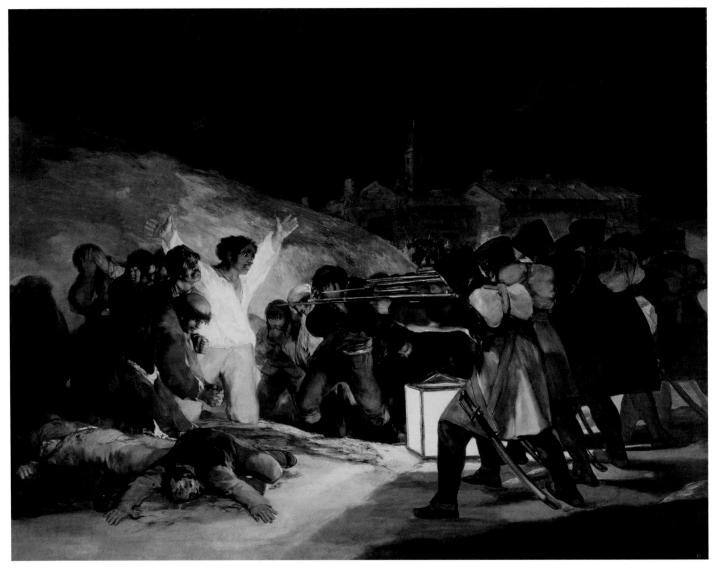

30–44 • Francisco Goya THIRD OF MAY, 1808 1814–1815. Oil on canvas, $8'9'' \times 13'4''$ (2.67 \times 4.06 m). Museo del Prado, Madrid.

Las Meninas by Velázquez (see FIG. 23-21), thereby raising his own status as well as that of the king. Like Velázquez, Goya includes himself in the painting, to the left behind the easel. The king and queen appear at the center of this large family portrait, surrounded by their immediate family. The figures are formal and stiff. Much has been written about how Goya seems to show his patrons as faintly ridiculous here. Some seem bored; the somewhat dazed king, chest full of medals, stands before a relative who looks distractedly out of the painting (perhaps the face was added at the last minute); the double-chinned queen gazes obliquely toward the viewer (at that time she was having an open affair with the prime minister); their eldest daughter, to the left, stares into space; and another, older relative behind seems almost surprised to be there. One French art critic even described the painting as resembling "The corner baker and his family after they have won the lottery." Yet the royal family was apparently satisfied with Goya's depiction. At a time when the authority of the Spanish aristocracy was crumbling, this complex representation of conflicted emotions, aspirations, and responsibilities may have struck a chord with them. Some viewers who first saw it may have thought its candid representations were refreshingly modern.

In 1808, Napoleon launched a campaign to conquer Spain and would eventually place his brother, Joseph Bonaparte (1768–1844), on the Spanish throne. At first many Spanish citizens, Goya included, welcomed the French, who brought political reform, including a new, more liberal constitution. But on May 2, 1808, a rumor spread through Madrid that the French planned to kill the royal family. The populace rose up against the French and a day of bloody street fighting ensued, followed by mass arrests. Hundreds were herded into a convent and then executed by a French firing squad before dawn on May 3rd. In Goya's impassioned memorial to that slaughter (FIG. 30-44), the violent gestures of the defenseless rebels and the mechanical efficiency of the tight row of executioners in the firing squad create a nightmarish

tableau. A spotlighted victim in a brilliant white shirt confronts his faceless killers with outstretched arms recalling the crucified Christ, an image of searing pathos. This painting is not a cool, didactic representation of civic sacrifice like David's Neoclassical Oath of the Horatii (see FIG. 30–37). It is an image of blind terror and desperate fear, the essence of Romanticism—the sensational current event, the loose brushwork, the lifelike poses, the unbalanced composition, and the dramatic lighting. There is no moral here, only hopeless rage. When asked why he painted such a brutal scene, Goya responded: "To warn men never to do it again."

Soon after, the Spanish monarchy was restored. Ferdinand VII (r. 1808, 1814–1833) once again reinstated the Inquisition and abolished the new constitution. In 1815, Goya was called before the Inquisition and charged with obscenity for an earlier painting of a female nude. He was acquitted and retired to his home outside Madrid, where he vented his anger at the world in a series of nightmarish "black paintings" rendered directly on the walls, and then spent the last four years of his life in France.

THE ART OF THE AMERICAS UNDER SPAIN

The sixteenth-century Spanish conquest of Central and South America led to the suppression of indigenous religions. Temples were demolished and replaced with Roman Catholic churches, while Franciscan, Dominican, and Augustinian friars worked to convert the indigenous populations. Some missionaries were so appalled by the conquerors' brutal treatment of the native peoples that they petitioned the Spanish king to help improve conditions.

In the course of the Mesoamericans' forced conversion to Roman Catholicism, Christian symbolism became inextricably mixed with the symbolism of indigenous religious beliefs. An example of such blending can be seen in colonial atrial crosses, carved early on by indigenous sculptors. Missionaries placed these crosses in church atriums, where converts gathered for education in Christianity. The sixteenth-century ATRIAL CROSS now in the Basilica of Guadalupe near Mexico City (FIG. 30-45) is richly carved in the low relief of native sculptural traditions and interweaves images from Christian and native religions into a dense and rich symbolic whole. The Christian images were probably copied from the illustrated books and Bibles of the missionaries. Visible here are the Arms of Christ (the "weapons" that Christ used to defeat the devil; the holy face, placed where his head would appear on a crucifix; the crown of thorns, draped around the cross bar; and the holy shroud, wrapped around the cross's arms. Winged angel heads and pomegranates surround the inscription at the top as symbols of regeneration. While the cross represents the redemption of humanity in Christianity, it symbolizes the tree of life in Mesoamerican religions. The blood that sprays out where the nails pierce the hands and feet of Christ are a reference to his sacrifice, and such representations of sacrificial blood were common in indigenous religious art.

Images of the Virgin Mary also took on a Mesoamerican inflection after she was believed to have appeared in Mexico. In

30–45 • ATRIAL CROSSBefore 1556. Stone, height 11'3" (3.45 m). Chapel of the Indians, Basilica of Guadalupe, Mexico City.

one such case, in 1531, a Mexican peasant named Juan Diego claimed that the Virgin Mary visited him to tell him in his native Nahuatl language to build a church on a hill where an Aztec goddess had once been worshiped, subsequently causing flowers to bloom so that Juan Diego could show them to the archbishop as proof of his vision. When Juan Diego opened his bundle of flowers, the cloak he had used to wrap them is said to have borne the image of a Mexican Mary, presented in a composition used in Europe to portray the Virgin of the Immaculate Conception, popular in Spain (see Fig. 23-22). The site of Juan Diego's vision was renamed Guadalupe after Our Lady of Guadalupe in Spain, and it became a venerated pilgrimage center. In 1754, pope Benedict XIV declared the VIRGIN OF GUADALUPE, as depicted here in a 1779 work by Sebastian Salcedo, the patron saint of the Americas (Fig. 30-46).

Spanish colonial builders sought to replicate the architecture of their native country in the Americas. One of the finest examples is the **MISSION SAN XAVIER DEL BAC**, in the American

30-46 • Sebastian Salcedo VIRGIN OF GUADALUPE

1779. Oil on panel and copper, 25" \times 19" (63.5 \times 48.3 cm). Denver Art Museum. Funds contributed by Mr. and Mrs. George G. Anderman and an anonymous donor (1976.56)

At the bottom right is the female personification of New Spain (Mexico) and at the left is Pope Benedict XIV (pontificate 1740–1758), who in 1754 declared the Virgin of Guadalupe to be the patroness of the Americas. Between the figures, the sanctuary of Guadalupe in Mexico can be seen in the distance. The four small scenes circling the Virgin represent the story of Juan Diego, and at the top three scenes depict Mary's miracles. The six figures above the Virgin represent Hebrew Bible prophets and patriarchs and New Testament apostles and saints.

30-47 • MISSION SAN XAVIER DEL BAC Near Tucson, Arizona. 1784-1797.

Southwest near Tucson, Arizona (FIG. 30-47). In 1700, the Jesuit priest Eusebio Kino (1644–1711) began laying the foundations for San Xavier del Bac using stone quarried locally by people of the Pima nation. The Pima had already laid out the desert site with irrigation ditches, so, as Father Kino wrote in his reports, there would be running water in every room and workshop of the new mission. In 1768, before construction began, the site was turned over to the Franciscans as part of a larger change in Spanish policy toward the Jesuits. Father Kino's vision was eventually realized by the Spanish Franciscan Juan Bautista Velderrain, who arrived at the mission site in 1776.

This huge church, 99 feet long with a domed crossing and flanking bell towers, is unusual for the area because it was built of bricks and mortar rather than adobe, which is made from earth and straw. The basic structure was finished by the time of Velderrain's death in 1790, and the exterior decoration was completed by his successor in 1797. The façade of San Xavier is not a copy of Spanish architecture, although the focus of visual attention on the central entrance to the church and the style of the decoration are consistent with the Spanish Baroque decoration. Since the mission was dedicated to Francis Xavier, his statue once stood at the top of the portal decoration, and there are still four female saints,

tentatively identified as Lucy, Cecilia, Barbara, and Catherine of Siena, in the niches. Hidden in the sculpted mass is one humorous element: a cat confronting a mouse, which inspired a local Pima saying: "When the cat catches the mouse, the end of the world will come" (cited in Chinn and McCarty, p. 12).

EARLY NINETEENTH-CENTURY ART: NEOCLASSICISM AND ROMANTICISM

Neoclassicism and Romanticism existed side by side well into the nineteenth century in European and American art. In fact, Neoclassicism survived in both architecture and sculpture beyond the middle of the century, as patrons and artists continued to use it to promote the virtues of democracy and republicanism. The longevity of Neoclassicism was also due in part to its embrace by art academies, where training was grounded in the study of antique sculpture and the work of Classical artists, such as Raphael. The Neoclassical vision of art as the embodiment of universal standards of taste and beauty complemented the academy's idea of itself as a repository of venerable tradition in fast-changing times.

Romanticism, whose roots in eighteenth-century Britain we have already seen (pages 929–932), took a variety of forms in the early nineteenth century. The common connecting thread continued to be an emphasis on emotional expressiveness and the unique experiences and tastes of the individual. Romantic paintings continued to explore dramatic subject matter taken from literature, current events, the natural world, or the artist's own imagination, with the goal of stimulating the viewer's sentiments and feelings.

DEVELOPMENTS IN FRANCE

Paris increasingly established itself as a major artistic center during the nineteenth century. Between 1800 and 1830, the French academy system was the arbiter of artistic success in Paris. The École des Beaux-Arts attracted students from all over Europe and the Americas, as did the ateliers (studios) of Parisian academic artists who offered private instruction. Artists competed fiercely for a spot in the Paris Salon, the annual exhibition that gradually opened to those who were not academy members. At the beginning of the nineteenth century there was a deep division between the poussinistes and rubénistes (see "Grading the Old Masters," page 763). The poussinistes argued that line, as used in the work of Poussin (see FIGS. 23-54, 23-55), created fundamental artistic structure and should be the basis of all painting. The rubénistes argued that essential structure could be achieved more eloquently through a sophisticated use of rich, warm color, as exemplified by the paintings of Rubens (see FIG. 23-27). Similarly, the relative value of the esquisse, a preliminary sketch for a much larger work, was hotly debated. Some claimed that it was simply a tool for the larger, finished work, while others began to argue that the fast, impulsive expression of imagination captured in the esquisse made the finished painting seem dull and flat by comparison. This emphasis on expressiveness blossoms in Romanticism between 1815 and 1830.

THE GRAND MANNER PAINTINGS OF DAVID AND

GROS With the rise of Napoleon Bonaparte, Jacques-Louis David re-established his dominant position in French painting. David saw in Napoleon the best hope for realizing France's Enlightenment-oriented political goals, and Napoleon saw in David a tested propagandist for revolutionary values. As Napoleon gained power and extended his rule across Europe, reforming law codes and abolishing aristocratic privilege, he commissioned David and his students to document his deeds.

In 1800, four years before Napoleon became emperor, David already glorifies him in **NAPOLEON CROSSING THE SAINT-BERNARD** (or *Bonaparte Crossing the Alps*) (**FIG. 30-48**). Napoleon is represented in the Grand Manner, and David used artistic license to imagine how Napoleon might have appeared as he led his troops over the Alps into Italy. Framed by a broad shock of red drapery, he exhorts his troops to follow as he charges uphill on his powerful rearing horse.

His horse's flying mane and wild eyes, coordinated with the swirl of his cape, convey energy, impulse, and power, backed up by the heavy guns and troops in the background. When Napoleon fell from power in 1814, David went into exile in Brussels, where he died in 1825.

Antoine-Jean Gros (1771–1835) began working in David's studio as a teenager and eventually vied with his master for commissions from Napoleon. Gros traveled with Napoleon in Italy in 1797 and later became an official chronicler of his military campaigns. His painting **NAPOLEON IN THE PLAGUE HOUSE AT JAFFA** (FIG. 30-49), like David's portrait, represents an actual event in the Grand Manner. During Napoleon's campaign against the Ottoman Turks in 1799, bubonic plague broke out among his troops. To quiet fears and forestall panic among his soldiers, Napoleon decided to visit the sick and dying, who were housed in a converted mosque in the town of Jaffa (now in Israel but then part of the Ottoman Empire). The format of Gros's painting—a shallow stage with a series of pointed arches framing the main

30-48 • Jacques-Louis David NAPOLEON CROSSING THE SAINT-BERNARD

1800–1801. Oil on canvas, 8'11" \times 7'7" (2.7 \times 2.3 m). Versailles, Châteaux de Versailles et de Trianon.

David flattered Napoleon by reminding the viewer of two other great generals from history who had led armies across the Alps—Charlemagne and Hannibal—by inscribing the names of all three on the rock at lower left.

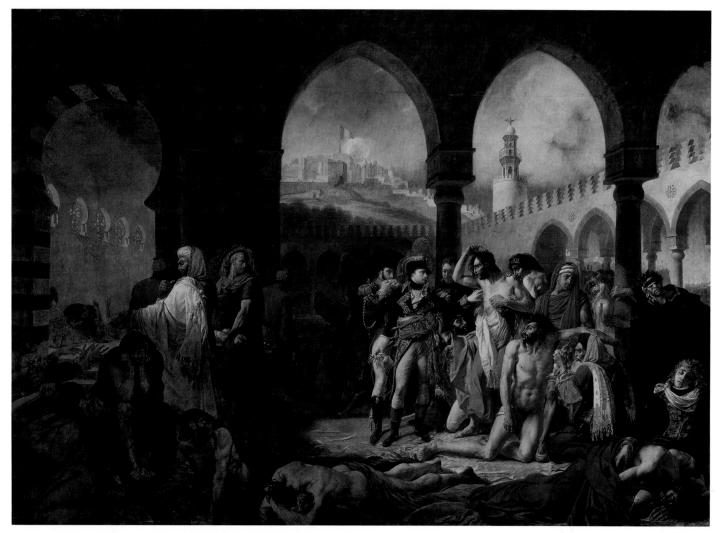

30-49 • Antoine-Jean Gros NAPOLEON IN THE PLAGUE HOUSE AT JAFFA 1804. Oil on canvas, $17'5'' \times 23'7''$ (5.32 \times 7.2 m), Musée du Louvre, Paris.

The huddled figures to the left were based on those around the mouth of hell in Michelangelo's Last Judgment (see Fig. 21–38).

protagonists—recalls David's *Oath of the Horatii* (see FIG. 30–37). But Gros's painting is quite different from that of his teacher. His color is more vibrant and his brushwork more spontaneous. The overall effect is Romantic, not simply because of the dramatic lighting and the wealth of details, both exotic and horrific, but also because the main action is meant to incite veneration of Napoleon the man more than republican sentiments in general. At the center of the painting, surrounded by a small group of soldiers and a doctor who keep a cautious distance from the contagious patients or hold handkerchiefs to their noses to block their stench, a heroic and fearless Napoleon reaches his bared hand toward the sores of one of the victims in a pose that was meant to evoke Christ healing the sick with his touch.

GÉRICAULT The life of Théodore Géricault (1791–1824), a major proponent of French Romanticism, was cut short by his untimely death at age 32, but his brief career had a large impact on

the early nineteenth-century Parisian art world. After a short stay in Rome in 1816-1817, where he discovered the art of Michelangelo, Géricault returned to Paris determined to paint a great modern history painting. He chose for his subject the scandalous and sensational shipwreck of the "Medusa" (FIG. 30-50; see "The Raft of the 'Medusa'," page 948). In 1816, this French ship bound for Senegal, ran aground close to its destination. Its captain, an incompetent aristocrat commissioned by the newly restored monarchy of Louis XVIII, reserved all six lifeboats for himself, his officers, and several government representatives. The remaining 152 passengers were set adrift on a makeshift raft. When those on the raft were rescued 13 days later, just 15 had survived, some only by eating human flesh. Since the captain had been a political appointee, the press used the horrific story to indict the monarchy for this and other atrocities in French-ruled Senegal. The moment in the story that Géricault chose to depict is one fraught with emotion, as the survivors on the raft experience both the fear that

A BROADER LOOK | The Raft of the "Medusa"

Théodore Géricault's monumental *The Raft of the "Medusa"* (FIG. 30–50) fits the definition of a history painting in that it is a large (16 by 23 feet), multi-figured composition that represents an event in history. It may not qualify, however, on the basis of its function—to expose incompetence and a willful disregard for human life rather than to ennoble, educate, or remind viewers of their civic responsibility. The hero of this painting is also an unusual choice for a history painting; he is not an emperor or a king, nor even an intellectual, but Jean Charles, a black man from French Senegal who showed endurance and emotional fortitude in the face of extreme peril.

Géricault's painting speaks powerfully through a composition that is arranged in a pyramid of bodies. The diagonal axis that begins in the lower left extends upward to the waving figure of Jean Charles; a

complementary diagonal beginning with the dead man in the lower right extends through the mast and billowing sail, directing our attention to a huge wave. The painting captures the moment between the hope of rescue and the despair that the distant ship has not seen the survivors. The figures are emotionally suspended between hope of salvation and fear of imminent death. Significantly, the "hopeful" diagonal in Géricault's painting terminates in the vigorous figure of Jean Charles. By placing him at the top of the pyramid of survivors and giving him the power to save his comrades by signaling to the rescue ship, Géricault suggests metaphorically that freedom is often dependent on the most oppressed members of society.

Géricault prepared his painting carefully, using each of the prescribed steps for history painting in the French academic system. The work was the culmination of extensive study

and experimentation. An early pen drawing (The Sighting of the "Argus," FIG. 30-51) depicts the survivors' hopeful response to the appearance of the rescue ship on the horizon at the extreme left. Their excitement is in contrast to the mournful scene of a man grieving over a dead youth on the right side of the raft. The drawing is quick, spontaneous and bursting with energy, like the esquisse. A later pen-and-wash drawing (FIG. 30-52) reverses the composition, creates greater unity among the figures, and establishes the modeling of their bodies through light and shade. This is primarily a study of light and shade. Other studies would have focused on further analyses of the composition, arrangement of figures, and overall color scheme. The drawings look ahead to the final composition of the The Raft of the "Medusa," but both still lack the figure of Jean Charles at the apex of the painting and

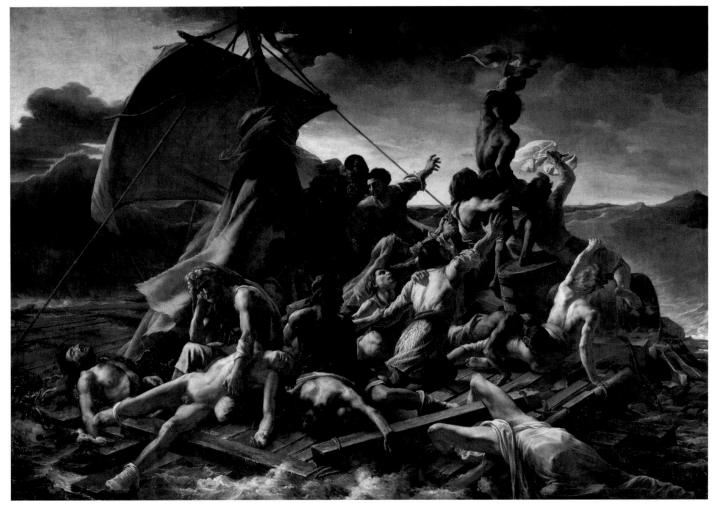

30–50 • Théodore Géricault THE RAFT OF THE "MEDUSA" 1818–1819. Oil on canvas, $16'1'' \times 23'6''$ (4.9×7.16 m). Musée du Louvre, Paris.

the dead and dying figures at the extreme left and lower right, which fill out the composition's base.

Géricault also made separate studies of many of the figures, as well as of actual corpses, severed heads, and dissected limbs (FIG. 30–53) supplied to him by friends who worked at a nearby hospital. For several months, according to Géricault's biographer, "his studio was a kind of morgue. He kept cadavers there until they were half-decomposed, and insisted on working in this charnel-house atmosphere..." However, he did not use cadavers for any specific figures in *The Raft of the "Medusa.*" Rather, he traced the outline of his final composition onto its large canvas, and then painted each body directly from a living model, gradually building up his composition figure by figure. He drew from corpses and body parts in his studio to make sure that he understood the nature of death and its impact on the human form.

Indeed, Géricault did not describe the actual physical condition of the survivors on the raft: exhausted, emaciated, sunburned, and close to death. Instead, following the dictates of the Grand Manner, he gave his men athletic bodies and vigorous poses, evoking the work of Michelangelo and Rubens (Chapters 21 and 23). He did this to generalize and ennoble his subject, elevating it above the particulars of a specific shipwreck in the hope that it would speak to more fundamental human conflicts: humanity against nature, hope against despair, and life against death.

30-51 • Théodore Géricault THE SIGHTING OF THE "ARGUS" (TOP)

1818. Pen and ink on paper, 13% \times 16% (34.9 \times 41 cm). Musée des Beaux-Arts. Lille.

30-52 • Théodore Géricault THE SIGHTING OF THE "ARGUS" (MIDDLE)

1818. Pen and ink, sepia wash on paper, $8^{1}\!/\!\!s'' \times 11^{1}\!/\!\!s''$ (20.6 \times 28.6 cm). Musée des Beaux-Arts, Rouen.

30-53 • Théodore Géricault STUDY OF HANDS AND FEET (BOTTOM)

1818–1819. Oil on canvas, $20\% _2"\times 25\% _{18}"$ (52 \times 64 cm). Musée Fabre, Montpellier.

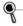

View the Closer Look feature for *The Raft of the "Medusa"* on myartslab.com

the distant ship might pass them by and the hope that they will be rescued.

Géricault exhibited *The Raft of the "Medusa"* at the 1819 Salon, where it caused considerable controversy. Most contemporary French critics and royalists interpreted the painting as a political jibe at the king, on whose good grace many academicians depended, while independent liberals praised Géricault's attempt to expose corruption. The debate raised the question of the point at which a painting crosses the line between art and political advocacy. Although it was intended to shock and horrify rather than to edify and ennoble, the painting conforms to academy rules in every other way. The crown refused to buy it, so Géricault exhibited *The Raft of the "Medusa"* commercially on a two-year tour of Ireland and England; the London exhibition alone attracted more than 50,000 paying visitors.

DELACROIX The French novelist Stendhal characterized the Romantic spirit when he wrote, "Romanticism in all the arts is what represents the men of today and not the men of those remote, heroic times which probably never existed anyway." Eugène Delacroix (1798–1863), the most important Romantic painter in Paris after Géricault's untimely death, depicted contemporary heroes and victims engaged in the violent struggles of the times. In 1830, he created what has become his masterpiece, **LIBERTY LEADING THE PEOPLE: JULY 28, 1830** (FIG. 30-54), a painting that encapsulated the history of France after the fall of Napoleon. When Napoleon was defeated in 1815, the victorious neighboring nations reimposed the French monarchy under Louis XVIII (r. 1815–1824), brother of Louis XVI. The king's power was limited by a constitution and a parliament, but the government became more conservative as years passed, undoing many

30–54 • Eugène Delacroix LIBERTY LEADING THE PEOPLE: JULY **28**, **1830** 1830. Oil on canvas, $8'6\frac{1}{2}'' \times 10'8''$ (2.6 × 3.25 m). Musée du Louvre, Paris.

revolutionary reforms. Louis's younger brother and successor, Charles X (r. 1824–1830), reinstated press censorship, returned education to the control of the Catholic Church, and limited voting rights. These actions triggered a large-scale uprising in the streets of Paris. Over the course of three days in July 1830, the Bourbon monarchical line was overthrown and Louis-Philippe d'Orléans (r. 1830–1848), replaced his more moderate cousin Charles X, promising to abide by a new constitution. This period in French history is known as the "July Monarchy."

In his large modern history painting Delacroix memorialized the July 1830 revolution just a few months after it took place. Though it records aspects of the actual event, it also departs from the facts in ways that further the intended message. Delacroix's revolutionaries are a motley crew of students, artisans, day laborers, and even children and top-hatted intellectuals. They stumble forward through the smoke of battle, crossing a barricade of refuse and dead bodies. The towers of Notre-Dame loom through the smoke and haze of the background. This much of the work is plausibly accurate. Their leader, however, is an energetic, allegorical figure of Liberty, personified by a gigantic, muscular, half-naked woman charging across the barricade with the revolutionary flag in one hand and a bayoneted rifle in the other. Delacroix has placed a Classical allegorical figure within the battle itself, outfitted with a contemporary weapon and Phrygian cap—the ancient symbol for a freed slave that was worn by the insurgents. He presents the event as an emotionally charged moment just before the ultimate sacrifice, as the revolutionaries charge the barricades to near-certain death. This dramatic example of Romantic painting is full of passion, turmoil, and danger—part real and part dream.

RUDE Artists working for the July Monarchy increasingly used the more dramatic subjects and styles of Romanticism to represent the 1830 revolution, just as Neoclassical principles had

been used to represent the previous one. Early in the July Monarchy, the minister of the interior decided, as an act of national reconciliation, to complete the triumphal arch on the Champs-Élysées in Paris begun by Napoleon in 1806. François Rude (1784–1855) received the commission for a sculpture to decorate the main arcade with a scene that commemorated the volunteer army that had halted a Prussian invasion in 1792–1793. Beneath

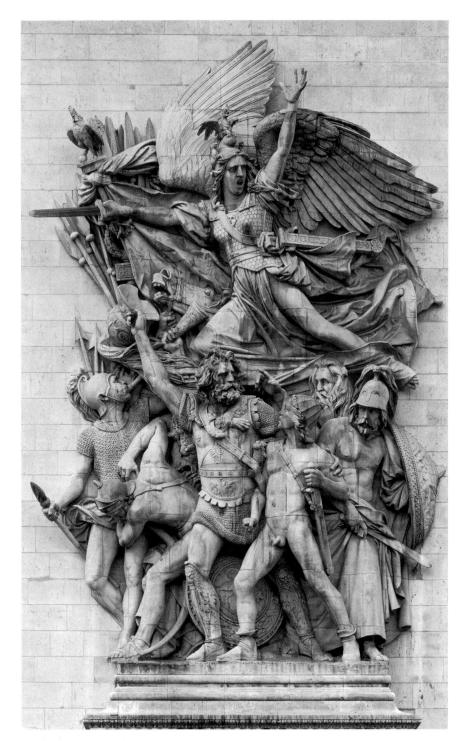

30-55 • François Rude DEPARTURE OF THE VOLUNTEERS OF 1792 (THE MARSEILLAISE)

Arc de Triomphe, Place de l'Étoile, Paris. 1833–1836. Limestone, height approx. 42′ (12.8 m).

the urgent exhortations of the winged figure of Liberty, the volunteers surge forward, some nude, others in Classical armor (**FIG. 30–55**). Despite these Classical details, the overall impact of this sculpture is Romantic. The crowded, excited group stirred patriotism in Paris, and the sculpture quickly became known simply as the *Marseillaise*, the name of the French national anthem written in 1792, the same year as the action depicted.

30–56 • Jean-Auguste-Dominique Ingres LARGE ODALISQUE 1814. Oil on canvas, approx. $35'' \times 64''$ (88.9 \times 162.5 cm). Musée du Louvre, Paris.

During Napoleon's campaigns against the British in North Africa, the French discovered the exotic Near East. Upper-middle-class European men were particularly attracted to the institution of the harem, partly as a reaction against the egalitarian demands of women of their own class that had been unleashed by the French Revolution.

INGRES Jean-Auguste-Dominique Ingres (1780–1867), perhaps David's most famous student, served as director of the French Academy in Rome between 1835 and 1841. As a teacher and theorist, Ingres became one of the most influential artists of his time. His paintings offer another variant on the Romantic and Neoclassical, combining the precise drawing, formal idealization, Classical composition, and graceful lyricism of Raphael (see Fig. 21–7) with an interest in creating sensual and erotically charged images that appeal to viewers' emotions.

Although Ingres fervently desired to be accepted as a history painter, it was his paintings of female nudes as orientalizing fantasies and his sultry portraits of aristocratic women that made him famous. He painted numerous versions of the **odalisque**, an exoticized version of a female slave or harem concubine. In his **LARGE ODALISQUE** (FIG. 30-56), the woman's cool gaze is leveled directly at her master, while she twists her reclined naked body in a sinuous, snakelike, concealing pose of calculated eroticism. The saturated cool blues of the couch and the curtain at the right set off the effect of her cool, pale skin and blue eyes, while the tight angularity of the crumpled sheets accentuates the the languid, sensual contours of her body. She is a male fantasy of a "white" slave. The exotic details of her headdress

and the brush of the peacock fan against her thigh only intensify her sensuality. Ingres's commitment to academic line and formal structure was grounded in his Neoclassical training, but his fluid, attenuated female nudes speak more strongly of the Romantic tradition.

Although Ingres complained that making portraits was a "considerable waste of time," his skill in rendering physical likeness with scintillating clarity and in mimicking in paint the material qualities of clothing, hairstyles, and jewelry was unparalleled. He painted many life-size and highly polished portraits, but he also produced—usually in just a day—exquisite, small portrait drawings that are extraordinarily fresh and lively. The charming PORTRAIT OF MADAME DÉSIRÉ RAOUL-ROCHETTE (FIG. **30-57**) is a flattering yet credible representation of the relaxed and elegant sitter. Her gloved right hand draws to Madame Raoul-Rochette's social status; fine kid gloves were worn only by members of the European upper class, who did not work with their hands. And her ungloved left hand reveals her marital status with a wedding band. Ingres renders her shiny taffeta dress, with its fashionably high waist and puffed sleeves, with deft economy and swift spontaneity, using subdued marks that suggest rather than describe the fabric. A a result, emphasis rests on the sitter's refined face and

30-57 • Jean-Auguste-Dominique Ingres PORTRAIT OF MADAME DÉSIRÉ RAOUL-ROCHETTE

1830. Graphite on paper, $12^5\%'' \times 9^1/2''$ (32.2 \times 24.1 cm). Cleveland Museum of Art, Ohio. Purchase from the J. H. Wade Fund (1927.437)

Madame Raoul-Rochette (1790–1878), née Antoinette-Claude Houdon, was the youngest daughter of the famous Neoclassical sculptor Jean-Antoine Houdon (see Fig. 30–41). In 1810, at age 20, she married Désiré Raoul-Rochette, a noted archaeologist, who later became the secretary of the Académie des Beaux-Arts (Academy of Fine Arts, founded in 1816 to replace the French Royal Academy of Painting and Sculpture) and a close friend of Ingres. Ingres's drawing of Madame Raoul-Rochette is inscribed to her husband ("Ingres to his friend and colleague, Mr. Raoul-Rochette"), whose portrait Ingres also drew around the same time.

elaborate coiffure, which Ingres has drawn precisely and modeled with subtle evocations of light and shade.

DAUMIER Honoré Daumier (1808–1879) came to Paris from Marseille in 1816. He studied drawing at the Académie Suisse, but he learned the technique of **lithography** (see "Lithography," page 954) as assistant to the printmaker Bélaird. Daumier published his first lithograph in 1829, at age 21, in the weekly satirical magazine *La Silhouette*. In the wake of the 1830 revolution in Paris, Daumier began supplying pictures to *La Caricature*, an anti-monarchist, pro-republican magazine, and the equally partisan *Le Charivari*, the first daily newspaper illustrated with lithographs. His 1834 lithograph, calling attention to the atrocities on **RUE TRANSNONAIN** (**FIG. 30–58**), was part of a series of large prints sold by subscription to raise money for *Le Charivari*'s legal defense fund and thus further freedom

30–58 • Honoré Daumier **RUE TRANSNONAIN, LE 15 AVRIL 1834**1834. Lithograph, 11" × 17%" (28 × 44 cm).
Bibliothèque Nationale, Paris.

TECHNIQUE | Lithography

Lithography, invented in the mid 1790s, is based on the natural antagonism between oil and water. The artist draws on a flat surface—traditionally, fine-grained stone (*lithos* is Greek for stone)—with a greasy, crayonlike instrument. The stone's surface is first wiped with water and then with an oil-based ink. The ink adheres to the greasy areas but not to the damp ones. After a series of such steps, a sheet of paper is laid face down on the inked stone, pressed together with a scraper, and then rolled through a flatbed press. This transfers ink from stone to paper, thus making lithography (like relief and intaglio) a direct method of creating a printed image. Unlike earlier processes, however, grease-based lithography enables the artist to capture the subtleties of drawing with crayon and a liquid mixture called *tusche*. Francisco Goya, Théodore Géricault, Eugène Delacroix, Honoré Daumier, and Henri de Toulouse-Lautrec used the medium to great effect.

Daumier is probably the greatest exponent of lithography in the nineteenth century. The technique was widely used in France for fineart prints and to illustrate popular magazines and even newspapers. By the 1830s, the print trade in France had exploded. Artists could use lithography to produce their own prints without the cumbersome, expensive, and time-consuming intermediary of the engraver. Daumier's picture of **THE PRINT LOVERS** (FIG. 30–59) shows three men who have fixed their attention on the folio of prints in front of them, despite being surrounded by works of art packed tightly on the wall behind them. By the end of the nineteenth century, inexpensive prints were in every house and owned by people at every level of society.

30–59 • Honoré Daumier **THE PRINT LOVERS** c. 1863–1865. Watercolor, black pencil, black ink, gray wash, $10\frac{1}{8}$ " × $12\frac{1}{8}$ " (25.8 × 30.7 cm). Musée du Louvre, Paris.

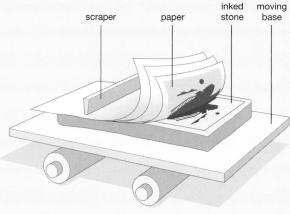

diagram of the lithographic process

Watch a video about the process of lithography on myartslab.com

of the press. A government guard had been shot and killed on the rue Transnonain—only a few blocks from Daumier's home—during a demonstration by workers, and in response, the riot squad killed everyone in the building where they believed the marksman was hiding. Daumier shows the bloody aftermath of the event: an innocent family disturbed from their sleep and then murdered. The wife lies in the shadows to the left, her husband in the center of the room, and an elderly man to the right. It takes a few minutes for viewers to realize that under the central figure's back there are also the bloody head and arms of a murdered child. Daumier was known for his biting caricatures and social commentary in print form, but this image is one of his most powerful.

ROMANTIC LANDSCAPE PAINTING

The Romantics saw nature as ever-changing, unpredictable, and uncontrollable, and they saw in it an analogy to equally unpredictable and changeable human moods and emotions. They found nature awesome, fascinating, powerful, domestic, and delightful, and landscape painting became an important visual theme in Romantic art.

CONSTABLE John Constable (1776–1837), the son of a successful miller, claimed that the quiet domestic landscape of his youth in southern England had made him a painter before he ever picked up a paintbrush. Although he was trained at the

Royal Academy, he was equally influenced by the seventeenth-century Dutch landscape-painting tradition (see FIG. 23–44). After moving to London in 1816, he dedicated himself to painting monumental views of the agricultural landscape (known as "six-footers"), which he considered as important as history painting. Constable's commitment to contemporary English subjects was so strong that he opposed the establishment of the English National Gallery of Art in 1832 on the grounds that it might distract painters by enticing them to paint foreign or ancient themes in unnatural styles.

THE HAY WAIN (FIG. 30-60) of 1821 shows a quiet, slow-moving scene from Constable's England. It has the fresh color and sense of visual exactitude that persuades viewers to believe that it must have been painted directly from nature. But although Constable made numerous drawings and small-scale color studies for his open-air paintings, the final works were carefully constructed images produced in the studio. His paintings are very large even for landscape themes of historic importance, never mind views derived from the local countryside. The Hay Wain represents England as Constable imagined it had been for centuries—comfortable,

rural, and idyllic. Even the carefully rendered and meteorologically correct details of the sky seem natural. The painting is, however, deeply nostalgic, harking back to an agrarian past that was fast disappearing in industrializing England.

TURNER Joseph Mallord William Turner (1775–1851) is often paired with Constable. The two were English landscape painters of roughly the same period, but Turner's career followed a different path. He entered the Royal Academy in 1789, was elected a full academician at the unusually young age of 27, and later became a professor at the Royal Academy Schools. By the late 1790s, he was exhibiting large-scale oil paintings of grand natural scenes and historical subjects, in which he sought to capture the **sublime**, a concept defined by philosopher Edmund Burke (1729–1797). According to Burke, when we witness something that instills fascination mixed with fear, or when we stand in the presence of something far larger than ourselves, our feelings transcend those we encounter in normal life. Such savage grandeur strikes awe and terror into the heart of the viewer, but there is no real danger. Because the sublime is experienced vicariously, it is

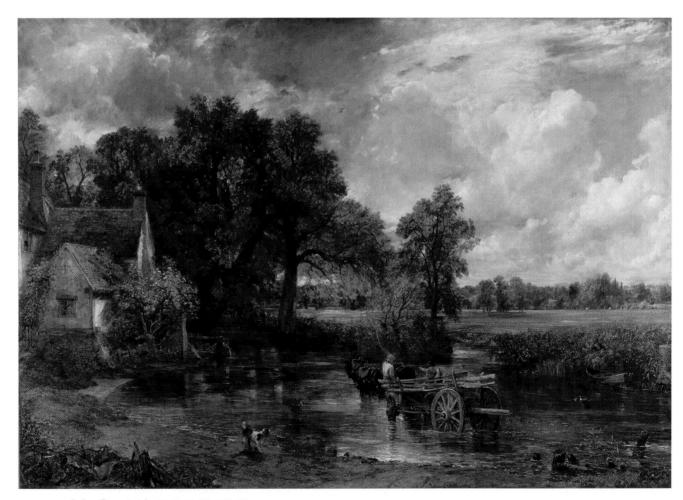

30–60 • John Constable **THE HAY WAIN** 1821. Oil on canvas, $51\frac{1}{4}$ " \times 73" (130.2 \times 185.4 cm). National Gallery, London. Gift of Henry Vaughan, 1886

Read the document related to John Constable on myartslab.com

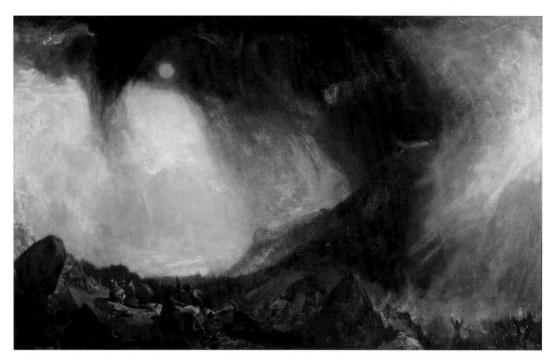

30-61 • Joseph Mallord William Turner SNOWSTORM: HANNIBAL AND HIS ARMY **CROSSING THE ALPS** 1812. Oil on canvas, $4'9''\times7'9''$ (1.46 \times 2.39 m). Tate, London.

30-62 • Joseph Mallord William Turner THE **BURNING OF THE** HOUSES OF LORDS AND COMMONS, **16TH OCTOBER 1834** Oil on canvas, $36\frac{1}{4}$ " \times $48\frac{1}{2}$ " (92.1 imes 123.2 cm). Philadelphia Museum of Art. The John Howard McFadden Collection, 1928

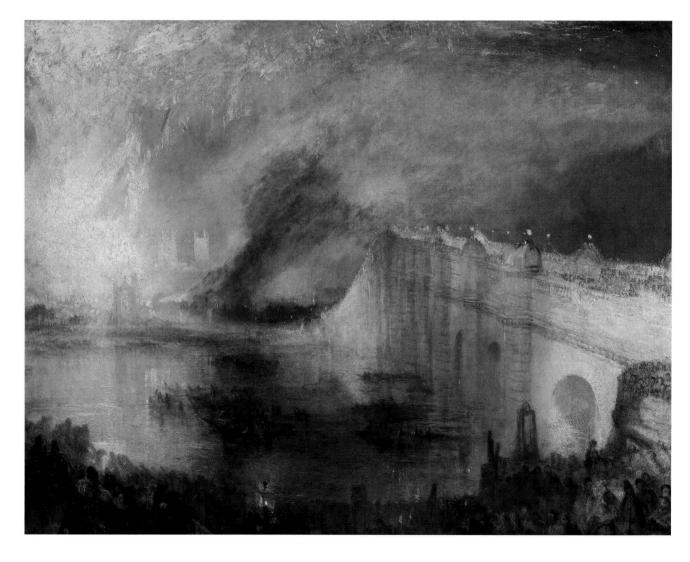

thrilling and exciting rather than threatening, and it often evokes the transcendent power of God. Turner translated this concept of the sublime into powerful paintings of turbulence in the natural world and the urban environment.

His **SNOWSTORM: HANNIBAL AND HIS ARMY CROSSING THE ALPS** (FIG. 30–61) of 1812 epitomizes Romanticism's view of the awesomeness of nature. An enormous vortex of wind, mist, and snow masks the sun and threatens to annihilate the soldiers marching below it. Barely discernible in the distance is the figure of Hannibal, mounted on an elephant to lead his troops through the Alps toward their encounter with the Roman army in 218 BCE. Turner probably meant his painting as an allegory of the Napoleonic Wars. Napoleon himself had crossed the Alps, an event celebrated by David in his laudatory portrait (see FIG. 30–48). But while David's painting, which Turner saw in Paris in 1802, conceived Napoleon as a powerful figure, commanding not only his troops but nature itself, Turner reduced Hannibal to a speck on the horizon, threatened with his troops by natural disaster, as if foretelling their eventual defeat.

Closer to home, Turner based another dramatic and thrilling work on the tragic fire that severely damaged London's historic Parliament building. Blazing color and light dominate **THE BURNING OFTHE HOUSES OF LORDS AND COMMONS, 16TH OCTOBER 1834** (FIG. 30-62), and we are not the only ones transfixed by the sight of a magnificent conflagration here. The foreground of the painting shows the south bank of the Thames packed with spectators. This fire was a national tragedy; these buildings had witnessed

some of the most important events in English history. Turner himself was witness to the scene and hurriedly made watercolor sketches on site; within a few months he had the large painting ready for exhibition. The painting's true theme is the brilliant light and color that spirals across the canvas in the explosive energy of loose brushwork, explaining why Turner was called "the painter of light."

COLE Thomas Cole (1801–1848) was one of the first great professional landscape painters in the United States. Cole emigrated from England at age 17 and by 1820 was working as an itinerant portrait painter. With the help of a patron, he traveled in Europe between 1829 and 1832, and upon his return to the United States he settled in New York and became a successful landscape painter. He frequently worked from observation when making sketches for his paintings. In fact, his self-portrait is tucked into the foreground of **THE OXBOW** (**FIG. 30–63**), where he stands turning back to look at us while pausing from his work. He is executing an oil sketch on a portable easel, but like most landscape painters of his generation, he produced his large finished works in the studio during the winter months.

Cole painted this work in the mid 1830s for exhibition at the National Academy of Design in New York. He considered it one of his "view" paintings because it represents a specific place and time. Although most of his other view paintings were small, this one is monumentally large, probably because it was created for exhibition at the National Academy. Its scale allows for a sweeping view of a spectacular oxbow bend in the Connecticut River from

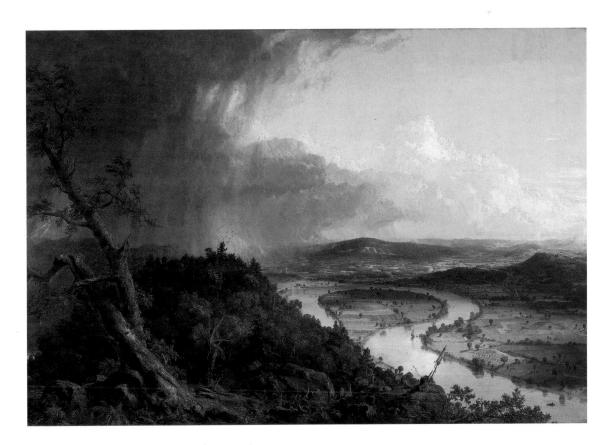

30-63 • Thomas Cole THE OXBOW 1836. Oil on canvas, $51\frac{1}{2}$ " \times 76" (1.31 \times 1.94 m). Metropolitan Museum of Art, New York. Gift of Mrs. Russell Sage, 1908 (08.228)

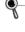

View the Closer Look for *The Oxbow* on myartslab.com

30-64 • Caspar David Friedrich ABBEY IN AN OAK FOREST 1809–1810. Oil on canvas, 44" × 68½" (111.8 × 174 cm). Nationalgalerie, Berlin.

the top of Mount Holyoke in western Massachusetts. Cole wrote that the American landscape lacked the historic monuments that made European landscape interesting; there were no castles on the Hudson River of the kind found on the Rhine, and there were no ancient monuments in America of the kind found in Rome. On the other hand, he argued, America's natural wonders, such as this oxbow, should be viewed as America's natural "antiquities." The painting's title tells us that Cole depicts an actual spot, but, like other landscape painters who wished to impart a larger message about the course of history in their work, he composed the scene to stress the landscape's grandeur and significance, exaggerating the steepness of the mountain and setting the scene below a dramatic sky. Along a great sweeping arc produced by the dark clouds and the edge of the mountain, he contrasts the two sides of the American landscape: its dense, stormy wilderness and its congenial, pastoral valleys with settlements. The fading storm seems to suggest that the land is bountiful and ready to yield its fruits to civilization.

FRIEDRICH In Germany, the Romantic landscape painter Caspar David Friedrich (1774–1840) conceived landscape as a vehicle through which to achieve spiritual revelation. As a young man, he had been influenced by the writings and teachings of Gotthard Kosegarten, a local Lutheran pastor and poet who taught that the divine was visible through a deep personal connection with nature. Kosegarten argued that just as God's book was the Bible, the landscape was God's "Book of Nature." Friedrich studied at the Copenhagen Academy before settling in Dresden, where the poet Johann Wolfgang von Goethe encouraged him to make landscape the principal subject of his art. He sketched from nature but painted in the studio, synthesizing his sketches with his memories of and feelings about nature. Through the

foggy atmosphere of **ABBEY IN AN OAK FOREST** (FIG. 30-64), a funeral procession of monks in the lower foreground is barely visible through the gloom that seems to be settling heavily down on the snow-covered world of human habitation. Most prominent are the boldly silhouetted trunks and bare branches of a grove of oak trees, and nestled among them the ruin of a Gothic wall, a formal juxtaposition that creates a natural cathedral from this cold and mysterious landscape.

GOTHIC AND NEOCLASSICAL STYLES IN EARLY NINETEENTH-CENTURY ARCHITECTURE

A mixture of Neoclassicism and Romanticism motivated architects in the early nineteenth century, many of whom worked in either mode, depending on the task at hand. Neoclassicism in architecture often imbued secular public buildings with a sense of grandeur and timelessness, while Romanticism evoked, for instance, the Gothic past with its associations of spirituality and community.

GOTHIC ARCHITECTURE The British claimed the Gothic as part of their patrimony and erected many Gothic Revival buildings during the nineteenth century, prominent among them the new **HOUSES OF PARLIAMENT** (**FIG. 30-65**). After Westminster Palace burned in 1834, in the fire so memorably painted by Turner (see **FIG. 30-62**), the British government announced a competition for a new building to be designed in the English Perpendicular Gothic style, harmonizing with the neighboring thirteenth-century church of Westminster Abbey where English monarchs are crowned.

30-65 • Charles Barry and Augustus Welby Northmore Pugin HOUSES OF PARLIAMENT, LONDON

1836–1860. Royal Commission on the Historical Monuments of England, London.

Pugin published two influential books in 1836 and 1841, in which he argued that the Gothic style of Westminster Abbey was the embodiment of true English genius. In his view, the Greek and Roman Classical orders were stone replications of earlier wooden forms and therefore fell short of the true principles of stone construction.

Charles Barry (1795–1860) and Augustus Welby Northmore Pugin (1812–1852) won the commission. Barry devised the essentially Classical plan of the new building, whose symmetry suggests the balance of powers within the British parliamentary system, while Pugin designed the intricate Gothic decoration. The leading advocate of Gothic architecture at this time, Pugin published Contrasts in 1836, in which he compared the troubled modern era of materialism and mechanization unfavorably with the Middle Ages, which he represented as an idyllic epoch of deep spirituality and satisfying handcraft. For Pugin, Gothic was not a style but a principle, like Classicism. The Gothic, he insisted, embodied two "great rules" of architecture: "first, that there should be no features about a building which are not necessary for convenience, construction or propriety; second, that all ornament should consist of enrichment of the essential structure of the building."

Most Gothic Revival buildings of this period, however, were churches, principally either Roman Catholic or Anglican (Episcopalian in the United States). The British-born American architect Richard Upjohn (1802–1878) designed many of the most important American examples, including **TRINITY CHURCH** in New York (**FIG. 30–66**). With its tall spire, long nave, and squared-off chancel, Trinity church quotes the early fourteenth-century British Gothic style particularly admired by Anglicans and Episcopalians. Every detail is rendered with historical accuracy, but the vaults are plaster, not masonry. The stained-glass windows above the altar were among the earliest of their kind in the United States.

NEOCLASSICAL ARCHITECTURE In several European capitals in the early nineteenth century, the Neoclassical designs of national museums positioned these buildings as both temples of culture and expressions of nationalism. Perhaps the most significant was the **ALTES MUSEUM** (Old Museum) in Berlin, designed in 1822 by Karl Friedrich Schinkel (1781–1841) and built between 1824 and 1830 (**FIG. 30–67**). Commissioned to display the royal art collection, the building was built directly across from the Baroque royal palace on an island in the Spree River in the heart of Berlin. The museum's imposing façade consists of

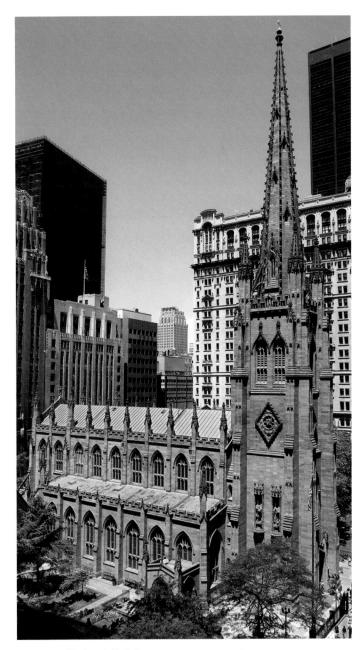

30-66 • Richard Upjohn TRINITY CHURCH, NEW YORK CITY 1839-1846.

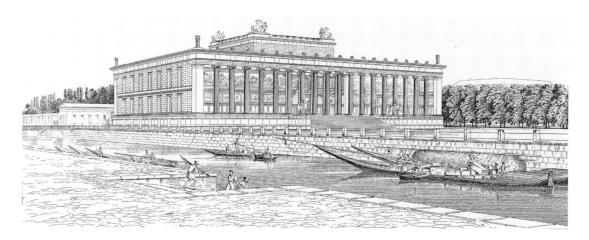

30-67 • Karl Friedrich Schinkel ALTES MUSEUM, BERLIN 1822-1830.

a screen of 18 Ionic columns raised on a platform with a central staircase. Attentive to the problem of lighting artworks on both the ground and the upper floors, Schinkel created interior court-yards on either side of a central rotunda. Tall windows on the museum's outer walls provide natural illumination, and partition walls perpendicular to the windows eliminate glare on the varnished surfaces of the paintings on display.

Neoclassical style was also popular for large public buildings in the United States, perhaps most significantly and symbolically in the U.S. Capitol, in Washington, DC, initially designed in 1792 by William Thornton (1759–1828), an amateur architect. His monumental plan featured a large dome over a temple front flanked by

two wings to accommodate the House of Representatives and the Senate. In 1803, President Thomas Jefferson (1743–1826), also an amateur architect, hired a British-trained professional, Benjamin Henry Latrobe (1764–1820), to oversee the actual construction of the Capitol. Latrobe modified Thornton's design by adding a grand staircase and Corinthian colonnade on the east front (FIG. 30–68). After the British gutted the building in the war of 1812, Latrobe repaired the wings and designed a higher dome. Seeking new symbolic forms for the nation within the traditional Classical vocabulary, he also created a variation on the Corinthian order for the interior by substituting indigenous crops such as corn and tobacco for the Corinthian order's acanthus leaves. In 1817, he resigned his

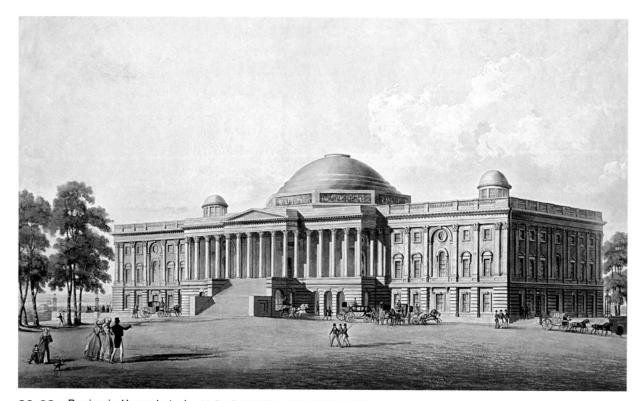

30–68 • Benjamin Henry Latrobe U.S. CAPITOL, WASHINGTON, DC c. 1808. Engraving by T. Sutherland, 1825. New York Public Library. I.N. Phelps Stokes Collection, Myriam and Ira Wallach Division of Art, Prints, and Photographs

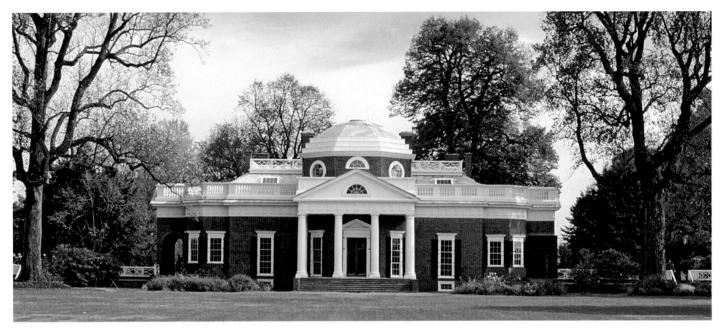

30-69 • Thomas Jefferson **MONTICELLO** Charlottesville, Virginia. 1769–1782, 1796–1809.

Watch a video about Monticello on myartslab.com

post. The reconstruction was completed under Charles Bulfinch (1763–1844), and another major renovation, resulting in a much larger dome, began in 1850.

Thomas Jefferson's graceful designs for the mountaintop home he called **MONTICELLO** (Italian for "little mountain") near Charlottesville, Virginia, employ Neoclassical architecture in a private setting (**FIG. 30-69**). Jefferson began the first phase of construction (1769–1782) when Virginia was still a British colony, using the English Palladian style (see Chiswick House, FIG. 30-15). By 1796, however, he had become disenchanted with both the English and

their architecture, and had come to admire French architecture while serving as the American minister in Paris. He then embarked upon a second building campaign at Monticello (1796–1809), enlarging the house and redesigning its brick and wood exterior so that its two stories appeared from the outside as one large story, in the manner then fashionable in Paris. The modern worlds of England, France, and America, as well as the ancient worlds of Greece and Rome, come together in this residence. In the second half of the nineteenth century, cultural borrowings would take on an even broader global scope.

THINK ABOUT IT

- **30.1** Summarize some of the key stylistic traits of French Rococo art and architecture, and explain how these traits relate to the social context of salon life. Then analyze one Rococo work from the chapter and explain how it is typical of the period style.
- 30.2 Explain why artists as visually diverse as Delacroix and Friedrich can be classified under the category of Romanticism. How useful is "Romanticism" as a classifying term?
- **30.3** How did the political climate during Francisco Goya's life affect his art? Focus your answer on a discussion of *Third of May*, 1808 (Fig. 30–44).
- **30.4** Discuss the relationship of the Enlightenment interest in archaeology with the new movement of Neoclassicism in the eighteenth century.

CROSSCURRENTS

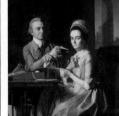

FIG. 30-1

Double portraits of couples are common in the history of European art. Assess the ways in which these two examples portray the nature of the marital relationship of these men and women. How do the portrayals represent the social structures and concerns of the cultural situations in which the couples lived?

√• **Study** and review on myartslab.com

FIG. 19-1

31–1 • Gustave Eiffel EIFFEL TOWER, PARIS 1887–1889. Photographed in March 1889. Height 984' (300 m).

Mid- to Late Nineteenth-Century Art in Europe and the United States

The world-famous EIFFEL TOWER (FIG. 31-1) is a proud reminder of the nineteenth-century French belief in the progress and ultimate perfectibility of civilization through science and technology. Structural engineer Gustave Eiffel (1832-1923) designed and constructed the tower to serve as a monumental approach to the 1889 Universal Exposition in Paris. When completed, it stood 984 feet tall and was the tallest structure in the world, taller than the Egyptian pyramids or Gothic cathedrals. The Eiffel Tower was the main attraction of the Universal Exposition, one of more than 20 such international fairs staged throughout Europe and the United States in the second half of the nineteenth century. These events showcased and compared international industry, science, and the applied, decorative, and fine arts. An object of pride for the French nation, the Eiffel Tower was intended to demonstrate France's superior engineering, technological and industrial knowledge, and power. Although originally conceived as a temporary structure, it still stands today.

The initial response to the Eiffel Tower was mixed. In 1887, a group of 47 writers, musicians, and artists wrote to Le Temps protesting "the erection ... of the useless and monstrous Eiffel Tower," which they described as "a black and gigantic factory chimney." Gustave Eiffel, however, said, "I believe the tower will have its own beauty," and that it "will show that [the French] are not simply an amusing people, but also the country of engineers." Indeed, when completed, the Eiffel Tower quickly became an international symbol of advanced thought and modernity among artists, and was admired by the public as a wondrous spectacle. Today it is the symbol of Paris itself.

The tower was one of the city's most photographed structures in 1889, its immensity dwarfing the tiny buildings below. Thousands of tourists to the Exposition bought souvenir photographs taken by professional and commercial photographers. This one, from late March 1889, shows the tower still under construction but almost complete. A close look at the bottom two tiers with the fairgrounds below betrays evidence of rapid last-minute construction in preparation for the May 6th opening.

LEARN ABOUT IT

- **31.1** Understand and evaluate the role played by academic art and architecture, as well as the emergence of various movements that arose in opposition to its principles, in the late nineteenth century.
- 31.2 Investigate the interest in subjects drawn from modern life, as well as the development of new symbolic themes, in Realist, Impressionist, and Post-Impressionist art.
- **31.3** Analyze the ways in which the movement toward realism in art reflected the social and political concerns of the nineteenth century.
- **31.4** Examine the early experiments that led to the emergence of photography as a new art form.

EUROPE AND THE UNITED STATES IN THE MID TO LATE NINETEENTH CENTURY

The technological, economic, and social transformations initiated by the Industrial Revolution intensified during the nineteenth century. Increasing demands for coal and iron necessitated improvements in mining, metallurgy, and transportation. Likewise, the development of the locomotive and steamship facilitated the shipment of raw materials and merchandise, made passenger travel easier, and encouraged the growth of cities (MAP 31-1). These changes also set in motion a vast population migration, as the rural poor moved to cities to find work in factories, mines, and mechanical manufacturing. Industrialists and entrepreneurs enjoyed new levels of wealth and prosperity in this system, but conditions for workers-many of them women and childrenwere often abysmal. Although new government regulations led to some improvements, socialist movements condemned the exploitation of workers by capitalist factory owners and advocated communal or state ownership of the means of production and distribution.

In 1848, workers' revolts broke out in several European capitals. In that year also, Karl Marx and Friedrich Engels published the *Communist Manifesto*, which predicted the violent overthrow of the bourgeoisie (middle class) by the proletariat (working class), the abolition of private property, and the creation of a classless society. At the same time, the Americans Lucretia Mott and Elizabeth Cady Stanton organized the country's first women's rights convention, in Seneca Falls, New York. They called for the equality of women and men before the law, property rights for married women, the acceptance of women into institutions of higher education, the admission of women to all trades and professions, equal pay for equal work, and women's suffrage.

The nineteenth century also witnessed the rise of imperialism. In order to create new markets for their products and to secure access to cheap raw materials and cheap labor, European nations established numerous new colonies by dividing up most of Africa and nearly a third of Asia. Colonial rule frequently suppressed indigenous cultures while exploiting the colonies for the economic development of the European colonial powers.

Scientific discoveries led to the invention of the telegraph, telephone, and radio. By the end of the nineteenth century, electricity powered lighting, motors, trams, and railroads in most European and American cities. Developments in chemistry created many new products, such as aspirin, disinfectants, photographic chemicals, and more effective explosives. The new material of steel, an alloy of iron and carbon, was lighter, harder, and more malleable than iron, and replaced it in heavy construction and transportation. In medicine and public health, Louis Pasteur's purification of beverages through heat (pasteurization) and the development of vaccines, sterilization, and antiseptics led to a dramatic decline in mortality rates all over the Western world.

Some scientific discoveries challenged traditional religious beliefs and affected social philosophy. Geologists concluded that the Earth was far older than the estimated 6,000 years sometimes claimed by biblical literalists. In 1859, Charles Darwin proposed that life evolved gradually through natural selection. Religious conservatives attacked Darwin's account, which seemed to deny divine creation and even the existence of God. Some of his more extreme supporters, however, suggested that the "survival of the fittest" had advanced the human race, with certain types of people—particularly the Anglo-Saxon upper classes—achieving the pinnacle of social evolution. "Social Darwinism" provided a rationalization for the poor conditions of the working class and a justification for colonizing the "underdeveloped" parts of the world.

Industrialists, merchants, professionals, the middle classes, some governments, and national academies of art became new sources of patronage in the arts. Large annual exhibitions in European and American cultural centers took on increasing importance as a means for artists to show their work, win prizes, attract buyers, and gain commissions. Cheap illustrated newspapers and magazines published art criticism that influenced the reception and production of art, both making and breaking artistic careers, and commercial art dealers emerged as important brokers of taste.

The second half of the nineteenth century saw vast changes in how art was conceptualized and created. Some artists became committed political or social activists as industrialization and social unrest continued, while others retreated into their own imagination. Some responded to the ways in which photography transformed vision and perception, many setting themselves up as photographers, while other artists emulated the new medium's clarity in their own work. Still others investigated the difference between photography's detailed but superficial description of visual reality and a deeper, more human reality as a source of inspiration, and others explored the artistic potential of photography's sometimes visually unbalanced compositions, its tendency to compress the illusion of depth and assert its flatness, its sharp framing and abrupt cropping of aspects of the broader world, its lack of an even focus across the picture plane or sometimes the reverse, or even the inability of early photography to "see" red and green equally, causing blank areas of white and black in a photograph. By the end of the century, while many artists were still exploring the reliability of observed reality, others were venturing ever farther into the realm of abstraction.

FRENCH ACADEMIC ARCHITECTURE AND ART

The Académie des Beaux-Arts (founded in 1816 to replace the disbanded Royal Academy of Painting and Sculpture) and its official art school, the École des Beaux-Arts, continued to exert a powerful influence over the visual arts in France during the nineteenth century. Academic artists controlled the Salon juries, and major public commissions routinely went to academic architects,

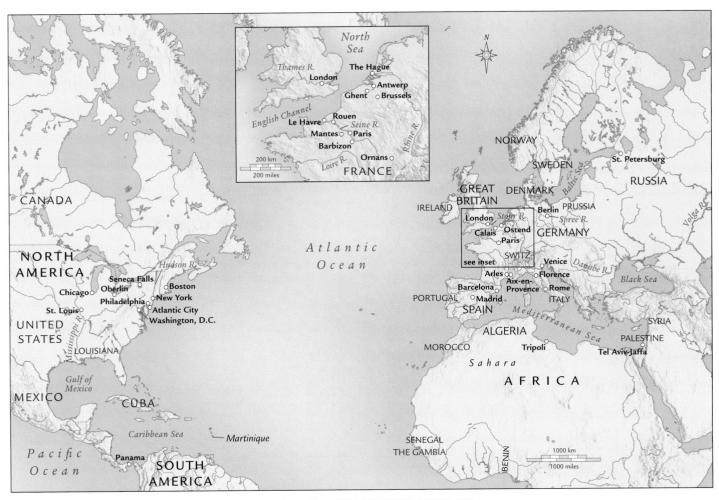

MAP 31-1 • EUROPE AND THE UNITED STATES IN THE NINETEENTH CENTURY

In the nineteenth century, Europe and the United States became increasingly industrialized and many European nations established colonial possessions around the world. Paris was firmly established as the center of the Western art world.

painters, and sculptors. It was to Paris that artists and architects from Europe and the United States came to study the conventions of academic art.

Academic art and architecture frequently depended upon motifs drawn from historic models—a practice called **historicism**. Elaborating on earlier Neoclassical and Romantic revivals, historicist art and architecture encompassed the sweep of history. Historicists often combined allusions to several different historical periods in a single work. Some academic artists catered to the public taste for exotic sights with Orientalist paintings (see "Orientalism," page 968). These works also combined disparate elements, borrowing from Egyptian, Turkish, and Indian cultures to create an imaginary Middle Eastern world.

ACADEMIC ARCHITECTURE

In 1848, after rioting over living conditions erupted in French cities, Napoleon III (r. as emperor 1852–1870) launched sweeping new reforms. The riots had devastated Paris's central neighborhoods, and Georges-Eugène Haussmann (1809–1891) was engaged to redraw the street grid and rebuild the city. Haussmann imposed

a new rational plan of broad avenues, parks, and open public places upon the medieval heart of Paris. He demolished entire neighborhoods, erasing networks of narrow, winding, medieval streets and summarily evicting the poor from their slums. Then he replaced what he had destroyed with grand new buildings erected along wide, straight, tree-lined avenues that were more suitable for horse-drawn carriages and strolling pedestrians.

The **OPÉRA** (**FIG. 31-2**), a new city opera house designed by Charles Garnier (1825–1898) and still a major Parisian landmark, was built at an intersection of Haussmann's grand avenues. Accessible from many directions, the Opéra was designed with transportation and vehicular traffic in mind, and with a modern cast-iron internal frame; yet in other respects it is a masterpiece of historicism derived mostly from the Baroque style, revived here to recall an earlier period of greatness in France. The massive façade, featuring a row of paired columns over an arcade, was intended to recall the seventeenth-century wing of the Louvre, an association meant to assert the continuity of the French nation and to flatter Napoleon III by comparing him favorably with Louis XIV. The building's primary function—as a place of entertainment for the

31-2 • Charles Garnier **OPÉRA, PARIS** 1861–1874.

31-3 • GRAND STAIRCASE, OPÉRA

Explore the architectural panoramas of the interior of the Opéra, Paris on myartslab.com

emperor, his entourage, and the high echelons of French society—accounts for its luxurious detail. The interior, described as a "temple of pleasure," was even more opulent, with neo-Baroque sculptural groupings, heavy gilded decoration, and a lavish mix of expensive, polychromed materials. More spectacular than the performance on stage was that on the grand, sweeping Baroque staircase (FIG. 31-3), where members of the Paris elite displayed themselves. As Garnier said, the purpose of the Opéra was to fulfill the human desire to hear, to see, and to be seen.

ACADEMIC PAINTING AND SCULPTURE

The taste that dominated painting and sculpture in the Académie des Beaux-Arts by the mid nineteenth century is well represented by **THE BIRTH OF VENUS** by Alexandre Cabanel (1823–1889), one of the leading academic artists of the time (**FIG. 31-4**). After studying with an academic master, Cabanel won the Prix de Rome in 1845, and garnered top honors at the Salon three times in the 1860s and 1870s. In his version of this popular mythological subject (compare **FIG. 20-40**), Venus floats above the waves, as flying *putti* playfully herald her arrival with conch shells. Cabanel's mastery of anatomy, flesh tones, and the rippling sea derives from his academic training and technical virtuosity. But the image also carries a strong erotic charge, in the languid limbs, arched back, and diverted eyes of Venus. This combination of mythological pedigree and sexual allure proved irresistible to Napoleon III, who bought *The Birth of Venus* for his private collection.

Although academic and avant-garde art are often seen as polar opposites, the relationship was more complex. Some academic artists

31-4 • Alexandre Cabanel THE BIRTH OF VENUS 1863. Oil on canvas, 52" × 90" (1.35 × 2.29 m). Musée d'Orsay, Paris.

experimented while maintaining academic conventions, while avant-garde artists held many academic practices in high esteem and sought academic approval. The academic artist Jean-Baptiste Carpeaux (1827–1875) illustrates the kind of experimentation that took place even within the academy. Carpeaux, who had studied at the École des Beaux-Arts under the Romantic sculptor François Rude (see Fig. 30–55), was commissioned to carve a large sculptural group for the façade of Garnier's Opéra. His work, **THE DANCE** (Fig. 31–5), shows a winged male personification of Dance leaping up joyfully in the midst of a compact group of mostly nude female dancers, an image of uninhibited Dionysian revelry. Like Cabanel's *Birth of Venus*, the work imbues a mythological subject with an erotic charge.

Unlike Cabanel's figures, Carpeaux's were not smooth and generalized in a Neoclassical manner, and this drew criticism from some academicians. The arrangement of his sculptural group also seemed too spontaneous, the facial expressions of the figures too vivid, their musculature too exact, their bone structure and proportions too much of this world, rather than reflections of an ideal one. Carpeaux's work signaled a new direction in academic art, responding to the values of a new generation of patrons from the industrial and merchant classes. These practical new collectors were less interested in art that idealized than in art that brought the ideal down to earth.

31-5 • Jean-Baptiste Carpeaux **THE DANCE** 1867–1868. Plaster, height approx. 15' (4.6 m). Musée d'Orsay, Paris.

ART AND ITS CONTEXTS | Orientalism

In **THE SNAKE CHARMER** (FIG. 31-6), French academic painter Jean-León Gérôme (1824–1904) luxuriates in the nineteenth-century fantasy of the Middle East—a characteristic example of **Orientalism**. A young boy, entirely naked, handles a python, while an older man behind him plays a fipple flute, and a huddled audience sits within the background shadows in a blue-tiled room decorated with calligraphic patterns. Gérôme paints the scene with photographic clarity and scrupulous attention to detail, leading us to think that it is an accurate representation of a specific event and locale. Gérôme traveled to the Middle East several times, and was praised by critics of the 1855 Salon for his ethnographic accuracy, but his *Snake Charmer* is a complete fiction, mixing Egyptian, Turkish, and Indian cultures together in a fantastized pastiche.

Orientalism, the European fascination with Middle Eastern cultures, dates to Napoleon's 1798 invasion of Egypt and his rampant looting of

Egyptian objects for the Louvre Museum, which he opened in 1804, and the 24-volume *Description de l'Egypte* (1809–1822), recording Egyptian people, lands, and culture that followed. In the 1840s and 1850s, British, French, and Italian photographers established studios at major tourist sites in the Middle East in order to provide photographs for visitors and armchair tourists at home, thus fueling a popular interest in the region.

The scholar Edward Said has described Orientalism, characterizing both academic and avant-garde art in the nineteenth century, as the colonial gaze upon the colonized Orient (the Middle East rather than Asia), seen by the colonizer as something to possess, as a "primitive" or "exotic" playground for the "civilized" European visitor. "Native" men become savage and despotic, and "native" women—and here boys—are sensuously described and sexually available.

31-6 • Jean-Léon Gérôme THE SNAKE CHARMER c. 1870. Oil on canvas, 33" × 481%" (83.8 × 122.1 cm). Clark Art Institute, Williamstown, MA. Acquired by Sterling and Francine Clark, 1942. (1955.51)

EARLY PHOTOGRAPHY IN EUROPE AND THE UNITED STATES

The nineteenth-century desire to record the faces of the new mercantile elite, their achievements and possessions, and even the imperial possessions of nations, found expression in photography. Since the late Renaissance, artists and others had sought a mechanical method for drawing from nature. One early device was the camera obscura (Latin, meaning "dark chamber"), which consists of a darkened room or box with a lens through which light passes,

projecting an upside-down image of the scene onto the opposite wall (or box side), which an artist can then trace. By the nine-teenth century, a small, portable camera obscura or even lighter *camera lucida* had become standard equipment for artists. Photography developed as a way to fix—that is, to make permanent—the images produced by a camera obscura (later called a "camera") on light-sensitive material.

Photography had no single "inventor." Several individuals worked on the technique simultaneously, each contributing some part to a process that emerged over many years. Around 1830, a handful of experimenters understood ways to "record" the image,

but the last step, "stopping" or "fixing" that image so that further exposure to light would not further darken the image, proved more challenging.

In France, while experimenting with ways to duplicate his paintings, Louis-Jacques-Mandé Daguerre (1787–1851) discovered that a plate coated with light-sensitive chemicals and exposed to light for 20 to 30 minutes would reveal a "latent image" when then exposed to mercury vapors. By 1837, he had developed a method of fixing his image by bathing the plate in a solution of salt, and he vastly improved the process by using the chemical hyposulphate of soda (known as "hypo") as suggested by Sir John Frederick Herschel (1792-1871). The final image was negative, but when viewed upon a highly polished silver plate it appeared positive. The resulting picture could not be duplicated easily and was very fragile, but its quality was remarkably precise. In Daguerre's photograph of his studio tabletop (FIG. 31-7), the details are exquisite (though impossible to see in reproduction, even using today's technology) and the composition mimics the conventions of still-life painting. Daguerre, after he patented and announced his new technology, produced an early type of photograph called a daguerreotype, in August 1839.

Even before Daguerre announced his photographic technique in France, the American artist Samuel Morse (1791–1872) traveled to Paris to negotiate exchanging information about his own invention, the telegraph, for information about Daguerre's photography. Morse introduced the daguerreotype process to America within weeks of Daguerre's announcement, and by 1841 had reduced exposure times enough to take portrait photographs (**FIG. 31-8**).

At the same time in England, Henry Fox Talbot (1800–1877), a wealthy amateur, made negative copies of engravings, lace, and plants by placing them on paper soaked in silver chloride and

31-7 • Louis-Jacques-Mandé Daguerre **THE ARTIST'S STUDIO**

1837. Daguerreotype, 6½" \times 8½" (16.5 \times 21.6 cm). Société Française de Photographie, Paris.

31-8 • DAGUERREOTYPE OF SAMUEL FINLEY BREESE MORSE

c. 1845. Sixth plate daguerreotype, $2^3\!\!/^{\!\!\!\!/}\times 3^1\!\!/^{\!\!\!/}$ (7 \times 8.3 cm). The Daguerreotype Collection of the Library of Congress, Washington, DC.

exposing them to light. He also found that the negative image on paper could be exposed again on top of another piece of paper to create a positive image, thus discovering the negative-positive process that became the basis of photographic printing. Talbot's negative could be used more than once, so he could produce a number of positive images inexpensively. But the **calotype**, as he later called it, produced a soft, fuzzy image. When he heard of Daguerre's announcement, Talbot rushed to make his own announcement and patent his process. The term for these processes—photography, derived from the Greek for "drawing with light"—was coined by Herschel.

The emerging technology of photography was quickly put to use in making visual records for contemporary audiences and future generations. Early on, however, photographers also experimented with the expressive possibilities of the new medium and worked to create striking compositions. Between 1844 and 1846, Talbot published a book in six parts entitled *The Pencil of Nature*, illustrated entirely with salt-paper prints made from calotype negatives. Most of the photographs were of idyllic rural scenery or carefully arranged still lifes; they were presented as works of art rather than documents of a precisely observed reality. Talbot realized that the imprecision of his process could not compete with the commercial potential of the daguerreotype, and so rather than trying to do so, he chose to view photography in visual and artistic terms. In

31–9 • Henry Fox Talbot **THE OPEN DOOR** 1843. Salt-paper print from a calotype negative, 5%" \times $7^{11}/_{16}$ " (14.3 \times 19.5 cm). Science Museum, London. Fox Talbot Collection

THE OPEN DOOR (FIG. 31-9), for example, shadows create a repeating pattern of diagonal lines that contrast with the rectlinear lines of the architecture. And it conveys meaning, expressing nostalgia for a rural way of life that was fast disappearing in industrial England.

In 1851, Frederick Scott Archer, a British sculptor and photographer, took a major step in the development of early photo-

graphy. Archer found that silver nitrate would adhere to glass if it was mixed with collodion, a combination of guncotton, ether, and alcohol used in medicinal bandages. When wet, this collodion—silver nitrate mixture needed only a few seconds' exposure to light to create an image. The result was a glass negative, from which countless positive proofs with great tonal subtleties could be made.

American photographers used this newly refined process to document the momentous events of the Civil War (1861–1865) in artfully composed pictures. Alexander Gardner (1821–1882)

31-10 • Alexander Gardner
THE HOME OF THE REBEL
SHARPSHOOTER: BATTLEFIELD
AT GETTYSBURG

1863. Albumen print, 7" \times 9" (18 \times 23 cm). Library of Congress, Washington, DC.

was a "camera operator" for Mathew Brady (1822–1896) at the beginning of the conflict, and, working with his assistant Timothy O'Sullivan (c. 1840-1882), he made war photographs that were widely distributed. THE HOME OF THE REBEL SHARPSHOOTER (FIG. 31-10) was taken after the Battle of Gettysburg in July 1863. The technical difficulties were considerable. Wet-plate technology required that the glass plate used to make the negative be coated with a sticky substance holding the light-sensitive chemicals. If the plate dried, the photograph could not be taken, and if dust contaminated the plate, the image would be ruined. Since long exposure times made action photographs impossible, early war photographs were taken in camp or in the aftermath of battle. Gardner's image seems to show a rebel sharpshooter who has been killed in his look-out. But this rock formation was in the middle of the battlefield, and had neither the height nor the view needed for a

sharpshooter. In fact, the photographers dragged the dead body to the site and posed it; the rifle propped against the wall was theirs. The staging of this photograph raises questions about visual fact and fiction. Like a painting, a photograph is composed to create a picture, but photography promises a kind of factuality that we do not expect from painting. Interestingly, the manipulation

TECHNIQUE | The Photographic Process

A camera is essentially a lightproof box with a hole, called an aperture, which is usually adjustable in size and regulates the amount of light that strikes the film. The aperture is covered with a lens, to focus the image on the film, and a shutter, a hinged flap that opens for a controlled amount of time in order to regulate the length of time the film is exposed to light—usually a small fraction of a second. Modern cameras with viewfinders and small single-lens reflex cameras are generally used at eye level, permitting the photographer to see virtually the same image that will be captured on film.

In modern black-and-white chemical photography, silver halide crystals (silver combined with iodine, chlorine, or other halogens) are suspended in a gelatin base to make an emulsion that coats the film; in early photography, before the invention of plastic, a glass plate was coated with a variety of emulsions. When the shutter is open, light reflected off objects enters the camera and strikes the film, exposing it. Pale objects reflect more light than dark ones. The silver in the emulsion collects most densely where it is exposed to the most light, producing a "negative" image on the film. Later, when the film is placed in a chemical bath (developed), the silver deposits turn black, as if tarnishing. The more light the film receives, the denser the black tone created. A positive image is created from a negative in the darkroom, where the film negative is placed over a sheet of paper that, like the film, has also been treated to make it light-sensitive. Light is then directed through

the negative onto the paper to create a positive image. Multiple positive prints can be generated from a single negative.

Today this chemical process has been largely replaced by digital photography, which records images as digital information files that can be manipulated on computers rather than in darkrooms. The exploitation of the artistic potential of this new photographic medium is a major preoccupation of contemporary artists.

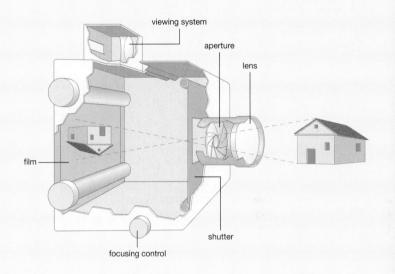

of this photograph did not concern nineteenth-century viewers, who understood clearly photography's inability to record the visual world without bias.

One of the most creative early photographers was Julia Margaret Cameron (1815-1879), who received her first camera as a gift from her daughters when she was 49. Her principal subjects were the great men and women of British arts, letters, and sciences, many of whom had long been family friends. Cameron's approach was experimental and radical. Like many of her portraits, that of the famous British historian THOMAS CARLYLE is deliberately slightly out of focus (FIG. 31-11): Cameron consciously rejected the sharp focus of commercial portrait photography, which she felt accentuated the merely physical attributes and neglected the inner character of the subject. By blurring the details, she sought to call attention to the light that suffused her subjects and to their thoughtful expressions. In her autobiography, Cameron said: "When I have had such men before my camera my whole soul has endeavoured to do its duty towards them in recording faithfully the greatness of the inner as well as the features of the outer man."

31-11 • Julia Margaret Cameron PORTRAIT OF THOMAS CARLYLE

1867. Silver print, 10" \times 8" (25.4 \times 20.3 cm). The Royal Photographic Society, Collection at National Museum of Photography, Film, and Television, England.

REALISM AND THE AVANT-GARDE

In reaction to the rigidity of academic training, some French artists began to consider themselves members of an **avant-garde**, meaning "advance guard" or "vanguard." The term was coined by the French military during the Napoleonic era to designate the forward units of an advancing army that scouted territory that the main force would soon occupy. Avant-garde artists saw themselves as working in advance of an increasingly bourgeois society. The term was first mentioned in connection with art around 1825 in the political programs of French utopian socialists. Henri de Saint-Simon (1760–1825) suggested that in order to transform modern industrialized society into an ideal state, it would be necessary to gather together an avant-garde of intellectuals, scientists, and artists to lead France into the future.

In 1831, the architect Eugène Viollet-le-Duc applied the term to the artists of Paris in the aftermath of the revolution of 1830. Viollet-le-Duc vehemently opposed the French academic system of architectural training. His concept of the avant-garde called for a small elite of independent radical thinkers, artists, and architects to break away from the Académie des Beaux-Arts and the norms of society in order to forge new thoughts, ideas, and ways of looking at the world and art. He foresaw that this life would require the sacrifice of artists' reputations and reduce sales of their work. Most avant-garde artists were neither as radical nor as extreme as Viollet-le-Duc, and, as we have seen, the relationship between the Académie des Beaux-Arts and the avant-garde was complex. Nonetheless, the idea was embraced by a number of artists who have come to characterize the period.

REALISM AND REVOLUTION

In the modern world of Paris at mid-century—a world plagued by violence, social unrest, overcrowding, and poverty—the grand, abstract themes of academic art seemed irrelevant to those thinkers who would come to represent the avant-garde. Rising food prices, high unemployment, political disenfranchisement, and government inaction ignited in a popular rebellion known as the Revolution of 1848, led by a coalition of socialists, anarchists, and workers. It brought an end to the July Monarchy and established the Second Republic (1848–1852). Conflicts among the reformers, however, led to another uprising, in which more than 10,000 of the working poor were killed or injured in their struggle against the new government's forces. Against this social and political backdrop a new intellectual movement, known as Realism, originated in the novels of Émile Zola, Charles Dickens, Honoré de Balzac, and others who wrote about the real lives of the urban lower classes. What art historians have labeled Realism is less of a style than a commitment to paint the modern world honestly, without turning away from the brutal truths of life for all people, poor as well as privileged.

COURBET Gustave Courbet (1819–1877) was one of the first artists to call himself "avant-garde" or "Realist." A big, blustery man, he was, in his own words, "not only a Socialist but a democrat and a Republican: in a word, a supporter of the whole Revolution." Born and raised near the Swiss border in the French town of Ornans, he moved to Paris in 1839. The street fighting in Paris in 1848 radicalized him and became a catalyst for two large canvases that have come to be regarded as the defining works of Realism.

Painted in 1849, the first of these, **THE STONE BREAKERS** (FIG. 31-12), depicts a young boy and an old man crushing rock

31-12 • Gustave Courbet THE STONE BREAKERS 1849. Oil on canvas, 5'3" × 8'6" (1.6 × 2.59 m). Formerly Gemäldegalerie, Dresden; destroyed in World War II.

to produce the gravel used for roadbeds. Stone breakers represent the disenfranchised peasants on whose backs modern life was being built. The younger figure strains to lift a large basket of rocks to the side of the road, dressed in tattered shirt and trousers, but wearing modern work boots. His older companion, seemingly broken by the lowly work, pounds the rocks as he kneels, wearing the more traditional clothing of a peasant, including wooden clogs. The boy thus seems to represent a grim future, while the man signifies an increasingly obsolete rural past. Both are conspicuously faceless. Courbet recorded his inspiration for this painting:

[N]ear Maisières [in the vicinity of Ornans], I stopped to consider two men breaking stones on the highway. It's rare to meet the most complete expression of poverty, so an idea for a picture came to me on the spot. I made an appointment with them at my studio for the next day On the one side is an old man, seventy On the other side is a young fellow ... in his filthy tattered shirt Alas, in labor such as this, one's life begins that way, and it ends the same way.

Two things are clear from this description: Courbet set out to make a political statement, and he invited the men back to his studio so that he could study them more carefully, following academic practice.

By rendering labor on the scale of a history painting—the canvas is over 5 × 8 feet—Courbet intended to provoke. In academic art, monumental canvases were reserved for heroic subjects, but Courbet asserts that peasant laborers should be venerated as heroes. Bypassing the highly finished style and inspiring message of history painting, he signifies the brutality of modern life in his rough use of paint and choice of dull, dark colors, awkward poses, and stilted composition. The scene feels realistically gloomy and degrading. In 1865, his friend, the anarchist philosopher Pierre-Joseph Proudhon (1809–1865), described *The Stone Breakers* as the first socialist picture ever painted, "an irony of our industrial civilization, which continually invents wonderful machines to perform all kinds of labor ... yet is unable to liberate man from the most backbreaking toil." Courbet himself described the work as a portrayal of "injustice."

Courbet began to paint A BURIAL AT ORNANS (FIG. 31-13) immediately after *The Stone Breakers* and exhibited the two paintings together at the 1850–1851 Salon. This is a vast painting, measuring roughly 10 by 21 feet, and depicts a rural burial life-size. A crush of people line up in rows across the length of the picture. The gravedigger kneels over the gaping hole in the ground, placed front and center, and flanked by a bored altar boy and a distracted dog; to the left, clergy dressed in red seem indifferent and bored; while to the right, the huddle of rural mourners—Courbet's

31–13 • Gustave Courbet **A BURIAL AT ORNANS** 1849. Oil on canvas, $10'3\frac{1}{2}" \times 21'9"$ (3.1 × 6.6 m). Musée d'Orsay, Paris.

A Burial at Ornans was inspired by the 1848 funeral of Courbet's maternal grandfather, Jean-Antoine Oudot, a veteran of the French Revolution of 1789. The painting is not meant as a record of that particular funeral, however, since Oudot is shown alive in profile at the extreme left of the canvas, his image adapted by Courbet from an earlier portrait. The two men to the right of the open grave, dressed not in contemporary but in late eighteenth-century clothing, are also revolutionaries of Oudot's generation. Their proximity to the grave suggests that one of their peers is being buried. Perhaps Courbet's picture links the revolutions of 1789 and 1848, both of which sought to advance the cause of democracy in France.

heroes of modern life—weep in genuine grief. Although painted on a scale befitting the funeral of a hero, Courbet's depiction has none of the idealization of traditional history painting; instead, it captures the awkward, blundering numbness of a real funeral and emphasizes its brutal, physical reality. When shown at the Salon, the painting was attacked by critics who objected to the elevation of a provincial funeral to this heroic scale, to Courbet's disrespect for the rules of academic composition, and even to the lack of any suggestion of the afterlife. Courbet had submitted his work to the Salon knowing that it would be denounced; he wanted to challenge the prescribed subjects, style, and finish of academic painting, to establish his position in the avant-garde, and to create controversy. At the cancellation of the 1854 Salon, and the rejection of some of his works by the International Exposition of 1855, Courbet constructed a temporary building on rented land near the fair's Pavilion of Art and installed a show of his own works that he called the "Pavilion of Realism," boldly asserting his independence from the Salon. Many artists after him would follow in his footsteps.

MILLET Similar accusations of political radicalism were leveled against Jean-François Millet (1814–1875). This artist grew up on a farm and, despite living and working in Paris between 1837 and 1848, he never felt comfortable with urban life. A state commission (with stipend), awarded for his part in the 1848 revolution, allowed him to move to the village of Barbizon, just south of Paris, where he painted the hardships and simple pleasures of the rural poor.

Among his best-known works is **THE GLEANERS** (**FIG. 31-14**), which shows three women gathering stray grain from the ground after harvest. Despite its soothing, warm colors, the scene is one of extreme poverty. Gleaning was a form of relief offered to the rural poor by landowners, although it required hours of backbreaking work to collect enough wheat to make a single loaf of bread. Two women bend over to reach the tiny stalks of grain remaining on the ground, while a third straightens to ease her back. When Millet exhibited the painting in 1857, critics noted its implicit social criticism and described the work as "Realist." Millet denied the accusations, but his paintings contradict him.

31-14 • Jean-François Millet THE GLEANERS 1857. Oil on canvas, $33'' \times 44''$ (83.8×111.8 cm). Musée d'Orsay, Paris.

31–15 • Jean-Baptiste-Camille Corot FIRST LEAVES, NEAR MANTES c. 1855. Oil on canvas, 13% × 18% (34 × 46 cm). Carnegie Museum of Art, Pittsburgh, Pennsylvania.

COROT The landscape paintings of Jean-Baptiste-Camille Corot (1796-1875) take a more romantic and less political approach to depicting rural life. After painting historical landscapes early in his career, Corot steadily moved toward more "naturalistic" and intimate scenes of rural France. FIRST LEAVES, NEAR MANTES (FIG. 31-15) depicts a scene infused with the soft mist of early spring in the woods. Corot's feathery brushwork representing the soft, new foliage contrasts with the stark, vertical tree trunks and branches, and, together with the fresh green of the new undergrowth, creates the lyrical mood of a clear spring day. A man and woman pause to talk on the road winding from left to right through the painting, while a woman labors in the woods at the lower right. Corot invites us to imagine ourselves in the picture and feel the crisp, bright air. These images of peaceful country life held great appeal for Parisians who had experienced the chaos of the 1848 revolution and who lived in an increasingly crowded, noisy, and fast-paced metropolis.

BONHEUR Rosa Bonheur (1822–1899) was one of the most popular French painters of farm life. Her success in what was then a male domain owed much to the socialist convictions of her parents, who belonged to a radical utopian sect—founded by the Comte de Saint-Simon (1760–1825)—that believed not only in the equality of women but also in a future female Messiah. Bonheur's father, a drawing teacher, provided most of her artistic training.

Bonheur dedicated herself to accurate depictions of modern draft animals, which were becoming increasingly obsolete as technology and industrialization transformed farming. She studied her subjects intensely by reading zoology books and making detailed studies in stockyards and slaughterhouses. In fact, to gain access to these all-male preserves, she had to obtain police permission to dress in men's clothing. Her professional breakthrough came at the Salon of 1848, where she showed eight paintings and won a first-class medal. **THE HORSE FAIR** (FIG. 31-16),

31–16 • Rosa Bonheur **THE HORSE FAIR** 1853–1855. Oil on canvas, $8'1/4'' \times 16'71/2''$ (2.45 \times 5.07 m). Metropolitan Museum of Art, New York.

Read the document related to Rosa Bonheur on myartslab.com

painted in 1853, was based on a horse market near Salpêtrière, but was also partly inspired by the Parthenon marbles in London and by the art of Géricault. The scene shows grooms displaying splendid Percheron horses, some walking obediently in their circle, others rearing up, not yet quite broken. Some have interpreted the painting as a commentary on the lack of rights for women in the 1850s, but it was not read that way at the time. Although unusually monumental for a painting of farm animals, it was highly praised at the 1848 Salon. When the painting later toured throughout Britain and the United States, members of the public paid to see it, and it was widely disseminated in print form on both sides of the Atlantic. In 1887, Cornelius Vanderbilt purchased it for the new Metropolitan Museum of Art in New York. Bonheur became so famous working within the Salon system that in 1865 she received France's highest award, membership in the Legion of Honor, becoming the first woman to be awarded its Grand Cross.

MANET: "THE PAINTER OF MODERN LIFE"

Along with the concept of the avant-garde, the idea of "modernity" also shaped art in France at this time. The experience of modern life—of constant change and renewal—was linked to the dynamic nature of the city. The themes of the modern city and of political engagement with modern life in an industrialized world are key to understanding the development of painting and literature in France in the second half of the nineteenth century.

In his 1863 essay "The Painter of Modern Life," poet Charles Baudelaire argued that, in order to speak for their time and place, artists' work had to be infused with the idea of modernity. He called for artists to be painters of contemporary manners and "of the passing moment and of all the suggestions of eternity that it contains," using both modern urban subjects and new approaches to seeing and representing the visual world. This break with the past was critical in order to comprehend and comment on the present. Especially after the invention of photography, art was expected to offer new ways of representing reality. One artist who rose to Baudelaire's challenge was the French painter Édouard Manet (1832–1883).

LE DÉJEUNER SUR L'HERBE At mid-century, the Académie des Beaux-Arts increasingly opened Salon exhibitions to nonacademic artists, resulting in a surge in the number of works submitted, and inevitably rejected by, the Salon jury. In 1863, the jury turned down nearly 3,000 works. A storm of protest erupted, prompting Emperor Napoleon III to order an exhibition of the rejected work called the Salon des Refusés ("Salon of the Rejected Ones"). Featured in it was Manet's painting LE DÉJEUNER SUR L'HERBE (THE LUNCHEON ON THE GRASS) (FIG. 31-17). A well-born Parisian who had studied in the early 1850s with the independent artist Thomas Couture (1815-1879), Manet had by the early 1860s developed a strong commitment to Realism and modernity, largely as a result of his friendship with Baudelaire. Le Déjeuner sur l'Herbe scandalized contemporary viewers all the way up to Napoleon III himself, provoking a critical avalanche that mixed shock with bewilderment. Ironically, the resulting succès de scandale ("success from scandal") helped establish Manet's career as a radical, avant-garde, modern artist.

31–17 • Édouard Manet LE DÉJEUNER SUR L'HERBE (THE LUNCHEON ON THE GRASS) 1863. Oil on canvas, 7' × 8'8" (2.13 × 2.64 m). Musée d'Orsay, Paris.

The most scandalous aspect of the painting was the "immorality" of Manet's theme: a suburban picnic featuring two fully dressed bourgeois gentlemen seated alongside a completely naked woman, with another scantily dressed woman in the background. Manet's scandalized audience assumed that these women were prostitutes, and the men their customers. Equally shocking were its references to important works of art of the past, which Académie des Beaux-Arts artists were expected to make, combined with its crude, unvarnished modernity. In contrast, one of the paintings that gathered most renown at the official Salon in that year was Alexandre Cabanel's *Birth of Venus* (see FIG. 31–4), which, because it presented nudity in a conventionally acceptable, Classical environment and mythological context, was favorably reviewed and quickly entered the collection of Napoleon III.

Manet apparently conceived of *Le Déjeuner sur l'Herbe* as a modern version of a Venetian Renaissance painting in the Louvre, *The Pastoral Concert*, then believed to be by Giorgione but now

attributed to both Titian and Giorgione or to Titian exclusively (see Fig. 21-25). Manet's composition also refers to a Marcantonio Raimondi engraving of Raphael's *The Judgment of Paris*—itself based on Classical reliefs of river gods and nymphs. Manet's modern interpretation of the scene, however, combined with his modern style, was intentionally provocative. Presenting the seamier side of city life under a flimsy guise of Classical art only underlined Manet's subversiveness. And the stark lighting and sharp outlining of his nude, the cool colors, the flat, cutout quality of his figures, who seem as if they are silhouetted cut-outs set against a painted backdrop, were unsettling to viewers accustomed to the traditional use of controlled gradations of shadows to model smoothly rounded forms nestled into logically mapped spaces.

OLYMPIA Shortly after completing *Le Déjeuner sur l'Herbe*, Manet painted **OLYMPIA** (**FIG. 31-18**), its title alluding to a socially

ART AND ITS CONTEXTS | The Mass Dissemination of Art

Just as contemporary artists can distribute photographic reproductions of their work, in the nineteenth century, artists used engraving or etching to reproduce their work for distribution to a larger audience.

Works of art that won prizes or created controversy were often engraved for reproduction by specialists in printmaking, and the prints sold at bookstores or magazine stands. J. M. W. Turner hired a team of engravers to capture the delicate tonal shadings of his works. An engraved copper plate could be printed upward of 100 times before the repeated pressing took its toll on image quality. In the later nineteenth century, artists increasingly used steel engraving, wood engraving, and

lithography for printing. Those more durable surfaces could print up to 10,000 copies of an image without much loss of quality, though only a few artists experienced such demand.

One of the canniest self-marketers of the century was Alexandre Cabanel. After Napoleon III bought *The Birth of Venus* (see Fig. 31–4), the artist sold the reproduction rights to the art dealer Adolphe Goupil, who in turn hired other artists to create at least two smaller-scale copies of the work. After the original artist had approved the copies and signed them, the dealer used these as models for engravers who cut the steel plates. The dealer then sold the smaller painted copies.

ambitious prostitute of the same name in a novel and play by Alexandre Dumas the Younger. Like *Le Déjeuner sur l'Herbe*, Manet's *Olympia* was based on a Venetian Renaissance source, Titian's "*Venus*" of *Urbino* (see Fig. 21–28), which Manet had earlier copied in Florence. At first, his painting appears to pay homage to Titian's in its subject matter (at that time believed to be a Venetian courtesan) and composition, but Manet made his modern

counterpart the very antithesis of Titian's reclining nude. Titian's female is curvaceous and softly rounded; Manet's is angular and flattened. Titian's colors are warm and rich; Manet's are cold and harsh, like a photograph; Titian's "Venus" looks coyly at the male spectator, Manet's Olympia appears coldly indifferent. And instead of looking up at us, Olympia gazes down at us, indicating that she is in the position of power and that we are subordinate,

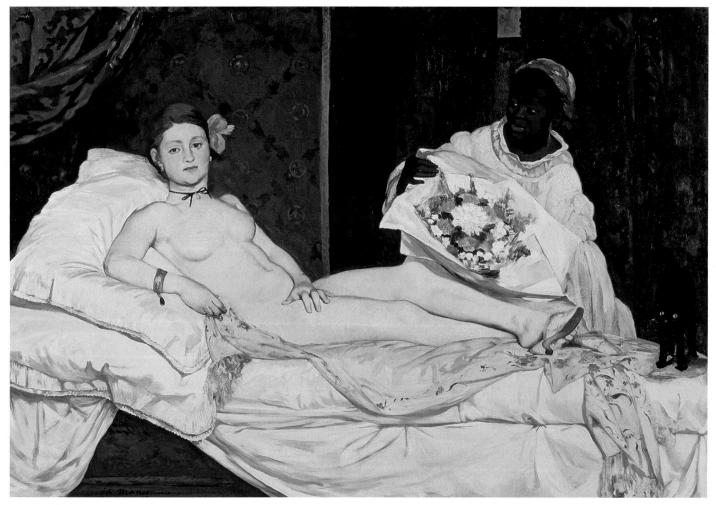

31–18 • Édouard Manet **OLYMPIA** 1863. Oil on canvas, 4'3" × 6'2½" (1.31 × 1.91 m). Musée d'Orsay, Paris.

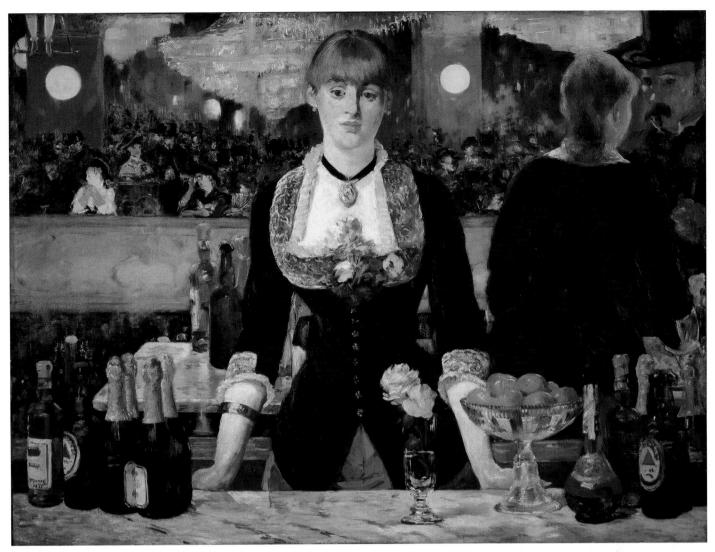

31-19 • Édouard Manet A BAR AT THE FOLIES-BERGÈRE
1881-1882. Oil on canvas. 37¾" × 51¼" (95.9 × 130 cm). The Samuel Courtauld Trust, The Courtauld Gallery, London. (P.1934.SC.234)

Q—[**View** the Closer Look for A Bar at the Folies-Bergère on myartslab.com

akin to the black servant at the foot of the bed who brings her a bouquet of flowers. Our relationship with Olympia is underscored by the reaction of her cat, which—unlike the sleeping dog in the Titian—arches its back at us. In reversing the Titian, Manet overturns the entire tradition of the accommodating female nude. Not surprisingly, conservative critics vilified *Olympia* when it was exhibited at the Salon of 1865.

Manet generally submitted his work to every Salon, but when several were rejected in 1867, he did as Courbet had done in 1855: He asserted his independence by renting a hall nearby and staging his own show. This made Manet the unofficial leader of a group of progressive artists and writers who gathered at the Café Guerbois in the Montmartre district of Paris. Among the artists who frequented the café were Degas, Monet, Pissarro, and Renoir, all of whom would soon exhibit together as the Impressionists and follow Manet's lead in challenging academic conventions.

LATER WORKS Manet worked closely with all these artists and frequently painted themes similar to those favored by the Impressionists, but always retaining his previous dedication to the portraval of modern urban life. In his last major painting, A BAR AT THE FOLIES-BERGÈRE (FIG. 31-19), he maintains his focus on the complex theme of gender and class relations in modern urban life. Here a hard-working young girl serves drinks at a bar in the famous nightclub that offered circuses, musicals, and vaudeville acts (note the legs of a trapeze artist in the upper left corner). She has an unfashionably ruddy face and hands scrubbed raw. In the glittering light created by the electric bulbs and mirrors of the café-concert she seems stiff and distant, certainly self-absorbed, perhaps even depressed, refusing to meet the gaze of her client. The barmaid is at once detached from the scene and part of it, one of the many items among the still life of liquor bottles, tangerines, and flowers, on display for purchase. This image is about sexualized looking and the barmaid's uneasy reflection in the mirror, which seems to acknowledge that both her class and gender expose her to visual and even sexual consumption.

RESPONSES TO REALISM BEYOND FRANCE

Artists of other nations embraced their own forms of realism in the period after 1850 as the social effects of urbanization and industrialization began to be felt in their countries. While these artists did not label themselves as "Realists" like their contemporaries in France, they did share an interest in presenting unflinching looks at grim reality that exposed the difficult lives of the working poor and the complexities of urban life.

REALISM IN RUSSIA: THE WANDERERS In Russia, a variant on French Realism developed in relation to a new concern for the peasantry. In 1861, the tsar abolished serfdom, emancipating Russia's peasants from the virtual slavery they had endured on the large estates of the aristocracy. Two years later, a group of painters inspired by the emancipation declared allegiance both to the peasant cause and to freedom from the St. Petersburg Academy of Art, which had controlled Russian art since 1754. Reacting against what they considered the escapist aesthetics of the academy, the members of the group dedicated themselves to a socially useful realism. Committed to bringing art to the people in traveling exhibitions, they called themselves "The Wanderers." By the late 1870s, members of the group, like their counterparts in music and literature, had also joined a nationalist movement to reassert what they considered to be an authentic Russian culture rooted in the traditions of the peasantry, rejecting the Western European customs that had long predominated among the Russian aristocracy.

Ilya Repin (1844-1930), who attended the St. Petersburg Academy and won a scholarship to study in Paris, joined the Wanderers in 1878 after his return to Russia. He painted a series of works illustrating the social injustices then prevailing in his homeland, including BARGEHAULERS ON THE VOLGA (FIG. 31-20). which features a wretched group of peasants condemned to the brutal work of pulling ships up the Volga River. To heighten our sympathy for these workers, Repin placed a youth in the center of the group, a young man who will soon be as worn out as his companions unless something is done to rescue him. This painting was a call to action.

REALISM IN THE UNITED STATES: A CONTINUING TRA-

DITION Though it was not a term used in the United States, realism—often with a political edge—was an unbroken tradition stretching back to Colonial portrait painters (see Fig. 30-1) and continuing in the pioneering work of photographers during the civil war (see FIG. 31-10). There were several kinds of realism in later nineteenth-century American art. Thomas Eakins (1844-1916). for instance, made a series of uncompromising paintings that were criticized for their controversial subject matter. Born in Philadelphia, Eakins trained at the Pennsylvania Academy of the Fine Arts, but since he thought the training in anatomy lacked rigor, he supplemented his studies at the Jefferson Medical College nearby. He later enrolled at the École des Beaux-Arts in Paris and then spent six months in Spain, where he encountered the profound realism of Baroque artists such as Jusepe de Ribera and Diego Velázquez (see FIGS. 23-17, 23-19). After he returned to Philadelphia in 1870, Eakins specialized in frank portraits and scenes of

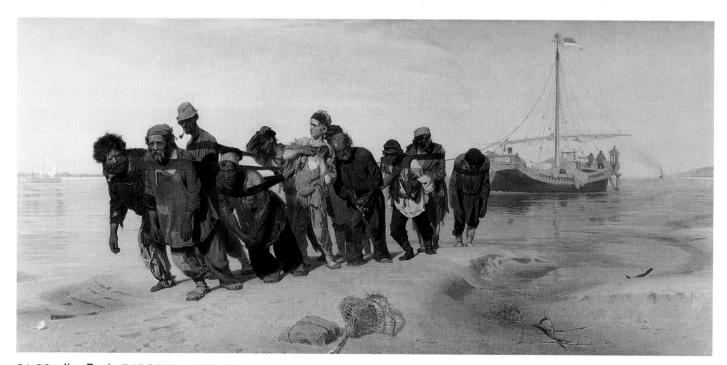

31-20 • Ilya Repin BARGEHAULERS ON THE VOLGA 1870–1873. Oil on canvas, $4'3^3/4'' \times 9'3''$ (1.3 × 2.81 m). State Russian Museum, St. Petersburg.

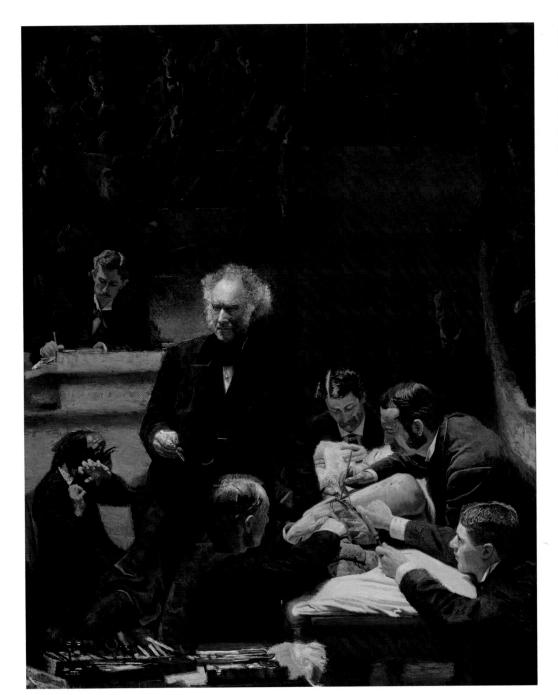

31-21 • Thomas Eakins
THE GROSS CLINIC

1875. Oil on canvas, $8' \times 6'5''$ (2.44 \times 1.98 m). Philadelphia Museum of Art, Pennsylvania. Gift of the Alumni Association to Jefferson Medical College in 1878 and purchased by the Pennsylvania Academy of the Fine Arts and the Philadelphia Museum of Art in 2007

Eakins, who taught anatomy and figure drawing at the Pennsylvania Academy of the Fine Arts, disapproved of the academic technique of drawing from plaster casts. In 1879, he said, "At best, they are only imitations, and an imitation of an imitation cannot have so much life as an imitation of nature itself." He added, "The Greeks did not study the antique ... the draped figures in the Parthenon pediment were modeled from life, undoubtedly."

everyday life whose lack of conventional charm generated little popular interest. But he was a charismatic teacher, and was soon appointed director of the Pennsylvania Academy.

THE GROSS CLINIC (Fig. 31-21) was one of Eakins's most controversial paintings. Although created specifically for the 1876 Philadelphia Centennial Exhibition, it was rejected for the fineart exhibition—the jury did not consider surgery a fit subject for art—and relegated to the scientific and medical display. The monumental painting shows Dr. Samuel David Gross performing an operation that he pioneered in the surgical amphitheater of Jefferson Medical College, as he pauses to lecture to medical students taking notes in the background—as well as to Eakins himself, whose self-portrait appears along the painting's right edge. A

woman at left, presumably a relative of the patient, cringes in horror at the bloody spectacle. At this time, surgeons were regarded with fear, especially teaching surgeons who frequently thought of the poor as objects on which to practice. But Eakins portrays Gross as a heroic figure, spotlighted by beams of light on his forehead and bloodied right hand with glinting scalpel. Principal illumination, however, is reserved for the patient, presented here not as an entire body but a dehumanized jumble of thigh, buttock, socked feet, and bunches of cloth. In conceiving this portrait, Eakins must have had Rembrandt's famous Baroque painting of Dr. Tulp in mind (see Fig. 23–34), and the American painter's use of light seems to point to a similar homage to scientific achievement—amid the darkness of ignorance and fear, modern science is the light of knowledge

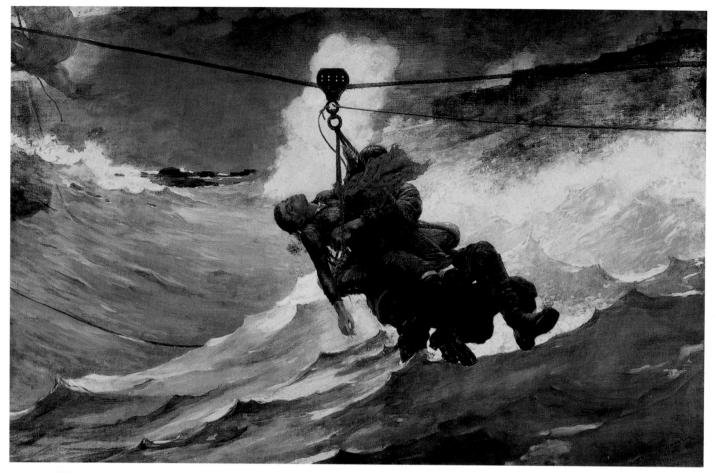

31–22 • Winslow Homer THE LIFE LINE 1884. Oil on canvas, $2834'' \times 44\%''$ (73 × 113.3 cm). Philadelphia Museum of Art, Pennsylvania. The George W. Elkins Collection, 1924

In the early sketches for this work, the man's face was visible. The decision to cover it focuses attention on the victim, and also on the true hero, the mechanical apparatus known as the "breeches buoy."

and the source of progress. The procedure showcased here, in fact, was a surgical innovation that allowed Dr. Gross to save a patient's leg that heretofore would have been routinely amputated.

Winslow Homer (1836-1910) also developed into a realist painter. Born in Boston, he began his career as a 21-year-old freelance illustrator for popular periodicals such as Harper's Weekly, which sent him to cover the Civil War in 1862. In 1867, after a ten-month sojourn in France, Homer returned to paint nostalgic visions of the rural scenes that had figured in his magazine illustrations, but following a sojourn during 1881-1882 in a tiny English fishing village on the rugged North Sea coast, Homer developed a commitment to depicting the working poor. Moved by the hard lives and strength of character of the people he encountered in England, he set aside idyllic subjects for themes of heroic struggle against natural adversity. In England, he had been particularly impressed by the "breeches buoy," a mechanical apparatus used for rescues at sea. During the summer of 1883, he made sketches of one imported by the lifesaving crew in Atlantic City, New Jersey. The following year he painted THE LIFE LINE (FIG. 31-22), which depicts a coastguard saving a shipwrecked woman

with the use of a breeches buoy—a testament not simply to valor but also to human ingenuity.

The sculptor Edmonia Lewis (1845-c. 1911) was born in New York State to a Chippewa mother and an African-American father, orphaned at the age of 4, and raised by her mother's family. As a teenager, with the help of abolitionists, she attended Oberlin College, the first college in the United States to grant degrees to women, and then moved to Boston. Her highly successful busts and medallions of abolitionist leaders and Civil War heroes financed her move to Rome in 1867, where she was welcomed into the sculptural circle of American expatriate artist Harriet Hosmer (1830-1908) and used Neoclassical style to address modern, realist concerns. Galvanized by the struggle of recently freed slaves for equality, Lewis created FOREVER FREE (FIG. **31-23**) in 1867 as a memorial to the Emancipation Proclamation (1862-1863). A diminutive woman kneels in prayerful gratitude beside the looming figure of her male companion, who boosts himself up on the ball that once bound his ankle and raises his broken shackles in a gesture of triumphant liberation. Lewis's enthusiasm outran her financial realities; she had to borrow money to pay

for the marble for this work. She shipped it from Rome back to Boston hoping that a subscription drive among abolitionists would redeem her loan. The effort was only partially successful, but her steady income from the sale of commemorative medallions eventually paid it off.

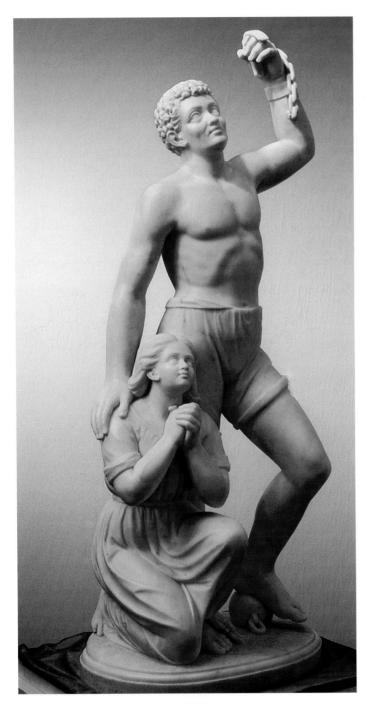

31–23 • Edmonia Lewis **FOREVER FREE** 1867. Marble, $411/4" \times 22" \times 17"$ (104.8 \times 55 \times 43.2 cm). Howard University Gallery of Art, Washington, DC.

This sculpture not only celebrates emancipation, but also subtly reflects white attitudes toward women and people of color. Lewis's female is less racialized and more submissive than her male counterpart to align her with the contemporary ideal of womanhood and make her more appealing to white audiences.

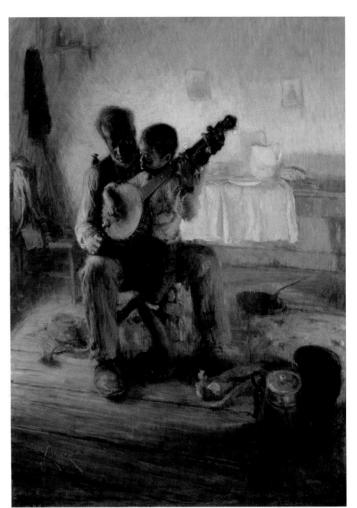

31–24 • Henry Ossawa Tanner THE BANJO LESSON 1893. Oil on canvas, $49''\times35\%''$ (124,4 \times 90 cm). Hampton University Museum, Virginia.

Among Eakins's students at the Pennsylvania Academy of the Fine Arts were women and African-Americans, groups often excluded from art schools. One of the star pupils was Henry Ossawa Tanner (1859-1937), who became the most successful African-American painter of the late nineteenth and early twentieth centuries. The son of a bishop in the African Methodist Episcopal Church, Tanner grew up in Philadelphia, and after studying at the academy, he initially worked as a photographer and drawing teacher in Atlanta. In 1891, to further his academic training, he moved to Paris, where his painting received favorable critical attention. In the early 1890s, he painted scenes from African-American and rural French life that combined Eakins's realism with the delicate brushwork he encountered in France. With strongly felt, humanizing images like THE BANJO LESSON (FIG. 31-24), he sought to counter caricatures of African-American life created by other artists. An elderly man is teaching a young boy seated on his lap, and as their seriousness and concentration connect them, their poverty seems to fade. The use of the banjo here is especially significant since it had become identified with images of minstrels—just the sort of derogatory caricatures that Tanner

sought to replace with his sympathetic genre scenes focused on the intimate interactions that brought dignity and pride to family life. After a trip to Palestine in 1897, Tanner turned to religious subjects, believing that Bible stories could illustrate the struggles and hopes of contemporary African-Americans.

DEVELOPMENTS IN BRITAIN Britain also encountered social and political upheaval at the middle of the nineteenth century. The depression of the "hungry forties," the Irish Potato Famine, and the Chartist Riots threatened social stability in England. Mid-century British artists painted scenes of religious, medieval, or moral exemplars using a tight realistic style that was quite different from both French and American Realism.

In 1848, seven young London artists formed the Pre-Raphaelite Brotherhood in response to what they considered the misguided practices of contemporary British art. Instead of the "Raphaelesque" conventions taught at the Royal Academy, the Pre-Raphaelites looked back to the Middle Ages and early Renaissance (before Raphael) for a beauty and spirituality that they found lacking in their own time. They believed this earlier art was more moralistic and "real."

Dante Gabriel Rossetti (1828–1882) was a leading member of the Pre-Raphaelite Brotherhood. His painting LA PIA DE' TOLO-MEI (FIG. 31-25) illustrates a scene from Dante's Purgatory in which La Pia (the Pious One), wrongly accused of infidelity and imprisoned by her husband in a castle, is dying. The rosary and prayer book at her side refer to her piety, while the sundial and ravens suggest the passage of time and her impending death. La Pia's continuing love for her husband is represented by his letters, which lie under her prayer book. The luxuriant fig leaves that surround her are traditionally associated with shame, and they seem to suck her into themselves. They have no source in Dante, but had personal relevance for Rossetti: Jane Burden, his model for this and many other paintings, was the wife of his friend William Morris, but she had also become Rossetti's lover. By fingering her wedding ring, La Pia/Jane suggests that she is a captive not of her husband but of her marriage, evoking Rossetti's own unhappy situation.

Other British artists drew inspiration from the medieval past as a panacea for modern life in London. William Morris (1834–1896) worked briefly as a painter under the influence of the Pre-Raphaelites before turning his attention to interior design and decoration. Morris's interest in crafts developed in the context of a

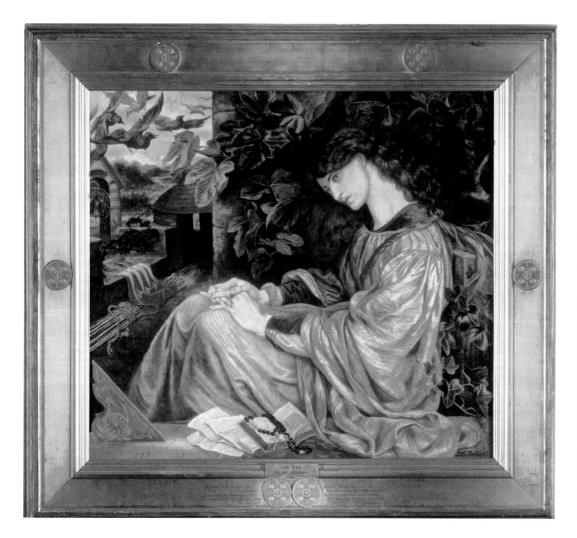

31-25 • Dante Gabriel Rossetti LA PIA DE' TOLOMEI

1868–1869. Oil on canvas, $41\frac{1}{2}$ " \times $47\frac{1}{2}$ " (105.4 \times 119.4 cm). Spencer Museum of Art, The University of Kansas. (1956.0031)

The massive gilded frame Rossetti designed for La Pia de' Tolomei features simple moldings on either side of broad, sloping boards. embellished with a few large roundels. The title of the painting is inscribed above the paired roundels at the lower center. On either side of them appear four lines from Dante's Purgatory spoken by the spirit of La Pia, in Italian at the left and in Rossetti's English translation at the right: "Remember me who am La Pia,-me / From Siena sprung and by Maremma dead. / This in his inmost heart well knoweth he/With whose fair jewel I was ringed and wed."

ART AND ITS CONTEXTS | Art on Trial in 1877

This is a partial transcript of Whistler's testimony at the libel trial that he initiated against the art critic John Ruskin. Whistler's responses often provoked laughter, and the judge at one point threatened to clear the courtroom.

- Q: What is your definition of a Nocturne?
- A: I have, perhaps, meant rather to indicate an artistic interest alone in the work, divesting the picture from any outside sort of interest which might have been otherwise attached to it. It is an arrangement of line, form, and color first ... The *Nocturne in Black and Gold* [see Fig. 31–27] is a night piece, and represents the fireworks at Cremorne.
- Q: Not a view of Cremorne?
- A: If it were called a view of Cremorne, it would certainly bring about nothing but disappointment on the part of beholders. It is an artistic arrangement. It was marked 200 guineas ...
- Q: I suppose you are willing to admit that your pictures exhibit some eccentricities; you have been told that over and over again?

- A: Yes, very often.
- Q: You send them to the gallery to invite the admiration of the public?
- A: That would be such a vast absurdity on my part that I don't think I could.
- Q: Did it take you much time to paint the *Nocturne in Black and Gold*? How soon did you knock it off?
- A: I knocked it off in possibly a couple of days; one day to do the work, and another to finish it.
- Q: And that was the labor for which you asked 200 guineas?
- A: No, it was for the knowledge gained through a lifetime.

The judge ruled in Whistler's favor; Ruskin had indeed libeled him. But he awarded Whistler damages of only one farthing. Since in those days the person who brought the suit had to pay all the court costs, the case ended up bankrupting the artist.

widespread reaction against the shoddy design of industrially produced goods. Unable to find satisfactory furnishings for his new home after his marriage in 1859, Morris designed and constructed them himself, with the help of friends, later founding a decorating firm to produce a full range of medieval-inspired objects. Although many of the furnishings offered by Morris & Company were expensive, one-of-a-kind items, others, such as the rush-seated chair illustrated here (FIG. 31-26), were inexpensive and simple, intended as a handcrafted alternative to machine-made furniture. Concerned with creating a "total" environment, Morris and his colleagues designed not only furniture but also stained glass, tiles, wallpaper, and fabrics, such as the "Peacock and Dragon" curtain seen in the background of FIGURE 31-26.

31-26 • FOREGROUND: Phillip Webb SINGLE CHAIR FROM THE SUSSEX RANGE

In production from c. 1865. Ebonized wood with rush seat, $33'' \times 161 \%'' \times 14''$ (83.8 \times 42 \times 35.6 cm).

BACKGROUND: William Morris "PEACOCK AND DRAGON" CURTAIN

1878. Handloomed jacquard-woven woolen twill, $12'10^{1}/2'' \times 11'5^{5}/8''$ (3.96 \times 3.53 m). Chair and curtain manufactured by Morris & Company. The William Morris Gallery, London Borough of Waltham Forest.

Morris and his principal furniture designer, Philip Webb (1831–1915), adapted the Sussex range from traditional rush-seated chairs of the Sussex region. The handwoven curtain in the background is typical of Morris's fabric designs in its use of flat patterning that affirms the two-dimensional character of the textile medium. The pattern's prolific organic motifs and soothing blue and green hues—the decorative counterpart to those of naturalistic landscape painting—were meant to provide relief from the stresses of modern urban existence.

Morris inspired what became known as the Arts and Crafts Movement. He rebelled against the idea that art was a highly specialized product made for a small elite, and he hoped to usher in a new era of art for the people. He said in lectures: "I do not want art for a few, any more than education for a few, or freedom for a

31-27 • James Abbott McNeill Whistler NOCTURNE IN BLACK AND GOLD, THE FALLING ROCKET

1875. Oil on panel, $23^34'' \times 18\%''$ (60.2 \times 46.7 cm). Detroit Institute of Arts, Detroit, Michigan. Gift of Dexter M. Ferry Jr. (46.309)

Read the document related to James Abbott McNeill Whistler's Nocturne in Black and Gold, The Falling Rocket on myartslab.com

few." A socialist, Morris opposed mass production and the deadening impact of factory life on the industrial worker. He argued that when laborers made handcrafted objects, they derived satisfaction from being involved in the entire process of creation and thus produced honest and beautiful things.

The American expatriate James Abbott McNeill Whistler (1834–1903) also focused his attention on the rooms and walls where art was hung, but he did so to satisfy elitist tastes for beauty as its own reward. He also became embroiled in several artistic controversies that laid the groundwork for abstraction in the next century. After flunking out of West Point in the early 1850s, Whistler studied art in Paris, where he was briefly influenced by Courbet's Realism; the two artists painted several seascapes

together. Whistler settled in London in 1859, after which his art began to take on a more "decorative" quality that he called "aesthetic" and which increasingly diverged from observed reality. He believed that the arrangement of a room (or a painting) could be aesthetically pleasing in itself, without reference to the outside world. He occasionally designed exhibition rooms for his art, with the aim of creating a total harmony of objects and space.

Whistler's ideas about art were revolutionary. He was among the first artists to conceive of his paintings as abstractions from rather than representations of observed reality, and he was among the first to collect Japanese art, fascinated by what he perceived as "decorative" line, color, and shape, although he understood little about its meaning or intent. By the middle of the 1860s, Whistler began to entitle his works "Symphonies" and "Arrangements," suggesting that their themes resided in their compositions rather than their subject matter. He painted several landscapes with the musical title "Nocturne," and when he exhibited some of these in 1877, he drew the scorn of England's leading art critic, John Ruskin (1819–1900), a supporter of the Pre-Raphaelites and their moralistic intentions. Decrying Whistler's work as carelessly lacking in finish and purpose, Ruskin's review asked how an artist could "demand 200 guineas for flinging a pot of paint in the public's face."

The most controversial painting in Whistler's 1877 exhibition was NOCTURNE IN BLACK AND GOLD, THE FALLING ROCKET (FIG. 31-27), and Ruskin's objections to it precipitated one of the most notorious court dramas in art history. Painted in restricted tonalities, at first glance the work appears completely abstract. In fact, the painting is a night scene depicting a fireworks show over a lake at Cremorne Gardens in London, with viewers vaguely discernible along the lake's edge in the foreground. Whistler took the term Nocturne from the titles of piano compositions by Frederic Chopin, hoping to evoke an association between the abstract qualities of art and music. After reading Ruskin's review, Whistler sued the critic for libel (see "Art on Trial in 1877," page 985). He deliberately turned the courtroom into a public forum, both to defend and to advertise his art. On the witness stand, he maintained that art has no higher purpose than creating visual delight and denied the need for paintings to have "subject matter." While Whistler never made a completely abstract painting, his theories were integral to the development of abstract art in the next century.

IMPRESSIONISM

The generation of French painters maturing around 1870 continued to paint modern urban subjects, but their perspective differed from that of Manet and the Realists. Instead of challenging social commentary, these younger artists painted pretty pictures of the upper middle class at leisure in the countryside and in the city, and although several members of this group painted rural scenes, their point of view tended to be that of a city person on holiday. They also began to paint not in the studio, but en plein air (outdoors, "in the open air"), in an effort to record directly the fleeting effects of light and atmosphere by applying flat expanses of pure color directly onto the canvas. Plein-air painting was greatly facilitated by the invention in 1841 of collapsible metal tubes for oil paint that artists could conveniently pack and take with them. Eschewing the tedium of the academic program for painting, with its elaborate prepatory drawings and underpainting, prelude to laborious work in the studio, the Impressionists sought instead to capture the play of light quickly, before it changed.

In April 1874, a group of these artists—including Paul Cézanne, Edgar Degas, Claude Monet, Berthe Morisot, Camille Pissarro, and Pierre-Auguste Renoir—exhibited together in Paris under the title of the Société Anonyme des Artistes Peintres, Sculpteurs, Graveurs, etc. (Anonymous Corporation of Artist-Painters,

Sculptors, Engravers, etc.). Pissarro organized the group along the lines advocated by anarchists such as Proudhon, who urged citizens to band together into self-supporting grass-roots organizations, rather than relying on state-sanctioned institutions. Pissarro envisioned the Société as a mutual aid group for artists who opposed the state-funded Salons. While the Impressionists are the most famous of its members today, at the time the group included artists working in several styles. All 30 participants agreed not to submit anything that year to the Salon, which had in the past often rejected their work. This was a declaration of independence from the Académie and a bid to gain the public's attention directly.

While their exhibition received some positive reviews, one critic, Louis Leroy, writing in the satirical journal Charivari, seized upon the title of Claude Monet's painting Impression: Sunrise (see Fig. 31–28), and dubbed the entire exhibition "impressionist." Leroy was ridiculing the fast, open brushstrokes and unfinished look of some of the paintings, but Monet and his colleagues embraced the term because it aptly described their aim of rendering the instantaneous impression and fleeting moment in paint. Seven more Impressionist exhibitions were held between 1876 and 1886, with the membership of the group varying slightly on each occasion; only Pissarro participated in all eight shows. The relative success of these exhibitions prompted other artists to organize their own alternatives to the Salon, and by 1900 the independent exhibition and gallery system had all but eradicated the French academic Salon system. Its centuries-old stranglehold on determining and controlling artistic "standards" was effectively ended.

LANDSCAPE AND LEISURE

Claude Monet (1840–1926) was a leading exponent of Impressionism. Born in Paris but raised in the port city of Le Havre, he trained briefly with an academic teacher but soon established his own studio. His friend Charles-François Daubigny urged him to "be faithful to his impression" and suggested that he create a floating studio on a boat and paint *en plein air*. Like other Impressionists, Monet's focus was the creation of a modern painting style, not the production of biting social commentary. Initially, the Impressionists celebrated the semirural pleasures of outings to the suburbs afforded to the middle class by the Paris train system. Few early works depict locations far from Paris; most feature the Parisians at leisure—walking, boating, and visiting the fashionable new parks within the city or just outside of town.

In the summer of 1870, the Franco-Prussian War broke out and Monet fled to London, where he spent time with Pissarro and his future art dealer, Paul Durand-Ruel. The disastrous loss of the major industrial regions of Alsace and Lorraine to Prussia at the end of the war devastated the French economy. In Paris, for two months between March and May 1871, workers rose up and established the Commune, a working-class city government, the suppression of which led to an estimated 20,000 dead and 7,500 imprisoned. The horror rocked Paris. Courbet was imprisoned for a short time and, in artists' circles, the fear of being branded as an

31-28 • Claude Monet IMPRESSION: SUNRISE 1872. Oil on canvas, $19" \times 24\%"$ (48 \times 63 cm). Musée Marmottan, Paris.

Read the document related to Claude Monet on myartslab.com

enemy of the state sent a chill through everyone. After 1871, overt political commentary in French art diminished even more, and the challenge of the avant-garde was expressed increasingly as an insular stylistic rebellion.

In 1873, just after returning to Paris, Monet painted IMPRES-SION: SUNRISE (FIG. 31-28), a view of the sun rising in the morning fog over the harbor at his home town of Le Havre. The painting is rendered almost entirely of strokes of color (Leroy sneeringly called them "tongue-lickings"). The foreground is ambiguous and the horizon line disappears among the shimmering shapes of steamships and docks in the background, clouded by a thick atmosphere of mist. Monet registers the intensity and shifting forms of a first sketch and presents it as the final work of art. He records the ephemeral play of reflected light and color and its effect on the eye, rather than describing the physical substance of forms and the spatial volumes they occupy. The American painter Lilla Cabot Perry, who befriended Monet in his later years, recalled him telling her:

When you go out to paint, try to forget what objects you have before you—a tree, a house, a field, or whatever. Merely think, Here is a little square of blue, here an oblong of pink, here a streak of yellow, and paint it just as it looks to you, the exact color and shape, until it gives your own naive impression of the scene before you.

31-29 • Claude Monet ROUEN CATHEDRAL: THE PORTAL (IN SUN)

1894. Oil on canvas, $39^{1}\!/\!_{4}^{\prime\prime}\times26^{\prime\prime}$ (99.7 \times 66 cm). Metropolitan Museum of Art, New York.

31–30 • Camille Pissarro **WOODED LANDSCAPE AT L'HERMITAGE, PONTOISE** 1878. Oil on canvas, $18^{5}/_{16}'' \times 22^{1}/_{16}''$ (46.5 \times 56 cm). Nelson-Atkins Museum of Art, Kansas City, Missouri. Gift of Dr. and Mrs. Nicholas S. Pickard

Monet continued to explore personal impressions of light and color during a long career that extended well into the twentieth century. Beginning in the 1880s and 1890s he focused his vision even more intently, exploring a limited number of outdoor subjects through several series of paintings: haystacks, poplar trees silhouetted against the sky, and the façade of Rouen Cathedral (FIG. 31-29). He painted the cathedral not as an expression of personal religious conviction, but because of his fascination with the way light played across its undulating stone surface, changing its appearance constantly as the lighting changed throughout the day. He painted more than 30 canvases of the Rouen façade, begun from direct observation of the cathedral from a second-story window across the street and finished later in his studio at nearby Giverny. In these paintings, Monet continued his Impressionist

pursuit of capturing the fleeting effects of light and atmosphere, but his extensive reworking of the paintings in his studio produced pictures that were more carefully orchestrated and laboriously executed that his earlier, more spontaneous, **plein air** works.

Monet's friend and fellow artist Camille Pissarro (1830–1903) offered a new Impressionist image of the landscape, painting scenes where the urban meets the rural. At times he portrayed the rural landscape on its own, but he often shows urban visitors to the countryside and small towns or factories embedded in the land as the city encroaches upon them. Born in the Dutch West Indies to French parents and raised near Paris, Pissarro studied art in Paris during the 1850s and early 1860s. In 1870, while he and Monet lived in London, Pissarro had already espoused the principles that would later blossom in Impressionism. The two artists worked

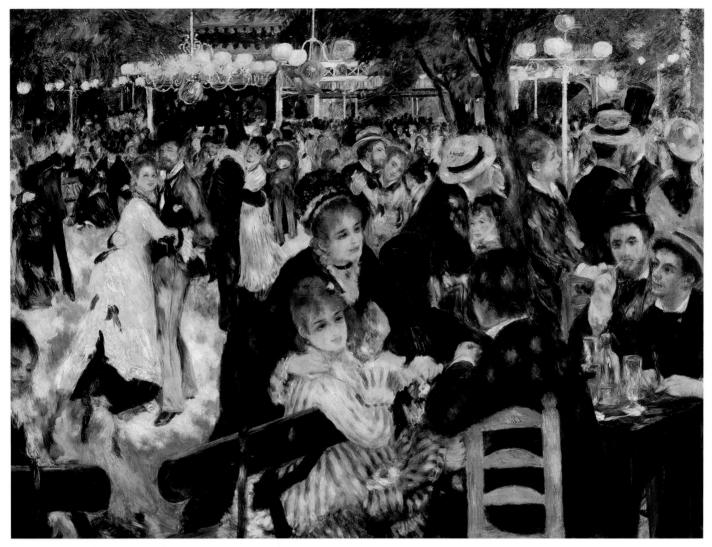

31–31 • Pierre-Auguste Renoir **MOULIN DE LA GALETTE** 1876. Oil on canvas, $4'31/2'' \times 5'9''$ (1.31 \times 1.75 m). Musée d'Orsay, Paris.

together in England, trying to capture what Pissarro described as "plein air light and fugitive effects" by lightening color intensity and hue, and loosening brushstrokes.

Following his return to France, Pissarro settled in Pontoise, a small, hilly village northwest of Paris where he worked for most of the 1870s in an Impressionist style, using high-keyed color and short brushstrokes to capture fleeting qualities of light and atmosphere. In the late 1870s, his painting became more visually complex with darkened colors. In his **WOODED LANDSCAPE AT L'HERMITAGE, PONTOISE** (FIG. 31-30), for instance, a foreground composition of trees screens the view of a rural path and village behind, flattening space and partly masking the figure at the lower right. Pissarro applies his paint thickly here, with a multitude of short, multi-directional brushstrokes.

In contrast, Impressionist painter Pierre-Auguste Renoir (1841–1919) focused most of his attention not on landscapes but on figures, producing mostly images of the middle class at leisure. When he met Monet at the École des Beaux-Arts in 1862, he was already working as a figure painter. Monet encouraged him

to lighten his palette and to paint outdoors, and by the mid 1870s Renoir was combining a spontaneous handling of natural light with animated figural compositions. In MOULIN DE LA GALETTE (FIG. 31-31), for example, Renoir depicts a convivial crowd relaxing on a Sunday afternoon at an old-fashioned dance hall—the Moulin de la Galette (the "Pancake Mill"), in the Montmartre section of Paris, which opened its outdoor courtyard during good weather. Renoir glamorizes the working-class clientele by placing his attractive bourgeois artist friends and their models among them, striking poses of relaxed congeniality, smiling, dancing, and chatting. He underscores the innocence of their flirtations by including children in the painting in the lower left, while emphasizing the ease of social relations through the relaxed informality of the scene. The overall mood is knit together by the dappled sunlight falling through the trees and Renoir's soft brushwork weaving blues and purples through the crowd and around the canvas. This naïve image of a carefree life of innocent leisure—a kind of bourgeois paradise removed from the real world—encapsulates Renoir's idea of the essence of art: "For me a picture should be

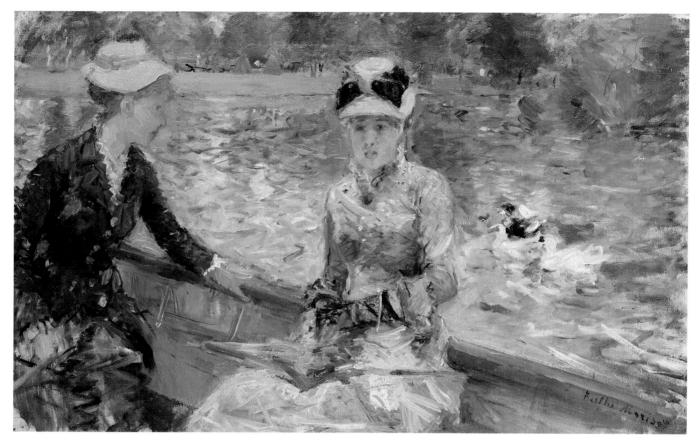

31–32 • Berthe Morisot **SUMMER'S DAY** 1879. Oil on canvas, $17^{13}/_6$ " \times $29^5/_6$ " (45.7 \times 75.2 cm). National Gallery, London. Lane Bequest, 1917

a pleasant thing, joyful and pretty—yes pretty! There are quite enough unpleasant things in life without the need for us to manufacture more."

Impressionist artist Berthe Morisot (1841–1895) defied societal conventions to become a professional painter. Morisot and her sister, Edma, copied paintings in the Louvre and studied with several teachers, including Corot, in the late 1850s and early 1860s. The sisters exhibited their art in the five Salons between 1864 and 1868, the year they met Manet. In 1869, Edma married and gave up painting to devote herself to domestic duties, but Berthe continued painting, even after her 1874 marriage to Manet's brother, Eugène, and the birth of their daughter in 1879. Morisot sent nine paintings to the first exhibition of the Impressionists in 1874 and showed her work in all but one of their subsequent shows.

As a respectable bourgeois lady, Berthe Morisot was not free to prowl the city looking for modern subjects, so she concentrated on depictions of women's lives, a subject she knew well. In the 1870s, she painted in an increasingly fluid and painterly style, flattening her picture plane and making her brushwork more prominent. In **SUMMER'S DAY** (FIG. 31-32), Morisot shows two elegant young ladies enjoying an outing on the lake of the fashionable Bois du Boulogne. First shown in the fifth Impressionist exhibition in 1880, the painting exemplifies the emphasis on formal features in Impressionist painting—the brushstrokes and the colors are as much its subject as the figures themselves.

MODERN LIFE

Subjects from urban life also attracted Edgar Degas (1834–1917), although his paintings are closer to Realism in their intensely frank portrayals that often suggest social commentary. Instead of painting outdoors, Degas composed his pictures in the studio from working drawings and photographs. His rigorous academic training at the École des Beaux-Arts in the mid 1850s and his three years in Italy studying the Old Masters blossomed in paintings characterized by complex compositional structure and striking representational clarity. In many respects his themes and style were closer to Manet's than to the Impressionists.

After a period of painting psychologically probing portraits of friends and relatives, during the 1870s, Degas began painting the modern life of Paris, especially its venues of entertainment and spectacle—the racetrack, the music hall, and the opera, usually focusing on the entertainers rather than on the bourgeois audience. He was especially drawn to the ballet in the 1870s and 1880s, at a time when it was in decline. Degas did not draw or paint actual dancers in rehearsal; rather, he hired dancers, often very young "ballet rats" (as he called them), to come to his studio to pose for him. **THE REHEARSAL ON STAGE (FIG. 31–33)**, for example, is a contrived scene, calculated to delight the eye but also to refocus the mind on the stern realities of modern life. Several of the dancers look bored or exhausted; others stretch, perhaps to mitigate the toll this physical work took on their bodies. In the right

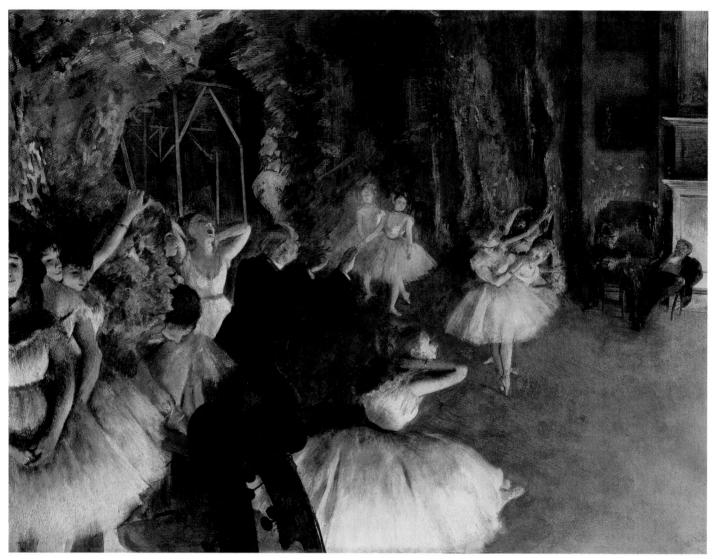

31-33 • Edgar Degas THE REHEARSAL ON STAGE

c. 1874. Pastel over brush-and-ink drawing on thin, cream-colored wove paper, laid on bristol board, mounted on canvas, 21% × 28% (54.3 × 73 cm). Metropolitan Museum of Art, New York. Bequest of Mrs. H. O. Havemeyer Collection, Gift of Horace Havemeyer, 1929 (29.160.26)

31-34 • Edgar Degas **THE TUB** 1886. Pastel on cardboard, 235%" \times 325%" $(60 \times 83$ cm). Musée d'Orsay, Paris.

31–35 • Mary Cassatt **MOTHER AND CHILD** c. 1890. Oil on canvas, $35\frac{1}{2}$ " \times 25%" (90.2 \times 64.5 cm). Wichita Art Museum, Kansas.

background slouch two well-dressed, middle-aged men, each probably a "protector" of one of the dancers. Because ballerinas generally came from lower-class families and exhibited their scantily clad bodies in public—something that "respectable" bourgeois women did not do—they were widely assumed to be sexually available, and they often attracted the attentions of wealthy men willing to support them in exchange for sexual favors.

The composition is set in a raked space, as if viewed from a box close to the stage. The abrupt foreshortening is emphasized by the dark scrolls of the double basses that jut up from the lower left. The angular viewpoint from above may derive from Japanese prints, which Degas collected, while the seemingly arbitrary cropping of figures on the left suggests photography, which he also practiced.

Whereas Degas's ballet paintings highlight informal moments associated with public performance, his later images of bathing women are furtive glimpses of intimate moments drawn from private life, usually rendered in the medium of pastel, which only heightens their sense of immediacy. **THE TUB** of 1886 (**FIG. 31-34**) represents a crouching woman, perched within a small tub, washing her neck with a sponge. Initially, this may seem to be two

separate pictures: at the left the compactly posed woman, balanced precariously on the steep floor of a receding interior space, and juxtaposed next to it on the right, a tipped-up table with a still life of objects associated with bathing. But when coordinated, they establish the viewer's elevated, domineering vantage point. The dramatic, flattened juxtaposition, as well as the compression and cropping of the close frame, are further examples of the impact of Japanese prints and photography on Degas's art.

Another artist who exhibited with the Impressionists but whose art soon diverged from them in both style and technique—conditioned in part by her contact with Degas—was American expatriate Mary Cassatt (1844–1926). Born near Pittsburgh to a well-to-do family and raised in the cosmopolitan world of Philadelphia, she studied at the Pennsylvania Academy of the Fine Arts between 1861 and 1865, then moved to Paris for further academic training and lived there for most of the rest of her life. The realism of the figure paintings she exhibited at the Salons of the early and mid 1870s attracted the attention of Degas, who invited her to participate in the fourth Impressionist exhibition in 1879. Although she, like Degas, remained a studio painter and printmaker, her distaste for what she called the "tyranny" of the Salon jury system made her one of the group's staunchest supporters.

Cassatt focused her paintings on the world she knew best: the domestic and social life of bourgeois women. She is known for extraordinarily sensitive representations of women with children, which, like the genre paintings of fellow expatriate Henry Ossawa Tanner (see Fig. 31-24), sought to counteract the clichéd stereotypes of her age. In MOTHER AND CHILD from about 1890 (FIG. 31-35), she uses a contrast between the loosely painted, Impressionist treatment of clothing and setting and the solidly modeled forms of faces and hands to rivet our attention on the tender connection between mother and child at bedtime, right after a bath. The drowsy face and flushed cheeks of the child and the weighty limbs have a natural quality, even though the space occupied by the figures seems flattened. Because the structured composition and familiar subject recall much earlier portrayals of the Virgin and Child, Cassatt elevates this small vignette of modern private life into a homage to motherhood and a dialogue with the history of art.

Gustave Caillebotte (1848–1894), another friend of Degas, was instrumental in organizing several Impressionist exhibitions and used his wealth to purchase the work of his friends, amassing a large collection of paintings. He studied with an academic teacher privately and qualified for the École des Beaux-Arts, but never attended. Caillebotte was fascinated by the regularized, radiating streets of Haussmann's Paris (see Fig. 31–2), and his subjects and compositions often represent life along the boulevards. **PARIS STREET, RAINY DAY** (Fig. 31–36) has an unconventional, almost telescopic, asymmetrical composition with a tipped perspective. The broad, wet streets create the subject of this painting, with anonymous, huddled Parisians mostly pushed to the periphery, their shiny umbrellas as prominent as their silhouetted bodies.

31-36 • Gustave Caillebotte PARIS STREET, RAINY DAY
1877. Oil on canvas, 83½" × 108¾" (212.2 × 276.2 cm). The Art Institute of Chicago. Charles H. and Mary F.S. Worcester Collection (1964.336)

Only the connected couple strolling toward us is fully realized and personalized. Squeezed between the lamppost and the saturated red and green of a shopfront, they stand within an internally framed rectangular composition, capped by the strong horizontal of the two juxtaposed umbrellas.

THE LATE NINETEENTH CENTURY

The Realists and Impressionists continued to create art until the end of the century, but by the mid 1880s they had relinquished their dominance to a younger generation of innovative artists. This period seems less unified, less directed, and less restricted geographically. Artists increasingly defined the avant-garde in terms of visual experimentation, developing new visual languages more appropriate to newly formulated messages.

These artists included French Post-Impressionists, who reinterpreted art as an expression of an interior world of the imagination or imposed a new scientific rigor on representations of the world around them; late nineteenth-century French sculptors, who studied the passionate physicality of the human form; Symbolist artists, who retreated into fantastical and sometimes horrifying worlds of the imagination; Art Nouveau artists, who rejected the rational order of the industrial world to create images and designs ruled by the writhing, moving asymmetrical shapes of growing plants; and even landscape architects, who recast the urban city-scape into a rambling natural landscape.

POST-IMPRESSIONISM

The English critic Roger Fry coined the term "Post-Impressionism" in 1910 to describe a diverse group of painters whose work he had collected for an exhibition. He acknowledged that these artists did

not share a unified approach to art, but they all used Impressionism as a springboard for developing their individual styles.

SEURAT Georges Seurat (1859–1891), who was born in Paris and trained at the École des Beaux-Arts, sought to "correct" Impressionism, which he found too intellectually shallow and too improvisational. He preferred the clarity of structure he saw in Classical relief sculpture, and the seemingly systematic but actually quite emotive use of color suggested by optics and color theory. He was particularly interested in the "law of the simultaneous contrast of colors" formulated by Michel-Eugène Chevreul in the 1820s. Chevreul observed that adjacent objects not only cast reflections of their own color onto their neighbors, but also create the effect of their **complementary color**. Thus, when a blue object is set next to a yellow one, the eye will detect in the blue object a trace

of purple, the complement of yellow, and in the yellow object a trace of orange, the complement of blue.

Seurat's goal was to find ways to create such retinal vibrations that enlivened the painted surface, using distinctive short, multi-directional strokes of almost pure color, in what came to be known as "Divisionism" or "Pointillism." In theory, these juxtaposed small strokes of color would merge in the viewer's eye to produce the impression of other colors. When perceived from a certain distance they would appear more luminous and intense than the same colors seen separately, while on close inspection Seurat's strokes and colors would remain distinct and separate.

Seurat's monumental painting **A SUNDAY AFTERNOON ON THE ISLAND OF LA GRANDE JATTE** (**FIG. 31–37**) was first exhibited at the eighth and final Impressionist exhibition in 1886. The theme of weekend leisure is typically Impressionist, but the

31–37 • Georges Seurat A SUNDAY AFTERNOON ON THE ISLAND OF LA GRANDE JATTE 1884–1886. Oil on canvas, 6'9½" × 10'1¼" (207 × 308 cm). The Art Institute of Chicago. Helen Birch Bartlett Memorial Collection (1926.22)

There was a social hierarchy in Parisian parks in the late nineteenth century; the Bois du Boulogne (see Fig. 31–32) was an upper-middle-class park in an area of grand avenues, whereas the Grande Jatte faced a lower-class industrial area across the river, and was easily accessible by train. The figures represent a range of "types" that would have been easily recognizable to the nineteenth-century viewer, such as the middle-class strolling man and his companion to the right, usually identified as a *boulevardier* (or citified dandy) and a *cocotte* (a single woman of the demi-monde), or the working-class *canotier* (oarsman) to the left.

-View the Closer Look for A Sunday Afternoon on the Island of La Grande Jatte on myartslab.com

A BROADER LOOK | Modern Artists and World Cultures: Japonisme

Deeply affected by recently imported examples of Japanese art and prints, which he appreciated for their "exotic" visual effects, Vincent van Gogh painted JAPONAISERIE: FLOWERING PLUM TREE (FIG. 31-39) in 1887. After a lengthy isolation, Japan was opened to Western trade and diplomacy in 1853, and in 1855 trade agreements permitted the regular exchange of goods. Among the first Japanese art objects to come to Paris was a sketchbook entitled Manga by Hokusai (1760-1849), which was eagerly passed around by Parisian artists. Several of them began to collect Japanese objects; the 1867 Paris International Exposition mounted the first show of Japanese prints in Europe; and immediately thereafter, Japanese lacquers, fans, bronzes, hanging scrolls, kimonos, ceramics, illustrated books, and ukiyo-e (prints of the "floating world," the realm of geishas and popular entertainment) began to appear for sale in specialty shops, art galleries, and even some department stores in Paris. The French obsession with Japan reached such a level by 1872 that the art critic Philippe Burty named the phenomenon Japonisme.

Vincent van Gogh admired the design and handcrafted quality of Japanese prints, which he both owned and copied. His Japonaiserie: Flowering Plum Tree is largely copied from Hiroshige's woodblock print Plum Orchard, Kameido (FIG. 31-38). Van Gogh places the same flattened tree with its asymmetrical branches, thin, shooting twigs, and tiny blossoms in his foreground; the same smaller trees in the middle ground; and the same railing in the background, behind which can be seen several figures and a small hut. Van Gogh has also appropriated Hiroshige's color scheme and flattened picture plane, as well as his banners of text. But he also made significant changes in his adaptation. He flattened the scene more extremely than Hiroshige. His grass is a uniform blanket of green, the gray trees with hard black outlines are flat and undifferentiated, and it is not clear whether

31-38 • Hiroshige PLUM ORCHARD,

No. 30 from One Hundred Famous Views of Edo. 1857. Woodblock print, $13^{1}\!/_{4}'' \times 8^{5}\!/_{8}''$ (33.6 \times 22.6 cm). Brooklyn Museum, New York. Gift of Anna Ferris (30.1478.30)

the yellow blossoms are in front of or behind the thickly painted red sky. Van Gogh also frames his painting with bold, orange borders containing pseudo-Japanese characters, executed crudely as if to accentuate the "primitiveness" of the image and its source. Van Gogh knew little about Japanese culture and less about the Japanese painting or printmaking tradition. He used the Hiroshige print as a prompt in order to conjure up what he saw as a simpler, more "primitive" culture than his own, at a time when other artists, like Paul Gauguin, traveled the world in search of "primitive" cultures to inspire their art.

31–39 • Vincent van Gogh JAPONAISERIE: FLOWERING PLUM TREE 1887. Oil on canvas, $21\frac{1}{2}$ " \times 18" (54.6 \times 45.7 cm). Vincent van Gogh Museum, Amsterdam.

rigorous technique, the stiff formality of the figures, and the highly calculated geometry of the composition produce a solemn effect quite at odds with the casual naturalism of Impressionism. Seurat painted the entire canvas using only 11 colors in three values. When viewed from a distance of about 9 feet, the painting reads as figures in a park rendered in many colors and tones; but when viewed from a distance of 3 feet, the individual marks of color become more salient, while the forms dissolve into abstraction.

From its first appearance, the painting has been the subject of a number of conflicting interpretations. Contemporary accounts of the island indicate that on Sundays—the newly designated official day off for French working families to spend time together—it was noisy, littered, and chaotic. By painting the island the way he did,

Seurat may have intended to represent an ideal image of working-class and middle-class life and leisure—a model of how tranquil the island, and perhaps life, *should* be in this fantasy of a harmonious blending of the classes. But some art historians see Seurat satirizing here the sterile habits and rigid attitudes of the growing Parisian middle class, not to mention their domineering presence within this working-class preserve. Or is he simply engaged in an intellectual exercise on the nature of form and color in works of art?

VAN GOGH Among the most famous Post-Impressionist artists is the Dutch painter Vincent van Gogh (1853–1890), who transformed his artistic sources into a highly expressive personal style. The oldest son of a Protestant minister, Van Gogh worked

31-40 • Vincent van Gogh THE STARRY NIGHT

1889. Oil on canvas, $28^3\!4'' \times 36^1\!4''$ (73 \times 93 cm). Museum of Modern Art, New York. Acquired through the Lillie P. Bliss Bequest (472.1941)

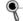

View the Closer Look for *The Starry Night* on myartslab.com

as an art dealer, a teacher, and an evangelist before deciding in 1880 to become an artist. After brief periods of study in Brussels, The Hague, and Antwerp, in 1886 he moved to Paris, where he encountered the Parisian avant-garde. Van Gogh adapted Seurat's Pointillism by applying brilliantly colored paint in multi-directional strokes of impasto (thick applications of paint) to give his pictures a turbulent emotional energy and a palpable surface texture.

Van Gogh was a socialist who believed that modern life, with its constant social change and focus on progress and success, alienated people from one other and from themselves (see "Modern Artists and World Cultures: Japonisme," page 996). His own paintings are efforts to communicate his emotional state by establishing a direct connection between artist and viewer, thereby overcoming the emotional barrenness of modern society. In a prolific output over only ten years, he produced paintings that contributed significantly to the later emergence of Expressionism, in which the intensity of an artist's emotional state will override any desire for fidelity to the actual appearance of things. Van Gogh described his working method in a letter to his brother:

I should like to paint the portrait of an artist friend who dreams great dreams, who works as the nightingale sings, because it is his nature. This man will be fair-haired. I should like to put my appreciation, the love I have for him, into the picture. So I will paint him as he is, as faithfully as I can—to begin with. But that is not the end of the picture. To finish it, I shall be an obstinate colorist. I shall exaggerate the fairness of the hair, arrive at tones of orange, chrome, pale yellow. Behind the head—instead of painting the ordinary wall of the shabby apartment, I shall paint infinity, I shall do a simple background of the richest, most intense blue that I can contrive, and by this simple combination, the shining fair head against this rich blue background, I shall obtain a mysterious effect, like a star in the deep blue sky.

One of the most famous examples of Van Gogh's approach is THE STARRY NIGHT (FIG. 31-40), painted near the asylum of Saint-Rémy, from careful observation and the artist's imagination. Above the quiet town, the sky pulsates with celestial rhythms and blazes with exploding stars. Contemplating life and death in a letter, Van Gogh wrote: "Just as we take the train to get to Tarascon or Rouen, we take death to reach a star." This idea is rendered visible here by the cypress tree, a traditional symbol of both death and eternal life, which rises dramatically to link the terrestrial and celestial realms. The brightest star in the sky is actually a planet, Venus, which is associated with love. It is possible that the picture's extraordinary energy also expresses Van Gogh's euphoric hope of gaining in death the love that had eluded him in life. The painting is a riot of brushwork, as rail-like strokes of intense color writhe across its surface. Van Gogh's brushwork is immediate, expressive, and intense, clearly more a record of what he felt than what he saw. During the last year and a half of his life, he

experienced repeated psychological crises that lasted for days or weeks. While they were raging, he wanted to hurt himself, heard loud noises in his head, and could not paint. The stress and burden of these attacks led him to the asylum where he painted *The Starry Night*, and eventually to suicide in July 1890.

GAUGUIN In painting from imagination more than from nature in The Starry Night, Van Gogh may have been following the advice of his close friend Paul Gauguin (1848-1903), who once counseled another artist: "Don't paint from nature too much. Art is an abstraction. Derive this abstraction from nature while dreaming before it, and think more of the creation that will result." Born in Paris to a Peruvian mother and a radical French journalist father, Gauguin lived in Peru until age 7. During the 1870s and early 1880s, he enjoyed a comfortable bourgeois life as a stockbroker, painting in his spare time under the tutelage of Pissarro. Between 1880 and 1886, he exhibited in the final four Impressionist exhibitions. In 1883, he lost his job during a stock market crash, and three years later he abandoned his wife and five children to pursue a full-time painting career. Gauguin knew firsthand the business culture of his time and came to despise it. Believing that escape to a more "primitive" place would bring with it the simpler pleasures of preindustrial life, Gauguin lived for extended periods in the French province of Brittany between 1886 and 1891, traveled to Panama and Martinique in 1887, spent two months in Arles with Van Gogh in 1888, and then in 1891 sailed for Tahiti, a French colony in the South Pacific. After a final sojourn in France in 1893–1895, Gauguin returned to French Polynesia, where he died in 1903.

Gauguin's art was inspired by sources as varied as medieval stained glass, folk art, and Japanese prints; he sought to paint in a "primitive" way, employing the so-called "decorative" qualities of folk art, such as brilliantly colored flat shapes, anti-naturalist color, and bold, black outlines. Gauguin called his style "synthetism," because he believed it synthesized observation and the artist's feelings in an abstracted application of line, shape, space, and color.

MAHANA NO ATUA (Day of the God) (see "A Closer Look," page 1000) is very much a product of such synthesis. Desapite its Tahitian subject, it was painted in France during Gauguin's brief return visit after two years in the South Pacific. He had gone to Tahiti hoping to find an unspoiled, preindustrial paradise, imagining the Tahitians to be childlike and close to nature. What he discovered was a thoroughly colonized country whose native culture was rapidly disappearing under the pressures of Westernization. In paintings such as this, however, Gauguin chose to ignore this reality and depict instead the Edenic ideal of his own imagination.

SYMBOLISM

Symbolism was an international movement in art and literature championed by a loose affiliation of artists who addressed the irrational fears, desires, and impulses of the human mind in their work. A fascination with the dark recesses of the psyche emerged over the last decades of the nineteenth century, encompassing

A CLOSER LOOK | Mahana no atua (Day of the God)

by Paul Gauguin, 1894. Oil on canvas, $27\%'' \times 35\%''$ (69.5 \times 90.5 cm), The Art Institute of Chicago. Helen Birch Bartlett Memorial Collection (1926.198)

Gauguin divided the painting into three horizontal zones. increasingly abstract from top to bottom. The upper zone, painted in the most lifelike manner, centers on the statue of a god set in a beach landscape populated by Tahitians.

As was his practice in many of his Tahitian paintings. Gauguin did not base this sculpted idol on a statue he saw in Tahiti, but rather on pictures he owned of the Buddhist temple complex at Borobudur (see Fig. 10-34).

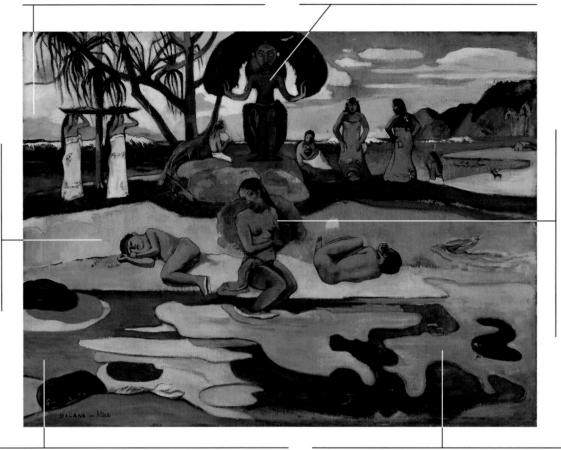

The central female bather dips her feet in the water and looks covly out at viewers, while, on either side of her, two androgynous figures recline in fetuslike postures. Their poses perhaps symbolize—left to right—birth, life, and death.

Filling the bottom third of the painting is a striking pool of water, abstracted into a dazzling array of bright colors and arranged in a puzzlelike pattern of flat, curvilinear shapes. The left half of this pool seems rooted in natural description, evoking spatial recession. But on the right it becomes flatter and more stylized.

By reflecting a strange and unexpected reality exactly where we expect to see a mirror image of the familiar world, this magic pool seems the perfect symbol of Gauguin's desire to evoke "the mysterious centers of thought." His aim was symbolic rather than descriptive works of art.

View the Closer Look for *Mahana no atua (Day of the God)* on myartslab.com

photographic and scientific examinations of the nature of insanity, as well as a popular interest in the spirit world of mediums. Some Symbolist artists sought escape from modern life in irrational worlds of unrestrained emotion as described by authors such as Edgar Allan Poe (1809-1849), whose terrifying stories of the supernatural were popular across Europe. It is hardly coincidental that Sigmund Freud (1856-1939), who compared artistic creation to the process of dreaming, wrote his pioneering The Interpretation of Dreams (1900) during this period.

The Symbolists rejected the value placed on rationalism and material progress in modern Western culture, choosing instead to explore the irrational realms of emotion, imagination, and

spirituality. They sought a deeper and more mysterious reality beyond everyday life, which they conveyed through strange and ambiguous subject matter and stylized forms that suggest hidden and elusive meanings. They often compared their works to dreams.

Symbolism in painting closely paralleled a similar movement among poets and writers. For example, Joris-Karl Huysmans's novel À Rebours (Against the Grain), published in 1884, has a single character, an aristocrat named Des Esseintes, who locked himself away from the world because "Imagination could easily be substituted for the vulgar realities of things." Claiming that nature was irrelevant, Des Esseintes mused: "Nature has had her day" and "wearied aesthetes" should take refuge in artworks "steeped in

ancient dreams or antique corruptions, far removed from the manner of our present day."

MOREAU A visionlike atmosphere pervades the later work of Gustave Moreau (1826–1898), an academic artist whom the Symbolists regarded as a precursor. They particularly admired Moreau's renditions of the biblical Salomé, the young Judaean princess who, at the instigation of her mother, Herodias, performed an erotic dance before her stepfather, Herod, and demanded as reward the head of John the Baptist (Mark 6:21–28). In **THE APPARITION** (FIG. 31-41), exhibited at the Salon of 1876, the seductive Salomé confronts a vision of the saint's severed head, which hovers open-eyed in midair, dripping blood and radiating holy light. Moreau depicted this sensual and macabre scene and its exotic setting in meticulous detail, with touches of jewel-like color to create an atmosphere of voluptuous decadence that amplifies Salomé's role as femme fatale who uses her sensuality to destroy her male victim.

The Symbolists, like many smaller groups of artists in the late nineteenth century, staged independent art exhibitions, but unlike the Impressionists,

31–41 • Gustave Moreau THE APPARITION 1874–1876. Watercolor on paper, $41\%6'' \times 28\%6''$ (106 \times 72.2 cm). Musée du Louvre, Paris.

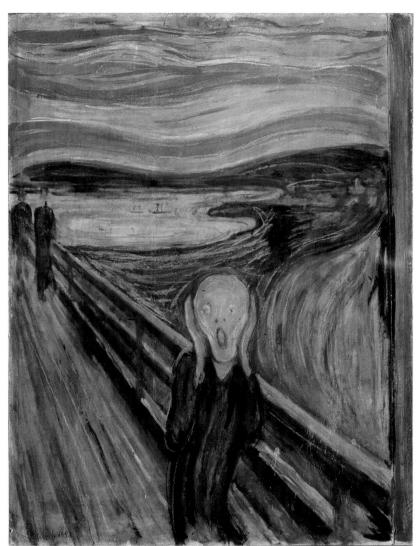

31–42 • Edvard Munch THE SCREAM ?1910. Tempera and oil on unprimed canvas, $33'' \times 26''$ (83.5 \times 66 cm). Munch Museum, Oslo.

who hired halls, printed programs, and charged a small admission fee for their exhibitions, the Symbolists mounted modest shows with little expectation of public interest. During the 1889 Universal Exposition, for example, they hung a few works in a café close to the fairgrounds, with the result that the exhibition went almost unnoticed by the press.

MUNCH Symbolism originated in France but had a profound impact on the avant-garde in other countries, where it frequently took on Expressionist tendencies. In Norway, Edvard Munch (1863–1944) produced a body of work that shows the terrifying workings of an anguished mind. **THE SCREAM** (**FIG. 31-42**) is the stuff of nightmares and horror movies; its harsh swirling colors and lines direct us wildly around the painting, but bring us right back to the haunting human head at the center and the echoes of its haunting scream, sensed visually. Munch described how the painting began: "One evening I was walking along a path; the city was on one side, and the fjord below. I was tired and ill I sensed a shriek passing through nature I painted this picture, painted the clouds as actual blood."

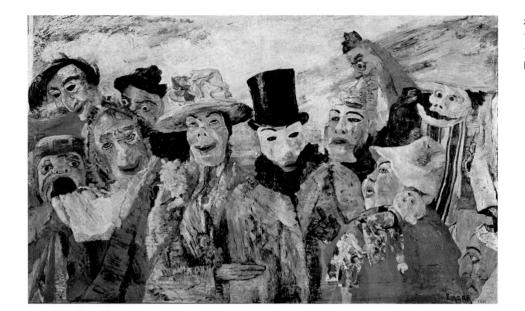

31–43 • James Ensor **THE INTRIGUE** 1890. Oil on canvas, $35\frac{1}{2}$ " \times 59" (90.3 \times 150 cm). Koninklijk Museum voor Schone Kunsten, Antwerp.

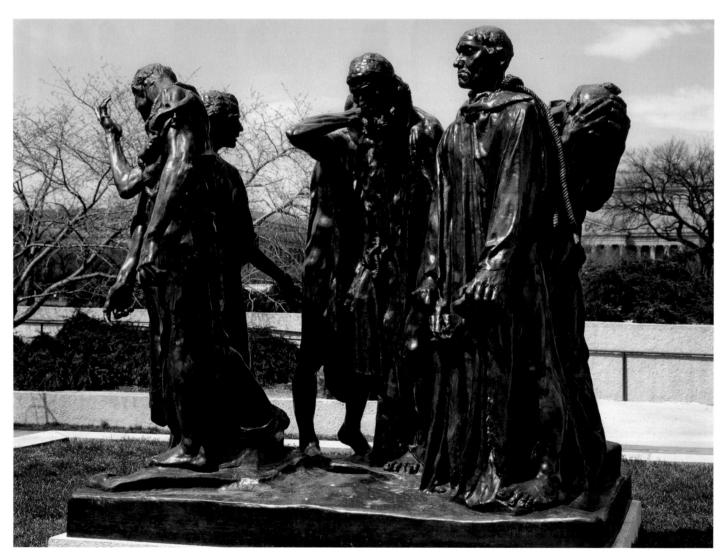

31-44 • Auguste Rodin THE BURGHERS OF CALAIS

1884–1889. Bronze, $6'10'1/2'' \times 7'11'' \times 6'6''$ (2.1 \times 2.4 \times 2 m). Hirshhorn Museum and Sculpture Garden, Smithsonian Institution, Washington, DC. Gift of Joseph H. Hirshhorn, 1966

Rodin's relocation of public sculpture from a high pedestal to a low base will lead, in the twentieth century, to the elimination of the pedestal itself and to the presentation of sculpture in the "real" space of the viewer.

ENSOR The Belgian painter and printmaker James Ensor (1860–1949) studied for four years at the Brussels Academy, but spent the rest of his life in the nearby coastal resort town of Ostend, where he produced equally terrifying paintings, also combining Symbolist and Expressionist tendencies. THE INTRIGUE (FIG. 31-43) shows a tightly packed group of agitated people, pushed toward the viewer into the foreground. Masks—modeled on the grotesque papier-mâché masks Ensor's family sold for the pre-Lenten carnival—conceal their faces, giving them a disturbing, mindless, menacing quality. Ensor's acidic colors and ener-getic handling of the painted surface only increase the viewers' anxiety.

FRENCH SCULPTURE

A defiance of conventional expectations and an interest in emotional expressiveness also characterize the work of late nineteenth-century Europe's most successful and influential sculptor, Auguste Rodin (1840–1917). Born in Paris, Rodin failed on three occasions to gain entrance to the École des Beaux-Arts and consequently spent the first 20 years of his career as an assistant to other sculptors and decorators. After a trip to Italy in 1875, where he saw the sculpture of Donatello and Michelangelo, Rodin developed a style of vigorously modeled figures in unconventional, even awkward poses, which was simultaneously scorned by academic critics and admired by the general public.

Rodin's status as a major sculptor was confirmed in 1884, when he won a competition to create **THE BURGHERS OF CAL-AIS** (FIG. 31-44), for the city of Calais, commemorating a local event from the Hundred Years' War. In 1347, Edward III of England offered to spare the besieged city if six leading citizens (burghers)—dressed only in sackcloth with rope halters and carrying the keys to the city—surrendered themselves to him for execution. Though it is unknown to them at this point, the king would be so impressed by their courage, that he would spare them.

The Calais commissioners were pleased neither with Rodin's conception of the event nor with his plan to display the figures on a low base, almost at street level, to suggest to viewers that ordinary people like themselves were capable of noble acts. Instead of calm, idealized heroes, Rodin presented ordinary-looking men in various attitudes of resignation and despair. He exaggerated their facial expressions, lengthened their arms, greatly enlarged their hands and feet, and swathed them in heavy fabric, showing not only how they may have looked but also how they must have felt as they forced themselves to take one difficult step after another. Rodin's willingness to stylize the human body for expressive purposes opened the way for subsequent sculptural abstractions.

Camille Claudel (1864–1943), who was Rodin's assistant while he worked on *The Burghers of Calais*, had already studied sculpture formally before joining Rodin's studio. She soon became his mistress, and their often-stormy relationship lasted 15 years. Most often remembered for her dramatic life story,

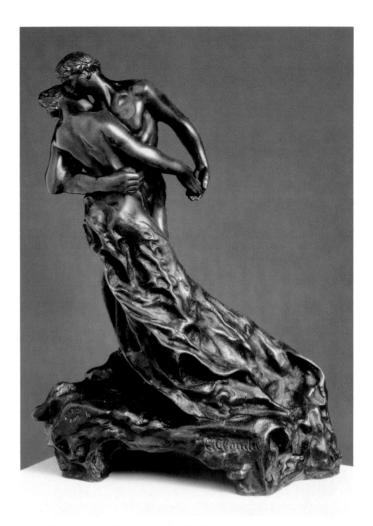

31-45 • Camille Claudel THE WALTZ 1892-1905. Bronze, height 9% (25 cm). Neue Pinakothek, Munich.

French composer Claude Debussy, a close friend of Claudel, displayed a cast of this sculpture on his piano. Debussy acknowledged the influence of art and literature on his musical innovations.

Claudel enjoyed independent professional success but suffered a breakdown that sent her to a mental hospital for the last 30 years of her life.

One of Claudel's most celebrated works is **THE WALTZ** (**FIG. 31–45**), produced in several versions and sizes between 1892 and 1905. The sculpture depicts a dancing couple, both nude, although the woman's lower body is covered with long, flowing drapery, a concession she made after an inspector from the Ministry of Fine Arts declared their sensuality unacceptable, recommending that her state commission for a marble version of the work be revoked. The subject of the waltz alone was controversial at this time because of the close contact demanded of dancers. Claudel added enough drapery to regain the commission, but she never finished it. She did, however, cast the modified *version* in bronze as a tabletop sculpture, in which the spiral flow of the cloth creates the illusion of rapturous movement as the embracing dancers twirl through space.

31-46 • Victor Horta STAIRWAY, TASSEL HOUSE, BRUSSELS 1892-1893.

ART NOUVEAU

The swirling mass of drapery in Claudel's *The Waltz* has a stylistic affinity with Art Nouveau (French for "new art"), a movement launched in the early 1890s that permeated all aspects of European design for more than a decade. Art Nouveau embraced the use of modern industrial materials but rejected the functional aesthetic of works such as the Eiffel Tower (see FIG. 31–1) that showcased exposed structure as architectural design. Art Nouveau artists and

architects drew particular inspiration from nature, especially from vines, snakes, flowers, and winged insects, whose delicate and sinuous forms were consistent with the graceful and attenuated aesthetic principles of the movement. The goal was to harmonize all aspects of design into an integrated whole, as found in nature itself.

HORTA The artist most responsible for developing the Art Nouveau style in architecture was the Belgian Victor Horta (1861–

1947). After academic training in Ghent and Brussels, Horta worked in the office of a Neoclassical architect in Brussels for six years before opening his own practice in 1890. In 1892, he received his first important commission, a private residence in Brussels for a Professor Tassel. The result, especially the house's entry hall and staircase (FIG. 31-46), was strikingly original. The ironwork, wall decoration, and floor tiles were all designed in an intricate series of long, graceful curves. Although Horta's sources are still debated, he was apparently impressed by the stylized linear designs of the English Arts and Crafts Movement of the 1880s. His concern for integrating the various arts into a more unified whole, like his reliance on sinuous decorative line, derived in part from English reformers such as William Morris.

GAUDÍ The application of graceful linearity to all aspects of design, evident in the entry hall of the Tassel House, began a vogue that spread across Europe. In Spain, where the style was called *Modernismo*, the major practitioner was the Catalan architect Antonio Gaudí i Cornet (1852–1926). Gaudí integrated natural forms into the design of buildings and parks that are still revolutionary in their dynamic freedom of line.

In 1904, the wealthy industrialist Josep Batllò commissioned Gaudí to design a private residence to surpass the lavish houses of other prominent families in Barcelona. Gaudí convinced his patron to retain the underlying structure of an existing building, but transform its façade and interior spaces. Gaudí's façade (FIG. 31-47) is a dreamlike fantasy of undulating sandstone sculptures and multicolored glass and tile surfaces, imaginatively mixing the Islamic, Gothic, and Baroque visual traditions of Barcelona. The gaping lower-story windows are the source of the building's nickname, the "house of yawns," while the use of what look like giant human tibias for upright supports led others to call it the "house of bones." The roof resembles a recumbent dragon with overlapping tiles as scales. A fanciful turret surfaces at its edge,

recalling the sword of St. George—patron of Catalunya—plunged into the back of his legendary foe. Gaudi's highly personal alternative to academic historicism and modern industrialization in urban

31-47 • Antonio Gaudí CASA BATLLÒ, BARCELONA 43 Passeig de Gracia. 1900–1907.

buildings such as this reflects his affinity with Iberian traditions as well as his concern to provide imaginative surroundings to enrich the lives of city dwellers.

31–48 • Hector Guimard **DESK** c. 1899 (remodeled after 1909). Olive wood with ash panels, $28^34'' \times 47^34''$ (73 × 121 cm). Museum of Modern Art, New York. Gift of Madame Hector Guimard

GUIMARD The leading French practitioner of Art Nouveau was Hector Guimard (1867–1942), who embraced the movement after meeting Horta in 1895. Guimard is most famous for his designs of entrances to the Paris Métro (subway) at the turn of the century, but he devoted much of his career to interior design and furnishings, such as this **DESK** that he made for himself (**FIG. 31-48**). Instead of a static and stable object, Guimard handcrafted an asymmetrical, organic entity that seems to undulate and grow around the person who sits at its workspace.

TOULOUSE-LAUTREC Henri de Toulouse-Lautrec (1864–1901) suffered from a genetic disorder that stunted his growth and left him physically disabled. Born into an aristocratic family in southern France, he moved to Paris in 1882, where his private academic training was transformed when he discovered the work of Degas. He also discovered Montmartre, the entertainment district of Paris that housed the most bohemian of the avant-garde artists. From the late 1880s, Toulouse-Lautrec dedicated himself to depicting the nightlife of Montmartre—the cafés, theaters, dance halls, and brothels that he himself frequented.

Between 1891 and 1901, Toulouse-Lautrec designed roughly 30 lithographic posters for Montmartre's more famous nightspots, advertising their most popular entertainers. One features the notoriously limber dancer JANE AVRIL performing the infamous can-can (FIG. 31-49). Toulouse-Lautrec places Avril on a stage that zooms into the background. The hand and face of a double-bass player, part of his instrument, and pages of music frame the poster in the extreme foreground at lower right—a bold foreshortening that recalls the compositions of Degas (see FIG. 31-33).

31-49 • Henri de Toulouse-Lautrec JANE AVRIL 1893. Lithograph, $50\frac{1}{2}$ " \times 37" (129 \times 94 cm). San Diego Museum of Art. Gift of the Baldwin M. Baldwin Foundation (1987.32)

But Toulouse-Lautrec's image emphasizes Avril's sexuality in order to draw in the crowds, while Degas's pictures coax visual beauty from frank Realism. Toulouse-Lautrec outlines his forms, flattens his space, and suppresses modeling to accommodate the cheap colored lithographic printing technique he used, but the resulting emphasis on bold silhouettes and curving lines is distinctively Art Nouveau.

THE BEGINNINGS OF MODERNISM

The history of late nineteenth-century architecture reflects a dilemma faced by the industrial city, caught between the classicizing tradition of the Beaux-Arts academic style and the materials, construction methods, and new aesthetic of industry. The École des Beaux-Arts, although marginalized by the end of the century by new trends in painting, came into its own as the training ground for European and American architects after 1880, while industrialization in places like Chicago simultaneously demanded new ways of thinking about tall and large buildings.

At the same time, Paul Cézanne, late in his life, altered the course of avant-garde painting by returning to an intense visual study of the world around him, scrutinizing it like a specimen on a dissecting table and urging younger artists to consider new ways of creating artistic meaning. In 1906, the year Cézanne died,

a retrospective exhibition of his life's work in Paris revealed his methods to the next generation of artists, who would be the creators of Modernism.

EUROPEAN ARCHITECTURE: TECHNOLOGY AND STRUCTURE

The pace of life speeded up considerably over the course of the nineteenth century. Industrialization allowed people to manufacture more, consume more, travel more, and do more, in greater numbers than before. Industrialization caused urbanization, which in turn demanded more industrialization. A belief in the perfectibility of society spawned more than 20 international fairs celebrating innovations in industry and technology. One of the first of these took place in London in 1851. The Great Exhibition of the Industry of All Nations was mounted by the British to display their industrial might, assert their right to empire, and quell lingering public unrest after the 1848 revolutions elsewhere in Europe. The centerpiece of the Great Exhibition, the Crystal Palace, introduced new modern building techniques and aesthetics.

THE CRYSTAL PALACE The revolutionary construction of THE CRYSTAL PALACE (FIG. 31-50), created by Joseph Paxton (1803–1865), featured a structural skeleton of cast iron that held iron-framed glass panes measuring 49 by 30 inches, the largest size that could be mass-produced at the time.

31–50 • Joseph Paxton **THE CRYSTAL PALACE**London. 1850–1851. Iron, glass, and wood. (Print of the Great Exhibition of 1851; printed and published by Dickinson Brothers, London, 1854.)

Prefabricated wooden ribs and bars supported the panes. The triple-tiered edifice was the largest space ever enclosed up to that time—1,851 feet long, covering more than 18 acres, and providing almost a million square feet of exhibition space. The central vaulted transept—based on the design for new cast-iron train stations—rose 108 feet to accommodate a row of the elm trees dear to Prince Albert, the husband of Queen Victoria (r. 1837–1901). By the end of the exhibition, 6 million people had visited it, most agreeing that the Crystal Palace was a technological marvel. Even so, most architects and critics, still wedded to Neoclassicism and Romanticism, considered it a work of engineering rather than legitimate architecture because the novelty of its iron and glass frame overshadowed its Gothic Revival style.

BIBLIOTHÈQUE NATIONALE Henri Labrouste (1801–1875)—trained as an architect at the École des Beaux-Arts, where he also taught—had a radical desire to fuse the École's historicizing approach to architecture with the technical innovations of industrial engineering. Although reluctant to push his ideas at the École, he pursued them in his architecture. The READING ROOM of the Bibliothèque Nationale (FIG. 31–51) is an example of this fusion. A series of domes form the ceiling—faced with bright white ceramic tiles, crowned with glass-covered oculi that light the reading room, and supported on thin iron arches and columns that open the space visually. The mixture of historical allusions in the classical detailing, combined with the vast open space made possible by industrial materials, is thoroughly modern.

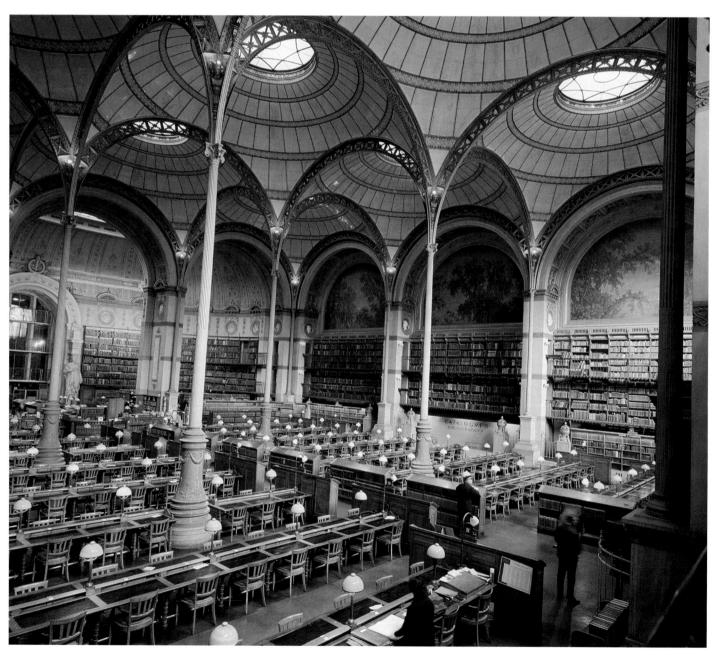

31-51 • Henri Labrouste READING ROOM, BIBLIOTHÈQUE NATIONALE, PARIS 1862-1868.

THE CHICAGO SCHOOL

In the United States, up until this time, as in Europe, major architectural projects were expected to embody Beaux-Arts historicism. But the modern city required new building types for industry, transportation, commerce, storage, and habitation—types that would accommodate more people and more activities in urban areas where land prices were skyrocketing. Chicago was a case in point. As the transportation hub for grain, livestock, and other produce headed from the rural Midwest to the cities of the east and west coasts, Chicago became a populous, wealthy city by the 1890s. As new department stores, commercial facilities, and office buildings were designed, primarily with practical needs in mind, Chicago also became the cradle for a novel way of thinking about urban design and construction, in which function gave birth to architectural form.

WORLD'S COLUMBIAN EXPOSITION Richard Morris Hunt (1827–1895) was the first American to study architecture at the École des Beaux-Arts in Paris. Extraordinarily skilled in Beaux-Arts historicism and determined to raise the standards of American architecture, he built in every accepted style, including Gothic, French Classicist, and Italian Renaissance. After the Civil War, Hunt built many lavish mansions for a growing class of wealthy eastern industrialists and financiers, emulating aristocratic European models.

Late in his career, Hunt supervised the design of the 1893 World's Columbian Exposition in Chicago, commemorating the 400th anniversary of Christopher Columbus's arrival in the Americas. Rather than focus on engineering wonders as in previous fairs

(although the exhibition included the first ferris wheel), the Chicago planning board decided to build "permanent buildings—a dream city." To create a sense of unity among these buildings (which were, in fact temporary, constructed from a mixture of plaster and fibrous materials, rather than masonry), a single style for the fair was settled upon—the Classical style, alluding to ancient Greece and republican Rome to reflect America's pride in its own democratic institutions as well as its emergence as a world power. A photograph of Hunt's **COURT OF HONOR** (FIG. 31-52) shows the Beaux-Arts style of the so-called "White City."

The World's Columbian Exposition was intended to be a model of the ideal American city—clean, spacious, carefully planned, and Classically styled—in contrast to the soot and overcrowding of most unplanned American cities. Frederick Law Olmsted, the designer of New York City's Central Park (see "The City Park," page 1010), was responsible for the exhibition's landscape design. He converted the marshy lakefront into a series of lagoons, canals, ponds, and islands, some laid out formally, as in the White City, and others informally, as in the "Midway," containing the busy conglomerate of pavilions representing "less civilized" nations. Between these two parts stood the ferris wheel, which provided a spectacular view of the fair and the city. After the fair, most of its buildings were demolished, but Olmsted's landscaping has remained.

RICHARDSON The second American architect to study at the École des Beaux-Arts was Henry Hobson Richardson (1838–1886). Born in Louisiana and educated at Harvard and Tulane, Richardson returned from Paris in 1865 to settle in New York. He designed architecture in a variety of revival styles but is most

31-52 • Richard Morris Hunt COURT OF HONOR, WORLD'S COLUMBIAN EXPOSITION, CHICAGO 1893. View from the east.

ELEMENTS OF ARCHITECTURE | The City Park

Parks originated during the second millennium BCE in China as enclosed hunting reserves for kings and the nobility. In Europe, from the Middle Ages to the eighteenth century, they remained private recreation grounds for the privileged. The first urban park intended for the public was in Munich, Germany. Laid out by Friedrich Ludwig von Sckell in 1789–1795 in the picturesque style of an English landscape garden (see FIG. 30–16), the park contained irregular lakes, gently sloping hills, broad meadows, and paths meandering through wooded areas.

The crowding and pollution of cities during the Industrial Revolution prompted the creation of large public parks whose green open spaces would help purify the air and provide city dwellers of all classes with a place for healthy recreation. Numerous municipal parks were built in Britain during the 1830s and 1840s and in Paris during the 1850s and 1860s, when Georges-Eugène Haussmann redesigned the former royal hunting forests of the Bois de Boulogne and the Bois de Vincennes in the English style favored by Emperor Napoleon III.

In American cities before 1857, the only public outdoor spaces were small squares found between certain intersections, or larger gardens, such as the Boston Public Garden, neither of which filled the growing need for varied recreational facilities in the city. For a time, landscaped suburban cemeteries in the picturesque style were popular sites for strolling, picnicking, and even horse racing—an incongruous set of uses that strikingly demonstrated the need for more urban parks.

The rapid growth of Manhattan in the nineteenth century spurred civic leaders to set aside parkland while open space still existed. The city purchased an 843-acre tract in the center of the island and in 1857 announced a competition for its design as Central Park. The competition required that designs include a parade ground, playgrounds, a site for an

exhibition or concert hall, sites for a fountain and for a viewing tower, a flower garden, a pond for ice skating, and four east—west cross-streets so that the park would not interfere with the city's vehicular traffic. The latter condition was pivotal to the winning design, drawn up by architect Calvert Vaux (1824–1895) and park superintendent Frederick Law Olmsted (1822–1903), which sank the crosstown roads in trenches hidden below the surface of the park and designed separate routes for carriages, horseback riders, and pedestrians (Fig. 31–53).

Believing that the "park of any great city [should be] an antithesis to its bustling, paved, rectangular, walled-in streets," Olmsted and Vaux designed picturesque landscaping in the English tradition, with the irregularities of topography and planting used as positive design elements. Except for a few formal elements, such as the tree-lined mall that leads to the Classically designed Bethesda Terrace and Fountain, the park is remarkably informal and naturalistic. Where the land was low, Olmstead and Vaux further depressed it, installing drainage tiles and carving out ponds and meadows. They planted clumps of trees to contrast with open spaces, and exposed natural outcroppings of schist to provide dramatic, rocky scenery. They arranged walking trails, bridle paths, and carriage drives through the park with a series of changing vistas. Intentionally appealing were the views from the apartment houses of the wealthy on the streets surrounding the park. An existing reservoir divided the park into two sections. Olmsted and Vaux developed the southern half more completely and located most of the sporting facilities and amenities there, while leaving the northern half more like a nature reserve. Largely complete by the end of the Civil War, Central Park was widely considered a triumph, launching a movement to build similar parks in cities across the United States.

31-53 • Frederick Law Olmsted and Calvert Vaux MAP OF CENTRAL PARK, NEW YORK CITY Revised and extended park layout as shown in a map of 1873.

Watch an architectural simulation about the city park on myartslab.com

famous for a robust, rusticated style known as Richardsonian Romanesque. In 1885, he designed the **MARSHALL FIELD WHOLESALE STORE** in Chicago (**FIG. 31-54**), drawing on the

design and scale of Italian Renaissance palaces such as the Palazzo Medici-Riccardi in Florence (see FIG. 20-7). Although the block-like, rough stone facing, the arched windows, and the decorated

31-54 • Henry Hobson Richardson MARSHALL FIELD WHOLESALE STORE, CHICAGO 1885–1887. Demolished c. 1935.

cornice all evoke historical architectural antecedents, Richardson's eclecticism resulted in a readily identifiable personal style.

Plain and sturdy, Richardson's building was a revelation to the young architects of Chicago, then engaged in rebuilding the city after the disastrous fire of 1871. About the same time, new technology for producing steel—a strong, cheap alloy of iron—created new structural opportunities for architects. William Le Baron Jenney (1832–1907) built the first steel-skeleton building in Chicago; his lead was quickly followed by younger architects in what was known as the Chicago School. The rapidly rising cost of urban land made tall buildings desirable; structural steel and the electric elevator (developed during the 1880s) made them possible.

SULLIVAN Equipped with new structural materials and improved passenger elevators, driven by new economic considerations, and inspired by Richardson's developments beyond Beaux-Arts historicism, the Chicago School architects produced not only a new style of architecture but a new kind of building—the skyscraper. An early example is Louis Sullivan's **WAINWRIGHT BUILDING** in St. Louis, Missouri (**FIG. 31-55**). The Boston-born Sullivan (1856–1924) studied for a year at the Massachusetts

Institute of Technology (MIT), home of the United States' first formal architecture program, and for an equally brief period at the École des Beaux-Arts in Paris, where he developed a distaste for historicism. He settled in Chicago in 1875, partly because of the building boom there that had followed the fire of 1871. In 1883 he entered into a partnership with the Danish-born engineer Dankmar Adler (1844–1900).

Sullivan's first major skyscraper, the Wainwright Building, has a U-shaped plan that provides an interior light-well for the illumination of inside offices. The ground floor, designed to house shops, has wide plate-glass windows for the display of merchandise. The second story, or mezzanine, also features large windows for the illumination of the shop offices. Above the mezzanine rise seven identical floors of offices, lit by rectangular windows. An attic story houses the building's mechanical plant and utilities. A richly decorated foliate frieze in terra-cotta relief crowns the building, punctuated by bull's-eye windows and capped by a thick cornice slab.

The Wainwright Building's outward appearance clearly articulates three different levels of function: shops at the bottom, offices in the middle, and mechanical utilities at the top. It illustrates Sullivan's stated architectural philosophy: "Form ever

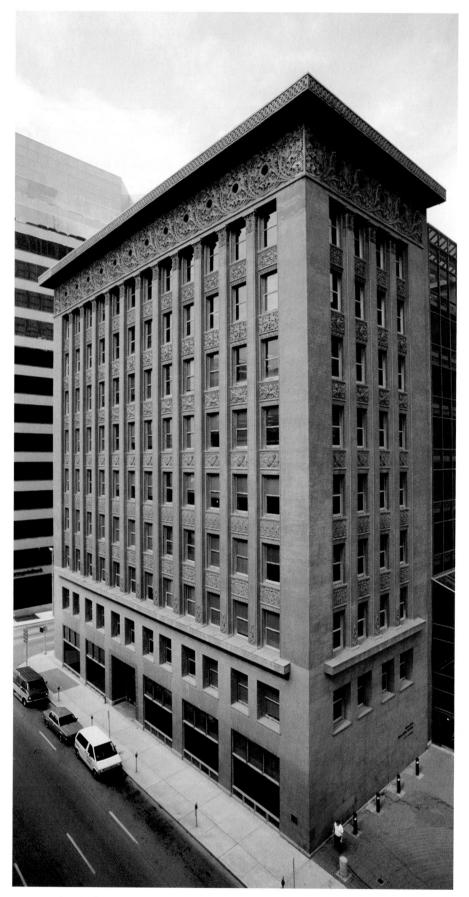

31-55 • Louis Sullivan **WAINWRIGHT BUILDING, ST. LOUIS** Missouri. 1890–1891.

Q View the Closer Look for the Wainwright Building on myartslab.com

follows function." This idea was adopted as a credo by Modernist architects, who used it to justify removal of all surface decoration from buildings. Sullivan designed the Wainwright Building for function, but he also created an expressive building. The thick corner piers, for example, are not structurally necessary—since an internal steel-frame skeleton supports the building—but they emphasize its vertical thrust. The thinner piers between the office windows, which rise uninterrupted from the third story to the attic, echo and reinforce its spring and verticality. As Sullivan put it, a tall office building "must be every inch a proud and soaring thing, rising in sheer exultation."

In the Wainwright Building that exultation culminates in the rich vegetative ornament that swirls around the crown of the building, serving a decorative function like that of the foliated capital of a Corinthian column. The tripartite structure of the building itself suggests the Classical column with its base, shaft, and capital, reflecting the lingering influence of Classical design principles. Only in the twentieth century would Modern architects reject tradition entirely to create an architectural aesthetic that was stripped of applied decoration.

CÉZANNE

No artist had a greater impact on the next generation of Modern painters than Paul Cézanne (1839–1906). The son of a prosperous banker in the southern French city of Aix-en-Provence, Cézanne studied art first in Aix and then in Paris, where he participated in the circle of Realist artists around Manet. His early pictures, somber in color and coarsely painted, often depicted Romantic themes of drama and violence, and were consistently rejected by the Salon.

In the early 1870s, under the influence of Pissarro, Cézanne changed his style. He adopted a bright palette and broken brushwork, and began painting landscapes. Like the Impressionists, with whom he exhibited in 1874 and 1877, Cézanne dedicated himself to the study of what he called the "sensations" of nature. Unlike the Impressionists, however, he did not seek to capture transitory effects of light and atmosphere; instead, he created highly structured paintings through

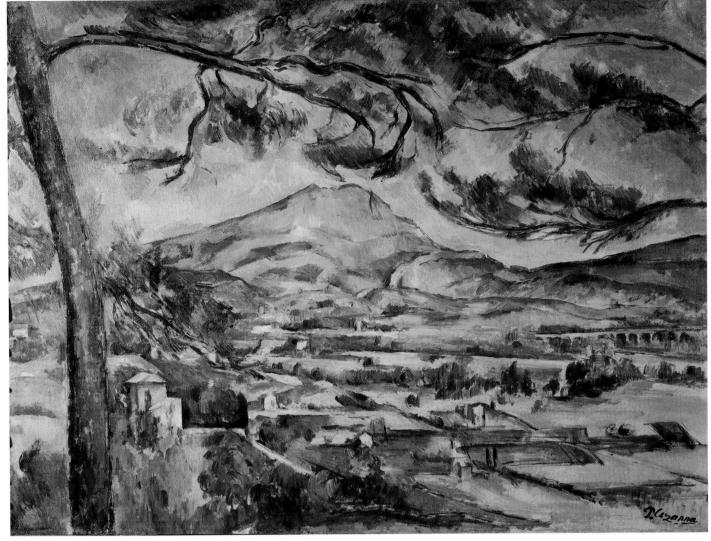

31–56 • Paul Cézanne **MONT SAINTE-VICTOIRE** c. 1885–1887. Oil on canvas, $25\frac{1}{2}$ × 32" (64.8 × 92.3 cm). Courtauld Gallery, London. © Samuel Courtauld Trust. (P.1934.SC.55)

• Watch a video about Paul Cézanne's Mont Sainte-Victoire on myartslab.com

a methodical application of color that merged drawing and modeling into a single process. His professed aim was to "make of Impressionism something solid and durable, like the art of the museums."

Cézanne's dedicated pursuit of this goal is evident in his repeated paintings of **MONT SAINTE-VICTOIRE**, a mountain close to his home in Aix, which he depicted in hundreds of drawings and about 30 oil paintings between the 1880s and his death in 1906. The painting in **FIGURE 31-56** presents the mountain rising above the Arc Valley, which is dotted with buildings and trees, and crossed at the far right by a railroad viaduct. Framing the scene to the left is an evergreen tree, which echoes the contours of the mountains, creating visual harmony between the two principal elements of the composition. The even light, still atmosphere, and absence of human activity create the sensation of timeless stillness.

Cézanne's handling of paint is deliberate and controlled. His brushstrokes, which vary from short, parallel hatchings, to light lines, to broader swaths of flat color, weave together the elements of the painting into a unified but flattened visual space. The surface design vies with the pictorial effect of receding space, generating tension between the illusion of three dimensions within the picture and the physical reality of its two-dimensional surface. Recession into depth is suggested by the tree in the foreground—a repoussoir (French for "something that pushes back") that helps draw the eye into the valley-and by the transition from the saturated hues in the foreground to the lighter values in the background, creating an effect of atmospheric perspective. But recession into depth is challenged by other more intense colors in both the foreground and background, and by the tree branches in the sky, which follow the contours of the mountain, avoiding overlapping and subtly suggesting that the two are on the same plane. Photographs of this scene show that Cézanne created a composition in accordance with a harmony that he felt the scene demanded, rather than reproducing in detail the lansdscape itself. His commitment to the painting as a work of art, which he called "something other than reality"—not a representation of nature but "a construction

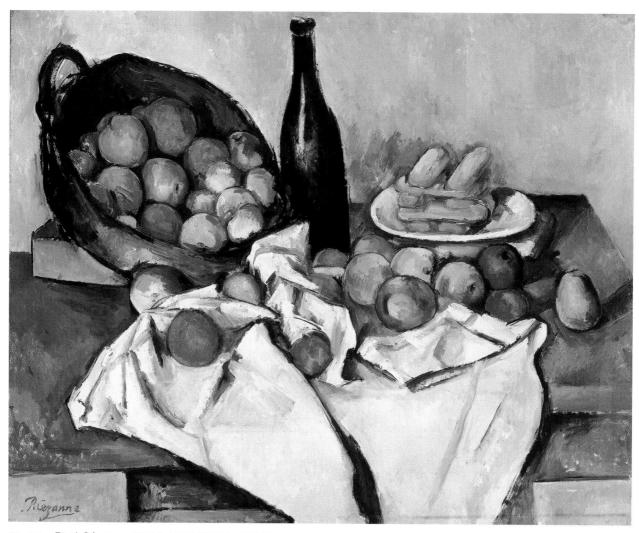

31-57 • Paul Cézanne STILL LIFE WITH BASKET OF APPLES 1880–1894. Oil on canvas, $24\%'' \times 31''$ (62.5 \times 79.5 cm). The Art Institute of Chicago. Helen Birch Bartlett Memorial Collection (1926.252)

after nature"—was a crucial step toward the modern art of the next century.

Spatial ambiguities of a different sort appear in Cézanne's later still lifes, in which many of the objects may seem at first glance to be incorrectly drawn. In **STILL LIFE WITH BASKET OF APPLES** (FIG. 31-57), for example, the right side of the table is higher than the left, the wine bottle has two distinct silhouettes, and the pastries on the table next to it tilt upward toward the viewer, while we seem to see the apples head-on. Such shifting viewpoints are not evidence of incompetence; they derive from Cézanne's willful rejection of the rules of traditional perspective. Although scientific linear perspective mandates that the eye of the artist (and hence the viewer) occupy a fixed point relative to the scene (see Renaissance Perspective," page 610), Cézanne presents the objects in his still lifes from a variety of different positions just as we might move around or turn our heads to take everything in. The composition as a whole, assembled from multiple sightings, is consequently complex and dynamic. Instead of faithfully reproducing static objects from a stable vantage point, Cézanne recreated, or reconstructed, our viewing experiences through time and space.

Cézanne enjoyed little professional success until the last years of his life, when his paintings became more complex internally and more detached from observed reality. THE LARGE BATH-ERS (FIG. 31-58), probably begun in the last year of his life and left unfinished, was the largest canvas he ever painted. It returns in several ways to the academic conventions of history painting as a monumental, multi-figured composition of nude figures in a landscape setting that suggests a mythological theme. The bodies cluster in two pyramidal groups at left and right, beneath a canopy of trees that opens in the middle onto a triangular expanse of water, landscape, and sky. The figures assume statuesque, often Classical poses and seem to exist outside recognizable time and space. Using a restricted palette of blues, greens, ochers, and roses, laid down over a white ground, Cézanne suffused the picture with a cool light that emphasizes the scene's remoteness from everyday life. Despite its unfinished state, The Large Bathers brings nineteenthcentury painting full circle by reviving the Arcadian landscape, a much earlier category of academic painting, while opening a new window on some radical rethinking about the fundamental practice and purpose of art.

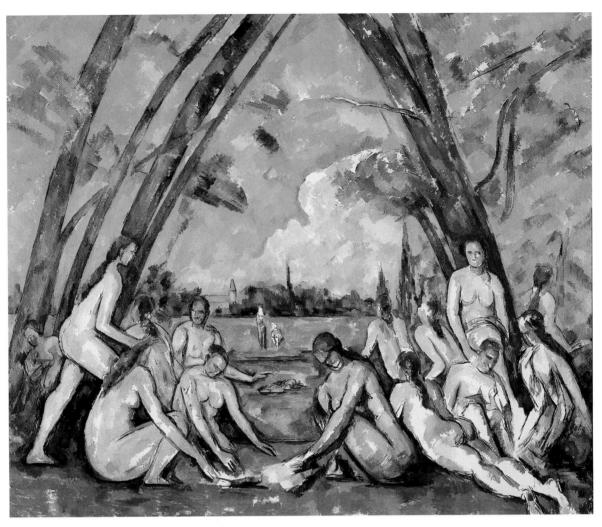

31–58 • Paul Cézanne THE LARGE BATHERS 1906. Oil on canvas, $6'10'' \times 8'2''$ (2.08 \times 2.49 m). Philadelphia Museum of Art. The W.P. Wilstach Collection

THINK ABOUT IT

- **31.1** Discuss the interests and goals of French academic painters and sculptors and explain how their work differed from other art of the same time and place, such as that of the Realists and Impressionists.
- **31.2** Discuss the innovative content of Impressionist paintings, and explain how it differs from that of traditional European paintings by focusing on one specific work discussed in the chapter.
- **31.3** Discuss Gustave Courbet's Realism in works such as *The Stone Breakers* (FIG. 31–12) and *A Burial at Ornans* (FIG. 31–13) in relation to the social and political issues of mid-century France.
- **31.4** Explain how the photographic process works and evaluate the roles played by Louis-Jacques-Mandé Daguerre and Henry Fox Talbot in the emergence of this medium.

CROSSCURRENTS

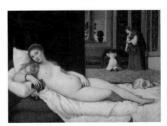

FIG. 21-28

FIG. 31-18

European artists often refer to or seek inspiration in works of art from the past when creating works that address the concerns of their own present. This is certainly the case with Manet, whose painting of *Olympia* recalls aspects of the composition and subject of Titian's "Venus" of Urbino. But the messages of these two works are very different. Analyze the meanings of these paintings. Do they express the concerns of artist, patron, society, or some mixture of the three?

Study and review on myartslab.com

1911–1912. Oil on canvas, $39\%'' \times 25\%''$ (100 × 65.4 cm). Museum of Modern Art, New York. Acquired through the Lillie P. Bliss Bequest (176.1945)

Modern Art in Europe and the Americas, 1900–1950

Pablo Picasso was a towering presence at the center of the Parisian art world throughout much of the twentieth century, continually transforming the forms, meanings, and conceptual frameworks of his art as his style and themes developed in relation to the many factors at play in the world around him. Early in the century in his great Cubist work MA JOLIE (FIG. 32-1) of 1911-1912, Picasso challenged his viewers to think about the very nature of communication through painting. Remnants of the subjects Picasso worked from are evident throughout, but any attempt to reconstruct the "subject"—a woman with a stringed instrument—poses difficulties for the viewer. Ma Jolie ("My Pretty One") is in some sense a portrait, though hardly a traditional one. Picasso makes us work to see and to understand the figure. We can discover several things about Ma Jolie from the painting; we can see parts of her head, her shoulders, and the curve of her body, a hand or a foot. But in Paris in 1911, "Ma Jolie" was also the title of a popular song, so the inclusion of writing and a musical staff in the painting may also suggest other meanings. Our first impulse might be to wonder what exactly is pictured on the canvas. To that question, Picasso provided the sarcastic answer, "It's My Pretty One!"

On the other hand, it might be argued that the human subject provided only the raw material for a formal, abstract arrangement. A subtle tension between order and disorder is maintained throughout this painting. For example, the shifting effect of the surface—a delicately patterned texture of grays and browns—is unified through the use of short, horizontal brushstrokes. Similarly, with the linear elements, strict horizontals and verticals dominate, although curves and angles break up their regularity. The combination of horizontal brushwork and right angles firmly establishes a grid that effectively counteracts the surface flux. Moreover, the repetition of certain diagonals and the relative lack of details in the upper left and upper right create a pyramidal shape reminiscent of Classical systems of compositional stability (see FIG. 21-5). Thus, what at first may seem a chaotic composition of lines and muted colors turns out to be a carefully organized design. For many, the aesthetic satisfaction of such a work depends on the way chaos seems to resolve itself into order.

In 1923, Picasso said, "Cubism is no different from any other school of painting. The same principles and the same elements are common to all. The fact that for a long time Cubism has not been understood ... means nothing. I do not read English, [but] this does not mean that the English language does not exist, and why should I blame anyone ... but myself if I cannot understand [it]?"

LEARN ABOUT IT

- 32.1 Assess the impact of Cubism on abstract art in the early twentieth century and explore how and why Abstract Expressionism transformed painting after 1940.
- **32.2** Examine the different ways that artists in the Modern period responded directly or indirectly to the violence of war.
- **32.3** Determine the political and economic impact of the Great Depression on interwar European and American art.
- **32.4** Investigate how Dada and Surrealism changed the form, content, and concept of art.

EUROPE AND AMERICA IN THE EARLY TWENTIETH CENTURY

At the beginning of the twentieth century, the fragile idea that "civilization" would inexorably continue to progress began to fissure and finally cracked in an orgy of violence during World War I. Beginning in August 1914, the war initially pitted the Allies (Britain, France, and Russia) against the Central Powers (Germany and the Austro-Hungarian Empire) and the Ottoman Empire. The United States eventually entered the war on the side of Britain and France in 1917, helping to guarantee victory for the Allies the following year.

World War I transformed almost every aspect of Western society—including politics, economics, and culture (MAP 32-1). The war was fought with twentieth-century technology but nineteenth-century strategies. Trench warfare and the Maxim gun caused the deaths of millions of soldiers and the horrible maiming of as many again. Europe lost an entire generation of young men; whole societies were shattered. Europeans began to question the nineteenth-century imperial social and political order that had precipitated this carnage and foreshadowed a change in the character of warfare itself. Future wars would be fought over ideology rather than—as in the nineteenth century—territory.

In the first half of the twentieth century, three very different political ideologies struggled for world supremacy: communism (as in the U.S.S.R. and China), fascism (as in Italy and Germany), and liberal-democratic capitalism (as in North America, Britain, and Western Europe). The October 1917 Russian Revolution led to the Russian Civil War and the eventual triumph of the Bolshevik ("Majority") Communist Party led by Vladimir Lenin (1870–1924), as well as to the founding of the U.S.S.R. in 1922. After Lenin's death and an internal power struggle, Joseph Stalin (1878–1953) emerged as leader of the U.S.S.R. Under Stalin, the U.S.S.R. annexed several neighboring states, suffered through the Great Purge of the 1930s, and lost tens of millions during the war against Nazi Germany.

Fascism first took firm root in Italy in October 1922 when Benito Mussolini (1883–1945) came to power. In Germany, meanwhile, the postwar democratic Weimar Republic collapsed under a combination of rampant hyperinflation and the enmity between communists, socialists, centrists, Christian Democrats, and fascists. By the time of the 1932 parliamentary election, Germany's political and economic deterioration had paved the way for a Nazi Party victory and the chancellorship of its leader, Adolf Hitler (1889–1945). Fascism was not limited to Germany and Italy—it was widespread throughout Central and Eastern Europe and on the Iberian peninsula, where General Francisco Franco (1892–1975) emerged victorious from the Spanish Civil War.

The economic impact of World War I was global. Although the United States emerged from it as the leading economic power in the world, hyperinflation in Germany during the 1920s, the repudiation of German war debt under the Versailles Treaty, and the United States Stock Market Crash of 1929 plunged the Western world into a Great Depression that exacerbated political hostility between the major European countries, served as an incubator for fascism and communism in Europe, and tore apart the social and political fabric of Britain and America. In the United States, President Franklin D. Roosevelt (1882–1945, president 1933–1945) created the New Deal programs in 1933 to stimulate the economy with government spending, and France and Britain took their first steps toward the modern welfare state. But ultimately only the military build-up of World War II would end the Great Depression. The war lasted from 1939 to 1945, and the human carnage it caused to both soldiers and civilians, particularly in German concentration camps, raised difficult questions about the very nature of our humanity.

Changes in scientific knowledge were also dramatic. Albert Einstein's publication of his Special Theory of Relativity in 1905 had shaken the foundations of Newtonian physics; they collapsed with the subsequent development of quantum theory by Niels Bohr, Werner Heisenberg, and Max Planck. These developments in physics also unlocked the Pandora's box of nuclear energy, first opened when the British split the atom in 1919, and unleashed on the world when America dropped nuclear bombs on Japan in 1945.

The early twentieth century also witnessed a multitude of innovations in technology and manufacturing: the first powered flight (1903); the mass manufacture of automobiles (1909); the first public radio broadcast (1920); the electrification of most of Western Europe and North America (1920s); and the development of both television (1926) and the jet engine (1937), to mention only a few. Technology led both to better medicines for prolonging life and to more efficient warfare, which shortened it. Information about the outside world became ever more accessible with the advent of radio, television, and film. Where the visual culture of the nineteenth century was based on paper, that of the early twentieth century was centered in photographs and films.

Just as quantum physics fundamentally altered our understanding of the physical world, developments in psychology transformed our conception of the workings of the mind, and consequently how we view ourselves. In 1900, Austrian psychiatrist Sigmund Freud published The Interpretation of Dreams, which posited that our behavior is often motivated not only by reason, but by powerful forces that work below our level of awareness. The human unconscious, as he described it, includes strong urges for love and power that must be managed if society is to remain peaceful and whole. For Freud, we are always attempting to strike a balance between our rational and irrational sides, often erring on one side or the other. Also in 1900, Russian scientist Ivan Pavlov began feeding dogs just after ringing a bell. Soon the dogs salivated not at the sight of food but at the sound of the bell. The discovery that these "conditioned responses" also exist in humans showed that if we manage external stimuli we can control people's appetites. Political leaders of all stripes soon exploited this realization.

MAP 32-1 • EUROPE, THE AMERICAS, AND NORTH AFRICA, 1900-1950

Thus the first half of the twentieth century was a time of exciting new theories and technologies, as well as increased access of ordinary people to consumer items, but it was also a time of cataclysmic social, economic, and political change, and a time when millions died in wars and concentration camps. These changes, whether for the better or for the worse, shaped the art of the early twentieth century.

EARLY MODERN ART IN EUROPE

Modern artists explored myriad new ways of seeing their world. Few read academic physics or psychology texts, but they lived in a world that was being transformed by such fields, along with so many other technological advances. Modern art was frequently subversive and intellectually demanding, and it was often visually, socially, and politically radical. It seems as if every movement in early twentieth-century art chose or acquired a distinctive label and wrote a manifesto or statement of intent, leading this to be described later as the age of "isms."

Yet most Modern art was still bound to the idea that works of art, regardless of how they challenged vision and thought, were still precious objects—primarily pictures or sculptures. But a few artistic movements—notably Dada and some elements of

Surrealism, both of them prompted by the horrors of World War I—challenged this idea. Their preoccupations built the foundation for much art after 1950.

THE FAUVES: WILD BEASTS OF COLOR

The Salon system still operated in France, but the ranks of artists dissatisfied with its conservative precepts were swelling. In 1903, a group of malcontents, including André Derain (1880-1954), Henri Matisse (1869-1954), Georges Rouault (1871-1958), and Albert Marquet (1875–1947), organized the alternative exhibition known as the Salon d'Automne (Autumn Salon), so named to distinguish it from the official Salon that took place every spring. The Autumn Salon, which continued until after World War I, promised juries more open to avant-garde art, and the first major Modern movement of the twentieth century made its debut in this Salon's disorderly halls. Paintings by Derain, Matisse, and Maurice de Vlaminck (1876-1958) exhibited in 1905 were filled with such explosive colors and blunt brushwork that the critic Louis Vauxcelles described the young painters as fauves ("wild beasts"), the French term by which they soon became known. These artists took the French tradition of color and strong brushwork to new heights of intensity and expressive power, and entirely rethought the picture's surface.

Among the first major Fauve works were paintings that Derain and Matisse made in 1905 in the French Mediterranean

32-2 • André Derain **MOUNTAINS AT COLLIOURE** 1905. Oil on canvas, $32'' \times 39^{1}\!\!/2''$ (81.5 × 100 cm). National Gallery of Art, Washington, DC. John Hay Whitney Collection

port town of Collioure. In MOUNTAINS AT COLLIOURE (FIG. 32-2), Derain used short, broad strokes of pure pigment, juxtaposing the complementary colors of blue and orange together as in the mountain range—or red and green together—as in the trees—to intensify the hue of each. He chose a range of seminaturalistic colors—the grass and the trees are green, the trunks are close to brown. This is recognizable as a landscape, but it is also a self-conscious exercise in painting. The uniform brightness of the colors undermines any effect of atmospheric perspective. As a consequence, viewers remain aware that they are looking at a flat canvas covered with paint, not an illusionistic rendering of the natural world. This tension between image and painting, along with the explosive effect of the color, generates a visual energy that positively pulses from the painting. Derain described his colors as "sticks of dynamite," and his stark juxtapositions of complementary hues as "deliberate disharmonies."

Matisse was equally interested in "deliberate disharmonies." His **THE WOMAN WITH THE HAT** (**FIG. 32-3**) proved particularly controversial at the 1905 Autumn Salon because of its thick swatches of crude, seemingly arbitrary, nonnaturalistic color and its broad and blunt brushwork—the sitter, an otherwise conventional subject for a portrait, has thick green stripes across her brow and down her nose. The uproar did not stop siblings Gertrude and Leo

32-3 • Henri Matisse **THE WOMAN WITH THE HAT** 1905. Oil on canvas, $31\%''\times23\%''$ (80.6 \times 59.7 cm). San Francisco Museum of Modern Art. Bequest of Elise S. Haas

32-4 • Henri Matisse LE BONHEUR DE VIVRE (THE JOY OF LIFE) 1905–1906. Oil on canvas, $5'81/2'' \times 7'93/4''$ (1.74 \times 2.38 m). The Barnes Foundation, Merion, Pennsylvania. (BF 719)

Stein, among the most important American patrons of avant-garde art at this time, from purchasing the work in 1905.

The same year, Matisse also began painting **LE BONHEUR DE** VIVRE (THE JOY OF LIFE) (FIG. 32-4), a large pastoral landscape depicting a golden age—a reclining nude in the foreground plays pan pipes, another piper herds goats in the right mid-ground, lovers embrace in the foreground while others frolic in dance in the background. Like Cézanne's The Large Bathers painted in the same year (see FIG. 31-58), The Joy of Life is academic in scale and theme, but avant-garde in most other respects—notably in the way the figures appear "flattened" and in the distortion of the spatial relations between them. Matisse emphasized expressive color, drawing on folk-art traditions in his use of unmodeled forms and bold outlines. In the past, artists might express feeling through the figures' poses or facial expressions, but now, he wrote, "The whole arrangement of my picture is expressive. The place occupied by figures or objects, the empty spaces around them, the proportions, everything plays a part The chief aim of color should be to serve expression as well as possible."

PICASSO, "PRIMITIVISM," AND THE COMING OF CUBISM

Of all Modern art "isms" created before World War I, Cubism was probably the most influential. The joint invention of Pablo Picasso (1881–1973) and Georges Braque (1882–1963)—who worked side by side in Paris, the undisputed capital of the art world before 1950—Cubism proved a fruitful launching pad for both artists, allowing them to comment on modern life and investigate the ways in which artists perceive and represent the world around them.

PICASSO'S EARLY ART Born in Málaga, Spain, Picasso was an artistic child prodigy. During his teenage years at the National Academy in Madrid, he painted highly polished works that presaged a conservative artistic career, but his restless temperament led him to Barcelona in 1899, where he involved himself in avant-garde circles. In 1900, he first traveled to Paris, and in 1904 he moved there and would live in France for the rest of his life. During this early period Picasso painted urban outcasts in weary

32-5 • Pablo
Picasso FAMILY OF
SALTIMBANQUES
1905. Oil on canvas, 6'11¾" ×
7'6¾" (2.1 × 2.3 m). National
Gallery of Art, Washington,
DC. Chester Dale Collection
(1963.10.190)

poses using a coldly expressive blue palette that led art historians to label this his Blue Period. These paintings seem motivated by Picasso's political sensitivity to those he considered victims of modern capitalist society, which eventually led him to join the Communist Party.

In 1904–1905, Picasso joined a larger group of Paris-based avant-garde artists and became fascinated with the subject of *saltim-banques* (traveling acrobats). He rarely painted these entertainers performing, however, focusing instead on the hardships of their existence on the margins of society. In **FAMILY OF SALTIM-BANQUES** (**FIG. 32-5**), a painting from his Rose Period (so called because of the introduction of that color into his palette), five *saltimbanques* stand in weary silence to the left, while a sixth, a woman, sits in curious isolation on the right. All seem psychologically withdrawn, as uncommunicative as the empty landscape they occupy. By 1905, Picasso began to sell these works to a number of important collectors.

Around 1906, Picasso became one of the first artists in Paris to appropriate images from African art in his paintings, inspired by an encounter with "primitive" art and art beyond the Western tradition that would prove decisive in the development of his

art. In 1906, the Louvre installed a newly acquired collection of sculpture from the Iberian peninsula (present-day Spain and Portugal) dating from the sixth and fifth centuries BCE, but it was an exhibition of African masks that he saw around the same time that really changed the way Picasso thought about art. The exact date of this encounter is not known, but it might have occurred at the Musée d'Éthnographie du Trocadéro (now the Musée du Quai Branly) which opened to the public in 1882, or at the Musée Permanent des Colonies (now the Musée National des Arts d'Afrique et d'Océanie), or in any number of Parisian shops that sold "primitive" objects, mostly brought back from French colonies in Africa. Picasso greatly admired the expressive power and formal strangeness of African masks, and since African art was relatively inexpensive, he also bought several pieces and kept them in his studio.

The term **primitivism**, as applied to the widespread tendency among Modern artists to scour the art of other cultures beyond the Western tradition for inspiration, is not benignly descriptive; it carries modern European perceptions of relative cultural superiority and inferiority. The inherent assumption is that Western culture is superior, more civilized, more developed, and more complex than other cultures, which are less civilized, less

developed, and simpler. It could be argued that, just as colonizing nations exploited "primitive" lands in the nineteenth century for their raw materials and labor to increase their own wealth and power, so Western artists exploited the visual cultures of "primitive" nations merely to amplify ideas about themselves. Many early Modern artists thus represented other cultures and appropriated their art without understanding—without really caring to understand—how those cultures actually functioned or how their art was used. This was the case with Picasso.

His contact with African art had a huge impact on **LES DEM- OISELLES D'AVIGNON (THE YOUNG LADIES OF AVIGNON)**(FIG. 32-6), one of the most radical and complex paintings of the twentieth century. Picasso deliberately sends mixed messages in this work, beginning with the title: Avignon was the seat of a papal court in the fourteenth century, so it may mean that these figures are young ladies of the court. On the other hand, "demoiselle" was also a euphemism for prostitute and "Avignon" was the name of a red-light district in Barcelona, forming the most common interpretation of the scene. The work's boldness resides not only in its subject matter, but also its size. Picasso may have undertaken such

a large (nearly 8 feet square) painting in 1907 to compete with both Matisse—who exhibited The Joy of Life in the 1906 Salon and Cézanne—whose Large Bathers was shown the same year. Like Matisse and Cézanne, Picasso revives and renegotiates the ideas of large-scale academic history painting, making use of the traditional subject of nude women shown in an interior space. There are other echoes of the Western tradition in the handling of the figures. The two in the center display themselves to the viewer like Venus rising from the sea (see FIGS. 20-40, 31-4), while that to the left takes a rigid pose with a striding stance, recalling a Greek kouros (see Fig. 5-18), and the one seated on the right might suggest the pose of Manet's Le Déjeuner sur l'Herbe (see FIG. 31-17). But not all visual references point to the Western tradition. Iberian sources stand behind the faces of the three leftmost figures, with their flattened features and wide, almond-shaped eyes. The mask-like faces of the two figures at right emulate African art.

Picasso has created an unsettling picture from these sources. The women are shielded by masks, flattened and fractured into sharp angular shapes. The space they inhabit is incoherent and convulsive. The central pair raise their arms in a conventional ges-

ture of accessibility but contradict it with their hard, piercing gazes and tight mouths that create what one art historian has called "a tidal wave of aggression." Even the fruit displayed in the foreground, symbols of female sexuality, seems brittle and dangerous. The women, Picasso suggests, are not the gentle and passive creatures that men would like them to be. This viewpoint contradicts an enduring tradition, prevalent at least since the Renaissance, of portraying sexual availability in the female nude, just as strongly as Picasso's treatment of space shatters the reliance on orderly perspective, equally standard since the Renaissance.

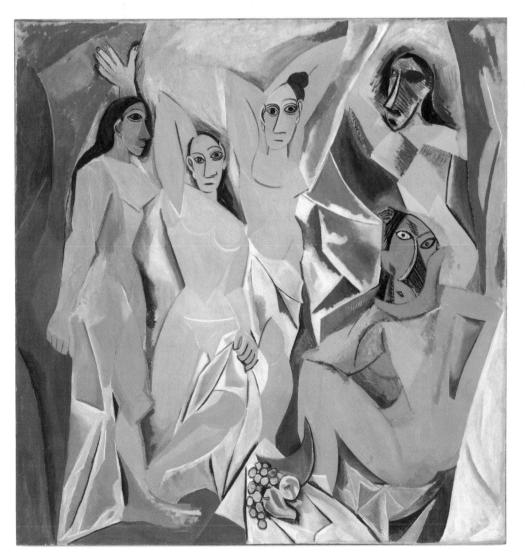

32-6 • Pablo Picasso LES DEMOISELLES D'AVIGNON (THE YOUNG LADIES OF AVIGNON)

1907. Oil on canvas, $8' \times 7'8''$ (2.43 \times 2.33 m). Museum of Modern Art, New York. Acquired through the Lillie P. Bliss Bequest (333.1939)

View the Closer Look for Les Demoiselles d'Avignon on myartslab.com

32–7 • Georges Braque **VIOLIN AND PALETTE** 1909–1910. Oil on canvas, 36% × 16% (91.8 × 42.9 cm). Solomon R. Guggenheim Museum, New York. (54.1412)

Most of Picasso's friends were shocked by his new work. Matisse, for example, accused Picasso of making a joke of Modern art and threatened to break off their friendship. But one artist, Georges Braque, enthusiastically embraced Picasso's radical ideas—he saw in *Les Demoiselles d'Avignon* a potential for new visual experiments. In 1907–1908, Picasso and Braque began a close working relationship that lasted until the latter went to war in 1914. Together, they developed Picasso's formal innovations by flattening pictorial space, by incorporating multiple perspectives within a single picture, and by fracturing form, all features these artists had admired in Cézanne's late paintings. According to Braque, "We were like two mountain climbers roped together."

ANALYTIC CUBISM Braque, a year younger than Picasso, was born near Le Havre, France, where he trained as a decorator. In 1900, he moved to Paris and began painting brightly colored Fauvist landscapes, but it was the 1906 Cézanne retrospective and Picasso's *Demoiselles* in 1907 that established his future course by sharpening his interest in altered form and compressed space. In his landscapes after 1908, he reduced nature's complexity to its essential colors and elemental geometric shapes, but the Autumn Salon rejected his work. Matisse dismissively referred to Braque's "little cubes," and the critic Louis Vauxcelles picked up the phrase, claiming that Braque "reduced everything to cubes," thereby giving birth to the art-historical label of Cubism.

Braque's 1908–1909 VIOLIN AND PALETTE (FIG. 32-7) shows the kind of relatively small-scale still-life paintings that the two artists created during their initial collaborative experimentation as they moved together toward the gradual abstraction of recognizable subject matter and space. The still-life items here are not arranged in a measured progression from foreground to background depth, but push close to the picture plane, confined to a shallow space. Braque knits the various elements—a violin, an artist's palette, and some sheet music—together into a single shifting surface of forms and colors. In some areas of the painting, these formal elements have lost not only their natural spatial relations but their coherent shapes as well. Where representational motifs remain—the violin, for example—Braque fragmented them to facilitate their integration into the compositional whole.

Picasso's 1910 Cubist **PORTRAIT OF DANIEL- HENRY KAHNWEILER** (**FIG. 32-8**) depicts the artist's first and most important art dealer in Paris, who saved many artists from destitution by buying their early works. Kahnweiler (1884–1979) was an early champion of Picasso's art and one of the first to recognize the significance of *Les Demoiselles*. His impressive stable of artists included—in

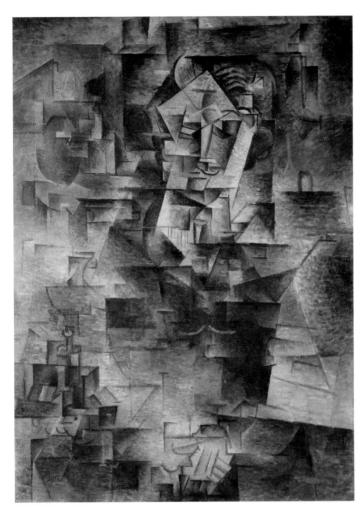

32-8 • Pablo Picasso PORTRAIT OF DANIEL-HENRY KAHNWEILER

1910. Oil on canvas, $39\frac{1}{2}$ " \times $28\frac{5}{6}$ " (100.6 \times 72.8 cm). The Art Institute of Chicago. Gift of Mrs. Gilbert W. Chapman in memory of Charles B. Goodspeed

addition to Picasso—Braque, André Derain, Fernand Léger, and Juan Gris. Since he was German, Kahnweiler fled France for Switzerland during World War I, while the French government confiscated all his possessions, including his stock of paintings, which was sold by the state at auction after the war. Being Jewish, he was forced into hiding during World War II.

Braque's and Picasso's paintings of 1909 and 1910 initiated what is known as Analytic Cubism because of the way the artists broke objects into parts as if to analyze them. In works of 1911 and early 1912, such as Picasso's *Ma Jolie* (see Fig. 32–1), they begin to take a somewhat different approach to the breaking up of forms, in which they did not simply fracture objects visually, but picked them apart and rearranged their components. Thus, Analytic Cubism begins to resemble the actual process of perception, during which we examine objects from various points of view and reassemble our glances into a whole object in our brain. Only Picasso and Braque reassembled their shattered subjects not according to the process of perception but conforming to principles of artistic composition, to communicate meaning rather than to represent

observed reality. For example, remnants of the subject are evident throughout Picasso's *Ma Jolie*, but any attempt to reconstruct from them the image of a woman with a stringed instrument would be misguided since the subject provided only the raw material for a formal composition. *Ma Jolie* is not a representation of a woman, a place, or an event; it is simply a painting.

SYNTHETIC CUBISM Works such as *Ma Jolie* brought Picasso and Braque to the brink of complete abstraction, but in the spring of 1912 they pulled back and began to create works that suggested more clearly discernible subjects. Neither artist wanted to break the link to reality; Picasso said that there was no such thing as completely abstract art, because "You have to start somewhere." This second major phase of Cubism is known as Synthetic Cubism because of the way the artists created complex compositions by combining and transforming individual elements, as in a chemical synthesis. Picasso's **LA BOUTEILLE DE SUZE (BOTTLE OF SUZE)** (**FIG. 32-9**), like many of the works he and Braque created from 1912 to 1914, is a **collage** (from the French *coller*, meaning "to glue"), a work composed of separate elements pasted

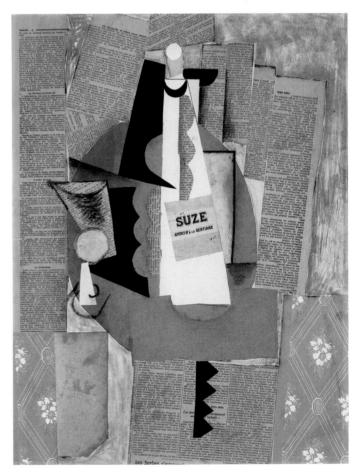

32-9 • Pablo Picasso LA BOUTEILLE DE SUZE (BOTTLE OF SUZE)

1912. Pasted paper, gouache, and charcoal, $25^3\!\!/4'' \times 19^3\!\!/4''$ (65.4 \times 50.2 cm). Mildred Lane Kemper Art Museum, Washington University in St. Louis. University purchase, Kende Sale Fund, 1946

together. At the center, assembled newsprint and construction paper suggest a tray or round table supporting a glass and a bottle of liquor with an actual label. Around this arrangement Picasso pasted larger pieces of newspaper and wallpaper.

As in earlier Cubism, Picasso offers multiple perspectives. We see the top of the blue table, tilted to face us, and simultaneously the side of the glass. The bottle stands on the table, its label facing us, while we can also see the round profile of its opening, as well as the top of the cork that plugs it. The elements together evoke not only a place—a bar—but also an activity—the viewer alone with a newspaper, enjoying a quiet drink. The newspaper clippings glued to this picture, however, disrupt the quiet mood. They address the First Balkan War of 1912–1913, which contributed to

32-10 • Pablo Picasso **MANDOLIN AND CLARINET** 1913. Construction of painted wood with pencil marks, 25%" \times 14%" \times 9" (58 \times 36 \times 23 cm). Musée Picasso, Paris.

the outbreak of World War I. Did Picasso want to underline the disorder in his art by comparing it with the disorder building in the world around him, or was he warning his viewers not to sit blindly and sip Suze while political events threatened to shatter the peaceful pleasures this work evokes? Or is this simply a painting?

Picasso employed collage three-dimensionally to produce Synthetic Cubist sculpture, such as **MANDOLIN AND CLARI-NET** (**FIG. 32-10**). Composed of wood scraps, the sculpture suggests the Cubist subject of two musical instruments, here shown at right angles to each other. Sculpture had traditionally been either carved, modeled, or cast. Picasso's sculptural collage was a new idea and introduced **assemblage**, giving sculptors the option not only of carving or modeling but also of constructing their works

by assembling found objects and unconventional materials. Another of Picasso's innovations was his introduction of space into the interior of the sculpture, created by gaps and holes. Since this sculpture creates volume by using both forms and spaces, rather than mass alone, Picasso has challenged the traditional conception of sculpture as a condensed solid form surrounded by space.

THE BRIDGE AND PRIMITIVISM

At the same time as Picasso and Braque were transforming painting in Paris, a group of radical German artists came together in Dresden as Die Brücke (The Bridge), taking their name from a passage in Friedrich Nietzsche's Thus Spake Zarathustra (1883) which describes contemporary humanity's potential as a "bridge" to a more perfect humanity in the future. Formed in 1905, The Bridge included architecture students Fritz Bleyl (1880-1966), Erich Heckel (1883-1970), Ernst Ludwig Kirchner (1880-1938), and Karl Schmidt-Rottluff (1884-1976). Other German and northern European artists later joined the group, which continued until 1913. These artists hoped The Bridge would be a gathering place for "all revolutionary and surging elements" who opposed Germany's "pale, overbred, and decadent" society.

Drawing on northern visual prototypes, such as Van Gogh or Munch, and adopting traditional northern media such as woodcuts, these artists created intense, brutal, expressionistic images of alienation and anxiety in response to Germany's rapid and intensive urbanization. Not surprisingly, among their favorite motifs were the natural world and the nude body—nudism was also a growing

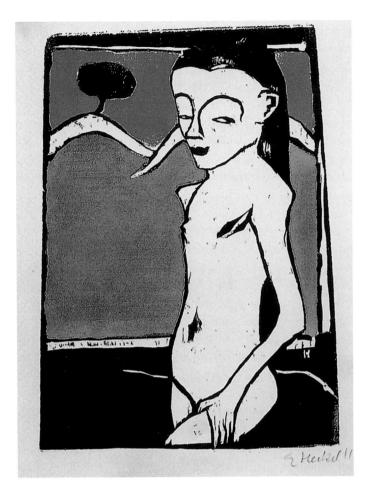

32–11 • Erich Heckel **STANDING CHILD** 1910. Color woodcut, $14\%'' \times 10\%''$ (37.5 \times 27.5 cm). Los Angeles County Museum of Art.

cultural trend in Germany in those years, as city dwellers forsook the city to reconnect with nature. Erich Heckel's three-color woodcut print **STAND-ING CHILD** (FIG. 32-11) of 1910 presents a strikingly stylized but powerfully expressive image of a naked girl—whose flesh is the reserved color of the paper itself—isolated against a spare background landscape created from broad areas of pure black, green, and red. She stares straight out at the viewer with an incipient, but already confident, sexuality that becomes more unsettling when we learn that this girl was the 12-year old Fränzi Fehrmann, a favorite of Brücke artists who, with her siblings, modeled to provide financial support for her widowed mother.

Although not part of the original Bridge group, Emil Nolde (1867–1956) joined in 1906 and quickly became its most committed member. Originally trained in industrial design, Nolde studied academic painting privately in Paris for a few months

in 1900, but he never painted as he was taught. Nolde regularly visited Parisian ethnographic museums to study the art of Africa and Oceania, which impressed him with the radical and forceful visual presence of the human figure, especially in masks. His painting MASKS (FIG. 32-12) of 1911 seems to derive both from what he saw in Paris, as well as the masquerades familiar to him from European carnivals (see FIG. 31-43). By merging these traditions, Nolde transforms his African and Oceanic sources into a European nightmare full of horror and implicit violence. The gaping mouths and hollow eyes of the hideously colored and roughly drawn masks taunt viewers, appearing to advance from the picture plane into their space. Nolde also uses the juxtaposition of complementaries to intensify his colors and the painting's emotionality. Nolde stopped frequenting The Bridge's studio in 1907 but remained friendly with the group's members. On the eve of World War I, Nolde accompanied a German scientific expedition to New Guinea, explaining that what attracted him to the "native art" of Pacific cultures was their "primitivism," their "absolute originality, the intense and often grotesque expression of power and life in very simple forms."

During the summers, members of The Bridge returned to nature, visiting remote areas of northern Germany, but in 1911 they moved to Berlin—perhaps preferring to imagine rather than actually live the natural life. Their images of cities, especially Berlin,

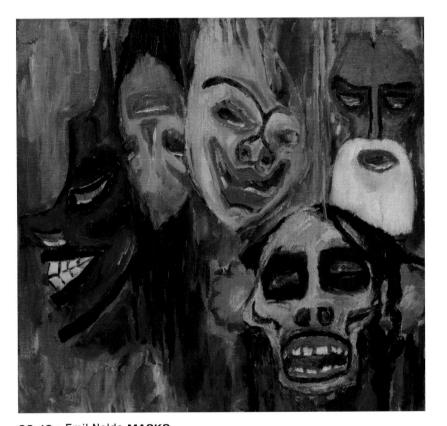

32–12 • Emil Nolde MASKS 1911. Oil on canvas, $28^34'' \times 30^1\!\!/2''$ (73.03 \times 77.47 cm). The Nelson-Atkins Museum, Kansas City, Missouri. Gift of the Friends of Art (54-90)

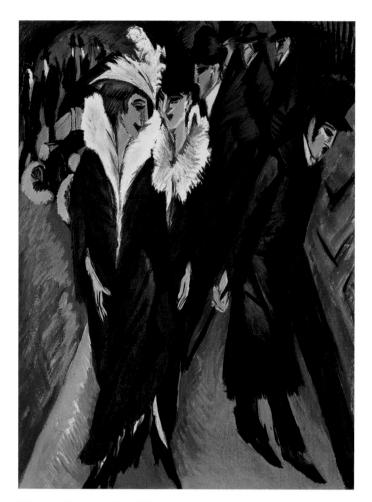

32–13 • Ernst Ludwig Kirchner STREET, BERLIN 1913. Oil on canvas, $47\frac{1}{2}" \times 35\frac{7}{8}"$ (120.6 \times 91 cm). Museum of Modern Art, New York. Purchase (274.39)

View the Closer Look for *Street, Berlin* on myartslab.com

are powerfully critical of urban existence. In Ernst Ludwig Kirchner's **STREET, BERLIN** (**FIG. 32-13**), two prostitutes—their profession advertised by their large feathered hats and fur-trimmed coats—strut past welldressed bourgeois men whom they view as potential clients. They seem to have deliberately embarrassed the man to their left, smirking as he hurriedly refocuses his attention on the shop window to the right. The figures are artificial and dehumanized, with masklike faces and stiff gestures. Their bodies crowd together, but they are psychologically distant. The harsh biting colors, tilted perspective, and brutal brushstrokes make this a disturbing Expressionistic image of urban degeneracy and alienation.

32–14 • Käthe Kollwitz **THE OUTBREAK** From the *Peasants' War* series. 1903. Etching, $20'' \times 23\%''$ (50.7 \times 59.2 cm). Kupferstichkabinett, Staatliche Museen zu Berlin.

INDEPENDENT EXPRESSIONISTS

Beyond the members of The Bridge, many other artists in Germany and Austria worked Expressionistically before World War I. For example, Käthe Kollwitz (1867-1945) used her art to further working-class causes and pursue social change. She perferred printmaking because its affordability gave it the potential to reach a wide audience. Between 1902 and 1908, she produced a series of seven etchings showing the sixteenth-century German Peasants' War. THE OUTBREAK (FIG. 32-14), a lesson in the power of group action, portrays the ugly fury of the peasants as they charge forward armed only with their tools, bent on revenge against their oppressors for years of abuse. The faces of the two figures at the front of the charge are particularly grotesque, while the leader, Black Anna—whom Kollwitz modeled on herself—signals the attack with a fierce gesture, her arms silhouetted against the sky. Behind her, the crowded and chaotic mass of workers wielding farm tools forms a passionate picture of political revolt.

Like Kollwitz, Paula Modersohn-Becker (1876–1907) studied at the Berlin School of Art for Women. In 1898, she moved to Worpswede, an artists' retreat in rural northern Germany. Dissatisfied with the Worpswede artists' naturalistic approach to rural life, after 1900 she made four trips to Paris to view recent developments in Post-Impressionist painting. Although obviously informed by the "primitivizing" tendencies of other artists such as Gauguin (see "A Closer Look," page 1000) toward women at the time, her **SELF-PORTRAIT WITH AN AMBER NECKLACE** (FIG. 32-15) subverts those same tendencies. The monumentalized image of Modersohn-Becker seems at home within nature, surrounded by plants, holding and wearing flowers. She looks out of the canvas directly at us, calmly returning our gaze and establishing

32–15 • Paula Modersohn-Becker **SELF-PORTRAIT WITH AN AMBER NECKLACE** 1906. Oil on canvas, 24" × 19¾" (61 × 50 cm). Öffentliche Kunstsammlung Basel.

a comfortable human connection. While painted in the manner of other Modernists, her tender self-portrait reveals an artist of strong independent ideas and a woman of sharp intelligence.

In contrast, the 1911 **SELF-PORTRAIT NUDE** (**FIG. 32-16**) of Austrian artist Egon Schiele (1890–1918) challenges viewers with his physical and psychological torment. The impact of Schiele's father's death from untreated syphilis when the artist was just 14, led him to conflate suffering with sexuality throughout his life. In many drawings and watercolors, Schiele portrays women in demeaning, sexually explicit poses that emphasize their animal nature, and in numerous self-portraits, the artist turns the same harsh gaze upon himself, revealing deep ambivalence toward sexuality and the body. In this self-portrait he stares wildly at us with anguish, his emaciated body stretched and displayed in a halo of harsh light, lacking both hands and genitals. Some have interpreted this representational mutilation in Freudian fashion as the artist's symbolic self-punishment for indulgence in masturbation, then commonly believed to lead to insanity.

SPIRITUALISM OF THE BLUE RIDER

Formed in Munich by the Russian artist Vassily Kandinsky (1866–1944) and the German artist Franz Marc (1880–1916), Der Blaue

32–16 • Egon Schiele **SELF-PORTRAIT NUDE** 1911. Gouache and pencil on paper, $20^{1}/4'' \times 13^{3}/4''$ (51.4 \times 35 cm). Metropolitan Museum of Art, New York. Bequest of Scofield Thayer, 1982 (1984.433.298)

Reiter ("The Blue Rider") was named for a popular image of a blue knight, the St. George on the city emblem of Moscow. Just as St. George had been a spiritual leader in society, so The Blue Rider aspired to offer spiritual leadership in the arts. Its first exhibition was held in December 1911 and included the work of 14 artists working in a wide range of styles, from realism to radical abstraction.

By 1911, Marc was mostly painting animals rather than humans, rendering them in big, bold forms painted in almost-primary colors. He felt animals were more "primitive" and thus purer than humans, enjoying a more spiritual relationship with nature. In **THE LARGE BLUE HORSES** (FIG. 32-17), the animals—blue, in an allusion to St. George and symbolizing natural spirituality—merge into a homogeneous whole. Their sweeping contours reflect the harmony of their collective existence and echo the curved lines of the hills behind them, suggesting that they live in harmony with their surroundings.

Marc THE
LARGE BLUE
HORSES
1911. Oil on
canvas, 3'53%" ×
5'111¼" (1.05 ×
1.81 m). Walker
Art Center,
Minneapolis.
Gift of T.B. Walker
Collection, Gilbert M.
Walter Fund, 1942

32-18 • Vassily Kandinsky IMPROVISATION 28 (SECOND VERSION)
1912. Oil on canvas, 43\%" × 63\%" (111.4 × 162.2 cm). Solomon R. Guggenheim Museum, New York. Solomon R. Guggenheim Founding Collection (37.239)

Read the document related to Vassily Kandinsky on myartslab.com

Born into a wealthy Moscow family, Kandinsky initially trained as a lawyer, but after visiting exhibitions of Modern art in Germany and taking private art lessons, he abandoned his legal career, moved to Munich, and established himself as an artist.

Kandinsky may have been a synesthete-someone who "hears" colors and "sees" sound. His art is clearly that of an artist for whom sound and color were inextricably linked. His early study of the work of Whistler (see FIG. 31-27) convinced him that the arts of painting and music were related—just as a composer organizes sound, so a painter organizes color and form. Kandinsky's musical interests led him to contact with Austrian composer Arnold Schoenberg, who around 1910 introduced a momentous change in musical history. Since antiquity, Western music had been based on the arrangement of notes into scales, or modes (such as today's common major and minor), chosen by composers for expressive reasons. Each note in any given scale had a role to play, and these roles operated in a clear hierarchy that served to reinforce what became known as the "tonal center," a kind of home base or place of repose in the musical composition. Schoenberg eliminated the tonal center and treated all tones equally, denying the listener any place of repose and prolonging the expressive tension of his music indefinitely. Kandinsky wondered, if music can exist without a tonal center, can painting exist without subject matter?

Kandinsky was thus one of the first artists to investigate the theoretical possibility of purely abstract painting. Like Whistler, he gave his works musical titles, such as "Composition" and "Improvisation," and aspired to make paintings that responded to his own inner state and would be entirely autonomous, making no reference to the visible world. In 1912, he painted a series of works, including IMPROVISATION 28 (FIG. **32-18**), that he claimed represented the first truly abstract art. In these works, colors leap and dance, expressing a variety of emotions. For Kandinsky, painting was a utopian spiritual force. He saw art's traditional focus on accurate rendering of the physical world as a misguided materialistic quest, and he hoped that his paintings would lead humanity toward a deeper awareness of spirituality and the inner world. Rather than searching for correspondence between the painting and the world where none is intended, the artist asks us to look at the painting as if we were hearing a symphony, responding instinctively and spontaneously to this or that passage, and then to the total experience. Kandinsky further explained the musical analogy in his book Concerning the Spiritual in Art: "Color directly influences the soul. Color is the keyboard, the eyes are the hammers, the soul is the piano with many strings. The artist is the hand that plays, touching one key or another purposively, to cause vibrations in the soul."

32–19 • Robert Delaunay **HOMAGE TO BLÉRIOT** 1914. Watercolor on paper, $31'' \times 26''$ (78×67 cm). Musée d'Art Moderne de la Ville de Paris. Donation of Henry-Thomas, 1976

EXTENSIONS OF CUBISM

As Cubist paintings emerged from the studios of Braque and Picasso, it was clear to the art world that they had altered the artistic discourse irrevocably. Cubism's way of viewing the world resonated with artists all over Europe, in Russia, and even in the United States. These artists interpreted Cubism in personal ways, significantly broadening and extending its visual message beyond the ideas and objects of Picasso and Braque.

FRANCE Robert Delaunay (1885-1941) and his wife, the Ukrainian-born Sonia Delaunay (1885-1979, born Sonia Stern and adopted by her uncle in 1890 as Sonia Terk; sometimes known as Sonia Delaunay-Terk), took the relatively monochromatic and static forms of Cubism in a new direction. Fauvist color inflected Delaunay's early work; his deep interest in communicating spirituality through color led him to participate in Blue Rider exhibitions. In 1910, he began to fuse his interest in color with Cubism to create paintings celebrating the modern city and modern technology. In HOMAGE TO BLÉRIOT (FIG. 32-19), Delaunay pays tribute to Louis Blériot—the French pilot who in 1909 became the first person to fly across the English Channel-by portraying his airplane flying over the Eiffel Tower, the Parisian symbol of modernity. The brightly colored circular forms that fill the rest of the canvas suggest the movement of the airplane's propeller, a blazing sun in the sky, and the great rose window of the Cathedral

32-20 • Sonia Delaunay CLOTHES AND CUSTOMIZED CITROËN B-12 (EXPO 1925 MANNEQUINS AVEC AUTO) From *Maison de la Mode*. 1925.

of Notre-Dame, representing Delaunay's ideas of "progressive" science and spirituality. This painting's fractured colors also suggest the fast-moving parts of modern machinery.

The critic Guillaume Apollinaire labeled the art of both Robert and Sonia Delaunay "Orphism" after Orpheus, the legendary Greek poet whose lute playing charmed wild beasts, thus implying that their art had similar power. They preferred the term "simultaneity," a concept based on Michel-Eugène Chevreul's law of the simultaneous contrast of colors that proposed collapsing spatial distance and temporal sequence into the simultaneous "here and now" to create a harmonic unity out of the disharmonious world. They envisioned a simultaneity that combined the modern world of airplanes, telephones, and automobiles with spirituality.

Sonia Delaunay produced Orphist paintings with Robert, but she also designed fabric and clothing on her own. She created new patterns similar to Cubist paintings that she called Simultaneous Dresses and exhibited a line of inexpensive ready-to-wear garments with bold geometric designs at the important 1925 International

32-21 • Fernand Léger THREE WOMEN

1921. Oil on canvas, $6^{\prime 1\!/\!2''} \times 8^{\prime} 3''$ (1.84 \times 2.52 m). Museum of Modern Art, New York. Mrs. Simon Guggenheim Fund

Exposition of Modern Decorative and Industrial Arts, decorating a Citroën sports car to match one of her ensembles for the exhibition (FIG. 32-20). She saw the sports car as an expression of the new automobile age, because like her clothing, this car was produced inexpensively for a mass market and because the small three-seater was designed specifically to appeal to the newly independent woman of the time, Delaunay's clientele base. Sadly, there are only black-and-white photographs of these designs.

Technology also fascinated Fernand Léger (1881-1955), who painted a more static but brilliantly colored version of Cubism based on machine forms. THREE WOMEN (FIG. 32-21) is a Purist, machine-age version of the French academic subject of the reclining nude. Purism was developed in Paris by Le Corbusier (b. Charles-Édouard Jeanneret, 1887-1965) and Amédée Ozenfant in a 1925 book, The Foundation of Modern Art, that argued for a return to clear, ordered forms and ideas to express the efficient clarity of the machine age. In Léger's painting, the women's bodies are constructed from large machinelike shapes arranged in an asymmetrical geometric grid that evokes both cool Classicism and an arrangement of plumbing parts. The women are dehumanized, with identical, bland, round faces; they seem to be assembled from standard, interchangeable parts. The exuberant colors and patterns that surround them suggest an orderly industrial society in which everything has its place.

ITALY In Italy, Cubism developed into Futurism, with its emphasis on portraying technology and a sense of speed. In 1908, Italy was a state in crisis Huge disparities of wealth separated the north from the south; four-fifths of the country was illiterate; poverty and near-starvation

were rampant; and as many as 50,000 people had recently died in one of the nation's worst earthquakes. On February 20, 1909, Milanese poet and editor Filippo Tommaso Marinetti (1876–1944) published "Foundation and Manifesto of Futurism" on the front page of the Parisian newspaper *Le Figaro*. He attacked everything old, dull, and "feminine," and proposed to shake Italy free of its past by embracing an exhilarating, "masculine," "futuristic," and even dangerous world based on the thrill, speed, energy, and power of modern urban life.

In April 1911, a group of Milanese artists followed Marinetti's manifesto with the "Technical Manifesto of Futurist Painting," in which they demanded that "all subjects previously used must be swept aside in order to express our whirling life of steel, of pride, of fever, and of speed." Some of these artists traveled to Paris for a Futurist exhibition in 1912, after which they used the visual forms of Cubism to express in art their love of machines, speed, and war.

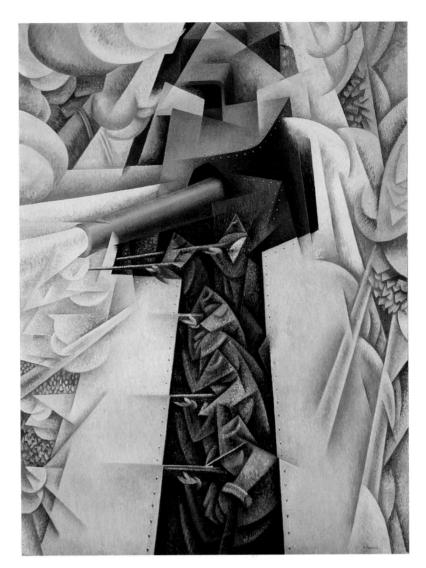

32–22 • Gino Severini ARMORED TRAIN IN ACTION 1915. Oil on canvas, 45^5 /s" \times 34^7 /s" (115.8 \times 88.5 cm). Museum of Modern Art, New York. Gift of Richard S. Zeisler (287.86)

Gino Severini (1883–1966) signed the "Technical Manifesto" while living in Paris, where he served as an intermediary between the Italian-based Futurists and the French avant-garde. Perhaps more than other Futurists, Severini embraced the concept of war as a social cleansing agent. In **ARMORED TRAIN IN ACTION** (FIG. 32-22) of 1915—probably based on a photograph of a Belgian armored car on a train going over a bridge—Severini uses the jagged forms and splintered overlapping surfaces of Cubism to describe a tumultuous scene of smoke, violence, and cannon blasts issuing from the speeding train as seen from a dizzying and disorienting viewpoint.

In 1912, Umberto Boccioni (1882–1916) argued for a Futurist "sculpture of environment," in which form should explode in a violent burst of motion from the closed and solid mass into the surrounding space. In **UNIQUE FORMS OF CONTINUITY IN SPACE** (FIG. 32-23), Boccioni portrays a figure striding powerfully through space, like the ancient *Nike* (*Victory*) of *Samothrace* (see

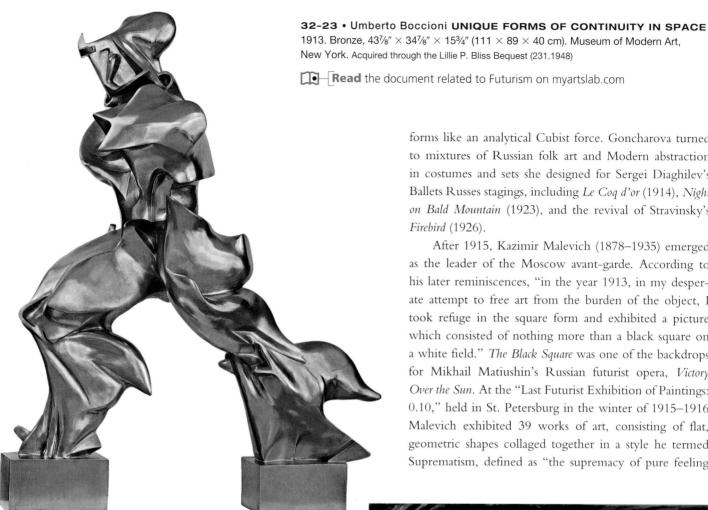

forms like an analytical Cubist force. Goncharova turned to mixtures of Russian folk art and Modern abstraction in costumes and sets she designed for Sergei Diaghilev's Ballets Russes stagings, including Le Coq d'or (1914), Night on Bald Mountain (1923), and the revival of Stravinsky's Firebird (1926).

After 1915, Kazimir Malevich (1878-1935) emerged as the leader of the Moscow avant-garde. According to his later reminiscences, "in the year 1913, in my desperate attempt to free art from the burden of the object, I took refuge in the square form and exhibited a picture which consisted of nothing more than a black square on a white field." The Black Square was one of the backdrops for Mikhail Matiushin's Russian futurist opera, Victory Over the Sun. At the "Last Futurist Exhibition of Paintings: 0.10," held in St. Petersburg in the winter of 1915-1916 Malevich exhibited 39 works of art, consisting of flat, geometric shapes collaged together in a style he termed Suprematism, defined as "the supremacy of pure feeling

FIG. 5-65), with muscular forms like wings flying out energetically behind it. Many of Boccioni's sculptures made use of unconventional materials; this sculpture was actually made of plaster and only cast in bronze after the artist's death. In keeping with his Futurist ideals, Boccioni celebrated Italy's entry into World War I by enlisting. He was killed in combat.

RUSSIA By 1900, Russian artists and art collectors in the cosmopolitan cities of St. Petersburg and later Moscow had begun to embrace avant-garde art, making trips to Paris to see it. Russian artists also drew on Futurist tendencies to celebrate technology and the aesthetic of speed. In 1912, Russian Futurist artists, also known as Cubo-Futurists-claiming to have emerged independently of Italian Futurism-began to move increasingly toward abstraction.

ELECTRIC LIGHT (FIG. 32-24), painted in 1913 by Natalia Goncharova (1881-1962), shows the brightly artificial light from a new electric lamp fracturing and dissolving its surrounding

32-24 • Natalia Goncharova ELECTRIC LIGHT

1913. Oil on canvas, $41\frac{1}{2}$ " \times 32" (105.5 \times 81.3 cm). Musée National d'Art Moderne, Centre National d'Art et de Culture Georges Pompidou.

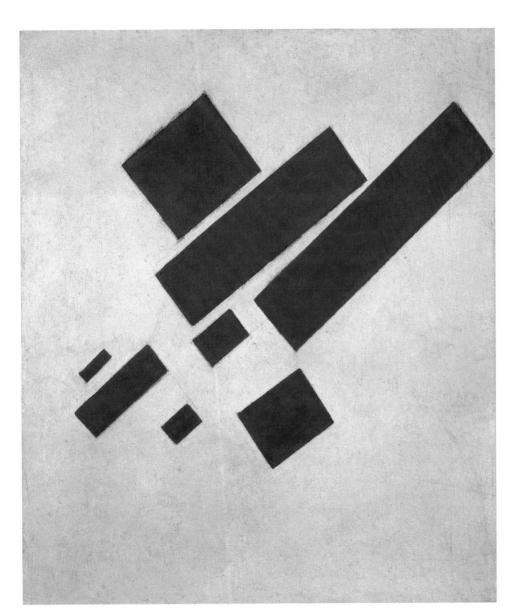

32-25 • Kazimir Malevich SUPREMATIST PAINTING (EIGHT RED RECTANGLES) 1915. Oil on canvas, $22\frac{1}{2}$ " × $18\frac{7}{6}$ " (57 × 48 cm). Stedelijk Museum, Amsterdam.

Read the document related to Kazimir Malevich on myartslab.com

32–26 • Vladimir Tatlin CORNER COUNTER-RELIEF 1915. Mixed media, $31\frac{1}{2}$ " \times 59" \times 29\\frac{1}{2}" (80 \times 150 \times 75 cm). Present whereabouts unknown.

in creative art." One of these works, **SUPREMATIST PAINTING (EIGHT RED RECTANGLES)** (**FIG. 32-25**), arranges eight red rectangles, set diagonally on a white ground—a pure abstraction.

At the same time Vladimir Tatlin (1885–1953) began to construct entirely abstract sculptures that he entitled **CORNER COUNTER-RELIEFS** (**FIG. 32-26**). He created these sculptures from various nonprecious, nonart materials such as metal, glass, wood, plaster, and wire. Although his move away from a conception of free-standing sculpture formed from traditional materials may have been inspired by a visit to Picasso's studio (see **FIG. 32-10**), Tatlin created his new formal and conceptual language for sculpture by actively using open and negative space, eliminating sculpture's reliance on mass and monumentality, and producing fragile and physically unstable objects that hung in the corners of rooms—the space formerly reserved for religious icons. In effect, Tatlin intended these "Counter-Reliefs" to be modern abstract replacements of the icons of the Russian Orthodox faith.

32–27 • Constantin Brancusi **THE NEWBORN** 1915. Marble, $5\frac{3}{4}$ " \times $8\frac{1}{4}$ " \times $5\frac{7}{6}$ " (14.6 \times 21 \times 14.8 cm). Philadelphia Museum of Art. Louise and Walter Arensberg Collection. (195.134.10)

TOWARD ABSTRACTION IN TRADITIONAL SCULPTURE

It is clear that sculpture underwent a revolution as profound as that of painting in the years prior to World War I. Perhaps Picasso's creation of three-dimensional works from diverse materials, assembled and hung on a wall rather than placed on pedestals—an idea developed in Russia by Tatlin-was the most radical innovation, but not all change involved new materials and display contexts. The Romanian artist Constantin Brancusi (1876-1957), who settled in Paris in 1904 and working in Rodin's studio by 1907, became immediately captivated by the "primitive" art on display in the city. He admired the semiabstracted forms of much art beyond the Western tradition, believing that the artists who made such art succeeded in capturing the "essence" of their subject. In Brancusi's search for a sculptural essence he, like Picasso, rejected superficial realism. Brancusi wrote, "What is real is not the external form but the essence of things. Starting from this truth it is impossible for anyone to express anything essentially real by imitating its exterior surface."

For Brancusi, the egg symbolized the potential for birth, growth, and development—the "essence" of life contained in a perfect, organic, abstract ovoid. In **THE NEWBORN** (FIG. 32-27) of 1915, he conflates its shape with the disembodied head of a human infant to suggest the essence of humanity at the moment of birth. In his 1924 **TORSO OF A YOUNG MAN** (FIG. 32-28), Brancusi distills the figure's torso and upper legs into three essential

32–28 • Constantin Brancusi **TORSO OF A YOUNG MAN** 1924. Bronze on stone and wood bases; combined figure and bases 40%" \times 20" \times 18½" (102.4 \times 50.5 \times 46.1 cm). Hirshhorn Museum and Sculpture Garden, Smithsonian Institution, Washington, DC.

and highly polished metal cylinders. Although its machine-like regularity might recall the works of Léger or the Futurists, this bold abstraction carries a Classical gravity and stillness, especially when perched atop the elemental earthiness of the impressive pedestal Brancusi created for it in wood and stone.

DADA: QUESTIONING ART ITSELF

When the Great War broke out in August 1914, most European leaders thought it would be over by Christmas. Both sides reassured their citizens that the efficiency of their armies and bravery of their soldiers would ensure a speedy resolution, that the political status quo would resume. These hopes proved illusory. World War I was the most brutal and costly in human history up to this time. On the Western Front in 1916 alone, Germany lost 850,000 soldiers, France 700,000, and Great Britain 400,000. The conflict settled into a vicious stalemate on all fronts as each side deployed new killing technologies, such as improved machine guns, flame throwers, fighter aircraft, and poison gas. On the home front, governments exerted control over industry and labor to manage the war effort, and ordinary people were forced to endure food rationing, propaganda attacks, and shameless war profiteering.

Horror at the enormity of the carnage arose on many fronts. One of the first artistic movements to address the slaughter and the moral questions it posed was Dada—a transnational movement with distinct local manifestations that arose almost simultaneously in Zürich, New York, Paris, and Berlin. If Modern art until that time questioned the traditions of art, Dada went further to question the concept of art itself. Witnessing how thoughtlessly life was discarded in the trenches, Dada mocked the senselessness of rational thought and even the foundations of modern society. It embraced a "mocking iconoclasm," even in its name, which has no real or fixed meaning. Dada is baby talk in German; in French it means "hobbyhorse"; in Romanian and Russian, "yes, yes"; in the Kru African dialect, "the tail of a sacred cow." Dada artists annihilated the conventional understanding of art as something precious, replacing it with a strange and irrational art about ideas and actions rather than about objects.

HUGO BALL AND THE CABARET VOLTAIRE Dada's opening moment was probably the first performance of poet Hugo Ball's poem "Karawane" at the Cabaret Voltaire. Ball (1886–1927) and his companion, Emmy Hennings (d. 1949), a nightclub singer, moved from Germany to neutral Switzerland when World War I broke out and opened the Cabaret Voltaire in Zürich on February 5, 1916. Cabaret Voltaire was based loosely on the bohemian artists' cafés of prewar Berlin and Munich, and its mad irrational world became a meeting place for exiled avant-garde writers and artists of various nationalities who shared Ball's and Hennings's disgust for the war.

It was here that Ball solemnly recited one of his sound poems, "KARAWANE" (FIG. 32-29), wearing a strange costume, with his legs and body encased in blue cardboard tubes and

32-29 • HUGO BALL RECITING THE SOUND POEM "KARAWANE"

Photographed at the Cabaret Voltaire, Zürich. 1916.

a white-and-blue "witch doctor's hat," as he called it, on his head. He also wore a huge, gold-painted cardboard cape that flapped when he moved his arms and lobsterlike cardboard hands or claws. The text of Ball's poem—included in the photograph documenting the event—consists of a string of nonsensical sounds, renouncing "the language devastated and made impossible by journalism," and mocking traditional poetry. He self-consciously abandoned the rationality of adulthood and created a new, and wholly incomprehensible private language of random sounds that seemed to mimic baby talk.

MARCEL DUCHAMP Although not formally a member of the movement, Marcel Duchamp (1887–1968) created some of Dada's most complex and challenging works. He also took Dada to New York when he crossed the Atlantic in 1915 to escape the war in Europe. In Paris in 1912, Duchamp had experimented with Cubism, painting *Nude Descending a Staircase No. 2*, one of the most controversial works to be included later in the Armory Show (see page 1041). But by the time Duchamp arrived in the

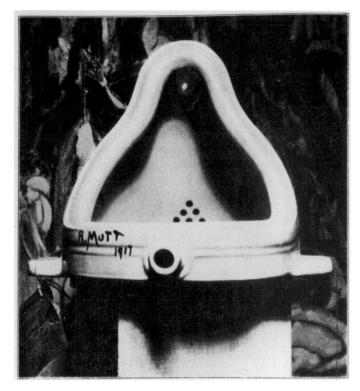

32-30 • Marcel Duchamp FOUNTAIN

1917. Porcelain plumbing fixture and enamel paint. Photograph by Alfred Stieglitz. Philadelphia Museum of Art, Pennsylvania. Louise and Walter Arensberg Collection (1998-74-1)

Stieglitz's photograph is the only known image of Duchamp's original *Fountain*, which mysteriously disappeared after it was rejected by the jury of the American Society of Independent Artists exhibition. In 1950, Duchamp produced several replicas of the lost original simply by buying more urinals and signing them "R. Mutt/1917." One of these replicas sold at auction in 1999 for \$1.76 million, setting a record for a work by Duchamp.

Watch a video about Marcel Duchamp on myartslab.com

United States, he had discarded painting, which he claimed had become for him a mindless activity, and had devised the Dada genre that he termed the **readymade**, in which he transformed ordinary, often manufactured objects into works of art.

Duchamp was warmly welcomed into the American art world. The American Society of Independent Artists invited him to become a founding member, and he chaired the hanging committee for its first annual "Forum" exhibition in 1917. The show advertised itself as unjuried—any work of art submitted with the entry fee of \$6 would be hung. Yet, in Dada fashion, Duchamp spent almost two years devising a work of art that would be shocking and offensive enough to be rejected, thus commenting on the contemporary process of art making and its exhibition. His anonymous submission was a common porcelain urinal that he purchased from a plumber, which he turned on one side so that it was no longer functional and signed "R. Mutt" in a play on the name of the urinal's manufacturer, J. L. Mott Iron Works. It was indeed rejected.

FOUNTAIN (FIG. 32-30) remains one of the most controversial works of art of the twentieth century. It is transgressive. It incites laughter, anger, embarrassment, and disgust, by openly referring to private bathroom activities, to human carnality and vulnerability. In it Duchamp questions the very essence of what constitutes a work of art. How much can be stripped away before the essence of art disappears? Since Whistler's famous court case (see "Art on Trial in 1877," page 985), most avant-garde artists agreed that a work of art need be neither descriptive nor wellcrafted but, before 1917, none would have argued, as Duchamp does in this piece, that "art" was primarily conceptual. For centuries, perhaps millennia, artists had regularly employed studio assistants to craft parts, if not all, of the art objects that they designed. On one level, Duchamp updated that practice into modern terms by arguing that art objects might not only be crafted (in part) by others, but that the objects of art could actually be mass-produced

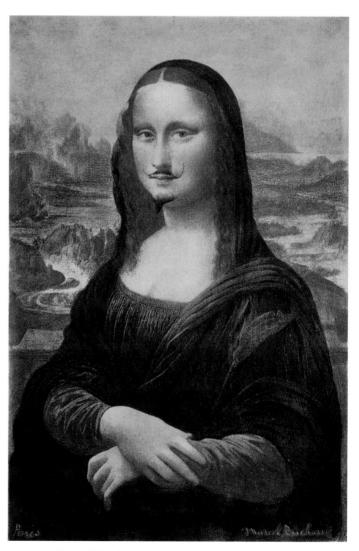

32–31 • Marcel Duchamp L.H.O.O.Q. 1919. Pencil on reproduction of Leonardo da Vinci's *Mona Lisa*, $7\%4'' \times 43\%''$ (19.7 \times 12.1 cm). Philadelphia Museum of Art, Pennsylvania. Louise and Walter Arensberg Collection

for the artist by industry. In a clever twist of logic, Duchamp simultaneously creates a commentary on consumption and on the irrationality of the modern age by arguing that the "readymade" work of art, as a manufactured object, simply bypasses the craft tradition, qualifying as a work of art through human conceptualization rather than by human facture.

When Fountain was rejected, as Duchamp anticipated it would be, the artist resigned from the Society of Independent Artists in mock horror, and published an unsigned editorial in a Dada journal detailing what he described as the scandal of the R. Mutt case. He wrote: "The only works of art America has given are her plumbing and bridges," adding, "Whether Mr. Mutt with his own hands made the fountain or not has no importance. He CHOSE it. He took an ordinary article of life, placed it so that its useful significance disappeared under the new title and point of view—created a new thought for that object."

After Duchamp returned to Paris, he challenged the French art world with a work that he entitled L.H.O.O.Q. (FIG. 32-31) and described as a "modified readymade." In 1911, a Louvre employee had stolen Leonardo's famous Mona Lisa (see Fig. 21-5), believing it should be returned to Italy. It took two years to recover it. While missing, however, the Mona Lisa became even more famous and was widely and badly reproduced on postcards and posters, and in advertising. In his work, Duchamp chose to comment on the nature of fame and on the degraded image of the Mona Lisa by purchasing a cheap postcard reproduction and drawing a mustache and beard on her famously enigmatic face. In doing so he turned a sacred cultural artifact into an object of crude ridicule. The letters that he scrawled across the bottom of the card, "L.H.O.O.Q.," when read aloud sound phonetically similar to the French slang phrase elle a chaud au cul, politely translated as "she's hot for it," thus adding a crude sexual innuendo to the already cheapened image. Like Fountain, this work challenges preconceived notions about what constitutes art and introduces ridicule and crude bodily functions as viable artistic content. As one of Dada's founders said: "Dada was born of disgust."

Duchamp made only a few readymades. In fact, he created very little art at all after about 1922, when he devoted himself almost entirely to chess. When asked about his occupation, he described himself as a "retired artist," but his early twentieth-century radical ideas about art continue to exert influence, especially since around 1960.

BERLIN DADA Early in 1917, Hugo Ball and the Romanian-born poet Tristan Tzara (1896–1963) organized the Galerie Dada in Zürich. Tzara also edited the magazine *Dada*, which quickly attracted the attention of like-minded artists and writers in several European capitals and in the United States. The movement spread farther when expatriate members of Hugo Ball's circle in Switzerland returned to their homelands after the war. Richard Huelsenbeck (1892–1974), for instance, took Dada to Germany, where he helped found the Club Dada in Berlin in April 1918.

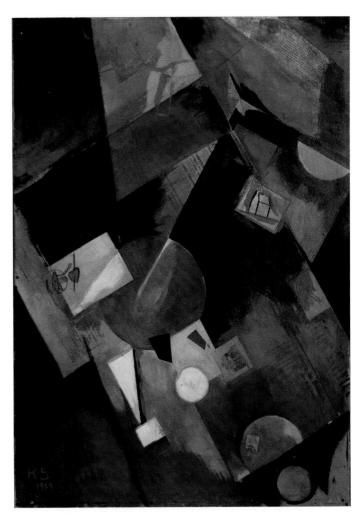

32-32 • Kurt Schwitters MERZBILD 5B (PICTURE-RED-HEART-CHURCH)

April 26, 1919. Collage, tempera, and crayon on cardboard, 32% × 23% (83.4 × 60.3 cm). Solomon R. Guggenheim Museum, New York. (52.1325)

Dada pursued a slightly different agenda and took on different forms in each of its major centers. One distinctive feature of Berlin Dada was its agitprop agenda. Compared to the more literary forms of Dada elsewhere, Berlin Dada also produced an unusually large amount of visual art—especially collage and **photomontage** (photographic collage).

Kurt Schwitters (1887–1948), for instance, who met Huelsenbeck and other Dadaists in 1919, used discarded rail tickets, postage stamps, ration coupons, beer labels, and other street detritus to create visual poetry. Schwitters termed his two- and three-dimensional works of art, made out of the wasted ephemera of the industrial world, *Merzbilder* (German for "refuse picture"). In these works Schwitters combines fragments of newspaper and other printed material with drawn or painted images. He wrote that garbage demanded equal rights with painting. In **MERZBILD 5B** (FIG. 32-32), Schwitters's collage includes printed fragments from the street with newspaper scraps to comment on the postwar disorder of defeated Germany. One fragment describes the brutal overthrow of the short-lived socialist republic in Bremen.

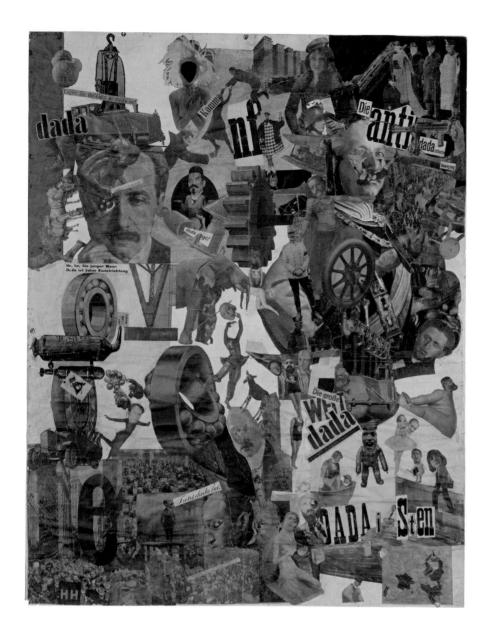

32-33 • Hannah Höch CUT WITH THE DADA KITCHEN KNIFE THROUGH THE LAST WEIMAR BEER-BELLY CULTURAL EPOCH IN GERMANY 1919. Collage, 44%" × 35%" (114×90 cm). Nationalgalerie, Staatliche Museen zu Berlin, Berlin.

Read the document related to Hannah Höch on myartslab.com

Hannah Höch (1889-1978) produced even more pointed political photomontages. Between 1916 and 1926, she worked for Verlag, Berlin's largest publishing house, designing decorative patterns and writing articles on crafts for a women's magazine. Höch considered herself part of the women's movement in the 1920s. She disapproved of contemporary mass-media representations of women and had to fight for her place as the sole woman among the Berlin Dada group, one of whom described her contribution disparagingly as merely conjuring up beer and sandwiches. In CUT WITH THE DADA KITCHEN KNIFE THROUGH THE LAST WEIMAR BEER-BELLY CULTURAL EPOCH IN GERMANY (FIG. 32-33), Höch combines images and words from the popular press, political posters, and photographs to create a complex and angry critique of the Weimar Republic in 1919. She shows women physically cutting apart the beer-bloated German establishment in this photomontage and includes portraits of androgynous Dada characters, such as herself and several other Berlin Dada

artists, along with Marx and Lenin. It is tempting to wonder which side she really thinks her fellow Dadaists stand on.

MODERNIST TENDENCIES IN AMERICA

When avant-garde Modern art was first widely exhibited in the United States, it received a cool welcome. While some American artists did work in abstract or Modern ways, most preferred to work in a more naturalistic manner, at least until around 1915.

STIEGLITZ AND THE "291" GALLERY

The chief proponent of European Modernism in the United States was the photographer Alfred Stieglitz (1864–1946), who in the years before World War I organized several small exhibitions featuring the art of major Modernists at a tiny gallery at 291 Fifth

Avenue, known simply as 291. Stieglitz, like Kahnweiler in Paris, supported many of the early American Modernist artists in New York. As a photographer himself, he sought to establish the legitimacy of photography as a fine art with these exhibitions.

Born in New Jersey to a wealthy German immigrant family, Stieglitz studied photography in the 1880s at the Technische

32-34 • Alfred Stieglitz THE FLATIRON BUILDING, NEW YORK

1903. Photogravure, $6^{11}/_{16}'' \times 3^{5}/_{16}''$ (17 \times 8.4 cm) mounted. Metropolitan Museum of Art, New York. Gift of J.B. Neumann, 1958 (58.577.37)

Hochschule in Berlin, quickly recognizing photography's artistic potential. In 1890, he began to photograph New York City street scenes. He promoted his views through an organization called the Photo-Secession, founded in 1902, and two years later opened the 291 gallery. By 1910, this gallery had become a focal point for both photographers and painters, with Stieglitz giving shows (sometimes their first) to artists such as Arthur Dove, John Marin, and Georgia O'Keeffe, and bringing to America the art of European artists such as Kandinsky, Braque, Cézanne, and Rodin.

In his own photographs, Stieglitz tried to compose poetic images of romanticized urban scenes. In **THE FLATIRON BUILD-ING** (**FIG. 32-34**), the tree trunk to the right is echoed by branches in the grove farther back, and in the wedge-shaped Flatiron Building to the rear. The entire scene is suffused with a misty wintery atmosphere, which the artist created by manipulating his viewpoint, exposure, and possibly both the negative and positive images. Ironically, Stieglitz softens and romanticizes the Flatiron Building, one of New York's earliest skyscrapers and a symbol of the city's modernity. The magazine *Camera Work*, a high-quality photographic publication that Stieglitz edited, and which published this photograph in photogravure form in 1903, also featured numerous photogravures of American and European Modernist art as well as some important American Modern art criticism.

THE ARMORY SHOW AND HOME-GROWN MODERNISM

In 1913, Modernist art arrived in New York en masse with an enormous exhibition held in the drill hall of the 69th Regiment Armory on Lexington Avenue between 25th and 26th Streets. Walt Kuhn (1877-1949) and Arthur B. Davies (1862-1928) were the principal organizers of the "Armory Show," which featured more than 1,600 works, a quarter of them by European artists. Most of the art, even the Modernist art, was well received and sold well, but the art of a few European Modernists, including Matisse and Duchamp in particular, caused a public outcry, in which they were described as "cousins to the anarchists." When selected works from the exhibition traveled on to Chicago, a few faculty and some students of the School of the Art Institute even hanged Matisse in effigy, while civic leaders called for a morals commission to investigate the show. Yet the exhibition consolidated American Modernist art and inspired its artists, who subsequently found more enthusiastic collectors and exhibition venues.

One of the most significant early American Modernists was Arthur Dove (1880–1946). Dove studied the work of the Fauves in Europe in 1907–1909, and he even exhibited at the Autumn Salon. After returning home, he began painting abstract nature studies about the same time as Kandinsky, although each was unaware of the other. Dove's **NATURE SYMBOLIZED NO. 2** (FIG. 32-35) is one of a remarkable series of small works that reveals his beliefs about the spiritual power of nature. But while Kandinsky's art focuses on an inner vision of nature, Dove abstract paintings reflect his deeply felt experience of the landscape itself, saying that

A CLOSER LOOK | Portrait of a German Officer

by Marsden Hartley. 1914. Oil on canvas, $68\frac{1}{4}$ " \times 41%" (1.78 \times 1.05 m). Metropolitan Museum of Art, New York. The Alfred Stieglitz Collection, 1949 (49.70.42)

Symbolic references to Freyburg include epaulettes, lance tips, and the Iron Cross he was awarded the day before he was killed.

Freyburg's regiment number ("4") is shown at the center of the abstracted chest along with a red cursive "E," which stands for "Edmund" (Hartley's given name). This places Hartley over Freyburg's heart.

The black-and-white checkerboard patterns represent Freyburg's love of chess.

The blue-and-white diamond pattern comes from the Bavarian flag; the red, white, and black bands constitute the flag of the German Empire, adopted in 1871; and the black-and-white stripes are those of the historic flag of Prussia.

The funereal black background heightens the intensity of the foreground colors.

The young man's age ("24") is noted in gold on blue.

Hartley identifies his subject with his initials ("Kv.F") in gold on red.

> While living in Berlin in 1914, Hartley fell in love with a young Prussian lieutenant, Karl von Freyburg, whom Hartley described as "in every way a perfect being-physically, spiritually, and mentally." Freyburg's death in World War I devastated Hartley, who memorialized his fallen lover in this symbolic portrait.

View the Closer Look for *Portrait of a German Officer* on myartslab.com

32–35 • Arthur Dove **NATURE SYMBOLIZED NO. 2** c. 1911. Pastel on paper, $18'' \times 21^5 \%''$ (45.8 \times 55 cm). The Art Institute of Chicago. Alfred Stieglitz Collection (1949.533)

he had "no [artistic] background except perhaps the woods, running streams, hunting, fishing, camping, the sky." Dove supported himself by farming in rural Connecticut, but he exhibited his art in New York and was both well received by and well connected to the New York art community.

Another pioneer of American Modernism who exhibited at the Armory Show was Marsden Hartley (1877–1943), who was also a regular exhibitor at the 291 gallery. Between 1912 and 1915, Hartley lived mostly abroad, first in Paris, where he discovered Cubism, then in Berlin, where he began to paint colorful Expressionistic art. Around 1914, however, Hartley developed a powerfully original and intense style of his own in *Portrait of a German Officer* (see "A Closer Look," opposite), a tightly arranged composition of boldly colored shapes and patterns, interspersed with numbers, letters, and fragments of German military imagery that symbolically memorialize Hartley's fallen lover, a tragic victim of the war.

Stieglitz "discovered" Georgia O'Keeffe (1887–1986)—born in rural Wisconsin, and already studying and teaching art between 1905 and 1915—when a New York friend showed him some of her charcoal drawings. Stieglitz's reported response: "At last, a woman on paper!" In 1916, he included O'Keeffe's work in a group show at 291 and mounted her first solo exhibition the following year. O'Keeffe moved to New York in 1918 and married Stieglitz in 1924. In 1925, she began to paint New York skyscrapers, which were acclaimed at the time as embodiments of American inventiveness and energy. But paintings such as CITY NIGHT (FIG. 32-36) are not unambiguous celebrations of lofty buildings. She portrays the skyscrapers from a low vantage point so that they appear to loom ominously over the viewer; their dark tonalities,

32–36 • Georgia O'Keeffe CITY NIGHT 1926. Oil on canvas, $48'' \times 30''$ (123 \times 76.9 cm). Minneapolis Institute of Arts. Gift of funds from the Regis Corporation, Mr. and Mrs. W. John Driscoll, the Beim Foundation, the Larsen Fund (80.28)

stark forms, and exaggerated perspective produce a sense of menace that also appears in the art of other American Modernists.

In 1925, O'Keeffe also began to exhibit a series of close-up paintings of flowers that have become her best-known subjects. In **RED CANNA** (FIG. 32-37), O'Keeffe brings the heart of the heavy sensual flower to the front and center of the picture plane, revealing its tender inner forms and soft, delicate surfaces. By painting the flower's hidden organic energy rather than the way it actually looks to a distant viewer, she creates from it a new abstract beauty, distilling the pure vigor of the plant's life force. Critics described O'Keeffe's flower paintings as elementally feminine and vaginal, and Stieglitz did little to dissuade viewers from this reading of O'Keeffe's art. In fact, he promoted it, in spite of O'Keeffe's strenuous objections to this critical caricature and its implicit pigeonholing of her as a "woman artist." In 1929, O'Keeffe began

32–37 • Georgia O'Keeffe **RED CANNA**1924. Oil on canvas mounted on Masonite, 36" × 29\%" (91.44 × 75.88 cm). Collection of the University of Arizona Museum of Art, Tucson. Gift of Oliver James (1950.1.4)

32–38 • Edward Weston SUCCULENT1930. Gelatin-silver print, 7½" × 9½" (19.1 × 24 cm). Collection Center for Creative Photography © 1981 Arizona Board of Regents.

spending summers in New Mexico and moved there permanently in the 1940s, dedicating her art to evocative representations of the local landscape and culture.

California artist Edward Weston (1886-1958) followed in O'Keeffe's footsteps with a series of experimental photographs begun in the late 1920s that emphasize the abstract patterns of plants by zooming in to extract them from their natural context. During a trip to New York in 1922, Weston had met O'Keeffe, as well as fellow photographers Stieglitz and Paul Strand (1890-1976), both kindred spirits in his own journey to claim photography as a legitimate medium of high art, capable of abstraction as well as documentation. In SUCCULENT (FIG. 32-38), Weston used straightforward camera work without any manipulation in the darkroom to portray his subject with startlingly crisp detail, well captured on his large-format glass negative. He argued that although the camera sees more than the human eye, the quality of the photographic image rests solely on the artistic choices made by the photographer.

EARLY MODERN ARCHITECTURE

New industrial materials and engineering innovations enabled twentieth-century architects to create tall buildings of unprecedented height that vastly increased the usable space in structures built on scarce and valuable city lots. At

the same time that Modern artists in Europe rejected the decorative in painting and sculpture, American architects increasingly embraced the plain geometric shapes and undecorated surfaces of skyscraper architecture.

EUROPEAN MODERNISM

In Europe, a stripped-down and severely geometric style of Modern architecture developed, partly in reaction to the natural organic lines of Art Nouveau. In Vienna, Adolf Loos (1870–1933), one of the pioneers of European architectural Modernism, insisted in his 1913 essay "Ornament and Crime" that "The evolution of a culture is synonymous with the removal of ornament from utilitarian objects." For Loos, ornament was a sign of cultural degeneracy. Thus his **STEINER HOUSE** (**FIG. 32–39**) is a stucco-covered, reinforced concrete construction without decorative embellishment. The rectangular windows, for instance, are completely plain, and they were arranged only in relation to the functional demands of interior spaces. Loos argued that the only purpose of

32-39 • Adolf Loos **STEINER HOUSE**, **VIENNA** 1910.

a building's interior was to provide protection from the elements.

The most important French Modern architect was Le Corbusier, who established several important precepts' that influenced architects for the next halfcentury. His VILLA SAVOYE (FIG. 32-40), a private home outside Paris, became an icon of the International Style (see "The International Style," page 1057) and reflects his Purist ideals in its geometric design and avoidance of ornamentation. It is also one of the best expressions of Le Corbusier's domino construction system, first elaborated in 1914, in which slabs of ferroconcrete (concrete reinforced with steel bars) rest on six free-standing steel posts, placed at the positions of the six dots on a domino playing piece. Over the next decade Le Corbusier further explored the possibilities of the domino system and in 1926 published "The Five Points of a New Architecture," in which he proposed raising houses above the ground on pilotis (free-standing posts); using flat roofs as terraces; using movable partition walls slotted between supports on the interior and curtain walls (nonload-bearing

32-40 • Le Corbusier VILLA SAVOYE, POISSY-SUR-SEINE France. 1929–1930.

Explore the architectural panoramas of the Villa Savoye on myartslab.com

walls) on the exterior to allow greater design flexibility; and using ribbon windows (windows that run the length of the wall). These became common features of Modern architecture. Le Corbusier described the Villa Savoye as "a machine for living in," meaning that it was designed as rationally and functionally as an automobile or a machine. After World War I—like his fellow Modern architects—Le Corbusier also developed designs for mass-produced standardized housing to help rebuild Europe's destroyed infrastructure.

AMERICAN MODERNISM

CONNECTION TO THE LAND Frank Lloyd Wright (1867–1959) was not only America's most important Modern architect, he was also one of the most influential architects in the world during the early twentieth century. After briefly studying engineering at the University of Wisconsin, Wright apprenticed to a Chicago architect, then spent five years with the firm of Dankmar Adler and Louis Sullivan (see Fig. 31–55), advancing to the post of chief drafter. In 1893, Wright established his own office, specializing in domestic architecture. Around 1900, he and several other architects in the Oak Park suburb of Chicago—together known as the Prairie School—began to design low, horizontal houses with flat roofs and heavy overhangs that echoed the flat plains of the prairie in the Midwest.

The **FREDERICK C. ROBIE HOUSE** (FIG. 32-41) is one of Wright's early **Prairie Style** masterpieces. A central chimney, above a fireplace that radiated heat throughout the house in the bitter Chicago winter, forms the center of the sprawling design.

Low, flat overhanging roofs—dramatically cantilevered on both sides of the chimney—shade against the summer sun, and open porches provide places to sleep outside in cool summer nights. Low bands of windows—many with stained glass—surround the house, creating a colored screen between the interior and the outside world, while also inviting those inside to look through the windows into the garden beyond.

The main story is one long space divided into living and dining areas by a free-standing fireplace. There are no dividing walls. Wright had visited the Japanese exhibit at the 1893 Chicago World's Fair and was deeply influenced by the aesthetics of Japanese architecture, particularly its sense of space and screenlike windows (see "Shoin Design," page 821). Wright's homes frequently featured built-in closets and bookcases, and he hid heating and lighting fixtures when possible. He also designed and arranged the furniture for his interiors (FIG. 32-42). Here, machine-cut components create the chairs' modern geometric designs, while their high backs huddle around the table to form the intimate effect of a room within a room. Wright integrated lights and flower holders into the posts closest to the table's corners so that there would no need for lights or flowers on the table.

Wright had an uneasy relationship with European Modernist architecture; he was uninterested in the machine aesthetic of Le Corbusier. Although he routinely used new building materials such as ferroconcrete, plate glass, and steel, he sought to maintain a natural sensibility, connecting his buildings to their sites by using brick and local wood or stone. **FALLINGWATER** (FIG. 32-43) in rural Pennsylvania is a prime example of this practice. It is also

32-41 • Frank Lloyd Wright FREDERICK C. ROBIE HOUSE, CHICAGO 1906–1909. Chicago History Museum. (HB-19312A2)

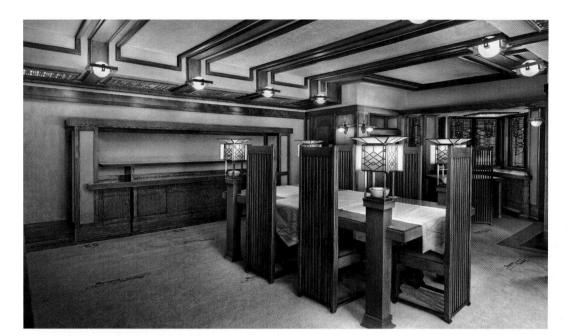

32-42 • Frank Lloyd Wright COLOR RECONSTRUCTION OF THE DINING ROOM, FREDERICK C. ROBIE HOUSE

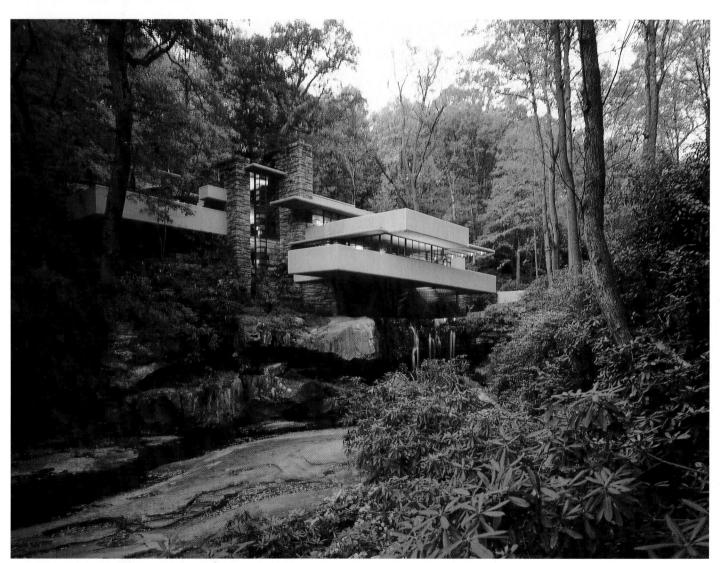

32-43 • Frank Lloyd Wright **FALLINGWATER (EDGAR KAUFMANN HOUSE), MILL RUN** Pennsylvania. 1937.

Explore the architectural panoramas of Fallingwater on myartslab.com

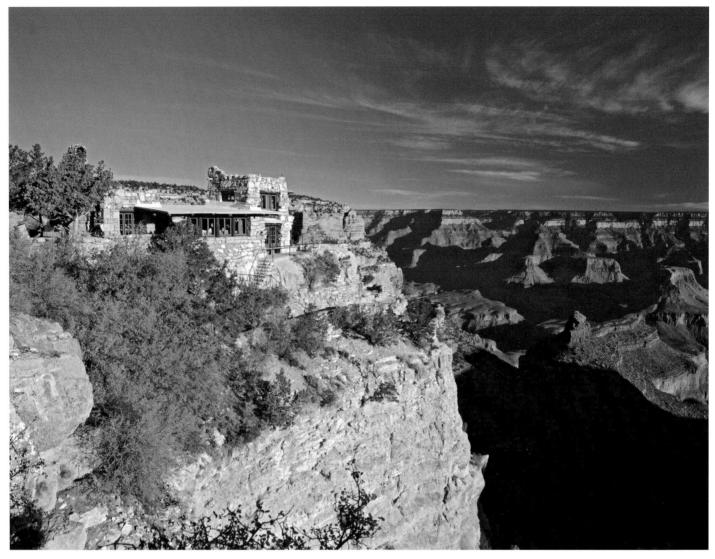

32–44 • Mary Colter LOOKOUT STUDIO, GRAND CANYON NATIONAL PARK Arizona. 1914. Grand Canyon National Park Museum Collection.

the most famous expression of Wright's conviction that buildings should not simply sit *on* the landscape but coordinate *with* it.

Fallingwater was commissioned by Edgar Kaufmann, a Pittsburgh department-store owner, to replace a family summer cottage on the site of a waterfall and a pool where his children played. To Kaufmann's surprise, Wright decided to build the new house right into the cliff and over the pool, allowing the waterfall to flow around and under the house. A large boulder where the family had sunbathed in the summers was used for the central hearthstone of the fireplace. In a dramatic move that engineers questioned (with reason, as subsequent history has shown), Wright used cantilevers to extend a series of broad concrete terraces out from the cliff to parallel the great slabs of natural rock below. Poured concrete forms the terraces, but Wright painted the material a soft earth tone. Long bands of windows and glass doors offer spectacular views, uniting woods, water, and house. Such houses do not simply testify to the ideal of living in harmony with nature; they declare war on the modern city. When asked what could

be done to improve city architecture, Wright responded: "Tear it down."

Mary Colter (1869–1958) expressed an even stronger connection to the landscape in her architecture. Born in Pittsburgh and educated at the California School of Design in San Francisco, she spent much of her career as architect and decorator for the Fred Harvey Company, a firm in the Southwest that catered to the tourist trade. Colter was an avid student of Native American arts, and her buildings quoted liberally from Puebloan traditions, notably in the use of exposed logs for structural supports. She designed several visitor facilities at Grand Canyon National Park, of which LOOKOUT STUDIO (FIG. 32-44) is the most dramatic. Built on the edge of the canyon's south rim, the building's foundation is in natural rock, and its walls are built from local stone. The roofline is deliberately irregular to echo the surrounding canyon wall. The only concession to modernity is a liberal use of glass windows and a smooth cement floor. Colter's designs for hotels and railroad stations throughout the region helped establish the distinctive Southwest style.

ELEMENTS OF ARCHITECTURE | The Skyscraper

The development of the skyscraper design and aesthetic depended on several things: The use of metal beams and girders for the structuralsupport skeleton; the separation of the building-support structure from the enclosing wall layer (the cladding); the use of fireproof materials and measures: the use of elevators; and the overall integration of plumbing. central heating, artificial lighting, and ventilation systems. The first generation of skyscrapers, built between about 1880 and 1900, were concentrated in the Midwest, chiefly in Chicago and St. Louis (see FIG. 31-55). Second-generation skyscrapers, mostly with over 20 stories, date from after 1895 and are found more frequently in New York. The first tall buildings were free-standing towers, sometimes with a base, such as the Woolworth Building of 1911-1913 (see Fig. 32-45). New York City's Building Zone Resolution of 1916 introduced mandatory setbacks decreases in girth as the building rose—to ensure light and ventilation to adjacent sites. Built in 1931, the 1,250-foot setback form of the Empire elevator shafts State Building, diagrammed here, has a streamlined design. The Art Deco (laver two) exterior cladding (see inset below) conceals the structural elements and mechanisms such as elevators that make its great height possible. The Empire State Building was the tallest building in the world when it was built and its distinctive profile ensures that it remains one of the most recognizable even today. stairwells (laver one) masonry wal girder beam cladding concrete setbacks heat slah source flooring skyscraper

Watch an architectural simulation about skyscraper construction on myartslab.com

THE AMERICAN SKYSCRAPER After 1900, New York City assumed a lead over Chicago in the development of the skyscraper, whose soaring height was made possible by the use of the steel-frame skeleton for structural support (see "The Skyscraper," above). New York clients, however, rejected the more utilitarian Chicago style of Louis Sullivan and others, preferring the historicizing approach then still popular on the east coast. The **WOOL-**

WORTH BUILDING (FIG. 32-45) of 1911–1913, designed by the Minnesota-based firm of Cass Gilbert (1859–1934), was the world's tallest building at 792 feet and 55 floors when first completed. Its Gothic-style external details, inspired by the soaring towers of late medieval churches, gave the building a strong visual personality. Because of its Gothic style, Gilbert called it his "Cathedral of Commerce."

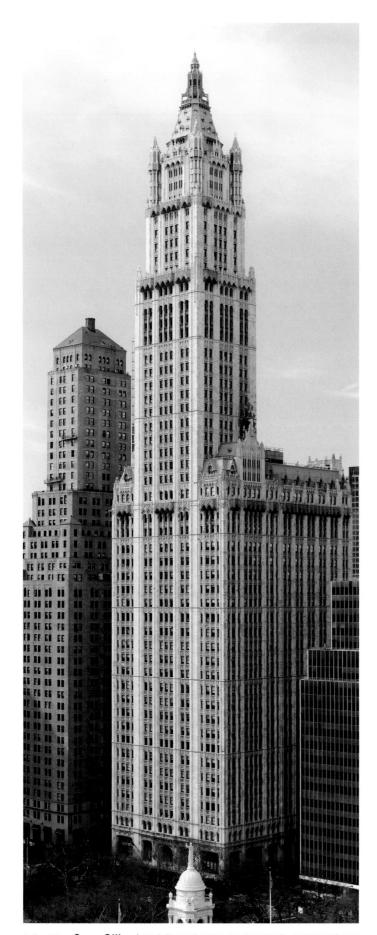

32–45 • Cass Gilbert WOOLWORTH BUILDING, NEW YORK 1911–1913.

ART BETWEEN THE WARS IN EUROPE

World War I had a devastating effect on Europe's artists and architects. Many responded to the destruction and loss of a generation of young men by criticizing the European tradition, while others concentrated on rebuilding. Either way, much of the art created between 1919 and 1939 addressed directly the needs and concerns of society in turmoil or transition.

UTILITARIAN ART FORMS IN RUSSIA

In the 1917 Russian Revolution, the radical socialist Bolsheviks overthrew the tsar, withdrew Russia from the world war, and turned inward to fight a civil war that lasted until 1920 and led to the establishment of the U.S.S.R. (Union of Soviet Socialist Republics). Most Russian avant-garde artists enthusiastically supported the Bolsheviks, who initially supported them.

CONSTRUCTIVISM The case of Aleksandr Rodchenko (1891–1956) is fairly representative. An early associate of Malevich (see FIG. 32–25), Rodchenko used drafting tools to make abstract drawings. He exhibited as a Suprematist in 1921 when he showed three large, flat, monochromatic panels painted red, yellow, and blue, which he titled *Last Painting* (now lost). After this, he renounced painting as a basically selfish activity and condemned self-expression as weak, unproductive, and socially irresponsible. Also in 1921, Rodchenko helped to establish the Constructivists, a post-revolutionary group of artists dedicated not to expressing themselves but to working collectively for the good of the state. They described themselves as workers who literally "constructed" art for the people. After 1921, Rodchenko worked as a photographer producing posters, books, textiles, and theater sets to promote communism.

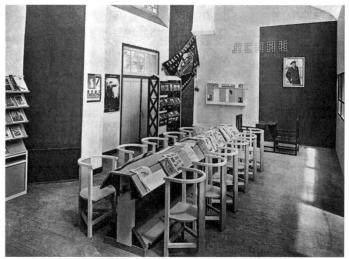

32-46 • Aleksandr Rodchenko **WORKERS' CLUB**Exhibited at the International Exposition of Modern Decorative and Industrial Arts, Paris. 1925. Art © Estate of Aleksandr Rodchenko/RAO, Moscow/VAGA, New York

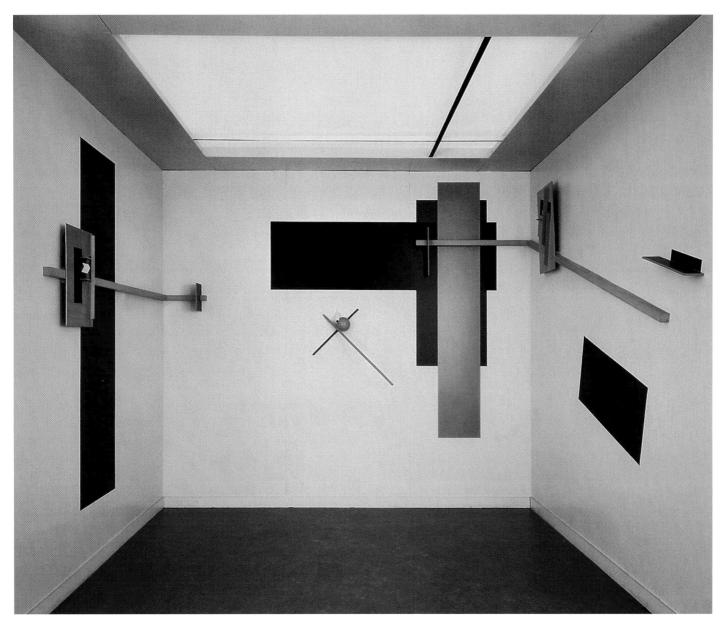

32–47 • El Lissitzky PROUN SPACECreated for the Great Berlin Art Exhibition. 1923, reconstruction 1971. Collection Van Abbemuseum, Eindhoven, The Netherlands.

In 1925, Rodchenko designed a model **WORKERS' CLUB** for the Soviet Pavilion at the Paris International Exposition of Modern Decorative and Industrial Arts (**FIG. 32-46**). Rodchenko emphasized ease of use and simplicity of construction; he made the furniture of wood because Soviet industry was best equipped for mass production in wood. The high, straight backs of the chairs were meant to promote a physical and moral posture of uprightness among the workers.

Another artist active in early Soviet Russia was El Lissitzky (1890–1941). After the Revolution, he taught architecture and graphic arts at the Vitebsk School of Fine Arts where Malevich also taught. By 1919, Lissitzky was both teaching and using a Constructivist vocabulary for propaganda posters and for artworks he called Prouns (pronounced "pro-oon"), thought to be an acronym for the Russian *proekt utverzhdenya novogo* ("project for the

affirmation of the new"). Although most Prouns were paintings or prints, there were a few early examples of **installation art** (**FIG. 32-47**)—artworks created for a specific site, arranged to create a total environment. Lissitzky rejected painting as too personal and imprecise, preferring to "construct" Prouns for the collective using the less personal instruments of mechanical drawing. Like many other Soviet artists of the late 1920s, Lissitzky also turned to more socially engaged projects such as architectural design, typography, photography, and photomontage for publication.

SOCIALIST REALISM In the mid 1920s, Soviet artists increasingly rejected abstraction in favor of a more universally accessible, and thus more politically useful, Socialist Realism that was ultimately established as official Soviet art. Many of Russia's pioneering Modernists and Constructivists, including Rodchenko,

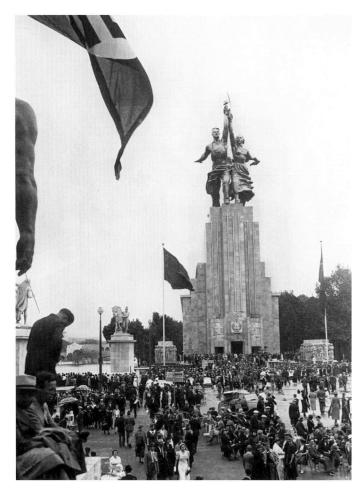

32-48 • Vera Mukhina WORKER AND COLLECTIVE FARM WOMAN

Sculpture for the Soviet Pavilion, Paris Universal Exposition. 1937. Stainless steel, height approx. 78' (23.8 m).

made the change willingly because they were already committed to the national cause, but others, who refused to change, were fired from public positions and lost public support.

The move to Socialist Realism was led by the Association of Artists of Revolutionary Russia (AKhRR), founded in 1922 to depict Russian workers, peasants, revolutionary activists, and the Red Army. AKhRR sought to document the history of the U.S.S.R. by promoting its leaders and goals. Artists were commissioned to create public paintings and sculptures as well as posters for mass distribution; their subjects were heroic or inspirational people and themes, and their style was an easily readable realism.

Vera Mukhina (1889–1953) was a member of AKhRR and is best known for her 78-foot-tall stainless-steel sculpture of a **WORKER AND COLLECTIVE FARM WOMAN** (FIG. 32-48) made for the Soviet Pavilion at the Paris Universal Exposition of 1937. The sculpture shows a powerfully built male factory worker and an equally powerful female farm laborer, with hammer and sickle held high in the air, the same two tools that appeared on the Soviet flag. The figures stand as equals, partners in their common cause, striding purposefully into the future with determined faces, their windblown clothing billowing behind them.

DE STIJL IN THE NETHERLANDS

In the Netherlands after World War I, abstraction took a different turn from that in the U.S.S.R. The Dutch artist Piet Mondrian (1872-1944) encountered Cubism on a trip to Paris in 1912, where he began to abstract animals, trees, and landscapes, searching for their "essential" form. After his return to the Netherlands, he met Theo van Doesburg (1883-1931) who, in 1917, started a magazine named De Stijl (The Style) that became a focal point for Dutch artists, architects, and designers after the war. Writing in the magazine, Van Doesburg argued that beauty took two distinct forms: sensual or subjective beauty, and a higher, rational, and universal beauty. He challenged De Stijl (note the term translates as "The Style" rather than "A Style") artists to aspire to universal beauty. Mondrian sought to accomplish this by eliminating everything sensual or subjective from his paintings, but he also followed M.H.J. Schoenmaekers's ideas about Theosophy, as expressed in his 1915 book New Image of the World. Schoenmaekers argued that an inner visual construction of nature consisted of a balance between opposing forces, such as heat and cold, male and female, order and disorder, and that artists might represent this inner construction in abstract paintings by using only horizontal and vertical lines and primary colors.

Mondrian's later paintings are visual embodiments of both Schoenmaekers's theory and De Stijl's artistic ideas. In COMPO-SITION WITH YELLOW, RED, AND BLUE (FIG. 32-49), for example, Mondrian uses the three primary colors (red, yellow, and blue), three neutrals (white, gray, and black), and a grid of horizontal and vertical lines in his search for the essence of higher beauty and the balance of forces. Mondrian's opposing lines and colors balance a harmony of opposites that he called a "dynamic equilibrium" and which he achieved by carefully plotting an arrangement of colors, shapes, and visual weights grouped asymmetrically around the edges of a canvas, with the center acting as a blank white fulcrum. Mondrian hoped that De Stijl would have applications in the real world by creating an entirely new visual environment for living, designed according to the rules of a "universal beauty" that, when perfectly balanced, would bring equilibrium and purity to the world. Mondrian said that he hoped to be the world's last artist, because, while art brought humanity to everyday life, when "universal beauty" infused all aspects of life, there would no longer be a need for art.

The architect and designer Gerrit Rietveld (1888–1964) applied Mondrian's principles of dynamic equilibrium and De Stijl's aesthetic theories to architecture and created one of the most important examples of the International Style (see "The International Style," page 1057). Interlocking gray and white planes of varying sizes, combined with horizontal and vertical accents in primary colors and black, create the radically asymmetrical exterior of the SCHRÖDER HOUSE in Utrecht (Fig. 32–50). Inside, the "RED-BLUE" CHAIR (Fig. 32–51) echoes this same arrangement. Sliding partitions allow modifications in the interior spaces used for sleeping, working, and entertaining. The patron of the house, Truus

32-49 • Piet Mondrian
COMPOSITION WITH YELLOW,
RED, AND BLUE

1927. Oil on canvas, 14%" \times 13%" (37.8 \times 34.9 cm). The Menil Collection, Houston. © 2012 Mondrian/Holtzman Trust c/o HCR International USA

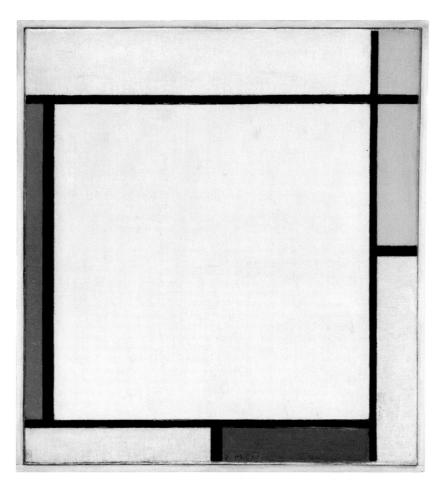

32-50 • Gerrit Rietveld **SCHRÖDER HOUSE, UTRECHT** The Netherlands. 1925.

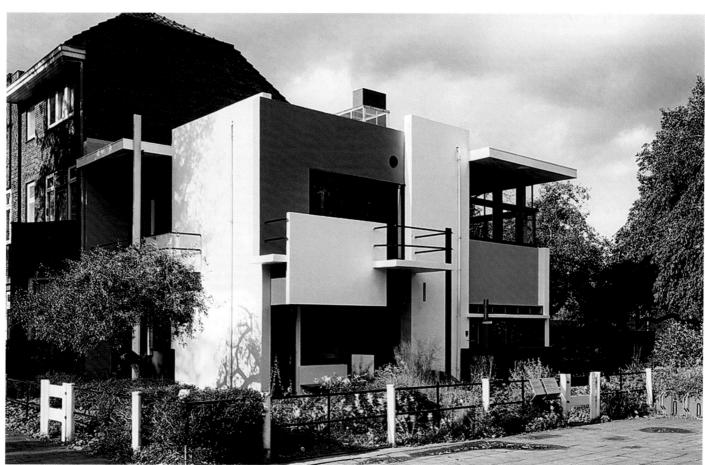

32-51 • Gerrit Rietveld INTERIOR, SCHRÖDER HOUSE, WITH "RED-BLUE" CHAIR 1925.

Schröder-Schröder, wanted a home that suggested an elegant austerity, with basic necessities sleekly integrated into a balanced and restrained whole.

THE BAUHAUS IN GERMANY

In Germany, the creators of the Bauhaus ("House of Building"), which had been founded by Walter Gropius (1883–1969) in Weimar in 1919, found the strict geometric shapes and lines of Purism (see Fig. 32–40) and De Stijl too rigid and argued that a true German architecture and design should emerge organically. Gropius brought together German architects, designers, and craftsmakers at the Bauhaus, where their collective creative energy could be harnessed to create an integrated system of design and production based on German traditions and styles. Gropius believed that he could revive the spirit of collaboration of the medieval building guilds (*Bauhütten*) that had erected Germany's cathedrals.

Although Gropius's "Bauhaus Manifesto" of 1919 declared that "the ultimate goal of all artistic activity is the building," the Bauhaus offered no formal training in architecture until 1927. Gropius only allowed his students to begin architectural training after they completed a mandatory foundation course and received full training in design and

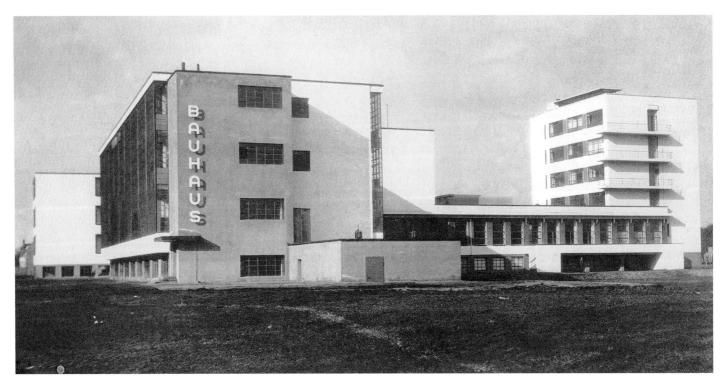

32-52 • Walter Gropius BAUHAUS BUILDING, DESSAU Anhalt, Germany. 1925–1926. View from northwest.

32-53 • Marianne Brandt **COFFEE AND TEA SERVICE** 1924. Silver and ebony, with Plexiglas cover for sugar bowl. Tray, 13" × 201/4" (33 × 51.5 cm). Bauhaus Archiv, Berlin.

all-male metal workshop, Brandt made an exceptional contribution to the Bauhaus.

Although the Bauhaus claimed that women were admitted on an equal basis with men, Gropius opposed their education as architects and channeled them into what he considered the more gender-appropriate workshops of pottery and textiles. Berlin-born Anni Albers (b. Annelise Fleischmann, 1899–1994) arrived at the school in 1922 and married the Bauhaus graduate and professor Josef Albers (1888–1976) in 1925. Obliged to enter the textiles workshop rather than the painting studio, Anni Albers made "pictorial" weavings and wall hangings (FIG. 32-54) that were so innovative that they actually replaced paintings on the walls of several modern buildings. Her decentralized, rectilinear designs make reference to the aesthetics of De Stijl, but differ in their open

crafts in the Bauhaus workshops. These included pottery, metalwork, textiles, stained glass, furniture, wood carving, and wall paintings. In 1922, Gropius also added a new emphasis on industrial design and the next year hired the Hungarian-born László Moholy-Nagy (1895–1946) to reorient the workshops toward more functional design suitable for mass production.

In 1925, when the Bauhaus moved to Dessau, Gropius designed its new building. Although the structure openly acknowledges its reinforced concrete, steel, and glass materials, there is also a balanced asymmetry to its three large cubic areas that was intended to convey the dynamism of modern life (FIG. 32-52). A glass-panel wall wraps around two sides of the workshop wing of the building to provide natural light for the workshops inside, while a parapet below demonstrates how modern engineering methods could create light, airy spaces. Both Moholy-Nagy and Gropius left the Bauhaus in 1928. The school eventually moved to Berlin in 1932, but lasted only one more year before the new German chancellor, Adolf Hitler, forced its closure (see "Suppression of the Avant-Garde in Nazi Germany," page 1056). Hitler opposed Modern art on two grounds. First, he believed it was cosmopolitan rather than nationalistic; second, he erroneously maintained that it was overly influenced by Jews.

Marianne Brandt's (1893–1983) elegant **COFFEE AND TEA SERVICE** (FIG. 32-53)—a prototype handcrafted in silver for mass production in cheaper metals—is an example of the collaboration between design
and industry at the Bauhaus. After the Bauhaus moved
to Dessau, Brandt also designed lighting fixtures and table
lamps for mass production, earning much-needed revenue
for the school. After the departure of Moholy-Nagy and
Gropius, Brandt took over the metal workshop for a year
before she too left, in 1929. As a woman in the otherwise

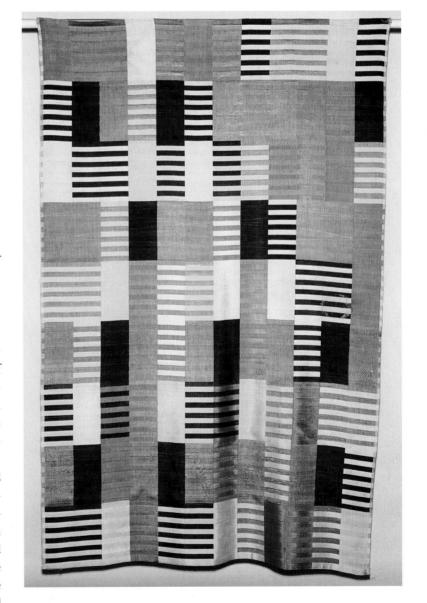

32–54 • Anni Albers **WALL HANGING** 1926. Silk, three-ply weave, $5'11^5/_{16}'' \times 3'11^5/_{10}''$ (1.83 \times 1.22 m). Harvard Art Museums/Busch-Reisinger Museum, Association Fund.

ART AND ITS CONTEXTS | Suppression of the Avant-Garde in Nazi Germany

In the 1930s, the avant-garde was increasingly disparaged by Hitler and the rising Nazi Party. This led to a concerted effort to suppress it. One of the principal targets was the Bauhaus. Through much of the 1920s, important artists such as Paul Klee, Vassily Kandinsky, Josef Albers, and Ludwig Mies van der Rohe taught classes there, but they struggled against an increasingly hostile and reactionary political climate. As early as 1924, conservatives accused the Bauhaus of being not only educationally unsound but also politically subversive. To avoid having the school shut down by the opposition, Gropius moved it to Dessau in 1925, at the invitation of Dessau's liberal mayor, but he left office soon after the relocation and his successors faced increasing political pressure to close the school as it was a prime center of Modernist practice. The Bauhaus moved again in 1932, this time to Berlin.

After Adolf Hitler came to power in 1933, the Nazi Party mounted an even more aggressive campaign against Modern art. In his youth Hitler had been a mediocre landscape painter, and he developed an intense hatred of the avant-garde. During the first year of his regime, the Bauhaus was forced to close permanently. A number of the artists, designers, and architects who had been on its faculty—including Albers, Gropius, and Mies—fled to the United States.

The Nazis also attacked German Expressionist artists, whose oftenintense depictions of German politics and the economic crisis after the war criticized the state and whose frequent caricatures of German facial features and body types undermined Nazi attempts to redraw Germans as idealized Aryans. Expressionist and avant-garde art was removed from museums and confiscated, and artists were forbidden to buy paint or canvas and were subjected to public intimidation.

In 1937, the Nazi leadership organized an exhibition of what they termed "Degenerate Art" in an attempt to ridicule the banned Modern art and erase its makers. The Nazis described avant-garde Modernism as sick and degenerate, presenting the confiscated paintings and sculptures as specimens of pathology and scrawling slogans and derisive commentaries on the walls of the exhibition (Fig. 32-55). Ironically, in Munich as many as 2 million people viewed the four-month exhibition of 650 paintings, sculptures, prints, and books confiscated from German museums and artists, and another 1 million visitors saw it on its three-year tour of German cities.

Large numbers of confiscated works destined for destruction were actually looted by Nazi officials and sold in Switzerland in exchange for foreign currency. The ownership of much of the surviving art is still in question. Many artists fled to neighboring countries or the United States, but some, like Ernst Ludwig Kirchner, whose *Street, Berlin* (see Fig. 32–13) appeared in the "Degenerate Art" exhibition, were driven to suicide by their loss. Even the work of artists sympathetic to the Nazi position was not safe. The works of Emil Nolde (see Fig. 32–12), who joined the Nazi Party in 1932, were also confiscated.

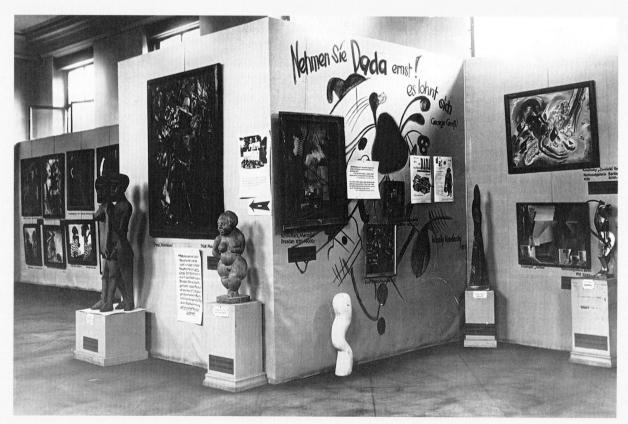

32–55 • THE DADA WALL IN ROOM 3 OF THE "DEGENERATE ART" ("ENTARTETE KUNST") EXHIBITION Munich. 1937. Art © Estate of George Grosz/Licensed by VAGA, New York, NY.

ELEMENTS OF ARCHITECTURE | The International Style

After World War I, increased communication among Modern architects led to the development of a common formal language, transcending national boundaries, which came to be known as the International Style. The first concentrated manifestation of the movement was in 1927 at the Deutscher Werkbund's Weissenhofsiedlung exhibition in Stuttgart, Germany, directed by Ludwig Mies van der Rohe (1886–1969), an architect who, like Gropius, was associated with the Bauhaus in Germany. The purpose of this semipermanent show was to present a range of model homes that used new technologies and made no reference to historical styles. The buildings featured flat roofs, plain walls, off-center openings, and rectilinear designs by Mies, Gropius, Le Corbusier, and others.

The term "International Style" gained currency as a result of a 1932 exhibition at the Museum of Modern Art in New York, "The International Style: Architecture Since 1922," organized by architectural historian Henry-Russell Hitchcock and architect and curator Philip Johnson. Hitchcock and Johnson identified three fundamental principles of the style.

The first was "the conception of architecture as volume rather than mass." The use of a structural skeleton of steel and ferroconcrete made it possible to eliminate loadbearing walls on both the exterior and the interior. As a result, buildings could be wrapped in skins of glass,

metal, or masonry, creating the effect of enclosed space (volume) rather than dense material (mass). Interiors featured open, free-flowing plans providing maximum flexibility in the organization of space.

The second was "regularity rather than symmetry as the chief means of ordering design." Regular distribution of structural supports and the use of standard building parts promoted rectangular regularity rather than the balanced axial symmetry of Classical architecture. The avoidance of Classical balance also encouraged an asymmetrical disposition of the building's components, including doors and windows.

The third was the rejection of "arbitrary applied decoration." The new architecture depended on the intrinsic elegance of its materials and the formal arrangement of its elements to produce harmonious aesthetic effects. The most extreme International Style buildings would be unadorned glass boxs.

According to Hitchcock and Johnson, the International Style originated in the Netherlands (De Stijl), France (Purism), and Germany (Bauhaus). After the 1932, it spread to the United States. The conceptual clarity of the International Style allowed it to remain vital until the 1970s, especially in the United States, where many of its original European architects, such as Mies and Gropius, who had escaped Hitler and the rise of Nazism in Germany in the 1930s, practiced.

acknowledgment of the natural process of weaving. Albers's goal was "to let threads be articulate ... and find a form for themselves to no other end than their own orchestration."

SURREALISM AND THE MIND

In France during the early 1930s, a group of artists and writers took a very different approach to Modernism in a revolt against logic and reason. Embracing irrational, disorderly, aberrant, and even violent social interventions, Surrealism emerged initially as an offshoot of Dada born from the mind of poet André Breton (1896-1966). Breton trained in medicine and psychiatry and served in a neurological hospital during World War I where he used Freudian analysis on shell-shocked soldiers. By 1924, Breton, still drawn to the vagaries of the human mind, published the "Manifesto of Surrealism," reflecting Freud's conception of the human mind as a battleground where the irrational forces of the unconscious wage a constant war against the rational, orderly, and oppressive forces of the conscious. Breton sought to explore humanity's most base, irrational, and forbidden sexual desires, secret fantasies, and violent instincts by freeing the conscious mind from reason. As Breton wrote in 1934, "we still live under the rule of logic." To escape this restraint, he and other Surrealists developed strategies to liberate the unconscious using dream analysis, free association, automatic writing, word games, and hypnotic trances. Surrealists studied acts of "criminal madness" and the "female mind" in particular, believing the latter to be weaker and more irrational than the male mind. The only way to improve the war-sick society of the 1920s, Breton thought, was to discover the more intense "surreality" that transcended rational constraint.

AUTOMATISM Surrealist artists employed a variety of techniques, including automatism—releasing the subconscious to create the work of art without rational intervention in order to produce surprising new juxtapositions of imagery and forms. Max Ernst (1891–1976), a self-taught German artist who collaborated in Cologne Dada and later joined Breton's circle in Paris, developed the automatist technique of frottage in 1925. First he rubbed a pencil or crayon over a piece of paper placed on a textured surface and allowed the resulting image to stimulate his imagination, discovering within it fantastic creatures, plants, and landscapes that he articulated more clearly with additional drawing. In painting, Ernst called this new technique grattage, with which he scraped layers of paint over a canvas laid on a textured surface, and then "revealed" the imagery he saw in the paint with additional painting. THE HORDE (FIG. 32-56) of 1927 shows a nightmarish scene of monsters advancing against an unseen force. Surely the horrors of World War I that Ernst had experienced firsthand in the German army lie behind such frightening images.

UNEXPECTED JUXTAPOSITIONS The paintings of Salvador Dalí (1904–1989) include more recognizable figures and forms, but they also reveal the visual wonders of a subconscious mind run wild. Dalí trained at the San Fernando Academy of Fine Arts in Madrid, where he mastered the traditional methods of illusion-

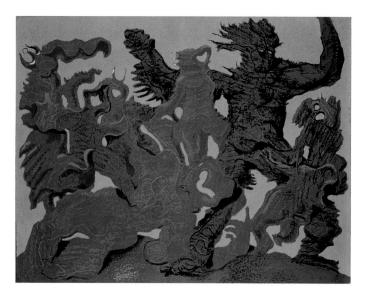

32–56 • Max Ernst THE HORDE 1927. Oil on canvas, $44\%'' \times 57\%''$ (114 \times 146.1 cm). Stedelijk Museum, Amsterdam.

istic representation, and traveled to Paris in 1928, where he met the Surrealists. Dalí's contribution to Surrealist theory was the "paranoid-critical method," in which he cultivated the paranoid's ability to misread, mangle, and misconstrue ordinary appearances, thus liberating himself from the shackles of conventional rational thought. Then he painted what he had imagined.

Dalí's paintings focus on a few key themes: sexuality, violence, and putrefaction. In the BIRTH OF LIQUID DESIRES (FIG. 32-57), we see a large yellow biomorphic form (an organic shape resembling a living organism)-looking like a monster's face, a painter's palette, or a woman's body—that serves as the backdrop for four figures. A woman in white embraces a hermaphroditic figure who stands with one foot in a bowl that is being filled with liquid by a third figure, partially hidden, while a fourth figure enters a cavernous hole to the left. A thick black cloud above the scene poses a question: "Consign: to waste the total slate?" Dalí claimed that he simply painted what his paranoid-critical mind had conjured up in his nightmares. Dalí's images are thus, as Breton advocated, "the true process of thought, free from the exercise of reason and from any aesthetic or moral purpose." They defy rational interpretation although they trigger fear, anxiety, and even regression in our empathetic minds.

Dalí's strangely compelling art also draws on the Surrealist interest in unexpected juxtapositions of disparate realities. Surrealists argued that by juxtaposing several disparate ordinary objects in strange new contexts artists could create uncanny surrealities. One of the most disturbingly exquisite and mockingly humorous examples is **OBJECT (LUNCHEON IN FUR)** (**FIG. 32-58**), by the Swiss artist Meret Oppenheim (1913–1985). Oppenheim was one of the few women invited to participate in the Surrealist movement. Surrealists generally treated women as their muses or as objects of

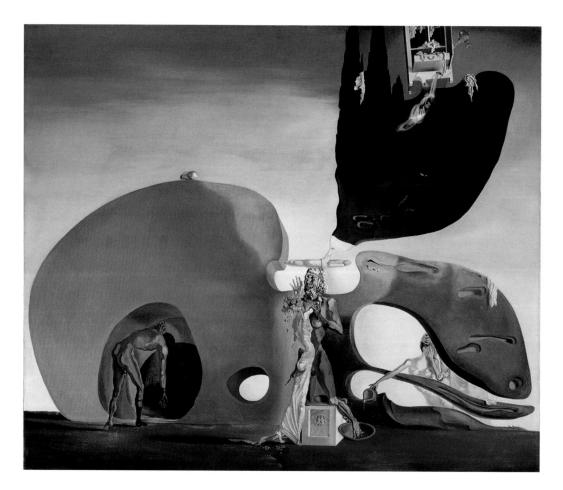

32–57 • Salvador Dalí **BIRTH OF LIQUID DESIRES** 1931–1932. Oil and collage on canvas, 37% × 44% (96.1 × 112.3 cm). The Solomon R. Guggenheim Foundation. Peggy Guggenheim Collection, Venice 1976 (76.2553 PG 100)

32-58 • Meret Oppenheim OBJECT (LUNCHEON IN FUR)

1936. Fur-covered cup, diameter 4%" (10.9 cm); fur-covered saucer, diameter 9%" (23.7 cm); fur-covered spoon, length 8" (20.2 cm); overall height, 27%" (7.3 cm). Museum of Modern Art, New York.

View the Closer Look for *Object* on myartslab.com

study, but not their equals: Picasso even claimed to have "given" Oppenheim the idea for this sculpture. *Object* consists of an actual cup, saucer, and spoon covered with the fur of a Chinese gazelle (chosen for its resemblance in texture to pubic hair). It transposes two objects (a tea setting and gazelle fur) from their ordinary reality, recontextualizes them in an irrational new surreality, and transforms them into an uncanny object that is simultaneously desirable and deeply disturbing.

BIOMORPHIC ABSTRACTION The Catalan artist Joan Miró (1893–1983) exhibited regularly with the Surrealists but never formally joined the movement. Miró's biomorphic abstraction is also intended to free the mind from rationality, but in a more benign manner. His COMPOSITION (FIG. 32-59) of 1933 is populated by curving biomorphic primal or mythic shapes that seem arranged by chance, emerging from the artist's mind uncensored, like doodles, to dance gleefully around the canvas. The Surrealists

32-59 • Joan Miró **COMPOSITION** 1933. Oil on canvas, 511/4" × 631/2" (130.2 × 161.3 cm). Wadsworth Athenaeum, Hartford, Connecticut.

used the free association of doodling to relax the conscious mind so that images could bubble up from the unconscious. Miró reportedly first doodled on his canvases, then painted the revealed shapes and forms. His images do seem to take shape before our eyes, but their identity is always in flux. Miró was also fascinated by children's art, which he thought of as spontaneous and expressive and, although he was a well-trained artist himself, he said that he wished he could learn to paint with the freedom of a child.

UNIT ONE IN ENGLAND

In 1933, the English artists Barbara Hepworth (1903–1975), Henry Moore (1898–1986), and Paul Nash (1889–1946), along with the poet and critic Herbert Read (1893–1968), founded Unit One. Although short-lived, this group promoted the use of hand-crafted, Surrealist-influenced biomorphic forms in sculpture, brought new energy to British art in the 1930s, and exerted a lasting impact on British sculpture.

Hepworth studied at the Leeds School of Art. She punctuated her exquisitely crafted sculptures with holes so that air and light

32-60 • Barbara Hepworth **FORMS IN ECHELON** 1938. Wood, $42\frac{1}{2}$ " \times $23\frac{2}{3}$ " \times 28" (108 \times 60 \times 71 cm). Tate, London. Presented by the artist 1964 © Bowness, Hepworth Estate.

Read the document related to Barbara Hepworth on myartslab.com

could pass through them. **FORMS IN ECHELON** (FIG. 32-60) consists of two biomorphic shapes carved in highly polished wood. Hepworth hoped that viewers would allow their eyes to play around with these organic forms, letting viewer imagination generate changing associations and meanings.

Moore also carved punctured sculptural abstractions, although his works were more obviously based on the human form. He also studied at the Leeds School of Art and then at the Royal College of Art in London. The African, Oceanic, and Pre-Columbian sculpture that he saw at the British Museum, however, had a more powerful impact on his developing aesthetic than his academic training. He felt that artists beyond the Western tradition showed a greater respect for the inherent qualities of materials such as stone or wood than their Western counterparts.

The reclining female nude is the dominant theme of Moore's art. The massive simplified body in **RECUMBENT FIGURE** (FIG. 32-61) refers to the *chacmool*, a reclining human form in Toltec and Maya art (see FIG. 13-14). Moore's sculptures also reveal his special sensitivity to the inherent qualities of his stone, which he sought out in remote quarries, always insisting that each of his works be labeled with the specific kind of stone he had used. While certain aspects of the human body are clearly described in this sculpture—the head, breasts, supporting elbow, and raised knee—other parts seem to flow together into an undulating mass suggestive of a hilly landscape. The cavity at the center inverts our expectations about the solid and void. In 1937, Moore wrote: "A hole can itself have as much shape-meaning as a solid mass."

MODERN ART IN THE AMERICAS BETWEEN THE WARS

A need for a national visual identity emerged in American art between the wars, but since the United States was a large, diverse nation with multiple "identities," attempts to consolidate the fiction of a single, essentially male, Anglo-Saxon national profile only heightened the visibility of the creative and experimental works of art by African Americans, immigrants, women, and others.

THE HARLEM RENAISSANCE

In the 1930s, hundreds of thousands of African Americans migrated from the rural, mostly agricultural American South to the urban, industrialized North to escape racial oppression and find greater social and economic opportunities. This Great Migration prompted the formation of the nationwide New Negro movement and the Harlem Renaissance in New York, which called for greater social and political activism among African Americans.

Harlem's wealthy middle-class African-American community produced some of the nation's most talented artists of the 1920s and 1930s, such as the jazz musician Duke Ellington, the novelist Jean Toomer, and the poet Langston Hughes. The movement's

32-61 • Henry Moore RECUMBENT FIGURE1938. Green Hornton stone,
35" × 52" × 29" (88.9 × 132.7 × 73.7 cm). Tate, London.

Moore created this work to fulfill a commission from Russianborn British architect Serge Chermayeff, who installed it on the terrace of his modern home on the Downs.

intellectual leader was Alain Locke (1886–1954), a critic and philosophy professor who argued that black artists should seek their artistic roots in the traditional arts of Africa rather than assimilate within mainstream American or European artistic traditions.

James Van Der Zee (1886–1983), a studio photographer who took carefully crafted portraits of the Harlem upper-middle classes, opened his studio in 1916, working both as a news reporter and a society photographer. **COUPLE WEARING RACCOON COATS**

WITH A CADILLAC (FIG. 32-62) captures a wealthy man and woman posing with their new car in 1932, at the height of the Great Depression. The photograph reveals the glamor of Harlem, then the center of African-American cultural life.

The painter Aaron Douglas (1898–1979), from Topeka, Kansas, moved to New York City in 1925. He developed a collaged silhouette style that owes much to African art and had a lasting impact on later African-American artists (see FIG. 33–73). He painted

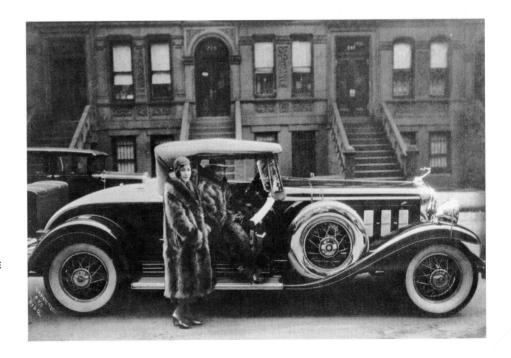

32-62 • James Van Der Zee COUPLE WEARING RACCOON COATS WITH A CADILLAC, TAKEN ON WEST 127TH STREET, HARLEM, NEW YORK

1932. Gelatin-silver print.

A BROADER LOOK | Guernica

In January 1937, as the Spanish Civil War between the Republicans and the Nationalists began to escalate, the Spanish artist Pablo Picasso, who was then living in Paris, was commissioned to make a large painting for the Spanish Pavilion of the 1938 Paris Exposition, a direct descendant of the nineteenth-century World's Fairs that resulted in the Crystal Palace and the Eiffel Tower. The 1938 Spanish Pavilion was the first Spanish national pavilion at any World's Fair.

As Picasso pondered what he might create for the exposition, on April 26, 1937, Nationalist-supporting German bombers attacked the town of Guernica in the Basque region of Spain, killing and wounding 1,600 civilians. The cold-blooded, calculating nature of the inhuman attack on Guernica shocked Europe. For more than three hours. 25 bombers dropped 100,000 pounds of explosives on the town, while more than 20 fighter planes strafed anyone caught in the streets trying to flee destroyed or burning buildings. Fires burned in Guernica for three days. By the end, one-third of the town's population was killed or wounded and 75 percent of its buildings had been destroyed (FIG. 32-63). The attack seemed to serve no military purpose, other than to allow Franco's Nationalist forces to terrorize civilian populations, but the true horror only emerged with the revelation that the German commander had planned the massacre merely as a "training mission" for the German air force. The horrified Picasso now had his subject for

On May 1, 1 million protesters marched in Paris, and the following day Picasso made his first preliminary sketches for his visual response to this atrocity. Picasso had been trained in the traditions of academic painting, and he planned **GUERNICA** (FIG. 32-64) as an monumental history painting detailing the historic, and ignoble, events of the attack. He made several preliminary sketches (esquisses) to develop the composition, colors, during ten days of intensive planning, before moving on to canvas. He worked at the painting itself—changing figures, altering colors, and developing his themes—for another month.

Guernica is a complex painting, layered with meaning. Picasso rarely used specific or obvious symbolism in his art, preferring to let individual viewers interpret specific details themselves. What is beyond question,

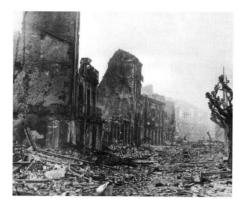

however, is that *Guernica* is a scene of brutality, chaos, terror, and suffering. Painted in black, white, and dark blue, the image resonates with anguish. It freezes figures in mid-movement in stark black and white as if caught by the flashbulb of a reporter's camera.

32-63 • RUINS OF GUERNICA, SPAIN April 1937.

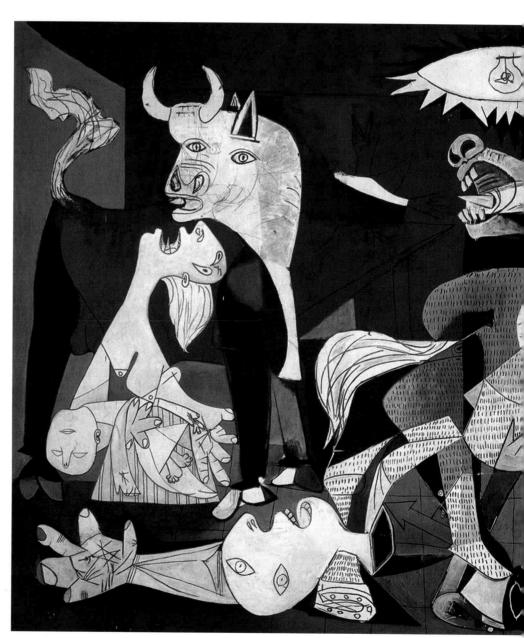

32-64 • Pablo Picasso GUERNICA

1937. Oil on canvas, 11'6" \times 25'8" (3.5 \times 7.8 m). Museo Nacional Centro de Arte Reina Sofía, Madrid. On permanent loan from the Museo del Prado, Madrid.

Many of the collected subjects are clearly identifiable: an expressionistically reconfigured head of a bull in the upper left, a screeching wounded horse in the center, broken human forms scattered across the expanse, a giant light bulb suggesting an all-seeing eye at the top, a lamp below it, and smoke and fire visible beyond the destroyed room in which the disjointed action takes place. These images have inspired a variety of interpretations. Some have seen in the bull and horse, symbols of Nationalist and Republican forces, variously

identified with one or the other. The light bulb, javelin, dagger, lamp, and bird have also been assigned specific meanings. Picasso, however, refused to acknowledge any particular significance to any of these seeming symbols. *Guernica*, he claimed, is about the massacred victims of this atrocity—beyond that, its meaning remains fluid.

Guernica appeared in the Spanish Pavilion along with other works of art supporting the Republican cause, including works by painter Joan Miró, sculptor Alexander Calder,

filmmaker Luis Buñuel, and others. Because Picasso refused to allow *Guernica* to be shown in Spain under the regime of Nationalist leader General Franco, it hung in the Museum of Modern Art in New York for years, finally traveling to Spain for installation in the Reina Sofía in Madrid only in 1981, six years after Franco's death. Since 1985, a tapestry copy of *Guernica* has hung as a powerful reminder of the brutal human cost of unrestrained warfare in the headquarters of the United Nations in New York.

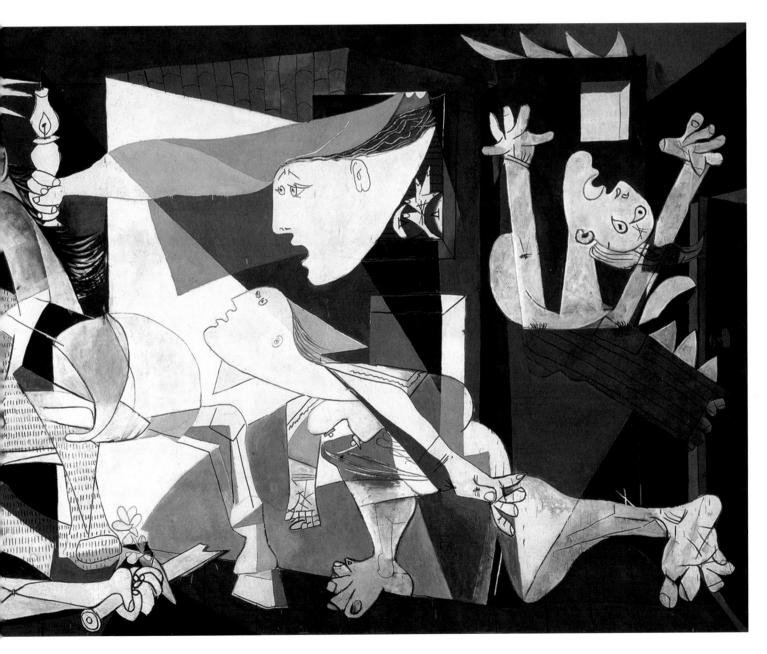

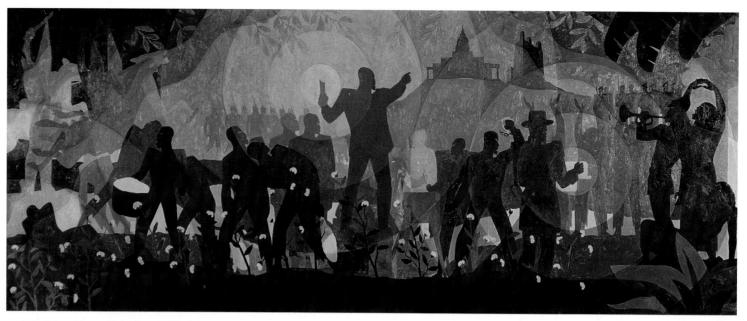

32-65 • Aaron Douglas ASPECTS OF NEGRO LIFE: FROM SLAVERY THROUGH RECONSTRUCTION

1934. Oil on canvas, $5'\times 11'7''$ (1.5 \times 3.5 m). Schomburg Center for Research in Black Culture, New York Public Library. Art © Heirs of Aaron Douglas/Licensed by VAGA, New York, NY

ASPECTS OF NEGRO LIFE: FROM SLAVERY THROUGH RECONSTRUCTION (FIG. 32-65) for the Harlem branch of the New York Public Library under the sponsorship of the Depressionera Public Works of Art Project. To the right, slaves are celebrating the 1863 Emancipation Proclamation of 1863, from which radiate concentric circles of light. At the center, an orator gestures dramatically, pointing to the United States Capitol in the background, as if to urge all African Americans, some of whom are still picking cotton in the foreground, to exercise their right to vote. To the left, Union soldiers leave the South after Reconstruction, while Ku Klux Klan members, hooded and on horseback, charge in, reminding viewers that the fight for civil rights has only just begun.

The career of sculptor Augusta Savage (1892–1962) reflects the myriad difficulties faced by African Americans in the art world. Savage studied at Cooper Union in New York, but her 1923 application to study in Europe was turned down because of her race. In a letter of protest, she wrote: "Democracy is a strange thing. My brother was good enough to be accepted in one of the regiments that saw service in France during the war, but it seems his sister is not good enough to be a guest of the country for which he fought." Finally, in 1930, Savage was able to study in Paris. On her return to the United States, she sculpted portraits of several African–American leaders, including Marcus Garvey and W.E.B.

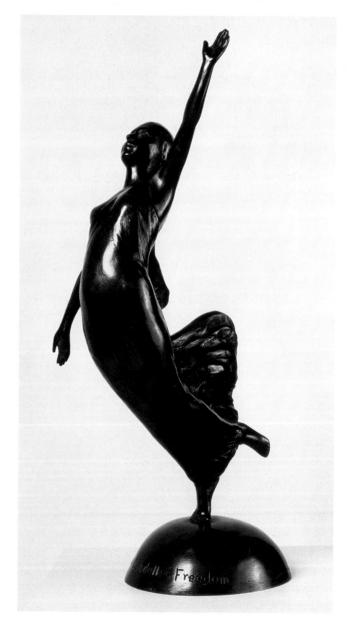

32-66 • Augusta Savage LA CITADELLE: FREEDOM 1930. Bronze, $14^{1}\!/2^{\prime\prime} \times 7^{\prime\prime} \times 6^{\prime\prime}$ (35.6 \times 17.8 \times 15.2 cm). Howard University Gallery of Art, Washington, DC.

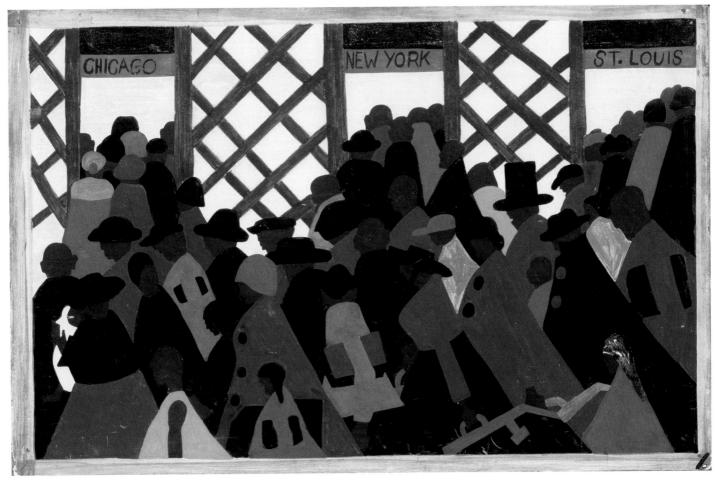

32-67 • Jacob Lawrence THE MIGRATION SERIES, PANEL NO. 1: DURING WORLD WAR INTERE WAS A GREAT MIGRATION NORTH BY SOUTHERN AFRICAN AMERICANS 1940–1941. Tempera on masonite, $12'' \times 18''$ (30.5 \times 45.7 cm). The Phillips Collection, Washington, DC.

DuBois. Inspired by the story of the Haitian Revolution in 1791 following the Slave Revolt (see FIG. 30–39), she portrayed a female figure of freedom in **LA CITADELLE: FREEDOM** (FIG. 32–66), raising her hand to the sky and balancing on the toes of one foot while she flies through the air. La Citadelle was the castle residence of one of Haiti's first leaders of African heritage. For Savage, it represented the possibility and promise of freedom and equality.

Savage established a small private art school in Harlem and received Federal funds under the Works Progress Administration (see "Federal Patronage for American Art During the Depression," page 1066) to transform it into the Harlem Community Art Center. Hundreds of these centers were eventually established all over the country, but Savage's became an unofficial salon for Harlem artists, poets, composers, dancers, and historians.

One of the best-known artists to emerge from the Harlem Community Art Center was Jacob Lawrence (1917–2000). Lawrence's early works often depict African-American history in several series of small narrative paintings, each accompanied by a text. His themes include the history of Harlem and the lives of Haitian revolutionary leader Toussaint L'Ouverture and American abolitionist John Brown. Lawrence created his most expansive

series in 1940–1941. Entitled **THE MIGRATION SERIES**, 60 panels chronicle the Great Migration, a journey that had brought Lawrence's own parents from South Carolina to Atlantic City, New Jersey. In the first panel (**FIG. 32-67**), African-American migrants stream through the doors of a Southern train station on their way to Chicago, New York, or St. Louis. Lawrence's boldly abstracted silhouette style, with its flat bright shapes and colors, draws consciously and directly—like that of Douglas—on African visual sources. Lawrence later illustrated books by Harlem Renaissance authors.

RURAL AMERICA

In the 1930s, other artists, known collectively as the Regionalists, developed Midwestern themes. In 1931, at the height of the Depression, Grant Wood (1891–1942), who later taught at the University of Iowa, painted **AMERICAN GOTHIC** (FIG. 32-69), which was purchased by the Art Institute of Chicago and established Wood's national fame. This picture embodied all that was good and bad about the heartland in the 1930s. Wood portrays an aging father standing with his unmarried daughter in front of their Gothic Revival framed house. Even for the time their clothes are

ART AND ITS CONTEXTS | Federal Patronage for American Art During the Depression

In the early 1930s, during the Great Depression, President Franklin D. Roosevelt's New Deal established a series of programs to provide relief for the unemployed and to revive the nation's economy, including several initiatives to create work for American artists. The 1933 Public Works of Art Project (PWAP) lasted only five months but supplied employment to 4,000 artists, who produced more than 15,000 works. The Treasury Department established a Section of Painting and Sculpture in October 1934, which survived until 1943, commissioning murals and sculptures for public buildings. The Federal Art Project (FAP) of the Works Progress Administration (WPA), which ran from 1935 to 1943, succeeded the PWAP and was the most important work-relief agency of the Depression era. By 1943, it had employed more than 6 million workers in programs that included, in addition to the FAP, the Federal Theater Project and the Federal Writers' Project. About 10,000 artists participated in the FAP. producing a staggering 108,000 paintings, 18,000 sculptures, 2,500 murals, and thousands of prints, photographs, and posters, all of which became public property. Many of the murals and sculptures, commissioned for public buildings such as train stations, schools, hospitals, and post offices, survive today, but most easel paintings were later sold as "plumber's canvas" and destroyed.

To build public support for Federal assistance in rural America, the Resettlement Agency (RA) and Farm Security Administration (FSA) hired photographers to document the effects of the Depression across the country in photographs available to this day, copyright-free, to any newspaper, magazine, or publisher. San Francisco-based Dorothea Lange (1895–1965), an RA/FSA photographer between 1935 and 1939, documented the plight of migrant farm laborers who fled the Dust Bowl conditions of the Great Plains and then flooded California looking for work.

MIGRANT MOTHER, NIPOMO, CALIFORNIA (Fig. 32-68) shows Florence Owens Thompson, a 32-year-old mother of seven children, a representative of the poverty suffered by thousands of migrant workers in California. Lange carefully constructed her photograph to tug at the heartstrings. She zooms in very close to the subject focusing on the mother's worn expression and apparent resolve. The composition may

32-68 • Dorothea Lange MIGRANT MOTHER, NIPOMO, CALIFORNIA

February 1936. Gelatin-silver print. Library of Congress, Washington, DC.

In 1960, Lange described the experience of taking this photograph: "I saw and approached the hungry and desperate mother, as if drawn by a magnet. I do not remember how I explained my presence or my camera to her, but I do remember she asked me no questions. I made five exposures, working closer and closer from the same direction. I did not ask her name or her history. She told me her age, that she was thirty-two. She said that they had been living on frozen vegetables from the surrounding fields, and birds that the children killed. She had just sold the tires from her car to buy food. There she sat in that lean-to tent with her children huddled around her, and seemed to know that my pictures might help her, and so she helped me. There was a sort of equality about it. (Popular Photography, Feb. 1960)

remind viewers of the images of the Virgin Mary holding the Child Jesus (see Fig. 21–7), or perhaps sorrowful scenes in which she contemplates his loss (see Fig. 21–9). Lange chose to eliminate from this photograph the makeshift tent in which the family is camped, the dirty dishes on a battered trunk, trash strewn around the campsite, and, most significant, Thompson's teenage daughter—all documented in her other photographs of the same scene. Lange decided to focus here on the purity and moral worth of her subject, for whom she sought Federal aid; she could not allude to the fact that Thompson had been a teenage mother, or even that she was Cherokee. Migrant Mother (then unidentified by name) became the "poster child" of the Great Depression, and her powerfully sad, distant gaze still resonates with audiences today, demonstrating the propaganda power of the visual image.

During the Depression, the FAP paid a generous average salary of about \$20 a week (a salesclerk at Woolworth's earned only about \$11) for painters and sculptors to devote themselves full time to art. New York City's painters, in particular, developed a group identity, meeting in the bars and coffeehouses of Greenwich Village to discuss art. The FAP thus provided the financial grounds on which New York artists built a sense of community—a community that would produce the Abstract Expressionists, and that allowed New York to supersede Paris as the center of the world of Modern art.

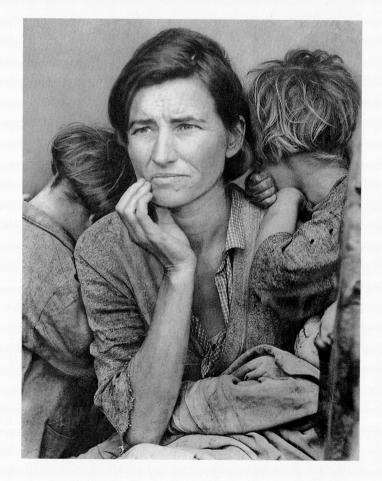

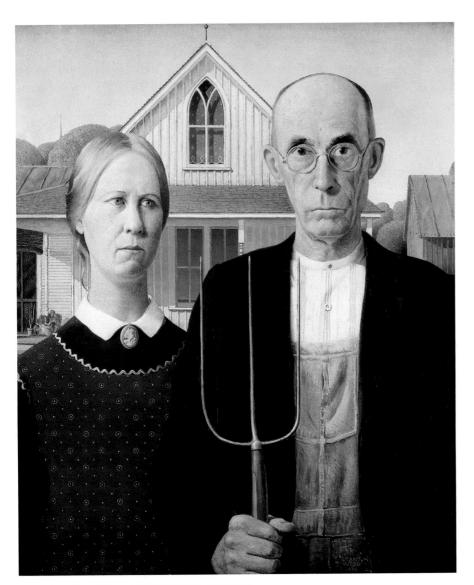

32–69 • Grant Wood **AMERICAN GOTHIC** 1930. Oil on beaverboard, 29% " \times 24%" (74.3 \times 62.4 cm). The Art Institute of Chicago. Friends of American Art Collection, 1930.934. Art © Figge Art Museum, successors to the Estate of Nan Wood Graham/Licensed by VAGA, New York, NY

old-fashioned. Wood's dentist and his sister Nan—wearing a home-made ricrac-edged apron and Wood's mother's cameo—posed for the painting; the building was modeled on an actual, modest small-town home in Eldon, Iowa. The daughter's long sad face echoes her father's—she is unmarried and likely to stay that way. In 1931, husbands were hard to come by in the Midwest because many young men had fled the farms for jobs in Chicago. With its tightly painted descriptive detail, this painting is a homage to the Flemish Renaissance painters that Wood admired.

32-70 • Tom Thomson THE JACK PINE 1916–1917. Oil on canvas, 49% × 54% (127.9 × 139.8 cm). National Gallery of Canada, Ottawa, Ontario. Purchase, 1918

CANADA

In the nineteenth century, Canadian artists, like their counterparts in the United States, began to assert independence from European art by painting Canada's great untamed wilderness. A number of Canadians, however, used the academic realism they learned in Paris to paint figurative subjects, while others painted the Canadian landscape through the lens of Impressionism.

LANDSCAPE AND IDENTITY In the early 1910s, a young group of Toronto artists, many of whom worked for the same commercial art firm, began to sketch together, adopting the rugged landscape of the Canadian north as an expression of national identity.

A key figure in this movement was Tom Thomson (1877–1917), who, as of 1912, spent the warm months of each year in Algonquin Provincial Park, a large forest reserve 180 miles north of Toronto. He made numerous small, swiftly painted, oil-on-board sketches as the basis for the full-size paintings that he executed in his studio during the winter. A sketch made in the spring of 1916 led to **THE JACK PINE** (**FIG. 32-70**). This tightly organized composition features a stylized pine tree rising from a rocky foreground and silhouetted against a luminous background of lake and sky,

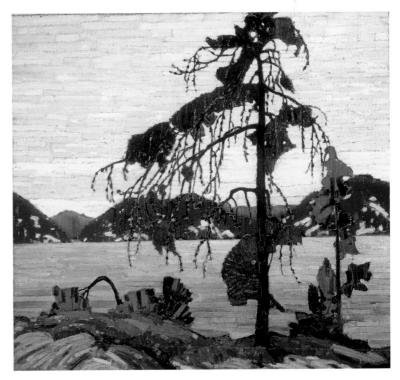

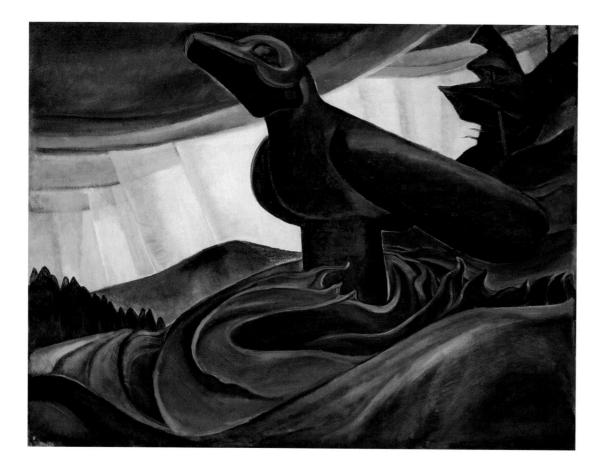

32-71 • Emily Carr BIG RAVEN 1931. Oil on canvas, 341/4" × 447/6" (87 × 114 cm). Collection of the Vancouver Art Gallery, Emily Carr Trust.

horizontally divided by cold blue hills. The hauntingly beautiful painting's reverential mood—suggesting a divine presence in the lonely northern landscape—has made it an icon of Canadian national art.

NATIVE AMERICAN INFLUENCE Born in Victoria, British Columbia, the West Coast artist Emily Carr (1871-1945) studied art in San Francisco, England, and Paris. On a 1907 trip to Alaska she encountered the monumental carved poles of Northwest Coast Native peoples and resolved to document these "real art treasures of a passing race." Over the next 23 years, Carr visited more than 30 sites across British Columbia, making drawings and watercolors as a basis for oil paintings. After a commercially unsuccessful exhibition of her Native subjects, Carr returned to Victoria in 1913, opened a boarding house, and painted very little for the next 15 years. In 1927, however, she was invited to participate in an exhibition of West Coast art at the National Gallery of Canada. On her trip east for the show's opening, Carr met members of the Group of Seven, which had been established in 1920 by some of Tom Thomson's former colleagues. They rekindled her interest in painting.

With the Group of Seven, Carr developed a dramatic and powerfully sculptural style full of dark, brooding energy. **BIG RAVEN** (**FIG. 32-71**), painted in 1931 from a 1912 watercolor, shows an abandoned village in the Queen Charlotte Islands where Carr found a carved raven on a pole, the surviving member of a

pair that originally marked a mortuary house. In her autobiography Carr described the raven as "old and rotting," but in the painting she shows it as strong and majestic, thrusting dynamically above the swirling vegetation, a symbol of enduring spiritual power and national pride.

MEXICO

The Mexican Revolution of 1910 overthrew the 35-year dictatorship of General Porfirio Díaz and initiated ten years of political instability. In 1920, reformist president Álvaro Obregón restored political order, and the leaders of his new government—as in the U.S.S.R.—engaged artists in the service of the people and state. Several Mexican artists received government commissions to decorate public buildings with murals celebrating the history, life, and work of the Mexican people. These artists painted in a naturalistic style because the new government believed abstract art was incomprehensible to the public at large.

Diego Rivera (1886–1957) was prominent in the Mexican mural movement that developed from these commissions. He enrolled in Mexico City's Academia de San Carlos at age 11, and from 1911 to 1919, he lived in Paris where he met Picasso and David Siqueiros (1896–1974), another Mexican muralist. Both Rivera and Siqueiros sought to create a revolutionary art in the service of the people in their public murals. In 1920–1921, Rivera traveled to Italy to study Renaissance frescoes, and he also visited ancient Mexican sites to study indigenous mural paintings. In 1945,

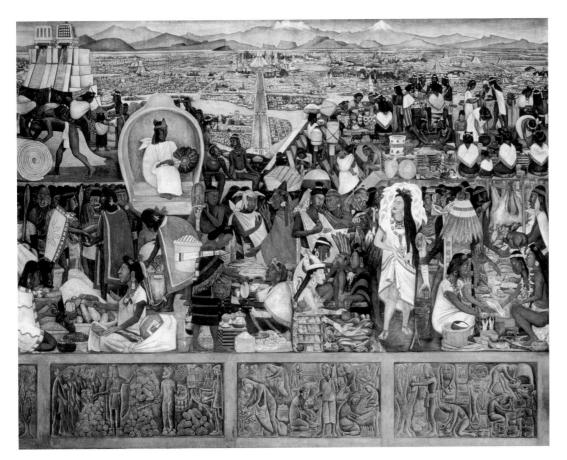

32-72 • Diego Rivera
THE GREAT CITY
OF TENOCHTITLAN
(DETAIL)

Mural in patio corridor, National Palace, Mexico City. 1945. Fresco, $16'1\%'' \times 31'101\%'' (4.92 \times 9.71 \text{ m}).$

Watch a video about Diego Rivera's fresco technique on myartslab.com

he painted **THE GREAT CITY OF TENOCH- TITLAN** (**FIG. 32-72**) as part of a mural cycle that used stylized forms and brilliant local colors to portray the history of Mexico in the National Palace in Mexico City. Rivera also painted murals in the United States.

The art of Frida Kahlo (1907–1954) is more personal. André Breton claimed Kahlo as a natural Surrealist, although she herself said: "I never painted dreams. I painted my own reality." That reality included her mixed heritage, born of a German father and Mexican mother. In a double self-portrait—**THE TWO FRIDAS** (FIG. 32-73)—Kahlo presents an identity split into two ethnic selves: the European one, in a Victorian dress; and the Mexican one, wearing traditional Mexican clothing. The painting also reflects her stormy relationship with Diego Rivera, whom she married in 1929 but was divorcing in 1939

32–73 • Frida Kahlo **THE TWO FRIDAS** 1939. Oil on canvas, $5'8\frac{1}{2}''\times5'8\frac{1}{2}''$ (1.74 \times 1.74 m). Museo de Arte Moderno, Instituto Nacional de Bellas Artes, Mexico City.

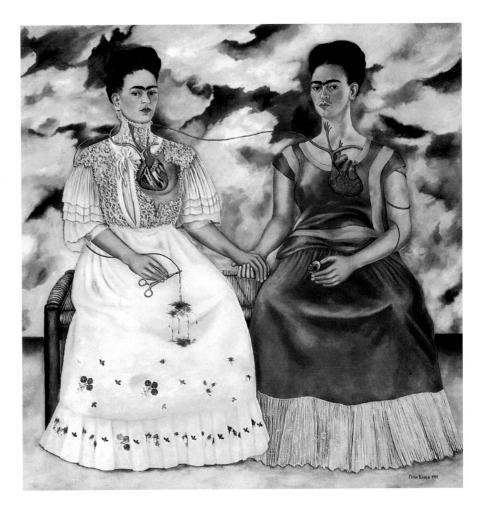

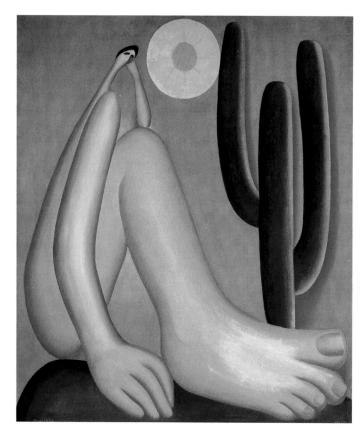

32-74 • Tarsila do Amaral ABAPORÚ (THE ONE WHO EATS)

1928. Oil on canvas, $34'' \times 29''$ (86.4 \times 73.7 cm). Museo de Arte Latinoamericano, Buenos Aires. Courtesy of Guilherme Augusto do Amaral/Malba-Coleccion Constantini, Buenos Aires.

while painting this picture. She told an art historian at the time that the Mexican image was the Frida whom Diego loved, and the European image was the Frida he did not. The two Fridas join hands and the artery running between them begins at a miniature portrait of Rivera as a boy held by the Mexican Frida, travels through the exposed hearts of both Fridas, and ends in the lap of the Europeanized Frida, who attempts without success to stem the flow of blood. Kahlo had suffered a broken pelvis in an accident at age 17, and she endured a lifetime of surgical interventions. This work alludes to her constant pain, as well as to the Aztec custom of human sacrifice by heart removal.

BRAZIL

Elsewhere in Latin America, art was often dominated by the academic tradition in the nineteenth century. Several nations had thriving academies and large art communities; artists traveled in significant numbers to study in Paris. By 1914, artists in many Latin American countries adopted their own versions of Impressionism to paint national themes. After the war, artists who studied abroad also brought home ideas drawn from Modern art and the European avant–garde which they translated into a specifically Latin American vision. For instance, in 1922, as Brazil marked the centenary of

its independence from Portugal, the avant-garde in São Paulo celebrated with Modern Art Week, an event Brazilian artists used to declare their artistic independence from Europe. Modern Art Week brought avant-garde poets, dancers, and musicians as well as visual artists to São Paulo and took on a distinctly confrontational character. Poets derided their elders in poetry, dancers enacted modern versions of traditional dances, and composer Hector Villa-Lobos (1887–1959) appeared on stage in a bathrobe and slippers to play new music based on Afro-Brazilian rhythms.

In 1928, the São Paulo poet Oswald de Andrade, one of Modern Art Week's organizers, wrote the *Anthropophagic Manifesto* proposing a tongue-in-cheek, if radical, solution to Brazil's seeming dependence on European culture. He suggested that Brazilians imitate the ancient Brazilians' response to Portuguese explorers arriving on their shore—eat them. He mockingly described this relationship as anthropophagic or cannibalistic and proposed that Brazilians gobble up European culture, digest it, let it strengthen their Brazilianness, and then get rid of it.

The painter who most closely embodies this irreverent attitude is Tarsila do Amaral (1887–1974), a daughter of the coffee-planting aristocracy who studied in Europe with Fernand Léger (see FIG.

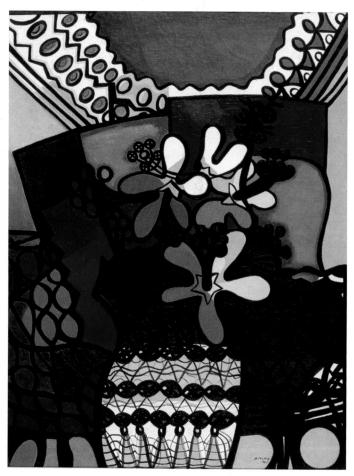

32–75 • Amelia Peláez MARPACÍFICO (HIBISCUS) 1943. Oil on canvas, $45\frac{1}{2}$ " \times 35" (115.6 \times 88.9 cm). Art Museum of the Americas, Washington, DC. Gift of IBM

32–21), among others. Her painting **ABAPORÚ** (**THE ONE WHO EATS**) (FIG. 32–74) shows an appreciation of the art of Léger and Brancusi (see FIGS. 32–21, 32–28), which Tarsila collected. But she also inserted several "tropical" clichés—the abstracted forms of a cactus and a lemon-slice sun. The subject is Andrade's irreverent cannibal, sitting in a caricatured Brazilian landscape, as if to say: If Brazilians are caricatured abroad as cannibals, then let us act like cannibals. As Andrade wrote in one of his manifestos: "Carnival in Rio is the religious outpouring of our race. Richard Wagner yields to the samba. Barbaric but ours. We have a dual heritage: The jungle and the school."

CUBA

Cuba's 1920s avant-garde was one of the most interdisciplinary, consisting of anthropologists, poets, composers, and even a few scientists, who gathered in Havana and called themselves "The Minority." They issued a manifesto in 1927 repudiating government corruption, "Yankee imperialism," and dictatorship on any continent. "Minority" artists, they urged, should pursue a new, popular, Modern art rooted in Cuban soil.

Amelia Peláez (1896–1968) left Cuba for Paris shortly after this manifesto was issued. When she returned home, she joined the

anthropologist Lydia Cabrera to study Cuban popular and folk arts. Her paintings focus on the woman's realm—the domestic interior—and national identity, as in MARPACÍFICO (HIBISCUS) (FIG. 32-75). Her visual language is Cubist, as seen in the flattened overlapping forms and compressed pictorial space, but it shows recognizable objects—a mirror, a tabletop, and local hibiscus flowers—whose heavy black outlines and pure color reflected the flat, fan-shaped stained-glass windows that decorate many Cuban homes.

POSTWAR ART IN EUROPE AND THE AMERICAS

The horrors of World War II surpassed even those of World War I. The human loss was almost too profound and grotesque to comprehend. Between loss of life in action, those killed in work camps and death camps (concentration camps), those lost to starvation, and those lost in the bombing of civilian targets, more than 30 million people died and a further estimated 40 million people were displaced. The unimaginable horror of the concentration camps and the awful impact of the dropping of nuclear bombs shook humanity to its core. Winston Churchill described the extent of the catastrophe: "What is Europe now? A rubble heap, a charnel house, a breeding ground of pestilence and hate."

FIGURAL RESPONSES AND ART INFORMEL IN EUROPE

Most European artists in the immediate postwar period tried to use their art to come to terms with what they had experienced, many debating about how best to do this. Some worked figuratively while others painted abstractions.

In England, Francis Bacon (1909–1992) captured in his canvases the horrors that haunted him. Bacon was self-taught and produced very few pictures until the 1940s. He served as an airraid warden during World War II and saw the bloody impact of the bombing of civilians in London firsthand. In **HEAD SUR-ROUNDED BY SIDES OF BEEF** (FIG. 32-76), Bacon presents the imperious Pope Innocent X, reduced to an anguished and insubstantial man, howling in a black void, as two bloody sides of beef enclose him in a claustrophobic box that contains his frightful screams and amplifies his terror. The painting was directly inspired by Diego Velázquez's 1650 portrait of Pope Innocent X and by Rembrandt's paintings of dripping meat. Bacon wrote of his art: "I hope to make the best human cry in painting ... to remake the violence of reality itself."

One of the most distinctive postwar European art movements was *Art Informel* ("formless art"), which was also called *tachisme*

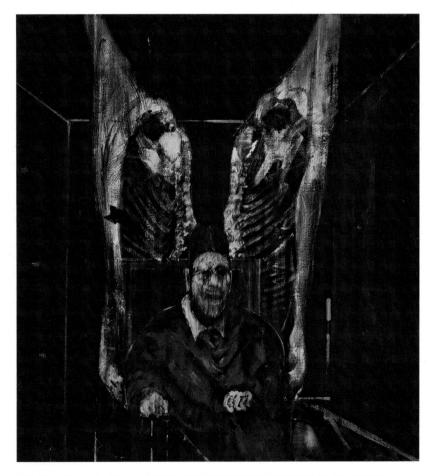

32-76 • Francis Bacon HEAD SURROUNDED BY SIDES OF BEEF 1954. Oil on canvas, $50\%''\times48''$ (129 \times 122 cm). The Art Institute of Chicago. Harriott A. Fox Fund (1956.1201)

32–77 • Wols (Wolfgang Schulze) **PAINTING** 1944–1945. Oil on canvas, 31% " \times 32" (81 \times 81.1 cm). Museum of Modern Art, New York. Gift of D. and J. de Menil Fund (29.1956)

(tache is French for "spot" or "stain"). Art Informel was promoted by French critic Michel Tapié (1909–1987) who suggested that art should express an authentic concept of postwar humanity through simple, honest marks.

The informal leader of Art Informel was Wolfgang Schulze, called Wols (1913-1951), who lived through the dislocation and devastation experienced by millions in Europe in the 1930s and 1940s. Born in Germany, Wols left his homeland in protest when Hitler came to power, first settling in Paris, where he worked as a photographer for Vogue and Harper's Bazaar. When the Germans occupied France, he fled to Spain but was arrested, stripped of his passport, and deported to spend the rest of the war as a stateless person in a refugee camp in southern France. When the war ended, Wols returned to Paris and resumed painting, producing passionate pictures by applying paint with whatever came to hand, scraping his heavy surfaces with a knife and allowing the paint to drip and run. PAINTING (FIG. 32-77) represents a disease-ridden and violent world in which the semiabstracted forms resemble either infected cells or dark, muddy bacterial growths. Wols was temporarily supported by the French philosopher and novelist Jean-Paul Sartre, but died of food poisoning in 1951.

EXPERIMENTS IN LATIN AMERICA

In Cuba, the abstract and Surrealist paintings of Wifredo Lam (1902–1980) embody the violence and anguish of his country's struggle against colonialism. Lam was of mixed Chinese, Spanish, and African heritage and brought issues of identity

and self-discovery to his art. He studied at the National Academy in Havana, moved to Paris, where he knew both Picasso and the Surrealists, and was forced to return to Cuba when the Nazis invaded France. He found himself on the same ship as the Surrealist leader André Breton; Lam disembarked at Havana, while Breton traveled on to New York. Once home, Lam explored his African-Cuban heritage in the company of anthropologist Lydia Cabrera and novelist Alejo Carpentier, and his work from the late 1940s reflects African-Cuban art, the polytheistic spirituality imagery of santería. The jagged, semi-abstracted forms of ZAMBE-ZIA, ZAMBEZIA (FIG. 32-78) recall European Modernism, but their source is in santería religious ritual; the central figure is a composite santería deity. "Zambezia" was the early colonial name for Zimbabwe in southeastern Africa, at this time a British colonial possession known as Rhodesia. Much earlier, Zambezia had been a source for slaves who were brought to Cuba. Lam said of his art: "I wanted with all my heart to paint the drama of my country In this way I could act as a Trojan horse spewing forth hallucinating figures with the power to surprise, to disturb the dreams of the exploiters."

In Buenos Aires, two groups of avant-garde artists formed immediately after the war—Arte Concreto-Invención and Madí, even though Argentina's fascist leader Juan Perón (1895–1974)

32–78 • Wifredo Lam ZAMBEZIA, ZAMBEZIA 1950. Oil on canvas, 49%" \times 43%" (125 \times 110 cm). Solomon R. Guggenheim Museum, New York. Gift, Mr. Joseph Cantor, 1974 (74.2095)

32-79 • Joaquín
Torres-Garcia
ABSTRACT ART IN
FIVE TONES AND
COMPLEMENTARIES
1943. Oil on board mounted
on panel, 20½" × 26¾"
(52.1 × 67 cm). Albright
Knox Art Gallery, Buffalo,
NY. Gift of Mr. and Mrs.
Armand J. Castellani, 1979

disliked Modern art profoundly. The best-known Latin American artist of the time was the Uruguayan Joaquín Torres-García (1874–1949), who established the "School of the South" in Montevideo, Uruguay's capital. Torres-García had spent 43 years in Europe before returning home after the war, but his art was deeply rooted in the indigenous art of the Inca (e.g., see FIG. 27-9), believing ancient Uruguayan culture to be a fertile soil in which to grow a new national and cultural visual identity. In **ABSTRACT ART IN FIVE TONES AND COMPLEMENTARIES** (FIG. 32-79), Torres-García fuses European ideas of abstraction and Modernism with Inca imagery and masonry patterns in a style that he named Constructive Universalism.

ABSTRACT EXPRESSIONISM IN NEW YORK

The United States recovered from World War II more quickly than Europe. Its territory was spared the ravages of war and the trauma it felt was limited to those Americans who saw action in Europe or the Pacific, to European refugees to the United States, and to Japanese-American citizens who had been interned. While the European art world took decades to recover and Paris lost its artistic vibrancy, New York, as the art historian Serge Guilbault wrote, "Stole the Idea of Modern Art."

THE CENTER SHIFTS TO NEW YORK Many leading European artists and writers escaped to the United States during World War II. By 1941, André Breton, Salvador Dalí, Fernand Léger,

Piet Mondrian, and Max Ernst were all living in New York, where they altered the character and artistic concerns of the art scene. American artists were most deeply affected by the work of the European Surrealist artists in New York, but ultimately Abstract Expressionist artists developed their own uniquely American artistic identities by drawing from, but radically reimagining, European and American Modernism.

The term "Abstract Expressionism" describes the art of a fairly wide range of artists in New York in the 1940s and early 1950s. It was not a formally organized movement but rather a loosely affiliated group of artists who worked in the city and were bound by a common purpose: to express their profound social alienation after World War II and to make new art that was both moral and universal.

The influential **Formalist** (concerning form over content) critic Clement Greenberg urged the Abstract Expressionists to consider their paintings "autonomous" and completely self-referential objects. The best paintings, he argued, made no reference to the outside world, but had their own internal narrative and order. Abstract Expressionism was also deeply influenced by the theories of the Swiss psychoanalyst Carl Jung (1875–1961), who described a collective unconscious of universal archetypes shared by all humans. The Abstract Expressionists aspired to create heroic and sublime worlds in paint inhabited by universal symbolic forms. As the 1940s progressed, the symbolic content of their paintings became increasingly personal and abstract. Some sought in "primitive," mythic imagery and archaic, archetypal, and primal

32-80 • Arshile Gorky **GARDEN IN SOCHI** c. 1943. Oil on canvas, 31" × 39" (78.7 × 99.1 cm). Museum of Modern Art, New York. Acquired through the Lillie P. Bliss Bequest (492.1969)

symbolism a connection among all people through the collective unconscious; several used biomorphic forms or developed an individual symbolic language in their paintings; all made passionate and expressive statements on large canvases. The Abstract Expressionists felt destined to make a major mark on art history, convinced that they had the power to transform the world with their art.

Though their paintings project a personal vision, the Abstract Expressionists shared a commitment to four major projects: (1) an interest in the tradition of painting, but a desire to rebel against it and to recalibrate the ideas of European Modernism; (2) a desire to treat the act of painting on canvas as a self-contained expressive exercise; (3) a mining of Jungian visual archetypes to communicate universal ideas in paint; and, (4) the ambition to paint sublime art on a heroic scale. Critic Harold Rosenberg divided Abstract Expressionism into two major categories—"Action painting" and "Color Field painting"—but the Abstract Expressionists disliked these terms, arguing, with good reason, that they were too simplistic. As general typologies, however, the terms remain useful.

THE FORMATIVE PHASE Arshile Gorky (1904–1948) was older than the other Abstract Expressionists, but his ideas and images resonated deeply with them. Gorky was born in Armenia and fled with surviving family members to the United States in 1920 during the Ottoman Turkish genocide of the Armenian people. His mother died soon after her escape, leaving Gorky mostly alone. The trauma of this loss fills his paintings. He threads

idyllic images of his childhood home and garden through Surrealist and Jungian ideas about the collective unconscious to create visual memorials to the people and places he has lost.

A series of paintings in the early 1940s called **GARDEN IN SOCHI** (FIG. 32-80) transform Gorky's memories of his father's garden in Khorkom, Armenia, into a mythical dreamscape. According to the artist, this garden was known locally as the Garden of Wish Fulfillment because it contained both a rock upon which village women, his mother included, rubbed their bared breasts when making a wish, as well as a "Holy Tree" to which people tied strips of clothing. In this painting, the mythical garden floats on a dense white ground. Forms, shapes, and colors coalesce into a bare-breasted woman to the left, the Holy Tree to the center, strips of clothing, and "the beautiful Armenian slippers" that Gorky and his father wore in Khorkom. The painting suggests vital life forces, an ancient connection to the earth, and Gorky's vision of a lost world that exists only in his memory.

JACKSON POLLOCK AND ACTION PAINTING Jackson Pollock (1912–1956) is the most famous Abstract Expressionist painter. Born in Wyoming. Pollock moved to New York in 1930. By all accounts, he was self-destructive from an early age, developing a drinking problem by age 16, reading Jung by 22, institutionalized for psychiatric problems and alcohol abuse at 26. Friends described two Pollocks—one shy and sober, the other obnoxious and drunk. When he entered Jungian psychotherapy in 1939,

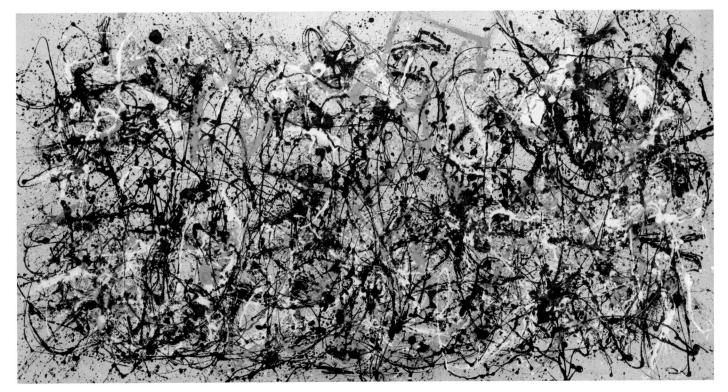

32-81 • Jackson Pollock AUTUMN RHYTHM (NUMBER 30) 1950. Oil on canvas, $8'9'' \times 17'3''$ (2.66 \times 5.25 m). Metropolitan Museum of Art, New York. George A. Hearn Fund, 1957 (57.92)

Read the document related to Jackson Pollock on myartslab.com

he already knew Jung's theory that visual images had the ability to tap into the primordial consciousness of viewers. Pollock remained free of alcohol for most of the 1940s, the period when he was supported emotionally by Lee Krasner. This was when he created his most celebrated works.

Pollock's first solo exhibition was in 1943 at Peggy Guggenheim's gallery. He was propelled into stardom by the critic Clement Greenberg, who, by 1947, described Pollock as "the most powerful painter in North America." Pollock pushed beyond the Surrealist strategy of automatic painting by placing unstretched, raw canvas on the floor, and throwing, dripping, and dribbling paint onto it to create abstract networks of overlapping lines as it fell. In 1950, *Time* magazine described Pollock as "Jack the Dripper," and two years later, Rosenberg coined the term "Action painting" for Pollock's painting process in an essay, "The American Action Painters." Rosenberg described the development and purpose of Action painting as follows: "At a certain moment the canvas began to appear to one American painter after another as an arena in which to act—rather than a space in which to reproduce, redesign, analyze, or 'express' an object, actual or imagined."

In 1950, while Pollock painted **AUTUMN RHYTHM** (**NUMBER 30**) (**FIG. 32–81**), Hans Namuth filmed him (**FIG. 32–82**). Pollock worked in a renovated barn, where he could reach into the laid canvas from all four sides. The German expatriate artist Hans Hofmann (1880–1966) had poured and dripped paint before Pollock, but Pollock's unrestrained gestures transformed the idea

of painting itself by moving around and within the canvas, dripping and scoring commercial-grade enamel paint (rather than specialist artist's paint) onto it using sticks and trowels. Some have described Pollock's urgent arcs and whorls of paint as chaotic, but he saw them as labyrinths that led viewers along complex paths and into an organic calligraphic web of natural and biomorphic forms. Pollock's compositions lack hierarchical arrangement, contain multiple moving focal points, and deny perspectival space. Yet, as the paint travels around the canvas, it never escapes the edges. There is a top and a bottom. Like a coiled spring, the self-contained painting bursts with anxious energy, ready to explode at any moment.

Autumn Rhythm is heroic in scale, almost 9 feet tall by over 17 feet wide. It engulfs the viewer's entire field of vision. According to Lee Krasner, Pollock was a "jazz addict" who spent many hours listening to the explosively improvised bebop of Charlie Parker and Dizzy Gillespie. His interests extended to Native American art, which he associated with his western roots and which enjoyed widespread coverage in popular and art magazines in the 1930s. Pollock was particularly intrigued by the images and processes of Navajo sand painters who demonstrated their work at the Natural History Museum in New York. Of course, he also drew on Jung's theories of the collective unconscious. But Pollock was more than the sum of his influences. His paintings communicate on a grand, Modern, primal level. In a radio interview, he said that he was creating for "the age of the airplane, the atom bomb, and the radio."

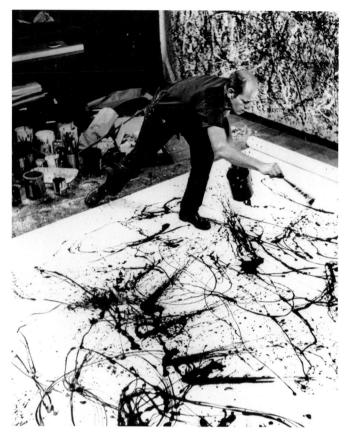

32–82 • Hans Namuth JACKSON POLLOCK1950. Courtesy Center for Creative Photography, University of Arizona.
© 1991 Hans Namuth Estate.

• Watch a video of Jackson Pollock painting on myartslab.com

OTHER ACTION PAINTERS Lee Krasner (1908–1984) studied in New York with Hans Hofmann and produced fully nonrepresentational paintings with all-over compositions several years before Pollock. She moved in with Pollock in 1942 and virtually stopped painting in order to take care of him. When they moved to Long Island in 1945, she set up a small studio in a guest bedroom, where she produced small, tight, gestural paintings. After Pollock's death in an automobile crash in 1956, however, Krasner took over his studio and produced a series of large, dazzling gestural paintings that marked her re-emergence into the mainstream art world. Works such as THE SEASONS (FIG. 32-83) feature bold, sweeping curves that express not only a new sense of liberation but also her powerful identification with the forces of nature in bursting, rounded forms and springlike colors. Krasner said that "Painting, for me, when it really 'happens' is as miraculous as any natural phenomenon."

In contrast, Willem de Kooning (1904–1997) wrote that "Art never seems to make me peaceful or pure," and remarked "I work out of doubt." An 1926 immigrant from the Netherlands who settled in New York, de Kooning made connections with several Modern artists, including Elaine Marie Fried, whom he married. His paintings were highly structured and controlled, guided by careful under-drawings. Although his gestural strokes appear spontaneous, they are, in fact, the result of hours of experiment and failure. De Kooning painted strokes, scraped them off, and repeated the process until the exact effect he wanted emerged. In 1953, he shocked the art world by moving away from pure abstraction with a series of figurative paintings of women. **WOMAN I** (FIG. 32–84) took the artist two years to complete, and de Kooning's wife Elaine estimated

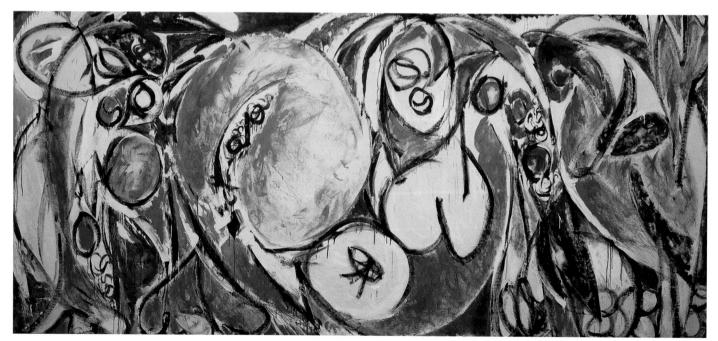

32-83 • Lee Krasner THE SEASONS

1957. Oil on canvas, $7'8\%'' \times 16'11\%''$ (2.36 \times 5.18 m). Whitney Museum of American Art, New York. Purchased with funds from Frances and Sydney Lewis (by exchange), the Mrs. Percy Uris Purchase Fund, and the Painting and Sculpture Committee (87.7)

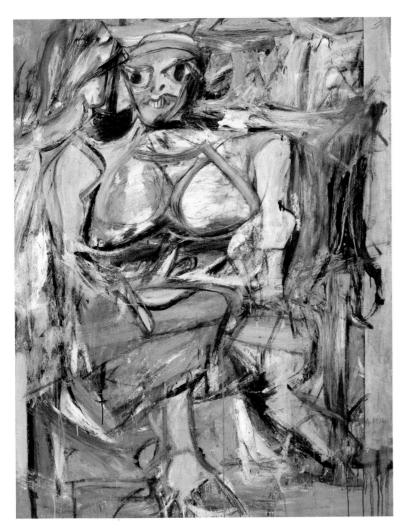

32-84 • Willem deKooning **WOMAN I**1950–1952. Oil on canvas,
75%" × 58" (192.7 ×
147.3 cm). Museum of
Modern Art, New York.

that he scraped and repainted it about 200 times. The portrayal of the woman seems at once grotesque and rapacious; the image is hostile, sexist, and powerfully sexual, full of implied violence and intense passion. De Kooning described his paintings in this series as images of great fertility goddesses like those he saw in prehistoric statuettes (see FIGS. 1-7, 1-8), or as a composite of stereotypes taken from the media and film.

A second generation of Abstract Expressionist painters assembled in the Greenwich Village neighborhood of New York during the 1950s, forming a close-knit community that organized discussion groups to share their ideas, and cooperative galleries to exhibit their work. Prominent among them was Joan Mitchell (1925-1992) who moved to New York after studying first at Smith College and then at the Art Institute in her native Chicago. After a decade in New York, painting energetic but lyrical abstract paintings that show the impact of Gorky and de Kooning in particular, she moved permanently to France in 1959, where she continued to develop her abstract style of painting, untouched by the new developments of Pop art that transformed the New York scene during the 1960s. Mitchell painted in a personal adaptation of Abstract Expressionism, visualizing her own memories of natural and urban landscapes and how they affected her. In LADYBUG (FIG. 32-85), she created energetic but controlled rhythms with gestural brushstrokes and set the lyrical complexity of her

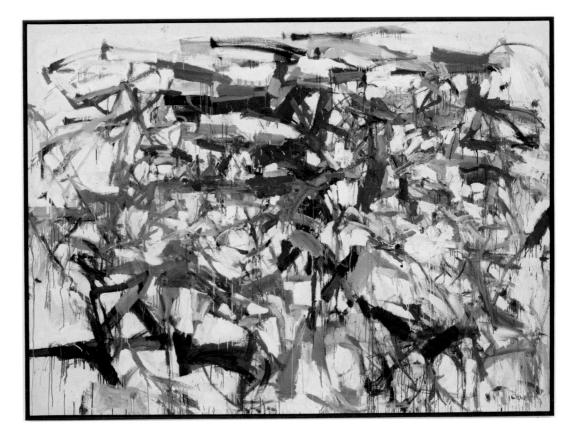

32-85 • Joan Mitchell LADYBUG

1957. Oil on canvas, $6'\%'' \times 9'$ (1.98 \times 2.74 m). Museum of Modern Art, New York. © Estate of Joan Mitchell. Purchase (385.1961)

32-86 • Jean-Paul Riopelle KNIGHT WATCH 1953. Oil on canvas, $38'' \times 76\%''$ (96.6 \times 194.8 cm). National Gallery of Canada, Ottawa, Ontario.

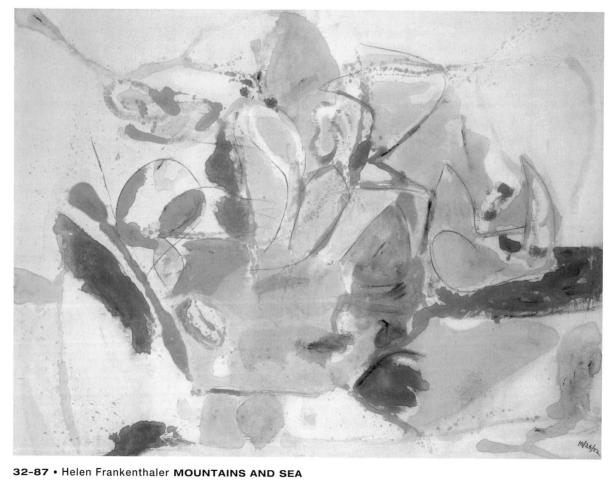

1952. Oil and charcoal on canvas, 7'23/4" × 9'81/4" (2.2 × 2.95 m). Helen Frankenthaler Foundation, Inc., on loan to the National Gallery of Art, Washington, DC.

distinctive palette against a neutral ground in a seeming nod to the figure and field relationship of traditional painting. She said, "The freedom in my work is quite controlled. I don't close my eyes and hope for the best."

Abstract Expressionism spread quickly to Canada. In his native Montreal, the French Canadian painter Jean-Paul Riopelle (1923–2002) worked with Les Automatistes, a group of artists using the Surrealist technique of automatism to create abstract paintings. In 1947, Riopelle moved to Paris and, in the early 1950s, in paintings such as **KNIGHT WATCH** (**FIG. 32-86**), he began to squeeze paint directly onto canvas before spreading it with a palette knife to create bright swatches of color traversed by networks of spidery lines.

Helen Frankenthaler (b. 1928) visited Pollock's studio in 1951 and began to create a more lyrical version of Action painting that had a significant impact on later artists. Like Pollock, she worked

on the floor, but she poured paint onto unprimed canvas in thin washes so that it soaked into the fabric rather than sitting on its surface. Frankenthaler described her process as starting with an aesthetic question or image, which evolved as the self-expressive act of painting took over—"I will sometimes start a picture feeling, What will happen if I work with three blues ...? And very often midway through the picture I have to change the basis of the experience. Or I add and add to the canvas When I say gesture, my gesture, I mean what my mark is. I think there is something now that I am still working out in paint; it is a struggle for me to both discard and retain what is gestural and personal." In **MOUNTAINS AND SEA** (FIG. 32-87), Frankenthaler poured several diluted colors onto the canvas and outlined selected forms in charcoal. The result reminded her of the coast of Nova Scotia where she frequently went to sketch.

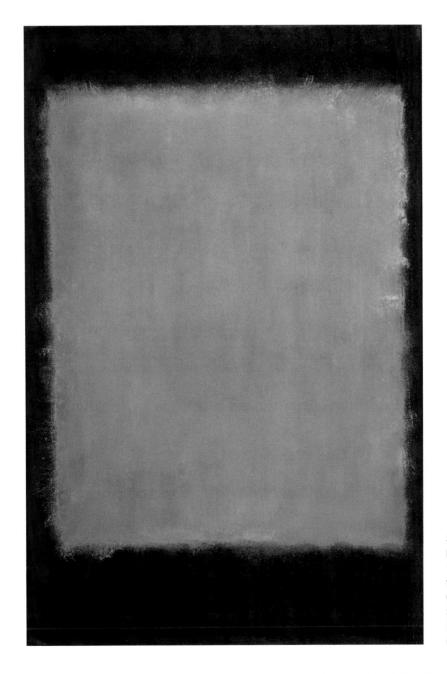

32-88 • Mark Rothko **LAVENDER AND MULBERRY**1959. Oil on paper mounted on fiberboard, 37%" $\times 24\%$ " (95.9 \times 62.8 cm). Hirshhorn Museum and Sculpture Garden, Smithsonian Institution, Washington, DC.
Gift of Joseph H. Hirshhorn 1966

COLOR FIELD PAINTING New York School artists used abstract means to express various kinds of emotional states, not all of them as urgent or improvisatory as those of the Action painters. The Color Field painters moved in a different direction, painting large, flat areas of color to evoke more transcendent, contemplative moods in paint.

Mark Rothko (1903–1970) had very little formal art training, but by 1940 he was already producing paintings that were deeply influenced by the European Surrealists and by Jung's archetypal imagery. By the mid 1940s, Rothko began to paint very large canvases with rectangular shapes arranged in a vertical format in which he allowed his colors to bleed into one another. Paintings such as **LAVENDER AND MULBERRY** (FIG. 32–88) or *Magenta*, *Black, Green, on Orange* (No. 3/No. 13) (see FIG. Intro-1), are not simply arrangements of flat geometric shapes on a canvas, nor are they atmospheric, archetypical landscapes. Rothko thought of his shapes as fundamental "ideas" expressed in rectangular form, unmediated by a recognizable subject, which sit in front of a painted field (hence the name "Color Field painting"). He preferred to show his paintings together in series or rows, illuminated indirectly to evoke moods of transcendental meditation.

Barnett Newman (1905–1970) also addressed modern humanity's existential condition in very large canvases, some painted mostly in a single brilliant, color, torn or split by thin jagged lines in another color that he called "zips." Newman claimed his art was about "[t]he self, terrible and constant." **VIR HEROICUS SUBLIMIS** (Latin for "Man, Heroic and Sublime") (**FIG. 32-89**) shows how Newman's total concentration on a single color focuses his meaning. The broad field of red does not describe any form; it

presents an absolute state of sublime redness across a vast, heroic canvas, interrupted only by the dangerous zips of other colors that threaten, like a tragic human flaw, to unbalance it. Newman wrote: "The present painter is concerned not with his own feelings or with the mystery of his own personality but with the penetration into the world mystery. His imagination is therefore attempting to dig into metaphysical secrets. To that extent his art is concerned with the sublime."

SCULPTURE OF THE NEW YORK SCHOOL Sculpture tended to resist the kind of instantaneous gestural processes developed by artists such as Pollock, although some sculptors managed to communicate both abstractly and Expressionistically in three dimensions. David Smith (1906-1965) learned to weld and rivet while working at an automobile plant in Indiana. He trained as a painter, but became a sculptor after seeing reproductions of welded metal sculptures by artists such as Picasso. Smith avoided the precious materials of traditional sculpture and created works out of standard industrial materials. After World War II, Smith began to weld horizontally formatted, open-form sculptures that were like drawings in space. The forms of the vertical CUBI series (FIG. 32-90) were actually determined by standardized, precut sizes of stainless-steel sheets. In photographs they sometimes look coldly industrial, but when observed outdoors as Smith intended, their highly burnished surfaces show the gestural marks of the sculptor's tools upon them, and reflect and refract the sun in different ways depending on the time of day, weather conditions, and distance from which they are viewed. Vaguely anthropomorphic like giant totemic figures, the sculptures are surprisingly organic when seen at close range.

32-89 • Barnett Newman VIR HEROICUS SUBLIMIS 1950–1951. Oil on canvas, 95%" \times 2131/4" (242 \times 541.7 cm). Museum of Modern Art, New York. Gift of Mr. and Mrs. Ben Heller

32-90 • David Smith CUBI

Cubi series shown installed at Bolton Landing, New York, in 1965. Cubi XVIII (left), 1964. Stainless steel, 9'8" (2.94 m). Museum of Fine Arts, Boston. Cubi XVII (center), 1963. Stainless steel, 9'2" (2.79 m). Dallas Museum of Fine Arts, Dallas. Cubi XIX (right), 1964. Stainless steel, 9'5%" (2.88 m). Tate, London. Art © Estate of David Smith/Licensed by VAGA, New York, NY.

THINK ABOUT IT

- **32.1** Discuss the goals and interests of the painters associated with Abstract Expressionism. Characterize the role played by Surrealism and other early twentieth-century avant-garde art movements in the formation of this new direction in Modern art.
- **32.2** Explain the impact of the two World Wars on the visual arts in Europe and North America. Use two works—one European and one American—as the focus of your discussion.
- **32.3** Summarize the events of the Great Depression and discuss its impact on American art.
- **32.4** Explain how both Dada and Surrealism changed the form, content, and concept of art. Which two works of art discussed in the chapter would you choose to represent these two movements? Why?

CROSSCURRENTS

FIG. 30-44

Throughout the history of art, artists have created eloquent and moving expressions of the horrific violence of war and political oppression. Discuss the political circumstances that led to the creation of these two examples, and assess how they relate to the styles of these two artists and their time. Who was the audience for these works?

FIG. 32-64

Study and review on myartslab.com

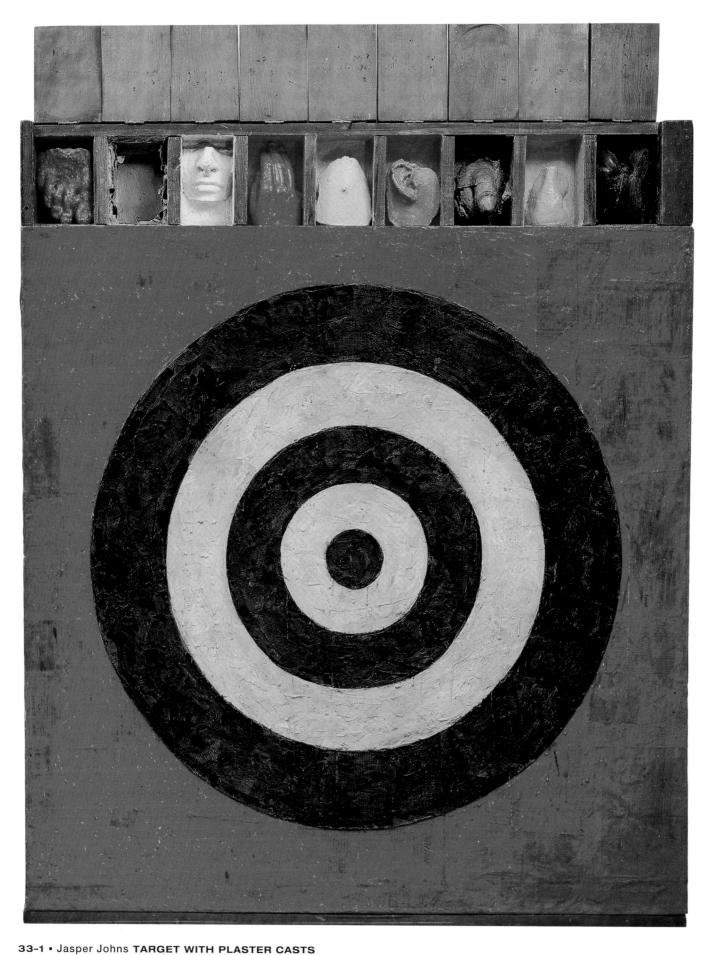

1955. Encaustic and collage on canvas with objects, 51" × 44" (129.5 × 111.8 cm). Collection Mr. and Mrs. Leo Castelli. Art © Jasper Johns/Licensed by VAGA, New York, NY.

The International Scene since 1950

In the early 1950s, a new generation of artists in New York challenged the artistic assumptions of the previous generation of Abstract Expressionists. They believed that art should be firmly anchored in real life. Two artists in particular, Jasper Johns and Robert Rauschenberg, questioned the goals of the New York School as defined by Clement Greenberg's version of Formalism: that art should be autonomous and internally coherent (deeply meaningful but abstract, with the act of painting as its subject, and with an all-over composition); that it should avoid the taint of popular culture and be exhibited in the isolated "white cube" of the gallery space; and that artists should be vigilantly self-critical. In **TARGET WITH PLASTER CASTS** (FIG. 33-1), Johns not only stretches formalism to its limits; he actually mocks it.

This work is neither a painting nor a sculpture but both. The arrangement of casts of body parts in recessed spaces across the top parodies the nonhierarchical manner of Abstract Expressionism, while the target pictured below is the very embodiment of hierarchy. The target's flatness of suggests an all-over composition, but targets always have a central focus. And neither the target nor the casts are abstractions; both actually refer to popular culture and the world around Johns. The target also raises thorny questions about the nature of representation: Is this a painting of a target or is it an actual target? The meaning of this work is fluid and unfixed—it contains recognizable body parts and a recognizable object (a target) but the purpose of their inclusion is unclear. Unlike Abstract Expressionist paintings, Johns's art is emotionally cool and highly cerebral. Like many artists of his generation, Johns reintroduces readily recognizable, realworld images and objects that he strategically recontextualized, in order to question the form, appearance, content, and meaning of art. Thus, like much art after 1950, Johns's art is as intellectual as it is visual.

Johns and Rauschenberg were critical figures in the New York art world and beyond. They expanded the intellectual bases of Abstract Expressionism, cooled its passion and intensity, and made art that connected to and was inspired by the vastly expanded visual culture of postwar America. They also prefigured the next generation's interest in introducing popular culture into art, its investigation of the conceptual foundations of art, its expanded understanding of the use of nontraditional materials in art, and its exploration of the performative possibilities of art.

LEARN ABOUT IT

- **33.1** Understand the "dematerialization" of the object since 1950 and account for its return after 1980.
- 33.2 Assess the ways in which artists since 1950 have introduced popular culture into the world of "high art."
- **33.3** Examine the engagement of artists since 1950 with social, political, cultural, and/or religious issues.
- **33.4** Explore the growing globalism of the contemporary art world and the ways it has created new opportunities, strategies, and subjects for artists today.

THE WORLD SINCE THE 1950s

The United States and the U.S.S.R. emerged from World War II as the world's most powerful nations. The Soviet occupation and sponsorship of communist governments in several Central and Eastern European states, and the emergence of the People's Republic of China in 1949 compelled the United States to attempt to contain the further expansion of Soviet power and communism into American spheres of influence, particularly in Western Europe, Japan, and Latin America. This precipitated a "Cold War" and what Winston Churchill described as the descending of an "Iron Curtain" across Europe (MAP 33-1). The United States initially provided both financial and political support to states sympathetic to American interests, but then resorted to military force, most notably in Korea (1950-1953) and then Vietnam (1954-1975). Europe lost most of its imperial holdings by the early 1960s. often after protracted guerrilla wars of the kind that the French experienced in Vietnam and Algeria. The British granted India independence in 1946 and by 1971 had withdrawn from "East of Suez."

During the Cold War, the United States and the U.S.S.R. amassed large nuclear arsenals, eventually adopting a strategy of mutually assured destruction, which was supposed to deter nuclear war by threatening to destroy the civilian population on both sides. The Cold War effectively ended with the fall of the Berlin Wall in October 1989. When the Soviet Union dissolved in 1992, the United States emerged as the world's unchallenged superpower.

The United Nations, sponsored by American power, was established in 1945 to provide collective security and legitimacy to the Anglo-American design for a new postwar world order. It eventually emerged as a forum for the sovereign recognition of the governments of the many newly independent states in Asia and Africa after the war. Despite the UN mandate to intervene in conflicts between states, however, its efforts to maintain global peace have proven inadequate in the face of ethnic and religious conflicts that have erupted around the world in regions such as the Indian subcontinent, central and eastern Africa, the Balkans, and the Middle East. The terrorist attacks on the World Trade Center and the Pentagon on September 11, 2001, exacerbated many preexisting racial, ethnic, and religious conflicts, and led to both civil wars and wars between states, most notably in the recent and controversial American-led wars in Afghanistan and Iraq.

THE ART WORLD SINCE THE 1950s

Since 1950, artists have faced fundamental questions: What is art? Do works of art have to be objects? Can art be purely idea? Is it some combination of idea and object? Artists of this period reconceptualized and reimagined art, producing radically new forms, content, ideas, and agendas. They have used art to address increasingly divisive and complex social and political questions for which there is no clear right or wrong answer. They have raised questions about gender, race, ethnicity, sexual orientation, religion, class,

death, colonialism, terrorism, violence against the less powerful, and resistance to power. Their art has not sought to edify us by showing moral exemplars (as in Neoclassicism); rather it has challenged us to question our own morality, behavior, and complacency. Much of this art is difficult to look at and to understand; we are frequently assaulted and accused by it. It is rarely pretty. But today's art holds a mirror to contemporary life, revealing things that we might not see or hear in any other context, and it forces us to confront ourselves in that mirror. We may not like recent art initially, but once we learn something about it, we will discover that, at its best, it has the power, like all great art, to affect us deeply—to engage us in challenging conversation.

THE EXPANDING ART WORLD

The generation of artists who began to make art in the 1950s increasingly addressed the real world, acknowledging its fragmentation, its relativism, and its messy relation to popular culture. Assemblage and collage broke apart the physical forms and the meanings of art along with the distinction between painting and sculpture, and high and low art. Pop artists investigated the power of advertising and explored a newly visible domestic world. Photographers showed us aspects of the world around us that we had not seen, or had chosen not to see, before.

ASSEMBLAGE

One new artistic path developed in the second half of the twentieth century was assemblage-combining disparate elements to construct a work of art. By 1950, Louise Nevelson (1899-1988) had already developed an Analytic Cubist-inspired version of assemblage. Prowling the streets of downtown Manhattan, she collected discarded packing boxes in which she would carefully arrange chair legs, broom handles, cabinet doors, spindles, and other wooden refuse. She painted these assemblages matte black to obscure the identity of the individual elements, to integrate them formally, and to provide an air of detached mystery. After stacking several of these boxes together against a studio wall, Nevelson realized that the accumulated effect was more powerful than viewing them individually and began creating monumental wall assemblages such as SKY CATHEDRAL (FIG. 32-2) of 1958. What she particularly liked about the new schema was the way it could transform an ordinary space just as the prosaic elements she worked with had themselves been transformed into a work of art. To add a further poetic dimension, Nevelson first displayed Sky Cathedral bathed in soft blue light, recalling moonlight.

Like Nevelson, visual artists Jasper Johns (b. 1930) and Robert Rauschenberg (1925–2008), and composer John Cage (1912–1992), consciously introduced the world around them (rather than representations of it) into their art and music, creating distinct sorts of assemblage. Cage, who taught for a time at Black Mountain College near Asheville, North Carolina, explored the idea of

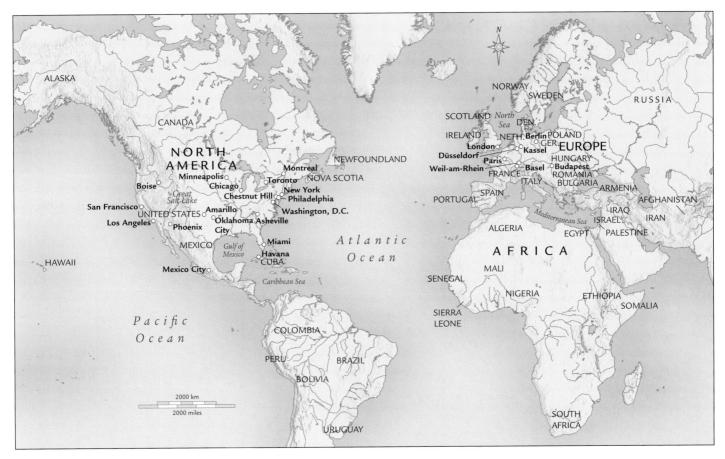

MAP 33-1 • THE WORLD SINCE 1950

International sites in the contemporary art world in the Americas, Europe, and Africa.

creating music that incorporated the ambient noises of the world around him. In 1952, Cage "composed" 4'33" (4 minutes 33 seconds). At the premiere in Woodstock, New York, the pianist came on stage, sat silently at the piano for 4 minutes and 33 seconds, and then closed the keyboard to signal the end of the work. The sounds of the work consisted of noise made by audience members as they rustled, shuffled, whispered, and coughed for four minutes and 33 seconds. Thus, the composition differs each time it is performed, gathering a new set of sounds and meanings in every new location and with every new audience, open to multiple interpretations. Similarly, Johns and Rauschenberg in their assemblages brought or "assembled" disparate found objects and images to create visual works of art with equally open-ended and multiple meanings.

33-2 • Louise Nevelson SKY CATHEDRAL 1958. Assemblage of wood construction painted black, $11'31_2'' \times 10'1_4'' \times 18'' \ (3.44 \times 3.05 \times 0.46 \ m)$. The Museum of Modern Art, New York.

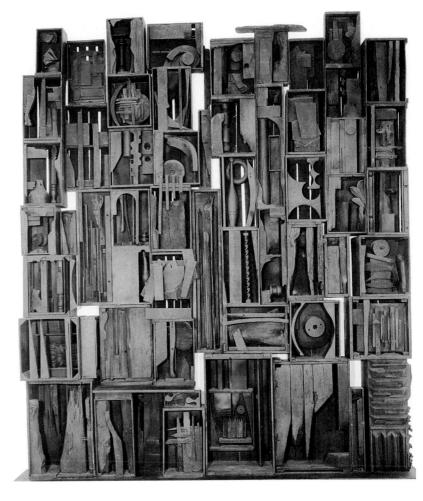

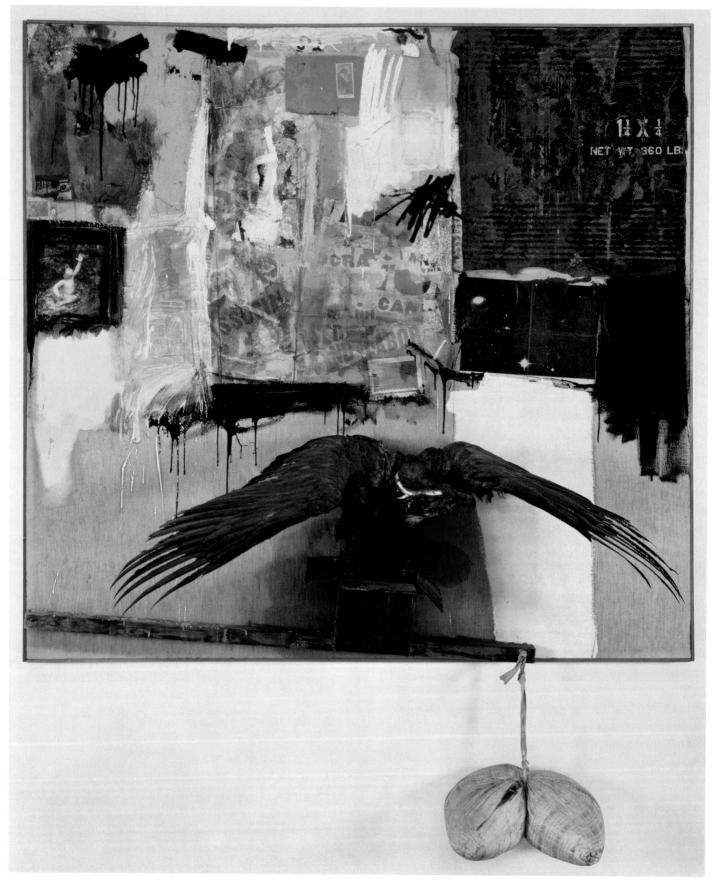

33-3 • Robert Rauschenberg CANYON

1959. Oil, pencil, paper, metal, photograph, fabric, wood on canvas, plus buttons, mirror, stuffed eagle, pillow tied with cord, and paint tube, $81\%'' \times 70'' \times 24''$ (2.08 \times 1.78 \times 0.61 m). Sonnabend Collection. Art © Estate of Robert Rauschenberg/Licensed by VAGA, New York, NY. (RR-00016)

Rauschenberg grew up in Texas and moved to New York to paint in 1947. He attended Black Mountain College where he studied with Cage and de Kooning (see FIG. 32-84), exploring ways to "work in the gap between art and life." In 1951, he exhibited a series of brightly lit blank white paintings in which the shadows cast by viewers on the canvases became the content of the work, a clear visual parallel to Cage's 4'33" of the following year. Between 1955 and 1960, Rauschenberg made a series of objects that he called combines—combinations of painting and sculpture using nontraditional art materials. CANYON (FIG. **33-3**) incorporates an assortment of old family photographs, public imagery (the Statue of Liberty), fragments of political posters (in the center), and various objects salvaged from the trash (the flattened steel drum at upper right), or purchased, and projecting three-dimensional forms such as a stuffed eagle (donated by a friend) perched on a box and a dirty pillow tied with cord and suspended from a piece of wood. The rich disorder, enhanced by the seemingly sloppy application of paint, challenges viewers to make sense of what they see. Since he meant his work to be open to various readings, Rauschenberg assembled material that each viewer might interpret differently. Cheerfully accepting the chaos and unpredictability of modern urban experience, he sought its metaphorical representation in art. "I only consider myself successful," he said, "when I do something that resembles the lack of order I sense."

When the Museum of Modern Art organized an exhibition titled "The Art of Assemblage" in 1961, Rauschenberg was one of two major American artists included in the show; the other was his fellow southerner, close friend, and at times lover, Jasper Johns. Inspired by the example of Marcel Duchamp (see FIG. 32-30), Johns produced controlled, cerebral, and puzzling works during the 1950s that addressed directly issues raised in contemporary art. Target with Plaster Casts (see FIG. 33-1)—neither a painting nor a sculpture but both—probes a psychological dimension that may stem from the artist's own anxieties and fears. The casts above the target fragment a human body without any sense of the organic whole, rendering them as blank and empty as the target itself. The viewer can complete the process of depersonalization by closing some, or just a few, of the hinged flaps over the closetlike boxes that contain the casts, obliterating all or a selective part of the human presence. The juxtaposition of fragmented and partially hidden body parts with the sharply defined target takes on richer meaning in the context of Johns's position as a gay artist in the restrictive, often paranoid, climate of Cold War America. Steadfastly silent but boldly present, in this painting personal identity remains elusive, selectively masked, removed from the center, and safely off target.

Johns, Cage, and Rauschenberg collaborated on several theatrical events that extended the idea of the assemblage into temporal space in the late 1950s and early 1960s. Cage composed music while Johns and Rauschenberg designed sets and sometimes actually performed. They worked with the Merce Cunningham Dance

Company, which specialized in creating dance based on everyday actions such as waiting for a bus or reading a newspaper. Prior to these events, none of the participants informed the others what they were planning to do, so the performances became legendary for their unpredictability.

HAPPENINGS AND PERFORMANCE ART

In the 1950s and 1960s, several artists, arguing that the artistic process was as important as the finished object, began to replace the traditional materials of art with the actions, movements, and gestures of their own bodies. These events were termed Happenings by Allan Kaprow, but the more common term is Performance art. Performance art owes a debt to Pollock (see FIG. 32-82)—whose physical enactment of the act of painting resulted in a work of art in its own right—and to Cage, Johns, and Rauschenberg, who relied on spontaneous and unpredictable actions to provide a new set of variables for each of their events. Performance art tears down the barrier that has traditionally existed between the viewer and the work of art as it literally comes to life and actively invades the viewers' space, both physically and intellectually. Performance art is often radical, and assaultive. It exists in the moment and, although often photographed or filmed, is ephemeral.

THE GUTAI GROUP Some of the earliest postwar performances took place in Japan. In 1954, several Japanese artists formed the Gutai (meaning "embodiment") group to "pursue the possibilities of pure and creative activity with great energy." In Gutai performances, the act of creating itself was the artwork. Gutai organized outdoor installations (art installed in a specific place for which it was made) theatrical events, and dramatic performances. At the second Gutai Exhibition in 1956, Shozo Shimamoto (b. 1928) performed HURLING COLORS (FIG. 33-4) by smashing bottles of paint against a canvas on the floor. He pushed Pollock's gestural painting technique to the point where the work of art resided in the performance of painting, not in the object produced. In fact, Gutai artists regularly destroyed the physical products they created at the end of each performance.

KAPROW In 1958, Allan Kaprow (1927–2006), another student of John Cage, began to create environments and, in 1959, Happenings. **YARD** (**FIG. 33-5**) was staged in 1961 within the walled garden space behind the Martha Jackson Gallery in Manhattan. Kaprow filled the space with used tires, tar paper, and barrels, and asked viewers to walk though it, to experience the smell and physicality of the rubber and tar firsthand, recontextualized (removed from one context to another to create a new meaning) in the art gallery space. Kaprow later described how gallery audiences—more formally dressed then than they would be today, especially the women, who wore dresses and heels—experienced aspects of the urban environment in unfamiliar and unanticipated ways as they tumbled in and over the tires.

33-4 • Shozo Shimamoto **HURLING COLORS** 1956. Happening at the second Gutai Exhibition, Tokyo.

KLEIN In Europe, Performance art occurred as part of the activities of the New Realism movement, a term coined by art critic Pierre Restany. Restany argued that the age of painting ended with the New York School and *Art Informel* and art would now take its form from the real world. He wrote: "The passionate adventure of the real, perceived in itself The New Realists consider the world a painting: a large, fundamental work of which they appropriate fragments."

The French artist Yves Klein (1928–1962) first staged his Anthropometries of the Blue Period in 1960, when he directed three female models covered in blue paint as they pressed their naked bodies against large sheets of paper to the musical accompaniment of a 20-piece orchestra playing a single note. The performance was clearly a satirical commentary on the perceived pretentiousness of Pollock's action painting, of which Klein wrote: "I dislike artists who empty themselves into their paintings. They spit out every rotten complexity as if relieving themselves." He offered instead a sensuous and diverting display, leading to a work created without even touching it himself.

Klein is perhaps best known for the 1960 **LEAP INTO THE VOID** (FIG. 33-6), a manipulated photograph showing the artist leaping from a wall into the street, arms outstretched with apparently nothing but the pavement below him. Klein originally published the photograph to support his mock claim that he could undertake lunar travel unaided, and published it again in a pamphlet denouncing NASA's bid to land a man on the moon as arrogant and foolish. Klein argued that his works were visible only as imprints, in this case his imprint on the pavement.

33-5 • Allan Kaprow YARD 1961. View of tires in court of Martha Jackson Gallery, New York, 1961.

33–6 • Yves Klein **LEAP INTO THE VOID** 1960. Photograph by Harry Shunk of a performance by Yves Klein at Rue Gentil-Bernard, Fontenay-aux-Roses, October 1960. Gelatin-silver print, $10\frac{3}{16}$ " × $7\frac{7}{8}$ " (25.9 × 20 cm).

SCHNEEMANN Many early Performance artists were women, whose bodies had been the object of the male gaze in art for centuries. Performance art enabled women to control how their bodies were viewed and to look back and even challenge their audience. One of the most important early examples is **MEAT JOY** (FIG. 33-7) by Carolee Schneemann (b. 1939), a radical feminist performance, first enacted by Jean-Jacques Lebel and the Kinetic Group Theater at the Festival de la Libre Expression in Paris, and a second time in New York, where it was filmed and photographed. Eight men and women first undressed one another, then danced, rolled on the floor ecstatically, and played with a mixture of raw fish, raw sausages, partially plucked raw and bloody chickens, wet paint, and scraps of paper. Schneemann wanted both performers and audience to smell, taste, and feel the body and its fluids. Critics described the piece variously as an erotic rite and a visceral celebration of flesh and blood. It countered the expectation that a work of art was something to be examined in the cool unemotional space of an art gallery with the viewer in control. The audience must have squirmed as control was wrenched away by the performers.

PHOTOGRAPHY

Photography was an important tool for documenting Performance art in the 1950s and 1960s, but it was also an important medium in its own right. Although the 1955 "Family of Man" exhibition of photographs at the Museum of Modern Art, New York, curated by Edward Steichen, presented a world at peace and in harmony,

33-7 • Carolee Schneemann MEAT JOY 1964. Gelatin-silver print. A photograph by Tony Ray-Jones, taken at a Performance art piece or happening by Carolee Schneeman, performed in Judson Memorial Church in November 1964.

33-8 • Robert Frank **TROLLEY, NEW ORLEANS**1955. Gelatin-silver print, 9" ×
13" (23 × 33 cm). The Art Institute of Chicago. © Robert Frank, from *The Americans*; courtesy Pace/MacGill Gallery, New York. Photography Gallery Fund (1961.943)

and illustrated magazines such as *Life* projected an image of modern life as comfortable, suburban, white, and domestic, other photographers emphasized an alternative view of American society.

FRANK Robert Frank (b. 1924), a Swiss photographer who emigrated to the United States in the 1940s, took gritty social portraits, trying to capture some of the disharmony that Johns and Rauschenberg presented in their art. In 1948, frustrated by the pressure and banality of news and fashion assignments, Frank abandoned his freelance work with magazines such as *Life* and *Vogue* and traveled to Peru and Bolivia. Four years later, he took

a series of photographs documenting the lives of Welsh coalminers, and he received a Guggenheim Fellowship in 1955 to travel around America photographing the "social landscape." Frank took more than 28,000 photographs that year, from which he chose 83 to publish in a book. The images were so raw, grim, and full of biting social commentary, however, that at first he could not find a publisher in the United States and instead published the book in France under the title *Les Américains* (1958). *The Americans* finally appeared in the United States the following year with an introduction by Jack Kerouac, a writer of the new Beat generation who criticized mainstream American values. In **TROLLEY, NEW**

33-9 • Diane Arbus photographed in 1970 holding CHILD WITH A TOY HAND GRENADE IN CENTRAL PARK, NEW YORK 1962. Gelatin-silver print.

ORLEANS (FIG. 33-8), stiff, smartly dressed white passengers sit in the front of the street car, while more casually posed African Americans sit in the back, as required by law in the 1950s. The composition of the image, in which the rectangular symmetry of the windows frames and isolates the figures, underscores visually both racial segregation and urban alienation, while the ghostly reflections on the closed windows along the top could almost be photographs themselves.

ARBUS Diane Arbus (1923–1971), even more than Frank, rejected the dictates of elegant art photography, partly because of her experience as a fashion photographer—she and her husband, Allan Arbus, had been *Seventeen* magazine's favorite cover photographers in the 1950s—but mostly because she did not want formal niceties to distract viewers from her riveting, often disturbing subjects (**FIG. 33–9**). Arbus moved beyond the boundaries of what had been acceptable artistic subject matter, photographing nudists, people with physical deformities, or others on the fringes of society. Since she usually allowed her subjects—like this disheveled and menacing child—to sense the presence of the camera, they confront the viewer directly, challenging the safe distance between us and what we view. "I really believe there

TOTAL LINE SCHOOL STATE OF THE STATE OF THE

are things that nobody would see," she said, "unless I photographed them."

POP ART

In the late 1950s, several artists began to focus attention on the midcentury explosion in visual culture, fueled by the growing presence of mass media and the growing disposable income of the postwar generation. Pop art originated in Britain, but its primary development was in the United States during the early 1960s, at a time when individual and mass identity was increasingly determined by how people looked and dressed, as well as by what they displayed and consumed. Homes, automobiles, and the visible display of objects—both within the home and on the person—reflected life as it was portrayed on television, in films, and in print advertising. Pop artists critiqued the superficiality of popular culture's fiction of the perfect home and perfect person.

HAMILTON In the 1950s, while the British government maintained that the country's postwar recovery depended on sustained consumption, an interdisciplinary collection of artists, architects, photographers, and writers came together as the Independent Group in London in order to discuss the place of art in this consumer society, periodically exhibiting at the Institute of Contem-

porary Arts. One of its members, Richard Hamilton (1922-2011), argued that modern mass visual culture was fast replacing traditional art for the general public, that movies, television, and advertising, not high art, defined standards of beauty. Society's idols were no longer politicians or military heroes but international movie stars; social status was increasingly measured by the number of one's possessions. To create a visual expression of this disharmonious world of excessive consumption, Hamilton created collages composed of images drawn from advertising. In JUST WHAT IS IT THAT MAKES TODAY'S HOMES SO DIFFERENT, SO **APPEALING?** (FIG. 33-10) from 1956, Hamilton critiques marketing strategies by imitating them. The title parodies an

33-10 • Richard Hamilton JUST WHAT IS IT THAT MAKES TODAY'S HOMES SO DIFFERENT, SO APPEALING? 1956. Collage, $10^{1}4'' \times 9^{3}4''$ (26 \times 24.7 cm). Kunsthalle Tübingen, Collection Zundel.

• Watch a podcast about Richard Hamilton's work on myartslab.com

advertising slogan, while the collage itself shows two figures named Adam and Eve in a domestic setting. Like the biblical forebears, these figures are almost naked, but the "temptations" to which they have succumbed are those of consumer culture. Adam is a bodybuilder and Eve a pin-up girl. In an attempt to recreate their lost Garden of Eden, the first couple has filled their home with all the best new products: a television, a tape recorder, a vacuum cleaner, modern furniture. Displayed on the wall is not "high art" but a poster advertising a romance novel, hung next to a portrait of John Ruskin, the critic who accused the painter Whistler of destroying art (see "Art on Trial in 1877," page 985). Adam holds a huge, suggestively placed Tootsie Pop, which the English critic Lawrence Alloway cited when he described this work as "Pop art," thus naming the broader movement. Like assemblages in the United States, Hamilton's collage comments on the visual overload of the 1950s and on culture's inability to differentiate between important and trivial images or between the advertising world and the real one. In 1968, Hamilton designed the cover for the Beatles's White Album, devoid of any images at all.

WARHOL By 1960, several American artists, like the earlier British Pop artists, began to incorporate images from popular mass culture into their art. Unlike their British counterparts, however, they developed a slicker Pop art style using the mass-production techniques of advertising to give their works a flat, commercial feel that would erase the presence of the hand of the artist, consciously defying Abstract Expressionism's emphasis on individual artistic practice. American Pop art both imitated and critiqued 1960s popular culture, often including images of newly independent women and their ambivalent relationship to domesticity. The emotional tone of Pop art was more ironic, camp, and cynical than the irreverent but serious stance of artists such as Johns and Rauschenberg. As Pop art flourished in the United States, Andy Warhol (1928–1987), artistic giant and playful heir to Duchamp's challenging ideas about the nature of art and its production, emerged as the dominant figure.

Warhol created an immense body of work between 1960 and his death in 1987, including prints, paintings, sculptures, and films. He published *Interview* magazine and managed The Velvet Underground, a radical and hugely influential rock band. Since he trained as a commercial artist, Warhol knew advertising culture well, and by 1962, he was incorporating images from American mass-media advertising in his art. He took as subjects popular consumer items such as Campbell's Soup cans and Coca-Cola bottles, reproducing them with the cheap industrial print method of **silkscreen** (in which a fine mesh silk screen is used as a printing stencil), as well as in paintings and sculptures.

In 1964, in his first sculptural project, Warhol hired carpenters to create plywood boxes identical in size and shape to the cardboard cartons used to ship boxes of Brillo soap pads to supermarkets. By silkscreening onto these boxes the logos and texts that appeared on the actual cartons, the artist created what were

essentially useless replicas of commercial packaging (FIG. 33-11). Stacking the fabricated boxes in piles, Warhol transformed the interior space of the Stable Gallery in New York into what looked like a grocery stockroom, simultaneously pointing to the commercial foundation of the art gallery system and critiquing the nature of art in a maneuver that aped Duchamp's 1917 transformation of a commercial urinal into *Fountain* (see FIG. 32-30), although in 1964 Warhol even abandoned the artifice of signature and date.

Warhol argued that whereas past art demanded thought and understanding, advertising and celebrity culture demanded only immediate attention, very quickly becoming uninteresting and boring. In keeping with this position, he suggested that art should be like movie stars, interesting for 15 minutes. In 1962, movie star Marilyn Monroe died suddenly, an apparent suicide. Warhol's MARILYN DIPTYCH (FIG. 33-12) is one of a series of silkscreens that Warhol made immediately after the actress's death. He memorializes the screen image of Monroe, using a famous publicity photograph transferred directly onto silkscreen, thus rendering it flat and bland so that Monroe's signature features—her bleachblond hair, her ruby lips, and her sultry blue-shadowed eyes-stand out as a caricature of the actress. The face portrayed is not that of Norma Jeane (Monroe's real name) but of Monroe the celluloid sex symbol as made over by the movie industry. Warhol made multiple prints from this screen, aided—as in the creation of the

33-11 • Andy Warhol BRILLO SOAP PADS BOX 1964. Silkscreen print on painted wood, $17'' \times 17'' \times 14''$ (43.2 \times 43.2 \times 35.6 cm). Collection of The Andy Warhol Museum, Pittsburgh.

Watch a video about the silkscreen process on myartslab.com

33–12 • Andy Warhol MARILYN DIPTYCH 1962. Oil, acrylic, and silkscreen on enamel on canvas, two panels, each 6'10" × 4'9" (2.05 × 1.44 m). Tate, London.

Brillo boxes—by a host of assistants working with assembly-line efficiency. In 1965, Warhol ironically named his studio "The Factory," further mocking the commercial aspect of his art by suggesting he was only in it for the profit.

The Marilyn Diptych, however, has deeper undertones. The diptych format carries religious connotations (see "Altars and Altarpieces," page 566), perhaps implying that Monroe was a martyred saint or goddess in the pantheon of departed movie stars. In another print, Warhol surrounded her head with the gold background used in Orthodox religious icons. Additionally, the flat and undifferentiated Monroes on the colored left side of the diptych contrast with those in black and white on the right side, which fade progressively as they are printed and reprinted without reinking the screen until all that remains of the original portrait is the ghostly image of a disappearing person.

Warhol was one of the first artists to exploit the realization that while the mass media—television in particular—seem to bring us closer to the world, they actually allow us to observe the world only as detached voyeurs, not real participants. We become

desensitized to death and disaster by the constant repetition of images on television, which we are able literally to switch off at any time. Warhol's art, especially in the *Marilyn Diptych*, is like television—the presentation is superficial and bland, uses seemingly mindless repetition, and inures us to the full impact of the tragic moment of death. Warhol, known for his quotable phrases, once said: "I am a deeply superficial person." But the seeming superficiality of his art is deeply intellectual.

RUSCHA In 1962, Andy Warhol's first solo show as a Pop artist—the exhibition of his 32 paintings of Campbell's Soup cans—took place not in New York, but in the Ferus Gallery in Los Angeles. By that time, a group of younger artists—some still in college—had already developed a West Coast version of Pop art in an environment famously saturated with fanciful commercial imagery and the glamorous artifice of the movie industry. Prominent among these artists was Ed Ruscha (b. 1937)—born in Omaha, Nebraska, raised in Oklahoma City, and settled in Los Angeles by 1956. Like Warhol, he challenged the hierarchies

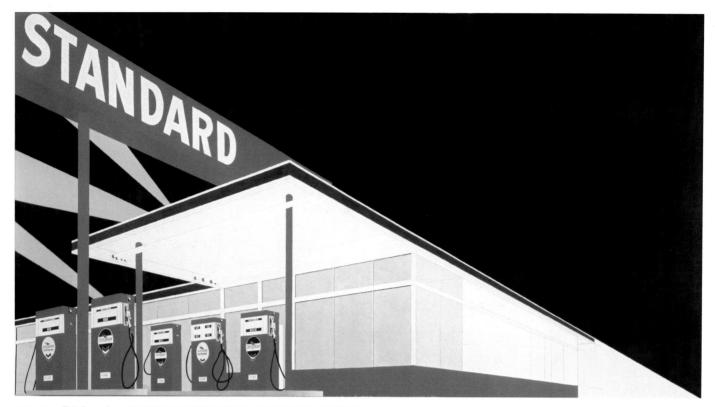

33-13 • Ed Ruscha STANDARD STATION, AMARILLO, TEXAS 1963. Oil on canvas, $5'5'' \times 10'$ (1.65 \times 3 m). Hood Museum of Art, Dartmouth College, Hanover, NH. Gift of James Meeker, Class of 1958

of fine art by portraying the products and bastions of American commerce, with a special concentration on signage in advertising. His monumental 1963 painting STANDARD STATION, AMARILLO, TEXAS (FIG. 33-13) is based on an image in a 1962 book of his 26 black-and-white photographs of gas stations along Route 66 between Oklahoma City and Los Angeles, a roadside culture he knew well from his travels on this highway. But in the painting, Ruscha pushes the image beyond representation to flattened abstraction and dramatic stylization, academic linear perspective and saturated pure color. Also in 1962, Ruscha's work appeared in a group show at the Pasadena Museum of Art—one of the first exhibitions of Pop art in America. It also included the paintings of East Coast artists Andy Warhol and Roy Lichtenstein.

LICHTENSTEIN Roy Lichtenstein (1923–1997) also investigated the various ways that popular imagery resonated with high art, imitating the format of comic books in his critique of mass-market visual culture. In 1961, while teaching at Rutgers University with Allan Kaprow (see FIG. 33–5), Lichtenstein began to make paintings based on panels from war and romance comic books. He tightened and clarified the source images to focus on significant emotions or actions,

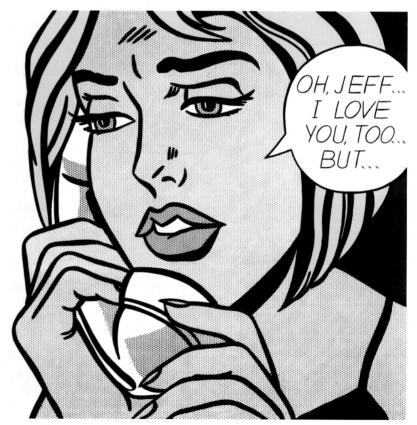

33–14 • Roy Lichtenstein **OH**, **JEFF** … I **LOVE YOU**, **TOO** … **BUT** … 1964. Oil and magna on canvas, $48'' \times 48''$ (122 \times 122 cm). Private collection.

simultaneously representing and parodying the flat, superficial ways in which a comic book communicates with its readers. The heavy black outlines, flat primary colors, and **Benday dots** used in commercial printing imitate the character of cartoons. **OH, JEFF ... I LOVE YOU, TOO ... BUT ...** (FIG. 33-14) compresses a popular romance storyline involving a crisis that temporarily threatens a love relationship into a single frame. But Lichtenstein plays ironic games by pitting illusion against reality; we know that comic books are unrealistically melodramatic, yet he presents this overblown episode vividly, almost reverently, enshrined in a work of high art.

OLDENBURG Like Warhol and Lichtenstein, Swedish-born artist Claes Oldenburg (b. 1929) created ironic critiques of consumer culture, in his case in the form of sculptures. Oldenburg foregrounds humor in his large-scale public projects, such as **LIPSTICK** (ASCENDING) ON CATERPILLAR TRACKS (FIG. 33-15), made

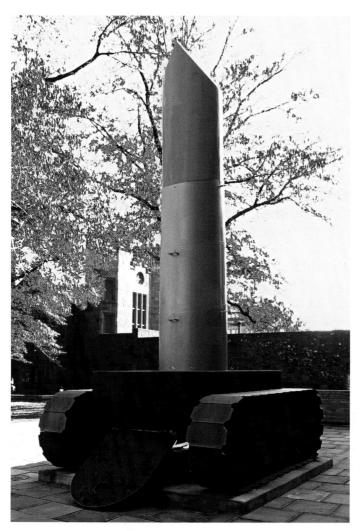

33-15 • Claes Oldenburg LIPSTICK (ASCENDING) ON CATERPILLAR TRACKS

1969, reworked 1974. Painted steel body, aluminum tube, and fiberglass tip, 21' \times 19'5½" \times 10'11" (6.70 \times 5.94 \times 3.33 m). Yale University Art Gallery, New Haven, Connecticut. © Claes Oldenburg, Coosje van Bruggen.

for his alma mater, Yale University. A group of graduate students from the Yale School of Architecture invited him to create this monument to the "Second American Revolution" of the late 1960s, a period marked by student demonstrations against the Vietnam War. Oldenburg mounted a giant lipstick tube on top of steel tracks taken from a Caterpillar tractor. Visually the sculpture suggests both the warlike aggression of a mobile missile launcher and the phallic eroticism of lipstick, perhaps in a play on the popular slogan of the time, "make love, not war." The lipstick was to have included a suggestive balloonlike vinyl tip that could be pumped up with air and then left to deflate slowly, but the pump was never installed and the drooping tip, vulnerable to vandalism, was quickly replaced with a metal one. The lipstick monument was installed provocatively on a campus plaza in front of both a war memorial and the president's office. Not surprisingly, Yale asked Oldenburg to remove it. In 1974, however, he reworked the sculpture in the more permanent materials of fiberglass, aluminum, and steel and donated it to Yale, where it was placed in the courtyard of Morse College.

THE DEMATERIALIZATION OF THE ART OBJECT

In the same decade when Pop artists critiqued the visual world of popular culture, other artists questioned the role, purpose, and relevance of the art object in contemporary culture. Their restlessness parallels the social upheaval that marked the era of the mid-1960s and early 1970s. During this period, the youth of Europe and America questioned the authority and rights of the state with civil rights movements, massive rallies against the draft and the Vietnam War, environmentalist and feminist movements, and the Paris revolts of 1968. Women artists made their presence felt in large numbers, and increasingly artists made art meant to be viewed outside the gallery system. The decade ended with a move toward noncommodifiable and "dematerialized" art.

MINIMALISM

Minimalism, which dominated the New York scene in the late 1960s, sought the dematerialization of the art object. In the mid-1960s, a group of articulate young sculptors, including Donald Judd (1928–1994), Robert Morris (b. 1931), and Carl Andre (b. 1935), proposed what was variously called ABC Art, Primary Structures, or Minimalism. They produced slab- or boxlike sculptures, frequently fabricated for them from industrial materials such as Plexiglas, fluorescent lighting, steel, and mirrors, totally rejecting the gesture and emotion invested in the handcrafted object, as well as the traditional materials of sculpture. Judd and Morris described their theories eloquently in the journal *Artforum*, by asking viewers to comprehend their art objects as united wholes without a focal point, allowing the energy of the work and the viewers' interest to be dissipated throughout the object in a kind of entropy.

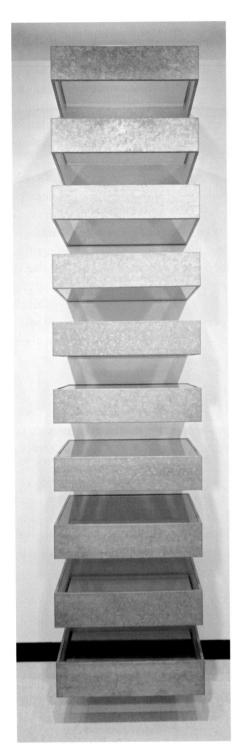

33–16 • Donald Judd **UNTITLED** 1969. Galvanized iron and Plexiglas, 10 units, each $6'' \times 27'/6'' \times 24''$ (15.24 \times 68.8 \times 60.96 cm), overall 120" \times 27 $^{1}/6'' \times 24''$ (3.05 \times 0.69 \times 0.61 m). Albright-Knox Art Gallery, Buffalo, NY. Art © Judd Foundation. Licensed by VAGA, New York, NY.

JUDD In 1965, Donald Judd argued in an *Artforum* article entitled "Specific Objects" that Minimalism should consist of real or "specific" objects. He chose mathematically constructed impersonal shapes arranged without hierarchy, legible as complete forms in a single glance, occupying real space, having neither a base below nor a glass case around them. **UNTITLED** of 1969 (**FIG. 33-16**)

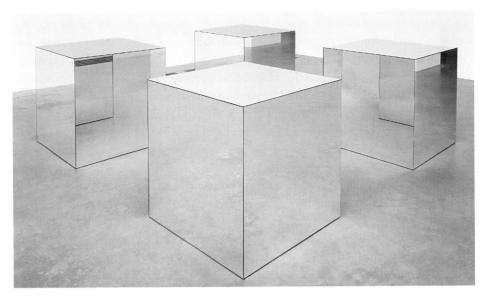

33-17 • Robert Morris **UNTITLED (MIRROR CUBE)** 1965–1971. Mirror, plate glass, and wood, $36'' \times 36'' \times 36''$ (91.4 × 91.4 × 91.4 cm). Tate. London.

consists of 10 identical rectangular units fabricated from galvanized iron and tinted Plexiglas, hung in a vertical row on the gallery wall. The arrangement avoids allusion to any imagined subject allowing the objects to be aggressively themselves. Judd offers viewers clear, self-contained visual facts, setting the conceptual clarity and physical perfection of his art against the messy complexity of the real world.

MORRIS By the early 1970s, Robert Morris chose to explore the banal and uninteresting by making simple, unitary objects. UNTITLED (MIRROR CUBE) (FIG. 33-17) groups four wooden cubes created from industrial mirror glass. They literally reflect and deflect any attempt to discover interest *in* the boxes themselves, which hold no meaning within their form. There is no point of focus; instead the boxes reflect the world around them. The artfulness of this piece lies almost entirely in the artistic concept behind it—interrogating the purposes and goals of the artist. The artists' manifestos worked hand-in-hand with actual objects to communicate the ideas of Minimalism. Viewers had to work hard to learn how to read, understand, and appreciate the art itself.

Minimalism had many critics. The formalist Michael Fried, for instance, wrote that Minimal objects suffered from "object-hood," that they held no more interest than nonart objects. He also criticized Minimalism for its "theatricality." In his view, Minimalism, like Pop art, demanded viewers' immediate attention but could not hold that attention long, therefore becoming very boring very quickly.

CONCEPTUAL AND PERFORMANCE ART

The logical extension of the Minimalist move away from the handcrafted art object was Conceptual art. Unlike Duchamp and Dada artists earlier in the century, who argued that the idea *is* the

work of art, Conceptual artists argue that "idea" and "form" are separable in art. Thus, for Conceptual artists, at times a physical object is an appropriate vehicle for a work of art, at other times a performance is more appropriate, and at still other times a conceptual manifestation, sometimes in the form of written or spoken instructions, is most appropriate. Conceptual art literally "dematerialized" the art object by suggesting that the catalyst for a work of art is a concept, and the means by which the concept is communicated can vary. Conceptual works of art usually leave behind some visual trace, in the form of a set of instructions, writing on a chalkboard, a performance, photographs, or a piece of film, and in some cases even objects. Conceptual art is theoretically driven and noncommodifiable because it leaves behind no precious object for purchase, although collectors and many museums now collect the remaining "trace" objects.

BEUYS Some of the most radical Conceptual art came out of Europe, and that of Joseph Beuys (1921–1986) was perhaps the most significant. He served as a fighter pilot in the German Luftwaffe during World War II, when he claimed to have been shot down over the Crimea and saved by Tartars who wrapped him in animal fat and felt. There is no evidence that this actu-

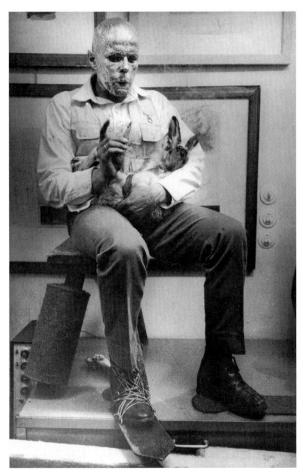

33-18 • Joseph Beuys **HOW TO EXPLAIN PICTURES TO A DEAD HARE**1965. Photograph of performance.

ally occurred, although something traumatic clearly happened to Beuys during the war. As an artist, he developed a mysterious shamanistic persona, and created a repertoire of significant materials and objects that he used symbolically and performatively in his art in an attempt to explain the inexplicable to audiences. Beuys's symbolism was deeply personal and difficult for others to grasp. His art centered on the desire to communicate and the complexities of that process.

In **HOW TO EXPLAIN PICTURES TO A DEAD HARE (FIG. 33-18)**, Beuys initially sat on a chair in a gallery surrounded by his own drawings, his head coated in honey and covered by a mask of gold leaf. In his lap he cradled a dead hare to which he muttered incomprehensibly. His left foot rested on felt, suggesting spiritual warmth, while his right foot rested on steel, symbolizing cold hard reason. He carried the hare's corpse around the gallery for several hours, quietly explaining his pictures, reasoning that he had as much chance of communicating fully with the dead hare as with another person thus performing the problems inherent in the normal communication. Beuys said: "Even a dead animal preserves more powers of intuition than some human beings."

KOSUTH Joseph Kosuth (b. 1945) abandoned painting in 1965 to examine the intersection between language and vision, abstract idea and concrete imagery. His early work was indebted to Duchamp, semiotic theory, and the linguistic philosophy of Ludwig Wittgenstein (1889–1951). Kosuth's art is not about beauty, but the imperfect possibilities of communication, either visual or verbal. **ONE AND THREE CHAIRS** (FIG. 33-19) is a visual

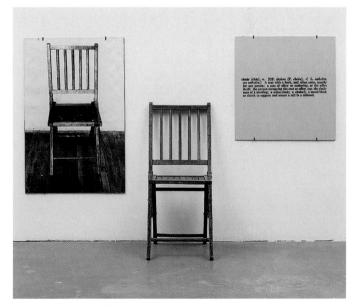

33–19 • Joseph Kosuth **ONE AND THREE CHAIRS** 1965. Wooden folding chair, photograph of chair, and photographic enlargement of dictionary definition of chair; chair, $32\%''\times14\%''\times20\%''$ (82.2 \times 37.8 \times 53 cm); photo panel, $36''\times24\%''$ (91.4 \times 61.3 cm); text panel $24\%''\times24\%''$ (61.3 \times 62.2 cm). Museum of Modern Art, New York. Larry Aldrich Foundation Fund (383.1970 a–c)

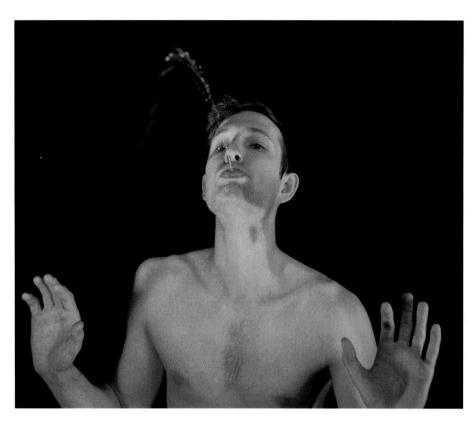

33-20 • Bruce Nauman SELF-PORTRAIT AS A FOUNTAIN

1966–1967. Color photograph, $193\!\!/^{\!\!\!/}\times 233\!\!/^{\!\!\!/}$ (50.1 \times 60.3 cm). Courtesy Leo Castelli Gallery, New York.

33-21 • Eva Hesse NO TITLE

1969–1970. Latex over rope, string, and wire; two strands, dimensions variable. Whitney Museum of American Art, New York. Purchase, with funds from Eli and Edythe L. Broad, the Mrs. Percy Uris Purchase Fund, and the Painting and Sculpture Committee (88.17 a-b)

Read the document related to Eva Hesse on myartslab.com

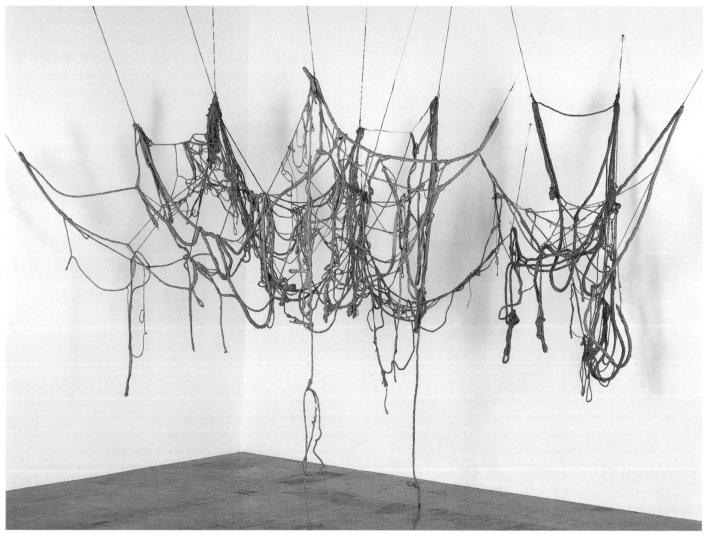

rendition of semiotic theory. In this installation there is an actual chair, a photograph of a chair, and a dictionary definition of "chair"—that is an object, an imperfect visual representation or idea of the object, and a verbal abstraction of the object. The title indicates that we can read this work as one chair represented three different ways or as three different chairs. Either way, Kosuth demonstrates the impossibility of precise representation and communication of an idea, leaving us to ponder the question: Which is the "real" chair?

NAUMAN In 1966–1967, the California-based artist Bruce Nauman (b. 1941) made a series of 11 color photographs based on wordplay and visual puns in which he cleverly complicated the problem of communication. In **SELF-PORTRAIT AS A FOUNTAIN** (**FIG. 33-20**), for example, the bare-chested artist tips his head back and spurts water into the air, thereby showing us that he is a fountain, or perhaps the *Fountain*, the title of Duchamp's infamous urinal (see **FIG. 32-30**). Nauman, like Kosuth, leaves us with the question: Which is the "real" fountain? Is it our abstracted idea of a fountain alluded to in the title (conceptual), Nauman's claim to be a fountain (visual), or could it be his sly reference to Duchamp's *Fountain* (art-historical)?

PROCESS ART

By the early 1970s, it was evident that Minimalism and Conceptualism had boxed art into an impossible absolutist corner—their reductivist approaches seemed too elitist, too detached from a society that was being torn apart by social and political conflict. Some artists refused to eliminate personal meaning from their work, and in opposition to Minimalism they explored the physicality, personality, even the sensuality of the process of making art.

HESSE Eva Hesse (1936–1970), for instance, infused her elegantly crafted art with personal history and meaning. She was born in Hamburg and narrowly escaped the Nazi Holocaust, moving to New York with her family in 1939. After graduating from the Yale School of Art in 1959, she painted dark Expressionistic self-portraits, but in 1964 she began to make abstract sculpture that adapted the vocabulary of Minimalism to her own, more self-expressive purpose. She wrote: "For me art and life are inseparable. If I can name the content [of my art] ... it's the total absurdity of life." NO TITLE (FIG. 33-21) is about instability; it takes on a different size and shape each time it is installed. The work consists of several skeins of rope dipped in latex, knotted and tangled, and then hung from wires attached to the gallery ceiling. It is fragile

and evocative, sensuous and delicate. Hesse embraced the instability, irrationality, and emotive power of art, reflecting her own life and emotions in the work. Her last pieces, made before her premature death from cancer, are heartbreaking.

WINSOR Jackie Winsor's (b. 1941) elegant and moving BURNT PIECE (FIG. 33-22), constructed from wire mesh, cement, and burnt wood, which Winsor worked intensively, also subverts the boxlike shapes of Minimalist sculpture. The detail is really only visible on the inside, within a closed, private, and secretive place. The woodwork refers to Winsor's childhood in Newfoundland, where her father was employed in the house-building trade.

33-22 • Jackie Winsor BURNT PIECE

1977–1978. Cement, burnt wood, and wire mesh, $36''\times36''\times36''$ (91.4 \times 91.4 \times 91.4 cm). © Jackie Winsor. Courtesy Paula Cooper Gallery, New York. Museum of Modern Art, Gift of Agnes Gund (90.1991)

A BROADER LOOK | The Dinner Party

Judy Chicago's THE DINNER PARTY (FIG. 33-23) is a large, complex, mixed-media installation dedicated to hundreds of women and women artists rescued from anonymity by early feminist artists and historians. It took five years of collaborative effort to make, and it drew on the assistance of hundreds of female and several male volunteers working as ceramists, needleworkers, and china painters. The Dinner Party includes a large, triangular table, each side stretching 48 feet; Chicago conceived of the equilateral triangle as a symbol of both the feminine and the equalized world sought by feminism. The table rests on a triangular platform of 2,300 triangular porcelain tiles comprising the "Heritage Floor" that bears the names of 999 notable women from myth, legend, and history. Along each side of the table are 13 place settings representing famous women-13 being the number of men at the Last Supper as well

as the number of witches in a coven. The 39 women thus honored by individual place settings include the mythical, including the goddess Ishtar and an Amazon, and historical personages such as the Egyptian queen Hatshepsut, the Roman scholar Hypatia, the medieval French queen Eleanor of Aquitaine, the author Christine de Pizan (see page 533), the Italian Renaissance noblewoman Isabella d'Este (see page 660), the Italian Baroque painter Artemisia Gentileschi (see FIG. 23-13), the eighteenth-century English feminist writer Mary Wollstonecraft, the nineteenth-century American abolitionist Sojourner Truth, and the twentieth-century American painter Georgia O'Keeffe (setting shown here).

Each larger-than-life place setting includes a 14-inch-wide painted porcelain plate, ceramic flatware, a ceramic chalice with a gold interior, and an embroidered napkin, sitting upon an elaborately ornamented woven and stitched runner, with techniques and motifs appropriate to the time and place in which each woman lived. Most of the plates feature abstract designs based on female genitalia because, as Chicago said, "that is all [these women] had in common They were from different periods, classes, ethnicities, geographies, experiences, but what kept them within the same confined historical space" was their biological sex. The empty plates represent the fact that they "had been swallowed up and obscured by history instead of being recognized and honored."

The prominent place accorded to china painting and needlework in *The Dinner Party* both celebrates traditional women's crafts and argues for their place in the pantheon of "high art," while at the same time informing the viewer about some of the unrecognized contributions that women have made to history.

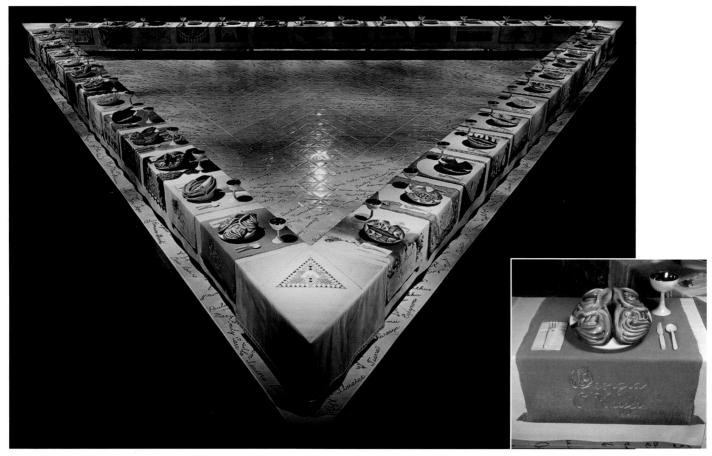

33-23 • Judy Chicago THE DINNER PARTY

1974–1979. Overall installation view. White tile floor inscribed in gold with 999 women's names; triangular table with painted porcelain, sculpted porcelain plates, and needlework, each side $48'\times42'\times3'$ ($14.6\times12.8\times1$ m). Brooklyn Museum of Art, New York. Gift of the Elizabeth A. Sackler Foundation (2002.10)

Georgia O'KeeffePlace setting, detail of *The Dinner Party*.

FEMINISM AND ART

The idea of feminist art developed alongside the women's liberation movement of the 1960s as a challenge to one of the major unspoken conventions of art history: that great art could only be made by men. Since the 1960s, there have been three waves of feminist art and art history.

A major aim of first-generation feminism artists was increased recognition for the accomplishment of women artists, both past and present. As feminists examined the history of art, they found that women had contributed to most of the movements of Western art but were almost never mentioned in histories of art. Art historians began to salvage the histories of as many women artists as possible, instating them in the "canon," and arguing that they were as accomplished and important as the male artists already enshrined within it. Early feminists also attacked the traditional Western hierarchy that placed "the fine arts" (painting, sculpture, architecture) at a level of achievement higher than "the crafts" (ceramics, textiles, jewelry making). Since most craft media have been historically dominated by women, favoring art over craft tends to relegate women's achievements to second-class status. Thus early feminist art tended to embrace craft media (see Introduction, page xxix). Meanwhile, early feminist artists represented the physicality and sexuality of the female body as defined by women rather than as it appeared in male fantasies. This early feminist art was essentialist; it focused on women's bodies and defined gender in biological terms.

The second wave of feminist art defined gender in more relativist terms. In 1971, Linda Nochlin wrote a groundbreaking essay entitled "Why Have There Been No Great Women Artists?" in which she argued that many women artists in history cannot be described as "great" if the only standard of judgment for "great" art is a masculine canon. Nochlin argued that art institutions had systematically denied women access to art education and opportunities available to men throughout history, thereby making competition on male terms impossible. Thus, the terms of the canon must be challenged and the art system changed so that women can compete on their own terms. Second-wave feminist artists deconstructed the canon by which art was currently judged and called for a re-evaluation of the place of so-called feminine arts, such as ceramics, textiles, jewelry making, and miniature painting. In 1972 and 1973, Laura Mulvey and John Berger also challenged how women are looked at (gazed upon) by men in life and in art.

Third-wave feminist art emerged in the 1990s. This latest generation of artists has addressed an expanded range of issues surrounding the discrimination against or denigration of women, including such hybrid concerns such as gender and class, gender and race, violence against women, postcolonialism, transgenderism, transnationalism, and eco-feminism. In the process they have explored the many strategies that women employ to navigate life.

CHICAGO AND SCHAPIRO Born Judy Cohen, Judy Chicago (b. 1939) adopted the name of the city of her birth in

33–24 • Miriam Schapiro PERSONAL APPEARANCE #3 1973. Acrylic and fabric on canvas, $60'' \times 50''$ (152.4 \times 127 cm). Private collection.

order to free herself from "all names imposed upon her through male social dominance." In the late 1960s, she began making abstracted images of female genitalia to challenge the male-dominated art world and to validate the female body and experience. In 1970, she established a feminist studio art course at Fresno State College (now California State University, Fresno) and the next year moved to Los Angeles to join the painter Miriam Schapiro (b. 1923) in establishing a Feminist Art Program at the new California Institute of the Arts (CalArts). At this time she also began to create *The Dinner Party*, one of the largest and best-known feminist artworks of the 1970s (see "*The Dinner Party*," opposite).

In 1971–1972, Chicago, Schapiro, and 21 of their female students created *Womanhouse*, a collaborative art environment located in a run-down Hollywood mansion which the artists renovated and filled with feminist installations. In collaboration with Sherry Brody, Schapiro also created *Dollhouse*, a mixed-media construction of several miniature rooms adorned with richly patterned fabrics. She subsequently began to incorporate pieces of fabric into her acrylic paintings, developing a type of work she called femmage (from "female" and "collage"). Schapiro's femmages, such as **PERSONAL APPEARANCE #3** (**FIG. 33–24**), celebrate traditional women's crafts with a formal and emotional richness that was meant to counter the Minimalist aesthetic

of the 1960s that she considered typically male. Schapiro later returned to New York to lead the Pattern and Decoration movement, a group of both female and male artists who merged the aesthetics of abstraction with ornamental motifs derived from women's craft, folk art, and art beyond the Western tradition in a nonhierarchical manner.

MENDIETA Ana Mendieta (1948–1985) was born in Cuba but sent to Iowa in 1961 as part of "Operation Peter Pan," which relocated 14,000 unaccompanied Cuban children after the 1959 revolution that brought Fidel Castro and communism to power in Cuba. Mendieta never fully recovered from the trauma of her removal. A sense of personal dislocation haunted her, and a desire to leave her bodily imprint on the earth drove Mendieta to use ritualistic actions in performances that connected her to the earth. She was inspired by both *santería*, the African–Cuban religion (see Fig. 32–78), and the work of Beuys (see Fig. 33–18). Mendi-

33-25 • Ana Mendieta UNTITLED, FROM THE TREE OF LIFE SERIES

1977. Color photograph, 20" \times 131/4" (50.8 \times 33.7 cm). \circledcirc Estate of Ana Mendieta Collection.

eta produced more than 200 body works called "Silhouettes" in which she "planted" herself in the earth, and she recorded these performances in photographs and on film. The **TREE OF LIFE** series (**FIG. 33-25**) was created in Iowa, where she studied and lived. This photograph shows Mendieta with arms upraised like an earth goddess, pressed against a tree and covered in mud, as if to invite the tree to absorb her and connect her to her "maternal source." Like many of Mendieta's other works, this piece celebrates the notion that women have a deeper identification than men with nature.

EARTHWORKS AND SITE-SPECIFIC SCULPTURE

In the early 1970s, as Process artists reintroduced the handcrafted into art, another group of artists began working with the earth itself, using it as a medium to manipulate, craft, and change. Using the land as their canvas, Earth artists made art outdoors, frequently manipulating raw materials found at the site to create earthworks that are usually site-specific (designed for a specific location). Some of these artists created vast sculptures that altered the landscape permanently, while others made ambitious temporary works. Some Earth art appeared in remote locations, directly accessible to only a few people, while other examples are available to many. Earth art, like Performance and Conceptual art, is often intended to be noncommodifiable but is frequently recorded in photographs and on film, with the result that these images become collectable objects rather than the work itself. Earth art should not be confused with Environmental art. The former uses the land (or city) as a place on which to make art, whereas the latter seeks to draw attention to an imperiled natural environment.

SMITHSON Robert Smithson (1938–1973) sought to illustrate what he called the "ongoing dialectic" in nature between the constructive forces that build and shape form, and the destructive forces that destroy it. SPIRAL JETTY (FIG. 33-26) of 1970, a 1,500-foot stone and earth platform spiraling into the Great Salt Lake in Utah, reflects these ideas. To Smithson, the salty water and algae of the lake suggested both the primordial ocean where life began and a dead sea that killed it. The abandoned oil rigs dotting the lake's shore brought to mind dinosaur skeletons and the remains of vanished civilizations. Smithson used the spiral because it is an archetypal shape that appears in nature—from galaxies to seashells-and has been used in human art for millennia. Unlike Modernist squares and circles, it is a "dialectical" shape, that opens and closes, curls and uncurls endlessly, suggesting growth and decay, creation and destruction, or in Smithson's words, the perpetural "coming and going of things." He ordered that no maintenance be done on Spiral Jetty so that the work would be governed by the natural elements over time. It is now covered with crystallized salt but remains visible, as can be seen on Google Earth.

33-26 • Robert Smithson SPIRAL JETTY

1969–1970. Mud, precipitated salt crystals, rocks, and water, length 1,500′ × width 15′ (457 × 4.5 m). Great Salt Lake, Utah. Art © Estate of Robert Smithson/ Licensed by VAGA, New York, NY.

Smithson incorporated one of the few living organisms found in the otherwise dead lake into his work: an alga that turns a reddish color under certain conditions. *Spiral Jetty* is one vehicle wide: To create the work, earth was hauled out into the lake in a huge landmoving truck.

CHRISTO AND JEANNE-CLAUDE The most visible site-specific artists in America were Christo Javacheff (b. 1935) and Jeanne-Claude de Guillebon (1935–2009), who embarked on vast projects (both rural and urban) that sometimes took many years of planning to realize. In 1958, Christo emigrated from Bulgaria to Paris, where he met Jeanne-Claude; they moved to New York together in 1964. Their work was political and interventionist, frequently commenting on capitalism and consumer culture by wrapping or packaging buildings or large swatches of land in fabric: They "wrapped" the Reichstag in Berlin and 1 million

square feet of Australian coastline, for instance. In each case the process of planning and battling bureaucracies was part of the art, frequently taking years to complete. By contrast, the wrapping itself usually took only a few weeks and the completed project was in place for even less time. Christo and Jeanne-Claude funded each new project from the sale of books, Christo's original artworks (like drawings and collages), and other ephemera relating to the preceding projects.

33-27 • Christo and Jeanne-Claude THE GATES, CENTRAL PARK, NEW YORK 1979–2005. Shown here during its installation in 2005.

In February 2005, Christo and Jeanne-Claude installed **THE GATES, CENTRAL PARK, NEW YORK, 1979–2005** (Fig. 33-27), a project that took 26 years to realize, during which time the artists battled their way through various New York bureaucracies, meeting many obstacles and making changes to the work along the way. They finally installed 7,503 saffron-colored nylon panels on "gates" along 23 miles of pathway in Central Park. The brightly colored flapping panels enlivened the frigid February landscape and were an enormous public success. The installation lasted for only 16 days.

ARCHITECTURE: MID-CENTURY MODERNISM TO POSTMODERNISM

The International Style, with its plainly visible structure and rejection of historicism, dominated new urban construction in much of the world after World War II, which meant that the utopian and revolutionary aspects of Modernist architecture settled into a form that largely came to stand for corporate power and wealth. Several major European International Style architects, such as Walter Gropius (see FIG. 32–52), migrated to the United States and assumed important positions in architecture schools, where they trained several generations of like-minded architects.

MID-CENTURY MODERNIST ARCHITECTURE

Ludwig Mies van der Rohe (1886–1969) created the most extreme examples of postwar International Style buildings (see "The International Style," page 1057). A former Bauhaus teacher and a refugee from Nazi Germany, Mies designed the rectilinear glass towers that came to personify postwar capitalism. The crisp, clean lines of the SEAGRAM BUILDING in New York City (FIG. 33-28), designed with Philip Johnson, epitomize the standardization and impersonality that became synonymous with modern corporations. Such buildings, with their efficient construction methods and use of materials, allowed architects to pack an immense amount of office space into a building on a very small lot; it was also economical to construct. Although criticized for building relatively unadorned glass boxes, Mies advocated: "Less is more." He did, however, use nonfunctional, decorative bronze beams on the outside of the Seagram Building to echo the functional beams inside and give the façade a sleek, rich, and dignified appearance.

Although the pared-down, rectilinear forms of the International Style dominated the urban skyline, other architects departed from its impersonal principles so that, even in commercial architecture, expressive designs using new structural techniques and more materials also appeared. For instance, the **TRANS WORLD AIRLINES (TWA) TERMINAL** (FIG. 33-29) at John F. Kennedy Airport in New York City, by the Finnish-born American architect Eero Saarinen (1910–1961), dramatically breaks out of the box. Saarinen sought to evoke the thrill and glamor of air travel by giving the TWA Terminal's roof two broad winglike canopies of reinforced concrete that suggest a huge bird about to take flight. The interior consists of large, open, dramatically flowing spaces. Saarinen designed each detail of the interior—from ticket counters to telephone booths—to complement his gull-winged shell.

33-28 • Ludwig Mies van der Rohe and Philip Johnson **SEAGRAM BUILDING, NEW YORK** 1954–1958.

33-29 • Eero Saarinen TRANS WORLD AIRLINES (TWA) TERMINAL, JOHN F. KENNEDY AIRPORT, NEW YORK 1956-1962.

Frank Lloyd Wright (see FIGS. 32–41, 32–42, 32–43) transformed museum architecture with the **GUGGENHEIM MUSEUM** (FIG. 33–30) in New York, designed as a sculptural work of art in its own right. The Guggenheim was created to house Solomon Guggenheim's personal collection of Modern art and,

like the TWA Terminal, took on an organic shape, in this case a spiral. The museum's galleries spiral downward from a glass ceiling, wrapping themselves around a spectacular five-story atrium. Wright intended visitors to begin by taking the elevator to the top floor and then walk down the sloping and increasingly

33-30 • Frank Lloyd Wright SOLOMON R. GUGGENHEIM MUSEUM, NEW YORK 1943-1959.

The large building behind the museum is a later addition, designed in 1992 by Gwathmey Siegel and Associates.

widening ramp, enjoying paintings along the way. Today, the interior maintains the intended intimacy of a "living room," despite alterations by the museum's first directors. Wright wanted the building to contrast with skyscrapers like the Seagram Building and become a Manhattan landmark—indeed, it remains one of the twentieth century's most distinctive museum spaces.

POSTMODERN ARCHITECTURE

In the 1970s, architects began to move away from the sleek glass-and-steel boxes of the International Style and reintroduce quotations from past styles into their designs. Architectural historians trace the origins of this new Postmodern style to the work of Jane Jacobs (1916–2006), who wrote *The Death and Life of Great American Cities* (1961), as well as to Philadelphia architect Robert Venturi (b. 1925), who rejected the abstract purity of the International Style by incorporating elements drawn from vernacular (meaning popular, common, or ordinary) sources into his designs.

Venturi parodied Mies van der Rohe's aphorism, "Less is more," with his own—"Less is a bore." He accused Mies and other Modernist architects of ignoring human needs in their quest for uniformity, purity, and abstraction, and challenged Postmodernism to address the complex, contradictory, and heterogeneous mixture of "high" and "low" architecture that comprised the modern city. Venturi encouraged new architecture to embrace eclecticism, and

he reintroduced references to past architectural styles into his own designs, and began to apply decoration to his buildings.

While writing his treatise on Postmodernism—Complexity and Contradiction in Architecture (1966)—Venturi designed a house for his mother (FIG. 33-31) that put many of his new ideas into practice. The shape of the façade returns to the traditional Western "house" shape that Modernists (see FIGS. 32-39, 32-40, 32-50) had rejected because of its clichéd historical associations. Venturi's vocabulary of triangles and squares is arranged in a playful asymmetry that skews the staid harmonies of Modernist design, while the curved moldings are a purely decorative flourish—heretical in the strict tenets of the International Style. But the most disruptive element of the façade is the deep cleavage over the door, which opens to reveal a mysterious upper wall and chimney top. The interior is also complex and contradictory. The irregular floor plan, including an odd stairway leading up to the second floor, is further complicated by irregular ceiling levels that are partially covered by a barrel vault.

In the 1970s, Postmodern ideas were also applied to commercial architecture. One of the first examples was the **AT&T CORPORATE HEADQUARTERS** (now the Sony Building) in New York City (**FIG. 33-32**) by Philip Johnson (1906–2005). This elegant, granite-clad skyscraper has 36 oversized stories, making it as tall as the average 60-story building. It mimics its International

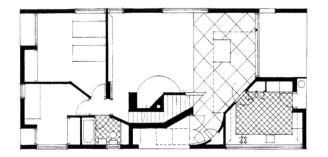

33-31 • Robert Venturi FAÇADE (A) AND PLAN (B), VANNA VENTURI HOUSE, CHESTNUT HILL Philadelphia, Pennsylvania. 1961–1964.

33-32 • Philip Johnson and John Burgee **MODEL OF THE AT&T CORPORATE HEADQUARTERS, NEW YORK** 1978–1983.

Style neighbors with its smooth uncluttered skin, while its Classical window groupings set between vertical piers also echo nearby skyscrapers from much earlier in the century. But the overall profile of the building bears a whimsical resemblance to the shape of a Chippendale highboy, an eighteenth-century chest of drawers with a long-legged base and angled top—Johnson seems to have intended a pun on the terms "highboy" and "high-rise." The round notch at the top of the building as well as the rounded entryway at its base suggest the coin slot and coin return of an old pay telephone in a clever reference to Johnson's patron, the AT&T telephone company.

POSTMODERNISM

Scholars disagree about the exact date when the theories of Postmodernism—developing in the 1970s—filtered through the Western art world, but most agree that it took place sometime in the early 1980s. By then, Modern ideas of art as absolute, ideal, pure, or perfect, and of the artist as a serious, single-minded individual who held her/himself above and apart from society, were beginning to seem both arrogant and foolhardy to younger artists.

Rather than a style, Postmodernism is perhaps better thought of as a strategy for making art. Its manifestations are many and varied. Postmodern artists reject the seriousness of Modernism, creating visually interesting, messy, sometimes contrary, and often political images that mock the rules of Modern art. They "appropriate" or take images wholesale from both "high art" and "popular" sources, repositioning and recontextualizing them, making them partially their own, twisting and changing their meanings. Postmodern artists create new images and new meanings out of the old, welcoming oddity, contradiction, and eccentricity, seriously questioning the idea of "originality."

Just as Modern art heralded an industrial, technological society, the advent of Postmodern art heralded a post-industrial, advanced capitalist society based on communication and information, and demanding a flexible population that embraces difference and change. Postmodern art reflects the **pluralism** (social and cultural diversity) of our globalized society, in which the only real constant is change and the only thing we have in common is difference. Postmodern art also embraces the vast visual culture of the 1980s, the age of personal computers, video cameras, cable television, and an emerging Internet culture; it harnesses images from this infinitely mutable world in which it is difficult to know what is real and what is not. As Andy Warhol observed presciently some time before, "I don't know where the artificial stops and the real starts."

PAINTING

Neo-Expressionism, one of the first international expressions of Postmodernism, was launched by two highly visible exhibitions in London ("A New Spirit") and Berlin ("Zeitgeist") in the early 1980s. Included in these exhibitions were large-scale figural paintings that recovered the luxury of the painted surface. Neo-Expressionism was almost exclusively a male movement: "A New Spirit" featured the art of 38 male artists and "Zeitgeist" featured the art of one female and 43 male artists.

KIEFER The German Neo-Expressionist Anselm Kiefer (b. 1945), born in the final weeks of World War II, both pays homage to and critiques the art of the German Expressionists of the 1930s, which was banned by the Nazis (see "Suppression of the Avant-Garde in Nazi Germany," page 1056). In the burned and barren landscape of **HEATH OF THE BRANDENBURG MARCH** (**FIG. 33-33**) from 1974 Kiefer grapples with his country's Nazi past, building on the

33–33 • Anselm Kiefer **HEATH OF THE BRANDENBURG MARCH** 1974. Oil, acrylic, and shellac on burlap, $3'10'/2'' \times 8'4''$ (1.18 × 2.54 m). Collection Van Abbemuseum, Eindhoven, The Netherlands © Anselm Kiefer.

ideas of his teacher Beuys. Instead of simply documenting Nazism in this painting, Kiefer juxtaposes the devastating physical impact of the war on the Brandenburg Heath (near Berlin) with Nazi history by scrawling the first words of the Nazi marching song "Märkische Heide, märkische Sand" across the road in the foreground, both quoting from the past and critiquing it.

BASQUIAT In the United States, the tragically short-lived Jean-Michel Basquiat (1960–1988) painted Neo-Expressionist canvases that grew out of graffiti art. The Brooklyn-born Basquiat was raised in middle-class comfort but rebelled by quitting high school and leaving home to become a street artist. For three years he covered the walls of lower Manhattan with short and witty philosophical texts signed with the tag "SAMO©." In 1980, Basquiat participated in the highly publicized "Times Square Show" which showcased the raw and aggressive styles of subway and graffiti artists. Basquiat said he wanted to make "paintings that look as if they were

33-34 • Jean-Michel Basquiat HORN PLAYERS 1983. Acrylic and oil paintstick on canvas, three panels, overall $8' \times 6'5''$ (2.44 \times 1.91 m). Broad Art Foundation, Santa Monica, California.

33-35 • Gerhard Richter MAN SHOT DOWN (1) ERSCHOSSENER (1) FROM OCTOBER 18, 1977
1988. Oil on canvas, $39\frac{1}{2}$ " \times 55 $\frac{1}{4}$ " (100 \times 140 cm). Museum of Modern Art, New York. © Gerhard Richter 2012. The Sidney and Harriet Janis Collection, gift of Philip Johnson, and acquired through the Lillie P. Bliss Bequest (all by exchange); Enid A. Haupt Fund; Nina and Gordon Bunshaft Bequest Fund; and gift of Emily Rauh Pulitzer (169.1995.g.)

made by a child," but in reality his work is a sophisticated mix of appropriated imagery from Modern art combined with blunt references to race and the street.

The strongly emotional **HORN PLAYERS** (FIG. 33-34) of 1983 portrays legendary jazz musicians Charlie Parker (upper left) and Dizzy Gillespie (center right) using urgent paint application and hurried lettering to convey Basquiat's dedication to jazz and his passionate determination to foreground African-American subjects in an unsentimental way. He said: "Black people are never portrayed realistically, not even portrayed, in Modern art, and I'm glad to do that." He died from a heroin overdose at age 27.

RICHTER Neo-Expressionism was only one of the many forms taken by Postmodern painting. German artist Gerhard Richter (b. 1932), for example, rejected the idea of adopting a single personal style, arguing that each painting's content should determine its form. In 1988, he created a series of paintings, including MAN SHOT DOWN (1) ERSCHOSSENER (1) FROM OCTO-BER 18, 1977 (FIG. 33-35) that featured life-size painted copies of grainy black-and-white newspaper photographs of the bodies of three members of the terrorist group Red Army Faction (commonly known as the Baader-Meinhof Gang), who were found dead in their prison cells in 1977, probably by suicide. They had been imprisoned for the kidnap and murder of Hans Martin Schleyer, president of the powerful German Federation of Industries. Richter simultaneously critiques the single-minded pursuit of a political ideologue willing to die for an idea, the powerful role of the mass media in creating meaning with images, and the value of the hand of the artist, even when, as in this case, it is almost invisible.

POSTMODERNISM AND GENDER

In 1982, critic Craig Owens argued that Postmodernism represents a crisis in normal cultural authority because of the way it questions the fictive homogeneity of Modernism. Moreover, since photography, which had never been fully integrated into the fine art canon, was perhaps the perfect medium for appropriating images, Owens argued that photography might also be the ideal medium for Postmodernism. Feminism had already challenged the "patriarchy" (the masculine control of power in society), and Owens characterized Modernism as patriarchal, authoritative, single-minded, and driven by the quest for originality and artistic mastery. He therefore argued that feminists and photographers were better positioned to create outstanding Postmodern art than the mostly male Neo-Expressionist painters. Postmodernism, feminism, and photography all forced viewers to confront difference; all challenged the authority of the canon; none particularly valued originality or individual artistic mastery. In keeping with this, many women artists used Postmodern strategies to create feminist art (see "The Guerrilla Girls," page 1110).

SHERMAN In 1977, Cindy Sherman (b. 1954) began work on her "Untitled Film Stills" series that exemplifies Postmodern strategies of looking. These black-and-white photographs eerily resemble publicity stills from the early 1960s, but they are actually contemporary photographs of Sherman herself in which she poses, appropriately made-up, in settings that seem to quote from the well-known plots of old movies. In UNTITLED FILM STILL #21 (FIG. 33-36), for instance, she appears as a small-town "girl" recently arrived in the big city to find work. Other photographs from the series show her variously as a Southern belle, a hardworking housewife, and a teenager waiting by the phone for a call.

33–36 • Cindy Sherman UNTITLED FILM STILL #21 1978. Black-and-white photograph, $8'' \times 10''$ (20.3 \times 25.4 cm). Courtesy of the artist and Metro Pictures, New York.

● Watch a video about Cindy Sherman on myartslab.com

ART AND ITS CONTEXTS | The Guerrilla Girls

In 1984, the Museum of Modern Art mounted "An International Survey of Painting and Sculpture," an exhibition that supposedly displayed the most important art of the time, yet of the 169 (mostly white) artists included in the exhibition, only 13 were women. By way of a rejoinder to this and several other such exhibitions, the following year the radical feminist group the Guerrilla Girls was founded in New York to function, they said, as "the conscience of the art world." Its members wear gorilla masks to hide their identity and to prevent personal reprisals; they call themselves "girls" as a play on the demeaning term "girl" as applied to women. Each Guerrilla Girl takes as a pseudonym the name of a famous dead woman artist. They have declared that the new "f" word is feminism.

Their mandate is to reveal gender and racial inequities in the art world, to demonstrate against discrimination, and to fight for the rights of women and artists of color. The Guerrilla Girls use the strategies of guerrilla warfare—they act covertly and strike anonymously at the heart of their enemy. They compile statistics on discrimination in the art world, produce sharp, witty, sophisticated posters that draw on the best advertising theory, and paste these posters at night on walls in the art districts of New York, close to offending galleries and museums. The posters are highly visible, damning, and very funny, and they have made a difference.

One of their most famous posters features a variation on Ingres's Large Odalisque (see Fig. 30–56) and the words "Do women have to be naked to get into the Met. Museum?" As the poster explains, 85 percent of the nudes on display in the Metropolitan Museum at the time (1989) were women, while less than 5 percent of art in the museum was by women. Sadly, the Guerrilla Girls repeated their survey in 2005 and found that there were even fewer women artists (3 percent), but, as they said, at least there were more naked men!

THE ADVANTAGES OF BEING A WOMAN ARTIST (FIG. 33-37)

delivers a clever, ironic, and sadly accurate list of the "benefits" of being a woman artist. Today's Guerrilla Girls have broadened their reach to address larger issues of race and political discrimination in the world. They have made significant differences in the art world, if not yet at the Met.

THE ADVANTAGES OF BEING A WOMAN ARTIST:

Working without the pressure of success

Not having to be in shows with men

Having an escape from the art world in your 4 free-lance jobs

Knowing your career might pick up after you're eighty

Being reassured that whatever kind of art you make it will be labeled femining

Not being stuck in a fenured teaching position

Seeing your ideas live on in the work of others

Having the opportunity to choose between career and motherhood

Not having to choke on those big cigars or paint in Italian suits

Having more time to work when your mate dumps you for someone younger

Being included in revised versions of art history

Not having to undergo the embarrassment of being called a genius

Getting your picture in the art magazines wearing a gorilla suit

A PUBLIC SERVICE MESSAGE FROM GUERRILLA GIRLS CONSCIENCE OF THE ART WORLD

33-37 • Guerrilla Girls THE ADVANTAGES OF BEING A WOMAN ARTIST

1988. Offset print, $17'' \times 22''$ (43.2 \times 55.9 cm). Collection of the artists. © Guerrilla Girls.

Critics have discussed these images in terms of second-wave feminism since they question the culturally constructed roles played by women in society, and since they critique the male gaze. In each, Sherman is both the photographer and the photographed. By assuming both roles, she complicates the relationship between the person looking and the person being observed, and she subverts the way in which photographs of women communicate stereotypes.

KRUGER Barbara Kruger (b. 1945) makes an even stronger point about how women are observed in **UNTITLED** (**YOUR GAZE HITS THE SIDE OF MY FACE**) (**FIG. 33-38**). Kruger began her career as a designer for *Mademoiselle* magazine before using photography to make art. Her signature style is a combination of black-and-white photographic images with the red three-color printing used in cheap advertising. Kruger appropriates the visual

33-38 • Barbara Kruger UNTITLED (YOUR GAZE HITS THE SIDE OF MY FACE)

1981. Photograph, red painted frame, 55" \times 41" (140 \times 104 cm). Mary Boone Gallery, New York. © Barbara Kruger.

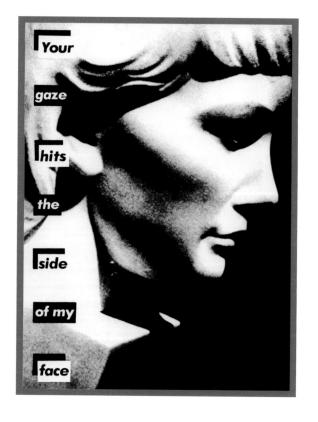

33-39 • Faith Ringgold TAR BEACH (PART I FROM THE WOMEN ON A BRIDGE SERIES)

1988. Acrylic on canvas, bordered with printed, painted, quilted, and pieced cloth, 74%" \times 68½" (190.5 \times 174 cm). Guggenheim Museum, New York. © Faith Ringgold 1988. Gift of Mr. and Mrs. Gus and Judith Lieber

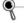

View the Closer Look for Tar Beach on myartslab.com

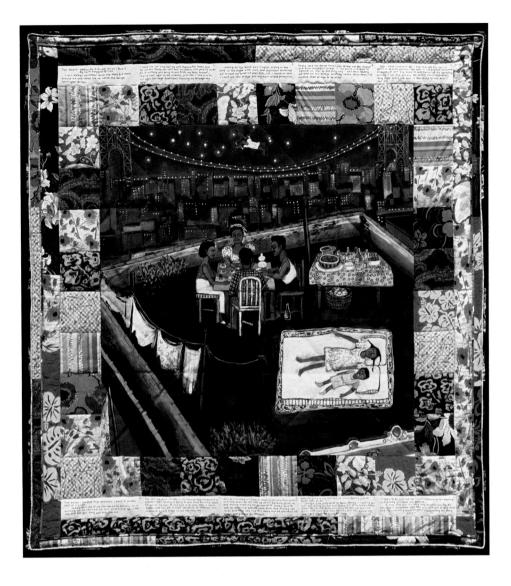

character of advertising—its layout style, and its characteristic use of slogans—to suggest and subvert the advertising image. Here she personalizes the relationship between viewer and viewed—the person who looks (the spectator) and the person who is looked at (the subject)—by addressing viewers directly with the personal pronoun "you." The spectator is active, while subject is passive. Usually the person who looks holds the power of the "gaze," implicitly subjugating the person being looked at. But if the person being looked at returns, rejects, or deflects the gaze, the traditional power relationship is upset. That is what happens in Kruger's image, where the observer ("you") is blocked by the subject, who declares that "your gaze" is deflecting by "the side of my face." Kruger's art is subversive and interventionist; she has distributed it on posters, on T-shirts, even on pencils and pens.

POSTMODERNISM AND RACE OR ETHNICITY

Other artists have likewise used Postmodern strategies to draw attention to racial and ethnic difference, advocating for change and exploring how race and gender combine to silence artists.

RINGGOLD Faith Ringgold (b. 1930) draws on the tradition of African-American quilt making combined with the heritage of African textiles to paint significant statements about race in America. In the early 1970s, Ringgold began to introduce traditional women's crafts into her art, painting on soft fabrics rather than on stretched canvases and framing her paintings with decorative quilted borders. Ringgold's mother, Willi Posey, a fashion designer and dressmaker, made the quilted borders until her death in 1981, after which Ringgold began to do the quilting herself. In 1977, Ringgold started writing her autobiography (We Flew Over the Bridge: The Memoirs of Faith Ringgold, 1995) but, unable to find a publisher, decided to sew her stories into quilts instead—what she termed "story quilting."

Animated by a feminist sensibility, Ringgold's story quilts are narrated by women and usually address women's issues. In **TAR BEACH** (**FIG. 33-39**), the narrator is 8-year-old Cassie Louise Lightfoot—although the story is actually based on Ringgold's own memories of growing up in Harlem. "Tar Beach" refers to the roof of the apartment building in which Ringgold's family lived. They

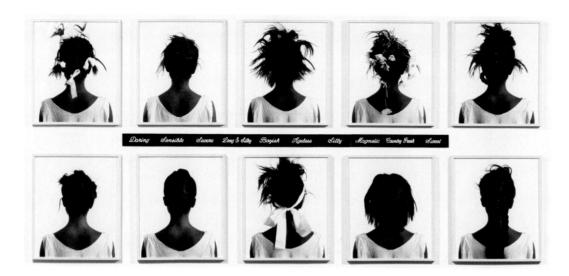

33-40 • Lorna Simpson **STEREO STYLES**1988. Ten black-and-white Polaroid prints and ten engraved plastic plaques, 5'4" × 9'8" (1.63 × 2.95 m) overall. Private collection.

slept there on hot summer nights, and Ringgold describes it as a magical place. Cassie and her brother lie on a blanket while their parents and neighbors play cards. She dreams that she can fly and that she can possess everything over which she passes. Cassie is shown flying over the George Washington Bridge, claiming it for herself; over a new union-constructed building, claiming it for her father who, as an African-American construction worker, was not allowed to join the union; and over an ice-cream factory, claiming for her mother "ice cream every night for dessert." Cassie's fantasy is charming, but it reminds viewers of the real social and economic prejudices that African Americans have faced in America's past and present.

SIMPSON In STEREO STYLES (FIG. 33-40), Lorna Simpson (b. 1960) arranges in a double row ten Polaroid images of African-American women photographed from behind. Each wears a different hairstyle, described variously and ironically as "Daring," "Sensible," "Severe," "Long and Silky," "Boyish," "Ageless," "Silly," "Magnetic," "Country Fresh," and "Sweet." Simpson frequently photographs African-American women with their faces turned away to suggest that they are seen only in terms of their bodies or, in this case, of their African-American hair styles. Her images ask us to consider how African-American women are stereotyped and to contemplate the role that hair plays as an indicator of race, gender, and class in society.

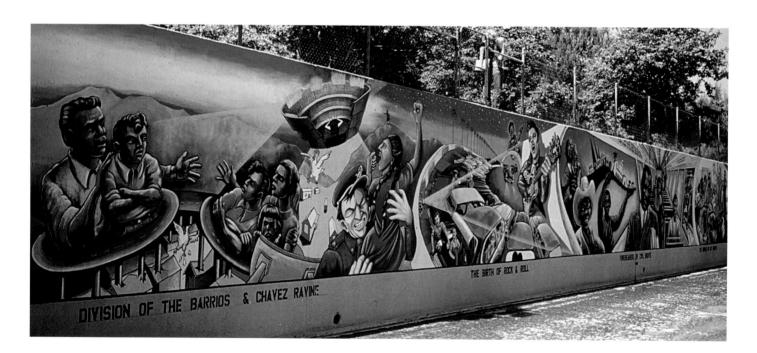

33-41 • Judith F. Baca THE DIVISION OF THE BARRIOS (DETAIL FROM THE GREAT WALL OF LOS ANGELES)

1976–1983 (section shown painted summer 1983). Acrylic on cast concrete, height 13' (4 m), overall length of mural approx. 2,500' (762 m). San Fernando Valley Tujunga Wash, Van Nuys, California. © SPARC.

33-42 • Kerry James Marshall MANY MANSIONS 1994. Acrylic on paper mounted on canvas, 1141/4" × 1351/6" (290 × 343 cm). The Art Institute of Chicago. Max V. Kohnstamm Fund (1995.147)

Watch a video about Kerry James Marshall on myartslab.com

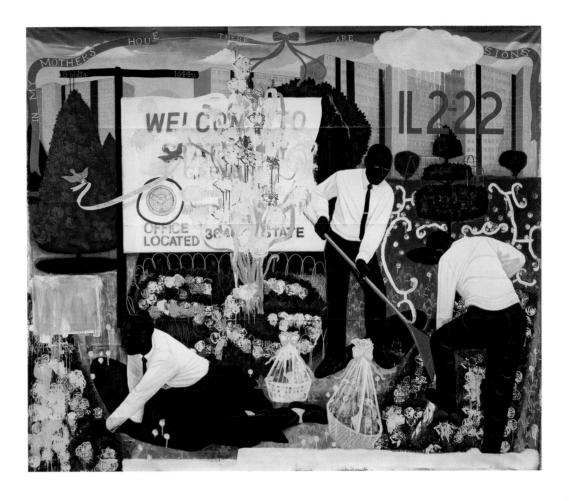

BACA Judith F. Baca (b. 1946) pays tribute to her Mexican-American heritage in *The Great Wall of Los Angeles*—begun in 1976 and extending almost 2,500 feet along a flood drainage canal—which looks back to the Mexican mural movement to recount the history of California as seen through Mexican-, African-, and Japanese-American eyes. This detail, **THE DIVISION OF THE BARRIOS** (FIG. 33-41), depicts the residents of a Mexican-American neighborhood protesting futilely against the division of their neighborhood by a new freeway. Other scenes include the deportation of Mexican-American citizens during the Great Depression and the internment of Japanese-American citizens during World War II. Like Judy Chicago's *Dinner Party* (see FIG. 33-23), Baca's *The Great Wall of Los Angeles* was a collaborative effort involving many professional artists and hundreds of young people.

MARSHALL MANY MANSIONS (FIG. 33-42) by African-American painter Kerry James Marshall (b. 1955) is a wry, ironic commentary on race, class, and poverty in American society. The work refers to Stateway Gardens, Chicago, one of the largest and worst-maintained housing projects in America. The scandalously inadequate conditions were the subject of much debate prior to its demolition in 2007. Marshall shows an unrealistically idyllic attempt by three African-American men—impossibly well dressed for gardening—to create an equally impossibly tidy garden that

includes manicured topiary in the background and flowerbeds in the foreground. The painting includes a number of biting details, including the statement "In my mother's house there are many mansions," which both changes the gender of the biblical quotation (John 14:2) and comments on the disrepair of the projects by labeling them, ironically, "mansions." Adding irony on top of irony, two cute cartoon bluebirds with a baby-blue ribbon fly into the scene like the birds that bring the fairy godmother's gifts to Cinderella in rags in the Disney film, while two Easter baskets neatly wrapped in plastic sit in the garden. Marshall based the off-center triangular composition of this large painting on Géricault's *The Raft of the "Medusa"* (see Fig. 30–50). He told an television interviewer from PBS, "That whole genre of history painting, that grand narrative style of painting, was something that I really wanted to position my work in relation to."

LUNA James Luna (b. 1950) asks us to confront Native American stereotypes in **THE ARTIFACT PIECE** (**FIG. 33-43**), first staged in 1987 in a hall dedicated to a traditional ethnographic exhibition at the Museum of Man in San Diego. Luna lay, almost naked, in a glass display case filled with sand embedded with artifacts from his life, including his favorite music and books, and personal legal papers. Museum-style labels pointed to marks and scars on his body that he had acquired while drinking or fighting, or in accidents. In this way, Luna literally turned his living body and his life

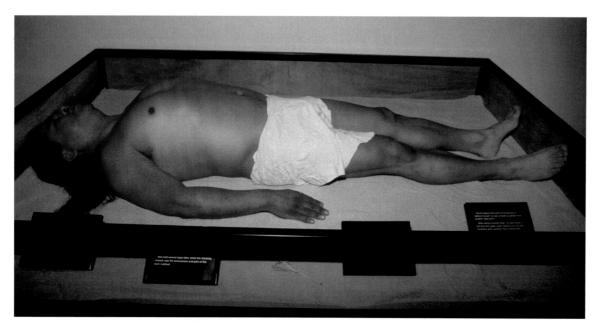

33-43 • James
Luna THE
ARTIFACT PIECE
First staged in 1987
at the Museum of
Man, San Diego. Luna
also performed the
piece for "The Decade
Show," 1990, in New
York.

into an ethnographic object for people to ogle, assess, and judge. By physically objectifying himself, he challenges our prejudices, stereotypes, and assumptions about Native Americans in general and about him specifically.

SCULPTURE

In the 1980s, several sculptors became embroiled in controversies over the nature and purpose of sculpture itself. Following in the footsteps of Andy Warhol (see FIG. 33–11), some of their works challenged sculptural orthodoxy by introducing images and objects appropriated from popular and mass culture, while others raised questions about the rights of sculptors to create deliberately confrontational or offensive works, especially when fulfilling government commissions for site-specific sculptures in the public domain.

KOONS Jeff Koons (b. 1955)—self-publicist and critical celebrant of the superficial, consumption-crazy suburban society of the 1980s—has enshrined as art such household objects as vacuum cleaners, inflatable bunny rabbits, topiary puppy dogs, and porcelain pornography, all with sly references to Duchamp (see Fig. 32–30). PINK PANTHER (Fig. 33–44) shows a cheesy centerfold pin-up's unsettling embrace of the cuddly cartoon figure. At more than 3 feet tall, this slick and glossy work is almost life-size, made from porcelain, a material more commonly used for knick-knacks than sculpture. The flat pastel colors recall Warhol's Marilyn Monroe portraits (see Fig. 33–12). Koons's unsettlingly bland and pretty work invites, even welcomes, critical disapproval, embracing kitschy lower-middle-class consumer culture without seeming to critique it, openly materialistic and straightforwardly shallow.

SERRA Richard Serra (b. 1939) studied sculpture at the University of California at Berkeley and at Santa Barbara, and at Yale. In his early works, he draped vulcanized rubber in different

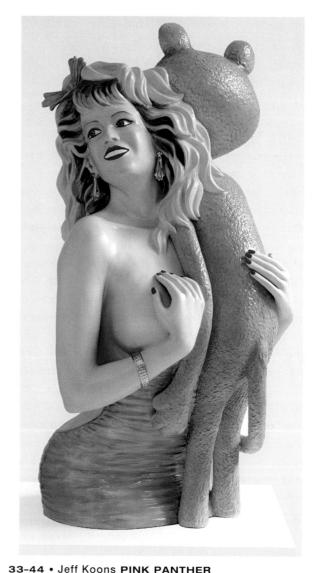

1988. Porcelain, ed. 1/3. 41" × 20½" × 19" (104.1 × 52.1 × 48.3 cm). Collection Museum of Contemporary Art, Chicago. © Jeff Koons.

Watch a video about Jeff Koons on myartslab.com

33-45 • Richard Serra TILTED ARC1981–1989. Jacob K. Javitz
Federal Plaza, New York.
Steel. Destroyed.

arrangements and threw molten lead against gallery walls, but in the early 1970s, he began making the sculptures from very large steel plates for which he is now (in)famous. In 1981, he won a commission from the General Services Administration (GSA) to create a sculpture, TILTED ARC (FIG. 33-45), for the banal plaza in front of the Javitz Federal Building in New York. The GSA approved plans for the proposed work, but once installed, the sculpture, a long curved Cor-Ten steel wall 120 feet long, 12 feet tall, and 21/2 inches thick, bisected the plaza, completely changing it as a public space and making it impossible to hold concerts or performances. Even casual use by those who worked in the building was made difficult. Over time Tilted Arc rusted and was soon covered in graffiti and pigeon droppings. Public outrage against it became so intense that in 1986 Serra's sculpture was removed to a Brooklyn parking lot, an action that incited further furor, this time among artists and critics. Serra argued that moving the sitespecific piece had destroyed it; he filed a lawsuit claiming censorship, but the Federal district court found no legal merit in his case.

Tilted Arc raised several important questions about the rights and responsibilities of artists, as well as the obligations of those who commission public works of art. Clearly Serra's sculpture had intentionally changed (for some spoiled) Javitz Plaza. In court, the artist did not attempt to defend his work on aesthetic grounds, but to claim the right to create the piece as planned and approved. This well-publicized legal case precipitated changes in the commissioning of public sculpture. Today neighborhood groups and local officials meet with artists well in advance of public commissions. Important questions, however, remain unresolved. Does the institution of such public safeguards lead to better public sculpture?

Or do they merely guarantee that it will be bland, inoffensive, and decorative?

LIN Maya Lin (b. 1959) was an architecture student at Yale University in 1981 when a jury of architects, landscape architects, and sculptors awarded her the commission for the VIETNAM VETER-ANS MEMORIAL (FIG. 33-46) near the Mall in Washington, DC. Lin (one of 2,573 who submitted design proposals) envisioned a simple and dramatic memorial cut into the ground in a V-shape. Two highly polished black granite slabs reach out from deep in the earth at the center. Each of these arms is 247 feet long, and they meet at a 130-degree angle where the slabs are 10 feet tall. The names of 58,272 American soldiers killed or declared missing in action during the Vietnam War are listed chronologically, in the order they died or were lost, beginning in 1956 at the shallowest point to the left and climaxing in 1968 at the tallest part of the sculpture, representing the year of highest casualties. Since the polished granite reflects the faces of visitors, they read the names of the dead and missing with their own faces superimposed over them. The memorial, commissioned by Vietnam Veterans for Vietnam Veterans, serves both to commemorate the dead and missing and to provide a place where survivors can confront their own loss. This sculpture is one of the best-known works of public art in the United States and has transformed the way the nation mourns its war dead. Visiting it is a powerful and profound experience.

Yet, when it was first commissioned, the Vietnam Veterans Memorial was the subject of intense debate. It was described as a "black gash in the Mall," its color contrasting with the pervasive

33-46 • Maya Lin VIETNAM VETERANS MEMORIAL, WASHINGTON, DC 1981–1983.

white marble of the surrounding memorials. Lin was accused of creating a monument of shame, one critic going so far as to claim that black was the universal color of "shame, sorrow, and degradation in all races, all societies." Opposition to the sculpture was so intense in some quarters that, in 1983, the Vietnam Veterans Memorial Fund commissioned a second, naturalistic sculpture showing three soldiers from Georgia-born artist Frederick Hart (1943–1999), placed 120 feet from the wall; in 1993, Texas sculpture of Glenda Goodacre (b. 1939) created a comparable sculpture of three nurses, added 300 feet to the south to memorialize the contribution of women during the war.

ART, ACTIVISM, AND CONTROVERSY: THE NINETIES

The passage from the 1980s to the 1990s was marked by what is commonly referred to as the "Culture Wars" (see "Controversies Over Public Funding for the Arts," page 1118), a confrontation between artists and public officials in America over freedom of

speech and public funding for the arts, particularly with regard to the right to make art that might be considered offensive or obscene by others. At the same time many artists who had previously worked on the periphery of society and established art institutions began to claim center stage by making aggressive images about identity and unequal treatment on the grounds of gender, sexual orientation, race, or class. Many of these artists worked with particular passion and urgency as they or their friends and partners died from AIDS. The 1990s also saw the beginning of the digital age, when a new interest in the mutability of photography and film opened imaginative new vistas for artists.

THE CULTURE WARS

In the early 1990s, several previously marginalized younger artists achieved fame by producing narrative images deliberately intended to disrupt, provoke, and offend viewers (see "Controversies over Public Funding of the Arts," page 1118). In the United States, Andres Serrano defamed an image of the Christian crucifix while Robert Mapplethorpe confronted audiences with openly gay sexuality. In the United Kingdom, Damien Hirst defiled the mortal

A CLOSER LOOK | Plenty's Boast

by Martin Puryear. 1994-1995. Red cedar and pine.

 $68'' \times 83'' \times 118''$ (172.7 \times 210.8 \times 299.7 cm). Nelson-Atkins Museum of Art, Kansas City, Missouri. © Martin Puryear. Purchase of the Renee C. Crowell Trust (F95-16 A-C)

Puryear spent a year with the Peace Corps in Sierra Leone, working with African carpenters to learn their woodworking methods and skills. Note the gentle and beautifully irregular handfinishing at the mouth of the sculpture and in the binding of its tail.

Puryear, who studied furniture making with James Krenov, maintains the highest craft standards. Notice the radiating grain on the inside of the horn, the spiraling grain on its tail, and the exquisite quality of the joints.

The clarity, abstract nature, and monumental scale (it is 51/2 feet tall) of the sculpture seem to refer to Minimalism, but evidence of the human hand in the crafting of the piece, as in the wobble in the line of the bell, suggests something closer to Process art.

The twisting tail suggests the empty shell of a strange animal or plant. Although it is lying passively at the moment, it looks as if it could flex quickly (note the jointing) to deliver a deadly sting. The bell shape evokes many forms, such as a musical horn, an old-fashioned gramophone horn, a flower's bell, or a cornucopia (horn of plenty).

Puryear wants viewers to see ghosts of resemblances in his allusive sculpture. Perhaps most obviously, Plenty's Boast suggests a cornucopia, filled with the fruits of harvest and symbolizing abundance. But the cone is empty, implying an "empty boast"—a phrase suggested by the title.

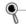

-View the Closer Look for *Plenty's Boast* on myartslab.com

ART AND ITS CONTEXTS | Controversies over Public Funding for the Arts

Should public money help pay for art that some taxpayers believe to be offensive and indecent? This question started a political battle in 1989–1990 after controversial works of art by Robert Mapplethorpe (1946–1989) and Andres Serrano (b. 1950) went on public display in exhibitions funded in part by the National Endowment for the Arts (NEA), an agency of the Federal government. The ensuing debate pitted artists and museum administrators against political and religious figures in what is now referred to as the "Culture Wars."

Serrano's *Piss Christ* (see Fig. 33–48) was at the center of the debate. Serrano did not use public money directly to create this work, but the Southeastern Center for Contemporary Art (SECCA), which exhibited *Piss Christ* in a group exhibition, was a recipient of NEA funds. The Reverend Donald Wildmon, leader of the American Family Association, described *Piss Christ* as "hate-filled, bigoted, anti-Christian, and obscene," and told his many followers to flood Congress and the NEA with letters protesting the misuse of public funds. Several high-profile conservative Republican politicians swiftly joined his attack.

At the same time, the traveling exhibition "The Perfect Moment," a retrospective of the work of photographer Mapplethorpe, who had recently died from AIDS, was canceled by the Corcoran Gallery of Art in Washington, DC, for fear that the show's content might cause offense or threaten the museum's government funding. "The Perfect Moment" had been organized by the Institute of Contemporary Art (ICA) in Philadelphia, was NEA-funded, and included several homoerotic and sadomasochistic images, including very provocative self-portraits of the artist. When it was shown in Cincinnati, the museum director was arrested. Additionally, in 1990 amid a flurry of debate, the NEA rescinded the grants awarded to four artists-who became known as the "NEA Four" (Karen Finley, John Fleck, Holly Hughes, and Tim Miller)—because they made lesbian, gay, or radical feminist art. Congress slashed NEA funding by \$45,000: the sum of Serrano's \$15,000 SECCA grant, plus the ICA's \$30,000 grant for the Mapplethorpe show. The NEA Four sued and won back their grants in 1993, but a so-called "obscenity clause" was added to NEA regulations requiring jurors to consider the "general standards of decency and respect for the diverse beliefs and values of the American public" when making awards.

During the next five years, the NEA was largely restructured by the Republican-controlled House of Representatives, some of whose members wanted to eliminate the agency altogether. In 1996, Congress reduced the NEA's budget by 40 percent.

Controversies over public funding continued, however. In 1999, the Brooklyn Museum of Art exhibited "Sensation: Young British Artists from the Saatchi Collection," causing another major controversy over public funding and offensive art. The Brooklyn Museum kept the show open in direct defiance of a threat from Mayor Rudolph Giuliani to eliminate city funding and evict the museum from its city-owned building if it persisted in showing art that he considered "sick" and "disgusting." Giuliani and Catholic leaders took particular

offense at Chris Ofili's **THE HOLY VIRGIN MARY** (FIG. 33–47). When the Brooklyn Museum of Art still refused to cancel the show, Giuliani withheld the city's monthly maintenance payment to the museum of \$497,554 and filed a suit in the state court to revoke its lease. In response, the museum filed for an injunction against Giuliani's actions on the grounds that they violated the First Amendment, and the United States District Court for the Eastern District of New York eventually barred Giuliani from punishing or retaliating against the museum in any way for mounting the exhibition. Guiliani had argued that Ofili's art fostered religious intolerance, but the court ruled that the government has "no legitimate interest in protecting any or all religions from views distasteful to them," adding that taxpayers "subsidize all manner of views with which they do not agree" and even those "they abhor."

33-47 • Chris Ofili THE HOLY VIRGIN MARY

1996. Acrylic, oil paint, polyester resin, paper collage, glitter, map pins, and elephant dung on linen, $7'11''\times5'11^5\!/_6''$ (2.44 \times 1.83 m). MONA, Museum of Old and New Art, Hobart, Tasmania, Australia © Chris Ofili.

remains of domestic animals while Chris Ofili created a racially and culturally hybrid Christian Madonna. The resulting social and political backlash triggered the Culture Wars.

SERRANO In 1987, Andres Serrano (b. 1950) created **PISS CHRIST** (**FIG. 33-48**). Like other artists of the time, Serrano's art explores social taboos in deliberately confrontational and offensive ways. His art dances between the luxuriously beautiful and the abject. His photographs of the homeless, Ku Klux Klansmen, suicides, and murder victims have proven so difficult for some viewers that they have inspired vandalism. *Piss Christ* is an almost 2-foothigh, brilliantly colored Cibachrome print of a Christian crucifix which the artist submerged in a Plexiglas box filled with his own urine. Serrano, who was raised a strict Catholic, has argued that this image is about confronting the physicality of the death of

33–48 • Andres Serrano PISS CHRIST 1989. Cibachrome print mounted on Plexiglas, $23\frac{1}{2}$ " \times 16" (59.7 \times 40.6 cm).

the body of Christ, sometimes too easily forgotten, and that it critiques the commercialization of Christ's image in the media, which is why it is also so provocative and offensive to others.

HIRST In London in the 1980s, a group of Young British Artists (YBAs) banded together to exhibit their work, led informally by Damien Hirst (b. 1965). In 1995, the Walker Art Center in Minneapolis mounted an exhibition entitled "Brilliant," featuring 22 British artists, many of whom used nontraditional materials and images in their art, had working-class backgrounds or sympathies, or had an adversarial relationship with mainstream society. Two years later, the London Royal Academy featured many of the same artists in "Sensation," an exhibition of art from the Charles Saatchi Collection, which consolidated the reputation of many YBAs. When the show traveled to the Brooklyn Museum in

1999, however, it was considered so offensive that the mayor of New York threatened to close the museum if it was not removed.

Damien Hirst is one of the most outrageous of the original YBAs and his most outrageous work of art may be For the Love of God (2007), a diamond-encrusted human skull with an asking price of \$100m. His art probes the physical reality of death and the impossibility of imagining our own death, and he frequently uses dead animals in his work. In MOTHER AND CHILD (DIVIDED) (FIG. 33-49) he has bisected vertically and longitudinally the bodies of a cow and her calf and displayed them in glass display cases filled with formaldehyde solution. This sculpture resembles the kind of display that viewers might see in a natural history museum—but with some significant differences. The cases are arranged so that viewers can walk not only around them, but also see between them. On the outside, these animals retain an amazingly lifelike look (even their eyelashes and individual hairs are visible) within the formaldehyde solution, but once we see the cleavages in their bones, muscles, organs, and flesh on the inside, the actuality of their death is overwhelming. Taking into account that in the 1990s British cattle were being slaughtered daily in an attempt to stop the spread of the terrifying BSE (Mad Cow Disease), Mother and Child (Divided) creates a feeling of being caught between life and death, between mother and child, between scientific presentation and, as in Serrano's work, a set of barely suppressed and disturbingly powerful emotions.

OFILI The art of Nigerian-British artist Chris Ofili (b. 1968) provided the focal point for criticism of the 1999 "Sensation" exhibition at the Brooklyn Museum. Ofili exhibited *The Holy Virgin Mary* (see FIG. 33–47), a glittering painting of a stylized African Madonna which includes among its myriad media elephant dung and

33-49 • Damien Hirst MOTHER AND CHILD (DIVIDED), EXHIBITION COPY 2007 (ORIGINAL 1993)
2007. Glass, painted stainless steel, silicone, acrylic, monofilament, stainless steel, cow, calf, and formaldehyde solution, two tanks at 821/3" × 1267/8" × 43" (209 × 322 × 109 cm), two tanks at 45" × 661/2" × 245/8" (114 × 169 × 62.5 cm). © 2012 Damien Hirst and Science Ltd. All rights reserved/DACS,London/ARS, NY. Photographed by Prudence Cuming Associates.

small found photographs of women's buttocks. Ofili, who spent a year in Zimbabwe studying the use of materials in art, explained that many African nations have a tradition of using found or salvaged objects and materials in both popular and high art. Ofili's painting is a contemporary bicultural reinvention of the Western Madonna tradition, and its use of elephant dung intends to reinforce this black Madonna's connection to the art and religion of Zimbabwe and to represent her fertility. Then-mayor of New York Rudolph Giuliani and his allies, however, considered the picture so shocking and sacrilegious that they ordered it removed immediately or the exhibition closed. Giuliani maintained that "There's nothing in the First Amendment that supports horrible and disgusting projects!"

ACTIVIST ART

The Culture Wars were fueled by a significant increase in Activist art during the 1990s. AIDS decimated the younger art scene in New York's East Village and triggered a global health crisis by mid decade. Increasingly, anger over the agony of those dying from, and losing friends and lovers to, AIDS, combined with government inaction, spilled over into art. Thus the 1990s opened with angry art about the body, AIDS, and identity, as well as with continued clamoring for acknowledgment of the discrimination faced by people of different races, ethnicities, classes, and sexual orientations. The Culture Wars were, in many ways, about artists searching for a place in the world while so many were fading from it.

GONZALEZ-TORRES In the mid-1980s, the spread of the human immunodeficiency virus (HIV), the underlying cause of AIDS, had begun to reap its deadly harvest within the gay community. Felix Gonzalez-Torres (1957–1996) created "**UNTITLED"** (**LOVERBOY**) (FIG. 33-50) in 1990 as his long-time partner Ross Laycock was dying from AIDS. The piece is deceptively simple: a stack of pale blue paper sat on the gallery floor and

33–50 • Felix Gonzalez-Torres "UNTITLED" (LOVERBOY) 1990. Blue paper, endless supply, $7\frac{1}{2}$ " (at ideal height) \times 29" \times 23" (19.1 \times 73.7 \times 58.4 cm). Installation view of *Felix Gonzalez-Torres* at Andrea Rosen Gallery, New York, 1990.

visitors followed instructions by taking a sheet as they walked by. As time passed, the stack of paper gradually diminished, the disappearance of which could be understood as a touching allegory of the slowly disappearing body of Gonzalez-Torres's partner. The artist said: "I wanted to make something that would disappear completely." There is a poignant directness to this work. Gonzalez-Torres himself died of AIDS in 1996.

WOJNAROWICZ David Wojnarowicz (1955–1992) railed against death before he too died from AIDS in 1992. In 1987, Wojnarowicz's lover, photographer Peter Hujar died from AIDS

Sometimes I come to hate people because they can't so I've gone empty, completely empty and all they seeds my arms and legs, my face, my height and posture alto. ago no longer exists; drifts spinning slowly into the way back there. I'm a xerox of my former sell, lead to dying any longer I am a stranger to others and tage to pretend that I am tag mar of that have histo I am glass, clear Econ glass Ad and ire made by Ylook familiar but Lag ete Salaber being redes. I am a stranger and I am moving, I am on to be on all fours? I am no longer animal mer made of circuits or disks. I am all emptiness and futility. I am form Level o longer find what head in the and of eyes have and nobody's words can and into all this from ouer. See the signs Met notice. I feel am a gas shuman. Lam a glass human disappearing it rain. Lam standing among all of you waving my invisible arms and all dis. I am shouting my invisible

33–51 • David Wojnarowicz "UNTITLED (HANDS)" 1992. Silver print with silkscreened text, $38^{\prime\prime} \times 26^{\prime\prime}$ (96.5 \times 66.0 cm). Courtesy of the estate of David Wojnarowicz and PPOW Gallery, New York.

and Wojnarowicz himself was diagnosed as HIV-positive. In response, he began to make forcefully aggressive art about the fear and confusion of watching a loved one die while facing one's own death. In **UNTITLED (HANDS)** (FIG. 33-51), Wojnarowicz photographed, in black and white, two bandaged hands outstretched as if in a begging gesture. Superimposed is a text in angry red type taken from Wojnarowicz's book *Memories That Smell Like Gasoline*, in which he describes how he is hollowing out from the inside and becoming invisible as he dies. Parts of Wojnarowicz's book were reprinted in the catalog of an exhibition, "Witnesses Against Our Vanishing," which featured art by and about artists

with AIDS and which became a flashpoint in the Culture Wars.

SMITH In sculpture of the early 1990s, the physicality of the human body reasserted itself as a site for the discourse on AIDS. The sculptor Kiki Smith (b. 1954), who lost a sister to AIDS, explores the body, bodily functions, and the loss of physical control that the dying experience in works such as the 1990 UNTITLED (FIG. 33-52). This disturbing sculpture shows two life-size naked figures, female and male, made from flesh-colored painted beeswax and hanging passively, but not quite lifelessly, side by side about a foot above the ground. Milk drips from the woman's breasts and semen drips down the man's leg, as if both have lost control of bodily functions that were once a source of vitality and pleasure. There is a profound sense of loss, but also of release. Smith has written that since our society abhors the reality of bodily functions, we strive to conceal and control them, making our loss of control as death nears humiliating and frightening. This sculpture asks us to consider bodily control-both our own sense of control and the control that others exert on our body as we die-and suggests that relinquishing it may be as liberating as it is devastating.

WODICZKO Some artists took their art beyond the gallery, not only advocating social change but working to make a tangible difference within society. In the late 1980s, Polishborn Canadian artist Krzysztof Wodiczko (b. 1943) created the HOMELESS VEHICLE (FIG. 33-53), designed in collaboration with the homeless in New York as "an instrument for survival for urban nomads." Wodiczko wanted to draw attention to the problem of homelessness in New York, one of the richest cities in

33-52 • Kiki Smith UNTITLED

1990. Beeswax with microcrystalline wax figures on metal stands, female figure installed height 6'1½" (1.87 m), male figure 6'4½" (1.95 m). Whitney Museum of American Art, New York. © Kiki Smith, courtesy The Pace Gallery.

33-53 • Krzysztof Wodiczko HOMELESS VEHICLE

1988–1989. Aluminum and mixed media. Variant 3 of 4, pictured at Trump Tower, New York. © Krzysztof Wodiczko.

Watch a video about Krzysztof Wodiczko on myartslab.com

33-54 • Rachel Whiteread HOUSE

1993. Corner of Grove and Roman Roads, London. 1993. Concrete. Destroyed 1994. Commissioned by Artangel. Received the Turner Prize, Tate Britain, London. © Rachel Whiteread. Photo: Sue Omerod. Courtesy of the artist, Luhring Augustine, New York, and Gagosian Gallery.

the richest country in the world. But he did not want simply to illustrate homelessness or evoke pity. Rather, he wanted to dramatize homelessness by making it visible while at the same time actually helping the homeless. The Homeless Vehicle is a modified and "upgraded" version of the shopping cart that so many homeless people use to carry around their worldly possessions. Wodiczko designed the cart with a waterproof and relatively safe sleeping pod, a series of baskets underneath in which to store belongings, and a brightly colored flag to indicate approach. The homeless who were lucky enough to get a vehicle were pleased with the way it worked, but the New York city authorities felt that the carts made the homeless too visible. They disappeared quickly.

WHITEREAD The British sculptor Rachel Whiteread (b. 1963) made her reputation as a YBA by casting the inverse of everyday objects such as a bathtub or worn mattress to reveal the ghostliness of their absence. In 1993, she turned her attention to the invisibility of the urban poor with her largest and most controversial work, HOUSE (FIG. 33-54). For this project, Whiteread

cast in concrete the inner space of an entire three-story terraced house, one of a row in London's East End slated for demolition by developers, who effectively erased the last vestiges of a community that had pulled together heroically during the Blitz in World War II. House is about how memories are contained in places and times, and how easily they can be destroyed. As the other houses around it were demolished, Whiteread sprayed concrete on the inner walls of "her house" to make a cast of the space within it. Then she dismantled the house itself. The white concrete left behind outlined a ghostly trace of the space within the house that had once been someone's home. The publicity surrounding Whiteread's House brought to the fore several critical issues in British society—including homelessness, the costs and benefits of urban renewal, and the social position of the working class by articulating controversial concerns in ways that are impossible using other means of communication. Whiteread intended House to make a political statement about "the state of housing in England; the ludicrous policy of knocking down homes like this and building badly designed tower blocks which themselves have to be knocked down after 20 years."

33-55 • Shirin Neshat **REBELLIOUS SILENCE** 1994. Black-and-white RC print and ink (photograph by C. Preston), 11" × 14" (27.9 × 35.6 cm). Barbara Gladstone Gallery, New York.

POSTCOLONIAL DISCOURSE

With increasing migration and the expansion of global communications and economies, questions of personal, political, cultural, and national identity also emerged in the 1990s. Postcolonial artists began to address issues of contested identity and the identity struggle of postcolonial peoples, and to investigate the dissonance produced by transnational (mis)communication between colonizers and the postcolonized. Many of these artists, such as Shirin Neshat and Rasheed Araeen, speak with unfamiliar but forthright and significant new artistic voices.

NESHAT In **REBELLIOUS SILENCE** (FIG. 33-55) from her 1994 "Women of Allah" series of photographs, Shirin Neshat (b. 1957) explores how Iranian women are stereotyped in the West, claiming that their Islamic identities are more varied and complex than

is frequently perceived. Each of Neshat's "Women of Allah" photographs portrays both a part of an Iranian woman's body-such as her hands or her feet-overwritten with Farsi text and a weapon. In Rebellious Silence, the woman wears the traditional chador but her face is exposed, overwritten with calligraphy and bisected by a rifle barrel. Both calligraphy and rifle seem to protect her from the viewer, but they also create a sense of incomprehensibility or foreignness that prompts us to try to categorize her. Likewise, although the woman wears a chador, she looks directly and defiantly out of the photograph at us, meeting and returning our gaze. She challenges us to acknowledge her as an individual—in this case a strong and beautiful woman—but simultaneously and paradoxically prompts us to see her as a stereotypical Iranian woman in a chador. Neshat confronts our prejudices while also raising questions about the position of women in contemporary Iran.

ARAEEN Pakistani artist Rasheed Araeen (b. 1935) lives in London, where he founded the journal Black Phoenix in 1978 (renamed Third Text in 1989), a leading journal on postcolonial art, culture, and ethnicity. Araeen's 1985-1986 GREEN PAINTING IV (FIG. 33-56) of nine equal-sized panels, the central five containing photographs of the head of a young bull with garlands around its neck, prepared for ritual sacrifice and framed above and below by Urdu text. The remaining four panels are uniformly green—the primary color in the Pakistani flag, an important color in Islam, and a color that Araeen associates with youthful rawness and flexibility, as in a green twig. Yet the central panels also form a cross. Araeen has said that his pictures are not just superimpositions of Western and Pakistani cultures, that they address "cutting and rupturing" and investigate postcolonial dissonance and miscommunication. He argues that when someone British or American recognizes the cross in his art, for

instance, they almost invariably read Pakistani culture through a Christian lens, thereby distorting, misinterpreting, and stereotyping the "other." Araeen's art calls for a more nuanced understanding of cultures on their own terms and according to their own visual languages.

SEARLE Berni Searle's (b. 1964) art explores her South African identity in the wake of Apartheid. In the **COLOR ME** series (**FIG. 33-57**), she photographs her head and torso coated with powdered pigment that changes her skin color from red to yellow to brown to white. Searle invites us to recognize that race and identity are not as simple as skin pigmentation, that superficial or skin-deep characteristics do not define a person. The fragility and impermanence of the pigmentation also underscore the instability of stereotypes and the complexity of real identity.

Araeen GREEN
PAINTING IV
1985–1986. Five color
photographs with Urdu
text and acrylic on four
plywood panels, 5'9" ×
6'10" (1.75 × 2.08 m).
Collection of the artist.

33-57 • Berni Searle UNTITLED, FROM COLOR ME SERIES 1998. Michael Stevenson Gallery, Cape Town. © Berni Searle.

HIGH TECH AND DECONSTRUCTIVIST ARCHITECTURE

Computer-aided design (CAD) programs with 3-D graphics transformed architecture and architectural practice in the 1980s and 1990s. These new tools enabled architects to design structures virtually, to calculate engineering stresses faster and more precisely, to experiment with advanced building technologies and materials, and to imagine new ways of composing a building's mass.

HIGH TECH ARCHITECTURE High Tech architects broke out of the restrictive shape of the Modernist "glass box" (see FIG. 33–28) to experiment with dramatically designed engineering marvels. These buildings are characterized by a spectacular use of new technologies, materials, equipment, and components, and frequently by their visible display of service systems such as heating and power.

The **HONG KONG & SHANGHAI BANK** (FIG. 33-58) by British architect Norman Foster (b. 1935) is among the most spectacular examples of High Tech architecture. Foster was invited to spare no expense in designing this futuristic 47-story skyscraper. The load-bearing steel skeleton, composed of giant masts and girders, is on the exterior. The individual stories hang

from it, making possible the uninterrupted rows of windows that fill the building with natural light. In addition, the banking hall in the lower part of the building has a ten-story atrium space that is flooded with daylight refracted into it by motorized "sunscoops" at the top of the structure that track the sun's rays and channel them into the building. The sole concession Foster makes to tradition in this design is his placement of two bronze lions taken from the bank's previous headquarters flanking the public entrance. Touching the lions before entering the bank is believed to bring good luck.

DECONSTRUCTIVIST ARCHITECTURE Deconstructivist architecture, more theory-based than High Tech, emerged in the early 1990s. Deconstructivist architects deliberately disturb traditional architectural assumptions about harmony, unity, and stability to create "decentered," skewed, and distorted designs. The aesthetic of Russian Suprematists and Constructivists (see FIG. 32-26) is an influence, as are the principles of Deconstruction as developed by French philosopher Jacques Derrida (1930-2004). Derridean Deconstruction asserts written texts possesses no single, intrinsic meaning, that meaning is always "intertextual," a product of one text's relationship to other texts. Meaning is always "decentered," "dispersed," or "diffused" through an infinite web of "signs," which themselves have unstable meanings. Deconstructivist architecture is likewise "intertextual," in that it plays with meaning by mixing diverse architectural features, forms, and contexts, and it is "decentered" in its diffusion as well as in its perceived instability of both meaning and form.

A good example of Deconstructivist architecture is the VITRA FIRE STATION in Weil-am-Rhein, Germany (FIG. 33-59), designed by Baghdad-born architect Zaha Hadid (b. 1950), who studied in London and established her practice there in 1979. Formally influenced by the paintings of Kasimir Malevich (see FIG. 32-25), the Vitra Fire Station features reinforced concrete walls that lean into one another, meet at unexpected angles, and jut out dramatically into space, denying a sense of visual unity or structural coherence, but creating a feeling of immediacy, speed, and dynamism appropriate to the building's function.

The Toronto-born, California-based Frank O. Gehry (b. 1929) also creates unstable and Deconstructivist building masses and curved winglike shapes that extend far beyond the building's mass. One of his most spectacular designs is the **GUGGENHEIM MUSEUM** in Bilbao, Spain (**FIG. 33–60**). In the 1990s, the designing of art museums became more and more spectacular as they increasingly came to define the visual landscape of cities. Gehry developed his asymmetrical design using a CATIA CAD program that enabled him to create a powerfully organic, sculptural structure. The complex steel skeleton is covered by a thin skin of silvery titanium that shimmers gold or silver depending on the time of day and the weather conditions. From the north the building resembles a living organism, while from other angles it looks like a giant ship, a reference to the industry on which Bilbao has traditionally depended, thereby identifying the museum with the city. Despite

33-58 • Norman Foster HONG KONG & SHANGHAI BANK, HONG KONG

1986.

Watch an architectural simulation about the steel skeleton of the Hong Kong and Shanghai Bank Corporation Limited building on myartslab.com

33-59 • Zaha Hadid VITRA FIRE STATION, WEIL-AM-RHEIN Germany. 1989-1993.

33-60 • Frank O. Gehry GUGGENHEIM MUSEUM, BILBAO Spain. 1993–1997. Sculpture of a spider in the foreground: Louise Bourgeois (1911–2010), Maman, 1999.

the sculptural beauty of the museum, however, the interior is a notoriously difficult space in which to display art, a characteristic this building shares with Frank Lloyd Wright's spiraling design of the New York Guggenheim (see FIG. 33–30), a notable forebear of Gehry's explorations of the bold sculptural potential of architecture.

VIDEO AND FILM

In the last decades of the twentieth century, the rapid development and increasingly widespread availability of hand-held video cameras created a new medium for artists. Video artists rejected traditional forms and meanings to make art that was deliberately nonprecious, often using the video image to address the place and prevalence of television in our culture. Today Video art is even more prevalent because of the explosion in digital and visual imagery. In fact, most contemporary Video art is digitally produced, while innovations in projecting video and DVD images on large screens (or on any surface) have transformed how and where Video art is projected and, to a certain extent, its subjects.

PAIK One of the pioneers of Video art was the Korean-born Nam June Paik (1931–2006), who composed experimental music in the late 1950s and early 1960s under the influence of John Cage. He began working with modified television sets in 1963, and making Video art in 1965, the same year that Sony released the first portable video camera. Paik predicted that just "as collage technique replaced oil paint, the cathode ray [television] tube will replace the canvas." Later, he worked with live, recorded, and computer-

generated images displayed on video monitors of varying sizes, which he often combined into works of art such as **ELECTRONIC SUPERHIGHWAY: CONTINENTAL U.S.** (FIG. 33-61), a work created for the Holly Solomon Gallery in New York. This featured a neon outline map of the continental United States set against a wall of dozens of computer-controlled video monitors displaying rapidly changing soundtracked images reflecting each state's culture and history; Alaska and Hawaii were on the side walls. The work addresses the prevalence and the power of the mixed messages transmitted by television. The monitor for New York State projected a closed-circuit live video feed of gallery visitors, who were thus transformed from passive spectators into active participants in the piece as the monitor constructed their media identity in front of them as they watched.

VIOLA In 1996, the California video artist Bill Viola (b. 1951) created **THE CROSSING** (FIG. 33-62), which consists of a double projection of two brilliantly colored videos on opposite sides of a 16-foot screen. On one side, Viola projects a video loop of a silhouetted man who slowly emerges from the background to fill the entire screen. As he begins, a drop of water starts to fall, growing in size as the man moves forward slowly until at last a deluge washes him away. The soundtrack meanwhile goes from a small dripping noise to a torrential roar. On the reverse screen, a similar scenario unfolds, except this time the man appears in the background with tiny flames licking at his feet and eventually growing into a wild conflagration that finally engulfs him as

33-61 • Nam June
Paik ELECTRONIC
SUPERHIGHWAY:
CONTINENTAL U.S.

1995. Forty-seven-channel closed-circuit video installation with 313 monitors, neon, steel structure, color, and sound, approx. 15' × 32' × 4' (4.57 × 9.75 × 1.2 m). The Smithsonian American Art Museum, Washington, DC. © Estate of Nam June Paik. Gift of the artist

33-62 • Bill Viola THE CROSSING

1996. Two channels of color video projections from opposite sides of a large dark gallery onto two back-to-back screens suspended from the ceiling and mounted on the floor; four channels of amplified stereo sound, four speakers. Height 16' (4.88 m).

the sound of the fire grows in intensity. But Viola is interested in the way that vision informs perception. In fact there is only one soundtrack—we simply perceive it differently according to which video we are watching. Viola's video is profoundly sensory but also meditative; its elemental symbolism is informed by Viola's spirituality and intense study of world religions.

GLOBALISM: INTO THE NEW MILLENNIUM

In the last decade, the growth in international art exhibitions and art fairs has created new opportunities for artists, dealers, and collectors to meet and network in ways that, until quite recently, would have been considered impossible, or unproductive. Until recently, the only truly international fora for new art were the Venice Biennale (established in 1903 and held every two years) and Documenta, in Kassel, West Germany (established in 1955 and held roughly every five years). Today there are at least 30 international biennial exhibitions around the world, as well as many more vast international art fairs: Art Basel in Switzerland, Art Basel Miami in Miami Beach, the Frieze Art Fair in London, the

Armory Show in New York, and the Fiore Internationale d'Art Contemporain (FIAC) in Paris, to mention just a few. At the same time, the Internet has allowed quick and easy visual access to art globally. We can find information on practically any exhibited art, and much that is not exhibited, in our homes on our laptops. This new globalism has forced artists to question how their own identities and those of others are formed, and to realize that neither identity nor art is as simple or as univalent as it might have seemed as recently as in the 1990s.

Art in the new millennium seems to be heading in several directions simultaneously, constantly shifting and recalibrating new perspectives and concerns as part of an increasingly complicated global discourse. The art of our own times may be the most difficult to classify and analyze, but it has increasingly focused on global issues, raising questions about national identities; ethnic and racial identities; colonial and postcolonial identities; human rights; global economic, political, and natural environments; the widening divide between the rich and poor, more powerful and less powerful, nations of the world; and technological change in every aspect of our lives. Today's artists are actively engaged in society at many levels and their art frequently reflects their ambition to be agents of change or stability in troubling and uncentered times.

ART AND TECHNOLOGY

SCULPTURE IN NEW MEDIA Dale Chihuly (b. 1941) has produced major public sculptures in glass for 30 years, but his creations are as fresh today as they were in 1975. Chihuly's sculptures are both technologically innovative and experimental. **THE SUN (FIG. 33–63)**, a multi-part blown-glass sculpture using the latest glassmaking techniques, shows Chihuly's profound interest in natural forms and global energies. The sun bursts forth in a multitude of twisting, wriggling, spiraling forms as if the unremittingly intense light of Phoenix has taken physical shape and come to life. Brilliantly liquid, visually thrilling, and accessible, this sculpture suggests a deeper connection with nature, inviting contemplation, meditation, and an awareness of global environmentalism.

DIGITAL PHOTOGRAPHY SINCE 2000 From the beginning, photography has been a malleable and mutable medium. Even in the nineteenth century, photographs were manipulated to create fictional imagery out of what appeared to be a factual visual record. It is often difficult and time-consuming to manipulate a chemical-mechanical process, however, and it was only with the development of digital technology that manipulation became a fast, easy, and standard way to create photographic images.

The Canadian artist Jeff Wall (b. 1946) uses multiple digital photographs and elaborate stage sets to create large, complex, photographic narratives that he considers analogous to the history paintings of the nineteenth century, and which he exhibits as gloriously colored transparencies mounted in light boxes—a format fre-

quently used in modern advertising in public places.

Wall creates his photographs like a movie director, carefully designing the sets and posing his actors. He takes multiple photographs that he then combines digitally to create one final transparency. AFTER "INVISIBLE MAN" BY RALPH ELLI-SON, THE PREFACE (FIG. 33-64) is an elaborate composition for which Wall spent 18 months designing and constructing the sets and three weeks actually taking photographs. The image illustrates a passage from Ralph Ellison's 1951 novel about an African-American man's search for fulfillment that ends in disillusionment and retreat. Wall shows us the cellar room, "warm and full of light," to which Ellison's character retreats and which is heated and lit by 1,369 light bulbs powered by electricity stolen from the power company. For Ellison, these lights only illuminate the sad truth of the character's existence.

INSTALLATION ART Tony Oursler's 2009 exhibition at Metro Pictures raises issues about how average Americans constructs their identities in the digital age. The installation included several oversized sculptural versions of things that we cannot seem to live without today: an enormous cellphone entitled **MULTIPLEXED** (**FIG. 33-65**), a giant five-dollar bill, a "forest of smoldering cigarettes," an arrangement of oversized selfhelp books, and a Genie bottle containing a video

33-63 • Dale Chihuly **THE SUN** 2008. Desert Botanical Garden, Phoenix, Arizona. Installed November 22, 2008–May 31, 2009.

33-64 • Jeff Wall AFTER "INVISIBLE MAN" BY RALPH ELLISON, THE PREFACE 1999–2001. Transparency in lightbox, $68\frac{1}{2}$ " \times $98\frac{5}{8}$ " (174 \times 250.5 cm).

Read the document related to Jeff Wall on myartslab.com

of the artist himself. Oursler's exhibition is a clever updating of Pop art's critique of consumer society, making sly references to Warhol, Oldenburg, and even Lichtenstein (see FIGS. 33–11, 33–15, 33–14). Objects come to life by means of superimposed animated

video projections that make the cigarettes seem to burn, "Abe" Lincoln to pull faces, Oursler himself to try to escape his bottle, and the cellphone (in this illustration) to spew forth, as the press release states, "disjointed snippets of conversations." Oursler's

33-65 • Tony Oursler **MULTIPLEXED** 2008. Fiberglass, $37'' \times 33'' \times 17''$ (94 \times 83.8 \times 43.2 cm). Metro Pictures. (MP 574)

art asks us to consider how the world of technology, constantly bombarding us with objects and images, creates an intense visual overload that frames our concept of identity.

ART AND IDENTITIES

The artists featured in this final section investigate their individual and group identities—a growing and ever-more complex concern in the new millennium—in a wide range of ways, breaking down traditional distinctions between medium and message in the process, and dissolving boundaries to create art that is as interesting, exciting, difficult, and confusing as the world itself is today.

BARNEY Between 1994 and 2002, Matthew Barney (b. 1967) created an already legendary series of films entitled *The Cremaster Cycle* in which he developed an arcane sexual mythology. The concept of gender mutability dominates the narrative, which questions gender assignation and roles throughout. The cremaster

33-66 • Matthew Barney CREMASTER 3: MAHABYN 2002. $46\frac{1}{2}$ " \times 54" \times 1½" (118 \times 137 \times 3.8 cm). © Matthew Barney.

muscle, for which the series is named, controls the ascent and descent of the testes, usually in response to changes in temperature but also in response to fear or sexual arousal. It also determines sexual differentiation in the human embryo. Barney uses a diagrammatic representation of the cremaster muscle as his visual emblem throughout the series.

Each film has its own complex narrative and catalog of multilayered symbols. Cremaster 3 (2002) describes the construction of the Chrysler Building in New York and features Richard Serra (see FIG. 33-45) as the architect. The New York Guggenheim Museum's rotunda (see FIG. 33-30) is the setting for one segment of the film. Barney, playing Serra's apprentice, dressed in a peachcolored kilt and gagged, must accomplish a series of tasks to assert his supremacy over Serra. As in a video game, Barney scales the walls of the Guggenheim rotunda to complete a task on each level before gaining enlightenment. Along the way he encounters a series of challenges—a line of Rockettes dressed as Masonic lambs, warring punk-rock bands, a leopard woman (played by Aimee Mullins), and finally Serra. The settings and costumes are lavish, and the epic plot is complex and interconnected. In MAHABYN (FIG. 33-66), Barney and the leopard woman transform into Masons by donning modified Masonic costume. The entire filmic cycle addresses the crisis of identity experienced by white, middle-class, heterosexual male artists in America during an era seemingly dominated by identity politics.

BEECROFT Vanessa Beecroft, an Italian artist who now lives in Los Angeles, also set her VB35 (FIG. 33-67) in the Guggenheim Museum's rotunda and also uses performance to examine gender roles, although she explores perceptions of the female body and femininity. Unlike Barney, Beecroft does not appear in her work, although many of her performances refer obliquely to her own battle with anorexia. In vb35—she numbers her performances; this is her 35th piece—she questions both the nature of today's distorted concept of feminine beauty and the prevalence of voyeuristic looking. Beecroft hired 15 professional fashion models—each fashionably thin, tall, and white—and directed them to stand in a loose group, facing forward. Ten wore high heels and designer bikinis, while five wore nothing but high heels. As they stood staring blankly ahead, the audience observed them from the foyer or the ramp of the museum, thus acquiescing in the gaze that objectified them. The performance was "invitation only," so the atmosphere was charged with exclusivity, but Beecroft complicated this piece by heightening the tension in two ways. First, the group of professional models whose business it is to be looked at commanded the museum; and second, the audience was instructed to behave in very precise ways—they were not allowed to make eye contact with or speak to the models, or in any way invade their physical or emotional space. This strategy cleverly inverted the normal relationship between looker and looked-at. A sexual charge filled the air, but ironically the models claimed control. Viewers found that they felt intimidated and

33-67 • Vanessa Beecroft VB35 PERFORMANCE 1998. Courtesy of the artist © 2012 Vanessa Beecroft. Solomon R. Guggenheim Museum, New York, NY (vb35.354.al)

discomfited, as though they had been caught in the act of looking illicitly. As one critic put it: "we found ourselves confronted by the cool authority of the art's nakedness, and we had no role to play ... so we drifted and loitered."

GU Wenda Gu (b. 1955) dedicates his art to bringing people together. Trained in traditional ink painting at China's National Academy of Fine Arts, he emigrated to the United States in 1987

and began an ongoing global project entitled "United Nations Series" in 1992. Each "monument" in this series is made from human hair collected from barbershops and hair salons worldwide, which Gu presses into bricks or weaves into carpets and curtains covered with ideograms of his own invention. **CHINA MONUMENT: TEMPLE OF HEAVEN** (FIG. 33-68) contains hair from many different nations and blended scripts based on Chinese, English, Hindi, and Arabic characters that "evoke the

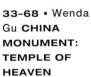

HEAVEN
1998. Installation with
screens of human
hair, wooden chairs
and tables, and video.
Commissioned by the
Asia Society. Permanent
collection of the Hong
Kong Museum of Art ©
Wenda Gu.

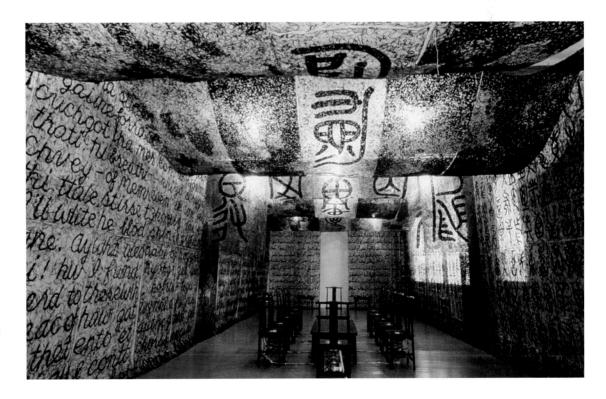

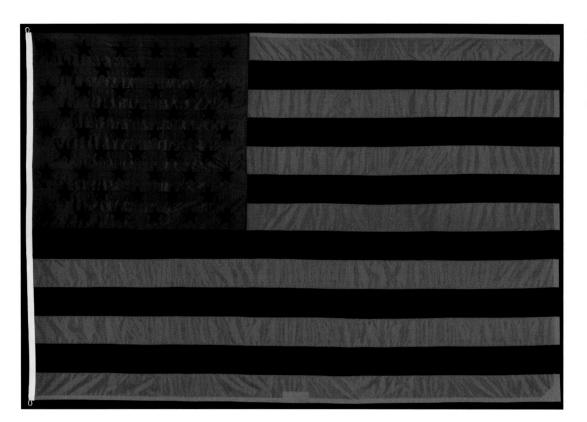

33-69 • David Hammons UNTITLED 2004. Nylon, 6' × 10' (1.82 × 3 m). Studio Museum, Harlem. Gift of the artist (04.2.19)

limitations of human knowledge." Gu also creates "national" monuments—examples have been installed in Poland, Israel, and Taiwan, among other places—made from hair collected in, and addressing issues specific to, that particular country. The "transnational" monuments from the "United Nations Series," on the other hand, address more global themes, using hair blended from several different countries to suggest a "brave new racial identity" for the new millennium.

HAMMONS A socially minded artist strongly committed to working in the public realm, David Hammons (b. 1943) is an outspoken critic of the gallery system in America, lamenting the lack of challenging content and representation of African Americans in exhibitions. He has described the art world as being "like Novocain. It used to wake you up but now it puts you to sleep." Hammons argues that only art that intervenes in and transacts with society is uncontaminated by commerce and capable of jolting people awake. In UNTITLED (FIG. 33-69), the artist creates a witty, poignant, and biting satire on the still-ambiguous place of African Americans in American society. Hammons originally created this flag in 1990 for the Studio Museum in Harlem, in response to a controversy concerning the flying of the Confederate flag on public buildings in some states. It has since been installed in several other museums, including the Museum of Modern Art in New York in 2000. The colors in Hammons's flag are those of the Pan-African or Universal Negro Improvement Association and African Communities League flag, which was created in 1920 by African Americans to symbolize the "Rights of Negro Peoples of the World." The red stands for the blood that unites all people

of African descent and that was spilled in the quest for liberation; the black stands for the symbolic nation of black people; and the green stands for the verdant lands of Africa.

SHONIBARE Yinka Shonibare (b. 1962), a British-Nigerian artist based in London, uses his art to examine how identity is constructed and perceived through the twists and turns of colonial history, as well as through class, race, and self-perception. HOW TO BLOW UP TWO HEADS AT ONCE (LADIES) (FIG. 33-70) is a life-size sculpture of two headless women whose skin color, and thus on a superficial level whose race, is indeterminate. Although the figures have women's bodies, they seem to have masculine hands. They face off against one another, striking dueling poses with nineteenth-century flintlock pistols pointed at each other's absent heads. They wear what appear to be nineteenth-century costumes, but their brightly colored dresses are made of a Dutch wax fabric that is usually associated with West African nations. The complexities of the history of the fabric, and the way that Shonibare uses it, give us some idea of the multiple and eliding meanings in this sculpture. This brilliantly colored and patterned fabric, worn by millions of Africans today, originally came from Indonesia, imported and copied by Dutch colonists in Africa and manufactured in bulk in cotton mills in Manchester, England, then exported to West Africa, where it was copied, modified, transformed, and now possessed. Ironically, Shonibare buys the fabric for his sculptures at London's Brixton market. His work, although witty and ironic, is also acerbic as it uncovers the tangled web of forces that construct identity and challenges our perceptions about race, postcolonialism, property, ownership, violence, and class.

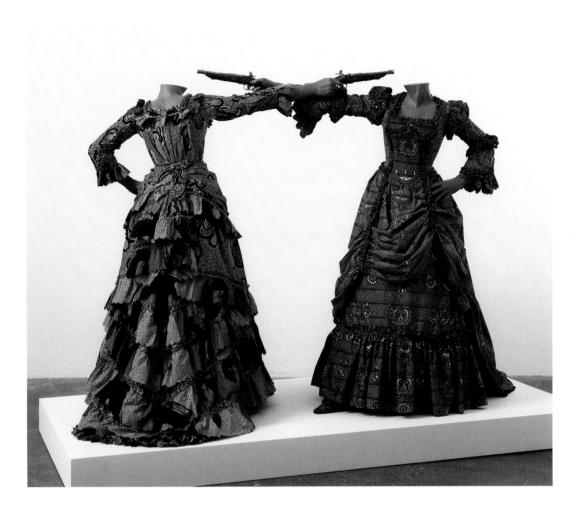

33-70 • Yinka Shonibare HOW TO BLOW UP TWO HEADS AT ONCE (LADIES)

2006. Two fiberglass mannequins, two prop guns, Dutch, wax printed cotton textile, shoes, leather riding boots, plinth, $93\frac{1}{2}$ " \times 63" \times 48" (237 \times 160 \times 122 cm). Museum purchase with funds provided by Wellesley College Friends of Art (2007.124.1-2)

Watch a video about Yinka Shonibare on myartslab.com

SIERRA Santiago Sierra (b. 1966), a Spanish artist living in Mexico City, also addresses race, ethnicity, and the capitalist exploitation of the poor in his interventionist artworks. At the 49th Venice Biennale in 2001, Sierra offered a visible commentary on the luxurious indulgence and elitist atmosphere of the exhibition, where both poverty and racial tension were invisible. Sierra paid 133 non-European men to dye their naturally black hair blond and to make themselves visible around Venice for the duration of the exhibition (**FIG. 33-71**). The shocking sight of white hair on dark-skinned men made them very visible, catapulting a group of individuals who normally melt into the background of society to front and center, persistent reminders not only of their presence but their relative poverty—the only reason their hair was blond was because they needed the money.

WILSON In the 1990s, artists increasingly critiqued the constructed narratives of traditional museum exhibitions. The

33-71 • Santiago Sierra 133 PEOPLE PAID TO HAVE THEIR HAIR DYED BLOND

2001. Arsenale, 49th Venice Biennale

Sierra paid 133 non-European men to dye their hair blond. In the exhibition, he presented video footage of the dyeing process.

33-72 • Fred Wilson **CHANDELIER MORI** 2003. United States Pavilion, 50th Venice Biennale. © Fred Wilson, courtesy The Pace Gallery.

museum was acknowledged as a place where curators, by making decisions about what works to show and how to arrange them, create art history rather than revealing it and, in the process, frequently reveal their own prejudices. Installation artist Fred Wilson (b. 1954) is best known for *Mining the Museum* (1992), an interventionist piece in which he inverted and subverted the Baltimore Historical Society's collection. Wilson "mined" the museum's storerooms and discovered that, while the objects exhibited were mostly about white history, there were numerous objects relating to African–American history in storage. He "inserted" many of these into the main museum display, including disturbing objects used to restrain African–American slaves, thereby upsetting and reshaping the story told in the original exhibition.

In 2003, Wilson represented the United States at the Venice Biennale with *Speak of Me As I Am*, a multi-part installation that focused on the history of Africans in Venice. This included several black sculptures made with Murano glass, a kind of glass made in Venice for centuries, set in a black-and-white tiled room with "graffiti" on the walls consisting of excerpts from African-American slave narratives and a video installation of Shakespeare's *Othello* being screened backwards. The title of the work, *Speak of Me As I Am*, is taken from words spoken by Othello, the "Moor," in Shakespeare's play. **CHANDELIER MORI** (FIG. 33-72), a part of Wilson's installation, is also made from Murano glass but, unlike the brilliantly glittering Venetian glass chandeliers seen around the city, this one emphasizes blackness. Wilson's title suggests the *memento mori* or *vanitas* painting that reminds viewers that death comes to all of us, drawing attention to the fact that the commerce

of Venice was built on the back of African labor and at the cost of African lives.

WALKER Kara Walker (b. 1969) makes some of the most challenging and provocative art made in America today, hitting raw nerves, shocking and horrifying viewers. She cuts large-scale silhouettes of figures out of black construction paper, waxing them to the walls of galleries, and illuminating them with projected light. In **DARKYTOWN REBELLION** (FIG. 33-73), she shows a slave revolt and massacre by covering the walls of the gallery with her black-silhouetted figures to tell an unfolding tale of horror. The room swirls with beautifully colored white, black, pink, green, blue, and yellow projected lights and shadows that dance on the walls. As we walk around the space looking at the figures, we step in front of the projector, casting our own shadows on the walls, placing us uncomfortably close to or actually within the narrative itself. Walker's stories are drawn variously from slave narratives, minstrel shows, advertising memorabilia, and even from Harlequin romance novels, blending fiction and fact to evoke a history of oppression and terrible violence. And she does not balk at portraying unpleasant or painful bodily functions, such as defecation, vomiting, and childbirth. Walker's characters are black and white stereotypes, even caricatures. She contrasts the tight, cramped features of her white people with the stereotypical black features of her African Americans. She even refers to some of her characters as "nigger wenches" or "pickaninnies."

Walker plays on white fears of miscegenation and insecurities about racial purity. She pushes so far over the border of the acceptable that visiting one of her installations can be an uncomfortable and disruptive experience. Her figures disturb us intensely because of what they make us do. As silhouettes, they are all black, which means that we cannot identify their race by skin color. In order to read the narrative, however, we need to differentiate the characters by looking for other visual markers of race, making us draw upon an entire history of ugly stereotypes in the process. We are forced to examine the figures for thin or big lips, flat or frizzy hair, elegant or raggedy clothes. In this way Walker catches us in racist acts, making clear that she is speaking to us personally, not to some theoretical racist, and that racism is neither theoretical nor a thing of the past. As Walker has said: "It's interesting that as soon as you start telling the story of racism you start reliving it."

Walker shows us that identity is not nearly as clear-cut in the early twenty-first century as we would like to think. We are all complicated beings, constantly negotiating and renegotiating our place in the world, changing and reinventing ourselves. Kara Walker's art is not pleasant, but it changes us by altering our perception of the world. It reminds us that the works of visual artists—past, present, and future—has the power to reveal things about the time and place in which they were created, but also about the world we now inhabit, in ways that are beyond the reach of any other form of communication. If this broad and long survey of the history of art has had a single unifying theme, it is that.

33-73 • Kara Walker **DARKYTOWN REBELLION** 2001. Cut paper and projection on wall, 14' × 37' (4.3 × 11.3 m) overall. Collection Musée d'Art Moderne Grand-Duc Jean, Mudam Luxembourg. © Kara Walker.

THINK ABOUT IT

- 33.1 Write about the importance of the dematerialized object in the art of postwar United States. Then discuss how representational art regained importance in later years, particularly after 1980, and explain the new forms taken by such representation.
- 33.2 Discuss the emergence of Pop art in the 1950s and 1960s and characterize the new subjects favored by Pop artists. Explain how and why Pop reacted to Abstract Expressionism.
- **33.3** Analyze how contemporary American artists have used their art to address the social and political issues surrounding race. Select and discuss the work of at least two artists from the chapter.
- **33.4** Explain how globalism has transformed the visual arts and discuss how artists use contemporary strategies to speak to issues in their local cultures.

CROSSCURRENTS

FIG. 32-43

FIG. 33-31

Distinguished twentieth-century architects have designed private homes as well as large, commercial, religious, or public buildings. Discuss the circumstances that led to the creation of these two famous houses. How do these works fit into the careers of their architects and also engage with the larger concerns of architectural design at the moment when they were built?

How is their physical context related to their design?

Study and review on myartslab.com

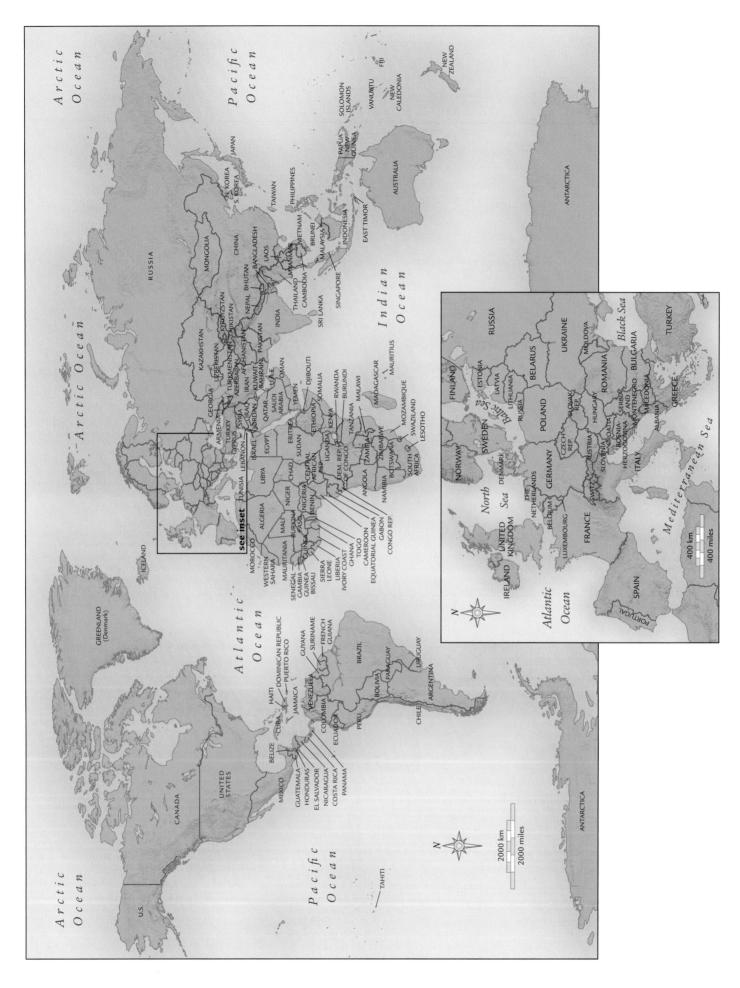

Glossary

abacus (p. 108) The flat slab at the top of a **capital**, directly under the **entablature**.

abbey church (p. 239) An abbey is a monastic religious community headed by an abbot or abbess. An abbey church often has an especially large **choir** to provide space for the monks or nuns.

absolute dating (p. 12) A method, especially in archaeology, of assigning a precise historical date at which, or span of years during which, an object was made. Based on known and recorded events in the region, as well as technically extracted physical evidence (such as carbon-14 disintegration). See also radiometric dating, relative dating.

abstract (p. 7) Of art that does not attempt to describe the appearance of visible forms but rather to transform them into stylized patterns or to alter them in conformity to ideals.

academy (p. 926) An institution established for the training of artists. Academies date from the Renaissance and after; they were particularly powerful, staterun institutions in the seventeenth and eighteenth centuries. In general, academies replaced guilds as the venues where students learned the craft of art and were educated in art theory. Academies helped the recognition of artists as trained specialists, rather than craftsmakers, and promoted their social status. An academician is an academy-trained artist.

acanthus (p. 110) A Mediterranean plant whose leaves are reproduced in Classical architectural ornament used on **moldings**, **friezes**, and **capitals**.

acroterion (pl. acroteria) (p. 110) An ornament at the corner or peak of a roof.

Action painting (p. 1074) Using broad gestures to drip or pour paint onto a pictorial surface. Associated with mid-twentieth-century American Abstract Expressionists, such as Jackson Pollock.

adobe (p. 399) Sun-baked blocks made of clay mixed with straw. Also: buildings made with this material.

aedicula (p. 609) A decorative architectural frame, usually found around a niche, door, or window. An aedicula is made up of a **pediment** and **entablature** supported by **columns** or **pilasters**.

aerial perspective (p. 626) See under perspective. agora (p. 137) An open space in a Greek town used as a central gathering place or market. Compare forum.

aisle (p. 225) Passage or open corridor of a church, hall, or other building that parallels the main space, usually on both sides, and is delineated by a row, or **arcade**, of **columns** or **piers**. Called side aisles when they flank the **nave** of a church.

akropolis (p. 128) The citadel of an ancient Greek city, located at its highest point and housing temples, a treasury, and sometimes a royal palace. The most famous is the Akropolis in Athens.

album (p. 796) A book consisting of a series of paintings or prints (album leaves) mounted into book form.

allegory (p. 627) In a work of art, an image (or images) that symbolizes an idea, concept, or principle, often moral or religious.

alloy (p. 23) A mixture of metals; different metals melted together.

altarpiece (p. xl) A painted or carved panel or ensemble of panels placed at the back of or behind and above an altar. Contains religious imagery (often specific to the place of worship for which it was made) that viewers can look at during liturgical ceremonies (especially the **Eucharist**) or personal devotions.

amalaka (p. 302) In Hindu architecture, the circular or square-shaped element on top of a spire (*shikhara*), often crowned with a **finial**, symbolizing the cosmos.

ambulatory (p. 224) The passage (walkway) around the **apse** in a church, especially a **basilica**, or around the central space in a **central-plan building**.

amphora (*pl.* **amphorae**) (p. 101) An ancient Greek or Roman jar for storing oil or wine, with an egg-shaped body and two curved handles.

animal style or interlace (p. 433) Decoration made of interwoven animals or serpents, often found in early medieval Northern European art.

ankh (p. 51) A looped cross signifying life, used by ancient Egyptians.

appropriation (p. xxviii) The practice of some Postmodern artists of adopting images in their entirety from other works of art or from visual culture for use in their own art. The act of recontextualizing the appropriated image allows the artist to critique both it and the time and place in which it was created.

apse (p. 192) A large semicircular or polygonal (and usually **vaulted**) recess on an end wall of a building. In a Christian church, it often contains the altar. "Apsidal" is the adjective describing the condition of having such a space.

arabesque (p. 267) European term for a type of linear surface decoration based on foliage and calligraphic forms, thought by Europeans to be typical of Islamic art and usually characterized by flowing lines and swirling shapes.

arcade (p. 170) A series of arches, carried by columns or piers and supporting a common wall or lintel. In a blind arcade, the arches and supports are engaged and have a purely decorative function. arch (p. 95) In architecture, a curved structural element that spans an open space. Built from wedgeshaped stone blocks called voussoirs placed together and held at the top by a trapezoidal keystone. It forms an effective space-spanning and weight-bearing unit, but requires buttresses at each side to contain the outward thrust caused by the weight of the structure. Corbeled arch: an arch or vault formed by courses of stones, each of which projects beyond the lower course until the space is enclosed; usually finished with a capstone. Horseshoe arch: an arch of more than a half-circle; typical of western Islamic architecture. Round arch: an arch that displaces most of its weight, or downward thrust along its curving sides, transmitting that weight to adjacent supporting uprights (door or window jambs, columns, or piers). Ogival arch: a sharply pointed arch created by S-curves. Relieving arch: an arch built into a heavy wall just above a post-andlintel structure (such as a gate, door, or window) to help support the wall above by transferring the load to the side walls. Transverse arch: an arch that connects the wall piers on both sides of an interior space, up and over a stone vault.

Archaic smile (p. 114) The curved lips of an ancient Greek statues in the period c. 600–480 BCE, usually interpreted as a way of animating facial features.

architrave (p. 107) The bottom element in an entablature, beneath the frieze and the cornice. archivolt (p. 478) A band of molding framing an arch, or a series of stone blocks that form an arch resting directly on flanking columns or piers.

ashlar (p. 99) A highly finished, precisely cut block of stone. When laid in even **courses**, ashlar masonry creates a uniform face with fine joints. Often used as a facing on the visible exterior of a building, especially as a veneer for the **façade**. Also called **dressed stone**.

assemblage (p. 1026) Artwork created by gathering and manipulating two- and/or three-dimensional found objects.

astragal (p. 110) A thin convex decorative **molding**, often found on a Classical **entablature**, and usually decorated with a continuous row of beadlike circles.

atelier (p. 946) The studio or workshop of a master artist or craftsmaker, often including junior associates and apprentices.

atmospheric perspective (p. 183) See under perspective.

atrial cross (p. 943) A cross placed in the atrium of a church. In Colonial America, used to mark a gathering and teaching place.

atrium (p. 158) An unroofed interior courtyard or room in a Roman house, sometimes having a pool or garden, sometimes surrounded by **columns**. Also: the open courtyard in front of a Christian church; or an entrance area in modern architecture.

automatism (p. 1057) A technique in which artists abandon the usual intellectual control over their brushes or pencils to allow the subconscious to create the artwork without rational interference.

avant-garde (p. 972) Term derived from the French military word meaning "before the group," or "vanguard." Avant-garde denotes those artists or concepts of a strikingly new, experimental, or radical nature for their time.

axis (p. xxxii) In pictures, an implied line around which elements are composed or arranged. In buildings, a dominant line around which parts of the structure are organized and along which human movement or attention is concentrated.

axis mundi (p. 300) A concept of an "axis of the world," which marks sacred sites and denotes a link between the human and celestial realms. For example, in Buddhist art, the axis mundi can be marked by monumental free-standing decorative pillars.

baldachin (p. 472) A canopy (whether suspended from the ceiling, projecting from a wall, or supported by columns) placed over an honorific or sacred space such as a throne or church altar.

bar tracery (p. 510) See under tracery.

barbarian (p. 149) A term used by the ancient Greeks and Romans to label all foreigners outside their cultural orbit (e.g., Celts, Goths, Vikings). The word derives from an imitation of what the "barblings" of their language sounded like to those who could not understand it.

barrel vault (p. 187) See under vault.

bas-relief (p. 325) Another term for low relief ("bas" is the French word for "low"). See under relief sculpture.

basilica (p. 191) A large rectangular building. Often built with a **clerestory**, side **aisles** separated from the center **nave** by **colonnades**, and an **apse** at one or both ends. Originally Roman centers for administration, later adapted to Christian church use.

bay (p. 170) A unit of space defined by architectural elements such as **columns**, **piers**, and walls.

beehive tomb (p. 98) A corbel-vaulted tomb, conical in shape like a beehive, and covered by an earthen mound.

Benday dots (p. 1095) In modern printing and typesetting, the individual dots that, together with many others, make up lettering and images. Often machine-or computer-generated, the dots are very small and closely spaced to give the effect of density and richness of tone.

bilum (p. 865) Netted bags made mainly by women throughout the central highlands of New Guinea. The bags can be used for everyday purposes or even to carry the bones of the recently deceased as a sign of mourning.

biomorphic (p. 1058) Denoting the biologically or organically inspired shapes and forms that were routinely included in abstracted Modern art in the early twentieth century.

black-figure (p. 105) A technique of ancient Greek **ceramic** decoration in which black figures are painted on a red clay ground. Compare **red-figure**.

blackware (p. 855) A **ceramic** technique that produces pottery with a primarily black surface with **matte** and glossy patterns on the surface.

blind arcade (p. 780) See under arcade.

bodhisattva (p. 311) In Buddhism, a being who has attained enlightenment but chooses to remain in this world in order to help others advance spiritually. Also defined as a potential Buddha.

Book of Hours (p. 549) A prayer book for private use, containing a calendar, services for the canonical hours, and sometimes special prayers.

boss (p. 556) A decorative knoblike element that can be found in many places, e.g. at the intersection of a Gothic **rib vault** or as a buttonlike projection on metalwork.

bracket, bracketing (p. 341) An architectural element that projects from a wall to support a horizontal part of a building, such as beams or the eaves of a roof.

buon fresco (p. 87) See under fresco.

burin (p. 592) A metal instrument used in **engraving** to cut lines into the metal plate. The sharp end of the burin is trimmed to give a diamond-shaped cutting point, while the other end is finished with a wooden handle that fits into the engraver's palm.

buttress, buttressing (p. 170) A projecting support built against an external wall, usually to counteract the lateral thrust of a vault or arch within. In Gothic church architecture, a flying buttress is an arched bridge above the aisle roof that extends from the upper nave wall, where the lateral thrust of the main vault is greatest, down to a solid pier.

cairn (p. 17) A pile of stones or earth and stones that served both as a prehistoric burial site and as a marker for underground tombs.

calligraphy (p. 275) Handwriting as an art form.

calyx krater (p. 119) See under krater.

calotype (p. 969) The first photographic process utilizing negatives and paper positives; invented by William Henry Fox Talbot in the late 1830s.

came (pl. cames) (p. 501) A lead strip used in the making of leaded or **stained-glass** windows. Cames have an indented groove on the sides into which individual pieces of glass are fitted to make the overall design.

cameo (p. 172) Gemstone, clay, glass, or shell having layers of color, carved in low relief (see under **relief sculpture**) to create an image and ground of different colors.

camera obscura (p. 750) An early cameralike device used in the Renaissance and later for recording images from the real world. It consists of a dark box (or room) with a hole in one side (sometimes fitted with a lens). The camera obscura operates when bright light shines through the hole, casting an upside-down image of an object outside onto the inside wall of the box.

canon of proportions (p. 64) A set of ideal mathematical ratios in art based on measurements, as in the proportional relationships between the basic elements of the human body.

canopic jar (p. 53) In ancient Egyptian culture, a special jar used to store the major organs of a body before embalming.

capital (p. 110) The sculpted block that tops a **column**. According to the **conventions** of the orders, capitals include different decorative elements (see **order**). A *historiated capital* is one displaying a figural composition and/or narrative scenes.

capriccio (pl. capricci) (p. 915) A painting or print of a fantastic, imaginary landscape, usually with architecture.

capstone (p. 17) The final, topmost stone in a **corbeled arch** or **vault**, which joins the sides and completes the structure.

cartoon (p. 501) A full-scale drawing of a design that will be executed in another **medium**, such as wall painting, **tapestry**, or **stained glass**.

cartouche (p. 187) A frame for a **hieroglyphic** inscription formed by a rope design surrounding an oval space. Used to signify a sacred or honored name. Also: in architecture, a decorative device or plaque, usually with a plain center used for inscriptions or epitaphs.

caryatid (p. 107) A sculpture of a draped female figure acting as a column supporting an entablature. cassone (pl. cassoni) (p. 616) An Italian dowry

cassone (pl. cassoni) (p. 616) An Italian dowry chest often highly decorated with carvings, paintings, inlaid designs, and gilt embellishments.

catacomb (p. 215) An underground cemetery consisting of tunnels on different levels, having niches for urns and sarcophagi and often incorporating rooms (cubicula).

cathedral (p. 220) The principal Christian church in a diocese, the bishop's administrative center and housing his throne (*cathedra*).

celadon (p. 358) A high-fired, transparent glaze of pale bluish-green hue whose principal coloring agent is an oxide of iron. In China and Korea, such glazes were typically applied over a pale gray stoneware body, though Chinese potters sometimes applied them over porcelain bodies during the Ming (1368–1644) and Qing (1644–1911) dynasties. Chinese potters invented celadon glazes and initiated the continuous production of celadon-glazed wares as early as the third century CE. cella (p. 108) The principal interior room at the

cella (p. 108) The principal interior room at the center of a Greek or Roman temple within which the cult statue was usually housed. Also called the **naos**.

celt (p. 383) A smooth, oblong stone or metal object, shaped like an axe-head.

cenotaph (p. 771) A funerary monument commemorating an individual or group buried elsewhere.

centering (p. 170) A temporary structure that supports a masonry **arch**, **vault**, or **dome** during construction until the mortar is fully dried and the masonry is self-sustaining.

central-plan building (p. 225) Any structure designed with a primary central space surrounded by symmetrical areas on each side, e.g., a **rotunda**.

ceramics (p. 20) A general term covering all types of wares made from fired clay.

chacmool (p. 396) In Maya sculpture, a half-reclining figure probably representing an offering bearer.

chaitya (p. 305) A type of Buddhist temple found in India. Built in the form of a hall or **basilica**, a *chaitya* hall is highly decorated with sculpture and usually is carved from a cave or natural rock location. It houses a sacred shrine or **stupa** for worship.

chamfer (p. 780) The slanted surface produced when an angle is trimmed or beveled, common in building and metalwork.

chasing (p. 432) Ornamentation made on metal by incising or hammering the surface.

château (*pl.* **châteaux**) (p. 693) A French country house or residential castle. A *château fort* is a military castle incorporating defensive works such as towers and battlements.

chattri (p. 780) In Indian architecture, a decorative pavilion with an umbrella-shaped **dome**.

chevron (p. 357) A decorative or heraldic motif of repeated Vs; a zigzag pattern.

chiaroscuro (p. 636) An Italian word designating the contrast of dark and light in a painting, drawing, or print. Chiaroscuro creates spatial depth and volumetric forms through gradations in the intensity of light and shadow.

choir (p. 225) The part of a church reserved for the clergy, monks, or nuns, either between the **transept** crossing and the **apse** or extending farther into the **nave**; separated from the rest of the church by screens or walls and fitted with stalls (seats).

cista (pl. **cistae**) (p. 157) Cylindrical containers used in antiquity by wealthy women as a case for toiletry articles such as a mirror.

clerestory (p. 57) In a **basilica**, the topmost zone of a wall with windows, extending above the **aisle** roofs. Provides direct light into the **nave**.

cloisonné (p. 257) An enameling technique in which artists affix wires or strips to a metal surface to delineate designs and create compartments (cloisons) that they subsequently fill with enamel.

cloister (p. 448) An enclosed space, open to the sky, especially within a monastery, surrounded by an **arcade**d walkway, often having a fountain and garden. Since the most important monastic buildings (e.g., dormitory, refectory, church) open off the cloister, it represents the center of the monastic world.

codex (*pl.* **codices**) (p. 245) A book, or a group of **manuscript** pages (folios), held together by stitching or other binding along one edge.

coffer (p. 197) A recessed decorative panel used to decorate ceilings or **vaults**. The use of coffers is called coffering.

coiling (p. 848) A technique in basketry. In coiled baskets a spiraling coil, braid, or rope of material is held in place by stitching or interweaving to create a permanent shape.

collage (p. 1025) A composition made of cut and pasted scraps of materials, sometimes with lines or forms added by the artist.

colonnade (p. 69) A row of **columns**, supporting a straight **lintel** (as in a **porch** or **portico**) or a series of **arch**es (an **arcade**).

colophon (p. 438) The data placed at the end of a book listing the book's author, publisher, illuminator, and other information related to its production. In East Asian **handscrolls**, the inscriptions which follow the painting are also called colophons.

column (p. 110) An architectural element used for support and/or decoration. Consists of a rounded or polygonal vertical **shaft** placed on a **base** and topped by a decorative **capital**. In Classical architecture, columns are built in accordance with the rules of one of the architectural **orders**. They can be free-standing or attached to a background wall (**engaged**).

combine (p. 1087) Combination of painting and sculpture using nontraditional art materials.

complementary color (p. 995) The primary and secondary colors across from each other on the color wheel (red and green, blue and orange, yellow and purple). When juxtaposed, the intensity of both colors increases. When mixed together, they negate each other to make a neutral gray-brown.

Composite order (p. 161) See under order. composite pose or image (p. 10) Combining different viewpoints within a single representation. composition (p. xxix) The overall arrangement, organizing design, or structure of a work of art. conch (p. 236) A halfdome.

connoisseur (p. 289) A French word meaning "an expert," and signifying the study and evaluation of art based primarily on formal, visual, and stylistic analysis. A connoisseur studies the style and technique of an object to assess its relative quality and identify its maker through visual comparison with other works of secure authorship. See also **Formalism**.

continuous narrative (p. 245) See under narrative image.

contrapposto (p. 120) Italian term meaning "set against," used to describe the Classical convention of representing human figures with opposing alternations of tension and relaxation on either side of a central **axis** to imbue figures with a sense of the potential for movement.

convention (p. 31) A traditional way of representing forms.

corbel, corbeling (p. 19) An early roofing and arching technique in which each **course** of stone projects slightly beyond the previous layer (a corbel) until the uppermost corbels meet; see also under **arch**. Also: **bracket**s that project from a wall.

corbeled vault (p. 99) See under vault.

Corinthian order (p. 108) See under order.

cornice (p. 110) The uppermost section of a Classical **entablature**. More generally, a horizontally projecting element found at the top of a building wall or **pedestal**. A *raking comice* is formed by the junction of two slanted cornices, most often found in **pediments**.

course (p. 99) A horizontal layer of stone used in building.

crenellation, crenellated (p. 44) Alternating high and low sections of a wall, giving a notched appearance and creating permanent defensive shields on top of fortified buildings.

crocket (p. 587) A stylized leaf used as decoration along the outer angle of spires, pinnacles, gables, and around **capital**s in Gothic architecture.

cruciform (p. 228) Of anything that is cross-shaped, as in the cruciform plan of a church.

cubiculum (pl. cubicula) (p. 220) A small private room for burials in a **catacomb**.

cuneiform (p. 28) An early form of writing with wedge-shaped marks impressed into wet clay with a **stylus**, primarily used by ancient Mesopotamians.

curtain wall (p. 1045) A wall in a building that does not support any of the weight of the structure.

cyclopean (p. 93) A method of construction using huge blocks of rough-hewn stone. Any large-scale, monumental building project that impresses by sheer size. Named after the Cyclopes (sing. Cyclops), one-eyed giants of legendary strength in Greek myths.

cylinder seal (p. 35) A small cylindrical stone decorated with **incised** patterns. When rolled across soft clay or wax, the resulting raised pattern or design served in Mesopotamian and Indus Valley cultures as an identifying signature.

dado (pl. dadoes) (p. 161) The lower part of a wall, differentiated in some way (by a **molding** or different coloring or paneling) from the upper section.

daguerreotype (p. 969) An early photographic process that makes a positive print on a light-sensitized copperplate; invented and marketed in 1839 by Louis-Jacques-Mandé Daguerre.

dendrochronology (p. xxxvi) The dating of wood based on the patterns of the tree's growth rings.

dentils (p. 110) A row of projecting rectangular blocks forming a **molding** or running beneath a **cornice** in Classical architecture.

desert varnish (p. 406) A naturally occurring coating that turns rock faces into dark surfaces. Artists would draw images by scraping through the dark surface and revealing the color of the underlying rock. Extensively used in southwest North America.

diptych (p. 212) Two panels of equal size (usually decorated with paintings or reliefs) hinged together.

dogu (p. 362) Small human figurines made in Japan during the Jomon period. Shaped from clay, the figures have exaggerated expressions and are in contorted poses. They were probably used in religious rituals.

dolmen (p. 17) A prehistoric structure made up of two or more large upright stones supporting a large, flat, horizontal slab or slabs.

dome (p. 187) A rounded vault, usually over a circular space. Consists of curved masonry and can vary in shape from hemispherical to bulbous to ovoidal. May use a supporting vertical wall (drum), from which the vault springs, and may be crowned by an open space (oculus) and/or an exterior lantern. When a dome is built over a square space, an intermediate element is required to make the transition to a circular drum. There are two systems. A dome on **pendentives** incorporates arched, sloping intermediate sections of wall that carry the weight and thrust of the dome to heavily buttressed supporting piers. A dome on squinches uses an arch built into the wall (squinch) in the upper corners of the space to carry the weight of the dome across the corners of the square space below. A halfdome or conch may cover a semicircular space.

domino construction (p. 1045) System of building construction introduced by the architect Le Corbusier in which reinforced concrete floor slabs are floated on six free-standing posts placed as if at the positions of the six dots on a domino playing piece.

Doric order (p. 108) See order.

dressed stone (p. 84) Another term for ashlar.

drillwork (p. 188) The technique of using a drill for the creation of certain effects in sculpture.

drum (p. 110) The circular wall that supports a **dome**. Also: a segment of the circular **shaft** of a **column**.

drypoint (p. 748) An **intaglio** printmaking process by which a metal (usually copper) plate is directly inscribed with a pointed instrument (**stylus**). The resulting design of scratched lines is inked, wiped, and printed. Also: the print made by this process.

earthenware (p. 20) A low-fired, opaque ceramic ware, employing humble clays that are naturally heat-resistant and remain porous after firing unless glazed. Earthenware occurs in a range of earth-toned colors, from white and tan to gray and black, with tan predominating.

earthwork (p. 1102) Usually very large-scale, outdoor artwork that is produced by altering the natural environment.

echinus (p. 110) A cushionlike circular element found below the **abacus** of a Doric **capital**. Also: a similarly shaped **molding** (usually with egg-and-dart motifs) underneath the **volute**s of an Ionic capital.

electronic spin resonance (p. 12) Method that uses magnetic field and microwave irradiation to date material such as tooth enamel and its surrounding soil.

elevation (p. 108) The arrangement, proportions, and details of any vertical side or face of a building. Also: an architectural drawing showing an exterior or interior wall of a building.

embroidery (p. 397) Stitches applied in a decorative pattern on top of an already-woven fabric ground.

en plein air (p. 987) French term (meaning "in the open air") describing the Impressionist practice of painting outdoors so artists could have direct access to the fleeting effects of light and atmosphere while working.

enamel (p. 255) Powdered, then molten, glass applied to a metal surface, and used by artists to create designs. After firing, the glass forms an opaque or transparent substance that fuses to the metal background. Also: an object created by the enameling technique. See also *cloisonné*.

encaustic (p. 246) A painting **medium** using pigments mixed with hot wax.

engaged (p. 171) Of an architectural feature, usually a **column**, attached to a wall.

engraving (p. 592) An intaglio printmaking process of inscribing an image, design, or letters onto a metal or wood surface from which a print is made. An engraving is usually drawn with a sharp implement (burin) directly onto the surface of the plate. Also: the print made from this process.

entablature (p. 107) In the Classical orders, the horizontal elements above the columns and capitals. The entablature consists of, from bottom to top, an architrave, a frieze, and a cornice.

entasis (p. 108) A slight swelling of the **shaft** of a Greek **column**. The optical illusion of entasis makes the column appear from afar to be straight.

esquisse (p. 946) French for "sketch." A quickly executed drawing or painting conveying the overall idea for a finished painting.

etching (p. 748) An intaglio printmaking process in which a metal plate is coated with acid-resistant resin and then inscribed with a stylus in a design, revealing the plate below. The plate is then immersed in acid, and the exposed metal of the design is eaten away by the acid. The resin is removed, leaving the design etched permanently into the metal and the plate ready to be inked, wiped, and printed.

Eucharist (p. 220) The central rite of the Christian Church, from the Greek word for "thanksgiving." Also known as the Mass or Holy Communion, it reenacts Christ's sacrifice on the cross and commemorates the Last Supper. According to traditional Catholic Christian belief, consecrated bread and wine become the body and blood of Christ; in Protestant belief, bread and wine symbolize the body and blood.

exedra (pl. exedrae) (p. 197) In architecture, a semicircular niche. On a small scale, often used as decoration, whereas larger exedrae can form interior spaces (such as an apse).

expressionism (p. 149) Artistic styles in which aspects of works of art are exaggerated to evoke subjective emotions rather than to portray objective reality or elicit a rational response.

façade (p. 52) The face or front wall of a building.

faience (p. 88) Type of **ceramic** covered with colorful, opaque glazes that form a smooth, impermeable surface. First developed in ancient Egypt.

fang ding (p. 334) A square or rectangular bronze vessel with four legs. The fang ding was used for ritual offerings in ancient China during the Shang dynasty.

fête galante (p. 910) A subject in painting depicting well-dressed people at leisure in a park or country setting. It is most often associated with eighteenth-century French Rococo painting.

filigree (p. 90) Delicate, lacelike ornamental work. fillet (p. 110) The flat ridge between the carved-out flutes of a column shaft.

finial (p. 780) A knoblike architectural decoration usually found at the top point of a spire, pinnacle, canopy, or gable. Also found on furniture. Also the ornamental top of a staff.

flutes (p. 110) In architecture, evenly spaced, rounded parallel vertical grooves incised on **shafts** of **columns** or on columnar elements such as **pilasters**.

flying buttress (p. 503) See under buttress.

flying gallop (p. 88) A non-naturalistic pose in which animals are depicted hovering above the ground with legs fully extended backwards and forwards to signify that they are running.

foreshortening (p. xxxi) The illusion created on a flat surface by which figures and objects appear to recede or project sharply into space. Accomplished according to the rules of **perspective**.

formal analysis (p. xxix) An exploration of the visual character that artists bring to their works through the expressive use of elements such as line, form, color, and light, and through its overall structure or composition.

Formalism (p. 1073) An approach to the understanding, appreciation, and valuation of art based almost solely on considerations of form. The Formalist's approach tends to regard an artwork as independent of its time and place of making.

forum (p. 176) A Roman town center; site of temples and administrative buildings and used as a market or gathering area for the citizens.

fresco (p. 81) A painting technique in which water-based pigments are applied to a plaster surface. If the plaster is painted when wet, the color is absorbed by the plaster, becoming a permanent part of the wall (buon fresco). Fresco secco is created by painting on dried plaster, and the color may eventually flake off. Murals made by both these techniques are called frescos.

frieze (p. 107) The middle element of an entablature, between the architrave and the cornice. Usually decorated with sculpture, painting, or moldings. Also: any continuous flat band with relief sculpture or painted decoration.

frottage (p. 1057) A design produced by laying a piece of paper over a textured surface and rubbing with charcoal or other soft **medium**.

fusuma (p. 820) Sliding doors covered with paper, used in traditional Japanese construction. *Fusuma* are often highly decorated with paintings and colored backgrounds.

gallery (p. 236) A roofed passageway with one or both of its long sides open to the air. In church architecture, the story found above the side **aisles** of a church or across the width at the end of the **nave** or **transepts**, usually open to and overlooking the area below. Also: a building or hall in which art is displayed or sold.

garbhagriha (p. 302) From the Sanskrit word meaning "womb chamber," a small room or shrine in a Hindu temple containing a holy image.

genre painting (p. 714) A term used to loosely categorize paintings depicting scenes of everyday life, including (among others) domestic interiors, parties, inn scenes, and street scenes.

geoglyph (p. 399) Earthen design on a colossal scale, often created in a landscape as if to be seen from an aerial viewpoint.

gesso (p. 546) A ground made from glue, gypsum, and/or chalk, used as the ground of a wood panel or the priming layer of a canvas. Provides a smooth surface for painting.

gilding (p. 90) The application of paper-thin gold leaf or gold pigment to an object made from another **medium** (for example, a sculpture or painting). Usually used as a decorative finishing detail.

giornata (pl. giornate) (p. 539) Adopted from the Italian term meaning "a day's work," a *giornata* is the section of a **fresco** plastered and painted in a single day.

glazing (p. 600) In ceramics, an outermost layer of vitreous liquid (glaze) that, upon firing, renders the ware waterproof and forms a decorative surface. In painting, a technique used with oil media in which a transparent layer of paint (glaze) is laid over another, usually lighter, painted or glazed area. In architecture, the process of filling openings in a building with windows of clear or stained glass.

gold leaf (p. 47) Paper-thin sheets of hammered gold that are used in gilding. In some cases (such as Byzantine icons), also used as a ground for paintings. gopura (p. 775) The towering gateway to an Indian

gopura (p. 775) The towering gateway to an Indian Hindu temple complex.

Grand Manner (p. 923) An elevated style of painting popular in the eighteenth century in which the artist looked to the ancients and to the Renaissance for inspiration; for portraits as well as history painting, the artist would adopt the poses, compositions, and attitudes of Renaissance and antique models.

Grand Tour (p. 913) Popular during the eighteenth and nineteenth centuries, an extended tour of cultural sites in France and Italy intended to finish the education of a young upper-class person primarily from Britain or North America.

granulation (p. 90) A technique of decoration in which metal granules, or tiny metal balls, are fused onto a metal surface.

graphic arts (p. 698) A term referring to those arts that are drawn or printed and that utilize paper as the primary support.

grattage (p. 1057) A pattern created by scraping off layers of paint from a canvas laid over a textured surface. Compare **frottage**.

grid (p. 65) A system of regularly spaced horizontally and vertically crossed lines that gives regularity to an architectural plan or in the composition of a work of art. Also: in painting, a grid is used to allow designs to be enlarged or transferred easily.

grisaille (p. 540) A style of monochromatic painting in shades of gray. Also: a painting made in this style.

groin vault (p. 187) See under vault.

grozing (p. 501) Chipping away at the edges of a piece of glass to achieve the precise shape needed for inclusion in the composition of a **stained-glass** window.

guild (p. 419) An association of artists or craftsmakers. Medieval and Renaissance guilds had great economic power, as they controlled the marketing of their members' products and provided economic protection, political solidarity, and training in the craft to its members. The painters' guild was usually dedicated to St. Luke, their patron saint.

hall church (p. 521) A church with nave and aisles of the same height, giving the impression of a large, open hall.

halo (p. 215) A circle of light that surrounds and frames the heads of emperors and holy figures to signify their power and/or sanctity. Also known as a nimbus.

handscroll (p. 343) A long, narrow, horizontal painting or text (or combination thereof) common in Chinese and Japanese art and of a size intended for individual use. A handscroll is stored wrapped tightly around a wooden pin and is unrolled for viewing or reading.

hanging scroll (p. 796) In Chinese and Japanese art, a vertical painting or text mounted within sections of silk. At the top is a semicircular rod; at the bottom is a round dowel. Hanging scrolls are kept rolled and tied except for special occasions, when they are hung for display, contemplation, or commemoration.

haniwa (p. 362) Pottery forms, including cylinders, buildings, and human figures, that were placed on top of Japanese tombs or burial mounds during the Kofun period (300–552 CE).

Happening (p. 1087) An art form developed by Allan Kaprow in the 1960s, incorporating performance, theater, and visual images. A Happening was organized without a specific narrative or intent; with audience participation, the event proceeded according to chance and individual improvisation.

hemicycle (p. 512) A semicircular interior space or structure.

henge (p. 17) A circular area enclosed by stones or wood posts set up by Neolithic peoples. It is usually bounded by a ditch and raised embankment.

hierarchic scale (p. 27) The use of differences in size to indicate relative importance. For example, with human figures, the larger the figure, the greater her or his importance.

hieratic (p. 484) Highly stylized, severe, and detached, often in relation to a strict religious tradition.

hieroglyph (p. 52) Picture writing; words and ideas rendered in the form of pictorial symbols.

high relief (p. 307) See under relief sculpture. historiated capital (p. 484) See under capital.

historicism (p. 965) The strong consciousness of and attention to the institutions, themes, styles, and forms of the past, made accessible by historical research, textual study, and archaeology.

history paintings (p. 926) Paintings based on historical, mythological, or biblical narratives. Once considered the noblest form of art, history paintings generally convey a high moral or intellectual idea and are often painted in a grand pictorial style.

horizon line (p. 569) A horizontal "line" formed by the implied meeting point of earth and sky. In **linear perspective**, the **vanishing point** or points are located on this "line."

horseshoe arch (p. 272) See under arch.

hue (p. 77) Pure color. The saturation or intensity of the hue depends on the purity of the color. Its value depends on its lightness or darkness.

hydria (p. 139) A large ancient Greek or Roman jar with three handles (horizontal ones at both sides and one vertical at the back), used for storing water.

hypostyle hall (p. 66) A large interior room characterized by many closely spaced **columns** that support its roof.

icon (p. 246) An image representing a sacred figure or event in the Byzantine (later the Orthodox) Church. Icons are venerated by the faithful, who believe their prayers are transmitted through them to God.

iconic image (p. 215) A picture that expresses or embodies an intangible concept or idea.

iconoclasm (p. 248) The banning and/or destruction of images, especially icons and religious art. Iconoclasm in eighth- and ninth-century Byzantium and sixteenth- and seventeenth-century Protestant territories arose from differing beliefs about the power, meaning, function, and purpose of imagery in religion.

iconography (p. xxxiii) Identifying and studying the subject matter and **conventional** symbols in works of art.

iconology (p. xxxv) Interpreting works of art as embodiments of cultural situation by placing them within broad social, political, religious, and intellectual contexts.

iconophile (p. 247) From the Greek for "lover of images." In periods of **iconoclasm**, iconophiles advocate the continued use of sacred images.

idealization (p. 134) A process in art through which artists strive to make their forms and figures attain perfection, based on pervading cultural values and/or their own personal ideals.

illumination (p. 431) A painting on paper or parchment used as an illustration and/or decoration in a manuscript or album. Usually richly colored, often supplemented by gold and other precious materials. The artists are referred to as illuminators. Also: the technique of decorating manuscripts with such paintings.

impasto (p. 749) Thick applications of pigment that give a painting a palpable surface texture.

impluvium (p. 178) A pool under a roof opening that collected rainwater in the **atrium** of a Roman house.

impost block (p. 170) A block of masonry imposed between the top of a **pier** or above the **capital** of a **column** in order to provide extra support at the springing of an **arch**.

incising (p. 118) A technique in which a design or inscription is cut into a hard surface with a sharp instrument. Such a surface is said to be incised.

ink painting (p. 812) A monochromatic style of painting developed in China, using black ink with gray washes.

inlay (p. 30) To set pieces of a material or materials into a surface to form a design. Also: material used in or decoration formed by this technique.

installation, installation art (p. 1051)

Contemporary art created for a specific site, especially a gallery or outdoor area, that creates a complete and controlled environment.

intaglio (p. 592) A technique in which the design is carved out of the surface of an object, such as an engraved seal stone. In the **graphic arts**, intaglio includes **engraving**, **etching**, and **drypoint**—all processes in which ink transfers to paper from incised, ink-filled lines cut into a metal plate.

intarsia (p. 618) Technique of **inlay** decoration using variously colored woods.

intuitive perspective (p. 182) See under perspective. Ionic order (p. 107) See under order.

iwan (p. 277) In Islamic architecture, a large, vaulted chamber with a monumental arched opening on one side.

jamb (p. 478) In architecture, the vertical element found on both sides of an opening in a wall, and supporting an **arch** or **lintel**.

Japonisme (p. 996) A style in French and American nineteenth-century art that was highly influenced by Japanese art, especially prints.

jasperware (p. 919) A fine-grained, unglazed, white **ceramic** developed in the eighteenth century by Josiah Wedgwood, often with raised designs remaining white above a background surface colored by metallic oxides.

Jataka tales (p. 303) In Buddhism, stories associated with the previous lives of Shakyamuni, the historical Buddha.

joggled voussoirs (p. 268) Interlocking voussoirs in an arch or lintel, often of contrasting materials for colorful effect.

joined-block sculpture (p. 373) Large-scale wooden sculpture constructed by a method developed in Japan. The entire work is made from smaller hollow blocks, each individually carved, and assembled when complete. The joined-block technique allowed production of larger sculpture, as the multiple joints alleviate the problems of drying and cracking found with sculpture carved from a single block.

kantharos (p. 117) A type of ancient Greek goblet with two large handles and a wide mouth.

keep (p. 477) The innermost and strongest structure or central tower of a medieval castle, sometimes used as living quarters, as well as for defense. Also called a donjon.

kente (p. 892) A woven cloth made by the Ashanti peoples of West Africa. *Kente* cloth is woven in long, narrow pieces featuring complex and colorful patterns, which are then sewn together.

key block (p. 828) The master block in the production of a colored **woodblock print**, which requires different blocks for each color. The key block is a flat piece of wood upon which the outlines for the entire design of the print were first drawn on its surface and then all but these outlines were carved away with a knife. These outlines serve as a guide for the accurate **registration** or alignment of the other blocks needed to add colors to specific parts of a print.

keystone (p. 170) The topmost **voussoir** at the center of an **arch**, and the last block to be placed. The pressure of this block holds the arch together. Often of a larger size and/or decorated.

kiln (p. 20) An oven designed to produce enough heat for the baking, or firing, of clay, for the melting of the glass used in **enamel** work, and for the fixing of vitreous paint on **stained glass**.

kiva (p. 405) A subterranean, circular room used as a ceremonial center in some Native American cultures.

kondo (p. 366) The main hall inside a Japanese Buddhist temple where the images of Buddha are housed.

korambo (p. 865) A ceremonial or spirit house in Pacific cultures, reserved for the men of a village and used as a meeting place as well as to hide religious artifacts from the uninitiated.

kore (pl. kourai) (p. 114) An Archaic Greek statue of a young woman.

koru (p. 872) A design depicting a curling stalk with a bulb at the end that resembles a young tree fern; often found in Maori art.

kouros (*pl.* **kouroi**) (p. 114) An Archaic Greek statue of a young man or boy.

kowhaiwhai (p. 872) Painted curvilinear patterns often found in Maori art.

krater (p. 99) An ancient Greek vessel for mixing wine and water, with many subtypes that each have a distinctive shape. *Calyx krater*: a bell-shaped vessel with handles near the base that resembles a flower calyx. *Volute krater*: a krater with handles shaped like scrolls.

Kufic (p. 275) An ornamental, angular Arabic script. **kylix** (p. 120) A shallow ancient Greek cup, used for drinking, with a wide mouth and small handles near the rim.

lacquer (p. 824) A type of hard, glossy surface varnish, originally developed for use on objects in East Asian cultures, made from the sap of the Asian sumac or from shellac, a resinous secretion from the lac insect. Lacquer can be layered and manipulated or combined with pigments and other materials for various decorative effects.

lakshana (p. 306) The 32 marks of the historical Buddha. The *lakshana* include, among others, the Buddha's golden body, his long arms, the wheel impressed on his palms and the soles of his feet, and his elongated earlobes.

lamassu (p. 42) Supernatural guardian-protector of ancient Near Eastern palaces and throne rooms, often represented sculpturally as a combination of the bearded head of a man, powerful body of a lion or bull, wings of an eagle, and the horned headdress of a god, usually possessing five legs.

lancet (p. 505) A tall, narrow window crowned by a sharply pointed arch, typically found in Gothic architecture.

lantern (p. 464) A turretlike structure situated on a roof, vault, or dome, with windows that allow light into the space below.

lekythos (pl. lekythoi) (p. 141) A slim ancient Greek oil vase with one handle and a narrow mouth.

linear perspective (p. 595) See under perspective. linga shrine (p. 315) A place of worship centered on an object or representation in the form of a phallus (the lingam), which symbolizes the power of the Hindu god Shiva.

lintel (p. 18) A horizontal element of any material carried by two or more vertical supports to form an opening.

literati painting (p. 793) A style of painting that reflects the taste of the educated class of East Asian intellectuals and scholars. Characteristics include an appreciation for the antique, small scale, and an intimate connection between maker and audience.

lithography (p. 953) Process of making a print (lithograph) from a design drawn on a flat stone block with greasy crayon. Ink is applied to the wet stone and adheres only to the greasy areas of the design.

loggia (p. 534) Italian term for a gallery. Often used as a corridor between buildings or around a courtyard, a loggia usually features an arcade or colonnade.

longitudinal-plan building (p. 225) Any structure designed with a rectangular shape and a longitudinal axis. In a cross-shaped building, the main arm of the building would be longer than any arms that cross it. For example, a **basilica**.

lost-wax casting (p. 36) A method of casting metal, such as bronze. A wax mold is covered with clay and plaster, then fired, thus melting the wax and leaving a hollow form. Molten metal is then poured into the hollow space and slowly cooled. When the hardened clay and plaster exterior shell is removed, a solid metal form remains to be smoothed and polished.

low relief (p. 40) See under relief sculpture.

lunette (p. 221) A semicircular wall area, framed by an **arch** over a door or window. Can be either plain or decorated.

lusterware (p. 277) Pottery decorated with metallic **glazes**.

madrasa (p. 277) An Islamic institution of higher learning, where teaching is focused on theology and law.

maenad (p. 104) In ancient Greece, a female devotee of the wine god Dionysos who participated in orgiastic rituals. Often depicted with swirling drapery to indicate wild movement or dance. Also called a Bacchante, after Bacchus, the Roman equivalent of Dionysos.

majolica (p. 573) Pottery painted with a tin **glaze** that, when fired, gives a lustrous and colorful surface.

mandala (p. 302) An image of the cosmos represented by an arrangement of circles or concentric geometric shapes containing diagrams or images. Used for meditation and contemplation by Buddhists.

mandapa (p. 302) In a Hindu temple, an open hall dedicated to ritual worship.

mandorla (p. 479) Light encircling, or emanating from, the entire figure of a sacred person.

manuscript (p. 244) A hand-written book or document.

maqsura (p. 272) An enclosure in a Muslim mosque, near the *mihrab*, designated for dignitaries. martyrium (pl. martyria) (p. 238) A church, chapel, or shrine built over the grave of a Christian martyr.

mastaba (p. 53) A flat-topped, one-story structure with slanted walls built over an ancient Egyptian underground tomb.

matte (p. 573) Of a smooth surface that is without shine or luster.

mausoleum (p. 175) A monumental building used as a tomb. Named after the tomb of King Mausolos erected at Halikarnassos around 350 BCE.

medallion (p. 222) Any round ornament or decoration. Also: a large medal.

medium (pl. media) (p. xxix) The material from which a work of art is made.

megalith (adj. megalithic) (p. 16) A large stone used in some prehistoric architecture.

megaron (p. 93) The main hall of a Mycenaean palace or grand house.

memento mori (p. 909) From Latin for "remember that you must die." An object, such as a skull or extinguished candle, typically found in a *vanitas* image, symbolizing the transience of life.

menorah (p. 186) A Jewish lampstand with seven or nine branches; the nine-branched menorah is used during the celebration of Hanukkah. Representations of the seven-branched menorah, once used in the Temple of Jerusalem, became a symbol of Judaism.

metope (p. 110) The carved or painted rectangular panel between the **triglyphs** of a Doric **frieze**.

mihrab (p. 265) A recess or niche that distinguishes the wall oriented toward Mecca (*qibla*) in a **mosque**.

millefiori (p. 434) A glassmaking technique in which rods of differently colored glass are fused in a long bundle that is subsequently sliced to produce disks or beads with small-scale, multicolor patterns. The term derives from the Italian for "a thousand flowers."

minaret (p. 274) A tower on or near a **mosque** from which Muslims are called to prayer five times a day.

minbar (p. 265) A high platform or pulpit in a mosque.

miniature (p. 245) Anything small. In painting, miniatures may be illustrations within **albums** or **manuscripts** or intimate portraits.

mirador (p. 280) In Spanish and Islamic palace architecture, a very large window or room with windows, and sometimes balconies, providing views to interior courtyards or the exterior landscape.

mithuna (p. 305) The amorous male and female couples in Buddhist sculpture, usually found at the entrance to a sacred building. The *mithuna* symbolizes the harmony and fertility of life.

moai (p. 875) Statues found in Polynesia, carved from tufa, a yellowish brown volcanic stone, and depicting the human form. Nearly 1,000 of these statues have been found on the island of Rapa Nui but their significance has been a matter of speculation.

modeling (p. xxix) In painting, the process of creating the illusion of three-dimensionality on a two-dimensional surface by use of light and shade. In sculpture, the process of molding a three-dimensional form out of a malleable substance.

module (p. 346) A segment or portion of a repeated design. Also: a basic building block.

molding (p. 319) A shaped or sculpted strip with varying contours and patterns. Used as decoration on architecture, furniture, frames, and other objects.

mortise-and-tenon (p. 18) A method of joining two elements. A projecting pin (tenon) on one element fits snugly into a hole designed for it (mortise) on the other.

mosaic (p. 145) Image formed by arranging small colored stone or glass pieces (**tesserae**) and affixing them to a hard, stable surface.

mosque (p. 265) A building used for communal Islamic worship.

Mozarabic (p. 439) Of an eclectic style practiced in Christian medieval Spain when much of the Iberian peninsula was ruled by Islamic dynasties.

mudra (p. 307) A symbolic hand gesture in Buddhist art that denotes certain behaviors, actions, or feelings.

mullion (p. 510) A slender straight or curving bar that divides a window into subsidiary sections to create tracery.

muqarna (p. 280) In Islamic architecture, one of the nichelike components, often stacked in tiers to mark the transition between flat and rounded surfaces and often found on the **vault** of a **dome**.

naos (p. 236) The principal room in a temple or church. In ancient architecture, the **cella**. In a Byzantine church, the **nave** and **sanctuary**.

narrative image (p. 215) A picture that recounts an event drawn from a story, either factual (e.g. biographical) or fictional. In **continuous narrative**, multiple scenes from the same story appear within a single compositional frame.

narthex (p. 220) The vestibule or entrance porch of a church.

nave (p. 191) The central space of a church, two or three stories high and usually flanked by **aisle**s.

necropolis (p. 53) A large cemetery or burial area; literally a "city of the dead."

nemes headdress (p. 51) The royal headdress of ancient Egypt.

niello (p. 90) A metal technique in which a black sulfur **alloy** is rubbed into fine lines engraved into metal (usually gold or silver). When heated, the alloy becomes fused with the surrounding metal and provides contrasting detail.

oculus (pl. oculi) (p. 187) In architecture, a circular opening. Usually found either as windows or at the apex of a **dome**. When at the top of a dome, an oculus is either open to the sky or covered by a decorative exterior lantern.

odalisque (p. 952) Turkish word for "harem slave girl" or "concubine."

oil painting (p. 575) Any painting executed with pigments suspended in a **medium** of oil. Oil paint has particular properties that allow for greater ease of working: among others, a slow drying time (which allows for corrections), and a great range of relative opaqueness of paint layers (which permits a high degree of detail and luminescence).

oinochoe (p. 126) An ancient Greek jug used for wine.

olpe (p. 105) Any ancient Greek vessel without a spout.

one-point perspective (p. 259) See under perspective.

orant (p. 220) Of a standing figure represented praying with outstretched and upraised arms.

oratory (p. 228) A small chapel.

order (p. 110) A system of proportions in Classical architecture that includes every aspect of the building's plan, elevation, and decorative system. Composite: a combination of the Ionic and the Corinthian orders. The capital combines acanthus leaves with volute scrolls. Corinthian: the most ornate of the orders, the Corinthian includes a base, a fluted column shaft with a capital elaborately decorated with acanthus leaf carvings. Its entablature consists of an architrave decorated with moldings, a frieze often containing relief sculpture, and a cornice with dentils. Doric: the column shaft of the Doric order can be fluted or smooth-surfaced and has no base. The Doric capital consists of an undecorated echinus and abacus. The Doric entablature has a plain architrave, a frieze with metopes and triglyphs, and a simple cornice. Ionic: the column of the Ionic order has a base, a fluted shaft, and a capital decorated with volutes. The Ionic entablature consists of an architrave of three panels and moldings,

a frieze usually containing sculpted relief ornament, and a cornice with dentils. *Tuscan*: a variation of Doric characterized by a smooth-surfaced column shaft with a base, a plain architrave, and an undecorated frieze. *Colossal* or *giant*: any of the above built on a large scale, rising through two or more stories in height and often raised from the ground on a **pedestal**.

Orientalism (p. 968) A fascination with Middle Eastern cultures that inspired eclectic nineteenth-century European fantasies of exotic life that often formed the subject of paintings.

orthogonal (p. 138) Any line running back into the represented space of a picture perpendicular to the imagined picture plane. In linear perspective, all orthogonals converge at a single vanishing point in the picture and are the basis for a grid that maps out the internal space of the image. An orthogonal plan is any plan for a building or city that is based exclusively on right angles, such as the grid plan of many major cities.

pagoda (p. 347) An East Asian **reliquary** tower built with successively smaller, repeated stories. Each story is usually marked by an elaborate projecting roof.

painterly (p. 253) A style of painting which emphasizes the techniques and surface effects of brushwork (also color, light, and shade).

palace complex (p. 41) A group of buildings used for living and governing by a ruler and his or her supporters, usually fortified.

palazzo (p. 602) Italian term for palace, used for any large urban dwelling.

palette (p. 183) A hand-held support used by artists for arranging colors and mixing paint during the process of painting. Also: the choice of a range of colors used by an artist in a particular work, as typical of his or her style. In ancient Egypt, a flat stone used to grind and prepare makeup.

panel painting (p. xli) Any painting executed on a wood support, usually planed to provide a smooth surface. A panel can consist of several boards joined together.

parchment (p. 245) A writing surface made from treated skins of animals. Very fine parchment is known as wellum

parterre (p. 761) An ornamental, highly regimented flowerbed; especially as an element of the ornate gardens of a seventeenth-century palace or **château**.

passage grave (p. 17) A prehistoric tomb under a **cairn**, reached by a long, narrow, slab-lined access passageway or passageways.

pastel (p. 914) Dry pigment, chalk, and gum in stick or crayon form. Also: a work of art made with pastels. pedestal (p. 107) A platform or base supporting a sculpture or other monument. Also: the block found below the base of a Classical column (or colonnade), serving to raise the entire element off the ground.

pediment (p. 107) A triangular gable found over major architectural elements such as Classical Greek porticos, windows, or doors. Formed by an entablature and the ends of a sloping roof or a raking cornice. A similar architectural element is often used decoratively above a door or window, sometimes with a curved upper molding. A broken pediment is a variation on the traditional pediment, with an open space at the center of the topmost angle and/or the horizontal cornice.

pendant (also **pendent**) (p. 640) One of a pair of artworks meant to be seen in relation to each other as a set.

pendentive (p. 236) The concave triangular section of a **vault** that forms the transition between a square or polygonal space and the circular base of a **dome**.

Performance art (p. 1087) A contemporary artwork based on a live, sometimes theatrical performance by the artist.

peristyle (p. 66) In Greek architecture, a surrounding **colonnade**. A peristyle building is surrounded on the exterior by a colonnade. Also: a peristyle court is an open colonnaded courtyard, often having a pool and garden.

perspective (p. xxvii) A system for representing three-dimensional space on a two-dimensional surface. Atmospheric or aerial perspective: a method of rendering the effect of spatial distance by subtle variations in color and clarity of representation. Intuitive perspective: a method of giving the impression of recession by visual instinct, not by the use of an overall system or program. Oblique perspective: an intuitive spatial system in which a building or room is placed with one corner in the picture plane, and the other parts of the structure recede to an imaginary vanishing point on its other side. Oblique perspective is not a comprehensive, mathematical system. One-point and multiple-point perspective (also called linear, scientific, or mathematical perspective): a method of creating the illusion of threedimensional space on a two-dimensional surface by delineating a horizon line and multiple orthogonal lines. These recede to meet at one or more points on the horizon (vanishing point), giving the appearance of spatial depth. Called scientific or mathematical because its use requires some knowledge of geometry and mathematics, as well as optics. Reverse perspective: a Byzantine perspective theory in which the orthogonals or rays of sight do not converge on a vanishing point in the picture, but are thought to originate in the viewer's eye in front of the picture. Thus, in reverse perspective the image is constructed with orthogonals that diverge, giving a slightly tipped aspect to objects.

photomontage (p. 1039) A photographic work created from many smaller photographs arranged (and often overlapping) in a composition, which is then rephotographed.

pictograph (p. 337) A highly stylized depiction serving as a symbol for a person or object. Also: a type of writing utilizing such symbols.

picture plane (p. 575) The theoretical plane corresponding with the actual surface of a painting, separating the spatial world evoked in the painting from the spatial world occupied by the viewer.

picturesque (p. 919) Of the taste for the familiar, the pleasant, and the agreeable, popular in the eighteenth and nineteenth centuries in Europe. Originally used to describe the "picturelike" qualities of some landscape scenes. When contrasted with the sublime, the picturesque stood for the interesting but ordinary domestic landscape.

piece-mold casting (p. 334) A casting technique in which the mold consists of several sections that are connected during the pouring of molten metal, usually bronze. After the cast form has hardened, the pieces of the mold are disassembled, leaving the completed object.

pier (p. 270) A masonry support made up of many stones, or rubble and concrete (in contrast to a column **shaft** which is formed from a single stone or a series of **drums**), often square or rectangular in plan, and capable of carrying very heavy architectural loads.

pietà (p. 230) A devotional subject in Christian religious art. After the Crucifixion the body of Jesus was laid across the lap of his grieving mother, Mary. When other mourners are present, the subject is called the Lamentation.

pietra serena (p. 602) A gray Tuscan sandstone used in Florentine architecture.

pilaster (p. 158) An **engaged** columnlike element that is rectangular in format and used for decoration in architecture

pilgrimage church (p. 239) A church that attracts visitors wishing to venerate **relic**s as well as attend religious services.

pinnacle (p. 503) In Gothic architecture, a steep pyramid decorating the top of another element such as a **buttress**. Also: the highest point.

plate tracery (p. 505) See under tracery. plein air (p. 989) See under en plein air.

plinth (p. 161) The slablike base or **pedestal** of a **column**, statue, wall, building, or piece of furniture.

pluralism (p. 1107) A social structure or goal that allows members of diverse ethnic, racial, or other groups to exist peacefully within the society while continuing to practice the customs of their own divergent cultures. Also: an adjective describing the state of having a variety of valid contemporary styles available at the same time

podium (p. 138) A raised platform that acts as the foundation for a building, or as a platform for a speaker. poesia (pl. poesie) (p. 656) Italian Renaissance paintings based on Classical themes, often with erotic overtones, notably in the mid-sixteenth-century works

polychromy (p. 524) Multicolored decoration applied to any part of a building, sculpture, or piece of furniture. This can be accomplished with paint or by the use of multicolored materials.

of the Venetian painter Titian.

polyptych (p. 566) An **altarpiece** constructed from multiple panels, sometimes with hinges to allow for movable wings.

porcelain (p. 20) A type of extremely hard and fine white **ceramic** first made by Chinese potters in the eighth century CE. Made from a mixture of kaolin and petuntse, porcelain is fired at a very high temperature, and the final product has a translucent surface.

porch (p. 108) The covered entrance on the exterior of a building. With a row of **columns** or **colonnade**, also called a **portico**.

portal (p. 40) A grand entrance, door, or gate, usually to an important public building, and often decorated with sculpture.

portico (p. 63) In architecture, a projecting roof or porch supported by **columns**, often marking an entrance. See also **porch**.

post-and-lintel (p. 19) An architectural system of construction with two or more vertical elements (posts) supporting a horizontal element (**lintel**).

potassium-argon dating (p. 12) Archaeological method of **radiometric dating** that measures the decay of a radioactive potassium isotope into a stable isotope of argon, and inert gas.

potsherd (p. 20) A broken piece of **ceramic** ware. *poupou* (p. 873) In Pacific cultures, a house panel, often carved with designs.

Prairie Style (p. 1046) Style developed by a group of Midwestern architects who worked together using the aesthetic of the prairie and indigenous prairie plants for landscape design to create mostly domestic homes and small public buildings.

predella (p. 550) The base of an **altarpiece**, often decorated with small scenes that are related in subject to that of the main panel or panels.

primitivism (p. 1022) The borrowing of subjects or forms, usually from non-European or prehistoric sources by Western artists, in an attempt to infuse their work with the expressive qualities they attributed to other cultures, especially colonized cultures.

pronaos (p. 108) The enclosed vestibule of a Greek or Roman temple, found in front of the **cella** and marked by a row of **columns** at the entrance.

proscenium (p. 148) The stage of an ancient Greek or Roman theater. In a modern theater, the area of the stage in front of the curtain. Also: the framing **arch** that separates a stage from the audience.

psalter (p. 256) In Jewish and Christian scripture, a book of the Psalms (songs) attributed to King David.

psykter (p. 126) An ancient Greek vessel with an extended base to allow it to float in a larger **krater**; used to chill wine.

putto (pl. putti) (p. 224) A plump, naked little boy, often winged. In Classical art, called a cupid; in Christian art, a cherub.

pylon (p. 66) A massive gateway formed by a pair of tapering walls of oblong shape. Erected by ancient Egyptians to mark the entrance to a temple complex.

qibla (p. 274) The **mosque** wall oriented toward Mecca; indicated by the *mihrab*.

quatrefoil (p. 508) A four-lobed decorative pattern common in Gothic art and architecture.

quillwork (p. 847) A Native American technique in which the quills of porcupines and bird feathers are dyed and attached to materials in patterns.

radiometric dating (p. 12) Archaeological method of absolute dating by measuring the degree to which radioactive materials have degenerated over time. For dating organic (plant or animal) materials, one radiometric method measures a carbon isotope called radiocarbon, or carbon-14.

raigo (p. 378) A painted image that depicts the Amida Buddha and other Buddhist deities welcoming the soul of a dying believer to paradise.

raku (p. 823) A type of **ceramic** made by hand, coated with a thick, dark **glaze**, and fired at a low heat. The resulting vessels are irregularly shaped and glazed and are highly prized for use in the Japanese tea ceremony.

readymade (p. 1038) An object from popular or material culture presented without further manipulation as an artwork by the artist.

red-figure (p. 119) A technique of ancient Greek **ceramic** decoration characterized by red clay-colored figures on a black background. The figures are reserved against a painted ground and details are drawn, not engraved; compare **black-figure**.

register (p. 30) A device used in systems of spatial definition. In painting, a register indicates the use of differing groundlines to differentiate layers of space within an image. In **relief sculpture**, the placement of self-contained bands of reliefs in a vertical arrangement.

registration marks (p. 828) In Japanese woodblock prints, two marks carved on the blocks to indicate proper alignment of the paper during the printing process. In multicolor printing, which used a separate block for each color, these marks were essential for achieving the proper position or registration of the colors.

relative dating (p. 12) Archaeological process of determining relative chronological relationships among excavated objects. Compare **absolute dating**.

relic (p. 239) Venerated object or body part associated with a holy figure, such as a saint, and usually housed in a **reliquary**.

relief sculpture (p. 5) A three-dimensional image or design whose flat background surface is carved away to a certain depth, setting off the figure. Called *high* or *low* (*bas-*) *relief* depending upon the extent of projection of the image from the background. Called *sunken relief* when the image is carved below the original surface of the background, which is not cut away.

reliquary (p. 366) A container, often elaborate and made of precious materials, used as a repository for sacred relics.

repoussé (p. 90) A technique of pushing or hammering metal from the back to create a protruding image. Elaborate reliefs are created by pressing or hammering metal sheets against carved wooden forms.

rhyton (p. 88) A vessel in the shape of a figure or an animal, used for drinking or pouring liquids on special occasions.

rib vault (p. 499) See under vault.

ridgepole (p. 16) A longitudinal timber at the apex of a roof that supports the upper ends of the rafters.

roof comb (p. 392) In a Maya building, a masonry wall along the apex of a roof that is built above the level of the roof proper. Roof combs support the highly decorated false façades that rise above the height of the building at the front.

rose window (p. 505) A round window, often filled with stained glass set into tracery patterns in the form of wheel spokes, found in the **façade**s of the **naves** and **transepts** of large Gothic churches.

rosette (p. 105) A round or oval ornament resembling a rose.

rotunda (p. 195) Any building (or part thereof) constructed in a circular (or sometimes polygonal) shape, usually producing a large open space crowned by a **dome**.

round arch (p. 170) See under arch.

roundel (p. 158) Any ornamental element with a circular format, often placed as a decoration on the exterior of a building.

rune stone (p. 442) In early medieval northern Europe, a stone used as a commemorative monument and carved or inscribed with runes, a writing system used by early Germanic peoples.

rustication (p. 602) In architecture, the rough, irregular, and unfinished effect deliberately given to the exterior facing of a stone edifice. Rusticated stones are often large and used for decorative emphasis around doors or windows, or across the entire lower floors of a building.

sacra conversazione (p. 630) Italian for "holy conversation." Refers to a type of religious painting developed in fifteenth-century Florence in which a central image of the Virgin and Child is flanked by standing saints of comparable size who stand within the same spatial setting and often acknowledge each other's presence.

salon (p. 907) A large room for entertaining guests or a periodic social or intellectual gathering, often of prominent people, held in such a room. Also: a hall or **gallery** for exhibiting works of art.

sanctuary (p. 102) A sacred or holy enclosure used for worship. In ancient Greece and Rome, consisted of one or more temples and an altar. In Christian architecture, the space around the altar in a church called the chancel or presbytery.

sarcophagus (pl. sarcophagi) (p. 49) A stone coffin. Often rectangular and decorated with **relief sculpture**.

scarab (p. 51) In ancient Egypt, a stylized dung beetle associated with the sun and the god Amun.

scarification (p. 409) Ornamental decoration applied to the surface of the body by cutting the skin for cultural and/or aesthetic reasons.

school of artists or painting (p. 285) An arthistorical term describing a group of artists, usually working at the same time and sharing similar styles, influences, and ideals. The artists in a particular school may not necessarily be directly associated with one another, unlike those in a workshop or atelier.

scriptorium (*pl.* **scriptoria**) (p. 244) A room in a monastery for writing or copying **manuscripts**.

scroll painting (p. 347) A painting executed on a flexible support with rollers at each end. The rollers permit the horizontal scroll to be unrolled as it is studied or the vertical scroll to be hung for contemplation or decoration.

sculpture in the round (p. 5) Three-dimensional sculpture that is carved free of any background or block. Compare **relief sculpture**.

serdab (p. 53) In ancient Egyptian tombs, the small room in which the ka statue was placed.

sfumato (p. 636) Italian term meaning "smoky," soft, and mellow. In painting, the effect of haze in an image. Resembling the color of the atmosphere at dusk, *sfumato* gives a smoky effect.

sgraffito (p. 604) Decoration made by incising or cutting away a surface layer of material to reveal a different color beneath.

shaft (p. 110) The main vertical section of a **column** between the **capital** and the base, usually circular in cross section.

shaft grave (p. 97) A deep pit used for burial.

shikhara (p. 302) In the architecture of northern India, a conical (or pyramidal) spire found atop a Hindu temple and often crowned with an *amalaka*.

shoin (p. 821) A term used to describe the various features found in the most formal room of upper-class Japanese residential architecture.

shoji (p. 821) A standing Japanese screen covered in translucent rice paper and used in interiors.

siapo (p. 876) A type of **tapa** cloth found in Samoa and still used as an important gift for ceremonial occasions.

silkscreen printing (p. 1092) A technique of printing in which paint or ink is pressed through a stencil and specially prepared cloth to reproduce a design in multiple copies.

sinopia (pl. sinopie) (p. 539) Italian word taken from Sinope, the ancient city in Asia Minor that was famous for its red-brick pigment. In **fresco** paintings, a full-sized, preliminary sketch done in this color on the first rough coat of plaster or *articio*.

site-specific (p. 1102) Of a work commissioned and/or designed for a particular location.

slip (p. 118) A mixture of clay and water applied to a **ceramic** object as a final decorative coat. Also: a solution that binds different parts of a vessel together, such as the handle and the main body.

spandrel (p. 170) The area of wall adjoining the exterior curve of an **arch** between its **springing** and the **keystone**, or the area between two arches, as in an **arcade**.

spolia (p. 471) Fragments of older architecture or sculpture reused in a secondary context. Latin for "hide stripped from an animal."

springing (p. 170) The point at which the curve of an **arch** or **vault** meets with and rises from its support.

squinch (p. 238) An **arch** or **lintel** built across the upper corners of a square space, allowing a circular or polygonal **dome** to be securely set above the walls.

stained glass (p. 287) Glass stained with color while molten, using metallic oxides. Stained glass is most often used in windows, for which small pieces of different colors are precisely cut and assembled into a design, held together by lead **cames**. Additional details may be added with vitreous paint.

stave church (p. 443) A Scandinavian wooden structure with four huge timbers (staves) at its core.

stele (pl. stelai), also stela (pl. stelae) (p. 27) A stone slab placed vertically and decorated with inscriptions or reliefs. Used as a grave marker or commemorative monument.

stereobate (p. 110) In Classical architecture, the foundation upon which a temple stands.

still life (pl. still lifes) (p. xxxv) A type of painting that has as its subject inanimate objects (such as food and dishes) or fruit and flowers taken out of their natural contexts.

stoa (p. 107) In Greek architecture, a long roofed walkway, usually having **column**s on one long side and a wall on the other.

stoneware (p. 20) A high-fired, vitrified, but opaque ceramic ware that is fired in the range of 1,100 to 1,200 degrees Celsius. At that temperature, particles of silica in the clay bodies fuse together so that the finished vessels are impervious to liquids, even without glaze. Stoneware pieces are glazed to enhance their aesthetic appeal and to aid in keeping them clean. Stoneware occurs in a range of earth-toned colors, from white and tan to gray and black, with light gray predominating. Chinese potters were the first in the world to produce stoneware, which they were able to make as early as the Shang dynasty.

stringcourse (p. 503) A continuous horizontal band, such as a **molding**, decorating the face of a wall.

stucco (p. 72) A mixture of lime, sand, and other ingredients made into a material that can easily be molded or modeled. When dry, it produces a durable surface used for covering walls or for architectural sculpture and decoration.

stupa (p. 302) In Buddhist architecture, a bell-shaped or pyramidal religious monument, made of piled earth or stone, and containing sacred **relics**.

style (p. xxxvi) A particular manner, form, or character of representation, construction, or expression that is typical of an individual artist or of a certain place or period.

stylobate (p. 110) In Classical architecture, the stone foundation on which a temple **colonnade** stands.

stylus (p. 28) An instrument with a pointed end (used for writing and printmaking), which makes a delicate line or scratch. Also: a special writing tool for **cuneiform** writing with one pointed end and one triangular.

sublime (p. 955) Of a concept, thing, or state of greatness or vastness with high spiritual, moral, intellectual, or emotional value; or something aweinspiring. The sublime was a goal to which many nineteenth-century artists aspired in their artworks.

sunken relief (p. 71) See under relief sculpture.

symposium (p. 119) An elite gathering of wealthy and powerful men in ancient Greece that focused principally on wine, music, poetry, conversation, games, and love making.

syncretism (p. 220) A process whereby artists assimilate and combine images and ideas from different cultural traditions, beliefs, and practices, giving them new meanings.

taotie (p. 334) A mask with a dragon or animal-like face common as a decorative motif in Chinese art.

tapa (p. 876) A type of cloth used for various purposes in Pacific cultures, made from tree bark stripped and beaten, and often bearing subtle designs from the mallets used to work the bark.

tapestry (p. 292) Multicolored decorative weaving to be hung on a wall or placed on furniture. Pictorial or decorative motifs are woven directly into the supporting fabric, completely concealing it.

tatami (p. 821) Mats of woven straw used in Japanese houses as a floor covering.

temenos (p. 108) An enclosed sacred area reserved for worship in ancient Greece.

tempera (p. 141) A painting **medium** made by blending egg yolks with water, pigments, and occasionally other materials, such as glue.

tenebrism (p. 723) The use of strong *chiaroscuro* and artificially illuminated areas to create a dramatic contrast of light and dark in a painting.

terra cotta (p. 114) A **medium** made from clay fired over a low heat and sometimes left unglazed. Also: the orange-brown color typical of this medium.

tessera (pl. **tesserae**) (p. 145) A small piece of stone, glass, or other object that is pieced together with many others to create a **mosaic**.

thatch (p. 16) Plant material such as reeds or straw tied over a framework of poles to make a roof, shelter, or small building.

thermo-luminescence dating (p. 12) A method of **radiometric dating** that measures the irradiation of the crystal structure of material such as flint or pottery and the soil in which it is found, determined by luminescence produced when a sample is heated.

tholos (p. 98) A small, round building. Sometimes built underground, e.g. as a Mycenaean tomb.

thrust (p. 170) The outward pressure caused by the weight of a **vault** and supported by **buttressing**. See also under **arch**.

tondo (pl. tondi) (p. 126) A painting or relief sculpture of circular shape.

torana (p. 302) In Indian architecture, an ornamented gateway arch in a temple, usually leading to the stupa.

torc (p. 149) A circular neck ring worn by Celtic warriors.

toron (p. 422) In West African **mosque** architecture, the wooden beams that project from the walls. Torons are used as support for the scaffolding erected annually for the replastering of the building.

tracery (p. 503) Stonework or woodwork forming a pattern in the open space of windows or applied to wall surfaces. In *plate tracery*, a series of openings are cut through the wall. In *bar tracery*, **mullions** divide the space into segments to form decorative patterns.

transept (p. 225) The arm of a **cruciform** church perpendicular to the **nave**. The point where the nave and transept intersect is called the crossing. Beyond the crossing lies the **sanctuary**, whether **apse**, **choir**, or chavet

transverse arch (p. 463) See under arch.

trefoil (p. 298) An ornamental design made up of three rounded lobes placed adjacent to one another.

triforium (p. 505) The element of the interior elevation of a church found directly below the **clerestory** and consisting of a series of arched openings in front of a passageway within the thickness of the wall.

triglyph (p. 110) Rectangular block between the **metope**s of a Doric **frieze**. Identified by the three carved vertical grooves, which approximate the appearance of the end of wooden beams.

triptych (p. 566) An artwork made up of three panels. The panels may be hinged together in such a way that the side segments (wings) fold over the central area.

trompe l'oeil (p. 618) A manner of representation in which artists faithfully describe the appearance of natural space and forms with the express intention of fooling the eye of the viewer, who may be convinced momentarily that the subject actually exists as three-dimensional reality.

trumeau (p. 478) A **column**, **pier**, or post found at the center of a large **portal** or doorway, supporting the **lintel**.

tugra (p. 288) A calligraphic imperial monogram used in Ottoman courts.

tukutuku (p. 872) Lattice panels created by women from the Maori culture and used in architecture.

Tuscan order (p. 158) See under order.

twining (p. 848) A basketry technique in which short rods are sewn together vertically. The panels are then joined together to form a container or other object.

tympanum (p. 478) In medieval and later architecture, the area over a door enclosed by an **arch** and a **lintel**, often decorated with sculpture or mosaic.

ukiyo-e (p. 828) A Japanese term for a type of popular art that was favored from the sixteenth century, particularly in the form of color **woodblock prints**. *Ukiyo-e* prints often depicted the world of the common people in Japan, such as courtesans and actors, as well as landscapes and myths.

undercutting (p. 212) A technique in sculpture by which the material is cut back under the edges so that the remaining form projects strongly forward, casting deep shadows.

underglaze (p. 800) Color or decoration applied to a **ceramic** piece before glazing.

upeti (p. 876) In Pacific cultures, a carved wooden design tablet, used to create patterns in cloth by dragging the fabric across it.

uranium-thorium dating (p. 12) Technique used to date prehistoric cave paintings by measuring the decay of uranium into thorium in the deposits of calcium carbinate that cover the surfaces of cave walls, to determine the minimum age of the paintings under the crust.

urna (p. 306) In Buddhist art, the curl of hair on the forehead that is a characteristic mark of a buddha. The *urna* is a symbol of divine wisdom.

ushnisha (p. 306) In Asian art, a round turban or tiara symbolizing royalty and, when worn by a buddha, enlightenment.

vanishing point (p. 610) In a perspective system, the point on the horizon line at which orthogonals meet. A complex system can have multiple vanishing points.

vanitas (p. xxxvi) An image, especially popular in Europe during the seventeenth century, in which all the objects symbolize the transience of life. Vanitas paintings are usually of still lifes or genre subjects.

vault (p. 17) An arched masonry structure that spans an interior space. Barrel or tunnel vault: an elongated or continuous semicircular vault, shaped like a half-cylinder. Corbeled vault: a vault made by projecting courses of stone; see also under corbel. Groin or cross vault: a vault created by the intersection of two barrel vaults of equal size which creates four side compartments of identical size and shape. Quadrant vault: a half-barrel vault. Rib vault: a groin vault with ribs (extra masonry) demarcating the junctions. Ribs may function to reinforce the groins or may be purely decorative.

veduta (pl. vedute) (p. 915) Italian for "vista" or "view." Paintings, drawings, or prints, often of expansive city scenes or of harbors.

vellum (p. 245) A fine animal skin prepared for writing and painting. See also **parchment**.

verism (p. 168) Style in which artists concern themselves with describing the exterior likeness of an object or person, usually by rendering its visible details in a finely executed, meticulous manner.

vihara (p. 305) From the Sanskrit term meaning "for wanderers." A vihara is, in general, a Buddhist monastery in India. It also signifies monks' cells and gathering places in such a monastery.

volute (p. 110) A spiral scroll, as seen on an Ionic capital.

 $\begin{array}{ll} \textbf{votive figure (p. 31)} & \text{An image created as a devotional} \\ \text{offering to a deity.} \end{array}$

voussoir (p. 170) Wedge-shaped stone block used to build an arch. The topmost voussoir is called a keystone. See also joggled voussoirs.

warp (p. 292) The vertical threads in a weaver's loom. Warp threads make up a fixed framework that provides the structure for the entire piece of cloth, and are thus often thicker than weft threads.

wattle and daub (p. 16) A wall construction method combining upright branches, woven with twigs (wattles) and plastered or filled with clay or mud (daub).

weft (p. 292) The horizontal threads in a woven piece of cloth. Weft threads are woven at right angles to and through the warp threads to make up the bulk of the decorative pattern. In carpets, the weft is often completely covered or formed by the rows of trimmed knots that form the carpet's soft surface.

westwork (p. 446) The monumental, west-facing entrance section of a Carolingian, Ottonian, or Romanesque church. The exterior consists of multiple stories between two towers; the interior includes an entrance vestibule, a chapel, and a series of galleries overlooking the nave.

white-ground (p. 141) A type of ancient Greek pottery in which the background color of the object was painted with a **slip** that turns white in the firing process. Figures and details were added by painting on or incising into this slip. White-ground wares were popular in the Classical period as funerary objects.

woodblock print (p. 591) A print made from one or more carved wooden blocks. In Japan, woodblock prints were made using multiple blocks carved in relief, usually with a block for each color in the finished print. See also woodcut.

woodcut (p. 592) A type of print made by carving a design into a wooden block. The ink is applied to the block with a roller. As the ink touches only on the surface areas and lines remaining between the carvedaway parts of the block, it is these areas that make the print when paper is pressed against the inked block, leaving the carved-away parts of the design to appear blank. Also: the process by which the woodcut is made.

yaksha, yakshi (p. 301) The male (yaksha) and female (yakshi) nature spirits that act as agents of the Hindu gods. Their sculpted images are often found on Hindu temples and other sacred places, particularly at the entrances.

yamato-e (p. 374) A native style of Japanese painting developed during the twelfth and thirteenth centuries, distinguished from Japanese painting styles that emulate Chinese traditions.

ziggurat (p. 28) In ancient Mesopotamia, a tall stepped tower of earthen materials, often supporting a shrine.

Bibliography

Susan V. Craig, updated by Carrie L. McDade

This bibliography is composed of books in English that are suggested "further reading" titles. Most are available in good libraries, whether college, university, or public. Recently published works have been emphasized so that the research information would be current. There are three classifications of listings: general surveys and art history reference tools, including journals and Internet directories; surveys of large periods that encompass multiple chapters (ancient art in the Western tradition, European medieval art, European Renaissance through eighteenth-century art, modern art in the West, Asian art, and African and Oceanic art, and art of the Americas); and books for individual Chapters 1 through 33.

General Art History Surveys and Reference Tools

- Adams, Laurie Schneider. Art Across Time. 4th ed. New York: McGraw-Hill, 2011.
- Barnet, Sylvan. A Short Guide to Writing about Art. 10th ed. Upper Saddle River, NJ: Pearson/Prentice Hall, 2010.
- Bony, Anne. Design: History, Main Trends, Main Figures. Edinburgh: Chambers, 2005.
- Boström, Antonia. *Encyclopedia of Sculpture*. 3 vols. New York: Fitzroy Dearborn, 2004.
- Broude, Norma, and Mary D. Garrard, eds. Feminism and Art History: Questioning the Litany. Icon Editions. New York: Harper & Row, 1982.
- Chadwick, Whitney. Women, Art, and Society. 4th ed. New York: Thames & Hudson, 2007.
- Chilvers, Ian, ed. *The Oxford Dictionary of Art.* 4th ed. New York: Oxford Univ. Press, 2009.
- Curl, James Stevens. A Dictionary of Architecture and Landscape Architecture. 2nd ed. Oxford: Oxford Univ. Press, 2006.
- Davies, Penelope J.E., et al. *Janson's History of Art: The Western Tradition*. 8th ed. Upper Saddle River, NJ: Prentice Hall, 2010.
- The Dictionary of Art. Ed. Jane Turner. 34 vols. New York: Grove's Dictionaries, 1996.
- Frank, Patrick, Duane Preble, and Sarah Preble. *Prebles'*Artforms. 10th ed. Upper Saddle River, NJ: Pearson/
 Prentice Hall, 2011.
- Gaze, Delia, ed. *Dictionary of Women Artists*. 2 vols. London: Fitzroy Dearborn, 1997.
- Griffiths, Antony. Prints and Printmaking: An Introduction to the History and Techniques. 2nd ed. London: British Museum Press, 1996.
- Hadden, Peggy. *The Quotable Artist*. New York: Allworth Press, 2002.
- Hall, James. Dictionary of Subjects and Symbols in Art. 2nd ed. Boulder, CO: Westview Press, 2008.
- Holt, Elizabeth Gilmore, ed. A Documentary History of Art. 3 vols. New Haven: Yale Univ. Press, 1986.
- Honour, Hugh, and John Fleming. *The Visual Arts: A History*. 7th ed. rev. Upper Saddle River, NJ: Pearson/Prentice Hall. 2010.
- Johnson, Paul. Art: A New History. New York: HarperCollins, 2003.
- Kemp, Martin, ed. The Oxford History of Western Art. Oxford: Oxford Univ. Press, 2000.
- Kleiner, Fred S. Gardner's Art through the Ages. Enhanced 13th ed. Belmont, CA: Thomson/Wadsworth, 2011.
- Kostof, Spiro. A History of Architecture: Settings and Rituals. 2nd ed. Revised Greg Castillo. New York: Oxford Univ. Press, 1995.
- Mackenzie, Lynn. *Non-Western Art: A Brief Guide*. 2nd ed. Upper Saddle River, NJ: Pearson/Prentice Hall,
- Marmor, Max, and Alex Ross, eds. Guide to the Literature of Art History 2. Chicago: American Library Association, 2005
- Onians, John, ed. *Atlas of World Art.* New York: Oxford Univ. Press, 2004.

- Sayre, Henry M. Writing about Art. 6th ed. Upper Saddle River, NJ: Pearson/Prentice Hall, 2009.
- Sed-Rajna, Gabrielle. *Jewish Art*. Trans. Sara Friedman and Mira Reich. New York: Abrams, 1997.
- Slatkin, Wendy. Women Artists in History: From Antiquity to the Present. 4th ed. Upper Saddle River, NJ: Pearson/ Prentice Hall. 2001.
- Sutton, Ian. Western Architecture: From Ancient Greece to the Present. World of Art. New York: Thames & Hudson, 1999.
- Trachtenberg, Marvin, and Isabelle Hyman. Architecture, from Prehistory to Postmodemity. 2nd ed. Upper Saddle River, NJ: Pearson/Prentice Hall, 2002.
- Watkin, David. A History of Western Architecture. 4th ed. New York: Watson-Guptill, 2005.

Art History Journals: A Select List of Current Titles

- African Arts. Quarterly. Los Angeles: Univ. of California at Los Angeles, James S. Coleman African Studies Center, 1967—.
- American Art: The Journal of the Smithsonian American Art Museum. 3/year. Chicago: Univ. of Chicago Press, 1987—
- American Indian Art Magazine. Quarterly. Scottsdale, AZ: American Indian Art Inc., 1975-.
- American Journal of Archaeology. Quarterly. Boston: Archaeological Institute of America. 1885–.
- Antiquity: A Periodical of Archaeology. Quarterly. Cambridge: Antiquity Publications Ltd., 1927—.
- Apollo: The International Magazine of the Arts. Monthly. London: Apollo Magazine Ltd., 1925–.
- Architectural History. Annually. Farnham, UK: Society of Architectural Historians of Great Britain, 1958–.
- Archives of American Art Journal. Quarterly. Washington, DC: Archives of American Art, Smithsonian Institution,
- Archives of Asian Art. Annually. New York: Asia Society, 1945–
- Ars Orientalis: The Arts of Asia, Southeast Asia, and Islam. Annually. Ann Arbor: Univ. of Michigan Dept. of Art History, 1954—.
- Art Bulletin. Quarterly. New York: College Art Association, 1913-.
- Art History: Journal of the Association of Art Historians. 5/year. Oxford: Blackwell Publishing Ltd., 1978–.
- Art in America. Monthly. New York: Brant Publications Inc., 1913–.
- Art Journal. Quarterly. New York: College Art Association, 1960-.
- Art Nexus. Quarterly. Bogota, Colombia: Arte en Colombia Ltda, 1976–.
- Art Papers Magazine. Bimonthly. Atlanta: Atlanta Art Papers Inc., 1976—.
- Artforum International. 10/year. New York: Artforum International Magazine Inc., 1962–.
- Artnews. 11/year. New York: Artnews LLC, 1902–.

 Bulletin of the Metropolitan Museum of Art. Quarterly. New York: Metropolitan Museum of Art, 1905–.
- Burlington Magazine. Monthly. London: Burlington Magazine Publications Ltd., 1903–.
- Dumbarton Oaks Papers. Annually. Locust Valley, NY: I.J. Augustin Inc., 1940-.
- J.J. Augustin Inc., 1940–. Flash Art International. Bimonthly. Trevi, Italy: Giancarlo Politi Editore, 1980–.
- Gesta. Semiannually. New York: International Center of Medieval Art, 1963–.
- History of Photography. Quarterly. Abingdon, UK: Taylor & Francis Ltd., 1976–.
- International Review of African American Art. Quarterly. Hampton, VA: International Review of African American Art. 1976—.
- Journal of Design History. Quarterly. Oxford: Oxford Univ. Press, 1988–.

- Journal of Egyptian Archaeology. Annually. London: Egypt Exploration Society, 1914-.
- Journal of Hellenic Studies. Annually. London: Society for the Promotion of Hellenic Studies, 1880–.
- Journal of Roman Archaeology. Annually. Portsmouth, RI: Journal of Roman Archaeology LLC, 1988–.
- Journal of the Society of Architectural Historians. Quarterly. Chicago: Society of Architectural Historians, 1940-.
- Journal of the Warburg and Courtauld Institutes. Annually. London: Warburg Institute, 1937–.
- Leonardo: Art, Science, and Technology. 6/year. Cambridge, MA: MIT Press, 1968–.
- Marg. Quarterly. Mumbai, India: Scientific Publishers, 1946–.
- Master Drawings. Quarterly. New York: Master Drawings Association, 1963–.
- October. Cambridge, MA: MIT Press, 1976-
- Oxford Art Journal. 3/year. Oxford: Oxford Univ. Press, 1978-.
- Parkett. 3/year. Zürich, Switzerland: Parkett Verlag AG, 1984–.
- Print Quarterly. Quarterly. London: Print Quarterly Publications, 1984–.
- Simiolus: Netherlands Quarterly for the History of Art. Quarterly. Apeldoorn, Netherlands: Stichting voor Nederlandse Kunsthistorische Publicaties, 1966–.
- Woman's Art Journal. Semiannually. Philadelphia: Old City Publishing Inc., 1980—.

Internet Directories for Art History Information: A Selected List

ARCHITECTURE AND BUILDING,

http://www.library.unlv.edu/arch/rsrce/webresources/
A directory of architecture websites collected by Jeanne
Brown at the Univ. of Nevada at Las Vegas. Topical lists include architecture, building and construction, design, history,
housing, planning, preservation, and landscape architecture.
Most entries include a brief annotation and the last date the
link was accessed by the compiler.

ART HISTORY RESOURCES ON THE WEB, http://witcombe.sbc.edu/ARTHLinks.html

Authored by Professor Christopher L.C.E. Witcombe of Sweet Briar College in Virginia, since 1995, the site includes an impressive number of links for various art-historical eras as well as links to research resources, museums, and galleries. The content is frequently updated.

ART IN FLUX: A DIRECTORY OF RESOURCES FOR RESEARCH IN CONTEMPORARY ART,

http://www.boisestate.edu/art/artinflux/intro.html

Cheryl K. Shurtleff of Boise State Univ. in Idaho has authored this directory, which includes sites selected according to their relevance to the study of national or international contemporary art and artists. The subsections include artists, museums, theory, reference, and links.

ARTCYCLOPEDIA: THE GUIDE TO GREAT ART ON THE INTERNET,

http://www.artcyclopedia.com

With more than 2,100 art sites and 75,000 links, this is one of the most comprehensive Web directories for artists and art topics. The primary search is by artist's name but access is also available by title of artwork, artistic movement, museums and galleries, nationality, period, and medium.

MOTHER OF ALL ART AND ART HISTORY LINKS PAGES,

http://umich.edu/~motherha

Maintained by the Dept. of the History of Art at the Univ. of Michigan, this directory covers art history departments, art museums, fine arts schools and departments, as well as links to research resources. Each entry includes annotations.

VOICE OF THE SHUTTLE,

http://vos.ucsb.edu

Sponsored by Univ. of California, Santa Barbara, this directory includes more than 70 pages of links to humanities and humanities-related resources on the Internet. The structured guide includes specific subsections on architecture, on art (modern and contemporary), and on art history. Links usually include a one-sentence explanation and the resource is frequently updated with new information.

AR TBABBLE.

http://www.artbabble.org/

An online community created by staff at the Indianapolis Museum of Art to showcase art-based video content, including interviews with artists and curators, original documentaries, and art installation videos. Partners and contributors to the project include Art21, Los Angeles County Museum of Art, The Museum of Modern Art, The New York Public Library, San Francisco Museum of Modern Art, and Smithsonian American Art Museum.

YAHOO! ARTS>ART HISTORY,

http://dir.yahoo.com/Arts/Art_History/

Another extensive directory of art links organized into subdivisions with one of the most extensive being "Periods and Movements." Links include the name of the site as well as a few words of explanation.

European Renaissance through Eighteenth-Century Art, General

- Black, C.F., et al. Cultural Atlas of the Renaissance. New York: Prentice Hall, 1993.
- Blunt, Anthony. Art and Architecture in France, 1500–1700.
 5th ed. Revised Richard Beresford. Pelican History of Art. New Haven: Yale Univ. Press, 1999.
- Brown, Jonathan. *Painting in Spain: 1500–1700*. Pelican History of Art. New Haven: Yale Univ. Press, 1998.
- Cole, Bruce. Studies in the History of Italian Art, 1250–1550. London: Pindar Press, 1996.
- Graham-Dixon, Andrew. Renaissance. Berkeley: Univ. of California Press, 1999.
- Harbison, Craig. The Mirror of the Artist: Northern Renaissance Art in Its Historical Context. Perspectives. New York: Abrams, 1995.
- Harris, Ann Sutherland. Seventeenth-Century Art & Architecture. 2nd ed. Upper Saddle River, NJ: Pearson/ Prentice Hall, 2008.
- Harrison, Charles, Paul Wood, and Jason Gaiger. An in Theory 1648–1815: An Anthology of Changing Ideas. Oxford: Blackwell, 2000.
- Hartt, Frederick, and David G. Wilkins. History of Italian Renaissance Art: Painting, Sculpture, Architecture. 7th ed. Upper Saddle River, NJ: Pearson/Prentice Hall, 2011
- Jestaz, Bertrand. The Art of the Renaissance. Trans. I. Mark Paris. New York: Abrams, 1994.
- Minor, Vernon Hyde. Baroque & Rococo: Art & Culture. New York: Abrams. 1999.
- Paoletti, John T., and Gary M. Radke. *Art in Renaissance Italy*. 3rd ed. Upper Saddle River, NJ: Pearson/Prentice Hall, 2005.
- Smith, Jeffrey Chipps. The Northern Renaissance. Art & Ideas. London and New York: Phaidon Press, 2004.
- Stechow, Wolfgang. Northern Renaissance, 1400–1600: Sources and Documents. Upper Saddle River, NJ: Pearson/ Prentice Hall, 1966.
- Summerson, John. Architecture in Britain, 1530–1830. 9th ed. Pelican History of Art. New Haven: Yale Univ. Press, 1993.
- Waterhouse, Ellis K. Painting in Britain, 1530–1790. 5th ed. Pelican History of Art. New Haven: Yale Univ. Press, 1994.
- Whinney, Margaret Dickens. Sculpture in Britain: 1530– 1830. 2nd ed. Revised John Physick. Pelican History of Art. London: Penguin, 1988.

Modern Art in the West, General

- Arnason, H.H., and Elizabeth C. Mansfield. *History of Modem Art: Painting, Sculpture, Architecture, Photography.* 6th ed.
 Upper Saddle River, NJ: Pearson/Prentice Hall, 2009.
- Ballantyne, Andrew, ed. Architectures: Modernism and After. New Interventions in Art History, 3. Malden, MA: Blackwell, 2004.
- Barnitz, Jacqueline. Twentieth-Century Art of Latin America. Austin: Univ. of Texas Press, 2001.
- Bjelajac, David. American Art: A Cultural History. Rev. and expanded ed. Upper Saddle River, NJ: Pearson/Prentice Hall, 2005.

- Bowness, Alan. *Modern European Art.* World of Art. New York: Thames & Hudson, 1995.
- Brettell, Richard R. Modern Art, 1851–1929: Capitalism and Representation. Oxford History of Art. Oxford: Oxford Univ. Press, 1999.
- Chipp, Herschel B. Theories of Modern Art: A Source Book by Artists and Critics. California Studies in the History of Art, 11. Berkeley: Univ. of California Press, 1984.
- Clarke, Graham. *The Photograph*. Oxford History of Art. Oxford: Oxford Univ. Press. 1997.
- Craven, David. Art and Revolution in Latin America, 1910–1990. New Haven: Yale Univ. Press, 2002.
- Craven, Wayne. American Art: History and Culture. 2nd ed. Boston: McGraw-Hill, 2003.
- Doordan, Dennis P. Twentieth-Century Architecture. New York: Abrams, 2002.
- Doss, Erika. Twentieth-Century American Art. Oxford History of Art. Oxford: Oxford Univ. Press, 2002.
- Edwards, Steve, and Paul Wood, eds. *Art of the Avant-Gardes*. Art of the 20th Century. New Haven: Yale Univ. Press, 2004.
- Foster, Hal, et al. Art Since 1900: Modernism, Antimodernism, Postmodernism. New York: Thames & Hudson, 2004.
- Gaiger, Jason, ed. Frameworks for Modern Art. Art of the 20th Century. New Haven: Yale Univ. Press, 2003.
- , and Paul Wood, eds. Art of the Twentieth Century: A Reader. New Haven: Yale Univ. Press, 2003.
- Hamilton, George Heard. Painting and Sculpture in Europe, 1880–1940. 6th ed. Pelican History of Art. New Haven: Yale Univ. Press, 1993.
- Hammacher, A.M. Modern Sculpture: Tradition and Innovation. Enl. ed. New York: Abrams, 1988.
- Harris, Ann Sutherland, and Linda Nochlin. Women Artists: 1550–1950. Los Angeles: Los Angeles County Museum of Art, 1976.
- Harrison, Charles, and Paul Wood, eds. Art in Theory: 1900–2000: An Anthology of Changing Ideas. 2nd ed. Malden, MA: Blackwell, 2003.
- Hunter, Sam, John Jacobus, and Daniel Wheeler. Modern Art: Painting, Sculpture, Architecture, Photography. 3rd rev. & exp. ed. Upper Saddle River, NJ: Pearson/Prentice Hall. 2004.
- Krauss, Rosalind E. Passages in Modern Sculpture. Cambridge, MA: MIT Press, 1977.
- Mancini, JoAnne Marie. Pre-Modernism: Art-World Change and American Culture from the Civil War to the Armory Show. Princeton, NJ: Princeton Univ. Press, 2005.
- Marien, Mary Warner. Photography: A Cultural History. 3rd ed. Upper Saddle River, NJ: Pearson/Prentice Hall, 2011.
 Meecham. Pam. and Julie Sheldon. Modern Art: A Critical
- Introduction. 2nd ed. New York: Routledge, 2005. Newlands, Anne. Canadian Art: From Its Beginnings to 2000.
- Willowdale, Ont.: Firefly Books, 2000.

 Phaidon Atlas of Contemporary World Architecture. London:
- Phaidon Press, 2004. Powell, Richard J. Black Art: A Cultural History. World of
- Art. 2nd ed. New York: Thames & Hudson, 2003.Rosenblum, Naomi. A World History of Photography. 4th ed.New York: Abbeville Press, 2007.
- Ruhrberg, Karl. Art of the 20th Century. Ed. Ingo F. Walther. 2 vols. New York: Taschen, 1998.
- Scully, Vincent Joseph. Modern Architecture and Other Essays. Princeton, NJ: Princeton Univ. Press, 2003.
- Stiles, Kristine, and Peter Selz. Theories and Documents of Contemporary Art: A Sourcebook of Artists' Writings. California Studies in the History of Art, 35. Berkeley: Univ. of California Press, 1996.
- Tafuri, Manfredo. Modem Architecture. History of World Architecture. 2 vols. New York: Electa/Rizzoli, 1986.
- Upton, Dell. Architecture in the United States. Oxford History of Art. Oxford: Oxford Univ. Press, 1998.
- Wood, Paul, ed. *Varieties of Modernism*. Art of the 20th Century. New Haven: Yale Univ. Press, 2004.
- Woodham, Jonathan M. Twentieth-Century Design. Oxford History of Art. Oxford: Oxford Univ. Press, 1997.

Chapter 30 Eighteenth- and Early Nineteenth-Century Art in Europe and North America

- Bailey, Colin B., Philip Conisbee, and Thomas W. Gaehtgens. The Age of Watteau, Chardin, and Fragonard: Masterpieces of French Genre Painting. New Haven: Yale Univ. Press in assoc. with the National Gallery of Canada, Ottawa, 2003.
- Boime, Albert. Art in an Age of Bonapartism, 1800–1815. Chicago: Univ. of Chicago Press, 1990.
- Art in an Age of Counterrevolution, 1815–1848. Chicago: Univ. of Chicago Press, 2004.

- ——. Art in an Age of Revolution, 1750–1800. Chicago: Univ. of Chicago Press, 1987.
- Bowron, Edgar Peters, and Joseph J. Rishel, eds. Art in Rome in the Eighteenth Century. London: Merrell in association with Philadelphia Museum of Art, 2000.
- Brown, David Blayney. *Romanticism*. London: Phaidon Press. 2001.
- Chinn, Celestine, and Kieran McCarty. *Bac: Where the Waters Gather.* Univ. of Arizona: Mission San Xavier Del Bac, 1977.
- Craske, Matthew. Art in Europe, 1700–1830: A History of the Visual Arts in an Era of Unprecedented Urban Economic Growth. Oxford History of Art. Oxford: Oxford Univ. Press, 1997.
- Denis, Rafael Cardoso, and Colin Trodd, eds. Art and the Academy in the Nineteenth Century. New Brunswick, NJ: Rutgers Univ. Press, 2000.
- Goodman, Elise, ed. Art and Culture in the Eighteenth Century: New Dimensions and Multiple Perspectives. Studies in Eighteenth-Century Art and Culture. Newark: Univ. of Delaware Press, 2001.
- Hofmann, Werner. Goya: To Every Story There Belongs Another. New York: Thames & Hudson, 2003.
- Irwin, David G. Neoclassicism. Art & Ideas. London: Phaidon Press, 1997.
- Jarrassé, Dominique. 18th-Century French Painting. Trans. Murray Wyllie. Paris: Terrail, 1999.
- Kalnein, Wend von. Architecture in France in the Eighteenth Century. Trans. David Britt. Pelican History of Art. New Haven: Yale Univ. Press, 1995.
- Levey, Michael. Painting in Eighteenth-Century Venice. 3rd ed. New Haven: Yale Univ. Press. 1994.
- Lewis, Michael J. *The Gothic Revival*. World of Art. New York: Thames & Hudson, 2002.
- Lovell, Margaretta M. Art in a Season of Revolution: Painters, Artisans, and Patrons in Early America. Early American Studies. Philadelphia: Univ. of Pennsylvania Press, 2005
- Monneret, Sophie. *David and Neo-Classicism*. Trans. Chris Miller and Peter Snowdon. Paris: Terrail, 1999.
- Natter, Tobias, ed. Angelica Kauffman: A Woman of Immense Talent. Ostfildern: Hatje Cantz, 2007.
- Porterfield, Todd, and Susan L. Siegfried. Staging Empire: Napoleon, Ingres, and David. University Park: Pennsylvania State Univ. Press, 2006.
- Poulet, Anne L. Jean-Antoine Houdon: Sculptor of the Enlightenment. Washington, DC: National Gallery of Art. 2003.
- Summerson, John. Architecture of the Eighteenth Century.
 World of Art. New York: Thames & Hudson, 1986.
- Wilton, Andrew, and Ilaria Bignamini, eds. *Grand Tour:*The Lure of Italy in the Eighteenth Century. London: Tate Gallery, 1996.

Chapter 31 Mid- to Late Nineteenth-Century Art in Europe and the United States

- Adams, Steven. The Barbizon School and the Origins of Impressionism. London: Phaidon Press, 1994.
- Bajac, Quentin. *The Invention of Photography*. Discoveries. New York: Abrams, 2002.
- Barger, M. Susan, and William B. White. The Daguereotype: Nineteenth-Century Technology and Modern Science. Washington, DC: Smithsonian Institution Press, 1991
- Benjamin, Roger. Orientalist Aesthetics: Art, Colonialism, and French North Africa, 1880–1930. Berkeley: Univ. of California Press, 2003.
- Bergdoll, Barry. European Architecture, 1750–1890. Oxford History of Art. New York: Oxford Univ. Press, 2000.
- Blühm, Andreas, and Louise Lippincott. Light!: The Industrial Age 1750–1900: Ant & Science, Technology & Society. New York: Thames & Hudson, 2001.
- Boime, Albert, The Academy and French Painting in the Nineteenth Century. 2nd ed. New Haven: Yale Univ. Press, 1986.
- Butler, Ruth, and Suzanne G. Lindsay. European Sculpture of the Nineteenth Century. Washington, DC: National Gallery of Art, 2000.
- Callen, Anthea. The Art of Impressionism: Painting Technique & the Making of Modernity. New Haven: Yale Univ. Press, 2000.
- Chu, Petra ten-Doesschate. Nineteenth Century European Art. 3rd. ed. Upper Saddle River, NJ: Pearson/Prentice Hall, 2012.
- Clark, T. J. The Painting of Modern Life: Paris in the Art of Manet and His Followers. Rev. ed. London: Thames & Hudson, 1999.

- Conrads, Margaret C. Winslow Homer and the Critics: Forging a National Art in the 1870s. Princeton, NJ: Princeton Univ. Press in assoc. with the Nelson-Atkins Museum of Art, 2001.
- Denis, Rafael Cardoso, and Colin Trodd. Art and the Academy in the Nineteenth Century. New Brunswick, NJ: Rutgers Univ. Press, 2000.
- Eisenman, Stephen F. Nineteenth Century Art: A Critical History. 3rd ed. New York: Thames & Hudson, 2007.
- Eitner, Lorenz. Nineteenth Century European Painting: David to Cezanne. Rev. ed. Boulder, CO: Westview Press, 2002.
- Frazier, Nancy. Louis Sullivan and the Chicago School. New York: Knickerbocker Press, 1998.
- Fried, Michael. Manet's Modernism, or, The Face of Painting in the 1860s. Chicago: Univ. of Chicago Press, 1996.
- Gerdts, William H. *American Impressionism*. 2nd ed. New York: Abbeville Press, 2001.
- Greenhalgh, Paul, ed. Art Nouveau, 1890–1914. London: V&A Publications, 2000.
- Grigsby, Darcy Grimaldo. Extremities: Painting Empire in Post-Revolutionary France. New Haven: Yale Univ. Press, 2002.
- Groseclose, Barbara. Nineteenth-Century American Art. Oxford History of Art. Oxford: Oxford Univ. Press, 2000.
- Harrison, Charles, Paul Wood, and Jason Gaiger. An in Theory 1815–1900: An Anthology of Changing Ideas. Oxford: Blackwell, 1998.
- Herrmann, Luke. Nineteenth Century British Painting. London: Giles de la Mare, 2000.
- Hirsh, Sharon L. Symbolism and Modern Urban Society. New York: Cambridge Univ. Press, 2004.
- Kaplan, Wendy. The Arts & Crafts Movement in Europe & America: Design for the Modern World. New York: Thames & Hudson in assoc. with the Los Angeles County Museum of Art, 2004.
- Kendall, Richard. Degas: Beyond Impressionism. London: National Gallery, 1996.
- Lambourne, Lionel. Japonisme: Cultural Crossings between Japan and the West. New York: Phaidon Press, 2005.
- Lemoine, Bertrand. Architecture in France, 1800–1900.

 Trans. Alexandra Bonfante-Warren. New York: Abrams, 1998.
- Lewis, Mary Tompkins, ed.. Critical Readings in Impressionism and Post-Impressionism: An Anthology. Berkeley: Univ. of California Press, 2007.
- Lochnan, Katharine Jordan. *Tumer Whistler Monet*. London: Tate Publishing in assoc. with the Art Gallery of Ontario, 2004.
- Miller, Angela L., et al. American Encounters: An, History, and Cultural Identity. Upper Saddle River, NJ: Pearson/ Prentice Hall, 2008.
- Noon, Patrick J. Crossing the Channel: British and French Painting in the Age of Romanticism. London: Tate Publishing, 2003.
- Pissarro, Joachim. Pioneering Modern Painting: Cézanne & Pissarro 1865–1885. New York: Museum of Modern Art, 2005.
- Rodner, William S. J.M.W. Tumer: Romantic Painter of the Industrial Revolution. Berkeley: Univ. of California Press, 1997.
- Rosenblum, Robert, and H.W. Janson. 19th Century Art. Rev. & updated ed. Upper Saddle River, NJ: Pearson/ Prentice Hall, 2005.
- Rubin, James H. *Impressionism. Art & Ideas*. London: Phaidon Press, 1999.
- Rybczynski, Witold. A Clearing in the Distance: Frederick Law Olmsted and America in the Nineteenth Century. New York: Scribner, 1999.
- Smith, Paul. Seurat and the Avant-Garde. New Haven: Yale Univ. Press, 1997.
- Thomson, Belinda. *Impressionism: Origins, Practice, Reception.* World of Art. New York: Thames & Hudson, 2000.
- Twyman, Michael. Breaking the Mould: The First Hundred Years of Lithography. The Panizzi Lectures, 2000. London: British Library, 2001.
- Vaughan, William, and Francoise Cachin. Arts of the 19th Century. 2 vols. New York: Abrams, 1998.
- Werner, Marcia. Pre-Raphaelite Painting and Nineteenth-Century Realism. New York: Cambridge Univ. Press, 2005.
- Zemel, Carol M. Van Gogh's Progress: Utopia, Modernity, and Late-Nineteenth-Century Art. California Studies in the History of Art, 36. Berkeley: Univ. of California Press, 1997.

Chapter 32 Modern Art in Europe and the Americas, 1900–1950

- Ades, Dawn, comp. Art and Power: Europe under the Dictators, 1930–45. Stuttgart, Germany: Oktagon in assoc. with Hayward Gallery. 1995.
- Antliff, Mark, and Patricia Leighten. Cubism and Culture. World of Art. London: Thames & Hudson, 2001.
- Bailey, David A. Rhapsodies in Black: Art of the Harlem Renaissance. London: Hayward Gallery, 1997.
- Balken, Debra Bricker. Debating American Modernism: Stieglitz, Duchamp, and the New York Avant-Garde. New York: American Federation of Arts, 2003.
- Barron, Stephanie, ed. Degenerate Art: The Fate of the Avant-Garde in Nazi Germany. Los Angeles: Los Angeles County Museum of Art, 1991.
- —, and Wolf-Dieter Dube, eds. German Expressionism: Art and Society. New York: Rizzoli, 1997.
- Bochner, Jay. An American Lens: Scenes from Alfred Stieglitz's New York Secession. Cambridge, MA: MIT Press, 2005.
- Bohn, Willard. The Rise of Surrealism: Cubism, Dada, and the Pursuit of the Marvelous. Albany: State Univ. of New York Press. 2002.
- Bowlt, John E., and Evgeniia Petrova, eds. Painting Revolution: Kandinsky, Malevich and the Russian Avant-Garde. Bethesda, MD: Foundation for International Arts and Education, 2000.
- Bown, Matthew Cullerne. Socialist Realist Painting. New Haven: Yale Univ. Press, 1998.
- Brown, Milton W. Story of the Armory Show. 2nd ed. New York: Abbeville Press, 1988.
- Chassey, Eric de, ed. American Art: 1908–1947, from Winslow Homer to Jackson Pollock. Trans. Jane McDonald. Paris: Réunion des Musées Nationaux, 2001.
- Corn, Wanda M. The Great American Thing: Modern Art and National Identity, 1915–1935. Berkeley: Univ. of California Press, 1999.
- Curtis, Penelope. Sculpture 1900–1945: After Rodin. Oxford History of Art. Oxford: Oxford Univ. Press, 1999.
- Dachy, Marc. Dada: The Revolt of Art. Trans. Liz Nash. New York: Abrams, 2006.
- Elger, Dietmar. Expressionism: A Revolution in German Art. Ed. Ingo F. Walther. Trans. Hugh Beyer. New York: Taschen, 1998.
- Fer, Briony. On Abstract Art. New Haven: Yale Univ. Press, 1997.
- Fletcher, Valerie J. Crosscurrents of Modernism: Four Latin American Pioneers: Diego Rivera, Joaquín Torres-García, Wifredo Lam, Matta. Washington, DC: Hirshhorn Museum and Sculpture Garden in assoc. with the Smithsonian Institution Press, 1992.
- Folgarait, Leonard. Mural Painting and Social Revolution in Mexico, 1920–1940: Art of the New Order. New York: Cambridge Univ. Press, 1998.
- Forgács, Eva. *The Bauhaus Idea and Bauhaus Politics*. Trans. John Bátki. New York: Central European Univ. Press, 1995.
- Frampton, Kenneth. Modem Architecture: A Critical History.
 4th ed. World of Art. London: Thames & Hudson,
- Gooding, Mel. Abstract Art. Movements in Modern Art. Cambridge: Cambridge Univ. Press, 2001.
- Grant, Kim. Surrealism and the Visual Arts: Theory and Reception. New York: Cambridge Univ. Press, 2005.
- Green, Christopher. Art in France: 1900–1940. Pelican History of Art. New Haven: Yale Univ. Press, 2000.
- Harris, Jonathan. Federal Art and National Culture: The Politics of Identity in New Deal America. Cambridge Studies in American Visual Culture. New York: Cambridge Univ. Press, 1995.
- Harrison, Charles, Francis Frascina, and Gill Perry. Primitivism, Cubism, Abstraction: The Early Twentieth Century. New Haven: Yale Univ. Press, 1993.
- Haskell, Barbara. The American Century: Art & Culture, 1900–1950. New York: Whitney Museum of American Art, 1999.
- Herskovic, Marika, ed. American Abstract Expressionism of the 1950s: An Illustrated Survey: With Artists' Statements, Artwork and Biographies. New York: New York School Press, 2003.
- Hill, Charles C. *The Group of Seven: Art for a Nation*. Ottawa: National Gallery of Canada, 1995.
- James-Chakraborty, Kathleen, ed. Bauhaus Culture: From Weimar to the Cold War. Minneapolis: Univ. of Minnesota Press, 2006.
- Karmel, Pepe. Picasso and the Invention of Cubism. New Haven: Yale Univ. Press, 2003.

- Lista, Giovanni. Futurism. Trans. Susan Wise. Paris: Terrail, 2001
- Lucie-Smith, Edward. Latin American Art of the 20th Century. 2nd ed. World of Art. London: Thames & Hudson, 2005.
- McCarter, Robert, ed. On and by Frank Lloyd Wright: A Primer of Architectural Principles. New York: Phaidon Press, 2005.
- Moudry, Roberta, ed. The American Skyscraper: Cultural Histories. New York: Cambridge Univ. Press, 2005.
- Rickey, George. Constructivism: Origins and Evolution. Rev. ed. New York: Braziller, 1995.
- Taylor, Brandon. Collage: The Making of Modem Art. London: Thames & Hudson, 2004.
- Weston, Richard. Modernism. London: Phaidon Press, 1996. White, Michael. De Stijl and Dutch Modernism. Critical Perspectives in Art History. New York: Manchester Univ. Press, 2003.
- Whitfield, Sarah. Fauvism. World of Art. New York: Thames & Hudson, 1996.
- Whitford, Frank. The Bauhaus: Masters and Students by Themselves. Woodstock, NY: Overlook Press, 1993.
- Zurier, Rebecca, Robert W. Snyder, and Virginia M. Mecklenburg. Metropolitan Lives: The Ashcan Artists and Their New York. Washington, DC: National Museum of American Art, 1995.

Chapter 33 The International Scene since 1950

- Alberro, Alexander, and Blake Stimson, eds. Conceptual Art: A Critical Anthology. Cambridge, MA: MIT Press, 1999.
- Archer, Michael. Art Since 1960. 2nd ed. World of Art. New York: Thames & Hudson, 2002.
- Atkins. Robert. Artspeak: A Guide to Contemporary Ideas, Movements, and Buzzwords. 2nd ed. New York: Abbeville Press, 1997.
- Ault, Julie. Art Matters: How the Culture Wars Changed America. Ed, Brian Wallis, Marianne Weems, and Philip Yenawine. New York: New York Univ. Press, 1999.
- Battcock, Gregory. Minimal Art: A Critical Anthology.
 Berkeley: Univ. of California Press, 1995.
- Beardsley, John. Earthworks and Beyond: Contemporary Art in the Landscape. 4th ed. ebook. New York: Abbeville Press. 2006
- Bird, Jon, and Michael Newman, eds. Rewriting Conceptual Art. Critical Views. London: Reaktion Books, 1999.
- Bishop, Claire. *Installation Art: A Critical History*. New York: Routledge, 2005.
- Blais, Joline, and Jon Ippolito. At the Edge of Art. London: Thames & Hudson, 2006.
- Buchloh, Benjamin H.D. Neo-Avantgarde and Culture Industry: Essays on European and American Art from 1955 to 1975. Cambridge, MA: MIT Press, 2000.
- Carlebach, Michael L. American Photojournalism Comes of Age. Washington, DC: Smithsonian Institution Press, 1997.
- Causey, Andrew. Sculpture Since 1945. Oxford History of Art. Oxford: Oxford Univ. Press, 1998.
- Corris, Michael, ed. Conceptual Art: Theory, Myth, and Practice. New York: Cambridge Univ. Press, 2004.
- De Oliveira, Nicolas, Nicola Oxley, and Michael Petry.

 Installation Art in the New Millennium: The Empire of the
 Senses. New York: Thames & Hudson, 2003.
- De Salvo, Donna, ed. Open Systems: Rethinking Art c. 1970. London: Tate Gallery, 2005.
- Fabozzi, Paul F. Artists, Critics, Context: Readings In and Around American Art Since 1945. Upper Saddle River, NJ: Pearson/Prentice Hall, 2002.
- Fineberg, Jonathan. Art Since 1940: Strategies of Being. 3rd ed. Upper Saddle River, NJ: Pearson/Prentice Hall, 2011.
- Flood, Richard, and Frances Morris. Zero to Infinity: Arte Povera, 1962–1972. Minneapolis, MN: Walker Art Center. 2001.
- Fried, Michael. "Art and Objecthood." Artforum 5 (June 1967): 12–23.
- Goldberg, RoseLee. Performance Art: From Futurism to the Present. Rev. and exp. ed. World of Art. London: Thames & Hudson, 2001.
- Goldstein, Ann. A Minimal Future? Art as Object 1958–1968. Los Angeles: Museum of Contemporary Art, 2004.
- Grande, John K. Art Nature Dialogues: Interviews with Environmental Artists. Albany: State Univ. of New York Press, 2004.
- Grosenick, Uta, ed. Women Artists in the 20th and 21st Century. New York: Taschen, 2001.
- —, and Burkhard Riemschneider, eds. Art at the Turn of the Millennium. New York: Taschen, 1999.
- Grunenberg, Christoph, ed. Summer of Love: Art of the Psychedelic Era. London: Tate Gallery, 2005.

- Hitchcock, Henry Russell, and Philip Johnson. The International Style. New York: Norton, 1995.
- Hopkins, David. After Modern Art: 1945–2000. Oxford History of Art. Oxford: Oxford Univ. Press, 2000.
- Jencks, Charles. The New Paradigm in Architecture: The Language of Post-Modernism. New Haven: Yale Univ. Press, 2002.
- Jodidio, Philip. New Forms: Architecture in the 1990s. Taschen's World Architecture. New York: Taschen, 2001.
- Johnson, Deborah, and Wendy Oliver, eds. Women Making Art: Women in the Visual, Literary, and Performing Arts Since 1960. Eruptions, vol. 7. New York: Peter Lang, 2001.
- Jones, Caroline A. Machine in the Studio: Constructing the Postwar American Artist. Chicago: Univ. of Chicago Press, 1996
- Joselit, David. American Art Since 1945. World of Art. London: Thames & Hudson, 2003.
- Legault, Réjean, and Sarah Williams Goldhagen, eds. Anxious Modernisms: Experimentation in Postwar Architectural Culture. Montréal: Canadian Centre for Architecture, 2000.
- Lucie-Smith, Edward. *Movements in Art Since 1945*. New ed. World of Art. London: Thames & Hudson, 2001.
- Madoff, Steven Henry, ed. *Pop Art: A Critical History*. The Documents of Twentieth-Century Art. Berkeley: Univ. of California Press, 1997.
- Moos, David, ed. The Shape of Colour: Excursions in Colour Field Art, 1950–2005. Toronto: Art Gallery of Ontario, 2005.

- Nochlin, Linda. "Why Have There Been No Great Women Artists?" An News 69 (January 1972): 22–39.
- Owens, Craig. "The Discourse of Others: Feminists and Postmodernism." In *The Anti-Aesthetic: Essays on Postmodern Culture*, ed. Hal Foster. Seattle: Bay Press, 1983: 57–82
- Paul, Christiane. *Digital Art*. 2nd ed. World of Art. London: Thames & Hudson, 2008.
- Phillips, Lisa. *The American Century: Art and Culture*, 1950–2000. New York: Whitney Museum of American Art. 1999.
- Pop Art: Contemporary Perspectives. Princeton, NJ: Princeton Univ. Art Museum, 2007.
- Ratcliff, Carter. The Fate of a Gesture: Jackson Pollock and Postwar American Art. New York: Farrar, Straus, Giroux, 1996
- Reckitt, Helena, ed. *Art and Feminism*. Themes and Movements. London: Phaidon Press, 2001.
- Robertson, Jean, and Craig McDaniel. Themes of Contemporary Art: Visual Art after 1980. 2nd ed. New York: Oxford Univ. Press, 2009.
- Robinson, Hilary, ed. Feminism-Art-Theory: An Anthology, 1968–2000. Malden, MA: Blackwell, 2001.
- Rorimer, Anne. New Art in the 60s and 70s: Redefining Reality. New York: Thames & Hudson, 2001.

- Sandler, Irving. Art of the Postmodern Era: From the Late 1960s to the Early 1990s. New York: Icon Editions, 1996.
- Shohat, Ella. Talking Visions: Multicultural Feminism in a Transnational Age. Documentary Sources in Contemporary Art, vol. 5. New York: New Museum of Contemporary Art, 1998.
- Smith, Terry. Contemporary Art: World Currents. Upper Saddle River, NJ: Pearson/Prentice Hall, 2011.
- Stiles, Kristine, and Peter Selz. Theories and Documents of Contemporary Art: A Sourcebook of Artists' Writings. California Studies in the History of Art, 35. Berkeley: Univ. of California, 1996.
- Sylvester, David. About Modern Art. 2nd ed. New Haven: Yale Univ. Press. 2001.
- Varnedoe, Kirk, Paola Antonelli, and Joshua Siegel, eds.

 Modem Contemporary: Art Since 1980 at MoMA. Rev. ed.
 New York: Museum of Modern Art. 2004.
- Waldman, Diane. Collage, Assemblage, and the Found Object. New York: Abrams, 1992.
- Weintraub, Linda, Arthur Danto, and Thomas McEvilley. Art on the Edge and Over: Searching for Art's Meaning in Contemporary Society, 1970s–1990s. Litchfield, CT: Art Insights, 1996.

Credits

Chapter 30

30.1 © 2007 Photo The Philadelphia Museum of Art/Art Resource/ Scala, Florence; 30.2 akg-images/Herve Champollion; 30.3 akg-image Erich Lessing; 30.4 Gerard Blott/Réunion des Musées Nationaux; 30.5 Rheinisches Bildarchiv Cologne; 30.6 The Wallace Collection, London/The Bridgeman Art Library; 30.7 Photograph © 1990 The Metropolitan Museum of Art/Art Resource, NY; 30.9 Picture Press Bild und Textagentur GmbH, Munich, Germany; 30.10 John Hammond/The National Trust Photo Library; 30.11 © 2012 The National Gallery, London/Scala, Florence; 30.12 © 2008 Photo Scala, Florence/BPK, Bildagentur fuer Kunst, Kultur and Geschichte, Berlin/Photo Jörg P. Anders; 30.13 Mondadoriportfolio/IKONA; 30.14 © 1999 Photo Scala, Florence, courtesy of the Ministero Beni e Att. Culturali; 30.15a © Achim Bednorz, Cologne; 30.16 Nick Meers/The National Trust Photo Library; 30.17 Image by courtesy of the Wedgwood Museum Trust Limited, Barlaston, Staffordshire, England; 30.18 Image by courtesy of the Wedgwood Museum Trustees, Barlaston, Staffordshire, England; 30.19 Robert Nauman 30.20 akg-images/A.F. Kersting; 30.21 © 2009 The National Gallery, London/Scala, Florence; 30.22 Photography © The Art Institute of Chicago; 30.23 © 2009 The National Gallery, London/Scala, Florence; 30.24 © National Gallery, London/Scala, Florence; 30.25 Royal Collection Trust/© HM Queen Elizabeth II 2012; 30.26 The Adolph D. and Wilkins C. Williams Fund. Photo: Katherine Wetzel. Virginia Museum of Fine Arts, Richmond: 30,28 Gift of the Duke of Westminster. National Gallery of Canada, Ottawa; 30.29 The Bridgeman Art Library; 30.30 © Tate, London 2012; 30.31 Image courtesy of the National Gallery of Art, Washington; 30.32 Yoshio Tomii/SuperStock; 30.33 Dorling Kindersley; 30.34 National Gallery of Canada; 30.35 RMN-Grand Palais (Musée du Louvre)/Gérard Blot; 30.36 Jean Feuillie © Centre des Monuments Nationaux; 30.37 RMN-Grand Palais/Gérard Blot/Christian Jean; 30.39 RMN-Grand Palais (Château de Versailles)/Gérard Blot; 30.40 The Metropolitan Museum of Art/Art Resource/Scala, Florence; 30.42 The Hispanic Society of America; 30.43 akg-images/Erich Lessing; 30.44 Oronoz-Nieto Museo Nacional del Prado; 30.45 Enrique Franco Torrijos; 30.47 Robert Frerck/Odyssey Productions, Inc; 30.48 Réunion des Musées Nationaux-Grand Palais (Château de Versailles)/Gérard Blot; 30.49 Art Resource/Réunion des Musées Nationaux/Musée du Louvre; 30.50 akg-images/Erich Lessing; 30.51 & 30.52 Réunion des Musées Nationaux/Philippe Bernard; 30.53 © Musée Fabre de Montpellier Agglomération, photograph by Frédéric Jaulmes; 30.54 RMN-Grand Palais (Musée du Louvre)/Hervé Lewandowski; 30.55 Paul M.R. Maeyaert; 30.56 RMN-Grand Palais (Musée du Louvre)/Thierry

Le Mage; 30.58 Bibliothèque Nationale de France; 30.59 © RMN (Musée d'Orsay)/Michèle Bellot; 30.60 © National Gallery, London/ Scala, Florence; 30.61 © Tate, London 2012; 30.62 Philadelphia Museum of Art. The John Howard McFadden Collection, 1928/ Scala, Florence/Art Resource, NY; 30.63 The Metropolitan Museum of Art/Art Resource/Scala, Florence; 30.64 Photo Scala, Florence/BPK, Bildagenturfuer Kunst, Kultur und Geschichte, Berlin; 30.65 © Peter Ashworth, London; 30.66 Leo Sorel Photography; 30.67 Photo Scala, Florence/BPK, Bildagentur fuer Kunst, Kultur und Geschichte, Berlin; 30.68 New York Public Library/Art Resource, N.Y; 30.69 David R. Frazier Photolibrary, Inc./Alamy.

Chapter 31

31.1 Giraudon/The Bridgeman Art Library; 31.2 Roger-Viollet/ TopFoto; 31.3 Giraudon/The Bridgeman Art Library; 31.4 © RMN (Musée d'Orsay)/Hervé Lewandowski; 31.5 akg-images/Erich Lessing; 31.6 The Bridgeman Art Library; 31.7 Societe Française de Photographie; 31.8 Courtesy of the Library of Congress; 31.9 National Museum of Photography, Film, and Television/Science & Society Picture Library; 31.10 Courtesy of the Library of Congress; 31.11 National Museum of Photography, Film, and Television/ Science & Society Picture Library; 31.12 Staatliche Kunstsan Dresden/The Bridgeman Art Library; 31.13 RMN-Grand Palais (Musée d'Orsay)/Gérard Blot/Hervé Lewandowski; 31.14 RMN-Grand Palais (Musée d'Orsay)/Jean Schormans; 31.15 Photograph © 2012 Carnegie Museum of Art, Pittsburgh; 31.16 © 2007 Image copyright The Metropolitan Museum of Art/Art Resource, NY Scala Florence: 31.17 RMN-Grand Palais (Musée d'Orsay) Hervé Lewandowski; 31.18 Herve Lewandowski/Art Resource/ Musée du Louvre; 31.20 The State Russian Museum/Corbis; 31.26 The William Morris Gallery, London, E17, England; 31.27 The Bridgeman Art Library; 31.28 Musée Marmottan, Paris/Bridgeman Art Library; 31.29 Image The Metropolitan Museum of Art/Art Resource/Scala, Florence; 31.31 Musée d'Orsay, Paris. RMN Réunion des Musées Nationaux; 31.32 © National Gallery, London/ Scala, Florence; 31.33 The Metropolitan Museum of Art/Art Resource, NY/Scala, Florence; 31.34 RMN-Grand Palais (Musée d'Orsay)/Hervé Lewandowski; 31.35 Wichita Art Museum, Kansas; 31.36 & 31.37 Photography © The Art Institute of Chicago; 31.39 Van Gogh Museum, Amsterdam (Vincent van Gogh Foundation) (s0115V/1962); 31.40 The Museum of Modern Art/Scala, Florence/ Art Resource; page 1000 Photography © The Art Institute of Chicago; 31.41 Musée du Louvre/RMN Réunion des Musées Nationaux, France. J. G. Berizzi; 31.42 © 2012 Munch Museum/

The Munch-Ellingsen Group/Artists Rights Society (ARS), NY; 31.43 Koninklijk Museum voor Schone Kunsten, Antwerp. Image courtesy of Reproductiefonds Vlaamse Musea NV; 31.44 Hirshhorn Museum and Sculpture Garden, Smithsonian Institution. Gift of Joseph H. Hirshhorn, 1966; 31.45 Blauel/Gnamm-ARTOTHEK; 31.46 © 2013 Victor Horta, Bastin, & Evrard/SOFAM—Belgium; 31.47 Vincent Abbey Photography; 31.48 The Museum of Modern Art/Scala, Florence/Art Resource, NY; 31.49 The Bridgeman Art Library; 31.50 V&A Picture Library; 31.51 © Paul Almasy/Corbis; 31.52 © Corbis; 31.53 Frederick Law Olmsted & Calvert Vaux/City of New York, Department of Parks; 31.54 Courtesy of the Library of Congress; 31.55 © Art on File/Louis H. Sullivan/Corbis; 31.56 The Bridgeman Art Library; 31.57 Photography © The Art Institute of Chicago; 31.58 The W.P. Wilstach Collection. Philadelphia Museum of Art/Art Resource, NY/Scala, Florence.

Chapter 32

32.1 The Museum of Modern Art, New York/Scala, Florence/Art Resource, NY. © 2012 Estate of Pablo Picasso/Artists Rights Society (ARS), New York; 32.2 Image courtesy of the National Gallery of Art, Washington © 2012 Artists Rights Society (ARS), New York/ ADAGP, Paris; 32.3 © 2012 Succession H. Matisse/Artists Rights Society (ARS), New York; 32.4 The Bridgeman Art Library © 2012 Succession H. Matisse/Artists Rights Society (ARS), New York; 32.5 Image courtesy of the National Gallery of Art, Washington. © 2012 Estate of Pablo Picasso/Artists Rights Society (ARS), New York; 32.6 The Museum of Modern Art/Scala, Florence/Art Resource NY. © 2012 Estate of Pablo Picasso/Artists Rights Society (ARS), New York; 32.7 © 2012 Artists Rights Society (ARS), New York ADAGP, Paris; 32.8 Photography © The Art Institute of Chicago © 2012 Estate of Pablo Picasso/Artists Rights Society (ARS), New York; 32.9 © 2012 Estate of Pablo Picasso Artists Rights Society (ARS), New York; 32.10 RMN/Béatrice Hatala © 2012 Estate of Pablo Picasso/Artists Rights Society (ARS), New York; 32.11 Digital Image Museum Associates/LACMA/Art Resource NY/ Scala, Florence © 2012 Artists Rights Society (ARS), New York/ VG Bild-Kunst, Bonn; 32.12 Gift of the Friends of Art. The Nelson-Atkins Museum of Art, Kansas City, Missouri. Photo: Jamison Miller; 32.13 © 2012 Digital image The Museum of Modern Art, New York/Scala, Florence; 32.14 Photo Scala, Florence/BPK. Bildagentur fuer Kunst, Kultur und Geschichte, Berlin © 2012 Artists Rights Society (ARS), New York/VG Bild-Kunst, Bonn; 32.15 akg-images; 32.16 The Metropolitan Museum of Art/Art Resource/ Scala, Florence; 32.18 © 2012 Artists Rights Society (ARS), New

York/ADAGP, Paris; 32.19 © 2012 White Images/Scala; 32.20 © L & M Services, B.V. The Hague 20120507; 32.21 & 32.22 Digital image, The Museum of Modern Art, New York/Scala, Florence. © 2012 Artists Rights Society (ARS), New York/ADAGP, Paris; 32.23 The Museum of Modern Art/Scala, Florence/Art Resource, NY; 32.24 Musée National d'Art Moderne. Centre National d'Art et de Culture. Georges Pompidou. Réunion des Musées Nationaux © 2012 Artists Rights Society (ARS), New York/ADAGP, Paris; 32.25 Collection Stedelijk Museum Amsterdam; 32.26 © Estate of Vladimir Tatlin/RAO Moscow: 32.28 Hirshhorn Museur and Sculpture Garden, Smithsonian Institution Gift of Joseph H. Hirshhorn, 1966 © 2012 Artists Rights Society (ARS), New York/ ADAGP, Paris; 32.27 Photo The Philadelphia Museum of Art/Art Resource/Scala, Florence © 2012 Artists Rights Society (ARS), New York/ADAGP, Paris; 32.29 © 2012 Kunsthaus Zürich. All rights reserved; 32.30 © Philadelphia Museum of Art/Scala, Florence/Art Resource, NY. © 2012 Artists Rights Society (ARS), New York/ ADAGP, Paris/Succession Marcel Duchamp; 32.31 © 2012 Artists Rights Society (ARS), New York/ADAGP, Paris/Succession Marcel Duchamp; 32.32 © 2012 Artists Rights Society (ARS), New York/ VG Bild-Kunst, Bonn; 32.33 © 2005 Photo Scala, Florence/BPK, Bildargentur fuer Kunst, Kultur und Geschichte, Berlin. Photo Jörg P. Anders. © 2012 Artists Rights Society (ARS), New York/ VG Bild-Kunst, Bonn; 32.34 The Metropolitan Museum of Art/ Scala, Florence/Art Resource NY; page 1042 The Metropolitan Museum of Art/Art Resource/Scala, Florence; 32.35 Photography © The Art Institute of Chicago; 32.36 & 32.37 © 2012 Georgia O'Keeffe Museum/Artists Rights Society (ARS), New York; 32.39 Gerald Zugmann Fotographie KEG; 32.40 White Images/ Scala, Florence © 2012 Artists Rights Society (ARS), New York/ADAGP, Paris/F.L.C.; 32.41 © 2012 Frank Lloyd Wright Foundation, Scottsdale, AZ/Artists Rights Society (ARS), NY; 32.42 Frank Lloyd Wright Preservation Trust © 2012 Frank Lloyd Wright Foundation, Scottsdale, AZ/Artists Rights Society (ARS), NY; 32.43 Thomas A Heinz, AIA, Photographer © Copyright Western Pennsylvania Conservancy 2007 © 2012 Frank Lloyd Wright Foundation, Scottsdale, AZ/Artists Rights Society (ARS), NY; 32.45 Photo: Andrew Garn; 32.44 Photo © 2008 Maria Langer www.flyingmphotos.com; 32.47 Photo: Peter Cox, Eindhoven, The Netherlands © 2012 Artists Rights Society (ARS), New York; 32.48 Art © Estate of Vera Mukhina/RAO, Moscow/VAGA, New York; 32.49 The Menil Collection, Houston; 32.50 Bildarchiv Monheim GmbH/Alamy; 32.51 Photo: Jannes Linders © 2012 Artists Rights Society (ARS), New York; 32.52 Bildarchiv Foto Marburg. Photo: Lucia Moholy © 2012 Artists Rights Society (ARS), New York/ VG Bild-Kunst, Bonn; 32.53 Bauhausarchiv-Museum für Gestaltung, Berlin, Germany © 2012 Artists Rights Society (ARS), New York/ VG Bild-Kunst, Bonn; 32.54 Photo: Imaging Department © President and Fellows of Harvard College BR48.132. © 2012 The Josef and Anni Albers Foundation/Artists Rights Society (ARS), New York; 32.55 Adk, Berlin, George Grosz-Archiv/Akademie der Kunste/Archiv Bildende Kunst; 32.56 Collection Stedelijk Museum Amsterdam © 2012 Artists Rights Society (ARS), New York/ADAGP, Paris; 32.57 © Salvador Dalí, Fundació Gala-Salvador Dalí, Artists Rights Society (ARS), New York 2012; 32.58 Purchase. The Museum of Modern Art/Licensed by Scala-Art Resource, NY. © 2012 Artists Rights Society (ARS), New York/ ProLitteris, Zürich: 32.59 Wadsworth Atheneum Museum of Art/ Art Resource, NY © 2012 Successió Miró/Artists Rights Society (ARS), New York/ADAGP, Paris; 32.60 © Tate, London 2012/

Henry Moore Foundation. Bowness/Hepworth Estate; 32.61 © Tate,

London 2012/Reproduced by permission of The Henry Moore Foundation DACS 2012/www.henry-moore.org; 32.62 © Donna Mussenden VanDerZee; 32.63 © 2012 Estate of Pablo Picasso/ Artists Rights Society (ARS), New York; 32.64 © Bettmann/Corbis; 32.65 Schomburg Center NYPL/Art Resource, NY; 32.67 © 2012 The Jacob and Gwendolyn Lawrence Foundation, Seattle/Artists Rights Society (ARS), New York; 32.68 Courtesy of the Library of Congress; 32.69 Photography © The Art Institute of Chicago; 32.70 National Gallery of Canada; 32.71 Photo by Trevor Mills, Vancouver Art Gallery; 32.72 & 32.73 Bob Schalkwijk/Art Resource, NY. © 2012 Banco de México Diego Rivera Frida Kahlo Museums Trust, Mexico, D.F./Artists Rights Society (ARS), New York; 32.74 Courtesy Guilherme Augusto do Amaral/Malba-Coleccion Costanini, Buenos Aires; 32.76 Photography © The Art Institute of Chicago © 2012 The Estate of Francis Bacon. All rights reserved/ ARS, New York/DACS, London; 32.77 Digital Image © The Museum of Modern Art/Scala © 2012 Artists Rights Society (ARS), New York/ADAGP, Paris; 32.78 © 2012 Artists Rights Society (ARS), New York/ADAGP, Paris; 32.79 Albright Knox Art Gallery/ Art Resource, NY/Scala, Florence; 32.80 © 2012 The Arshile Gorky Foundation/The Artists Rights Society (ARS), New York; 32.81 © 2012 The Pollock-Krasner Foundation/Artists Rights Society (ARS), New York; 32.83 Photo: Geoffrey Clements © 2012 The Pollock-Krasner Foundation/Artists Rights Society (ARS), New York; 32.84 © 2010 Digital Image, The Museum of Modern Art, New York/ Scala, Florence. © 2012 The Willem de Kooning Foundation/ Artists Rights Society (ARS), New York; 32.85 Digital image 2012 The Museum of Modern Art, New York/Scala, Florence: 32.86 National Gallery of Canada. © 2012 Artists Rights Society (ARS), New York/SODRAC, Montreal; 32.87 Image courtesy of the National Gallery of Art, Washington © 2012 Estate of Helen Frankenthaler/Artists Rights Society (ARS), New York; 32.88 Hirshhorn Museum and Sculpture Garden, Smithsonian Institution, Photography by Lee Stalsworth © 1998 Kate Rothko Prizel & Christopher Rothko/Artists Rights Society (ARS), New York; 32.89 The Foundation, New York/Artists Rights Society (ARS), New York

Chapter 33

33.1 Courtesy Castelli Gallery, Photo: Rudolph Burckhardt; 33.2 © 2012 Digital image The Museum of Modern Art, New York/ Scala, Florence © 2012 Estate of Louise Nevelson/Artists Rights Society (ARS), New York; 33.4 Courtesy of Shozo Shim 33.5 Research Library, The Getty Research Institute, Los Angeles, California (980063). Photo: Ken Heyman; 33.6 © The Metropolitan Museum of Art/Art Resource, NY/Scala, Florence Shunk-Kender © 2012 Artists Rights Society (ARS), New York/ ADAGP, Paris; 33.7 NMeM/Tony Ray-Jones/Science & Society © 2012 Carolee Schneemann/Artists Rights Society (ARS), New York; 33.8 Photography © The Art Institute of Chicago; 33.9 © Stephen A. Frank; 33.10 © R. Hamilton. All Rights Reserved, DACS 2012; 33.11 © 2012 The Andy Warhol Foundation for the Visual Arts, Inc./Artists Rights Society (ARS), New York; 33.12 © Tate, London 2012 Marilyn Monroe LLC under license authorized by CMG Worldwide Inc., Indianapolis, IN © 2012 The Andy Warhol Foundation for the Visual Arts, Inc./Artists Rights Society (ARS), New York; 33.14 © The Estate of Roy Lichtenstein/ DACS 2012; 33.16 Albright Knox Art Gallery/Art Resource, NY/ Scala, Florence; 33.17 Tate, London 2012 © 2012 Robert Morris/ Artists Rights Society (ARS), New York; 33.18 Performed at Galerie Schmela, Dusseldorf Courtesy Ronald Feldman Fine Arts,

NY © Ute Klophaus/© 2012 Artists Rights Society (ARS), New York/VG Bild-Kunst, Bonn; 33.19 The Museum of Modern Art/ Scala, Florence @ 2012 Joseph Kosuth/Artists Rights Society (ARS), New York; 33.20 Eric Pollitzer/Leo Castelli Gallery, NY. © 2012 Bruce Nauman/Artists Rights Society (ARS), New York; 33.21 © The Estate of Eva Hesse. Courtesy Hauser & Wirth.
Photo Geoffrey Clements; 33.22 © Digital Image, The Museum of Modern Art, New York/Scala, Florence; 33.23 and inset Collection of The Brooklyn Museum of Art, Gift of the Elizabeth A. Sackler Foundation. Photograph © Donald Woodman/Through the Flower © 2012 Judy Chicago/Artists Rights Society (ARS), New York; 33.24 Photography Robert Hickerson: 33.25 Courtesy Galerie Lelong, New York; 33.26 Photo Gianfranco Gorgoni. Courtesy James Cohan Gallery, New York; 33.27 Photo: Wolfgang Volz. © 2005 Christo and Jeanne-Claude; 33.28 Photo: Andrew Garn © 2012 Artists Rights Society (ARS), New York/VG Bild-Kunst, Bonn; 33.29 Photo: Karen Johnson; 33.30 Photo: Andrew Garn. © 2012 Frank Lloyd Wright Foundation, Scottsdale, AZ/Artists Rights Society (ARS), NY; 33.31a Rollin La France, courtesy Venturi, Scott Brown and Associates, Inc; 33.32 Richard Payne, FAIA; 33.33 Photo: Peter Cox, Eindhoven, The Netherlands. © Anselm Kiefer Courtesy Gagosian Gallery; 33.34 Broad Art Foundation, Santa Monica, California. © 2012 The Estate of Jean-Michel Basquiat/ ADAGP, Paris/ARS, New York AGP, Paris and DACS, London 2010; 33.35 © Digital Image, The Museum of Modern Art, New York/Scala, Florence; 33.36 Courtesy the artist and Metro Pictures; 33.37 Courtesy www.guerrillagirls.com; 33.38 Photo courtesy Mary Boone Gallery, New York; 33.40 Courtesy of the artist; 33.41 © SPARC www.sparcmurals.org; 33.42 Image courtesy of the artist and Jack Shainman Gallery, NY; 33.43 Courtesy James Luna; 33.44 Photography © Museum of Contemporary Art, Chicago; 33.45 Photo by David Aschkenas. © 2012 Richard Serra/Artists Rights Society (ARS), New York; 33.46 © Frank Fournier; page 1117 Courtesy Donald Young Gallery, Chicago; 33.47 Courtesy Victoria Miro Gallery, London; 33.48 @ Andres Serrano/Courtesy of the artist and Yvon Lambert Paris, New York; 33.49 Tate, London 2010. Photographed by Prudence Cuming Associates © 2012 Damien Hirst and Science Ltd. All rights reserved/DACS, London/ARS, NY; 33.50 © The Felix Gonzalez-Torres Foundation. Courtesy of Andrea Rosen Gallery, New York. Photo: Peter Muscato; 33.52 Whitney Museum of American Art, New York. Johansen Krause; 33.53 Courtesy Galerie Lelong, New York; 33.55 © Shirin Neshat. Courtesy Gladstone Gallery; 33.56 Courtesy of the artist; 33.57 Courtesy of Michael Stevenson, Cape Town; 33.58 Ian Lambot/Foster and Partners; 33.59 F1 ONLINE/SuperStock; 33.60 AAD Worldwide Travel Images/ Alamy; 33.61 © 2011 Smithsonian American Art Museum/Art Resource/Scala; 33.62 Courtesy Bill Viola Studio LLC. Performer: Phil Esposito; Photo: Kira Perov; 33.63 Chihuly Inc; 33.64 Courtesy Marian Goodman Gallery; 33.65 Courtesy of the artist and Metro Pictures; 33.66 Photo by Chris Winget. © Matthew Barney, courtesy Barbara Gladstone Gallery (Part of the Cremaster Cycle 1994-2002); 33.68 Photo by Jiang Min; 33.69 Studio Museum in Harlem. Photo by Marc Bernier; 33.70 © the artist. Courtesy James Cohan Gallery. Photo by Jason Mandella; 33.71 Courtes Lisson Gallery. © 2012 Artists Rights Society (ARS), New York/ VG Bild-Kunst, Bonn; 33.72 Photograph by Ellen Labenski; 33.73 Installation view: Kara Walker: My Complement, My Enemy, My Oppressor, My Love. Walker Art Center, Minneapolis, 2007. Photo: Dave Sweeney © Kara Walker/Courtesy of Sikkema Jenkins & Co.,

Index

Analytic Cubism 1024-5

Anatomy Lesson of Dr. Tulp, The (Rembrandt) 981

Figures in italics refer to illustrations and captions

Α 925 skyscrapers 1011-12, 1012, 1049, 1049, 1050 À Rebours (Huysmans) 1000-1 Spain 1005, 1005 (Art Nouveau), 1126, 1127, Angiviller, Count d' 936 Anthropophagic Manifesto (Andrade) 1070, 1071 Abaporú (The One Who Eats) (Amaral) 1070, 1128 (Deconstructivist) Apollinaire, Guillaume 1032 Spanish colonial 943, 945, 945 Apollo 916 Argentinian art 1072-3 Abbey in an Oak Forest (Friedrich) 958, 958 ABC Art 1095 Apollo Belvedere 916 Armored Train in Action (Severini) 1033, 1033 abolition movement 921 Apparition, The (Moreau) 1001, 1001 Armory Show, New York (1913) 1037, 1041, 1129 Abstract Art in Five Tones and Complementaries Araeen, Rasheed 1124 (Torres-García) 1073, 1073 Green Painting IV 1124, 1125 Art Basel (fair), Switzerland 1129 Abstract Expressionism 1066, 1073-80, 1074-81 Arbus, Allan 1091 Art Basel Miami (fair), Florida 1129 abstract sculpture 1036, 1036-7 Arbus, Diane 1090, 1091 art history 916 Academicians of the Royal Academy (Zoffany) 926 Child with a Toy Hand Grenade in Central Park, Art Informel 1071-2, 1088 Académie des Beaux-Arts, Paris 964, 966, 972, New York 1090 Art Nouveau 994 architecture 1004, 1004-5 (Belgium), 1005, 977 Arc de Triomphe, Paris 951, 951 academies 926, 964-5 Archer, Frederick Scott 970 1005 (Spanish) furniture 1006, 1006 architecture see Académie des Beaux-Arts, Paris; French American 943, 945, 945 (Spanish colonial), Arte Concreto-Invención 1072 Royal Academy of Painting and Sculpture; 959, 959 (Gothic Revival), 960, 960-61, Artform (journal) 1095, 1096 Royal Academy of Art, London 961 (Neoclassical), 1009, 1009-12, 1011, Artifact Piece, The (Luna) 1113-14, 1114 Action painting 1074, 1075-6, 1075, 1076, 1088 1012 (Chicago School), 1046, 1046, 1047, Artist's Studio, The (Daguerre) 969, 969 Activist art 1120-21, 1121, 1122, 1123, 1123 Adler, Dankmar 1011, 1046 1048, 1048, 1104-6, 1105 (Modernist), Arts and Crafts Movement 985-6 Advantages of Being a Woman Artist, The (Guerrilla 1104, 1104 (International Style), 1106, Aspects of Negro Life: From Slavery Through Girls) 1110, 1110 1106-7, 1107 (Postmodern) Reconstruction (Douglas) 1064, 1064 assemblages 1026, 1084-5, 1085, 1086, 1087 African Americans Art Nouveau 1004, 1004-5, 1005 Harlem Renaissance 1060-61, 1064-5 Bauhaus 1054, 1054, 1055 Association of Artists of Revolutionary Russia painting 983, 983-4, 1065, 1065, 1112, 1112 Belgium 1004, 1004-5, 1005 (Art Nouveau) (AKhRR) 1052 quiltmaking 1111, 1111-12 Britain 918, 918-19 (Neo-Palladian), 920, atomic bombs 1018 sculpture 982-3, 983, 1064, 1064-5 921-2, 922, 958-9, 959, (Gothic Revival), atrial crosses (Spanish American) 943, 943 After "Invisible Man" by Ralph Ellison, The Preface 1007, 1007-8 (19th century), 1125-6, AT&T Corporate Headquarters, New York (Wall) 1130, 1131 1126 (1980s) (Johnson and Burgee) 1106-7, 1107 AIDS 1118, 1120-21 Chicago School 1009, 1009-12, 1011, 1012 (model) Albani, Cardinal Alessandro 915-16 Deconstructivist 1126, 1127, 1128 Augustinian missionaries 943 De Stijl 1052, 1053, 1054 Albers, Anni (née Annelise Fleischmann) 1055 France 912-13, 913 (Rococo), 932, 933, 934 architecture 1044-5, 1045 (Modernist) silk wall hanging 1055, 1055, 1057 (Neoclassical), 962, 963, 965-6, 966, painting 1029, 1029 Albers, Josef 1055, 1056 Albert, Prince Consort 1008 1008, 1008 (19th century), 1045, 1045-6 automatism 1057 Automatistes, Les 1079 Alembert, Jean le Rond d' 934 (Modernist) Alloway, Lawrence 1092 Germany 912-13, 913 (Rococo), 959-60, Autumn Rhythm (Number 30) (Pollock) 1075, Amaral, Tarsila do 1070-71 960 (Neoclassical), 1054, 1054, 1055 avant-garde artists (19th century) 972, 988, 1007, Abaporú (The One Who Eats) 1070, 1071 (Bauhaus), 1126, 1126 (Deconstructivist) American Gothic (Wood) 106, 1067, 1067 Gothic Revival 920, 921-2, 922, 958-9, 959 1038 American Revolution (1776) 906 International Style 1052, 1057, 1104, 1104 American Society of Independent Artists 1038, Modernist 1044-6, 1045 (European), 1046, В 1046, 1047, 1048, 1048, 1104, 1104-6, Baca, Judith F.: The Division of the Barrios (from American War of Independence 906 1105 (American) The Great Wall of Los Angeles) 1112, 1113 Americans (Frank) 1090 Neoclassical 932, 933, 934 (French), 959-60, 960 (German), 960, 960-61, 961 Bacon, Francis 1071

(American)

Andrade, Oswald de: Anthropophagic Manifesto

Andrews, Robert: portrait (Gainsborough) 924,

1070, 1071

Andre, Carl 1095

Neo-Palladian 918, 918-19

Rococo 912-13, 913

Postmodern 1106, 1106-7, 1107

Netherlands 1052, 1053, 1054 (De Stijl)

Head Surrounded by Sides of Beef 1071, 1071

Ball, Hugo 1037, 1039 Bleyl, Fritz 1026 sculpture 1060, 1060 Hugo Ball Reciting the Sound Poem "Karawane" Boccioni, Umberto 1033, 1034 silverwork 921 1037, 1037 Unique Forms of Continuity in Space 1033-4, Young British Artists 1118, 1119, 1123 Ballets Russes 1034 see also London Balzac, Honoré de 972 Boffrand, Germaine: Salon de la Princesse, Hôtel British Committee to Abolish the Slave Trade 921 Bamberg, Bavaria, Germany: church of the de Soubise, Paris 907, 907-8 Brody, Sherry 1101 Vierzehnheiligen (Neumann) 912-13, 913 Bohr, Niels 1018 bronzes Banjo Lesson, The (Tanner) 983, 983-4 Bologna, Italy: Academy of Art 914 African-American 1064, 1064-5 Bar at the Folies-Bergère, A (Manet) 979, 979-80 Bonaparte, Joseph 942 French (19th century) 1002, 1003, 1003 Barcelona, Spain: Casa Batllò (Gaudí) 1005, 1005 Bonaparte, Napoleon see Napoleon Bonaparte Italian Futurist 1033-4, 1034 Bargehaulers on the Volga (Repin) 980, 980 Bonaparte Crossing the Alps (David) 946, 946, 957 Brooklyn Museum of Art: "Sensation: Young Barney, Matthew: The Cremaster Cycle 1132, 1132 Bonheur, Rosa 975, 976 British Artists from the Saatchi Collection" Baroque 907, 909 The Horse Fair 975-6, 976 1118, 1119-20 Barry, Sir Charles: Houses of Parliament, London Bonheur de Vivre, Le (The Joy of Life) (Matisse) Brown, Lancelot ("Capability") 919 958-9, 959 1021, 1021, 1023 Brücke, Die (The Bridge) 1026-8, 1027, 1028 Basquiat, Jean-Michel 1108-9 Borghese, Prince Camillo 917 Brussels: Tassel House (Horta) 1004, 1005 Horn Players 1108, 1109 Borghese, Pauline 917 Bulfinch, Charles: U.S. Capitol, Washington, DC 961 Bateman, Ann and Peter: George III goblet 921 Pauline Borghese as Venus (Canova) 917, 917 Bunbury, Lady Sarah 924 Bateman, Hester: George III double beaker 921 Boston, Massachusetts Lady Sarah Bunbury Sacrificing to the Graces Baudelaire, Charles 976 Public Garden 1010 (Reynolds) 923-4, 924 "The Painter of Modern Life" 976 Tea Party (1773) 905 Buñuel, Luis 1063 Bauhaus 1054-5, 1056, 1057 Bottle of Suze (Picasso) 1025, 1025-6 Burgee, John: AT&T Corporate Headquarters, architecture 1054, 1054, 1055 Boucher, François 908, 910, 911 New York 1106-7, 1107 (model) silk wall hanging 1055, 1055, 1057 Girl Reclining: Louise O'Murphy 910, 910 Burghers of Calais, The (Rodin) 1002, 1003 silver coffee and tea service 1055, 1055 Bouteille de Suze, La (Bottle of Suze) (Picasso) Burial at Ornans, A (Courbet) 973, 973-4 Beauvais tapestry manufactory 910 1025, 1025-6 Burke, Edmund 955 Beecroft, Vanessa 1132 Brady, Mathew 970 Burlington, Richard Boyle, 3rd Earl of 918 VB35 1132-3, 1133 Brancusi, Constantin 1036 Chiswick House, London 918, 918-19, 932 Bélaird (printmaker) 953 The Newborn 1036, 1036 Burning of the Houses of Lords and Commons, 16th Belgium Torso of a Young Man 1036, 1036-7 October 1834 (Turner) 956, 957 art 1002, 1003 Brandt, Marianne 1055 Burnt Piece (Winsor) 1099, 1099 Art Nouveau architecture 1004, 1004-5 coffee and tea service 1055, 1055 Burrows, Alice and George: George III snuffbox Belley, Jean-Baptiste 938 Braque, Georges 1021, 1024, 1025, 1031, 1041 921 portrait (Girodet-Trioson) 938, 938 Violin and Palette 1024, 1024 Burty, Philippe 996 Benedict XIV, Pope 943 Brazil 1070 Bentley, Richard: Strawberry Hill Picture Gallery, painting 1070, 1070-71 C Twickenham, England 922, 922 Breton, André 1057, 1069, 1072, 1073 Berger, John 1101 "Manifesto of Surrealism" 1057 Cabanel, Alexandre 966 Berlin 1027-8 Bridge, The 1026-8, 1027, 1028 The Birth of Venus 966, 967, 977, 978 Altes Museum (Schinkel) 959-60, 960 Brillo Soap Pads Box (Warhol) 1092, 1092 Cabaret Voltaire, Zürich 1037 Club Dada 1039 Britain 906, 913, 928, 984, 1018, 1037, 1084 Cabrera, Lydia 1072 Street, Berlin 1028, 1028, 1056 architecture 918, 918-19 (Neo-Palladian), 920, CAD (computer-aided design) 1125 Beuys, Joseph 1097, 1102 921-2, 922, 958-9, 959 (Gothic Revival), Cage, John 1084-5, 1087, 1128 How to Explain Pictures to a Dead Hare 1097, 1007, 1007-8 (19th century), 1125-6, 4'33" 1085 1097 1126 (1980s) Caillebotte, Gustave 993 Bibliothèque Nationale, Paris (Labrouste) 1008, ceramics 919, 920 Paris Street, Rainy Day 993-4, 994 1008 iron bridges 928, 928 (18th century) Calder, Alexander 1063 Big Raven (Carr) 1068, 1068 landscape gardens 919, 919 calotypes 969 Bilbao, Spain: Guggenheim Museum (Gehry) landscape painting 954-5, 955, 956, 957 camera obscura 915, 968 1126, 1127, 1128 (Romantic) Camera Work (magazine) 1041 biomorphic forms 1058, 1059, 1059-60 Neoclassicism 917 cameras 971, 971 Birth of Liquid Desires (Dalí) 1058, 1058 painting 922-31, 923-7, 929-31 (18th Cameron, Julia Margaret 971 Birth of Venus, The (Cabanel) 966, 967, 977, 978 century), 954-5, 955, 956, 957 Portrait of Thomas Carlyle 971, 971 Black Mountain College, North Carolina 1084, (Romantic), 984, 984 (Pre-Raphaelite), Campbell, Colen 918 1087 1071, 1071 (postwar) Canadian landscape painting 1067, 1067-8 Black Phoenix (magazine) 1124 philosophy 906, 955 Canaletto (Giovanni Antonio Canal) 915 Black Square, The (Malevich) 1034 photography 969-70, 970, 971, 971 The Doge's Palace and the Riva degli Schiavoni Blake, William 930-31 Pop art 1091, 1091-2 (Canaletto) 914, 915 Newton 931, 931 portraiture 923-4, 924, 925 Canova, Antonio 916-17 Blaue Reiter, Der ("The Blue Rider") 1029 Romanticism 917-18; in painting 954-5, 955, Pauline Borghese as Venus 917, 917 Blériot, Louis 1031

956, 957

Canyon (Rauschenberg) 1086, 1087

capitalism 1018, 1104 cappricio (pl. capricci) 915 Caprichos, Los (Goya) 940-41, 941 Caricature, La (magazine) 953 Carlyle, Thomas: photographic portrait (Cameron) 971, 971 Carpeax, Jean-Baptiste 967 The Dance 967, 967 Carr, Emily 1068 Big Raven 1068, 1068 Carriera, Rosalba 914 Charles Sackville, 2nd Duke of Dorset 914, 915 Carter, Frances 924, 925 Casa Batllò, Barcelona (Gaudí) 1005, 1005 Cassatt, Mary 993 Mother and Child 993, 993 Castle of Otranto, The (Walpole) 921 Catherine II ("the Great") 939 Central Park, New York (Olmsted and Vaux) 1010, 1010 ceramics Sèvres 910 Wedgwood jasperware 919, 920 Cézanne, Paul 987, 1007, 1012-13, 1041 The Large Bathers 1014, 1015, 1023 Mont Sainte-Victoire 1013, 1013-14 Still Life with Basket of Apples 1014, 1014 Chandelier Mori (Wilson) 1136, 1136 Chardin, Jean-Siméon 934 The Governess 934, 934 Charivari, Le (newspaper) 953, 987 Charles III, of Spain 940 Charles IV, of Spain 940 Charles X, of France 951 Charles, Jean 948 Charlottesville, Virginia: Monticello (Jefferson) 961, 961 Chermayeff, Serge 1061 Chevreul, Michel-Eugène 995, 1032 Chicago, Illinois 1007, 1009, 1041, 1049 Court of Honor, World's Columbian Exposition (1893) (Hunt) 1009, 1009 Marshall Field Wholesale Store (Richardson) 1010-11, 1011 "Prairie School" 1046 Robie House (Wright) 1046, 1046, 1047 Stateway Gardens 1113 World's Columbian Exposition (1893) 1009, 1009, 1046 Chicago, Judy 1101 The Dinner Party 1100, 1100, 1101 Womanhouse 1101 Chihuly, Dale 1130 The Sun 1130, 1130 Child with a Toy Hand Grenade in Central Park, New York (Arbus) 1090 China Monument: Temple of Heaven (Gu) 1133, 1133-4 Chiswick House, London (Burlington) 918, 918-19, 932

interior and gardens (Kent) 919

Chopin, Frederic 987 Christo (Javacheff) and Jeanne-Claude (de Guillebon) 1103 The Gates, Central Park, New York 1103, 1103 Churchill, Winston 1071, 1084 Chute, John: Strawberry Hill Picture Gallery, Twickenham, England 922, 922 Cincinnatus 940 Citadelle, La: Freedom (Savage) 1064, 1065 Claude Lorrain 919 Claudel, Camille 1003 The Waltz 1003, 1003, 1004 Clodion (Claude Michel) 908 The Invention of the Balloon (Clodion) 912, 912 Clothes and Customized Citroën B-12 (S. Delaunay (-Terk)) 1032, 1032-3 Coalbrookdale, England: Severn River bridge (Darby) 928, 928 "Cold War" 1084, 1087 Cole, Thomas 957 The Oxbow 957, 957-8 collage 1025, 1025-6, 1039, 1039-40, 1040, 1091, 1091-2 Color Field painting 1074, 1079, 1080 Color Me series (Searle) 1124, 1125 Colter, Mary 1048 Lookout Studio, Grand Canyon National Park, Arizona 1048, 1048 combines (Rauschenberg) 1086, 1087 communism 1018, 1022 Communist Manifesto (Marx and Engels) 964 complementary colors 995 Composition (Miró) 1059, 1059 Composition with Yellow, Red, and Blue (Mondrian) computer-aided design (CAD) 1125 Conceptual art 1096-7, 1097, 1098, 1099 Constable, John 954-5 The Hay Wain 955, 955 Constructivism, Russian 1050, 1050-51, 1126 Cooke, Elizabeth: George III salver 921 Copley, John Singleton 905, 931, 932 Thomas Mifflin and Sarah Morris (Mr. and Mrs. Mifflin) 904, 905 Watson and the Shark 931-2, 932 Corday, Charlotte 937 Corneille, Pierre: Horace 936 Cornelia Pointing to Her Children as Her Treasures (Kauffmann) 927, 927 Corner Counter-Reliefs (Tatlin) 1035, 1035 Corot, Jean-Baptiste-Camille 975, 991 First Leaves, near Mantes 975, 975 Couple Wearing Raccoon Coats with a Cadillac (Van Der Zee) 1061, 1061 Courbet, Gustave 972, 974, 986, 987 A Burial at Ornans 973, 973-4 The Stone Breakers 972, 972-3 Couture, Thomas 976 Cremaster Cycle, The (Barney) 1132, 1132 Crossing, The (Viola) 1128-9, 1129 Crystal Palace, London (Paxton) 1007, 1007-8

Cuban art 1070, 1071, 1072, 1072, 1102, 1102 Cubi (D. Smith) 1080, 1081 Cubism 1017, 1021, 1031 Analytic 1024-5 Synthetic 1025-6 "Culture Wars" (USA) 1116, 1118, 1120 Cunningham (Merce) Dance Company 1087 Curie, Marie 933 curtain walls 1045-6 Cut with the Dada Kitchen Knife Through the Last Weimar Beer-Belly Cultural Epoch in Germany (Höch) 1040, 1040 D Dada 1019, 1037-8, 1037, 1037-9, 1038, 1057, 1096 - 7Berlin Dada 1039, 1039-40, 1040 Daguerre, Louis-Jacques-Mandé 969 The Artist's Studio 969, 969 daguerreotypes 969, 969 Dalí, Salvador 1057-8, 1073 Birth of Liquid Desires 1058, 1058 Dance, The (Carpeaux) 967, 967 Darby, Abraham, III: Severn River bridge, Coalbrookdale, England 928, 928 Darkytown Rebellion (Walker) 1136, 1137 Darwin, Charles 964 Daubigny, Charles-François 987 Daumier, Honoré 953 The Print Lovers 954, 954 Rue Transnonain, Le 15 Avril 1834 953, 953-4 David, Jacques-Louis 936, 937, 938, 946 Death of Marat 937, 937-8 Napoleon Crossing the Saint-Bernard (Bonaparte Crossing the Alps) 946, 946, 957 Oath of the Horatii 936, 936-7, 943 Davies, Arthur B. 1041 Day of the God (Gauguin) 999, 1000 Death of General Wolfe, The (West) 928-30, 930, 932, 940 Death of Marat (David) 937, 937-8 Deconstructivist architecture 1126, 1127, 1128 Degas, Edgar 979, 987, 991, 993, 1006 The Rehearsal on Stage 991, 992, 993 The Tub 992, 993 "Degenerate Art" exhibition, Munich (1937) 1056, 1056 Déjeuner sur l'Herbe, Le (The Luncheon on the Grass) (Manet) 976-7, 977, 1023 de Kooning, Elaine (née Fried) 1076 de Kooning, Willem 1076, 1087 Woman I 1076-7, 1077 Delacroix, Eugène 950 Liberty Leading the People: July 28, 1830 950, 950-51 Delaunay, Robert 1031 Homage to Blériot 1031, 1031-2 Delaunay(-Terk), Sonia 1031, 1032-3 Clothes and Customized Citroën B-12 1032, 1032 - 3

Demoiselles d'Avignon, Les (Picasso) 1023, 1023-4 Eiffel, Gustave: Eiffel Tower, Paris 962, 963, Forms in Echelon (Hepworth) 1060, 1060 Departure of the Volunteers of 1792 (Rude) 951, 1004, 1031 Einstein, Albert 1018 Derain, André 1019, 1025 Electric Light (Goncharova) 1034, 1034 Mountains at Collioure 1020, 1020 Electronic Superhighway: Continental U.S. (Paik) 1128, 1128 Derrida, Jacques 1126 Description de l'Egypte 968 elevators, electric 1011 Dessau, Germany: Bauhaus Building (Gropius) Ellington, Duke 1060 1099 1054, 1055, 1056 Ellison, Ralph: The Invisible Man 1130 4'33" (Cage) 1085 De Stijl 1052, 1054, 1057 Encyclopédie (Diderot and d'Alembert) 934 architecture 1052, 1053, 1054 Engels, Friedrich see Marx, Karl furniture 1052, 1054 England see Britain paintings 1052, 1053 engravings 977, 978 1037, 1084 De Stijl (magazine) 1052 Enlightenment, the 906, 907, 919, 922, 924, Deutscher Werkbund: Weissenhofsiedlung exhibition, Stuttgart (1927) 1057 Ensor, James 1003 Diaghilev, Sergei: Ballets Russes 1034 The Intrigue 1002, 1003 Díaz, General Porfirio 1068 Ernst, Max 1057, 1073 Dickens, Charles 972 The Horde 1057, 1058 Diderot, Denis 934, 939 etchings 915, 915, 940-41, 941, 978 Encyclopédie 934 Etruria pottery factory, Staffordshire, England Diego, Juan 943 digital photography 971, 1130 Experiment on a Bird in the Air-pump, An (J. Dinner Party, The (Chicago) 1100, 1100, 1101 Wright) 924, 925, 926 Division of the Barrios, The (from The Great Wall of Expressionism 999, 1003 Los Angeles) (Baca) 1112, 1113 German and Austrian 1028, 1028-9, 1029, "Divisionism" 995 documentary photography 970, 970, 1066, 1066 Documents (exhibitions), Kassel, Germany 1129 F Doesburg, Theo van 1052 Dollhouse (Schapiro) 1101 Fallingwater, Mill Run, Pennsylvania (Wright) Dominican missionaries 943 1046, 1047, 1048 Dorset, Charles Sackville, 2nd Duke of: portrait Family of Charles IV (Goya) 941, 941-2 century) (Carriera) 914, 915 Family of Saltimbanques (Picasso) 1022, 1022 Douglas, Aaron 1061, 1065 FAP see Federal Arts Project posters 1006, 1006-7 Aspects of Negro Life: From Slavery Through fascism 1018, see also Nazi Party Reconstruction 1064, 1064 Fauves/Fauvism 1019-21, 1020, 1021 Dove, Arthur 1041, 1043 Federal Art Project 1066 Nature Symbolized No. 2 1041, 1043 Fehrmann, Fränzi 1027 Doyen, Gabriel-François 911-12 feminism/feminist art 1100-2, 1100-2, 1109, Dresden, Germany 916 1109-11, 1110 Academy of Art 926 Ferdinand VII, of Spain 943 DuBois, W.E.B. 1064-5 Ferus Gallery, Los Angeles 1093 Duchamp, Marcel 1037-8, 1039, 1087, 1092, fêtes galantes 910 Frank, Robert 1090 1096-7 Finley, Karen 1118 Americans 1090 Fountain 1038, 1038-9, 1092, 1099 Fiore Internationale d'Art Contemporain, Paris L.H.O.O.Q. 1038, 1039 1129 Nude Descending a Staircase, No. 2 1037 First Leaves, near Mantes (Corot) 975, 975 du Châtelet, Madame 907 Flatiron Building, New York (Stieglitz) 1041, Dumas, Alexandre: Olympia 978 1041 Durand-Ruel, Paul 987 Fleck, John 1118 Flitcroft, Henry and Hoare, Henry: Park at Stourhead, Wiltshire, England 919, 919

Florence, Italy 913

follies, garden 919

Academy of Art 914

Fontenelle, Bernard de 906

Formalism 1073, 1083

For the Love of God (Hirst) 1119

Forever Free (Lewis) 982-3, 983

Fontainebleau, Palace of, France 910

Eakins, Thomas 980-81, 981, 983 The Gross Clinic 981, 981-2 Earth art/earthworks 1102, 1103 East India Company 905 École des Beaux-Arts, Paris 946, 964, 967, 980, 990, 991, 993, 995, 1003, 1007, 1008, 1009, 1011

Foster, Norman: Hong Kong & Shanghai Bank, Hong Kong 1125-6, 1126 Foucault, Jean-Bernard 933 Foundation of Modern Art, The (Le Corbusier and Ozenfant) 1033 Fountain (Duchamp) 1038, 1038-9, 1092, Fragonard, Jean-Honoré 908, 911 The Swing 911, 911-12 France 906, 907, 913, 928, 932, 987, 1018, architecture 912-13, 913 (Rococo), 932, 933, 934 (Neoclassical), 962, 963, 965-6, 966, 1008, 1008 (19th century), 1045, 1045-6 (Modernist) Art Nouveau furniture 1006, 1006 First Republic (1792-95) 912, 937 literature 972, 1000-1 lithography 953, 953-4, 954, 1006, 1006-7 magazines and newspapers 953, 987 painting 908, 908-12, 909-11 (Rococo), 934, 934-9, 935-9 (18th century), 946-51, 947-50, 952, 952 (Romantic), 972 (avant-garde), 972, 972-80, 973-9 (Realist), 979, 987-91, 988-92, 993, 994 (Impressionist), 994-5, 995, 999, 1000 (Post-Impressionist), 1001, 1001 (Symbolist), 1019-21, 1020, 1021 (Fauves), 1021, 1024, 1024, 1025 (Cubist), 1031-3, 1032 (early 20th photography 969, 969 sculpture 908, 912, 912 (Rococo), 951, 951 (Romantic), 967, 967, 994, 1002, 1003, 1003 (19th century) Second Republic (1848-52) 972 see also French Revolution; Paris Franciscan missionaries 943 Franco, General Francisco 1018, 1063 Franco-Prussian War (1870-71) 987 Trolley, New Orleans 1090, 1090-91 Frankenthaler, Helen 1079 Mountains and Sea 1078, 1079 Franklin, Benjamin 921, 939 French Revolution (1789) 906, 907, 937, 938 French Royal Academy of Painting and Sculpture, Paris 910, 911, 914, 926, 935, 938-9, 964, see also Salon, Paris Freud, Sigmund 930, 1057 The Interpretation of Dreams 1000, 1018 Fried, Michael 1096 Friedrich, Caspar David 958 Abbey in an Oak Forest 958, 958 Frieze Art Fair, London 1129 frottage 1057

Fry, Roger 994-5

furniture Art Nouveau desk 1006, 1006 Arts and Crafts chair 985, 985 De Stijl chair 1052, 1054 Fuseli, John Henry 929 The Nightmare 929-30, 930 Futurism, Italian 1033, 1033-4, 1034, 1037 Gainsborough, Thomas 924 Robert Andrews and Frances Carter (Mr. and Mrs. Andrews) 924, 925 Garden in Sochi (Gorky) 1074, 1074 Chiswick House, London (Kent) 919 Stourhead (Flitcroft and Hore), Wiltshire, England 919, 919 Gardner, Alexander 970 The Home of the Rebel Sharpshooter: Battlefield at Gettysburg 970, 970-71 Garnier, Charles: Opéra, Paris 965-6, 966, 967 Garvey, Marcus 1064 Gates, Central Park, New York (Christo and Jeanne-Claude) 1103, 1103 Gaudí v Cornet, Antonio 1005 Casa Batllò, Barcelona 1005, 1005 Gauguin, Paul 999, 1028 Mahana no atua (Day of the God) 999, 1000 Gehry, Frank O. 1126 Guggenheim Museum, Bilbao, Spain 1126, 1127, 1128 George III, of Britain 915, 924, 928 Géricault, Théodore 947, 949, 950 The Raft of the "Medusa" 947, 948, 948-9, 950, 1113 The Sighting of the "Argus" 948, 949 Study of Hands and Feet 949, 949 Germany 1018, 1037 architecture 912-13, 913 (Rococo), 959-60, 960 (Neoclassical), 1054, 1054, 1055 (Bauhaus), 1126, 1126 (Deconstructivist) Dada collage 1039, 1039-40, 1040 painting 916, 916 (Neoclassical), 958, 958 (Romantic), 1026-8, 1027, 1028 (Die Brücke/The Bridge), 1028, 1028-9, 1029, 1056 (Expressionist), 1029, 1030 (Der Blaue Reiter/"The Blue Rider"), 1107-8, 1108 (Neo-Expressionist), 1109, 1109 (Postmodern), 1071, 1072 (Art Informel) Rococo church decoration 912-13, 913 see also Nazi Party Gérôme, Jean-Léon 968 The Snake Charmer 968, 968 Gersaint, Edmé-François 908, 909 Gilbert, Cass: Woolworth Building, New York

1049, 1050

Gillespie, Dizzy 1109

910

Girl Reclining: Louise O'Murphy (Boucher) 910,

Girodet-Trioson, Anne-Louis 938 Portrait of Jean-Baptiste Belley 938, 938 Giuliani, Mayor Rudolph 1118, 1120 Gleaners, The (Millet) 974, 974 Gobelins tapestry manufactory 910 Goethe, Johann Wolfgang von 958 Gogh, Vincent van 996, 998-9 Japonaiserie: Flowering Plum Tree 996, 997 The Starry Night 998, 999 Goncharova, Natalia: Electric Light 1034, 1034 Gonzales-Torres, Felix: "Untitled" (Loverboy) 1120, 1120-21 Goodacre, Glenda: Vietnam Memorial 1116 Gorky, Arshile 1074, 1077 Garden in Sochi 1074, 1074 Gothic Revival 921 architecture 920, 921-2, 922, 958-9, 959 Goupil, Adolphe 978 Governess, The (Chardin) 934, 934 Goya y Lucientes, Francisco 940, 943 Family of Charles IV 941, 941-2 The Sleep of Reason Produces Monsters (from Los Caprichos) 940-41, 941 Third of May, 1808 942, 942-3 Grand Canyon National Park, Arizona: Lookout Studio (Colter) 1048, 1048 "Grand Manner" (Reynolds) 923, 924, 928, 946, 949 Grand Tour, the 913 grattage 1057 Great City of Tenochtitlan, The (Rivera) 1069, 1069 Great Depression 1018, 1066, 1113 Great Exhibition of the Industry of All Nations, London (1851) 1007 Great Wall of Los Angeles, The (Baca) 1112, 1113 Green Painting IV (Araeen) 1124, 1125 Greenberg, Clement 1073, 1075, 1083 Greuze, Jean-Baptiste 934 The Village Bride (The Marriage, The Moment when a Father Gives his Son-in-law a Dowry) 934. 935 Gris, Juan 1025 Gropius, Walter 1054-5, 1056, 1057, 1104 Bauhaus Building, Dessau 1054, 1055 "Bauhaus Manifesto" 1054 Gros, Antoine-Jean 946 Napoleon in the Plague House at Jaffa 946-7, Gross Clinic, The (Eakins) 981, 981-2 Group of Seven 1068 Gu. Wenda 1133, 1134 China Monument: Temple of Heaven 1133, Guernica (Picasso) 1062-3, 1062-3 Guerrilla Girls, The 1110 The Advantages of Being a Woman Artist 1110, 1110 Guggenheim, Peggy: gallery 1075 Guggenheim Museum, Bilbao, Spain (Gehry) 1126, 1127, 1128

Guggenheim Museum, New York (Wright) 1105, 1105-6, 1128 Guillebon, Jeanne-Claude de see Christo and Ieanne-Claude Guimard, Hector 1006 desk 1006, 1006 Paris Métro entrances 1006 Gutai Group, the 1087, 1088 Н Hackwood, William: "Am I Not a Man and a Brother?" medallion 920, 921 Hadid, Zaha 1126 Vitra Fire Station, Weil-am-Rhein, Germany 1126, 1127 Haiti 938 Haitian Revolution (1791) 1065 Hamilton, Gavin 915, 916 Hamilton, Richard 1091 Just What Is It That Makes Today's Homes So Different, So Appealing? 1091, 1091-2 Hamilton, William 919 Hammons, David 1134 Untitled 1134, 1134 Happenings 1087, 1088 Harlem Renaissance 1060-61, 1064-5 Hart, Frederick: Vietnam Memorial 1116 Hartley, Marsden 1043 Portrait of a German Officer 1042, 1043 Haussmann, Georges-Eugène 965, 1010 Hay Wain, The (Constable) 955, 955 Head Surrounded by Sides of Beef (Bacon) 1071, 1071 Heath of the Brandenburg March (Kiefer) 1107-8, Heckel, Erich 1026 Standing Child 1027, 1027 Heisenberg, Werner 1018 Hepworth, Barbara 1060 Forms in Echelon 1060, 1060 Herculaneum, Italy 913, 916 Herschel, Sir John Frederick 969 Hesse, Eva 1099 Not Title 1098, 1099 Hiroshige (Ando Tokitaro): Plum Orchard, Kameido 996, 996 Hirst, Damien 1116, 1119 For the Love of God 1119 Mother and Child (Divided) 1119, 1120 historicism 965 history paintings 923-4, 926-9, 927, 929, 936,

936-7, 950, 950-51 Hitchcock, Henry-Russell 1057 Hitler, Adolf 1018, 1055, 1056, 1057 Hoare, Henry: Stourhead gardens, Wiltshire, England (with Flitcroft) 919, 919 Höch, Hannah 1040 Cut with the Dada Kitchen Knife Through the

Last Weimar Beer-Belly Cultural Epoch in

Germany 1040, 1040

Hofmann, Hans 1075, 1076

Hogarth, William 922 The Marriage Contract (from Marriage à la Mode suite) 922-3, 923, 934 Holy Virgin Mary, The (Ofili) 1118, 1118, 1119-20 Homage to Blériot (R. Delaunay) 1031, 1031-2 Home of the Rebel Sharpshooter: Battlefield at Gettysburg (Gardner) 970, 970-71 Homeless Vehicle (Wodiczko) 1121, 1122, 1123 Homer, Winslow 982 The Life Line 982 Hong Kong & Shanghai Bank, Hong Kong

(Foster) 1125-6, 1126 Horde, The (Ernst) 1057, 1058 Horn Players (Basquiat) 1108, 1109 Horse Fair, The (Bonheur) 975-6, 976 Horta, Victor 1004-5, 1006

Tassel House, Brussels 1004, 1005 hôtels, Parisian 907,

Houdon, Jean-Antoine 939, 953 George Washington 939-40, 940 House (Whiteread) 1123, 1123

Houses of Parliament, London (Barry and Pugin) 958-9, 959

How To Blow Up Two Heads At Once (Ladies) (Shonibare) 1134, 1135

How To Explain Pictures To a Dead Hare (Beuvs) 1097, 1097

Huelsenbeck, Richard 1039

Hughes, Holly 1118 Hughes, Langston 1060

Hujar, Peter 1121

Hunt, Richard Morris 1009

Court of Honor, World's Columbian Exposition, Chicago (1893) 1009, 1009 Hurling Colors (Shimamoto) 1087, 1088 Huysmans, Joris-Karl: A Rebours 1000-1

ı

Impression: Sunrise (Monet) 987, 988, 988 Impressionist painting 979, 987-91, 988-92, 993,

Improvisation 28 (Kandinsky) 1030, 1031 Independent Group 1091 Industrial Revolution 906, 964 Ingres, Jean-Auguste-Dominique 952 Large Odalisque 952, 952, 1110 Portrait of Madame Désiré Raoul-Rochette 952-3,

installation art 1051, 1051, 1101, 1130-32, 1131

Institute of Contemporary Arts, London 1091 International Exposition, Paris (1855) 974 International Exposition of Modern Decorative and Industrial Arts, Paris (1925)

Workers' Club (Rodchenko) 1050, 1051 International Style (architecture) 1052, 1057, 1104, 1104

Internet, the 1129

Interpretation of Dreams, The (Freud) 1000, 1018 Intrigue, The (Ensor) 1002, 1003

Iranian photography 1124, 1124 iron, use of 928, 962, 963, 1007-8 Italy 1018 academies of art 914 Grand Tour 913 painting 914, 914-15 (18th century) prints 915, 915 sculpture 916-17, 917 (Neoclassical), 1033-4, 1034 (Futurist)

J

Iack Pine, The (Thomson) 1067, 1067-8 Jacobins 937, 938 Jacobs, Jane: The Death and Life of Great American Cities 1106 Jane Avril (Toulouse-Lautrec) 1006, 1006-7 Japanese prints 993, 996, 996 Japonaiserie: Flowering Plum Tree (van Gogh) 996, 997 Japonisme 996 Jefferson, Thomas 939, 960 Monticello, Charlottesville, Virginia 961, 961 Jenney, William Le Baron 1011 Jesuits 945

Johns, Jasper 1083, 1084, 1087, 1090, 1092 Target with Plaster Casts 1082, 1083, 1087 Johnson, Philip 1057

AT&T Corporate Headquarters, New York 1106-7, 1107 (model)

Seagram Building, New York 1104, 1104 Joy of Life, The (Matisse) 1021, 1021, 1023 Judd, Donald 1095, 1096

Untitled (1969) 1096, 1096

Jung, Carl 1073, 1074-5

Just What Is It That Makes Today's Homes So Different, So Appealing? (R. Hamilton) 1091, 1091 - 2

K

Kahlo, Frida 1069, 1070 The Two Fridas 1069, 1069-70 Kahnweiler, Daniel-Henry 1024-5 portrait (Picasso) 1024, 1025 Kandinsky, Vassily 1029, 1031, 1041, 1056 Concerning the Spiritual in Art 1031 Improvisation 28 1030, 1031 Kaprow, Allan 1087, 1094 Yard 1087, 1088

Kauffmann, Angelica 915, 926, 926-7 Cornelia Pointing to Her Children as Her Treasures 927, 927

Kaufmann, Edgar 1048

Kaufmann House, Mill Run, Pennsylvania (Wright) 1046, 1047, 1048

Kent, William: Chiswick House (interior and gardens), London 918, 919

Kerouac, Jack 1090

Kiefer, Anselm 1107

Heath of the Brandenburg March 1107-8, 1108

Kinetic Group Theater 1089 Kino, Father Eusebio 945 Kirchner, Ernst Ludwig 1026, 1056 Street, Berlin 1028, 1028, 1056 Klee, Paul 1056 Klein, Yves Anthropometries of the Blue Period 1088 Leap into the Void 1088, 1089 Knight Watch (Riopelle) 1078, 1079 Kollwitz, Käthe 1028 The Outbreak 1028, 1028 Koons, Jeff 1114 Pink Panther 1114, 1114 Korean War (1950-53) 1084 Kosuth, Joseph 1097 One and Three Chairs 1097, 1097, 1099 Krasner, Lee 1075, 1076 The Seasons 1076, 1076 Kruger, Barbara 1110-11 Untitled (Your Gaze Hits the Side of My Face)

1110, 1110-11 Ku Klux Klan 1064 Kuhn, Walt 1041

L

La Fayette, Madame de 907 Labille-Guiard, Adélaïde 938-9 Self-Portrait with Two Pupils 938, 939 Labrouste, Henri 1008 Bibliothèque Nationale, Paris 1008, 1008 Lady Sarah Bunbury Sacrificing to the Graces (Reynolds) 923-4, 924 Ladybug (Mitchell) 1077, 1077, 1079 Lafavette, marquis de 939 Lam, Wifredo 1072 Zambezia, Zambezia 1072, 1072 landscape painting American 957, 957-8 British 954-5, 955, 956, 957 (Romantic) Canadian 1067, 1067-8 German 958, 958

French 975, 975, 989, 989-90 (19th century) Lange, Dorothea 1066 Migrant Mother, Nipomo, California 1066, 1066 Large Bathers, The (Cézanne) 1014, 1015, 1023 Large Blue Horses, The (Marc) 1029, 1030 Large Odalisque (Ingres) 952, 952, 1110 Last Painting (Rodchenko) 1050 Latrobe, Benjamin Henry: U.S. Capitol, Washington, DC 960, 960-61

Lavender and Mulberry (Rothko) 1079, 1080 Lawrence, Jacob 1065

The Migration Series 1065, 1065 Laycock, Ross 1120, 1121 Leap into the Void (Klein) 1088, 1089

Lebel, Jean-Jacques 1089

Le Corbusier (Charles-Édouard Jeanneret) 1045, 1046, 1057

"The Five Points of a New Architecture" 1045

Matisse, Henri 1019, 1020, 1041 The Foundation of Modern Art (with Ozenfant) M Le Bonheur de Vivre (The Joy of Life) 1021, 1021, Villa Savoye, Poissy-sur-Seine, France 1045, Ma Iolie (Picasso) 1016, 1017, 1025 1023 magazines 953, 964, 1090, 1091, 1095, 1096, The Woman with the Hat 1020, 1020-21 1045-6 Léger, Fernand 1025, 1037, 1070, 1073 Matiushin, Mikhail: Victory Over the Sun 1034 Meat Joy (Schneemann) 1089, 1089 Three Women 1032, 1033 Magenta, Black, Green, on Orange (No. 3/No. 13) Lenin, Vladimir 1018 (Rothko) 1080 medical developments 964 Leonardo da Vinci: Mona Lisa 1039 Mahabyn (from The Cremaster Cycle) (Barney) Meeting of Antony and Cleopatra, The (Mengs) 919 memento mori 909 Leroy, Louis 987, 988 1132, 1132 Mahana no atua (Day of the God) (Gauguin) 999, Mendieta, Ana 1102 Lewis, Edmonia 982 Untitled (from The Tree of Life series) 1102, Forever Free 982-3, 983 1000 Malevich, Kazimir 1034, 1050, 1051, 1126 1102 L.H.O.O.Q. (Duchamp) 1038, 1039 Mengs, Anton Raphael 916, 928, 940 Liberty Leading the People: July 28, 1830 The Black Square 1034 The Meeting of Antony and Cleopatra 919 (Delacroix) 950, 950-51 Suprematist Painting (Eight Red Rectangles) 1035, Parnassus 916, 916 Lichtenstein, Roy 1094-5 Oh, Jeff...I Love You, Too...But... 1094, 1095 Meninas, Las (Velázquez) 941-2 Man Shot Down (1) Erschossener (1) from October 18, 1977 (Richter) 1109, 1109 Merzbild 5B (Picture-Red-Heart-Church) Life magazine 1090 Mandolin and Clarinet (Picasso) 1026, 1026 (Schwitters) 1039, 1039 Life Line, The (Homer) 982 Manet, Édouard 976, 991 Merzbilder (Schwitters) 1039 Lin, Maya 1115 Mexican painting 1068-70, 1069 Vietnam Veterans Memorial, Washington, DC A Bar at the Folies-Bergère 979, 979-80 1115-16, 1116 Le Déjeuner sur l'Herbe (The Luncheon on the Mexican Revolution (1910) 1068 Lipstick (Ascending) on Caterpillar Tracks Grass) 976-7, 977, 1023 Mexico City Olympia 977-9, 978 Academy of Art 926 (Oldenburg) 1095, 1095 Atrial Cross, Basilica of Guadalupe (Spanish Lissitzky, El 1051 Manet, Eugène 991 American) 943, 943 Proun Space (installation) 1051, 1051 Many Mansions (Marshall) 113, 113 Michel, Claude see Clodion literature, French Symbolist 1000-1 Mapplethorpe, Robert 1116, 1118 Mies van der Rohe, Ludwig 1056, 1057, 1104, lithography 953, 953, 954, 954, 1006, 1006-7 maps Europe and North America in the 18th Locke, John 906 Seagram Building, New York 1104, 1104 London 915 century 906 Europe and the United States in the 19th Mifflin, Thomas: portrait (Copley) 904, 905 Burning of the Houses of Lords and Commons, Migrant Mother, Nipomo, California (Lange) 1066, 16th October 1834 (Turner) 956, 957 century 965 1066 Chiswick House (Burlington and Kent) 918, Europe, the Americas, and North Africa, Migration Series, The (Lawrence) 1065, 1065 918-19,932 1900-1950 1019 Crystal Palace (Paxton) 1007, 1007-8 The World since 1950 1085 Miller, Tim 1118 Millet, Jean-François 974 Frieze Art Fair 1129 Marat, Jean-Paul 937, 937 Great Exhibition of the Industry of All Marc, Franz 1029 The Gleaners 974, 974 The Large Blue Horses 1029, 1030 Minimalism 1095, 1096 Nations (1851) 1007 in sculpture 1095-6, 1096 Houses of Parliament (Barry and Pugin) 956, Marie Antoinette, Queen 934-5 957, 958-9, 959 Marie Antoinette with Her Children (Vigée-Lebrun) Mining the Museum (Wilson) 1136 Miró, Joan 1059, 1060, 1063 935, 935-6 Institute of Contemporary Arts 1091 Marilyn Diptych (Warhol) 1092-3, 1093 Composition 1059, 1059 Royal Academy of Art, London 923, 926, 926, missionaries, Christian 943 Marin, John 1041 927, 928, 984, 1119 Mr. and Mrs. Andrews (Gainsborough) 924, 925 St. Paul's Cathedral (Wren) 932 Marinetti, Filippo Tommaso: "Foundation and Mr. and Mrs. Mifflin (Copley) 904, 905 Manifesto of Futurism" 1033 Lookout Studio, Grand Canyon National Park, Mitchell, Joan 1077 Marpacífico (Hibiscus) (Peláez) 1070, 1071 Arizona (Colter) 1048, 1048 Ladybug 1077, 1077, 1079 Loos, Adolf 1044 Marquet, Albert 1019 Modernism 1007, 1107 Steiner House 1044-5, 1045 Marriage, The Moment when a Father-in-law Gives in American art 1019, 1040-41, 1043 Los Angeles: Ferus Gallery 1093 his Son-in-law a Dowry (Greuze) 934, 935 in architecture 1044-6, 1045 (European), Louis XIV, of France 909 Marriage Contract, The (from Marriage à la Mode 1046, 1046, 1047, 1048, 1048, 1104, suite) (Hogarth) 922-3, 923, 934 Louis XV, of France 907, 910 Marseillaise, The (Rude) 951, 951 1104–6, 1105 (American) portraits 910 (Boucher), 914 (Carriera) Marshall, Kerry James: Many Mansions 113, Modersohn-Becker, Paula 1028 Louis XVI, of France 936, 950 Self-Portrait with an Amber Necklace 1028-9, Louis XVIII, of France 947, 950 Marshall Field Wholesale Store, Chicago 1029 Louis-Philippe, of France 933 Moholy-Nagy, László 1055 (Richardson) 1010-11, 1011 Louvre Museum, Paris 968, 1022, 1039 Mondrian, Piet 1052, 1073 Salon Carré 926 Marx, Karl, and Engels, Friedrich: Communist Composition with Yellow, Red, and Blue 1052, Luna, James: The Artifact Piece 1113-14, 1114 Manifesto 964 1053 Lunar Society, Birmingham 924 masks, African 1022 Monet, Claude 979, 987, 989, 990 Masks (Nolde) 1027, 1027 Luncheon in Fur (Oppenheim) 1058-9, 1059

Massachusetts Institute of Technology (MIT)

1011

Luncheon on the Grass, The (Le Déjeuner sur

l'Herbe) (Manet) 976-7, 977, 1023

Impression: Sunrise 987, 988, 988

Rouen Cathedral: The Portal 988, 989

Monroe, Marilyn 1092-3, 1093 Mont Sainte-Victoire (Cézanne) 1013, 1013-14 Monticello, Charlottesville, Virginia (Jefferson) 961, 961 Moore, Henry 1060 Recumbent Figure 1060, 1061 Moreau, Gustave 1001 The Apparition 1001, 1001 Morisot, Berthe 987, 991 Summer's Day 991, 991 Morisot, Edma 991 Morley, Elizabeth: George III toddy ladle 921 Morris, Jane (née Burden) 984 Morris, Robert 1095, 1096 Untitled (Mirror Cube) 1096, 1096 Morris, Sarah: portrait (Copley) 904, 905 Morris, William 984-6 "Peacock and Dragon" curtain 985, 985 Morris & Company 985 Sussex range chair 985, 985 Morse, Samuel Finley Breese 969 daguerreotype portrait 969 Moser, Mary 926, 926 Mother and Child (Cassatt) 993, 993 Mother and Child (Divided) (Hirst) 1119, 1120 Mott, Lucretia 964 Moulin de la Galette (Renoir) 90, 990-91 Mountains and Sea (Frankenthaler) 1078, 1079 Mountains at Collioure (Derain) 1020, 1020 Mukhina, Vera: Worker and Collective Farm Woman 1052, 1052 Multiplexed (Oursler) 1130-32, 1131 Mulvey, Laura 1101 Munch, Edvard 1001 The Scream 1001, 1001 Museum of Modern Art, New York 1063 "The Art of Assemblage" (1961) 1087 "Family of Man" (1955) 1089 "The International Style: Architecture Since 1922" (1932) 1057 "An International Survey of Painting and Sculpture" (1984) 1110 Mussolini, Benito 1018

N

Namuth, Hans: Jackson Pollock 1075, 1076 Naples, Italy 913 Napoleon Bonaparte 912, 917, 933, 936, 938, 939, 942, 946, 950, 951, 968 Napoleon III, of France 965, 966, 976, 977, 978, Napoleon Crossing the Saint-Bernard (Bonaparte Crossing the Alps) (David) 946, 946, 957 Napoleon in the Plague House at Jaffa (Gros) 946-7, 947 Nash, Paul 1060 National Endowment for the Arts (NEA) 1118 Native Americans 1066, 1066

Nature Symbolized No. 2 (Dove) 1041, 1043, 1043 Nauman, Bruce 1099 Self-Portrait as a Fountain 1098, 1099 Nazi Party 1018, 1055, 1056, 1057, 1107 "Degenerate Art" exhibition, Munich (1937) 1056, 1056 NEA see National Endowment for the Arts "NEA Four" 1118 negatives, photographic 969, 970 Neoclassicism 913, 915-16, 917, 945 in architecture 932, 933, 934 (French), 959-60, 960 (German), 960, 960-61, 961 in painting 916, 916 (German), 926-7, 927 (in Britain), 936, 936-8, 937 (French) in sculpture 912, 939, 939-40 (French), 916-17, 917 (Italian), 982-3, 983 (African American) Neo-Expressionist painting 1107-9, 1108 Neo-Palladianism 918, 918-19 Neshat, Shirin 1124 Rebellious Silence 1124, 1124 Netherlands architecture 1052, 1053, 1054 (De Stijl) painting 996, 997, 998, 998-9 Neumann, Johann Balthasar: church of the Vierzehnheiligen, Bavaria, Germany 912-13, 913 Sky Cathedral 1084, 1085 Vir Heroicus Sublimis 1080, 1080 Academy of Art 926 Armory Show (1913) 1037, 1041, 1129 AT&T Corporate Headquarters (Johnson and Burgee) 1106-7, 1107 (model) Central Park (Olmsted and Vaux) 1010, 1010 The Flatiron Building (Stieglitz) 1041, 1041 The Gates, Central Park, New York (Christo and Jeanne-Claude) 1103, 1103 Guggenheim Museum (Wright) 1105, 1105-6, 1128 Metropolitan Museum of Art 976, 1110

Nevelson, Louise 1084 New Negro movement 1060 New Realism movement 1088 Newborn, The (Brancusi) 1036, 1036 Newman, Barnett 1080 newspapers 953, 964 Newton (Blake) 930, 931, 931 Newton, Sir Isaac 906 New York 1066, 1073 National Academy of Design 957 Seagram Building (Mies van der Rohe and Johnson) 1104, 1104 Trans World Airlines (TWA) Terminal, Kennedy Airport (Saarinen) 1104, 1105 Trinity Church (Upjohn) 959, 959 291 Fifth Avenue (gallery) 1040-41, 1043 Woolworth Building (Gilbert) 1049, 1050 World Trade Center (9/11) 1084 see also Brooklyn Museum; Museum of Modern Art

New York School 1080, 1083, 1088 sculpture 1080, 1081 Nietzsche, Friedrich: Thus Spake Zarathustra 1026 Nightmare, The (Fuseli) 929-30, 930 No Title (Hesse) 1098, 1099 Nochlin, Laura: "Why Have There Been No Great Women Artists?" 1101 Nocturne in Black and Gold, the Falling Rocket (Whistler) 985, 986, 987 Nolde, Emil 1027, 1056 Masks 1027, 1027 nuclear bombs 1018 Nude Descending a Staircase, No. 2 (Duchamp) 1037

O

Oath of the Horatii (David) 936, 396-7, 943 Object (Luncheon in Fur) (Oppenheim) 1058-9, 1059 Obregón, Álvaro 1068 Ofili, Chris: The Holy Virgin Mary 1118, 1118, 1119-20 Oh, Jeff...I Love You, Too...But... (Lichtenstein) 1094, 1095 O'Keeffe, Georgia 1041, 1043-4, 1100, 1100 City Night 1043, 1043 Red Canna 1043, 1044 Oldenburg, Claes 1095 Lipstick (Ascending) on Caterpillar Tracks 1095, 1095 Olmsted, Frederick Law Central Park, New York 1010, 1010 World's Columbian Exhibition landscape design 1009 Olympia (Manet) 977-9, 978 One and Three Chairs (Kosuth) 1097, 1097, 1099 One Hundred Famous Views of Edo (Hiroshige) 996, 996 Open Door, The (Talbot) 970, 970 Opéra, Paris (Garnier) 965-6, 966, 967 Oppenheim, Meret 1058-9 Object (Luncheon in Fur) 1058-9, 1059 Orientalism 964, 968 Orléans, Philippe, duc d' 907 Orphism 1032 O'Sullivan, Timothy 970 Oudot, Jean-Antoine 973 Oursler, Tony: Metro Pictures exhibition 1130-32, 1131 Outbreak, The (Kollwitz) 1028, 1028 Owens, Craig 1109 Oxbow, The (Cole) 957, 957-8 Ozenfant, Amédée: The Foundation of Modern Art (with Le Corbusier) 1033

P

Padí 1072 Paik, Nam June 1128 Electronic Superhighway: Continental U.S. 1128, 1128

painting 1068, 1068

painting	Pakistani art 1124, 1125	Personal Appearance #3 (Schapiro) 1101, 1101-2
Abstract Expressionist 1073–80, 1074–80	Palladio, Andrea see Neo-Palladianism	Philadelphia, Pennsylvania
African-American 983, 983-4, 1065, 1065,	Pantheon, Rome (Piranesi) 915, 915	Abolition Society 921
1112, 1112	Panthéon (church of Sainte-Geneviève), Paris	Centennial Exhibition (1876) 981
American 904, 905, 927–9, 929, 931–2,	(Soufflot) 932, 933, 934	Institute of Contemporary Art 1118
932 (18th century), 957, 957–8	Paris 913, 965, 972, 987, 993, 1095	Jefferson Medical College 980, 981
(Romantic), 980–92, 981–3 (Realist),	Académie des Beaux-Arts 964, 966, 972, 977	Vanna Venturi House, Chestnut Hill (Venturi)
993, 993 (Impressionist), 1065, 1067,	Arc de Triomphe 951, 951	1106, 1106
1067 (Regionalist), 1073–80, 1074–81	Bibliothèque Nationale (Labrouste) 1008,	Philip V, of Spain 940
(Abstract Expressionism), see also African-	1008	photography 968-9, 971, 971
American painting	Café Guerbois 979	American 969, 970-71 (19th century), 1040-
Brazilian 1070, 1070–71	Carrousel Arch 912	41, 1041, 1044, 1044, 1061, 1061, 1066,
in Britain 922-31, 923-7, 929-31 (18th	École des Beaux-Arts 946, 964, 967, 980, 990,	1066 (early 20th century), 1089, 1089-91
century), 954-5, 955, 956, 957	991, 993, 995, 1003, 1007, 1008, 1009,	1090 (1950s and 1960s), 1109, 1109-10
(Romantic), 984, 984 (Pre-Raphaelite),	1011	(Postmodern)
1071, 1071 (postwar)	Eiffel Tower (Eiffel) 962, 963, 1004, 1031	British 969-70, 970, 971, 971
Canadian 1067, 1067-8	Exposition (1938) 1062	Cuban 1102, 1102
Cuban 1070, 1071, 1072, 1072	Festival de la Libre Expression 1089	digital 971, 1130
Dutch 996, 997, 998, 998–9	Fiore Internationale d'Art Contemporain	documentary 970, 970, 1066, 1066
Expressionist 1028, 1028-9, 1029	1129	French 969, 969
French 908, 908–12, 909–11 (Rococo), 934,	French Royal Academy of Painting and	Iranian 1124, 1124
934–9, <i>935–9</i> (18th century), 946–51,	Sculpture 910, 911, 914, 926, 935, 938–9,	photomontage 1039
947-50, 952, 952 (Romantic), 972 (avant-	964, see also Salon, Paris	Pia de'Tolomei, La (Rossetti) 984, 984
garde), 972, 972-80, 973-9 (Realist), 979,	hôtels 907	Picasso, Pablo 1017, 1021-2, 1024, 1031, 1035,
987-91, <i>988-92</i> , 993, 994 (Impressionist),	International Exposition of Modern	1036, 1068, 1072
994-5, 995, 999, 1000 (Post-	Decorative and Industrial Arts (1925)	La Bouteille de Suze (Bottle of Suze) 1025,
Impressionist), 1001, 1001 (Symbolist),	1050, 1051	1025-6
1019–21, 1020, 1021 (Fauves), 1021,	Louvre 926, 968, 1022, 1039	Family of Saltimbanques 1022, 1022
1024, 1024, 1025 (Cubist), 1031-3, 1032	Métro entrances (Guimard) 1006	Guernica 1062-3, 1062-3
(early 20th century)	Opéra (Garnier) 965–6, 966, 967	Ma Jolie 1016, 1017, 1025
German 916, 916 (Neoclassical), 958, 958	Panthéon (church of Sainte-Geneviève)	Mandolin and Clarinet 1026, 1026
(Romantic), 1026-8, 1027, 1028 (Die	(Soufflot) 932, 933, 934	Portrait of Daniel-Henry Kahnweiler 1024, 1025
Brücke/The Bridge), 1028, 1028-9, 1029,	Salon de la Princesse, Hôtel de Soubise	picturesque gardens, English 919
1056 (Expressionist), 1029, 1030 (Der	(Boffrand) 907, 907–8	Pilgrimage to the Island of Cythera (Watteau) 909,
Blaue Reiter/"The Blue Rider"), 1107-8,	Universal Exposition (1889) 963, 1001	909-10
1108 (Neo-Expressionist), 1109, 1109	Universal Exposition (1937) 1052, 1052	Pima nation 945
(Postmodern), 1071, 1072 (Art Informel)	Vendôme Column 912	Pink Panther (Koons) 1114, 1114
Impressionist 979, 987-91, 988-92, 993, 994	see also Salons	Piranesi, Giovanni Battista 915
Italian 914, 914-15 (18th century)	Paris Street, Rainy Day (Caillebotte) 993-4, 994	View of the Pantheon, Rome (etching) 915, 915
landscape painting 954-5, 955, 956, 957	Parker, Charlie 1109	Piss Christ (Serrano) 1118, 1119, 1119
(British), 957, 957-8 (American), 958,	parks, urban 1010	Pissarro, Camille 979, 987, 989–90, 1012
958 (German), 975, 975, 989, 989–90	Central Park, New York (Olmsted and Vaux)	Wooded Landscape at L'Hermitage, Pontoise 989,
(French), 1067, 1067-8 (Canadian)	1010, 1010	990
Mexican 1068–70, 1069	Parnassus (Mengs) 916, 916	Planck, Max 1018
Native American 1068, 1068	Pasadena Museum of Art: Pop art exhibition	plein air painting 987, 989, 990
Neoclassical 913, 915, 916, 916, 926–7, 927,	1094	Plenty's Boast (Puryear) 1117
945	pastels 914, 992	Plum Orchard, Kameido (Hiroshige) 996, 996
Neo-Expressionist 1107–9, 1108	Pasteur, Louis 964	pluralism 1107
Post-Impressionist 994–5, 995, 998, 998–9,	Pastoral Concert, The (Titian) 977	Poe, Edgar Allan 1000
<i>1000</i> , 1012–14, <i>1013</i> –15	Pavlov, Ivan 1018	"Pointillism" 995, 999
Postmodern 1107–9, 1108, 1109	Paxton, Joseph: The Crystal Palace 1007, 1007–8	Poissy-sur-Seine, France: Villa Savoye (Le
Rococo 908, 908–12, 908–11	"peacock and Dragon" curtain (Morris) 985, 985	Corbusier) 1045, 1045–6
Romantic 929–32, <i>930–32</i> (in Britain),	Peláez, Amelia 1071	Pollock, Jackson 1074–5, 1076, 1076, 1079,
946–51, 947–50, 952, 952 (French)	Marpacífico (Hibiscus) 1070, 1071	1088
Spanish 940–43, <i>941</i> , <i>942</i> (18th century),	Pencil of Nature, The (Talbot) 969	Autumn Rhythm (Number 30) 1075, 1075
1057–8, 1058, 1059, 1059–60 (Surrealist);	Pennsylvania Academy of the Fine Arts 980, 983,	Pompadour, Madame de 910
see also Picasso, Pablo	993 D. Communication 1097, 1099, 0, 1099	Pompeii, Italy 913
Symbolist 1000–1, 1001, 1002, 1003	Performance art 1087, 1088–9, 1089	Pop art 1091, 1091–5, 1092–5, 1131
Uruguayan 1073, 1073	Perón, Juan 1072–3	Portrait of a German Officer (Hartley) 1042, 1043
see also portraiture; self-portraits	Perpendicular Gothic style 958–9, 959	Portrait of Daniel-Henry Kahnweiler (Picasso) 1024
Painting (Wols) 1072, 1072	Perry, Lilla Cabot 988	1025

American 904, 905 in France 972, 972-80, 973-9, 986, 994 Academy of St. Luke 914, 927 British 923-4, 924, 925 in Russia 980, 980 French Academy 910, 926 in United States 980-82, 981, 982, 983, 983-4 French 935, 935-6, 936, 952, 953 Pantheon 915, 195 Italian 914, 914-5 Rebellious Silence (Neshat) 1124, 1124 Villa Albani 915-16; Parnassus (Mengs) 916, 916 Recumbent Figure (Moore) 1060, 1061 photographic 969, 969, 971, 971 Villa Borghese: Pauline Borghese as Venus "Red-Blue" Chair (Rietveld) 1052, 1054 (Canova) 917, 917 see also self-portraits Red Canna (O'Keeffe) 1043, 1044 Posey, Willi 1111 Roosevelt, President Franklin D. 1018 Post-Impressionists 994-5, 995, 998, 998-9, Rehearsal on Stage, The (Degas) 991, 992, 993 Rosenberg, Harold 1074, 1075 1000, 1012-14, 1013-15 Rembrandt van Rijn 1071 Rossetti, Dante Gabriel 984 Postmodernism 1107 The Anatomy Lesson of Dr. Tulp 981 La Pia de' Tolomei 984, 984 in architecture 1106, 1106-7, 1107 Renoir, Pierre-Auguste 979, 987, 990 Rothko, Mark 1080 Moulin de la Galette 990, 990-91 and gender 1109-11 Lavender and Mulberry 1079, 1080 in painting 1107-9, 1108, 1109 Repin, Ilya 980 Magenta, Black, Green, on Orange (No. 3/No. 13) and race/ethnicity 1111-14 Bargehaulers on the Volga 980, 980 poussinistes 946 Restany, Pierre 1088 Rouault, Georges 1019 Prairie Style houses (Wright) 1046 Reynolds, Sir Joshua 923, 927, 928, 929, 930 Rouen Cathedral: The Portal (Monet) 988, 989 Pre-Raphaelite Brotherhood 984 Fifteen Discourses to the Royal Academy 923, 928 Rousseau, Jean-Jacques 939 Lady Sarah Bunbury Sacrificing to the Graces Primary Structures 1095 Royal Academy of Art, London 923, 926, 926, 923-4, 924 927, 928, 984, 1119 primitivism 1022-3, 1027 Print Lovers, The (Daumier) 954, 954 Ribera, Jusepe de 980 rubénistes 956 prints/printmaking 954, 954, 977, 978 Richardson, Henry Hobson 1009-10 Rubens, Peter Paul: Marie de' Medici cycle 908 Daumier 953, 953-4, 954 Marshall Field Wholesale Store 1010-11, Rude, François 967 Goya 940-41, 941 Departure of the Volunteers of 1792 (The Richmond, Virginia, State Capitol: George Piranesi 915, 915 Marseillaise) 951, 951 Raimondi 977 Washington (Houdon) 939-40, 940 Rue Transnonain, Le 15 Avril 1834 (Daumier) 953, 953 - 4Toulouse-Lautrec 1006, 1006-7 Richter, Gerhard 1109 Warhol 1092, 1092-3, 1093 Man Shot Down (1) Erschossener (1) from October Ruscha, Ed 1093-4 18, 1977 1109, 1109 Prix de Rome 911, 926, 936, 939, 966 Standard Station, Amarillo, Texas 1094, 1094 Process art 1098, 1099, 1099 Rietveld, Gerrit 1052 Ruskin, John: Whistler trial 985, 987, 1038 Proudhon, Pierre-Joseph 973, 987 "Red-Blue" Chair 1052, 1054 Russia/Soviet Union 1018, 1034, 1050, 1084 Proun Space (Lissitzky) 1051, 1051 Schröder House, Utrecht 1052, 1053, 1054, Constructivism 1050, 1050-51, 1126 Prouns (Lissitzky) 1051 Cubo-Futurists 1034, 1034 Pugin, Augustus Welby Northmore 959 Ringgold, Faith 1111 Socialist Realism 1051-2 Houses of Parliament, London 958-9, 959 Tar Beach (from Women on a Bridge series) "The Wanderers" (group) 980, 980 Purism 1033, 1054, 1057 1111, 1111-12 Russian Revolution (1917) 1018, 1050 Puryear, Martin: Plenty's Boast 1117 Riopelle, Jean-Paul 1079 Knight Watch 1078, 1079 S Rivera, Diego 1068 Q The Great City of Tenochtitlan 1069, 1069 Saarinen, Eero: Trans World Airlines (TWA) quantum theory 1018 Robie House, Chicago (F. Wright) 1046, 1046, Terminal, Kennedy Airport, New York 1104, Rococo style 907, 916, 932, 934 Saatchi Collection 1118, 1119 R architecture 912-13, 913 Said, Edward 968 Raft of the "Medusa," The (Géricault) 947, 948, church decoration (Germany) 912-13, 913 St. Louis, Missouri: Wainwright Building 948-9, 950, 1113 interior decoration 907, 907-8 (Sullivan) 1011-12, 1012 railways 964 painting 908, 908-12, 909-11 St. Petersburg Academy of Art 980 sculpture 908, 912, 912 Raimondi, Marcantonio: The Judgment of Paris Saint-Simon, Count Henri de 972, 975 (engraving) 977 Rodchenko, Aleksandr 1050 Salcedo, Sebastian: Virgin of Guadalupe 943, 944 Raoul-Rochette, Madame Désiré (née Last Painting 1050 Salon, Paris 926, 934, 946, 987, 1019; 934 (1739), Antoinette-Claude Houdon): portrait Workers' Club 1050, 1051 936 (1775), 950 (1819), 975, 976 (1848), (Ingres) 952-3, 953 Rodin, Auguste 1003, 1036, 1041 973, 974 (1850-51), 976 (1863), 979 (1865), Raphael (Raffaello Sanzio) 945, 952 The Burghers of Calais 1002, 1003 979 (1867), 1001 (1876), 1023 (1906) Romanticism 907, 917-18, 922, 950 The Judgment of Paris 977 Salon d'Automne, Paris 1019 rationalism 906, 907 in landscape painting 954-5, 955, 956, 957 Salon des Refusés, Paris 976 Rauschenberg, Robert 1083, 1084, 1085, 1087, salons, Parisian 907 (British), 957, 957-8 (American), 958, 958 1090, 1092 Savage, Augusta 1064, 1065 Canyon 1086, 1087 in painting 929-32, 930-32 (in Britain), 942, La Citadelle: Freedom 1064, 1065 942-3 (Spanish), 946-51, 946-50, 952, Raynal, abbot Guillaume 938 Schapiro, Miriam 1101, 1102

952-3 (French)

in sculpture 951, 951

Realism (in painting)

Rome 913, 915

Dollhouse 1101

Personal Appearance #3 1101, 1101-2

Read, Herbert 1060

readymades (Duchamp) 1038-9

portraiture

Armored Train in Action 1033, 1033 steel, development of 964, 1011, 1018 Self-Portrait Nude 1029, 1029 Steichen, Edward 1089 Severn River Bridge, Coalbrookdale, England Schinkel, Karl Friedrich: Altes Museum, Berlin Stein, Gertrude and Leo 1020-21 959-60, 960 (Darby III), 928, 928 Sévigné, Madame de 907 Steiner House, Vienna (Loos) 1044-5, 1045 Schmidt-Rottluff, Karl 1026 Stendhal (Marie-Henri Beyle) 950 Sèvres porcelain manufactory 910 Schneemann, Carolee 1089 Sherman, Cindy: Untitled Film Stills 1109, Stereo Styles (Simpson) 1112, 1112 Meat Joy 1089, 1089 1109-10 Stieglitz, Alfred 1041, 1043, 1044 Schoenberg, Arnold 1031 The Flatiron Building, New York 1041, 1041 Schoenmaekers, M. H. K.: New Image of the World Shimamoto, Shozo: Hurling Colors 1087, 1088 291 Fifth Avenue (gallery) 1040-41, 1043 Shonibare, Yinka 1134 1052 Still Life with Basket of Apples (Cézanne) 1014, 1014 Schröder House, Utrecht (Rietveld) 1052, 1053, How To Blow Up Two Heads At Once (Ladies) 1054, 1054 1134, 1135 Stone Breakers, The (Courbet) 972, 972-3 Schulze, Wolfgang see Wols Sierra, Santiago 1135 Stourhead, Wiltshire, England: gardens (Flitcroft Schwitters, Kurt 1039 133 People Paid to Have Their Hair Dyed Blond and Hoare) 919, 919 Merzbild 5B (Picture-Red-Heart-Church) 1039, 1135, 1135 Strand, Paul 1044 Sighting of the "Argus," The (Géricault) 948, 949 Strawberry Hill, Twickenham, England (Walpole) 1039 Signboard of Gersaint, The (Watteau) 908, 908, 909 920,921-2Merzbilder 1039 Scream, The (Munch) 1001, 1001 Silhouette, La (magazine) 953 Picture Gallery (Walpole, Chute, and Bentley) silkscreen prints 1092, 1092-3, 1093 922, 922 sculpture Street, Berlin (Kirchner) 1028, 1028, 1056 African-American 982-3, 983, 1064, 1064-5 silverwork Bauhaus 1055, 1055 stuccowork, Rococo 908 American 1080, 1081 (New York School), Study of Hands and Feet (Géricault) 949, 949 1095-6, 1096 (Minimalist), 1114, British 921 Simpson, Lorna: Stereo Styles 1112, 1112 sublime, concept of the 955, 957 1114-16, 1115, 1116 (1980s), 1130, 1130 Siqueiros, David 1068 Succulent (Weston) 1044, 1044 (new media), see also African-American site-specific works 1102, 1103, 1103 suffrage movements, US 921, 964 sculpture Sullivan, Louis 1011, 1046, 1049 British 1060, 1060 Sky Cathedral (Nevelson) 1084, 1085 Cubist 1026, 1026 skyscrapers, American 1011, 1049, 1049, 1050 Wainwright Building, St. Louis, Missouri French 908, 912, 912 (Rococo), 951, 951 slave trade 921, 931-2, 938 1011-12, 1012 Sleep of Reason Produces Monsters, The (from Los Sun, The (Chihuly) 1130, 1130 (Romantic), 967, 967, 994, 1002, 1003, Caprichos) (Gova) 940-41, 941 Sunday Afternoon on the Island of La Grande Jatte, A 1003 (19th century) (Seurat) 995, 995, 998 Italian 916-17, 917 (Neoclassical), 1033-4, Smith, David 1080 Suprematism 1035, 1050, 1126 1034 (Futurist) Cubi 1080, 1081 Suprematist Painting (Eight Red Rectangles) Smith, Kiki 1121 Mexican 943, 943 (Malevich) 1035, 1035 Untitled (1990) 1121, 1122 Minimalist 1095-6, 1096 Smithson, Robert 1102 Surrealism 1019, 1057, 1059-60, 1073 Neoclassical 916-17, 917 (Italian), 939-40, Spiral Jetty 1102, 1103 and automatism 1057, 1079 940 (French) in painting 1057-8, 1058, 1059, 1059-60 Rococo 908, 912, 912 Snake Charmer, The (Gérôme) 968, 968 Swing, The (Fragonard) 911, 911-12 Snowstorm: Hannibal and His Army Crossing the Romanian 1036, 1036-7 Symbolism 994, 999-1000 Romantic 951, 951 Alps (Turner) 956, 957 in painting 1000-1, 1001, 1002, 1003 Seagram Building, New York (Mies van der "Social Darwinism" 964 Socialist Realism 1051-2 Synthetic Cubism 1025-6 Rohe and Johnson) 1104, 1104 Searle, Berni 1124 Société Anonyme des Artistes Peintres, Untitled (from Color Me series) 1124, 1125 Sculpteurs, Graveurs, etc. 987 т Soufflot, Jacques-Germain: Panthéon (church of Seasons, The (Krasner) 1076, 1076 Sainte-Geneviève), Paris 932, 933, 934 tachisme 1071–2 self-portraits South African art 1124, 1125 Talbot, Henry Fox 969 Self-Portrait as a Fountain (Nauman) 1098, 1099 The Open Door 970, 970 Self-Portrait Nude (Schiele) 1029, 1029 Soviet Union see Russia Spain 940, 942, 943 The Pencil of Nature 969 Self-Portrait with an Amber Necklace Tanner, Henry Ossawa 983, 993 (Modersohn-Becker) 1028-9, 1029 architecture (Art Nouveau) 1005, 1005 The Banjo Lesson 983, 983-4 Self-Portrait with Two Pupils (Labille-Guiard) painting and etching 940-43, 941, 942 (19th century), 1057-8, 1058, 1059, 1059-60 Tapié, Michel 1072 938, 939 (Surrealist); see also Picasso, Pablo Tar Beach (from Women on a Bridge series) The Two Fridas 1069, 1069-70 Serra, Richard 1114-15 Spanish Civil War (1936-9) 1018, 1062 (Ringgold) 1111, 1111-12 Target with Plaster Casts (Johns) 1082, 1083, 1087 Speak of Me As I Am (Wilson) 1136 Tilted Arc 1115, 1115 Tatlin, Vladimir 1035, 1036 Serrano, Andres 1116, 1118 Spiral Jetty (Smithson) 1102, 1103 Corner Counter-Reliefs 1035, 1035 Piss Christ 1118, 1119, 1119 Staël, Madame de 907 Stalin, Joseph 1018 ter Broch, Gerard 909 Seurat, Georges 995, 999 A Sunday Afternoon on the Island of La Grande Standard Station, Amarillo, Texas (Ruscha) 1094, textiles 1094 Bauhaus silk wall hanging (A. Albers) 1055, Jatte 995, 995, 998 1055, 1057 Seven Years War (1756-63) 928 Standing Child (Heckel) 1027, 1027 Gobelin tapestries 910 Stanton, Elizabeth Cady 964 Seventeen magazine 1091

Severini, Gino 1033

Schiele, Egon 1029

Starry Night, The (van Gogh) 998, 999

Theosophy 1052 Third of May, 1808 (Goya) 942, 942-3 Third Text (magazine) 1124 Thomas Mifflin and Sarah Morris (Mr. and Mrs. Mifflin) (Copley) 904, 905 Thompson, Florence Owens 1066, 1066 Thomson, Tom 1067, 1068 The Jack Pine 1067, 1067-8 Thornton, William: U.S. Capitol, Washington, DC 960 Three Women (Léger) 1032, 1033 Thus Spake Zarathustra (Nietzsche) 1026 Tilted Arc (Serra) 1115, 1115 Titian The Pastoral Concert 977 "Venus" of Urbino 978, 979 Toomer, Jean 1060 Torres-García, Joaquin 1073 Abstract Art in Five Tones and Complementaries 1073, 1073 Torso of a Young Man (Brancusi) 1036, 1036-7 Toulouse-Lautrec, Henri de 1006 Jane Avril (poster) 1006, 1006-7 Trans World Airlines (TWA) Terminal, Kennedy Airport, New York (Saarinen) 1104, 1105 Tree of Life series (Mendieta) 1102, 1102 Trinity Church, New York (Upjohn) 959, 959 Trolley, New Orleans (Frank) 1090, 1090-91 Tub, The (Degas) 992, 993 Tucson, Arizona: Mission San Xavier del Bac 943, 945, 945 Turner, Joseph Mallord William 955, 957, 978 The Burning of the Houses of Lords and Commons, 16th October 1834 956, 957 Snowstorm: Hannibal and His Army Crossing the Alps 956, 957 Twickenham, England: Strawberry Hill (Walpole and others) 920, 921-2, 922 Two Fridas, The (Kahlo) 1069-70 291 Fifth Avenue (gallery), New York 1040-41, 1043

Tzara, Tristan 1039

U

Unique Forms of Continuity in Space (Boccioni)

1033–4, 1034
Unit One 1060
United Nations 1084
United States of America 906, 913, 1018, 1084
American War of Independence 906
architecture 943, 945, 945 (Spanish colonial),
959, 959 (Gothic Revival), 960, 960–61,
961 (Neoclassical), 1009, 1009–12, 1011,
1012 (Chicago School), 1046, 1046, 1047,
1048, 1048, 1104–6, 1105 (Modernist),
1104, 1104 (International Style), 1106,
1106–7, 1107 (Postmodern)
Conceptual art 1096–7, 1097, 1098, 1099
"Culture Wars" 1116, 1118, 1120

documentary photography 1066, 1066 feminism/feminist art 1100-2, 1100-2, 1109-11, 1110 Great Depression 1018 Harlem Renaissance 1060-61, 1064-5 Neo-Expressionist 1108, 1108-9 painting 904, 905, 927-9, 929, 931-2, 932 (18th century), 957, 957-8 (Romantic), 980-92, 981-3 (Realist), 993, 993 (Impressionist), 1065, 1067, 1067 (Regionalist), 1073-80, 1074-81 (Abstract Expressionist), see also African-American painting; Whistler, James Abbott McNeill photography 969, 970-71 (19th century), 1040-41, 1041, 1044, 1044, 1061, 1061, 1066, 1066 (early 20th century), 1089, 1089-91, 1090 (1950s and 1960s), 1109, 1109-10 (Postmodern) Pop art 1092, 1092-5, 1093-5 sculpture 1080, 1081 (New York School), 1095-6, 1096 (Minimalist), 1114, 1114-16, 1115, 1116 (1980s), 1130, 1130 (new media), see also African-American sculpture skyscrapers 1011-12, 1012, 1049, 1049, 1050 suffrage movement 921 video art 1128-9, 129 women's rights movement 964 Works Progress Administration 1065, 1066 see also African Americans; Native Americans Universal Exposition, Paris (1937) 1052, 1052 Universal Exposition, Paris (1889) 963, 1001 Untitled (Hammons) 1134, 1134 Untitled (Judd) 1096, 1096 Untitled (K. Smith) 1121, 1122 Untitled Film Stills (Sherman) 1109, 1109-10 "Untitled" (Loverboy) (Gonzales-Torres) 1120, Untitled (Mirror Cube) (R. Morris) 1096, 1096 Untitled (Your Gaze Hits the Side of My Face) (Kruger) 1110, 1110-11 Upjohn, Richard 959 Trinity Church, New York 959, 959

V

Utrecht, Netherlands: Schröder House (Rietveld)

Uruguayan art 1073, 1073

1052, 1053, 1054, 1054

Vanderbilt, Cornelius 976
Van Der Zee, James 1061
Couple Wearing Raccoon Coats with a Cadillac
1061, 1061
vanitas themes 909
Vanna Venturi House, Chestnut Hill, Philadelphia
(Venturi) 1106, 1106
Vaux, Calvert: Central Park, New York 1010,
1010
Vauxcelles, Louis 1019
VB35 (Beecroft) 1132–3, 1133

veduta (pl. vedute) 915 Velázquez, Diego 980 Las Meninas 941-2 Pope Innocent X 1071 Velderrain, Juan Bautista 945 Venice, Italy 913 The Doge's Palace and the Riva degli Schiavoni (Canaletto) 914, 915 Venice Biennale 1129, 1135, 1135, 1136, 1136 Venturi, Robert 1106 Complexity and Contradiction in Architecture 1106 Vanna Venturi House, Chestnut Hill, Philadelphia 1106, 1106 "Venus" of Urbino (Titian) 978, 979 Versailles, Palace of 910 Versailles, Treaty of 1018 Vicenza, Italy: Villa Rotonda (Palladio) 918 Victory Over the Sun (Matiushin) 1034 Video art 1128, 1128-9, 1129 Vienna: Steiner House (Loos) 1044-5, 1045 Vierzehnheiligen church, Bavaria, Germany (Neumann) 912-13, 913 Vietnam Veterans Memorial, Washington, DC (Lin) 1115-16, 1116 Vietnam War (1954-75) 1084, 1095, 1115 View of the Pantheon, Rome (Piranesi) 915, 915 Vigée-Lebrun, Marie-Louise-Élisabeth 935 Marie Antoinette with Her Children 935, 935-6 Villa Albani, Rome 915-16 Parnassus (ceiling fresco) 916, 916 Village Bride, The (Greuze) 934, 935 Villa-Lobos, Hector 1070 Villa Rotonda, Vicenza, Italy (Palladio) 918 Villa Savoye, Poissy-sur-Seine, France (Le Corbusier) 1045, 1045-6 Viola, Bill: The Crossing 1128-9, 1129 Violin and Palette (Braque) 1024, 1024 Viollet-le-Duc, Eugène 972 Vir Heroicus Sublimis (Newman) 1080, 1080 Virgin of Guadalupe (Salcedo) 943, 944 Vitra Fire Station, Weil-am-Rhein, Germany (Hadid) 1126, 1127 Vlaminck, Maurice de 1019

W

Voltaire 939

Wainwright Building, St. Louis, Missouri
(Sullivan) 1011–12, 1012

Walker, Kara 1136

Darkytown Rebellion 1136, 1137

Walker Art Center, Minneapolis: "Brilliant"
1119

Wall, Jeff 1130

After "Invisible Man" by Ralph Ellison, The
Preface 1130, 1131

Walpole, Horace 921, 930

The Castle of Otranto 921

Strawberry Hill, Twickenham 920, 921–2, 922

Waltz, The (Claudel) 1003, 1003, 1004

Declaration of Independence 931

"Wanderers, The" 980 Warhol, Andy 1092, 1093, 1094, 1107 Brillo Soap Pads Box 1092, 1092 Marilyn Diptych 1092-3, 1093 Washington, George: statue (Houdon) 939-40, Washington, DC Corcoran Gallery of Art 1118 U.S. Capitol (Latrobe) 960, 960-61 Vietnam Veterans Memorial (Lin) 1115-16, 1116 Watson, Brook 931, 932 Watson and the Shark (Copley) 931-2, 932 Watteau, Jean-Antoine 908 Pilgrimage to the Island of Cythera 909, 909-10 The Signboard of Gersaint 908, 908, 909 Webb, Philip: Sussex range chair 985, 985 Wedgwood, Josiah 919-20, 924 "Am I Not a Man and a Brother?" (jasperware medallion) 920, 921 The Apotheosis of Homer (jasperware) 919, 920 Weil-am-Rhein, Germany: Vitra Fire Station (Hadid) 1126, 1127 Weimar Republic 1040, 1054 Weissenhofsiedlung exhibition, Stuttgart (1927) 1057 West, Benjamin 915, 927-8 The Death of General Wolfe 928-30, 930, 932,

940 Weston, Edward 1044 Succulent 1044, 1044 Whistler, James Abbott McNeill 986–7, 1031, 1038 Nocturne in Black and Gold, the Falling Rocket

985, 986, 987 Whiteread, Rachel 1123 *House* 1123, *1123* Wildmon, Reverend Donald 1118 Wilson, Fred Chandelier Mori 1136, 1136 Mining the Museum 1136 Speak of Me As I Am 1136 Winckelmann, Johann Joachim 916, 928, 929, 932 The History of Ancient Art 916 Thoughts on the Imitation of Greek Works in Painting and Sculpture 916 Winsor, Jackie 1099 Burnt Piece 1099, 1099 Wittgenstein, Ludwig 1097 Wodiczko, Krzysztof: Homeless Vehicle 1121, 1122, 1123 Wojnarowicz, David 1121 "Untitled (Hands)" 1121, 1121 Wolfe, General James 928-9, 929

Woman I (de Kooning) 1076–7, 1077
Woman with the Hat, The (Matisse) 1020, 1020–21
Womanhouse (art environment) 1101
Women on a Bridge series (Ringgold) 1111,
1111–12
women's rights movement 964, see also
feminism/feminist art
Wood, Grant 1065
American Gothic 1064, 1067, 1067
woodblock prints, Japanese 996, 996
woodcut, color 1027, 1027
Wooded Landscape at L'Hermitage, Pontoise

Wols (Wolfgang Schulze) 1072

Painting 1072, 1072

Worker and Collective Farm Woman (Mukhina) 1052, 1052

Woolworth Building, New York (Gilbert) 1049,

(Pissarro) 989, 990

Workers' Club (I Exposition of Industrial Arts, I Works Progress Admin World War I 1018, 1019 World War II 1018, 1071, World's Columbian Expositi Worpswede, Germany: artists' re Wren, Sir Christopher: St. Paul's London 932 Wright, Frank Lloyd 1046 Fallingwater (Kaufmann House), Mil Pennsylvania 1046, 1047, 1048 Guggenheim Museum, New York 1105, 1105-6, 1128 Prairie Style houses 1046 Robie House, Chicago 1046, 1046, 1047 Wright, Joseph, of Derby 924 An Experiment on a Bird in the Air-pump 924, 925, 926

Yard (Kaprow) 1087, 1088 Young British Artists (YBAs) 1118, 1119, 1123 Young Ladies of Avignon, The (Picasso) 1023, 1023–4

Z

Zambezia, Zambezia (Lam) 1072, 1072
Zoffany, Johann: Academicians of the Royal Academy 926
Zola, Émile 972
Zürich 1037
Cabaret Voltaire 1037

Odchecko), International. Modern Decorative and Marie (1925) 1050, 1051 The Common 1031, 1030, 1051 072. 1113. 1000; Teat 1028 athedra. Run.